MW01487183

The Connoisseur's Book of Japanese Swords

Kokan Nagayama

Translated by Kenji Mishina

Kodansha International
Tokyo • New York • London

NOTE TO THE READER:

In general, whenever possible, Japanese terms have been used for specialized sword vocabulary. Basic sword terminology is explained in Chapter 2, while other terms appear in the Glossary.

Given their frequent appearance in the text, Japanese terms have been set in roman rather than italic type.

People's names in the text are given in the Japanese order, with family name first.

Kanji have also been given for the names of swordsmiths who are of particular historical significance.

Originally published as *Token Kantei Tokuhon* (Nagayama Bijutsu Token Kenma-jo, Tokyo, 1995 [rev. ed.]).

Distributed in the United States by Kodansha America, LLC, and in the United Kingdom and continental Europe by Kodansha Europe Ltd.

Published by Kodansha International Ltd., 17–14 Otowa 1-chome, Bunkyo-ku, Tokyo 112-8652.

First edition, 1997
20 19 18 17 16 15 14 13 12 11 10 18 17 16 15 14 13 12 11 10

www.kodansha-intl.com

CONTENTS

Chapter III THE WORKMANSHIP OF THE LEADING SWORDSMITHS 115

The Main Schools and Evolution of the Mino (美濃) Tradition 215

Workmanship of Shinto Times 226

Provinces and Schools of Shinto Times 233

Chapter IV GUIDE TO JAPANESE SWORD APPRECIATION 307

FOREWORD

In no other country or culture has the sword achieved the level of technical perfection and spiritual importance that it has in Japan. Nowadays a great many people outside the country are inspired by the Japanese sword as both a work of art and the definitive edged weapon. This inspiration may take the form of aesthetic appreciation or interest in practical applications such as kendo and iai-do, but it has never been easy for a non-Japanese person to study and fully understand the Japanese sword. When many of the early large collections were made by wealthy European and American collectors in the Meiji period, Japanese swords were considered to be exotic weapons of great quality and therefore worthy of collection. A few of these collectors wrote pioneering books on the subject at this time, which remained the only works available in English for many years. It is only comparatively recently—in the last thirty years or so—that translations of books by Japanese authorities have started to find their way onto the bookshelves of collectors outside the country. Although some were of little practical use, others gave basic information on swords and fittings; in many cases it was these early publications which fired the interest of a postwar generation of Japanese sword collectors worldwide.

One of the many problems, especially for the beginning or less advanced student of the Japanese sword, is the terminology involved. The words used to describe various components and features are often rather poetic and obscure, and for the most part unfamiliar to any modern Japanese person who is not specifically trained in sword history. Initially, coming to grips with these alien terms may be very

difficult, but it is certainly worth the effort to learn at least the most commonly used expressions. It is surprising how easy it is to talk to someone from another culture, with virtually no common language, when both fully understand the terminology of a shared interest. This is similar to many other specialized fields that have their own technical vocabulary. If these terms are difficult to absorb, then the old-fashioned kanji (Chinese characters) used in blade inscriptions would at first appear to be an unscaleable mountain.

When I first began collecting and studying Japanese swords in the late 1960s, I was amazed that a number of perfectly ordinary non-Japanese people who were interested in swords were actually able to read the kanji that comprised the signatures on the nakago, or tang. This feat seemed to me so far beyond the capabilities of mere Western mortals, and of my limited brain capacity in particular, that I almost gave up the study then and there. Fortunately I persevered, and some thirty years later I am now frequently asked to translate signatures for others. Whilst it is still not always easy, I have become reasonably competent at it, proving that practice and familiarity do triumph in the end. I can well understand, therefore, how strange it can seem to see someone look at a blade on which no inscription is visible, and then go on to attribute it not only to a swordmaking period, but to specify a school, or even the particular swordsmith who made it! Is this magic, or some sort of divine inspiration? No! It is simply proficiency at kantei nyusatsu.

Kantei is the process whereby, studying the shape, quality, construction and individual

characteristics of a blade, an accurate attribution may be made as to its age and maker. This is an important and fundamental learning process and a degree of competence in it is essential to fully understanding and appreciating the beauty that is the Japanese sword. I often notice at sword club meetings that members seem unwilling or nervous about participating in kantei sessions, possibly to avoid a perceived embarrassment at reaching a wrong conclusion. This is a negative approach that should be avoided. A wrong answer is often more educational than a correct attribution, since it provides new facts for one's mental data-base. Frequently in Japan I have been asked to do kantei, sometimes on the most unexpected of occasions. This may indeed be a traumatic experience, especially when it must be done in the presence of well-known, knowledgeable people in the sword world. The opportunities for making a complete fool of oneself are almost infinite. In this case, after gathering all the facts together in one's often jet-lagged brain, one must boldly and irrevocably deliver an answer. Once invited, there is no hope of declining to take part, because the loss of face and credibility would be enormous, just as one cannot very well refuse to join in a karaoke sing-song on a night out. A good judgement, even if not "atari" (the actual swordsmith), is a passport to being shown better swords since it serves to convince everyone that you have at least some idea of what you are looking at. Now it is apparent that the viewing of a better sword would not be wasted on you. A close answer will produce hints, such as "You're in the right period but the wrong school," which may be followed up by a second and a third attempt—opportunities to amend your answers in keeping with the hints given.

The practice of kantei has been criticized as laying too much emphasis on simply naming the swordsmith or putting a blade into a neat category, whilst paying little or no attention to appreciation of the quality of the blade. This is not altogether true, as the quality of a blade may well lead one to judge that it was made by a certain swordsmith who was capable of that quality of workmanship, rather than another who was not. I am sure that a full understanding of the sword's origins, gained from successful kantei, will allow an informed appreciation of the artistic properties of a particular blade.

It is always assumed that the participant in a kantei session is familiar with the formalities of sword-handling, and indeed it is important that these be observed for the sake of tradition, politeness and even safety. One could argue that a non-Japanese should pay even more attention and observe greater formality in this situation than his Japanese colleagues, whose familiarity with the occasion may sometimes lead to lapses in the correct etiquette. Such lapses, whilst not ideal, may be overlooked in a Japanese, but might draw attention to the foreigner and possibly jeopardize sword-viewing opportunities for others that might come along later.

The fourteenth-century historical volume *Masu Kagami* notes that Emperor Gotoba of the early Kamakura period was an excellent appraiser of swords; there are indications too that swords were studied even earlier, for their artistic value. Foremost in this activity was the Hon'ami family, who for centuries were the foremost appraisers and polishers of swords for the Tokugawa shoguns, and before that held administrative sword positions (bugyo) for the Ashikaga shoguns. They gave reliable written appraisals and certificates of authenticity (kanteisho) or inscribed red-lacquered attributions on originally unsigned blades or gold attributions on shortened blades. As a family, they were held in great esteem. In order to polish a sword properly, a polisher must have knowledge of the blade's style and maker, and as such polishers are necessarily skilled at kantei. Their understanding of a blade is helped by seeing it in the various intermediate stages of polishing when details become visible that are not always apparent when the polish is finished. It is entirely appropriate, therefore, that *The Connoisseur's Book of Japanese Swords* was written by Nagayama-sensei, one of Japan's top polishers of mukansa grade and a judge of the

annual sword polishing competition, as well as the current head of the Hon'ami polishing tradition.

Nagayama-sensei studied kantei and polishing under Hon'ami Koson, a great polisher and appraiser of Japanese swords. *The Connoisseur's Book of Japanese Swords* is a detailed guide to kantei, which gives remarkable detail on the characteristics of traditions and schools of swordmaking, as well as the individual swordsmiths themselves. Translated by Mishina-sensei, the head pupil of the Nagayama Kenshujo, the book explains the history and development of the Japanese sword over the centuries, from the early continental imports of straight hira-zukuri (ridgeless) blades to the fully-developed Japanese sword with which we are familiar today. It also places the various schools and swordsmiths in historical context. Charts outlining the distinguishing features of individual swordsmiths' work will be of great help in making educated judgements at kantei sessions. Detailed features of blades are illustrated with Nagayama-sensei's own oshigata. These beautifully drawn oshigata, graphically illustrate the various subtle hataraki (workings, or activity) that appear on and embellish the Japanese sword, as well as showing the different horimono, or carvings, favored at different times by different schools and swordsmiths. They represent a creative and original way of illustrating such features.

Nagayama-sensei and his senior pupils have for many years now taken an enlightened approach to the study of Japanese swords outside of Japan. They have been of great assistance to collectors here in Great Britain and in other countries, travelling and living abroad, organizing exhibitions, teaching us and polishing our swords, always in an altruistic spirit. This translation is another example of this same approach. In the past we have often struggled on our own or in small groups to gain an understanding of this peculiarly Japanese cultural asset, and with many of the definitive books on the subject still untranslated, a wealth of information has in the past been inaccessible to the non-Japanese reader.

There is no substitute for handling a blade and looking at it closely to see and understand the subtleties and workings of the blade. The weight, balance, and general feeling play a part in sword appreciation, as do the lines, patterns, and contrasts of the metal itself. It is not possible to gain this insight from books alone, however well produced they may be. Close scrutiny and handing of blades is the only way to gain real understanding of the Japanese sword, but this book will help clarify one's thinking and observations and put things into context. As the title implies, it is a guide to kantei, and is not meant as a substitute for hands-on experience, but rather, an invaluable and constant reference work.

"As there is a way associated with the sword, so it is here."

CLIVE SINCLAIRE
Chairman of the Token Society of Great Britain

TRANSLATOR'S NOTE

I would like to take this opportunity to convey my heartfelt thanks to my friends Clive Sinclaire, chairman of the Token Society of Great Britain, and the late Tony Chapman, former chairman of the society. They both were of great help to me, and never failed to encourage me to complete this difficult task. I have also been encouraged and supported by the enthusiasm shown by the members of the society, and would like to thank them as well.

I would also like to compliment my wife Yuko for her wonderful help, and for her farsightedness in choosing my Christmas present—a word processor. It has improved my work in many ways and greatly accelerated its completion. Since our marriage two years ago I have felt guilty about spending most of my weekend time translating. Now I will be able to spend more time with both my wife and my daughter Miyako, who was born last November. I am well aware of the efforts that non-Japanese sword-lovers are making to rapidly deepen their understanding of the field. I hope that this translation will facilitate the study of the Japanese sword around the world, and bring an increased understanding of the sword's real beauty to a wider audience.

PREFACE

The Japanese sword, one of the nation's representative art forms, is at the same time a cultural heritage bespeaking a long and varied history. The sword was of course originally designed to serve as a weapon, but any study of it will soon reveal that it was a strict insistence on perfecting the function, whether practical or aesthetic, appropriate to successive ages that gave each age a distinctive style of its own. In a sense indeed the sword's artistic value derives precisely from this insistence on function. The sword, moreover, has a symbolic significance; in the past it was often referred to as the "soul of the samurai," and the notion of the sword as an abiding symbol of spiritual values still seems to resonate in the heart of people today.

With all works of art, it seems, a true appreciation of their value depends to an important degree on a basically intellectual discernment; the purely intuitive response tends to be overly personal. Although it is important to develop this personal response by viewing as many excellent works as possible, the intuition must eventually be developed into a more rigorous judgement founded in theory. Of all the Japanese arts, the sword has the most systematic theoretical basis. It is this that makes it possible for a connoisseur to take up a specimen sight unseen, examine it, and then pronounce on the period and place where it was made, the school to which its maker belonged, and even at times the swordsmith's individual name—a procedure known as *kantei* (appraisal, or assessment). Attaining a level of knowledge at which it becomes possible to make such appraisals as a personal hobby calls for no special talent, and can be done by anyone who

applies himself diligently to the subject.

In nyusatsu—a kind of quiz game that often forms part of a kantei-kai ("appraisal meeting") —the business of estimating a piece and submitting one's own judgement on it is not only pleasurable in itself, but also one of the most effective ways of getting to know swords. First of all, one is in the company of many others linked by a common interest. Then, as one's power of discrimination increases, so appreciation of the beauty of the swords deepens. One finds in the end that the quality and range of one's interest, and its objects, have become far removed from what they were at first. At this stage, there are various different courses that the individual may pursue: he may concentrate his future studies on one particular swordsmith; he may do research on sword inscriptions; or he may turn his attention to sword decoration, swordguards or other accessories, all of which employ the finest techniques of decorative art.

The present volume is in no way intended as a specialist or scholarly work. My hope in writing it was to provide a guide for the non-specialist who is hesitating whether or not to go further into the subject. The idea grew steadily during the years that I spent as a sword polisher and, incidentally, as a lecturer at various gatherings of enthusiasts. In my talks at such gatherings, I used as my text my two-volume *Nihon-to Kantei no Kihon*, but this was, as it were, a homemade affair, emended and supplemented in the course of exchanges with members of sword appreciation associations. As such, I had always felt that it was somewhat lacking in the qualities that would qualify it as a book for the general market. The present work, thus, while based on that volume, has

been thoroughly rewritten, and all the illustrations have been redone, so that it should be visually self-explanatory, interesting to the general reader, and at the same time serve as a kind of encyclopedia of the subject.

In the past, systematization of the study of Japanese swords was effected by classifying blades into categories labelled with the place of the sword's provenance followed by the word "mono" (here equivalent to "piece" or "specimen")—as in "Bizen-mono," "Soshu-mono," and so on. First the name of the province where a particular piece originated was given, then the period, the school, and, finally, an account of the style of the individual swordsmith. The trouble with this method was that it naturally took a long time to acquaint oneself with all the swordsmiths who had been active at some point in history; learning enough about swords to make an appraisal was a laborious business.

It was to obviate this difficulty that a method of appraisal was developed that classified sword styles into six traditions, comprising the five characteristic styles that appeared at the sites of ancient sword production—Yamashiro, Yamato, Bizen, Sagami and Mino—together with the special styles of the Shinto ("new sword") tradition. The use of the term "five traditions" does not seem to date back very far, and seems furthermore to have been used without precise definitions. It appears that it was Hon'ami Koson, my own teacher, who—in the period from the Meiji era on into the Taisho era, when there was a growing tendency to see the Japanese sword as an example of fine and decorative art—first clearly established the "six traditions" approach with the idea of further educating the average enthusiast and encouraging general interest in Japanese swords.

I myself believe, with Koson, that the concept of the six traditions provides an effective approach to sword appraisal, and have accepted it here, though with some modifications. First, I felt that it was important to emphasize just how the Japanese sword has changed in the course of history: the shape of a sword is typical of its period. Secondly, I felt it was necessary to give a firm grasp of the charac-

teristics of the six traditions, which is helpful in understanding the various schools. Add to these two complementary requirements a knowledge of the styles of the leading swordsmiths, and one is equipped to join in the nyusatsu gatherings mentioned above. If I have succeeded in the admittedly ambitious task of supplying this information, the aims of this volume as a general introduction to, and encyclopedia of, the Japanese sword will have been fulfilled.

HISTORY OF
THE JAPANESE SWORD

EARLY BACKGROUND

Japan of the prehistoric Jomon period was basically a hunting-and-gathering society. People had not yet begun to forge metal, although they did make use of basic stone tools. The word "Jomon" means "cord-marked," and this period is distinguished from earlier ones by the appearance of the decorated coil-built pottery from which it derives its name. The introduction of metal tools and rice farming techniques, probably from the nearby Asian continent, led to rapid cultural progress and a transition to the agriculturally-based Yayoi period. This was to last nearly six hundred years, from about 300 B.C. to A.D. 300, when burial practices became more sophisticated and special burial mounds were created.

The iron tools and weapons brought to Japan during the Yayoi period were clearly more efficient than stone or bronze implements, and the resulting increase in productivity was a driving force in the formation of the nation of Japan. Such tools were initially obtained from the continent or forged by continental craftsmen who had immigrated to Japan. Soon, however, Japanese began to create their own iron tools. They manufactured iron by heating and deoxidizing iron sand and ore, and formed tools by hammering out the iron. These sophisticated skills culminated in the forging of weapons, particularly the sword.

The main requirements of a sword which is to be used as a weapon are that it must not break or bend; it must cut well and prove durable. Japanese swordsmiths went to great lengths to try to determine which techniques, materials, and methods would produce swords that would answer this description. The result of their efforts is the nihonto, or the Japanese sword, highly esteemed to this day as both a weapon and an example of fine art. The renowned beauty of the Japanese sword was in fact originally just a fortuitous side-effect of efforts to produce a practical weapon.

Japan's oldest histories, the *Kojiki* and the *Nihon Shoki*, contain hints that in ancient times the sword was regarded not only as a prized weapon, but also as an object of worship. In fact, one of the three sacred Imperial regalia—objects said to have been handed down directly from the gods to the founder of the Imperial line and to symbolize the emperor's legitimacy—is a sword. Other evidence for the weapon's sacred connotations is in the discovery of swords in the sites of ancient burial mounds, as well as the inclusion of swords among the sacred objects held by many shrines and temples throughout Japan.

Since the Japanese sword was originally developed for use in combat, changes in battle methods inevitably influenced the nature of the weapon, most noticeably in terms of its shape. As a result the shape, or sugata, of a sword is a useful indicator of its approximate age. The sugata also reflects the aesthetic trends of the times, as does the surface-grain pattern (jihada) and the temper line (hamon).

Japanese swords thus varied from one period to the next. The following broad sketch of

the periods into which Japanese history is usually classified will help in understanding the terminology used to describe the many different types of swords that have been produced throughout the country's history, including the jokoto, the Koto, the Shinto, the Shinshinto, the gendaito, the showato, and the shinsakuto.

Early Heian period (794–1099) The period of the jokoto, prior to the emergence of the Japanese sword as we know it today.

Late Heian to early Kamakura period (1100–1232) The establishment of the Kamakura shogunate in 1185 marked the end of the Heian period. The earliest Japanese swords date from this time.

Mid- to late Kamakura period (1232–1333) The Kamakura period came to a close with the defeat of the Hojo clan in 1333. Many excellent smiths begin to appear in various locales throughout Japan and to develop unique styles of workmanship.

Nanbokucho period (1333–1392) This sixty-year period lasted from the end of the Kamakura period until the competing southern and northern Imperial courts were reunited. Until the start of this period, all long blades were tachi.

Muromachi period (1392–1573) According to political chronologies, this period includes the Sengoku, or Warring States, period. In sword classification, however, the Bunroku era is also included, extending the period to 1595. During this time, which marks the end of the Koto era, the katana replaced the tachi.

Azuchi-Momoyama period Usually reckoned as the years from 1574 to Tokugawa Ieyasu's victory at Sekigahara and ascension to power in 1600. In sword history, 1596–1644, or from the beginning of the Keicho to the end of the Kan'ei eras. The swords of this time are considered to be early Shinto.

Edo period In traditional political chronology, the Edo period ended with the Taisei Hokan in 1867, when the last shogun, Tokugawa Yoshinobu, relinquished control to the emperor. In sword history, 1664–1781, mid- to late Shinto blades. After the Genroku era, which began in 1688, fewer smiths continued their trade.

End of the Edo period through early Meiji (1781–1876) This is the era of the Shinshinto, which ends in 1876 with the decree of the Haitorei, prohibiting the wearing of swords in public.

Mid-Meiji to the present The period of the so-called gendaito, or modern sword. Although there was little demand for Japanese swords from the late Meiji through the Taisho periods, swordsmiths somehow managed to preserve the traditional methods of swordmaking. Mass-produced swords, generally known as showato, were manufactured in large quantities through the end of World War II, when the occupation authorities prohibited the making of swords altogether for a number of years. It remains illegal today to produce swords for use as weapons, so since shortly after the war, when sword production resumed, all swords made in Japan have been art swords. These more recently-produced swords are known as shinsakuto, in order to differentiate them from other gendaito. While the shinsakuto is clearly an art object, it has still not lost its original capacity for use as a weapon.

Yamato period (大和時代) (645–710)

Taika (大化) 645–650	Hakochi (白雉) 650–654	Shucho (朱鳥) or Suzaku (朱雀) 686
Taiho (大宝) 701–704	Keiun (慶雲) 704–708	Wado (和銅) (begins 708)

Nara period (奈良時代) (710–794)

Reiki (霊亀) 715–717　　Yoro (養老) 717–724
Jinki (神亀) 724–729　　Tenpyo (天平) 729–749
Tenpyo Kanpo (天平感宝) 749
Tenpyo Shoho (天平勝宝) 749–757
Tenpyo Hoji (天平宝字) 757–765　　Tenpyo Jingo (天平神護) 765–767
Jingo Keiun (神護景雲) 767–770　　Hoki (宝亀) 770–780
Tenno (天応) 781–782　　Enryaku (延暦) 782–806

Heian period (平安時代) (794–1185)

Daido (大同) 806–810	Ninna (仁和) 885–889	Koho (康保) 964–968
Konin (弘仁) 810–824	Kanpyo (寛平) 889–898	Anna (安和) 968–970
Tencho (天長) 824–834	Shotai (昌泰) 898–901	Tenroku (天禄) 970–973
Jowa (承和) 834–848	Engi (延喜) 901–923	Ten'en (天延) 973–976
Kasho (嘉祥) 848–851	Encho (延長) 923–931	Jogen (貞元) 976–978
Ninju (仁寿) 851–854	Johei (承平) 931–938	Tengen (天元) 978–983
Saiko (斉衡) 854–857	Tengyo (天慶) 938–947	Eikan (永観) 983–985
Ten'an (天安) 857–859	Tenryaku (天暦) 947–957	Kanna (寛和) 985–987
Jogan (貞観) 859–877	Tentoku (天徳) 957–967	
Gangyo (元慶) 877–885	Owa (応和) 961–964	
Eien (永延) 987–989	Joryaku (承暦) 1077–1081	Eiji (永治) 1141–1142
Eiso (永祚) 989–990	Eiho (永保) 1081–1084	Koji (康治) 1142–1144
Shoryaku (正暦) 990–995	Otoku (応徳) 1084–1087	Tenyo (天養) 1144–1145
Chotoku (長徳) 995–999	Kanji (寛治) 1087–1094	Kyuan (久安) 1145–1151
Choho (長保) 999–1004	Kaho (嘉保) 1094–1096	Ninpyo (仁平) 1151–1154
Kanko (寛弘) 1004–1012	Eicho (永長) 1096–1097	Kyuju (久寿) 1154–1156
Chowa (長和) 1012–1017	Jotoku (承徳) 1097–1099	Hogen (保元) 1156–1159
Kannin (寛仁) 1017–1021	Kowa (康和) 1099–1104	Heiji (平治) 1159–1160
Jian (治安) 1021–1024	Choji (長治) 1104–1106	Eiryaku (永暦) 1160–1161
Manju (万寿) 1024–1028	Kasho (嘉承) 1106–1108	Oho (応保) 1161–1163
Chogen (長元) 1028–1037	Tennin (天仁) 1108–1110	Chokan (長寛) 1163–1165
Choryaku (長暦) 1037–1040	Ten'ei (天永) 1110–1113	Eiman (永万) 1165–1166
Chokyu (長久) 1040–1044	Eikyu (永久) 1113–1118	Nin'an (仁安) 1166–1169
Kantoku (寛徳) 1044–1046	Gen'ei (元永) 1118–1120	Kao (嘉応) 1169–1171
Eisho (永承) 1046–1053	Hoan (保安) 1120–1124	Joan (承安) 1171–1175
Tengi (天喜) 1053–1058	Tenji (天治) 1124–1126	Angen (安元) 1175–1177
Kohei (康平) 1058–1065	Daiji (大治) 1126–1131	Jisho (治承) 1177–1181
Jiryaku (治暦) 1065–1069	Tensho (天承) 1131–1132	Yowa (養和) 1181–1182
Enkyu (延久) 1069–1074	Chosho (長承) 1132–1135	Juei (寿永) 1182–1184
Joho (承保) 1074–1077	Hoen (保延) 1135–1141	Genryaku (元暦) 1184–1185

Kamakura period (鎌倉時代) (1185–1333)

Bunji (文治) 1185–1190	Shoji (正治) 1199–1201	Genkyu (元久) 1204–1206
Kenkyu (建久) 1190–1199	Kennin (建仁) 1201–1204	Ken'ei (建永) 1206–1207

Jokoto

Koto

Jogen (承元) 1207–1211
Kenryaku (建暦) 1211–1213
Kenpo (建保) 1213–1219
Jokyu (承久) 1219–1222
Joo (貞応) 1222–1224
Gennin (元仁) 1224–1225
Karoku (嘉禄) 1225–1227
Antei (安貞) 1227–1229
Kangi (寛喜) 1229–1232
Joei (貞永) 1232–1233
Tenpuku (天福) 1233–1234
Bunryaku (文暦) 1234–1235
Katei (嘉禎) 1235–1238
Ryakunin (暦仁) 1238–1239
Enno (延応) 1239–1240

Ninji (仁治) 1240–1243
Kangen (寛元) 1243–1247
Hoji (宝治) 1247–1249
Kencho (建長) 1249–1256
Kogen (康元) 1256–1257
Shoka (正嘉) 1257–1259
Shogen (正元) 1259–1260
Bun'o (文応) 1260–1261
Kocho (弘長) 1261–1264
Bun'ei (文永) 1264–1275
Kenji (建治) 1275–1278
Koan (弘安) 1278–1288
Shoo (正応) 1288–1293
Einin (永仁) 1293–1299
Shoan (正安) 1299–1302

Kengen (乾元) 1302–1303
Kagen (嘉元) 1303–1306
Tokuji (徳治) 1306–1308
Engyo (延慶) 1308–1311
Ocho (応長) 1311–1312
Showa (正和) 1312–1317
Bunpo (文保) 1317–1319
Gen'o (元応) 1319–1321
Genko (元亨) 1321–1324
Shochu (正中) 1324–1326
Karyaku (嘉暦) 1326–1329
Gentoku (元徳) 1329–1331
Genko (元弘) 1331–1334

Nanbokucho period (南北朝時代) (1333–1392)

(Nancho [South Imperial Court] era)

Genko (元弘) 1331–1334
Kenmu (建武) 1334–1336
Engen (延元) 1336–1340
Kokoku (興国) 1340–1346

Shohei (正平) 1346–1370
Kentoku (建徳) 1370–1372
Bunchu (文中) 1372–1375
Tenju (天授) 1375–1381

Kowa (弘和) 1381–1384
Genchu (元中) 1384–1392

(Hokucho [North Imperial Court] era)

Shokyo (正慶) 1332–1334
Kenmu (建武) 1334–1338
Ryakuo (暦応) 1338–1342
Koei (康永) 1342–1345
Jowa (貞和) 1345–1350
Kan'o (観応) 1350–1352

Bunna (文和) 1352–1356
Enbun (延文) 1356–1361
Koan (康安) 1361–1362
Joji (貞治) 1362–1368
Oan (応安) 1368–1375
Eiwa (永和) 1375–1379

Koryaku (康暦) 1379–1381
Eitoku (永徳) 1381–1384
Shitoku (至徳) 1384–1387
Kakyo (嘉慶) 1387–1389
Koo (康応) 1389–1390
Meitoku (明徳) 1390–1394

Muromachi period (室町時代) (1392–1573)

Genchu (元中) 1384–1392
Oei (応永) 1394–1428
Shocho (正長) 1428–1429
Eikyo (永亨) 1429–1441
Kakitsu (嘉吉) 1441–1444
Bun'an (文安) 1444–1449
Hotoku (宝徳) 1449–1452
Kyotoku (亨徳) 1452–1455
Kosho (康正) 1455–1457

Choroku (長禄) 1457–1460
Kansho (寛正) 1460–1466
Bunsho (文正) 1466–1467
Onin (応仁) 1467–1469
Bunmei (文明) 1469–1487
Chokyo (長亨) 1487–1489
Entoku (延徳) 1489–1492
Meio (明応) 1492–1501
Bunki (文亀) 1501–1504

Eisho (永正) 1504–1521
Taiei (大永) 1521–1528
Kyoroku (亨禄) 1528–1532
Tenbun (天文) 1532–1555
Koji (弘治) 1555–1558
Eiroku (永禄) 1558–1570
Genki (元亀) 1570–1573

Azuchi-Momoyama period (安土桃山時代) (1573–1600)

Tensho (天正) 1573–1592
Keicho (慶長) 1596–1615

Bunroku (文禄) 1592–1596

Edo period (江戸時代) (1600–1867)

Keicho (慶長) 1596–1615
Genna (元和) 1615–1624
Kan'ei (寛永) 1624–1644
Shoho (正保) 1644–1648

Keian (慶安) 1648–1652
Joo (承応) 1652–1655
Meireki (明暦) 1655–1658
Manji (万治) 1658–1661

Kanbun (寛文) 1661–1673
Enpo (延宝) 1673–1681
Tenna (天和) 1681–1684
Jokyo (貞亨) 1684–1688

Koto

Shinto

MAP OF JAPAN IN THE EDO PERIOD

(Please note: All place names in parentheses are the modern-day prefectural equivalents of the respective provinces.)

Kinai: Yamashiro 山城 (modern-day Kyoto Prefecture), Yamato 大和 (Nara), Settsu 摂津 (Osaka and Hyogo), Kawachi 河内 (Osaka), and Izumi 和泉 (Osaka).

San'yodo: Harima 播磨 (Hyogo), Bizen 備前 (Okayama), Mimasaka 美作 (Okayama), Bitchu 備中 (Okayama), Bingo 備後 (Hiroshima), Aki 安芸 (Hiroshima), Suo 周防 (Yamaguchi), and Nagato 長門 (Yamaguchi).

San'indo: Tanba 丹波 (Kyoto and Hyogo), Tango (丹後), Tajima 但馬 (Hyogo), Inaba 因幡 (Tottori), Hoki 伯耆 (Tottori), Izumo 出雲 (Shimane), Iwami 石見 (Shimane), and Oki 隠岐 (Shimane).

Nankaido: Kii 紀伊 (Wakayama and Mie), Awaji 淡路 (Hyogo), Awa 阿波 (Tokushima), Sanuki 讃岐 (Kagawa), Iyo 伊予 (Ehime), and Tosa 土佐 (Kochi).

Tokaido: Iga 伊賀 (Mie), Ise 伊勢 (Mie), Shima 志摩 (Mie), Owari 尾張 (Aichi), Mikawa 三河 (Aichi), Totomi 遠江 (Shizuoka), Suruga 駿河 (Shizuoka), Izu 伊豆 (Shizuoka), Kai 甲斐 (Yamanashi), Sagami 相模 (Kanagawa), Musashi 武蔵 (Tokyo, Saitama, and Kanagawa), Awa 安房 (Chiba), Kazusa 上総 (Chiba), Shimousa 下総 (Chiba and Ibaraki), and Hitachi 常陸 (Ibaraki).

Tosando: Omi 近江 (Shiga), Mino 美濃 (Gifu), Hida 飛騨 (Gifu), Shinano 信濃 (Nagano), Kozuke 上野 (Gunma), Shimotsuke 下野 (Tochigi), Iwaki 磐城 (Fukushima), Iwashiro 岩代 (Fukushima), Rikuzen 陸前 (Miyagi and Iwate), Rikuchu 陸中 (Iwate and Akita), Mutsu 陸奥 (Aomori and Akita), Uzen 羽前 (Yamagata), and Ugo 羽後 (Akita and Yamagata).

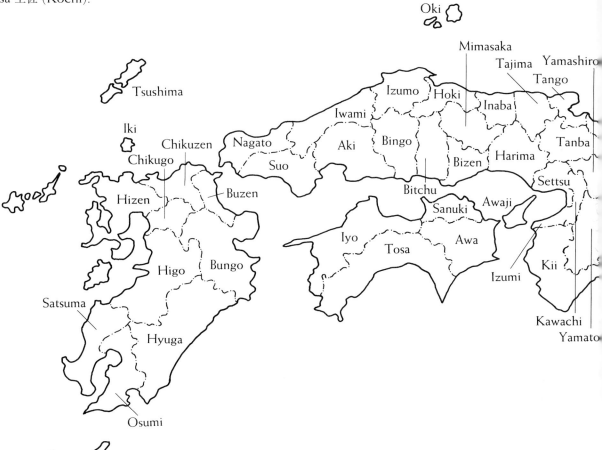

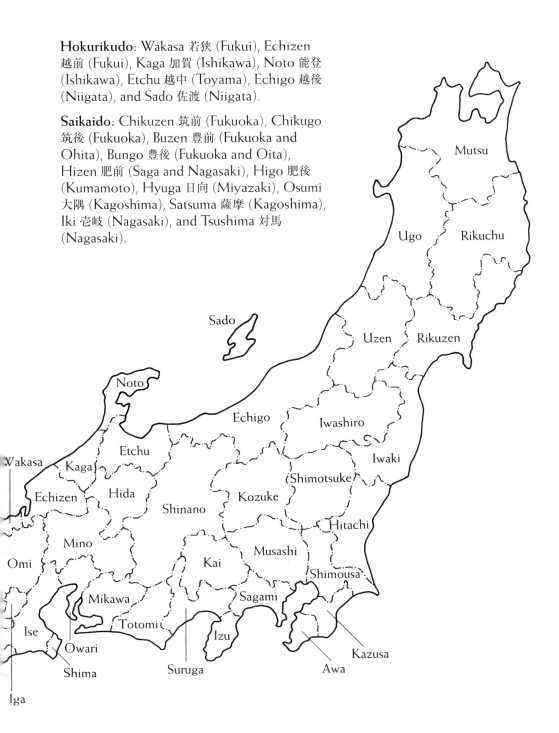

Hokurikudo: Wakasa 若狭 (Fukui), Echizen 越前 (Fukui), Kaga 加賀 (Ishikawa), Noto 能登 (Ishikawa), Etchu 越中 (Toyama), Echigo 越後 (Niigata), and Sado 佐渡 (Niigata).

Saikaido: Chikuzen 筑前 (Fukuoka), Chikugo 筑後 (Fukuoka), Buzen 豊前 (Fukuoka and Ohita), Bungo 豊後 (Fukuoka and Oita), Hizen 肥前 (Saga and Nagasaki), Higo 肥後 (Kumamoto), Hyuga 日向 (Miyazaki), Osumi 大隅 (Kagoshima), Satsuma 薩摩 (Kagoshima), Iki 壱岐 (Nagasaki), and Tsushima 対馬 (Nagasaki).

CHANGES IN THE SHAPE OF THE JAPANESE SWORD

1. Heian period
2. Early Kamakura period
3. Mid-Kamakura period
4. Mid-Kamakura period
5. Late Kamakura period
6. Late Kamakura period
7. Mid-Nanbokucho period
8. Late Nanbokucho period
9. Early Muromachi period
10. Early Muromachi period
11. Late Muromachi period
12. Momoyama period
13. Early Edo period
14. Late Edo period

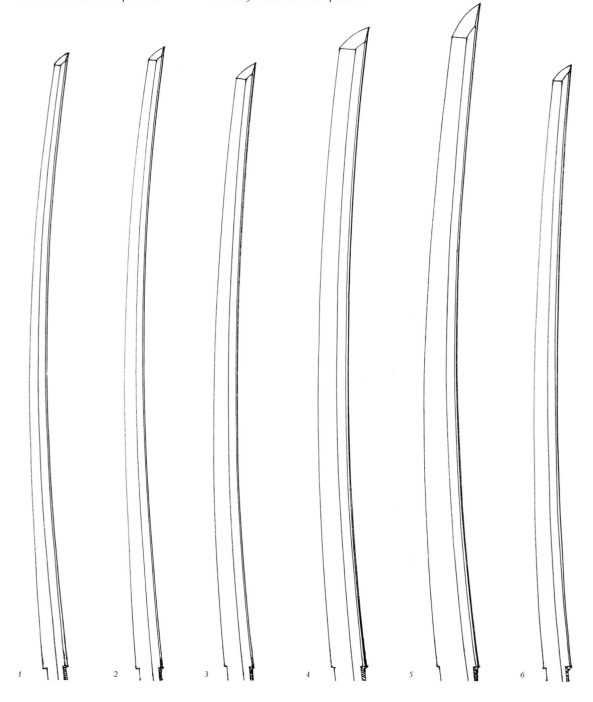

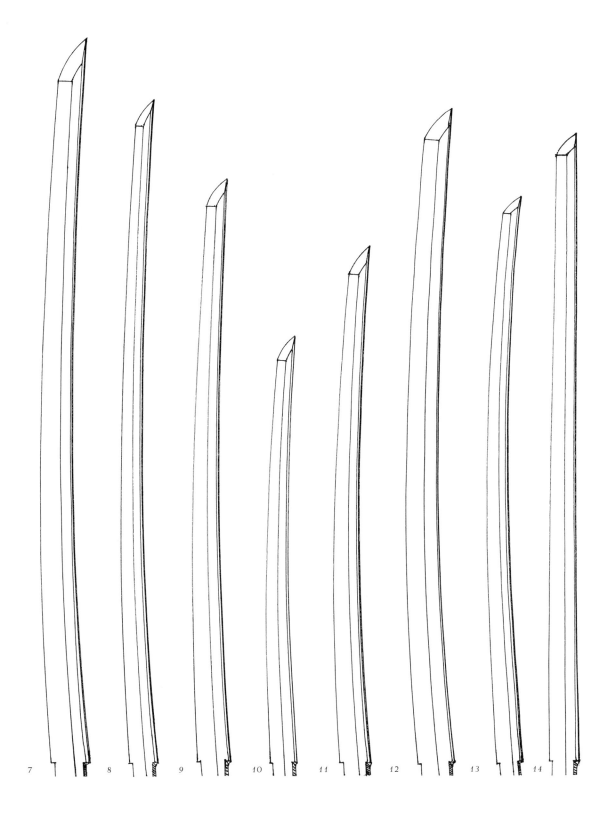

7 8 9 10 11 12 13 14

BEFORE THE MID-HEIAN PERIOD: THE JOKOTO

The typical blade produced prior to the tenth century was a straight uncurved sword, or chokuto. Such swords are also classified as jokoto, or ancient swords, and in sword terminology the period of their production is referred to as the jokoto era. It is believed that the transition from the straight jokoto to a curved blade occurred during the mid-Heian period (794–1185), and that by late mid-Heian the unique shape of the Japanese sword as we know it today (referred to collectively as nihonto) had clearly emerged.

There are many different types of jokoto, including the tsurugi, the tachi, the warabite no tachi, and the tosu, all of which have been excavated from ancient burial mounds or handed down as part of the collections of treasures held by shrines and temples.

The tsurugi is a symmetrical double-edged blade designed to be used as a thrusting weapon, while the tachi is basically a single-edged blade used for cutting.

The jokoto tachi is not curved, unlike the tachi of the fully-developed nihonto. Blades more than 60 cm in length are called tachi (大刀), while shorter blades are referred to with a different pair of Chinese characters read with the same pronunciation, of "tachi" (横刀 / 横剣) In fact, there are four different combinations of Chinese characters used for different types of tachi. They are all, however, known as chokuto, and were carried with the cutting edge facing down, suspended from a belt worn around the waist.

Archaeologists believe that the sword evolved from a thrusting to a cutting weapon between the early and the mid-Kofun period (the period of ancient burial mounds, spanning A.D. 300 through 710).

The warabite no tachi is a wide, thick, relatively short blade. The blade and the hilt are one continuous piece, forged of steel of a single type. The hilt resembles a piece of bracken (warabi), and it is this that gives the sword its name. The pommel is rounded, and curves around toward the cutting edge.

Tosu are short blades generally similar in shape to kogatana (small knives); some speculate that the kogatana in fact derived from this earlier form.

Flat, double-edged blades (hira-zukuri) first appeared during the Kofun (tumulus) period; later, blades with kiriha-zukuri construction were created. In kiriha-zukuri blades, a line, essentially equivalent to the shinogi, runs along quite close to the cutting edge; the shinogiji is very wide. During the Nara period (710–794) the kissaki-moroha-zukuri blade structure seems to have been popular. In kissaki-moroha-zukuri blades, the kissaki (tip) is sharpened on both edges, while the lower part of the blade is shaped differently from the kissaki. Shinogi-zukuri tachi are also seen occasionally among work dating from about this period; this type has its ridge lines set closer to the back of the blade than in previous styles, and is recognized as the prototype of the nihonto.

Excavated jokoto are rarely found in perfect

condition because the humid climate of Japan quickly corrodes iron. We do, however, know something of the original workmanship, as a result of modern polishing. Such blades were probably forged of a single piece of steel (and not with the fusion of steel types seen in later blades), with a coarse surface-grain pattern of running itame-hada, or the same mixed with o-mokume-hada, and a temper line based on suguha. The border between the temper line and the rest of the blade's surface is obscured and does not form a clear line. These typical features (considered flaws in finer blades) seem to result from the use of low-quality material, lack of skill in forging and tempering, and the wear and tear associated with actual use. It is not known with certainty whether swordsmiths of ancient times incorporated a clay coating (tsuchioki) on blades during the tempering process.

Some excellent jokoto blades, however, have been preserved or unearthed; some satisfy the criteria for consideration as Japanese sword masterpieces and are not at all inferior in the beauty of the steel or the surface grain to later work. It appears that, except in regard to shape, the fundamental elements of sword production were already understood and were being implemented by the Nara period. Some of these famous ancient blades are described below.

Kondoso kanto no tachi (Kochi Prefecture, owned by Komura Shrine, National Treasure [kokuho])
Blade length is 68.4 cm; the sword is a kiriha-zukuri tachi with slight uchi-zori, maru-mune, and kamasu kissaki. The steel is whitish and the surface-grain pattern is running itame-hada with ji-nie and a great deal of chikei. The hamon is suguha with ko-nie, with a tendency toward midare. The tang is unaltered, the tip shape is kurijiri, the tang is finished by hammering rather than filing, and there is one peg hole. This sword dates from the end of the Kofun period. Tachi of this period typically have mountings decorated with elaborate metalwork. The various kinds of mountings are classified on the basis of their distinctively-shaped pommels, and are referred to as kanto-dachi (ring pommel), kabutsuchi-no-tachi (tubular pommel), keito-no-tachi (fist-shaped pommel), ento-no-tachi (rounded pommel), hoto-no-tachi (square pommel), etc.

Heishi Shorin ken (Osaka Prefecture, owned by Shitenno Temple, National Treasure [kokuho]) Blade length is 65.8 cm; kiriha-zukuri tachi with slight uchi-zori, maru-mune, and kamasu kissaki. The surface-grain pattern is quite beautiful, with dense ko-mokume-hada with ji-nie. The hamon is suguha consisting of thick bright nioi with abundant ko-nie and kinsuji. The boshi is ko-maru and turns back. The Chinese characters "Hei Shi Sho Rin" are inlaid in gold near the bottom of the inside of the blade (when worn in tachi style, the side that faces the body). The temple also owns another National Treasure, the Shichi Sei Ken, said to have belonged to Prince Shotoku, but this is not the equal of the Heishi Shorin Ken in quality. The Shichi Sei Ken is still in perfect condition and a Chinese religious pattern is inlaid on the blade. It is highly likely that both of these blades were brought to Japan from the Asian continent.

The swords of the Shoso-in
A number of blades have been stored for centuries in the Shoso-in (a collection of precious ornamental and fine art objects from the eighth century). These include fifty-five swords, five te-hoko (hand spears), thirty-three hoko (spears), and seventy-two tosu. According to the inventory *Todaiji Kenbutsucho*, compiled in 756, these blades were produced in the Nara period. The structural details of these swords are now generally known, thanks to research and improved polishing techniques which began in the Meiji period. There are no extant signed swords from the Nara period, even though swordsmiths are said to have been ordered by the government of that time to sign their blades.

Futsunomitama no tsurugi (Ibaraki Prefecture, owned by Kashima Shrine, National Treasure [kokuho])

Blade length is 223.5 cm; the blade is kiriha-zukuri tachi, and there are four traces of welds on the blade. The surface-grain pattern is a coarse o-itame-hada mixed with dense ko-itame-hada and with ji-nie. The hamon is suguha consisting of ko-nie mixed with ko-notare and sunagashi; koshiba is found at the base. The tang is original and unaltered, finished by hammering; it contains one peg hole. The blade seems to date from the early Heian period.

Kondo-so Kurourushi no tachi (Kyoto Prefecture, owned by Kurama Temple, Important Cultural Asset [juyo bunka zai])

Kiriha-zukuri tachi with maru-mune. The surface-grain pattern is dense masame-hada in the hiraji and running itame-hada in the shinogiji. The hamon is suguha consisting of nioi, and nijuba appears in the bottom. The boshi is ko-maru and turns back. The blade is said to have belonged to the Seii tai shogun, Sakanoue no Tamuramaro, who was active in subduing the Ezo (Ainu) during the Enraku era (782–806).

Kogarasu-maru (Imperial collection)

Blade length is 62.8 cm, while the sori is 1.2 cm; the blade is kissaki-moroha-zukuri with iori-mune. The surface-grain pattern is itame-hada with a tendency toward masame-hada, with ji-nie. The hamon is suguha mixed with ko-midare consisting of ko-nie with hotsure and sunagashi. The hamon starts above the hamachi (yaki-otoshi). The boshi is ko-maru with hakikake and turns back significantly. There are bo-bi on the shinogi and nagainata-hi at the base; at their ends each becomes kaki-nagashi. The tang is original and untouched, and has one peg hole; it is also filed (a characteristic of later nihonto). The blade is distinctly curved toward the notches that divide the blade from the tang. The Kogarasu-maru differs from the kissaki-moroha-zukuri tachi of the Shoso-in in that the cutting edge running along the back (mune) is longer. The blade is believed to have been a family treasure of the Heishi (Taira clan), but its original attribution to the smith Amakuni of the Taiho era (701–704) is doubtful. Today it is widely believed to be the work of a Yamato-province smith of the early Heian period. The distinct curvature suggests that this is an example of the transitional stage from the jokoto tachi to the early nihonto tachi, which is characterized by deep koshi-zori and noticeable funbari.

Kenukigata tachi

The blade and the handle are made of a single piece of steel. The term kenukigata ("hair tweezers") derives from the fact that the center of the hilt is pierced and resembles this implement. Kenukigata tachi are also known as efu no tachi, since they were worn by the efu (imperial guards); these blades are also sometimes referred to as "yaken" in old documents. This kind of tachi seems gradually to have evolved from a practical weapon to a symbolic object, used only in ceremonies. In portraits of Minamoto no Yoritomo and Taira no Shigemori (Kyoto Prefecture, owned by Jingo Temple) by Fujiwara no Takanobu (1142–1205), the two men are formally dressed and wear kenukigata tachi. Other extant examples are the tachi of Sugawara no Michizane (Fukuoka Prefecture, owned by Dazaifu Tenmangu, Important Cultural Asset), the tachi owned by Hogan Temple of Shiga Prefecture and nominated as an Important Cultural Asset, and the tachi of Fujiwara no Hidesato (Mie Prefecture, the Chokokan of Ise Shrine, Important Cultural Asset). The tachi of Fujiwara no Hidesato is still in perfect condition and displays very clearly the original workmanship. The surface-grain pattern is running itame-hada and shares features in common with the jokoto as well as with the Kogarasu-maru. The hamon is suguha mixed with ko-notare and consists of nie with kinsuji. The blade is obviously shinogi-zukuri, but the shinogiji is wider than that of the nihonto. The curvature is quite shallow but suddenly deepens at the habaki-moto, and as a result the blade is considered to have substantial koshi-zori. Its shape and workmanship both suggest that the kenukigata tachi is part of the transitional stage between the Kogarasu-maru and early nihonto such as those forged by Hoki Yasutsuna and Sanjo Munechika.

LATE HEIAN TO EARLY KAMAKURA: EMERGENCE OF THE TACHI

The evolution from the jokoto to the nihonto, or the Japanese sword as we know it today, represented remarkable progress; the new style of blade was undoubtedly superior, in a practical sense, to the jokoto tachi. From an artistic point of view too, the elegant shape, surface-grain pattern, temper line, and tang were much more refined than those of the jokoto tachi, with the result that the sword's beauty was greatly enhanced.

The shinogi-zukuri, which was only occasionally seen in the previous period but had the advantage of greater sharpness, now became the basic form. Shinogi-zukuri developed from kiriha-zukuri. As the ridge line (shinogi) is moved toward the back side of the blade (mune), the angle of the edge becomes steeper in the front section, making the blade sharper. (According to this theory, the tanto is the sharpest of blades.) But a blade that is *too* sharp breaks easily, and so is useless against hard objects like armor. Likewise, the hira-zukuri blade was losing popularity, because its flat surface prevents it from moving smoothly when used as a weapon, and requires a great deal of power to effect the cut. The very act of cutting with it puts substantial pressure on the blade.

Therefore, it was necessary to take into account three conditions—namely, the thickness of the back of the blade, the height of the ridge line, and the location of the ridge line—in order to perfect the form of the Japanese sword and create a blade that would be sharp, solid, and strong.

Although jokoto tachi had some curvature, this was usually uchi-zori, or directed inward. An ordinary outward curvature was usually produced only by accident. The curvature of the nihonto, however, was clearly intentionally achieved. Curvature, or sori, results from tempering a blade that is structured with the ridge line relatively close to the back side of the blade, and that has a wider temper line than is typical of jokoto blades. The actual curve is caused by the difference in shrinkage along the cutting edge versus along the back. This natural curvature was then developed by smiths into the elegant sori of the Japanese sword.

Since the primary purpose of the Japanese sword is cutting, blades with curvature logically have a mechanical advantage over chokuto. In actual use, the sword is not swung simply to strike and cut an object; in fact, three actions need to be performed in a single motion— these are the initial cut, the deepening of the cut, and the withdrawal of the blade.

When did the curved sword, after the evolution from hira-zukuri and kiriha-zukuri to shinogi-zukuri, first make an appearance? This is a difficult question, but it seems probable that the curved sword appeared at some point in the two centuries of the mid-Heian period, after passing through the transitional stages of Kogarasu-maru and kenukigata. We can infer from extant blades that the nihonto tachi had evolved by the end of the Heian period. This theory takes into account descriptions of actual

warfare, the fighting style of the times, and various recorded historical incidents.

In 794 Emperor Kanmu moved the capital from Nara to Kyoto. It is widely believed that during this era of aristocratic rule, court nobles enjoyed a highly sophisticated style of life, and that the general peace characterizing the era lasted for four hundred years. This is not an entirely accurate image.

In the early to mid-Heian period, powerful clans began to ignore the basic principle, promulgated under the ritsuryo system (codes of laws and ethics based on a Chinese model) which provided for strict governmental control of land and the people who farmed it. They began privately to cultivate wasteland in order to increase their wealth and extend their influence. At the same time, a large number of farmers left their lands, preferring homelessness to the heavy burden of supporting others. The government was losing control over the powerful clans and found itself in a political stalemate that it could not break. For generations the Fujiwara clan had controlled the aristocratic government, together with influential nobles such as the Sugawara and Tachibana clans, who owned vast manors.

Nobles who were no longer able to count on promotion within the government and powerful clans in the countryside alike began to arm themselves in order to protect their land and property. This increased the demand for weapons and gave rise to a new class of bushi (warriors).

From a cultural perspective, the Heian period can be divided into two parts. The first was strongly influenced by the Tang-dynasty culture of China, but the Japanese gradually began to echo their geographic remove from the continent with the development of their own culture. The transition from a writing system composed of Chinese characters (kanji) to a Japanese syllabary (kana) symbolizes this change.

In 984, the government issued a decree restricting the wearing of swords, in which ordinary people were banned from wearing them without special permission. The very need for such a ban indicates that the possession of weapons had become common by that time among the general public.

Battles were in fact fought on various scales throughout this period. Early in the Heian period, there were continuous attempts at invasion into the Ezo (Ainu) country in the north. The civil war of the Shohei and Tengyo eras (935–941) occurred when Taira no Masakado and Fujiwara no Sumitomo mounted a rebellion against the government; after that battle, the customary fighting style is said to have changed from hand-to-hand combat to the use of horses. In theory, it is obvious that curved swords would have an advantage over straight swords when cutting is done downward from horseback.

Later, in the campaigns of the Zenkunen (1051–1062) and the Gosannen (1083–1087), large, fierce battles were fought against rebels in the Oshu district (the northern part of Japan's main island of Honshu). Clearly, the effectiveness of the Japanese sword was developed and perfected through many hardships and experiences on the battlefield. As a result, many excellent smiths emerged in locations throughout the country. The Mogusa smiths appear to have played an important role in the Oshu district, but while they are mentioned in the old sword books, no authenticated examples of their work survive.

The civil war of the Hogen era (1156) resulted from the power struggle between the royal family and noble families vying for the Imperial regency; at this time it became evident that the court nobles had been losing power for some time, while the warrior class had been gaining strength. In the civil wars of the Heiji era (1159), the Taira clan, one of the two largest warrior clans, became extremely influential. The struggle between the Taira and the Minamoto clans eventually forced the nobles to relinquish their power.

In 1185, Minamoto no Yoritomo, who defeated the Taira, reorganized local administration of the country and was inaugurated as Seii tai shogun; he then transferred the center of governmental administration from Kyoto to

Kamakura. A new relationship was established between the shogunate and its retainers. The government guaranteed lands, while retainers were obliged in return to pledge their services. The government also sent its vassals to local administrations and had them ready small armies there. Demand for the Japanese sword naturally increased and extensive technical exchanges occurred between different schools, as the government promoted its policy of military readiness.

The Genji (or Minamoto) clan retained control of the government for three generations (Yoritomo, Yoriie, and Sanetomo), after which point the Hojo clan came to power. Retired emperor Gotoba, who had relinquished his throne to the emperor Tsuchimikado in 1198, established his own court in an attempt to restore imperial rule. He organized troops and consolidated his military power. After the death of the first shogun, Yoritomo, the shogunate was thrown into a state of confusion by the rebellion of several powerful warrior clans. Gotoba took advantage of the subsequent turmoil to declare war against the Regent Hojo Yoshitoki in 1221, in an attempt to overthrow the shogunate. The revolt was promptly quelled, however, by the government, which was able to band together quickly, presenting a united front to the offensive, and bringing an end to this brief episode, known as the Jokyu Disturbance.

Gotoba's activities are of particular interest because he was an enthusiastic sword-lover, with a deep knowledge and appreciation of the weapon. He even engaged in the tempering of blades himself. In addition, he summoned swordsmiths from Yamashiro, Bizen, and Bitchu provinces, and had them forge blades in his palace. There is no doubt that his activity encouraged swordsmiths and was a great impetus to sword production.

In terms of general history, the Kamakura period may be divided into three parts, of fifty years each, and the first of these retains many traces of the elegant culture of the Heian-period nobles. The same influence can be seen in the Japanese swords produced in early

Kamakura. Common traits in workmanship can be seen in swords produced from the end of the mid-Heian period through the early Kamakura period.

Old records list the names of smiths Amakuni (天国) and Amakura (天座) during the Taiho era (701–704), as well as Shinsoku (神息) of Usa (Kyushu) during the Wado era (708–715), but no genuine signed blades of any of the three have been authenticated to date. The same documents mention that Yasutsuna (安綱) of Hoki province (伯耆国) was active during the Daido era (806–810), but judging from his well-known extant work "Dojigiri Yasutsuna," he seems, in fact, to have lived at the end of the Heian period.

Sanjo Munechika (三条宗近) of Yamashiro province, maker of the important tachi "Mikazuki Munechika," first appeared during the Eien era (987–989); Ko-Bizen Tomonari (古備前友成) and Ko-Bizen Masatsune (古備前正恒) are also believed to have been active around this time.

The tachi of this early part of the Kamakura period typically has a blade 82–85 cm in length), deep tori-zori inclined to be koshi-zori, tapering mihaba with funbari, ko-kissaki, hira-niku, and an elegant and dignified sugata. This sugata appeared throughout the early Kamakura period. Hi and horimono are finely engraved, and the design of the horimono is rather simple. In the early stage of the Kamakura period, swords were produced by smiths not belonging to any particular swordmaking tradition (majiwarimono). Later the Yamashiro tradition was established and grew very popular. This was followed next by the rise of the Bizen tradition.

Unlike the tang of jokoto blades, that of early-Kamakura blades was elaborately finished, and it became common practice at this time for swordsmiths to sign their work. The habaki area of these blades is deeply curved, and the tang itself slightly so. Some tangs (kijimono-gata) of the period have an extreme taper about halfway down, so that the hilt can be mounted with rivets rather than the more usual peg.

In Yamashiro province, the smith Sanjo Munechika was succeeded by Sanjo Yoshiie

(三条吉家), Gojo Kanenaga (五条兼永), and Gojo Kuninaga (五条国永). During the early Kamakura period, Awataguchi- (粟田口) school smiths Kunitomo (国友), Hisakuni (久国), Kuniyasu (国安), and Kunikiyo (国清) were active. Ohara Sanemori (大原真守), Aritsuna (有綱), and Yasuie (安家) belong to the Ohara (大原) school, led by Yasutsuna, in Hoki province. The Ko-Bizen school in Bizen province included Tomonari, Masatsune, Nobufusa (信房), Sanetsune (真恒), Takahira (高平), Kanehira (包平), Sukehira (助平), and others. In the Kamakura period, Norimune (則宗), Sukemune (助宗), Narimune (成宗), Sukeshige (助茂), and others of the thriving Ko-Ichimonji school began to produce blades. The Ko-Aoe school in Bitchu province included Moritsugu (守次), Sadatsugu (貞次), Tsunetsugu (恒次), Suketsugu (助次), Tsuguie (次家), Masatsune (正恒), Yasutsugu (康次), Nobutsugu (延次), Tametsugu (為次), and others.

Other smiths, including Miike Mitsuyo (三池光世) of Chikugo (筑後) province (Kyushu), Choen (長円) of Bizen (豊前) province, Sadahide (定秀) and Yukihira (行平) of Bungo (豊後) province, Naminohira Yukiyasu (波平行安) and Yukimasa (行正) of Satsuma (薩摩) province, also appeared during this period. In addition, old documents list swordsmiths from Yamato province and the Oshu district as being active at about this time, but extant works by smiths from these areas have yet to be authenticated.

Although most tachi dating from mid-Heian through early Kamakura have a sugata similar to that described above, there are a few exceptions, such as the noted tachi "O-Kanehira" by Ko-Bizen Kanehira, a tachi produced by Ko-Bizen Sanetsune and owned by the Toshogu Palace of Mount Kuno, the noted tachi "O-denta" by Miike Mitsuyo, and an unsigned tachi inscribed "Sohaya no tsurugi o utsusu nari." In contrast to the more common tachi of the period, with their narrow mihaba, ko-kissaki and funbari, these tachi have wider and less tapering mihaba and ikubi-kissaki.

Extant tanto from the mid-Heian and early Kamakura periods include blades by Ko-Bizen Tomonari, Awataguchi Hisakuni, and Bungo Yukihira, all with a slight outward curvature.

Ken produced at this time were used only in religious ceremonies, and were of little practical value as weapons. As with tanto of this period, extant examples are quite rare, but works do exist by Sanjo Munechika, Gojo Kanenaga, and Gojo Kuninaga; there are also unsigned ken attributed to Amakuni, Shinsoku, and Yukihira.

THE GOBAN KAJI

Those swordsmiths who were summoned to the palace by imperial order of retired emperor Gotoba were known as "goban kaji." They worked for the ex-emperor in monthly shifts and are believed to have been the finest swordsmiths of their day. Only smiths from the Awataguchi school of Yamashiro province, the Ko-Ichimonji school of Bizen province, and the Ko-Aoe school of Bitchu province were selected for this honor.

The following smiths are listed as goban kaji in one of the oldest lists of swordsmiths, the *Showa Mei Zukushi*, a document produced during the Showa era (1312–1317) and now preserved at the Kanchiin Temple:

January: Norimune (Bizen province, Ichimonji school)

February: Sadatsugu (Bitchu province, Aoe school)

March: Nobufusa (Bizen province, Ichimonji school)

April: Kuniyasu (Yamashiro province, Awataguchi school)

May: Tsunetsugu (Bitchu province, Aoe school)

June: Kunitomo (Yamashiro province, Awataguchi school)

July: Muneyoshi (Bizen province, Ichimonji school)

August: Tsuguie (Bitchu province, Aoe school)

September: Sukemune (Bizen province, Ichimonji school)

October: Yukikuni (Bizen province, Ichimonji school)

November: Sukenari (Bizen province, Ichimonji school)

December: Sukenobu (or Sukechika, Bizen province, Ichimonji school)

Gotoba is said to have selected Awataguchi Hisakuni and Ichimonji Nobufusa from among his goban kaji to collaborate with him on his own tempering; this pair of smiths was known as "hoju kenko" (swordsmiths selected for the honor of working with Gotoba). Gotoba's work is respectfully referred to as "Gyo-saku," "Gosho-yaki," or "Kiku-gyo-saku," from the sixteen- or twenty-four–petal chrysanthemum (kiku) engraved in fine lines on the tang. Ichimonji Norimune was also known by the name "Kiku-Ichimonji," while Ichimonji Sukemune was called "O-Ichimonji." Other documents have slightly different lists of goban kaji smiths, but this may have been the result of certain smiths' use of new names, or a simple notational error.

MID- TO LATE KAMAKURA PERIOD: EMERGENCE OF UNIQUE REGIONAL STYLES

After the defeat of the court nobles in the Jokyu Disturbance of 1221, the Kamakura shogunate expanded its power. Three retired emperors—Gotoba, Tsuchimikado, and Juntoku—were exiled. Meanwhile, the estates of the court nobles and the warriors known to be loyal to the imperial court were confiscated by the shogunate. New administrative systems were introduced, and the imperial court was kept under strict observation. With the promulgation in 1232 of the Goseibai Shikimoku (the first codification of the laws and ethics of the warrior) the shogunate government was consolidated in both name and fact for the first time in Japanese history.

During the Heian period, the aristocracy had been at the core of society and culture, but in the Kamakura period the warrior class became the main driving force of both politics and culture. By mid-Kamakura, this class had reached the peak of its prosperity, and evidence of the influence of its aesthetic—in general, a preference for realism over symbolism, dynamism over subtlety, power over delicacy—was everywhere. Its influence was felt in painting, sculpture, literature, swordsmithing, and many other artistic pursuits.

Sword production was thriving in various regions, and unique styles of workmanship had been established by master smiths. This included the Bizen tradition, characterized by choji midare consisting of nioi and utsuri; the Yamashiro tradition, with the nashiji-hada typical of the Awataguchi school and the suguha

or choji midare based on nie of the Rai school; the Yamato tradition with its masame-hada and suguha, and the Soshu tradition with its active ji and ha with ji-nie, chikei, and kinsuji.

The tachi of the mid-Kamakura period developed a grand and dignified sugata, quite distinct from the gentle and elegant sugata of the late Heian through the early Kamakura periods. Blades typically have a wide and less tapering mihaba, thicker kasane, and stout ikubi-kissaki. Another typical feature is hamaguri-ba, which has full hira-niku from the cutting edge to the yakigashira (the top of the irregular pattern of the temper line).

The development of a more efficient sword in the Kamakura period was the result of hard experience. In 1274 and 1281 Japan was invaded by the Mongolians; this directly affected the evolution of the Japanese sword.

In the late thirteenth century, the storm of the Mongol army was raging in all its fury across the Eurasian continent. After conquering Korea, Kublai Khan began in 1268 to dispatch a series of delegates to Japan, to insist that the country acknowledge his sovereignty. In the face of the shogunate's refusal, he sent vast forces to attack the northern part of Kyushu, first in 1274, and again in 1281. It is reported that thirty-five hundred ships and a force of a thousand men were mobilized for the second invasion. But both Mongol fleets were crushed by typhoons—kamikaze, or "divine wind," as these fortuitous storms came to be called—and the invasions failed. Kublai

Khan planned a third invasion that never materialized.

In anticipation of a third invasion, the government made every possible effort to strengthen its coastal defenses, and ordered the warriors of the Kyushu district to be ready to mount a defensive action at a moment's notice. Japanese warriors had never before encountered such an enemy, who was protected by leather armor and wielded a very stout sword—clearly superior to theirs— in a unique style of fighting.

Experience gained in battle against the Mongols resulted in modifications to the nihonto that appeared first in the temper line. The Ichimonji school of Bizen province had already developed a gorgeous o-choji midare and juka-choji midare temper line, but a more modest suguha choji midare was created, after the invasions, by the swordsmith Nagamitsu (長光); this was followed by the kataochi gunome temper line of Kagemitsu (景光). Parallel developments were also seen in the Rai and Awataguchi schools of Yamashiro province.

Apparently, the reason for the change in the temper line from an irregular pattern to one based on suguha (a straight temper line) was the belief that a simpler, straight temper line would result in a stronger sword. Blades with wide temper lines reaching nearly to the ridge line look gorgeous, but tend to break.

Speaking personally for a moment from my own experience as a sword polisher, it seems that blades with gorgeous choji midare and temper lines of uniform hardness must have fulfilled their function in battle prior to the Mongol invasions by incorporating other features such as plentiful ashi inside the hamon, and relatively rough surface-grain patterns with utsuri, to produce steel of varying hardnesses, and so increase the blades' flexibility.

The Soshu tradition's rise to popularity following the Mongolian invasions was rapid and overwhelming. As also occurred with other types of arts and crafts, methods of sword production were disseminated by the craftsmen themselves, including such smiths as Awataguchi Kunitsuna (粟田口国綱) of Yamashiro province, Saburo Kunimune (三郎国宗) of Bizen province, and Ichimonji Sukezane (一文字助真) of Bizen province, who moved from main production sites to entirely new locations. Shintogo Kunimitsu (新藤後国光) initially developed the Yamashiro tradition and established his own style of workmanship during the Einin era (1293–1299). His style was further developed by Yukimitsu (行光) and Masamune (正宗), who did a great deal to develop the Soshu tradition.

Swords of the Soshu tradition typically have abundant ji-nie as well as chikei in the ji, and a hamon consisting of nie with vigorous activity such as kinsuji and inazuma. The various kinds of activity in the surface and the cutting edge are caused by the use of a mixture of materials of different hardnesses, which is thought to increase the effectiveness of the Japanese sword.

With Kamakura as the country's administrative center, warriors traveled to that city and back from around the country; this movement seems to have encouraged technical exchange among swordsmiths and aided the ongoing development of swordsmithing techniques. The Soshu tradition became more influential than any other, beginning in the late Kamakura period.

At the end of the Kamakura period, blades grew longer, taking on a longer kissaki and a more dignified shape than had been seen in mid-Kamakura. Hira-niku also becomes less full, which suggests that swords were no longer expected to pierce very hard objects such as heavy armor.

A group of swordsmiths known as the "unchangeable smiths" continued to produce swords with the same elegant shape seen in the late Heian and early Kamakura periods. These smiths also modified the styles of those periods to produce a blade with a more magnificent shape. The elegant style was preferred by the aristocrats, who still retained influence in Kyoto. At that time, the nation's culture, economy, and politics were each divided between two separate structures, one controlled by the warriors of the shogunate government, and the other by the aristocrats of the Imperial court. The so-called unchangeable smiths included Rai Kunitoshi (来国俊), Ryokai (了戒),

Rai Kunimitsu (来国光), Enju Kunimura (延寿国村), Enju Kunisuke (延寿国資), Osafune Nagamitsu, Osafune Kagemitsu, Osafune Sanenaga (長船真長), Ukai Unsho (鵜飼雲生), and others.

The Awataguchi school continued to thrive in Yamashiro province, and Kuniyoshi (国吉), Kunimitsu (国光), and Yoshimitsu (吉光) were active at this time. Beginning in mid-Kamakura, the Rai school replaced the Awataguchi as the main school in Yamashiro province, and Kuniyuki (国行), Niji Kunitoshi (二字国俊), Rai Kunitoshi, Kunimitsu, and Kunitsugu (国次) were all producing prolific work. Chudo Rai Mitsukane (中堂来光包) and Ryokai also belonged to this school, but they worked in a style slightly different from the others'. The Ayanokoji school seems to have been a branch of the Sanjo school, and its members Sadatoshi (定利) and Sadayoshi (定吉) are well known.

Bizen province completely dominated the sword-producing provinces, in both quality and quantity. The Ichimonji school of the early Kamakura period is known as Ko-Ichimonji, and a group which lived in Fukuoka in Bizen province and was active in the mid-Kamakura period is known as the Fukuoka Ichimonji. The leading smiths of the Fukuoka Ichimonji school are Yoshifusa (吉房), Sukezane, Norifusa (則房), Sukefusa (助房), Yoshihira (吉平), Yoshimune (吉宗), Yoshimochi (吉用), Yoshimoto (吉元), and Sukemori (助守). Sukezane was given the name Kamakura Ichimonji after he moved to the city of Kamakura and became one of the pioneers of the Soshu tradition. Norifusa became known as Katayama Ichimonji after he moved to Katayama in Bitchu province.

The Yoshioka Ichimonji school was founded by Sukeyoshi (助吉), who produced swords in Yoshioka, Bizen province; members Sakon Shogen Sukemitsu (左近将監助光) and Sukeyoshi (助義) are quite well known. Yoshiuji (吉氏) of the Iwato Ichimonji (or Shochu Ichimonji) school was also active at about this time.

The smiths of the Osafune school flourished from the mid-Kamakura period through the end of the Muromachi period, and a large number of their blades have survived. Mitsutada (光忠)

founded this school; he was succeeded by Nagamitsu, Kagemitsu, and Kanemitsu (兼光). Other noteworthy members of the school include Sanenaga, Nagamoto (長元), Kagemasa (景政), and Chikakage (近景).

There were also many splendid smiths in Bizen province, including Hatakeda Moriie (畠田守家) and Sanemori (真守) of the Hatakeda school, Unsho, Unji (雲次), and Unju (雲重) of the Ukai school, Wake no Sho Shigesuke (和気庄重助), Kokubunji Sukekuni (国分寺助国), and Yoshii Kagenori (吉井景則).

Bizen's neighboring province of Bitchu was home to many swordsmiths as well. The Aoe school was one of the most outstanding of the Bitchu schools. Its work can be roughly divided into three periods: Ko-Aoe, or Early Aoe (corresponding to late Heian through early Kamakura); Chu-Aoe, or Mid-Aoe (mid-Kamakura to Nanbokucho); and Sue-Aoe, or late Aoe (Muromachi period). Shigetsugu (重次), Yoshitsugu (吉次), Naotsugu (直次), and Hidetsugu (秀次) were the leading smiths of this school during the latter part of the Kamakura period.

It is believed that the earliest nihonto swordsmiths worked in Yamato province. During the Kamakura period, temples and shrines centered in Nara began to amass considerable political power, and the monks consequently armed themselves. These monk-warriors were supplied with blades by groups of swordsmiths affiliated with a particular temple or shrine. Eventually some of the smiths were transferred to other areas in which these temples or shrines were active, and established there the swordsmithing schools of the Yamato Go Ha (Five schools of Yamato province), which included the Senjuin, Tegai, Taima, Hosho, and Shikkake schools. Taima Kuniyuki (当麻国行), Tegai Kanenaga (手掻包永), Hosho Sadamune (保昌貞宗), Hosho Sadayoshi (保昌貞吉), and Shikkake Norinaga (尻懸則長) were the leading smiths of the Yamato Go Ha.

Smiths Kunitsuna, Sukezane, and Kunimune moved to Kamakura in Sagami province, where they began producing swords. However, Shintogo Kunimitsu (新藤後国光) must be

credited with the development of the Soshu tradition (Soshu was another name for Sagami); he was succeeded by his son, Kunihiro (国広). This school included Yukimitsu, Masamune, and Sadamune (貞宗), all of whom are outstanding figures in the history of the Japanese sword.

The late Kamakura period saw the emergence of master smiths in areas throughout the country that were not previously known as sword centers, including Hoju (宝寿) of the Oshu district; Norishige (則重) of Etchu province; Kaneuji (兼氏) of Mino province; Nio Kiyotsuna (二王清綱) of Suo province; Ryosai (良西), Nyusai (入西), Sairen (西蓮), Jitsua (実阿), and Samonji (左文字) of Chikuzen province; Miike Mitsuyo of Chikugo province; Enju Kunimura, Kuniyasu (国泰), Kunisuke, Kuninobu (国信), Kunitoki (国時), and Kuniyoshi (国吉) of Higo province; and Naminohira Yukiyasu (波平行安) of Satsuma province.

The rate of production of tanto increased remarkably during the latter part of the Kamakura period. Awataguchi Yoshimitsu, Rai Kunitoshi, Shintogo Kunimitsu, Osafune Kagemitsu, Etchu Norishige, and Samonji are considered to have been masterful tanto makers, and a number of their blades survive. While the tanto of the mid-Kamakura period is of standard length (between 25 and 26 cm), that of late Kamakura is hira-zukuri with uchi-zori, has no curvature, and is longer than blades made earlier. Tanto with slight curvature and a wider mihaba, disproportionate to overall blade length, are seen at the end of the Kamakura period.

The production of nagamaki seems to have begun during the Heian period, though no examples dating from before mid-Kamakura have yet been found. The naginata of the late Kamakura period has a relatively shallow curvature in the upper part of the blade, while the mihaba in the monouchi area is not as wide as that of later blades.

Signed ken from this period are extant, forged by smiths including Awataguchi Kuniyoshi, Awataguchi Yoshimitsu, Niji Kunitoshi, Hosho Sadayoshi, Osafune Mitsutada, Osafune Nagamitsu, Saburo Kunimune, and Hatakeda

Sanemori. The ridge line of these blades runs along the center of both sides; the length is shorter than standard, and the mihaba tapers less than in similar blades of earlier times. The ken of particular regions or schools do not have enough features in common to make attribution based on those classifications possible, unlike the tachi of the same period.

Japanese history entered a new phase in the wake of the fall of the Hojo clan and the Kamakura shogunate in 1333. Japanese sword production also evinced signs of a new movement that started at the close of the Kamakura period, and was more fully developed in the following period.

THE TENKA GO KEN

During the Muromachi period, the Ashikaga shogun family owned five tachi that they regarded as invaluable treasures. These came to be known as Tenka Go Ken (天下五剣), or "Five swords famous throughout the country." All were produced prior to the mid-Kamakura period and are still considered great masterpieces.

These were the "Oni-maru Kunitsuna" by Awataguchi Kunitsuna (栗田口国綱), which is said to have lain waste to a ghost who was haunting the Regent Hojo Tokiyori; the "Odenta Mitsuyo" by Miike Mitsuyo (三池光世), named for its magnificent, dignified sugata; the "Dojigiri Yasutsuna" by Hoki Yasutsuna (伯耆安綱), said to have been used by Minamoto Yorimitsu to subjugate a demon who was bothering the villagers living near its lair on Mt. Oe; "Mikazuki Munechika" by Sanjo Kunitsuna (三条国綱), named for the blade's uchinoke (a specific kind of activity) which resembles crescent moons; and "Juzu-maru Tsunetsugu" by Aoe Tsunetsugu (青江恒次), which is said to have belonged to the great Buddhist priest Nichiren, who hung a juzu (Buddhist rosary) on its hilt.

THE NANBOKUCHO PERIOD:
THE ORIGIN OF THE O-DACHI

Even during the reign of the shogun and his warriors in the Kamakura period, royalists continued to struggle to restore imperial rule; the revolt led by the retired emperor Gotoba during the Jokyu era was but one example of their efforts. After two unsuccessful attempts to overthrow the shogunate in 1324 and 1331, Emperor Godaigo finally wrested control back from the Hojo clan, and began a direct imperial administration in 1333. He ordered Prince Morinaga, Kusunoki Masashige, and other royalists to rebel against the shogunate government, and with Nitta Yoshisada's attack on Kamakura, the imperial forces at last defeated the Hojos, who until then had grasped at power under the pretext of assisting the shogunate.

The shogunate had suffered serious financial problems since the Mongolian invasions, and discontent was growing among its vassal warriors about the government's failure to reward them sufficiently for their efforts in defense of the country. Many powerful warriors in the countryside favored a return to imperial rule, and joined the campaign against the shogunate. The restoration led by Godaigo is known as the Kenmu Restoration.

But direct imperial rule did not last long. In 1335 Ashikaga Takauji, an important figure in the restoration, turned on Emperor Godaigo, and replaced him with a rival claimant to the imperial throne. Godaigo retreated to Yoshino in Kii province, and in 1337 established the Nancho, or Southern Imperial Court, while the court supported by the Ashikaga clan remained in Kyoto and was known as the Hokucho, or Northern Imperial Court. These rival courts continued running separate administrations until their reunification in 1392. These sixty years are known as the Nanbokucho period, or the period of the Northern and Southern Courts.

At first, the courts shared military and political power, but before long the confrontation evolved into a nationwide struggle between prominent warrior lords. The influence of the warriors, who until that point had merely been local officials of the Kamakura shogunate, was increasing, foreshadowing the rise of the warlords soon after.

As a result of this sixty-year power struggle, demand for swords rose tremendously. Interestingly, some smiths of this period used Nancho-era, and others Hokucho-era dates when inscribing the tangs of their swords—further evidence of just how confused the political situation was.

It has already been mentioned that the elegant shape of the Kamakura-period tachi evolved, late in that period, into a more magnificent sugata, greater in overall length and with a longer kissaki. At the beginning of the Nanbokucho period, this trend was continued and became extremely exaggerated, with blades becoming so much longer, wider, and bigger that they were quite ostentatious.

Tachi of this period had long blades with wide mihaba, large kissaki, relatively shallow sori, and thin kasane disproportionate to the

wide mihaba. Enormous tachi called seoi-tachi (shouldering swords) and nodachi (field swords), with blades 120–150 cm in length, were forged. Most of these were shortened during the Momoyama period and reshaped into katana; a considerable number of unsigned blades from the Nanbokucho period are extant in shortened form.

The Soshu tradition of swordsmithing was at its height, and was adopted even in Bizen province, where of course the Bizen tradition had flourished throughout the Kamakura period. The result was the So-den Bizen, a mixture of features of the Bizen and Soshu traditions. Meanwhile, the Yamashiro and Yamato traditions were in decline, and the Mino tradition was on the rise.

In Soshu (Sagami province), Hiromitsu (広光) and Akihiro (秋広) succeeded the former master smiths of the Soshu tradition. Also active at this time were Nobukuni (信国), who was one of Sadamune's students; Kunishige (国重), who is believed to have been one of Masamune's students; and Kuninobu (国信) and Kunihira (国平) of the Hasebe (長谷部) school in Yamashiro province. The traditional workmanship of all these smiths was gradually lost in the face of the Soshu tradition's overwhelming influence.

In Bizen province, the students of Kanemitsu I, including Kanemitsu II (二代 兼光), Tomomitsu (倫光), Masamitsu (政光), Motomitsu (基光), Yoshimitsu (義光) and Yoshikage (義景) were renowned. Also from this province were Motoshige (元重), who is believed to be a student of Sadamune's; Chogi (長義), Nagashige (長重), and Kanenaga (or Kencho) (兼長) of the So-den Bizen tradition; and Omiya Morikage (盛景). In the later Nanbokucho period, a group known as Kozorimono, including smiths Hidemitsu (秀光) and Nariie (成家) was established. In neighboring Bitchu province, Tsugunao (次直), Tsuguyoshi (次吉), Sadatsugu (貞次), Yoshitsugu (吉次), Naotsugu (直次), and Moritsugu (守次) of the Chu-Aoe school were active, while in Bingo province Masaie (正家), Masahiro (正広), and Masanobu (正信) of the Ko-Mihara school were relatively well known.

Shizu Saburo Kaneuji appeared in Mino province at the end of the Kamakura period, and the name Kaneuji continued to be used by his sucessors. Smiths of the Kaneuji school moved to Naoe (also in Mino province) and are generally known as Naoe Shizu. This school includes Kanetomo (兼友), Kanetsugu (兼次), Kanenobu (兼信), and Kanetoshi (兼俊). In addition, there were Kinju (金重), who is thought to have been a forerunner of the Sue-Seki school; and Tametsugu (為継), who moved to Mino from Etchu (越中) province and is believed to have studied with either Morishige or Go Yoshihiro (郷義弘).

Kunimitsu (国光), Kunimune (国宗), and Kunifusa (国房) of the Uda (宇多) school, which was related to Norishige, were active in Etchu province. Also active were master smith Go Yoshihiro in Etchu; Kuniyuki (国行) in Echizen province; Yamamura Masanobu (山村正信) in Echigo province; and Norishige's students Fujishima Tomoshige (藤島友重) and Sanekage (真景) in Kaga province. Swordsmiths were distributed throughout Japan as far as the San'indo, including Kagenaga (景長) in Inaba province; Kunimitsu (国光) in Tajima province; and Naotsuna (直綱) and Sadatsuna (貞綱) in Iwami province.

Samonji, a master smith of Chikuzen, replaced the conventional Kyushu method of sword production entirely, working instead in the popular Soshu tradition. His school includes Yasuyoshi (安吉), Yoshisada (吉貞), Yukihiro (行弘), Kunihiro (国弘), and Hiroyuki (弘行), who are all skillful smiths. Elsewhere, Tomoyuki (友行), Tokiyuki (時行), and Tomomitsu (友光) of the Takada school of Bungo province, the Enju school of Higo province, and the Naminohira school of Satsuma province all adhered to the production methods that were traditional in Kyushu.

In the Oshu district, smiths including Gunsho (軍勝) and Hoju (宝寿), who were related to the Gassan school, Toshiyasu (世安) of the Mogusa school, and others left extant works made not in the Nanbokucho style, but in the late-Heian and early-Kamakura style.

Nanbokucho-period sword production reached its peak in the Enbun (1356–1361)

and Joji eras (1362–1368); after this point workmanship became subdued, and the sugata began to be transformed into that of the Muromachi period.

The tanto of the Nanbokucho period are hira-zukuri, generally with mitsu-mune, wide mihaba, saki-zori, proper fukura and thin kasane. Blade length ranges from 30–43 cm, thus these tanto are known as sunnobi tanto (extended or longer knives) or ko-wakizashi (short swords).

In contrast, tanto were also forged that were shorter than those produced in the early and mid-Kamakura periods. The blade is characterized by a wide mihaba disproportionate to the decreased overall length, thin kasane, and slight sori.

In addition to tachi and tanto, nagamaki also became enormous in size, with fairly wide mihaba in the monouchi area, and saki-zori that was not as deep as in the Muromachi naginata. The blade remained well-balanced and not overweight, due to the thin kasane. Naginata with long hafts bound spirally with metal or cane are sometimes referred to as nagamaki, but they are now more properly classified on the basis of the shape of the blade. Most nagamaki were shortened, and it is rare to find one in its original shape. In addition to shortening the tang, the upper portion of the back of the blade was usually removed, and the blade properly reshaped for use as a katana or wakizashi. This process is known as nagamaki naoshi.

THE MUROMACHI PERIOD:
THE UCHIGATANA

The sixty-year standoff between the Southern and Northern Courts came to an end in 1392 when both sides agreed that the successor to the throne would be chosen alternately from the imperial lines of each court. This agreement was reached during the reign of Ashikaga Yoshimitsu, who had succeeded Takauji and Yoshiakira as head of the Ashikaga shogunate. Following the subjugation in 1392 and 1399 of two powerful feudal lords who were hostile to the Ashikaga clan, the shogun Yoshimitsu had further solidified his political power by becoming more closely allied with the emperor.

Nevertheless, the shogun's army did not maintain its own military forces, and so was not strong enough to control the increasingly powerful feudal lords. This was one of the main reasons for the Ashikaga clan's decline. In 1441 the shogun Yoshinori was killed by a member of the influential Akamatsu clan, whose activities he had attempted to suppress. With the death of its leader, the shogunate lost what little authority it had retained, and powerful feudal lords from the Hosokawa clan, the Shiba clan, the Hatakeyama clan, and the Yamana clan took control of the real power.

Vassals of feudal lords also became politically important figures, and began to play active roles in determining the lines of succession within their clans, complicating the conflicts that were occurring throughout the country, so that these no longer involved only brother against brother but in many cases drew in large numbers of their supporters as well. Finally one

particularly fierce struggle, over the question of succession within the shogunal family, began between two powerful feudal lords, Yamana and Hosokawa. This grew in scale to the point at which, in 1467, it divided the country in two. This was the start of the Sengoku period, or the Warring States period, which lasted about a hundred years, until two men, Oda Nobunaga and Toyotomi Hideyoshi, emerged as sengoku daimyo (warlords) to end the civil war at last.

In political history, the Muromachi period is thought of as ending with the downfall of the Ashikaga shogunate in 1573. But in Japanese sword history, this period is regarded, for the sake of convenience, as continuing through the Bunroku era (1592–1596).

There were not as many skillful smiths active in Muromachi as in previous periods, and yet notable changes in workmanship were introduced. This was the last period of Koto blade production, and was also the point at which the foundation of a new style, the Shinto, was established. The period is subdivided into two classes of workmanship—early and late Muromachi —corresponding to the periods before and after the rebellion of the Onin era in 1467.

In the early Muromachi period, warriors attempted to keep alive the culture of the early Kamakura period, and this trend was reflected in sword production as well. The exaggerated and ostentatious sugata of the Nanbokucho period disappeared, and blades began to have narrow mihaba, small kissaki and gentle sugata similar to those of early Kamakura. But the

tachi of this era differ from the early Kamakura in that the curvature of Muromachi blades was typically saki-zori, while the older blades had had elegant tori-zori.

When using a tachi, two discrete actions—the draw from the scabbard and the cut—are necessary. But when using a katana, the drawing action is continuous and becomes the cutting action; in other words, both actions may be performed at the same time. The katana appeared as a result of changes in the way that battles were fought; combat had become quite fierce and required quicker response.

The signature of tachi and katana was usually inscribed on the outside of the tang; the side that appeared on the outside varied, depending on whether a blade was worn tachi style (cutting edge down) or katana style (cutting edge up). Thus the signatures on katana (katana-mei) and tachi (tachi-mei) are typically located on opposite sides.

Early Muromachi represented a transitional stage in the evolution from the tachi to the katana, and the shape of its katana is not clearly distinct from that of its tachi. In many cases smiths simply chose to use a tachi-mei or a katana-mei as the occasion demanded; the choice of signature style would depend solely on how a blade was to be used. Old picture scrolls serve as evidence that blades were used in katana style prior to the Muromachi period, but the use of such swords appears to have been limited to common soldiers, and not to have extended to high-ranking warriors or military commanders. It is interesting to note that higher-ranking warriors also came to wear the blade in katana style for daily use at the start of the Muromachi period. A quick draw with the katana was also required for life off the battlefield, both offensively and defensively. The katana of the early Muromachi period is 70 to 73 cm long, while the so-called uchigatana from the Bunki era (1501–1504) through the Tenbun era (1532–1555) is about 60 cm, and no longer than 70 cm. After the Koji era (1555–1558), the katana lengthens again, to about 73 cm.

The uchigatana seems to have first appeared in about the Eikyo era (1429–) and to have evolved into its final form by the Onin era (1467–1468). There are a number of extant Eiroku- and Tensho-era (1558–1591) uchigatana. Generally these have a stout sugata and deep saki-zori; the blade is suitable for single-handed use because its thin kasane and short tang make it relatively light. Even in blades shorter than 60 cm, the uchigatana can be distinguished from the Shinto wakizashi on the basis of the way in which it was used.

Thus, over the two centuries of the Muromachi period, tachi were replaced by katana, and the uchigatana was developed and came into widespread use. By the end of the Muromachi period, the long katana appeared, to be followed later by the development of the Momoyama-period Shinto blade.

During this period, domestic industry grew more diverse and highly developed; trade also became very active. Ashikaga Yoshimitsu opened up trade with the Ming dynasty of China, which included the import of coins as a means of enriching and strengthening the country. Since no native Japanese coins had yet officially been minted, Chinese coins were used widely instead. Tax payments in cash began to replace payment in kind of rice and other crops.

As one part of this increased activity in international trade, a large number of Japanese swords were exported to China. An old document notes that Bizen and Bingo smiths produced the greatest number of swords for export, followed by Mino and Hokuriku (district) smiths. More than one hundred thousand swords are listed as having been exported.

Despite the Japanese sword's clear superiority to their own native blades, the Chinese do not appear to have used them in either practice or battle. Instead, the Ming dynasty is said to have chosen to import this large number of Japanese swords strictly as a means of buying up the weapons of Japanese pirates, who were a constant menace to their ships. Since the end of the Kamakura period, armed fishermen and peasants of northern Kyushu and the Inland Sea did engage in trade, and often attacked

commercial ships along the continental coast of the Japan Sea. In fact, however, most of the supposed Japanese pirates are believed to have been Chinese pirates in disguise. Their activities declined after the establishment of a new trade system requiring licenses from both the Japanese and Chinese governments.

Based on export figures for the Japanese sword and its importance as an export product, it seems that the market system was well established by the Momoyama period. Sword production had been completely industrialized, and mass-production techniques implemented in order to cope with the huge demand from the Japanese warlords. Sometimes an entire family of smiths moved to a different province to manufacture swords for a particular feudal clan leader. As a result, the work of many smiths lost any individual characteristics, but at the same time, common features began to be seen in Sue-Koto (or late Muromachi–period) blades forged throughout the country.

Mass-produced swords dating from after the civil war of the Onin era (1467–1469) are called kazu-uchi mono (mass-produced swords) or tabagatana (bundled swords) because of their low quality. Elaborately forged swords were also being produced by skillful smiths by order of powerful warlords; these are called chumon-uchi (custom-made swords). Usually the smith's real name is inscribed on the tang of the chumon-uchi, as is the date, and occasionally the name of the customer. The workmanship of mass-produced blades is always far inferior to the custom-made, even among blades forged by the same smith. The large number of extant chumon-uchi blades forged by Bizen Osafune smiths is an indicator of these smiths' skill and prosperity.

More swordsmiths were active in Japan during the Muromachi period than at any other point in history. Bizen smiths were most numerous, followed by those of Mino; these two provinces accounted for more than half the smiths working in this period. The Bungo, Hokuriku, Bingo (Mihara-school), Yamato and Soshu smiths were also relatively active. The Aoe school, which had been thriving

until the Nanbokucho period, began to decline at this time.

At the beginning of the Muromachi period the Oei-Bizen school was active, and Morimitsu (盛光), Yasumitsu (康光) and Moromitsu (師光), the so-called "three Mitsu of the Oei era," played an important role in swordsmithing, as did Iesuke (家助) and Tsuneie (経家). Smiths active from the middle through the end of the Muromachi period are generally called Sue-Bizen, and outstanding smiths of this time included Norimitsu (則光) Sukemitsu (祐光), Toshimitsu (利光), Tadamitsu (忠光), Katsumitsu (勝光), Munemitsu (宗光), Kiyomitsu (清光), and Sukesada (祐定). Norimitsu, Sukemitsu, and Toshimitsu in particular were known as Eikyo-Bizen smiths because they were active during the Eikyo era (1429–1440), between the periods of the Oei-Bizen and the Sue-Bizen smiths. Katsumitsu of the Kansho era (1460–1466), Jirozaemon Katsumitsu, Yosozaemon no Jo Sukesada, Hikobei no Jo Sukesada, Genbei no Jo Sukesada, Gorozaemon no Jo Kiyomitsu, and Magoemon no Jo Kiyomitsu were particularly skilled Sue-Bizen smiths, and their blades were especially highly prized.

Among the smiths of the Sue-Seki school of Mino province, Izumi no Kami Kanesada (和泉守兼定) and Kanemoto (兼元) are distinguished by their superior skill; their names were passed down for generations. Traditionally most Sue-Seki smiths used the Chinese character "kane" as part of their names. Well-known members of this school included Zenjo Kaneyoshi (兼吉), Kanemitsu (兼光), Kanetsune (兼常), Hachiya Kanesada (蜂屋兼貞), Sakakura Seki Masatoshi (正利), and Kanefusa (兼房). After the smiths of Osafune—which had been the center of sword production in Bizen—were ruined by continuous flooding during the Tensho era (1573–1592), Mino province began to play a more important role in sword production. At the beginning of Shinto times, many Mino smiths moved to other provinces to help meet continuing demand after the Bizen flooding.

In Yamashiro province, the followers of Nobukuni (信国), Sanjo Yoshinori (三条吉則), and

Heianjo Nagayoshi (平安城長吉) were active, while the Rai and Hasebe schools had dwindled in importance. Later generations of the Tegai school and the Shikkane school continued their work in Yamato province, as did Masatsugu (政次) of the Kanabo school; Masahiro (正広) and Tsunahiro (綱広) produced swords in Sagami province, while Yasukuni (康国), Yasuharu (康春), and Fusamune (総宗) were located in Odawara (Sagami province). Suruga province was home to Sukemune (助宗), Yoshisuke (義助), and Hirosuke (広助), and in Ise provine Muramasa (村正) and Masashige (正重) were active. The Hokurikudo group consisted of Tomoshige (友重), Kagemitsu (景光), Yukimitsu (行光), and Kiyomitsu (清光) of the Fujishima school; and Ietsugu (家次) of the Kaga-Aoi school in Kaga province. In the Takada school of Bungo province, Shizumasa (鎮政), Shizunori (鎮教), Shizutada (鎮忠), Muneyuki (統行), Munemasa (統正), Taira Osamori (平長盛), and Taira Shizumori (平鎮守) were relatively noteworthy.

Meanwhile, the musket was introduced to Japan by the Portuguese for the first time in 1543. Several warlords showed great interest in the new weapon—immediately recognizing its superiority to the sword—and ordered smiths of Kunitomo (Omi province), Sakai (Settsu province), and Hirado (Hizen province) to begin producing it in large numbers. It is reported that more than three hundred thousand muskets were made in the ten years that followed the introduction of this revolutionary weapon. Oda Nobunaga was the first warlord to take advantage of the superior range and efficiency of the musket in the battle of River An (1570), and later dealt a deadly blow to the mounted troops of the powerful Takeda clan, employing new tactics specially formulated for musket troops in the battle of Nagashino (1575). The defeat of the Takeda clan, who had been widely believed to be invincible, astonished other warlords, and brought widespread changes in military tactics.

Oda Nobunaga adopted a strategy in which foot soldiers, who were able to put the musket to most effective use, played an important role. Troops armed with muskets would open fire in order to provide cover for a charge by spearsmen. These battles would then conclude with close combat with swords.

Yari (spears) also became more important on the battlefield as a result of these new tactics, and were wielded not only by foot soldiers but by high-ranking officers as well. A number of naginata were also produced in this period, not of the enormous size seen in the Nanbokucho period, but with an extremely wide monouchi area and an exaggerated saki-zori. Naginata, together with the yari, became one of the main weapons in a general's arsenal. These changes in tactics also had considerable influence on the shape of the sword.

Now that katana had become more popular than tachi, they began to be worn together with wakizashi. Two types of wakizashi are seen in the early Muromachi period. One is essentially a small katana, under 60 cm in length and of shinogi-zukuri construction, while the other is an enlarged tanto of hira-zukuri construction, more than 30 cm long. In either case, the length typically ranges from about 39 to 51 cm. The shinogi-zukuri wakizashi is the original sho (short blade) of the daisho (pair of long and short swords) that became popular in the Edo period. Hira-zukuri wakizashi of this period are longer than those of the Nanbokucho period, while Muromachi tanto tend to have a wide mihaba, deep saki-zori and a rounded fukura, and an actual blade length about the same as that of the previous period.

One type of small tanto with uchi-zori was obviously a copy of mid-Kamakura–period blades forged by Yamashiro smiths. There were also two kinds of longer tanto, between 28 and 29 cm long; one of these has a standard mihaba and no curvature and was favored by Bizen smiths, while the other was popular with Mino smiths and has a wider mihaba and saki-zori.

In the Sengoku period (late Muromachi), a unique style of tanto appeared, which was known as the yoroidoshi. This is a dagger useful for stabbing the enemy while grappling at close quarters. It has a tapering mihaba, iori-mune, thick kasane at the bottom and thin kasane at the top. Occasionally the yoroidoshi

is found with moroha-zukuri construction. The length of these blades generally ranges from 20 to 22 cm, but may sometimes be under 15 cm.

The late Muromachi period was a time of civil war, in which savages battles were fought throughout the country. But with the appearance of two great military strategists, Oda Nobunaga and Toyotomi Hideyoshi, the civil war came to an end and the country was united under a single authority. Toyotomi Hideyoshi issued a law banning farmers and peasants from possessing weapons and armor; all such arms were confiscated on the pretext of collecting the material to build a huge statue of the Buddha. This katanagari (sword hunt) was the final step in Toyotomi's policy of consolidating his administration's authority.

Oda Nobunaga is said to have favored the blades of Osafune Mitsutada, while Toyotomi Hideyoshi favored the work of Soshu smiths like Yukimitsu, Masamune, and Sadamune. But despite the interest of these two powerful lords, the era of Koto blades came to a close in the aftermath of the civil war, and was succeeded by that of the Shinto blade.

JAPANESE SWORDS DESIGNATED AS MEIBUTSU

In Japan, such highly prized items as the utensils used in the tea ceremony are often handed down from generation to generation, and the very greatest of these are accorded special status. This is true of swords as well, and sword masterpieces are referred to as meibutsu, or noted swords. This special designation seems to have been current during the Muromachi period, but the term is applied now only to swords listed in the *Kyoho Meibutsucho*, compiled by the Hon'ami family centuries later, during the Kyoho era (1716–1735).

The *Kyoho Meibutsucho* lists 166 swords, as well as 81 yakemi (blades that were burned, destroying the hamon). All are Koto blades made before the Nanbokucho period. They came from various of the active swordsmithing provinces of the time and include 89 Soshu, 68 Yamashiro, twenty-three Etchu, twenty-three Bizen, fourteen Chikuzen, eight Yamato, seven

Mino, seven Bungo, and five Bitchu blades. Forty-one blades were forged by Masamune, nineteen by Sadamune, sixteen by Toshiro Yoshimitsu, eleven by Go Yoshihiro, etc. These figures make clear that Soshu blades were highly prized at the time of the list's compilation; the number of Bizen blades, on the other hand, is surprisingly low. A total of about one hundred of these meibutsu are known to exist today.

The *Kyoho Meibutsucho* also provides information about the nicknames, signatures, length, price and history of these blades. Many blades were named after their owners, or for their shape or sharpness. The blades of Masamune, Sadamune, Yoshimitsu, Go Yoshihiro, and the Soshu-den smiths were quite high-priced. Yoshimitsu, Masamune, and Go Yoshihiro were known as the "San Saku" (Three great smiths), and their blades were extremely popular with feudal lords.

In addition to the meibutsu, the book also lists particularly well-known smiths, and swords with special nicknames or titles. The following list is an example:

Tenka Go Ken (Five great swords) (天下五剣): Doji-giri Yasutsuna, Mikazuki Munechika, Onimaru Kunitsuna, O-denta, and Juzumaru Tsunetsugu.

Tenka San So (Three great spears) (天下三槍): Nihongo, Tonbogiri, and Otegine.

Bizen San Hira (Three great "Hira" of Bizen) (備前三平): Ko-bizen Kanehira, Sukehira, and Takahira.

Kyo Go Kaji (Five great swordsmiths of Kyoto) (京五鍛冶): Kinmichi, Rai Kinmichi, Masatoshi, Yoshimichi, and Hisamichi.

Edo San Saku (Three great swordsmiths of Edo) (江戸三作): Kiyomaro, Masahide, and Naotane.

Masamune Juttetsu (Ten excellent students of Masamune) (正宗十哲): Go Yoshihiro, Norishige, Kaneuji, Kinju, Rai Kunitsugu, Hasebe Kunishige, Osafune Kanemitsu, Shogi, Samonji, and Sekishu Naotsuna.

Sadamune Santetsu (Three excellent students of Sadamune) (貞宗): Nobukuni, Osafune Motoshige, and Hojoji Kunimitsu.

THE MOMOYAMA PERIOD: NEW METHODS AND TRENDS IN SWORD PRODUCTION

The Sengoku period saw the longest and fiercest civil war in Japanese history, which resulted in a number of far-reaching social changes. The unification of the country by Oda Nobunaga and Toyotomi Hideyoshi marked the start of a government that was completely administered by warriors, and the now firmly-entrenched warrior class came to dominate Japanese society.

The Minamoto, Hojo, and Ashikaga clans had all tried to create pure shogunates, but they were unable to counter the aristocratic feudalism handed down since ancient times, because each of them had relied on the main-tenance of certain aspects of the old system in their administration. But the new government completely destroyed the old system and reduced the aristocracy to a mere shell. The government then supplanted the aristocrats by absorbing the old forms of authority into itself.

Toyotomi Hideyoshi began a massive inves-tigation into the size and quality of arable land in 1583, and then implemented drastic farmland reforms which included giving farmers land but depriving them of swords. This increased the gulf between the samurai and farmer classes, while making it impossible for farmers to earn a living by any means other than cultivating rice. This basic structure provided the foun-dation for a feudal society that was to last nearly three hundred years.

After the death of Toyotomi Hideyoshi in 1598, Tokugawa Ieyasu took power at the battle of Sekigahara (1600) and put the final touches to the creation of a feudal society governed solely by warriors.

In political history, the Azuchi-Momoyama period is defined as starting with the downfall of the Ashikaga clan in 1573 and ending in 1601, but when describing cultural history the Momoyama period is extended to include the Kan'ei era (1624–1644), because the cultural influence of this dynamic period continued until that time. In Japanese sword history, the Momoyama period is considered to begin with the first year of the Keicho era (1596) and continue through the end of the Kan'ei era (1644), thus including the very earliest period of Shinto production.

The term "Shinto" first appeared in the book *Shinto Bengi*, published during the An'ei era (1772–1781) by Kamata Natae. It means, liter-ally, "new sword," in contrast to the Koto, or "old sword." The Japanese sword changed in more than just name; the beginning of the Keicho era brought pronounced changes to smiths' style of workmanship at well.

In order to produce high-quality work, swordsmiths needed the patronage of a pow-erful lord, a shrine, or a temple. Production sites needed to be located in areas with convenient access to sword buyers as well as to suppliers of high-quality iron and charcoal. Yamashiro, Yamato, Bizen, Soshu, and Mino provinces, which had been active sword-producing provinces during Koto times, satisfied both these conditions, and the smiths in these locales developed distinct traditions.

Toyotomi Hideyoshi introduced a new administrative and military system that dramatically altered the political structure of the nation, and succeeded in subjugating the other prominent warrior lords (daimyo) under his rule. Most of these were in fact either his retainers or had fought with him to unify the country, and they set about building new castle towns to serve as the administrative and commercial centers of their provinces.

Swordsmiths gathered near these new castle towns, where they were employed by these daimyo. There was no longer any difficulty in acquiring the necessary raw materials, regardless of where smiths were located, thanks to the remarkable development of a nationwide transportation system. Thus, the original Five Traditions of Swordsmithing, which had always been strongly tied to specific locales began to lose their unique characteristics. Utterly new workmanship, created in various provinces, supplanted the old traditions; this new style of blade is what is meant by the term "Shinto." A number of Shinto smiths appeared in Kyoto, Edo, Osaka (a new commercial center), and in the larger cities of each province, including Saga (in Hizen), Kagoshima (in Satsuma), Fukui (in Echizen), and Kanazawa (in Kaga).

Civil war fueled demand for swords during the last hundred years of the Muromachi period but, as was noted, most of these were mass-produced and of low quality. Once the country had been unified, the demand for this kind of blade abruptly ceased. In a reflection of wider cultural trends of the Momoyama period, the sword was expected not only to be a superior weapon, but to have great artistic value as well. Smiths of the Momoyama period endeavored to recreate the masterpieces of the Kamakura and Nanbokucho periods.

Keicho Shinto (swords produced during the Keicho era) were not shaped like the Kamakura and Nanbokucho swords on which they were modeled; instead smiths reproduced the shape of shortened blades without signatures (osuriage mumei). These blades were between 73 and 76 cm in length and had only slight curvature. During this period the wearing of daisho (a pair of swords—one a wakizashi and the other a katana) came into common use. Kenjutsu (the art of fencing), which was rapidly evolving at this time, also appears to have had a significant influence on the form of the Keicho Shinto.

The difference between Koto and Shinto blades is best determined by examining the steel of a blade and its surface-grain pattern. The quality and character of the steel are based on both the quality of raw materials and the smith's forging skill.

One historical record states that advanced steelmaking processes were employed on a large scale beginning in the Oei era (1394–1428). The large number of swords produced in late Muromachi allows us to estimate roughly the quality of that era's steel production. Improved methods of steel manufacture led not only to increased production, but also to more uniform quality. Mass production of kazu-uchi mono blades, which were not markedly inferior to custom-made swords in their effectiveness, could never have occurred without this new steel.

There is no question that steel manufacturing processes were much better developed in Shinto times than previously, and that Shinto smiths were able to obtain steel of far better quality. During the late Muromachi period, older methods of sword production were abandoned amid the increasing reliance on mass production of low-quality swords. At the same time, new methods of sword production were invented, such as ko-buse and makuri, which have been handed down to the present day.

In addition, during late Muromachi, an entirely new type of steel was introduced by the Dutch and Portuguese; this was the so-called nanbantetsu (also known as hyotantetsu or konohatetsu). We know now that this new Western steel was not equal to the native Japanese steel (tamahagane) and that it was not really an appropriate material for sword production because it contained too much sulphur and phosphorus, which are believed to make blades weak and brittle. Even so, famous smiths such as Echizen Yasutsugu (越前康継) and his students including Tosa no Kami Tadayoshi

(土佐守忠吉), Dewa no Kami Yukihiro (出羽守行広), Echizen no Kami Sukehiro (越前守助広), and Omi no Kami Sukenao (近江守助直) used nanbantetsu; they noted this point on the tang of blades they made with it.

The Gokaden (five traditions of swordsmithing) declined in importance as swordsmiths migrated to new areas and raw material of a uniform quality became widely available. Many active smiths moved to other locales from Mino province, where they had reached the height of their prosperity during the late Muromachi period, and their Mino tradition-based workmanship then became influential on new methods of sword production. But in general, mainstream production tended toward adaptation and refinement of the Soshu tradition.

In the past, warriors who distinguished themselves in battle had been rewarded with grants of land. But the Ashikaga government responded to the new problem of a shortage of land available for distribution by presenting military heroes with swords instead of land. The Hon'ami family, who had been employed by successive shogunates, established a system of sword appraisal and attribution (kantei) together with a pricing system for nihonto, and issued authorized origami certificates. Under this pricing system, Soshu swords were considered more valuable than others, because of their great popularity. The Soshu tradition came to represent mainstream sword production, while the formerly-revered Bizen tradition declined in significance.

Umetada Myoju (埋忠明寿) of Yamashiro province is generally regarded as the founder of the Shinto methods, but in fact he was widely known as a master metalworker rather than as a swordsmith, and produced only a small number of blades. Members of the school that he founded include Higashiyama Yoshihira (東山美平); Higo no Kami Teruhiro (肥後守輝広), who moved to Hiroshima in Aki province; Teruhiro II (二代 播磨守輝広), who was employed by Lord Asano; and Hizen Tadayoshi (肥前忠吉), who was employed by Lord Nabeshima of Saga.

At about the same time, Shinano no Kami (Horikawa) Kunihiro (信濃守国広) was active in Kyoto, and created a number of masterpieces. His school includes Kuniyasu (国安), Osumi no Jo Masahiro (大隅掾正弘), Dewa Daijo Kunimichi (出羽大掾国路), Echigo no Kami Kunitomo (越後守国儔), Heianjo Yukihiro (平安城弘幸), Awa no Kami Ariyoshi (阿波守在吉), Izumi no Kami Kunisada (和泉守国貞), Kawachi no Kami Kunisuke (河内守国助), and Yamashiro no Kami Kunikiyo (山城守国清). All were skillful smiths who emerged as the forerunners of the new Yamashiro and Osaka smiths.

Meanwhile Kanemichi, who moved from Mino to Yamashiro province, established a new school as well. His four sons, Iga no Kami Kinmichi (伊賀守金道), Tanba no Kami Yoshimichi (丹波守吉道), Etchu no Kami Masatoshi (越中守正俊), and Rai Kinmichi (来金道) were skilled smiths, and are now known, together with succeeding generations, as the Mishina school.

In Edo, Echizen Yasutsugu was employed by Tokugawa Ieyasu, and his two families in Edo and Echizen provinces were active through the end of the Edo period. Noda Hankei (野田繁慶), originally a gunsmith, was famous for his unique interpretation of Soshu tradition.

In addition, the following smiths were well known: Yamashiro Daijo Kunikane (山城大掾国包) of Sendai; Sagami no Kami Masatsune (相模守政常) of Owari province; Mino no Kami Masatsune II (二代 美濃守政常); Hida no Kami Ujifusa (飛騨守氏房) of Owari province; Hoki no Kami Nobutaka (伯耆守信高) of Owari province; Nanki Shigekuni (南紀重国) of Wakayama (in Kii province); Kanewaka (兼若) of Kaga province; (Kunihiro's student) Yamashiro no Kami Kunikiyo of Echizen province; Higo Daijo Sadakuni (肥後大掾貞国), which is another name used by Echizen Yasutsugu or possibly the name of his younger brother; the Tadayoshi school of Hizen province; the Dotanuki school of Higo province; the Nobukuni school of Chikuzen province; and Izu no Kami Masafusa (伊豆守正房) and the Naminohira school of Satsuma province.

THE EDO PERIOD: EMERGENCE OF DISTINCT EASTERN AND WESTERN STYLES

The Tokugawa shogunate government finished sorting out the problems it had inherited from Toyotomi Hideyoshi and created a strong foundation—built on a long-term perspective—for the maintenance of its power. The government introduced a number of policies intended to keep the daimyo under firm control, including forming a number of expedient political marriages and requiring that each lord make regular, formal visits (sankin kotai) to Edo with his entire retinue. Lords who proved disloyal to the Tokugawa family were stripped of many privileges. During the Genroku era (1688–1704), the Tokugawa family's control was extensive, since they held lands yielding four million koku of rice, while their direct retainers held three million koku.

In Japanese sword history, the Edo period spans about 140 years, from the beginning of the Shoho era (1644) through the end of the An'ei era (1781). If the Keicho Shinto can be said to represent the Momoyama period, the Kanbun Shinto is surely representative of the Edo period.

Peace held under the Tokugawas, and both warriors and civilians were grateful that civil war had ended at last. Edo was well on its way to becoming the world's largest city, and Osaka and Kyoto were growing too. Even during the highly creative Momoyama period, smiths tended to look back to the Kamakura and the Nanbokucho period for examples of the finest blades. But during Edo, in the wake of the founding of a new political system, a new and unprecedented style of workmanship emerged.

Shinto blades in the Edo period were no longer copies of shortened tachi without signatures, as the Keicho Shinto of the Momoyama period had been; they were well-balanced and refined, with shallow curvature and tapering mihaba.

The length of the swords carried by members of the warrior class was restricted by the government in 1638, with katana being limited to 84.8 cm and wakizashi to 51.5 cm. These restrictions were relaxed slightly in 1712, in the case of katana to 87.6 cm, and wakizashi to 54.5 cm. Naturally, long katana were no longer popular, and the length of katana was standardized at about 70 cm (now referred to as josun, or standard length).

Shinto smiths created original, flamboyant temper lines unlike any seen before. Juzuba by Nagasone Kotetsu (長曾禰虎徹), toran-midare by Echizen no Kami Sukehiro (越前守助広), kobushigata choji by Kawachi no Kami Kunisuke II (二代 河内守国助) and representational hamon such as sudare-ba, kikusui-ba, Yoshino and Fujimi Saigyo were created by the later Tanba no Kami Yoshimichi (丹波守吉道) and others. The new tradition which these smiths created became known as the Shinto tokuden tradition. Meanwhile, some smiths experimented with the Soshu tradition, or with the other four traditions that had been largely neglected during the Momoyama period.

The workmanship typical of Kyoto and Osaka (Kansai, or western Japan), and Edo (Kanto, eastern Japan) were distinctly different. The Kansai style is represented by Sukehiro and Shinkai (真改) and referred to as Osaka Shinto, while the style favored in Edo is represented by Kotetsu and known as Edo Shinto.

Sukehiro and Shinkai produced gorgeous, sophisticated blades, while Kotetsu produced sturdy, powerful swords; this difference reflects the respective character of each region. Osaka was located close to Kyoto and had served as one of the most important cultural and economic centers since medieval times; Edo, on the other hand, was a new city inhabited by warriors who followed a strict code of behavior (bushido) requiring them to live simple, healthy, moral lives.

Many Shinto smiths adopted the custom of adding a title to their signature, such as "Echizen no Kami" or "Yamashiro Daijo." These titles were, in fact, the same as those used by the daimyo who helped rule the country, and they served a means of self-aggrandizement intended to make clear the smiths' high social standing, as the Edo-period class system solidified. Such titles were also sometimes used by doctors, Shinto priests, and craftsmen. A few Mino-province smiths added a similar sort of title to their signatures as well. "Kami" (守), "Suke" (介), "Jo" (掾), and "Sakan" (目) were the four titles used most often during Koto times.

By the end of the Edo period, smiths were making great efforts to acquire titles, since these increased the price of their blades. For generations, the Iga no Kami Kinmichi family held the privilege of processing and delivering applications for swordsmiths' titles to the Imperial court.

Cutting tests also became popular at this time, and blades from the period with inscriptions (tameshi-mei) on their tangs describing the results of test-cutting can often be seen. Yamano Kaemon, Yamano Kanjuro, and Yamada Asaemon, who were in the employ of the government, were skillful test-cutters. Because of their official status, they were permitted to use criminals' corpses for their cut-

ting tests, and they inscribed the results on the tangs, in phrases such as "Futatsu do otosu" ("cut two trunks") or "Mitsu do saidan" ("cut three trunks"). Very sharp swords were called wazamono, and warriors were proud to carry wazamono even during this peaceful reign.

There is no doubt that tameshi-mei attracted customers, and could raise the price of a sword in much the same way that a title could, even during a time of lasting peace and low demand for swords. A majority of tameshi-mei blades are made in the Edo Shinto style, which is natural enough, given Edo's character as a city of warriors.

The number of swordsmiths decreased after the Genroku era, and few distinguished smiths appeared. Swordsmiths not in the employ of daimyo actively sought to cultivate customers from among the wealthy merchant class, and so were consigned to produce a large number of wakizashi. Tanto, on the other hand, are quite rare in this period.

Blade engravings (horimono) were beginning to lose their religious significance and become purely ornamental. The work of Ikkanshi Tadatsuna (一竿子忠綱), who engraved elaborate and gorgeous horimono on blades with toran midare, is a good example of this trend.

The eighth shogun, Tokugawa Yoshimune, who is regarded as the restorer of Tokugawa Ieyasu's policy, grew concerned to see his warriors becoming, in peacetime, self-indulgent spendthrifts. In response, he took into his service the famous scholar of classical Japanese, Arai Hakuseki, and implemented the Kyoho Reforms, which were economic measures intended to curb extravagant spending by the warrior class and restore the shogunate's treasury.

Shogun Yoshimune held a swordmaking contest in Edo Castle in 1720. Contestants included Mondo no Sho Masakiyo (主水正正清), Ichinohira Yasuyo (一平安代), Omi no Kami Hisamichi (近江守久道), Iga no Kami Kinmichi III (三代 伊賀守金道), Nobukuni Shigekuni (信国重包), and Musashi Taro Yasukuni (武蔵太郎安国). The Satsuma smiths in particular achieved remarkable results.

The Kyoho Reforms brought a temporary increase in the demand for swords, but the warrior class's return to a stoic ethical code was short-lived, and the next upsurge in sword production did not occur until the appearance of the Shinshinto.

The leading smiths of the Edo period are as follows:

In Osaka, Inoue Izumi no Kami Kunisada II, who later came to be called Shinkai, made his appearance; his school includes Kaga no Kami Sadanori (加賀守貞則), Hokuso Harukuni (北窓治国), Doi Shinryo (土肥真了), and Inoue Kiho (井上奇峰). Another outstanding smith of the Osaka Shinto style was Tsuda Echizen no Kami Sukehiro, whose student was Omi no Kami Sukenao (近江守助直). Sukenao also had a considerable influence on Echigo no Kami Kanesada (越後守包貞) and Sakakura Gonnoshin Terukane (坂倉言之進照包). Kawachi no Kami Kunisuke II, who was generally known as Naka Kawachi, created a unique type of hamon; his school included Musashi no Kami Kunitsugu (武蔵守国次), Higo no Kami Kuniyasu (肥後守国康), and Ise no Kami Kuniteru (伊勢守国輝). Others who were well known include Soboro Sukehiro (ソボロ助広), father of Tsuda Echizen no Kami Sukehiro; Ikkanshi Tadatsuna; Mutsu no Kami Kaneyasu (陸奥守包保); and Tatara Nagayuki (多々良長幸).

In the Mishina school of Kyoto, Iga no Kami Kinmichi II (二代 伊賀守金道), Tanba no Kami Yoshimichi II (二代 丹波守吉道), Yamato no Kami Yoshimichi (大和守吉道) and Etchu no Kami Masatoshi II (二代 越中守正俊) (the latter two of whom were later to move to Osaka) were active.

In Edo, Nagasone Kotetsu was the leading smith of the Edo Shinto style, and his students Okimasa (興正) and Okihisa (興久) were also very skillful. Others active in the Edo Shinto style at this time included Kazusa no Suke Kaneshige (上総介兼重), Yamato no Kami Yasusada (大和守安定), Heki Mitsuhira (日置光平), Musashi Daijo Korekazu (武蔵大掾是一), Hojo-ji Masahiro (法城寺正弘), Hojoji Yoshitsugu (法城寺吉次), and Ogasawara Nagamune (小笠原長旨).

The Tadayoshi school undertook sword production on a large scale, as this was an important financial resource for the Nabeshima clan; many Hizen-province swords were exported to other areas. Mutsu no Kami Tadayoshi III (陸奥守忠吉), Harima Daijo Tadakuni (播磨大掾忠国), Kawachi no Kami Masahiro (河内守正広), Dewa no Kami Yukihiro, and Iyo no Jo Munetsugu (伊予掾宗次) were well known.

In other provinces, Miyoshi Nagamichi (三善長道) of Aizu (Iwashiro province), the later Yasutsugu (後代 康継) of Echizen province, the later Kanewaka (後代 兼若) of Kaga province, Kozuke Daijo Sukesada (上野大掾祐定) of Bizen province, Mizuta Yogoro Kunishige (水田与五郎国重) of Bitchu province, the Nobukuni school of Chikuzen province, Koretsugu (是次) and Moritsugu (守次) of the Fukuoka Ishido school, and Muneyuki (統行) and Matsuba Motoyuki (松葉本行) of Bungo province were active.

RANKING OF WAZAMONO

The book *Kaiho Kenjaku*, written in 1815 by Yamada Asaemon Yoshitoshi, discusses and ranks the sharpness of one-hundred-eighty swords on which the author did cutting tests. This document provides interesting insight into the way that people thought about Japanese swords at the time. Needless to say, Yamada tested only a limited number of swords, and does not seem to have included any old Koto masterpieces. His evaluations were as follows:

Saijo O-wazamono (Best)

Leading swordsmiths:
<Koto> Osafune Hidemitsu (長船秀光), Kanemoto I (初代 兼元); Kanemoto II (二代 兼元); (Oei era) Mihara Masaie (三原正家 [応永]); and Osafune Motoshige (長船元重).

<Shinto> Nagasone Okisato Kotetsu (長曾祢興里虎徹); Tatara Nagayuki (多々良長幸); Mutsu no Kami Tadayoshi (陸奥守忠吉); Sukehiro I (初代 助広); Kunikane I (初代 国包); Tadayoshi I (初代 忠吉); Nagasone Okimasa (長曾祢興正); and Nagamichi I (初代 長道).

O-wazamono (Excellent)

Leading swordsmiths:
<Koto> Sakyo no Suke Yasumitsu (左京亮康光); (Mino

province) Izumi no Kami Kanesada (和泉守兼㝎 [美濃]); Yosozaemon Sukesada (与三左衛門祐定); Hikobei Sukesada (彦兵衛祐定); (Tensho era) Toshiro Sukesada (藤四郎祐定 [天正]); Shuri no Suke Morimitsu (修理亮盛光); (Bunmei era) Fujishima Tomoshige (藤島友重 [文明]), and Takatenjin Kaneaki (高天神兼明).

<Shinto> (Kaga province, Genroku era) Kanenori (加州兼則 [元禄]), Horikawa Kuniyasu (堀川国安), Echigo no Kami Kanesada II (二代 越後守包貞), Horikawa Kunihiro (堀川国広), (Kaga province) Katsukuni I (初代 加州勝国), Higo no Kami Kuniyasu I (初代 肥後守国康), Omi Daijo Tadahiro (近江大掾忠広), Kakutsuda Sukehiro (Kaku Tsuda) (角津田助広), Izumi no Kami Kunisada I (初代 和泉守国貞), Mondo no Sho Masakiyo (主水正正清), Ichinohira Yasuyo (一平安代), Echizen no Kami Nobuyoshi (越前守信吉), Kanewaka I (初代 加州兼若); and Tsushima no Kami Sadashige (対馬守貞重).

Ryo-wazamono (Very Good)

Leading swordsmiths:
<Koto> Osafune Morikage (長船盛景); Sukeemon Norimitsu (助右衛門則光); Gorozaemon Norimitsu (五郎左衛門則光); (Mino province) Kanesada III (三代 兼定 [美濃]); Kanabo Masazane (金房正真); Osafune Hidesuke (長船秀助); Tsunahiro I (初代 相州綱広); (Bunki era) Seki Kanefusa (関兼房 [文亀]); Fukusaboro Kanetsune (福三郎兼常); Sakyo no Shin Munemitsu (左京進宗光); Jirozaemon Iesuke II (次郎左衛門 二代 家助); Tadamitsu I (初代 忠光); Tadamitsu II (二代 忠光); Tadamitsu III (三代 忠光); Ukyo no Suke Katsumitsu (右京亮勝光); Jirozaemon Katsumitsu (次郎左衛門勝光); Takada Yukinaga (高田行長); Sakakura Masatoshi I (初代 坂倉正利); Sakakura Masatoshi II (二代 坂倉正利); Norimitsu I (Norimitsu) (初代 法光); Norimitsu II (二代 法光); Ujifusa I (初代 氏房); and (Kakitsu era) Sukemitsu (祐光 [嘉吉]).

<Shinto> (Kyoto, Osaka) Tanba no Kami Yoshimichi I (初代 丹波守吉道 [京・大阪]); Omi no Kami Sukenao (近江守助直); Iga no Kami Sadatsugu (伊賀守貞次); Ishido Korekazu I (初代 石堂是一); Ikkanshi Tadatsuna (一竿子忠綱); (Kyoto, Osaka) Tanba no Kami Yoshimichi II (二代 丹波吉道 [京・大阪]); Yasutsugu I (初代 康継); Yasutsugu II (二代 康継); Aizu Masanaga (会津政長); Echigo no Kami Kunitomo (越後守国儔); Tango no Kami Naomichi (丹後守直道); Kazusa no Suke Kaneshige (上総介兼重); (Echizen province) Kanetane I (初代 越前兼植); Heki Mitsuhira (日置光平); Nanki Shigekuni I (初代 南紀重国); Aizu Kanesada (会津兼定); (descendant of Eisho Sukesada) Sukesada IX (九代 祐定 [永正]); (Echizen province) Kanenori (越前兼則 [兼法同人]); Ise Daijo Yoshihiro (伊勢大掾吉広); Heki Tsunemitsu (日置常光); Yasuhiro I (初代 康広); Hisamichi I (初代 久道); Yamato Daijo Masanori I (初代 大和大掾正則); Oyogo Kunishige (大与五国重); Okayama Kunimune (岡山国宗); Musashi

no Kami Yoshikado (武蔵守吉門); Kunikane II (二代 国包); Yamashiro Daijo Kunitsugu I (初代 山城大掾国次); Tadayuki I (初代 忠行); Izumi no Kami Tadashige (和泉守忠重); Yamato no Kami Yasusada (大和守安定); and Heki Munehiro (日置宗弘).

Wazamono (Good)

Leading swordsmiths:
<Koto> Katsubei Kiyomitsu (勝兵衛清光); Gorozaemon Kiyomitsu (五郎左衛門清光); Kanabo Masatsugu (金房政次); Jurozaemon Harumitsu (十郎左衛門春光); Shitahara Terushige (下原照重); and Nio Kiyozane (二王清実).

<Shinto> Tsuda Sukehiro (Maru Tsuda) (丸津田助広); Inoue Shinkai (井上真改); Musashi no Kami Kanenaka (武蔵守兼中); Hidari Mutsu no Kami Kaneyasu (左陸奥包保); Shimosaka Munemichi (or Munetsugu) (下坂宗道 [宗次同人]); Doi Shinryo II (二代 土肥真了); Kobayashi Kuniteru (小林国輝); Yamashiro no Kami Hidetoki I (初代 山城守秀辰); Toren Morihisa (東連守久); Umetada Shigeyoshi (埋忠重義); Kawachi no Kami Kunisuke I (初代 河内守国助); Yamashiro no Kami Toshinaga I (初代 山城守歳長); Aizu Kanetomo I (初代 会津兼友); Suzuki Kaga no Kami Sadanori (鈴木加賀守貞則); Aizu Kunisada (会津国貞); Shinano Daijo Tadakuni I (初代 信濃大掾忠国); Higo no Kami Teruhiro (肥後守輝広); Kawachi no Kami Kunisuke II (二代 河内守国助); Kawachi no Kami Kunisuke III (三代 河内守国助); (Settsu province) Kunimitsu (摂津国光); Mutsu no Kami Toshinaga I (初代 陸奥守歳長); Yamato no Kami Yoshimichi I (初代 大和守吉道); Yamato no Kami Yoshimichi II (二代 大和守吉道); Takayanagi Sadahiro (高柳貞広); (Tosa province) Yoshikuni (土州吉国); Echigo no Kami Kanesada I (初代 越後守包貞); (Osaka) Hiromasa (広政 [大坂]); Onizuka Yoshikuni (鬼塚吉国); Nobukuni Shigekane (信国重包); Sagami no Kami Kunitsuna (相模守国綱); Nobukuni Shigesada (信国重貞); Kinshiro Hisamichi II (金四郎 二代 久道); Hojoji Masahiro (法城寺正弘); Iga no Kami Kinmichi I (初代 伊賀守金道); Kanetane (Edo) (兼植 [江戸]); Sakakura Masatoshi I (初代 坂倉正俊); Hoki no Kami Hirotaka (伯耆守汎隆); Tsutsui Kiju (筒井紀充); Hitachi no Kami Mineshige I (初代 常陸守宗重); Suketaka (Osaka) (助高 [大坂]); Hachiman'yama Kiyohira (八幡山清平); (Echizen province) Shigetaka I (初代 越前重高); Tadayoshi IV (四代 忠吉); Obama Kuniyoshi (小浜国義); Kanekuni I (初代 包国); Shimosaka Tsuguhiro (下坂継広); Koriyama Kunitake (郡山国武); Seki Tomotsune (関友常); Tsuguhira I (初代 継平); Izumo no Kami Sadashige (出雲守貞重); Nobuyoshi I (Kyoto) (初代 京信吉); Harima Daijo Tadakuni I (初代 播磨大掾忠国); Izumi no Kami Kinmichi I (初代 和泉守金道); Izumi no Kami Kinmichi II (二代 和泉守金道); Dewa no Kami Yukihiro I (初代 出羽守行広); Kishinmaru Kunishige (鬼神丸国重); Takada Sadayuki I (初代 高田貞行); Takada Muneyuki I (初代 高田統行); Izumo Daijo Yoshitake I (初代 出雲大掾吉武);

Izumo Daijo Yoshitake II (二代 出雲大掾吉武); Takada
Shigeyuki (高田重行); (Osaka) Yasunaga (康永 (大坂));
Yamashiro no Kami Kunikiyo I (初代 山城守国清);
Yamashiro no Kami Kunikiyo II (二代 山城守国清);
Sendai Yasutomo II (二代 仙台安倫); (Osaka) Kunikore
(国維大坂); Harima Daijo Kiyomitsu (播磨大掾清光);
Gorozaemon Kiyomitsu (五郎左衛門清光); Katsuie I (初
代 勝家); Katsuie II (二代 勝家); Hoki no Kami Nobutaka
I (初代 伯耆守信高); Hoki no Kami Nobutaka II (二代 伯
耆守信高); Kozuke no Suke Yoshimasa (上野介吉正);
(Osaka) Nagatsuna (長綱 [大坂]); Tegarayama Ujishige
I (初代 手柄山氏重); Tachibana Ippo (橘一法); Senjuin
Morikuni (千手院盛国); Dewa Daijo Kunimichi I (初代
出羽大掾国路); (Mimasaka province) Kanekage (作州兼
景); (Osaka) Kuniyuki (国幸 [大坂]); Kawachi Daijo
Masahiro I (初代 河内大掾正広); (Osaka) Sukenobu (助信
[大坂]); Motoyuki I (or Yukihira) (初代 本行 [行平同人]);
Bitchu Daijo Masanaga (備中大掾正永); and Hanabusa
Sukekuni (花房祐国).

LATE EDO THROUGH EARLY MEIJI: EMERGENCE OF THE SHINSHINTO

Following the death of shogun Yoshimune, Tanuma Okitsugu wielded power as roju (chief senior councillor of the shogunate government) and attempted to implement a series of new policies. Although his efforts aimed at improving the government's financial situation, they ultimately failed because the system of paying the shogunate's warrior retainers in salaries of rice was unable to survive the transition to a monetary economy. The standard of living declined, and the country was beset by a string of natural disasters.

The influence of the Tokugawa family was waning. Wealthy merchants began to gain in power, and ukiyoe (popular woodblock prints), dime novels, erotica, and other kinds of popular culture became fashionable with the citizenry.

Matsudaira Sadanobu, then–chief senior councillor, carried out the so-called Kansei Reform, the main points of which were the promotion of frugality and the implementation of a government-controlled economy. Subsequently, the shogun Ienari took over direct rule of the government; this was followed by the Tenpo Reforms of Mizuno Tadakuni, Matsudaira's successor. Despite these successive efforts to restore health to the economy, the government's fiscal difficulties continued.

The major daimyo launched their own attempts to revive the economy, acting outside the government's controls. The daimyo in the western part of the country were relatively successful in these efforts, and this set the stage for their future role as the driving force in the Meiji Restoration.

In the countries of the West, meanwhile, the Industrial Revolution was well underway, and foreign governments sent ships to place pressure on Japan to open its doors to international trade. The shogunate had no clear policy for dealing with foreigners, and domestic opinion was split. Some thought that Japan had no choice but to open the country, while others insisted on repelling foreigners, by force if necessary. Still others demanded immediate governmental reform. Imperialism increased in popularity because of a renewed interest in classical Japanese literature. This reactionary tendency and the campaign that it fostered were soon to bring sweeping historical changes.

In 1858, Senior Minister Ii Naosuke began a massive purge of officials opposed to the shogunate's policy of beginning to engage in trade with the West. He ordered the execution of several imperialists and placed a number of daimyo under house arrest or other restrictions. In 1860, just outside the Sakurada Gate of Edo castle, Ii was assassinated by imperialists in retaliation. Radical imperialists gained power at the court in Kyoto, with the backing of the Choshu clan, which was spearheading a campaign to "revere the emperor and expel the barbarians."

But after a succession of setbacks, the anti-foreigner campaign finally collapsed altogether. First, British ships bombarded and burned much of the Satsuma town of Kagoshima in retaliation for the murder by Satsuma warriors

of a British citizen. Next the radical Choshu clan was driven from Kyoto in 1863 by the less-vehemently anti-foreigner Satsuma and Aizu clans. Finally, the Choshu clan suffered decisive defeat at the hands of a fleet sent by Britain, France, the Netherlands, and the United States in the Battle of the Bakan Channel (also known as the Shimonoseki Bombardment).

Thus the imperialist faction discovered through bitter experience that expulsion of foreigners was not feasible, and that refusal to open the country consistently brought reprisals. Overthrowing the Tokugawa shogunate and opening the country became the goals of a new campaign supported by anti-government daimyo from Satsuma, Choshu, and Hizen. The shogunate could no longer cope with domestic social change or the demands of Japan's new international status, and the last shogun, Tokugawa Yoshinobu, was forced to turn control of the government over to the Emperor in 1867. Imperial rule was restored.

The turmoil accompanying the Meiji Restoration placed a further strain on sword production, which had already been in decline, with no truly distinguished smith active since the Genroku era. At this time, however, Kawabe Hachiro Masahide (川部儀八郎正秀), a retainer of the Akimoto clan (Uzen province), and Nankai Taro Tomotaka (南海太郎朝尊), who had moved to Kyoto from Tosa province, began to advocate "fukkoto" (producing blades using the methods of the Kamakura and Nanbokucho periods). Many smiths took up the challenge and attempted to replicate the old Koto blades. Sword production again flourished.

Swords produced between 1781 and 1876, the year in which the government issued the Haitorei decree banning the wearing of swords, are known as Shinshinto or, alternatively, fukkoto. There were a few smiths active during the Meiwa (1764-), Bunka (1804-), and Bunsei eras (1818-), but they are regarded, for the sake of convenience, as Shinshinto smiths.

Swords were produced in the Shinshinto era in a style different from that of Shinto blades; smiths stressed practicality and tried to revive the methods of the Kamakura and Nanbokucho

periods. In addition to katana and wakizashi, a large number of tanto, which had been rare in Shinto times, were produced.

Taikei Naotane (大慶直胤), Minamoto no Kiyomaro (源清麿), and others produced o-nagamaki (long nagamaki), in a reflection of the ongoing bloody conflicts. Saito Kiyondo (斎藤清人), Sa no Yukihide (左行秀), and others produced the so-called kinnoto (imperialist sword [勤王刀]), which was between 75 and 84 cm in length and without curvature, and had a shinogi-zukuri construction. Supporters of the Emperor are said to have worn this type of blade as the Edo period drew to a close.

Mainstream sword production followed the Bizen and Soshu traditions, but Shinshinto smiths also worked successfully to some extent in all five of the earliest traditions, and in the Shinto tokuden tradition. One characteristic of the Shinshinto era is that swordsmiths did not necessarily confine themselves to working in a single tradition, but attempted to combine production methods from various traditions. In this, they were not entirely successful.

Edo became a center of sword production during this period. Swordsmiths came from around the country to study under Suishinshi Masahide, who is said to have had more than one hundred students. Taikei Naotane and Hosokawa Masayoshi (細川正義) were the best of his Suishinshi school. The second-generation Sadahide later succeeded to the name Masahide. Jiro Taro Naokatsu (次郎太郎直勝) was a student of Taikei Naotane's.

The Kato (加藤) brothers, Tsunahide (綱英) and Tsunatoshi (綱俊), were both skillful smiths, the former excelling at toran-midare, and the latter at choji midare. Koyama Bizen no Suke Munetsugu (固山備前介宗次) and Unju Korekazu (運寿是一) also belong to their school. Tairyusai Sokan (泰龍斎宗寛) was a student of Koyama Munetsugu's.

Minamoto no Kiyomaro was the best of the Shinshinto smiths. He moved to Edo from Shinano province and his work, an imitation of the style of Shizu Kaneuji, met with success. His school includes Kurihara Nobuhide (栗原信秀), Suzuki Masao (鈴木正雄), and Saito

Kiyondo. His elder brother Yamamura Masao (山浦真雄) and Masao's son Kanetora (兼虎), continued to produce blades in Shinano province.

Although Osaka sword production was not as active as it had been in Shinto times, Ozaki Suketaka (尾崎助隆) attempted to reproduce the toran-midare of Tsuda Sukehiro, and Gassan Sadayoshi (月山貞吉) and his son-in-law Sadakazu worked in the Gokaden and Shinto tokuden traditions. Sadakazu (貞一) was also an excellent engraver.

The Mito Tokugawa family of Hitachi province were intent on maintaining military readiness, and Lord Tokugawa Nariaki (烈公 or 徳川斉昭) encouraged swordsmiths while also engaging in sword production himself. He had Norimune (徳宗) and Norikatsu (徳勝) work in the Yamato tradition, while he himself forged a unique surface-grain pattern known as yaku-mo gitae. Ichige Tokurin (市毛徳鄰) and Naoe Sukemasa (直江助政) studied under Ozaki Suketaka of Osaka.

There were no distinguished smiths in the Oshu district, although Tegarayama Masashige (手柄山正繁), Aizu Kanesada (兼定), the later Nagamichi (長道), and Sumi Motooki (角元興) are relatively well known for their unique workmanship.

In addition, Okachiyama Nagasada (御勝山 永貞) of Mino province, the later Iga no Kami Kinmichi (伊賀守金道) of Kyoto, Nankai Taro Tomotaka, Yokoyama Sukenaga (横山祐永) and Sukekane (祐包) of Bizen province, Hamabe Toshinori (浜部寿格), and Minryushi Toshizane (眠龍子寿実) of Inaba province were active during this period. Sa no Yukihide of Tosa province was another outstanding Shinshinto smith. Tadayoshi VIII (八代 忠吉) of Hizen province carried on the tradition of hizento. Yamato no Kami Motohira (大和守元平) and Hoki no Kami Masayoshi (伯耆守正幸) created a unique style based in the Soshu tradition.

MID-MEIJI THROUGH THE PRESENT DAY: ART SWORDS

The Tokugawa shogunate was overthrown, and the Meiji Restoration achieved, in 1868. The Meiji government began to modernize Japan, taking Western countries as their models. Naturally enough, demand for the Japanese sword declined abruptly with the introduction of a Western military system, and most smiths had to give up sword production altogether.

The traditions of the warrior culture, unsuited to the new age, fell away one after another. The government's policy was to try to modernize and to catch up with the West as quickly as possible; for the old traditions—including the wearing of swords—were considered a hindrance.

In 1869, Mori Arinori submitted to the government a proposal concerning the ban on sword-carrying. The following year, the government banned civilians from wearing swords, and the year after that warriors were encouraged to cut off their topknots (a symbol of their warrior status) and also to go out without their traditional pair of swords. But many warriors ignored the government's push toward modernization and maintained their traditional wear.

A military conscription system was adopted in 1876, together with a more extensive ban on the wearing of swords, known as the Haitorei, which excluded only high-ranking officials such as ex-daimyo, the military, and policemen. Warriors gradually came to accept their new lifestyle and abandoned their swords, though there were some dissidents who rebelled against the Haitorei.

After the decree of the Haitorei, sword production, which had thrived at the end of the Edo period, dropped off rapidly, and swordsmiths were forced to look for other work.

Despite Saigo Takamori's armed rebellion against the imperial government, the dispatch of troops to Taiwan, the Sino-Japanese War, and the Russo-Japanese War, military activity during the Meiji era did not help to increase the demand for new blades. Evidently, a sufficient number of swords had been produced in the past to supply the military's needs. In modern battles, the Japanese sword appears to have been used as a symbol to raise morale, rather than as a weapon against the enemy.

The artistic value of the Japanese sword was recognized even in the very earliest stages of the country's sword history, and the formulation of appreciation and evaluation methods helped connoisseurs to develop a discerning eye. After the Meiji Restoration, swordmaking came to be recognized as an art form, and swords were highly regarded for their aesthetic value. A new policy which sought to preserve important cultural assets was implemented, and the government created the Department of Antiquities and Conservation in 1871. This was followed by the establishment of a temporary department of research on cultural assets, and then by the enactment in 1897 of a law requiring that historic shrines and temples be preserved.

The system of nominating swords as National Treasures also began in 1897; only works owned

by shrines and temples were eligible. The law was amended in 1929, extending the honor to swords owned by the state, public organizations, museums, or private collectors. In 1933 a law concerning the nomination of important art work was issued to preserve objects of historical and artistic importance, and to prevent significant pieces from leaving the country.

The Meiji emperor was an avid sword-lover and very knowledgeable about the Japanese sword; he also had a deep interest in sword production. He began to designate especially talented craftsman as Teishintsu Gigei In (essentially the equivalent of the title of Living National Treasure used today) in 1890. Organized by the Imperial family, this system was designed to encourage craftsmen and to preserve the traditional skills of Japanese arts and crafts. This designation soon came to be considered the greatest honor that a Japanese craftsman could achieve. Swordsmiths Gassan Sadakazu (月山貞一) and Miyamoto Kanenori (宮本包則), together with talented craftsmen from other fields, including master metalworker Kano Natsuo, were nominated as the first of these "special authorized craftsmen to the court."

For most smiths, however, this was a very difficult time, and few swords were actually produced. In addition to Gassan Sadakazu and Miyamoto Kanenori, Horii Taneyoshi (堀井胤吉), Izumi no Kami Kanesada XI (十一代 和泉守兼定), Henmi Yoshitaka (逸見義隆), Sakurai Masatsugu (桜井正次), Gassan Sadakatsu (月山貞勝), Hayama Enshin (羽山円真), and Kasama Shigetsugu (笠間繁継) were relatively active.

The demand for swords as weapons increased as a result of World War I, the dispatch of troops to Siberia, and the Manchurian Incident; during World War II, sword production reached its height. A large number of so-called showato were produced for the use of military officers, but the blades were not forged with traditional techniques, and the vast majority were not of a quality high enough to merit consideration as art swords.

There were a few smiths who continued to produce swords in the traditional methods,

including Gassan Sadakatsu, Kasama Shigetsugu, and Takahashi Sadatsugu (高橋貞次) of the Gassan school; Kurihara Hikosaburo Akihide (栗原彦三郎昭秀), who was the founder of the Nihonto Tanren Denshujo (Japanese Sword Forging Institute) and his students Akimoto Akitomo (秋元昭友), Konno Akimune (今野昭宗), Ishii Akifusa (石井昭房), Miyairi Akihira (宮入昭平), and Yoshiwara Kuniie (吉原国家); Ikeda Yasumitsu (池田靖光) and Kajiyama Yasunori (梶山靖徳) of the Yasukuni Jinja Nihonto Tanrenkai; and Kasama Shigetsugu's students Miyaguchi Toshihiro (宮口寿広), Sakai Shigemasa (酒井繁正), and Tsukamoto Okimasa (塚本起正).

Formal scientific research on the structure and composition of the Japanese sword began after the Taisho era (1912–1926). Dr. Tawara Kuniichi, in collaboration with smith Kasama Shigetsugu, built a laboratory at Tokyo University where he analyzed the Japanese sword from a metallurgical point of view. The results were published as *Nihonto no Kagakuteki Kenkyu* (Scientific research on the Japanese sword), which remains the definitive work on the subject.

For a time after Japan's defeat in World War II, the sword was considered merely a weapon. Orders to destroy all existing swords, including art objects and works of historical significance, were handed down from the General Headquarters of the Allied Forces. Sword production was also completely banned. Sword-lovers joined forces to overcome this crisis, and eventually the GHQ agreed to allow the ownership of blades which had artistic value. In 1948, the Nihon Bijutsu Token Hozon Kyokai, or NBTHK (日本美術刀剣保存協会), was established by a group of enthusiastic collectors, researchers, connoisseurs, and craftsmen who assumed responsibility for the preservation of the Japanese sword and the swordsmithing craft, and worked toward preventing any future threats to the Japanese sword's continued existence.

In 1950, the Cultural Properties Law (bunkazai hogoho) replaced the earlier National Treasure system. Since then, 880 swords have been nominated as Important Cultural

Assets (juyo bunkazai), and 122 of these have been designated as National Treasures.

Sword production finally resumed in 1953 after the Agency for Cultural Affairs authorized qualified smiths. Thus the Japanese sword formally joined the field of arts and crafts. This was of momentous significance for those smiths who had been unable to work in the immediate postwar years. The first swordmaking contest was held in 1955, and the blades entered were exhibited at the Tokyo Metropolitan Museum. This event is now widely known as the Shinsaku Meitoten, and is held annually in a department store in Tokyo.

Meanwhile, Takahashi Sadatsugu was designated a Living National Treasure (juyo mukei bunkazai) in 1955; Miyairi Akihira received this same honor in 1963, followed by Gassan Sadakazu in 1971 and Sumitani Masamine in 1979. At present, more than three hundred smiths are at work producing blades.

Swords produced after the end of the Shinshinto era are generally known as gendaito, but it seems inappropriate to group the blades of prewar and postwar smiths into the same category. Some postwar smiths have already produced masterpieces which are fully the equal of Shinto and Shinshinto. In the future we can expect to see gendaito as excellent as the Koto blades produced by Ichimonji of Bizen province or Masamune of Soshu.

SWORD APPRAISAL
TERMINOLOGY

TYPES OF SWORDS

Swords vary according to the period in which they were forged, the use to which they were put, and the manner in which they were worn. The basic types include:

Tachi (大刀): Chokuto, or straight swords, were produced in ancient times. This precursor to the classic Japanese blade is over 60 cm in length and is not curved. Swords shortened to less than 60 cm are also called "tachi," but that term is written with different Chinese characters.

Tachi (太刀): This is a curved sword with a blade longer than 60 cm. It was worn suspended from the belt with the blade edge facing the ground. Tachi were produced primarily during Koto times, i.e., prior to 1596. Later, some blades originally produced as tachi were converted into katana by shortening the tang (or the portion of the blade that extends below

the hamachi and munemachi); this process inevitably caused any signature to be lost. Blades longer than 90 cm are known as o-dachi (long tachi), while those 60 cm or shorter are known as ko-dachi (short tachi).

Katana: Katana have blades longer than 60 cm and are worn thrust through the belt, with the cutting edge facing upward. This term is also frequently used to refer to Japanese swords in general. The katana superseded the tachi beginning in the Muromachi period (after 1392). One distinctive style, produced in late Muromachi, is known as the uchigatana; it is deeply curved in the upper part of the blade and is wielded with one hand.

Wakizashi: Blades greater than 30 and less than 60 cm in length are known as wakizashi. During the Edo period, this was the shorter of the pair of swords worn by Japanese warriors; merchants were not permitted to carry katana, but were allowed to wear the shorter wakizashi. Special terms are used for blades of unusual length: o-wakizashi (long wakizashi) and ko-wakizashi (short wakizashi).

● JAPANESE SWORDS OF VARIOUS TYPES

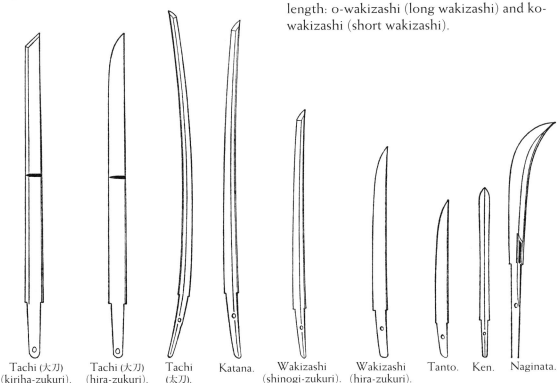

Tachi (大刀)
(kiriha-zukuri).

Tachi (大刀)
(hira-zukuri).

Tachi
(太刀).

Katana.

Wakizashi
(shinogi-zukuri).

Wakizashi
(hira-zukuri).

Tanto.

Ken.

Naginata.

Tanto: Tanto are blades shorter than 30 cm, with a standard length of about 26 cm. Blades just slightly longer than 30 cm are sometimes referred to as sunnobi tanto (longer tanto). Depending on the way in which a blade is mounted and worn, it can be called either a tanto or a kaiken (a tanto concealed in one's clothing). Most tanto are constructed in the flat style (hira-zukuri), but other forms, such as double-edged blades (moroha-zukuri), are occasionally found.

Ken: Ken are straight double-edged blades. They are used, together with a hilt known as the sankozuka, as an implement of esoteric Buddhism, rather than as a weapon.

Naginata and nagamaki: A naginata is a long-hafted sword, wielded in large, sweeping strokes. Most naginata have no yokote, and the blades often have a distinctive carved groove. Typically, a naginata has a wide blade with a large point, and a long tang. Today the blade commonly referred to as a naginata is dramatically curved and quite wide toward the tip, while a more standard-shaped blade is called a nagamaki.

Nagamaki-naoshi (remodeled nagamaki) is the term used for a blade that has been reshaped into a katana or wakizashi, thus altering its original length and curvature.

Yari: A yari is a spear. In most cases the tang is inserted into the haft, but a fukuro yari (lit., "bag spear," referring to the shape of the tang) slips over the haft. Yari were produced mainly after the Muromachi period, and vary greatly with both the historical period and individual maker. A sugu yari or suyari is a straight double-edged spear; a particularly long variation is known as an omi yari. A kama (sickle) yari has a branch off the blade. Other types of spears include the sasaho (in the shape of a bamboo leaf) yari, the jumonji yari (cross-shaped), the Kikuchi yari (named after a clan), hira-sankaku (isosceles triangle) yari, etc.

Hoko: The hoko is a spear thought to be the forerunner of the yari. Bronze hoko first appeared in ancient times and there are extant iron yari from the Nara period (710–794).

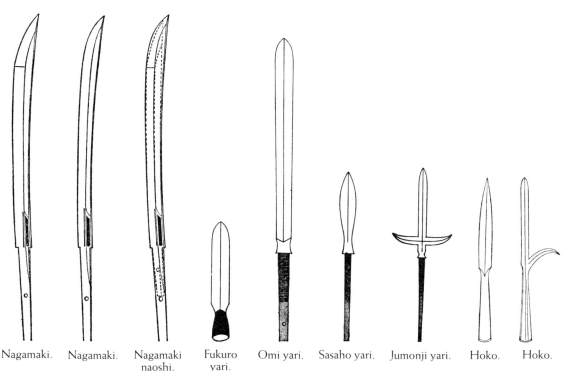

Nagamaki. Nagamaki. Nagamaki naoshi. Fukuro yari. Omi yari. Sasaho yari. Jumonji yari. Hoko. Hoko.

PARTS OF THE SWORD

Toshin: The sword; the sword as a whole.

Kami: The blade. The portion of the sword that is inserted into the scabbard (saya), from the blade tip (kissaki) to the notches marking the beginning of the tang (machi).

Nakago: The tang of the sword; that part of the blade, below the machi, which is inserted into the hilt (tsuka). It is finished by hammering or filing, and often bears a carved signature. The hilt is attached by means of a peg (mekugi) inserted through a special hole (mekugi ana) in the nakago.

Nakagojiri: The butt end of the nakago; its shape is important in determining the province and school of the swordsmith.

Mune: The back edge of the blade, opposite the cutting edge, from the tip of the kissaki to the beginning of the nakago.

Shinogi: The ridge along the side of the blade, between the edge and the mune, that extends from the yokote to the nakagojiri. The difference in the thicknesses of the shinogi and mune is referred to as "low" or "high."

Ko-shinogi: The diagonal line separating the kissaki from the back of the blade above the shinogi; also, a continuation of the shinogi.

Yokote: The line lying at a right angle to the cutting edge and dividing the kissaki from the rest of the blade.

Hasaki: The blade's razor-sharp cutting edge.

Fukura: The cutting edge of the kissaki. The fukura curves to a greater or lesser degree; this curvature can be described as "rounded," "not rounded," etc.

Iori: The top ridge of the mune. Iori, in Japanese, means the ridge-line of a roof.

Oroshi: The slope from the iori to the edge of the mune. The degree of sloping can be referred to as "steep" or "gentle."

Munesaki: The tip of the mune at the kissaki; also called matsubasaki (pine-needle tip).

Kissaki: The fan-shaped part of the blade above the yokote and the ko-shinogi. It may be whitened by polishing. Its size is described as "large" or "small."

Machi: The notches dividing the blade proper from the tang. The notch on the blade side is called the hamachi; that on the mune side is known as the munemachi.

Mitsukado: The point at which the yokote, shinogi, and ko-shinogi meet.

Monouchi: The primary cutting area. In tachi and katana, this is a 15-cm–area beginning about 10 cm below the yokote; the location of the monouchi in wakizashi and tanto is proportionate to the blade's length.

Hiraji: The area between the shinogi and hamon, also known as the hira. With polishing, this area becomes blue-black. Its surface is curved, and its width is referred to as niku (meat), which can be modified by the terms "full" or "scarce," "not full."

Shinogiji: The flat surface between the shinogi and the mune, which can be burnished to a glittering black. The shinogiji is described as being wide or narrow.

Hamon: The ha is the tempered edge of the blade; the tempering process hardens the blade, making it suitable for cutting. The hamon is the border between the ha and the hiraji. Japanese swords exhibit an extraordinary variety of hamon patterns and shapes, which show up as a brilliant white when the sword is held up to the light. Individual features visible within the hamon are known as hataraki, or activity (also "workings"); these features are important elements in sword appreciation.

Boshi: The word boshi usually refers to a hat or cap; in sword terminology, it refers to the hamon of the kissaki.

● DIAGRAMMING THE PARTS OF THE JAPANESE SWORD

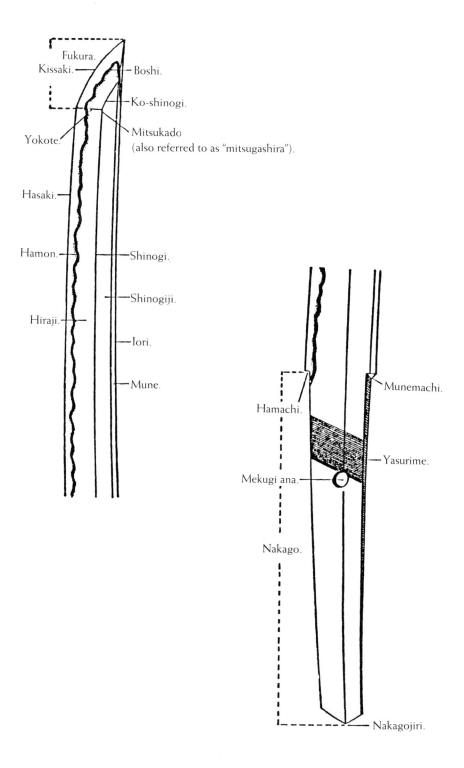

Fukura.
Kissaki.——— ⌐ Boshi.

———Ko-shinogi.

Mitsukado
(also referred to as "mitsugashira").

Yokote.

Hasaki.

Hamon.——— ——Shinogi.

——Shinogiji.

Hiraji.

——Iori.

——Mune.

Munemachi.

Hamachi.

——Yasurime.

Mekugi ana.——

Nakago.

——Nakagojiri.

MEASURING THE JAPANESE SWORD

Although Japanese swords are composed almost entirely of curves and curved surfaces, there is a standard method of measurement, described by the terms defined below.

Ha-watari or nagasa: Blade length; a straight line measured from the munemachi to the tip of the kissaki (A–B). Also known as the hacho.

Sori: Curvature of the blade; the longest horizontal distance (D) from the back edge of the blade to the line linking A and B. The degree of sori is described as "deep" or "shallow."

Kasane: Thickness, specifically the thickness of the mune (F–G); described as "thick" or "thin." The thickness at the munemachi is considered the basic thickness, or motokasane, while the thickness at the yokote is known as the sakikasane (tip thickness).

Mihaba: The width of the blade, or the distance (H–I) from the back edge to the cutting edge. Motohaba (bottom width) is the width at the machi of the blade, while sakihaba (top width) is the width at the yokote. A blade's mihaba can be described as "wide" or "narrow."

Kissaki size: The vertical line (J–K) extending from the yokote to the tip of the kissaki.

● MEASURING THE SWORD

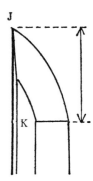

TYPES OF SWORD STRUCTURES (TSUKURIKOMI)

Hira-zukuri: A blade without shinogi or yokote; nearly flat on both sides. This type first appeared in tachi produced in ancient times. Tanto and ko-wakizashi from after the Heian period (after 806) are often hira-zukuri.

Kiriha-zukuri: A line, essentially equivalent to the shinogi, runs along quite close to the cutting edge; the shinogiji is very wide. This shape apparently evolved from the hira-zukuri, and, apart from later imitations, is found only in swords produced in ancient times.

Katakiriha-zukuri: One side is hira-zukuri or shinogi-zukuri (see below), while the other is kiriha-zukuri. This type originated around the end of the Kamakura period (1288–1334); it was particularly fashionable at the beginning of the Edo period (1596–1643) and later at the end of the Edo period (1781–1867).

Moroha-zukuri: A two-edged blade in which, unlike the ken, each side is different. This blade type, which may be curved, is generally seen in tanto produced after the middle of the Muromachi period (about 1467).

Shinogi-zukuri: Blades with shinogi quite close to the mune, that have yokote and sori. These were produced after the Heian period, around 987, and are also known as hon-zukuri.

Shobu-zukuri: Similar to shinogi-zukuri, but without yokote. The shape is sharp and resembles an iris leaf. It is common in tanto and wakizashi of the Muromachi period.

● VARIOUS TSUKURIKOMI

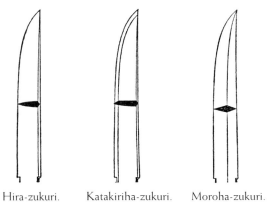

Hira-zukuri. Katakiriha-zukuri. Moroha-zukuri.

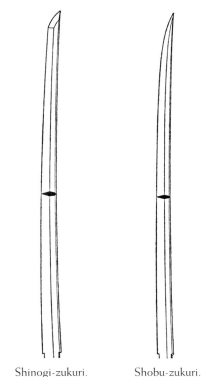

Shinogi-zukuri. Shobu-zukuri.

TYPES OF KISSAKI

The kissaki is the fan-shaped area at the tip of the blade bounded by the fukura, yokote, koshinogi, and munesaki. Depending on the length and width of the blade as a whole, the area may be classified as ko-kissaki, chu-kissaki, or o-kissaki. The length of the fukura also affects the size of the kissaki, which usually varies with the period in which the blade was produced. However, like other parts of the Japanese sword, the kissaki was sometimes reshaped in later periods. So a sword's kissaki should always be carefully checked. One way to determine if a kissaki's original shape has been changed is to compare the width of the hamon around the yokote and the boshi (particularly the head of the boshi) areas. Kissaki in which the hamon is narrower at the head of the boshi than at the yokote may have been reshaped at some point. Yakizume are also sometimes reshaped as a result of polishing from the mune side.

Ko-kissaki: Small kissaki. The upper part of the blade is narrow, and the entire kissaki is small in proportion to the rest of the blade. The ko-kissaki is a feature of the tachi pro-duced at the end of the Heian period and the beginning of the Kamakura period.

Chu-kissaki: Medium-sized kissaki, and the most prevalent type. This type of kissaki was widespread in all periods, beginning in mid-Kamakura (from 1232).

O-kissaki: Large kissaki. The size appears exaggerated in comparison with the blade's length and width.

Kamasu kissaki: The "kamasu," or "saury pike," is a variety of long-snouted fish. The kamasu kissaki has fukura which is hardly rounded at all and which resembles a saury's head. Virtually all chokuto have kamasu kissaki. Some say that most swords in early Koto times had kamasu kissaki, and that any other types seen in swords of this period should be considered the result of reshaping.

Ikubi kissaki: "Ikubi" refers to the neck of the wild boar. The ikubi kissaki's length is shorter than the sakihaba, or width of the yokote area. The ikubi kissaki is found in mid-Kamakura–period blades.

● KISSAKI

Ko-kissaki. Chu-kissaki.

O-kissaki. Kamasu kissaki. Ikubi kissaki.

● FUKURA

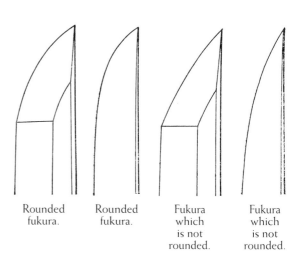

Rounded fukura. Rounded fukura. Fukura which is not rounded. Fukura which is not rounded.

TYPES OF MUNE

The "mune," or "ridge," is opposite the cutting edge of the blade and so is sometimes referred to as the "back," "back edge," or "back ridge." Terminology describing the mune focuses on the characteristics of its lines and surfaces. The mune is an important point to consider in sword appraisal.

Kaku-mune/hira mune: A completely flat back surface found only on ancient swords.

Iori-mune/gyo no mune: "Iori" means "roof." This type of mune resembles an A-frame roof, with two surfaces. After Koto times, this became the most popular style of mune. A steep oroshi, or slope, may be seen in the blades of the Yamato (Nara-Prefecture) schools, their related schools, and the Shinto swordsmith Hankei. The blades of Bizen (Okayama Prefecture) and related schools have gentle slopes.

Mitsu-mune/shin no mune: Mitsu-mune has three surfaces and may be found in the blades of the Soshu (Kanagawa Prefecture) and related schools, as well as in the tanto of Yamashiro (Kyoto Prefecture) schools. Early Soshu-school blades have a wide top surface and steep oroshi, but swords of the Sue-Soshu school have a narrow top surface.

In Shinto blades the mitsu-mune may often be found on the work of Umetada Myoju, the Horikawa school, and Echizen Yasutsugu, all of whom worked in the style of Soshu-den (one of the five basic styles of sword production).

Maru-mune/so no mune: This rare mune has a rounded surface; it is occasionally found on swords of the Ko-Aoe school, Saikaido, and Hokurikudo.

● BACK EDGES OF BLADES

● SWORDS VIEWED FROM THE MUNE SIDE

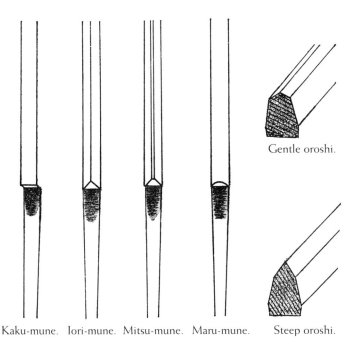

Gentle oroshi.

Steep oroshi.

Kaku-mune. Iori-mune. Mitsu-mune. Maru-mune.

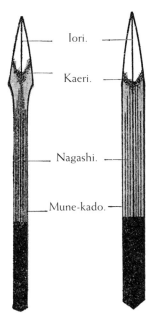

Iori.

Kaeri.

Nagashi.

Mune-kado.

Mune-saki (also referred to as "matsuba-saki").

HEIGHT AND WIDTH OF THE SHINOGI

The height and width of the shinogi, and the degree of niku (curvature of the surface of the hiraji) vary according to the period and school. Sometimes these features are indicative of a particular swordsmith or school. When there is a substantial difference between the kasane and the distance between the two shinogi, the shinogi is said to be high. High shinogi may be seen among the work of the Yamato and related schools, such as the Uda, Mihara, Nio, Kongobei, and Naminohira.

In Shinto times, Nanki Shigekuni and Kunikane also produced high shinogi, since these two smiths followed the Yamato-den (another of the five basic styles of sword production). When the kasane is very thin, the shinogi appears to be quite high. In work of the Sue-Bizen school (Sukesada, Kiyomitsu, Harumitsu, etc.) and the Sue-Seki school (Kanesada, etc.) the thinning is intentional. Sue-Soshu, Sue-Seki (Seki is a city in Gifu Prefecture) and Sue-Bizen were all groups that were active during the Sengoku period (1467–1568).

The shinogi may also be raised, depending upon the type of tsukuri-komi—for example shobu-zukuri, kanmuri-otoshi-zukuri and naginata. Likewise nagamaki-naoshi also have a high shinogi. This sort of shinogi may often be found in the blades of the Hojoji Kunimitsu, the Katayama Ichimonji schools, the Naoe Shizu school, and the Kanemitsu and Chogi schools. Beginning in Shinto times, there were some swordsmiths who made this feature an integral part of their style—for example, the Echizen Yasutsugu school, Minamoto Kiyomaro, and Taikei Naotane.

Low shinogi can generally be seen in swords from the Osafune school of the mid-Kamakura period (1232–1287). Swords with thick kasane and low shinogi may be seen among the work of the Ichimonji and Kozori schools. Among Sue-Bizen–school blades, thick kasane are often found in which the shinogi actually appears to be lower than the kasane. In Shinto times too, there are some swords in which the height of the shinogi appears to be at the same level, or even lower than, the kasane, such as the work of Tsuda Sukehiro, Omi no Kami Sukenao, and the Hizen school.

The height of the shinogi is to some extent related to the shinogiji, and generally increases with the width of the shinogiji. Thus, swords of the Yamato-related schools have a wide shinogiji, as do the swords of Nanki Shigekuni and Kunikane, since these two smiths followed the Yamato tradition. On the other hand, blades of the Soshu and related schools generally have narrow shinogiji.

Hira-niku naturally decreases after repeated polishing, but Shinto and Shinshinto swords in their original state have some hira-niku, regardless of how often they have been polished. Swords produced in mid-Kamakura have full hira-niku, with the ha-niku between the hamon and the cutting edge being particularly full. These swords are called hamaguri-ba (ha and ba both mean "blade," while hamaguri means "clam"). Swords of the Nanbokucho period have comparatively less hira-niku.

● WIDTH OF THE SHINOGI

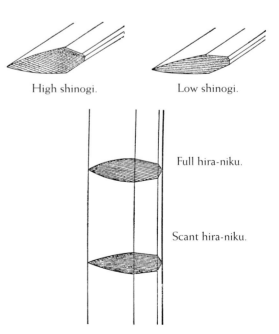

High shinogi.　　Low shinogi.

Full hira-niku.

Scant hira-niku.

DETERMINING A SWORD'S PERIOD FROM THE SUGATA

Sugata refers to the shape of the sword as a whole. The sugata changes according to the period, and therefore is always an indicator of the period in which a sword was produced.

1. Late Heian period (987–1181)

Shinogi-zukuri tachi, a ha-watari of about 85 cm, a slightly narrow mihaba, a ko-kissaki, a wide motohaba, entirely torii-zori but tending toward koshi-zori. The shinogi-zukuri tachi has not only elegance but stability and dignity.

Leading swordsmiths: The Sanjo (三条) school (Munechika [宗近], Yoshiie [吉家], Gojo Kanenaga [五条兼永], Gojo Kuninaga [五条国永]), the Yasutsuna (安綱) school (Hoki Yasutsuna [伯耆安綱], Ohara Sanemori [大原真守]), the Ko-Bizen (古備前) school (Tomonari [友成], Masatsune [正恒]), the Ko-Aoe school (古青江) (Moritsugu [守次], Masatsune [正恒]), the Naminohira (波平) school (Yukiyasu [行安], Yukimasa [行正]), etc.

2. Early Kamakura period (1182–1231)

The basic sugata differs little from that of swords of the late Heian period, but there is an overall sense of increased grandeur. Specifically, the kissaki is a bit larger, and the saki-haba a little wider.

Leading swordsmiths: The Awataguchi (粟田口) school (Kunitomo [国友], Hisakuni [久国], Kuniyasu [国安], Kunikiyo [国清]), the Ko-Ichimonji (古一文字) school (Norimune [則宗], Sukemune [助宗], Narimune [成宗], Sukeshige [助茂]), the Ko-Aoe (古青江) school (Sadatsugu [貞次], Suketsugu [助次], Yasutsugu [康次], Nobutsugu [延次]), Bungo Yukihira (豊後行平), etc.

3. Mid-Kamakura period (1232–1287)

Shinogi-zukuri tachi with a mihaba that is a bit wide, a sakihaba that is not as narrow as in previous periods, and a chu-kissaki. Torii-zori, tending toward koshi-zori, with a wide motohaba, hira-niku, and appropriate kasane. The sugata is even more magnificent than in earlier periods.

Leading swordsmiths: The Awataguchi (粟田口) school (Kuniyoshi [国吉], Kunitsuna [国綱], Yoshimitsu [吉光]), the Rai (来) school (Kuniyuki [国行], Niji Kunitoshi [二字国俊]), Ayanokoji Sadatoshi (綾小路定利), Shintogo Kunimitsu (新藤五国光), the Ichimonji (一文字) school (Yoshifusa [吉房], Sukezane [助真], Suketsuna [助綱], Norifusa [則房]), Saburo Kunimune (三郎国宗), the Ko-Osafune (古長船) school (Mitsutada [光忠], Nagamitsu [長光], Kagehide [景秀]), Hatakeda Moriie (畠田守家), the Chu-Aoe (中青江) school (Suketsugu [助次], Shigetsugu [重次]), etc.

4. Mid-Kamakura period (1232–1287)

One more sugata—the grandest of all—appears in this period. Shinogi-zukuri tachi, torii-zori, ikubi-kissaki, wide mihaba, with little difference between the width of the motohaba and that of the sakihaba, hamaguri-ba with full hira-niku between the hamon and the hasaki (sharpened edge), kasane which are rather thick, high shinogi, and narrow shinogiji.

Leading swordsmiths: The Ichimonji (一文字) school, Osafune Mitsutada [長船光忠], Niji Kunitoshi [二字国俊], etc.

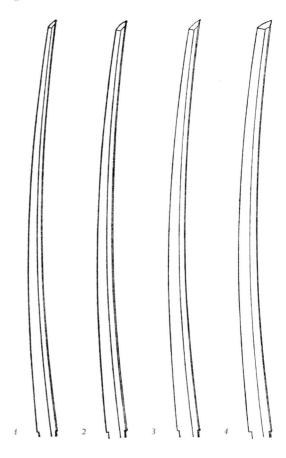

wakizashi was worn as the smaller sword (sho) of the daisho, or pair of swords; the larger sword (dai) was the katana. Ha-watari is about 50 cm, chu-kissaki, with a narrow mihaba. The motohaba is a bit wide, and the sori is shallow, inclining toward saki-zori. Hira-zukuri, shobu-zukuri, and u-no-kubi-zukuri may also be seen in wakizashi of this period. All smiths produced wakizashi during this period.

13. Momoyama period (1573–1643)

Shinogi-zukuri katana, ha-watari of about 75 cm, shallow sori, rather long chu-kissaki or o-kissaki, and proportionate kasane. The sugata is similar to that of a shortened tachi originally produced in the Kamakura or the Nanbokucho periods; in addition, during this period, swords with katahiriha-zukuri were produced by Myoju, the Horikawa school, and the Yasutsugu school; these are referred to as "Keicho Shinto."

Leading swordsmiths: Umetada Myoju (埋忠明寿), the Horikawa (堀川) school (Kunihiro 国弘, Kunimichi [国路], Kuniyasu [国安], Kunitomo [国儔], Kunikiyo [国清]), the Mishina (三品) school (Etchu no Kami Masatoshi [越中守正俊], Iga no Kami Kinmichi [伊賀守金道], Tanba no Kami Yoshimichi [丹波守吉道]), Echizen Yasutsugu (越前康継), Higo Daijo Sadakuni (肥後大掾貞国), Hankei (繁慶), Nanki Shigekuni (南紀重国), Yamashiro Daijo Kunikane (山城大掾国包), Sagami no Kami Masatsune (相模守政常), Hida no Kami Ujifusa (飛騨守氏房), Higo no Kami Teruhiro (肥後守輝広), Tadayoshi I (初代 忠吉), Izu no Kami Masafusa (伊豆守正房), etc.

14. Early Edo period (1644–1687)

Shinogi-zukuri katana, ha-watari of about 70 cm, shallow sori, chu-kissaki, and narrow sakihaba. This style is known as "Kanbun Shinto."

Leading swordsmiths: Inoue Shinkai (井上真改), Echizen no Kami Sukehiro (越前守助広), Omi no Kami Sukenao (近江守助直), Kunisuke II (二代 国助), Echigo no Kami Kanesada (越後守包貞), Itakura Gonnoshin Terukane (板倉言之進照包), Tatara Nagayuki (多々良長幸), the Nagasone (長曾禰) school (Kotetsu [虎徹], Okimasa [興正]), the Hojoji (法城寺) school (Masahiro [正弘], Yoshitsugu [吉次]), Yamato no Kami Yasusada (大和守安定), Kunikane II (二代 国包), Miyoshi Nagamichi (三善長道), etc.

15. Mid-Edo period (1688–1780)

Shinogi-zukuri katana, ha-watari slightly longer than that of Kanbun Shinto, deeper sori, chu-kissaki.

Leading swordsmiths: Ikkanshi Tadatsuna (一竿子忠綱), Nobukuni Yoshikane (信国吉包), Nobukuni Shigekuni (信国重包), Musashi Taro Yasukuni (武蔵太郎安国).

16. Momoyama period to mid-Edo period

From the Momoyama period through the mid-Edo period, shinogi-zukuri wakizashi were also made, with ha-watari of over 45 cm. The sori, kasane, and mihaba of these wakizashi are in proportion to the katana of the period. They were worn as the sho of the daisho. Most swordsmiths produced wakizashi.

17. Late Edo period to Meiji period (1781–1876)

During this period many swordsmiths imitated the shinogi-zukuri katana which was popular in Koto times, with its ha-watari of about 75 cm, chu-kissaki, proportionate mihaba, deep sori, and wide motohaba.

Leading swordsmiths: Suishinshi Masahide (水心子正秀), Taikei Naotane (大慶直胤), Nankai Taro Tomotaka (南海太郎朝尊), Hosokawa Masayoshi (細川正義), Minamoto Kiyomaro (源清麿), Koyama Munetsugu (固山宗次), Gassan Sadakazu (月山貞一), etc.

Shinogi-zukuri katana, chu-kissaki or o-kissaki, wide mihaba, wide sakihaba.

Leading swordsmiths: Taikei Naotane (大慶直胤), Minamoto Kiyomaro (源清麿), Sa Yukihide (左行秀), Hoki no Kami Masayoshi (伯耆守正幸), Yamato no Kami Motohira (大和守元平), etc.

Shinogi-zukuri katana, ha-watari of about 85 cm, a blade with hardly any sori. Also referred to as "kinnoto" ("royalist's sword").

Leading swordsmiths: Sa Yukihide (左行秀), Saito Kiyondo (斎藤清人), etc.

Nagamaki naoshi-zukuri katana (produced as katana but in imitation of nagamaki naoshi). O-kissaki, wide mihaba, very wide sakihaba, deep sori.

Leading swordsmiths: Taikei Naotane (大慶直胤), Minamoto Kiyomaro (源清麿), etc.

Shinogi-zukuri wakizashi, chu-kissaki or o-kissaki, wide mihaba. Shobu-zukuri and other unusual types can be seen.

Leading swordsmiths: Most swordsmiths produced such wakizashi.

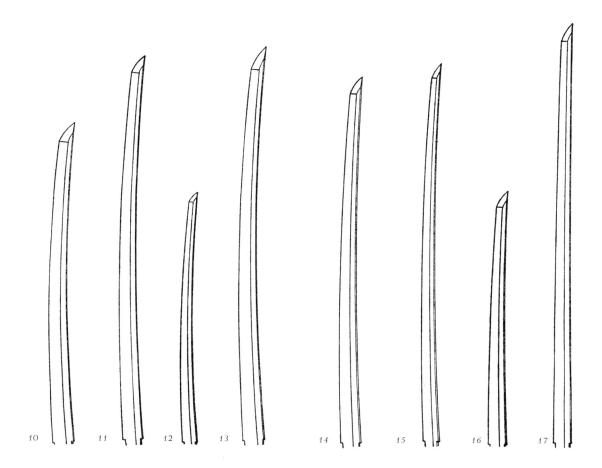

10 11 12 13 14 15 16 17

TANTO AND KO-WAKIZASHI

1. Late Heian period through early Kamakura period (987–1231)

Hira-zukuri tanto, ha-watari less than 24 cm, uchi-zori; very few of this type have survived.

Leading swordsmiths: The Awataguchi (粟田口) school (Kunitomo [国友], Hisakuni [久国]), Bungo Yukihira (豊後行平), etc.

2. Mid-Kamakura period (1232–1287)

Hira-zukuri tanto, ha-watari of 21–26 cm, (standard length of tanto is 25–26 cm), uchi-zori, proportionate kasane.

Leading swordsmiths: The Awataguchi (粟田口) school (Norikuni [則国], Kuniyoshi [国吉], Yoshimitsu [吉光]), Rai Kunitoshi (来国俊), the Shintogo (新藤五) school (Kunimitsu [国光], Kunihiro [国弘]), etc.

3. Late Kamakura period (1288–1333)

Hira-zukuri tanto, ha-watari of about 26 cm,

uchi-zori, kasane and mihaba in proportion. Sugata similar to that of the previous period.

Leading swordsmiths: The Rai (来) school (Kunimitsu [国光], Kunitsugu [国次]), Osafune Kagemitsu (長船景光), Masamune (正宗) school (Yukimitsu [行光], Masamune [正宗]), Norishige (則重), etc.

Hira-zukuri tanto, ha-watari of about 28 cm, mu-zori or with very shallow sori, a mihaba that is a little wider than in the previous period.

Leading swordsmiths: The Rai (来) school (Kunimitsu [国光], Kunitsugu [国次]), Sadamune (貞宗).

Hira-zukuri tanto, a mihaba that is wide in comparison to the ha-watari. Thin kasane and shallow sori.

Leading swordsmiths: Yukimitsu (行光), etc.

Kanmuri otoshi-zukuri or u-no-kubi-zukuri tanto, thin kasane, mu-zori.

Leading swordsmiths: The Taima (当麻) school, Ryokai (了戒), Shikkake Norinaga (尻懸則長), etc.

Katakiriha-zukuri tanto, mu-zori or with very shallow sori.

Leading swordsmiths: Sadamune (貞宗), Osafune Kagemitsu (長船景光), Kanro Toshinaga (甘露俊長), Takagi Sadamune (高木貞宗), etc.

4. Nanbokucho period (1334–1389)

Hira-zukuri ko-wakizashi, ha-watari of about 30 cm, rounded fukura, thin kasane, saki-zori.

Leading swordsmiths: The Hasebe (長谷部) school (Kunishige [国重], Kuninobu [国信]), Nobukuni (信国), the Masamune (正宗) school (Hiromitsu [広光], Akihiro [秋広]), the Kanemitsu (兼光) school (Osafune Kanemitsu [長船兼光], Tomomitsu [倫光], Yoshimitsu [義光]), the Chu-Aoe (中青江) school (Tsugunao [次直], Tsuguyoshi [次吉]), Sa Yasuyoshi (左安吉), Takada Tomoyuki (高田友行), the Shizu (志津) school (Kanetome [兼友], Kanetsugu [兼次]), etc.

5. Early Muromachi period (1392–1428)

Hira-zukuri ko-wakizashi, longer ha-watari than seen in previous periods, narrow mihaba, shallow sori.

Leading swordsmiths: The Oei-Bizen (応永備前) school (Osafune Morimitsu [長船盛光], Yasumitsu [康光]), Nobukuni III (三代 信国), etc.

Hira-zukuri tanto, ha-watari less than 30 cm in length, mihaba in proportion, mu-zori.

Leading swordsmiths: The Oei-Bizen (応永備前) school (Morimitsu [盛光], Yasumitsu [康光]), Nobukuni (信国), etc.

Kanmuri-otoshi-zukuri tanto, mihaba in proportion, mu-zori.

Leading swordsmiths: Tegai Kanezane (手掻包真), the Nio (二王) school (Kiyonaga [清永], Kiyokage [清景]), etc.

6. Late Muromachi period (1467–1572)

Hira-zukuri ko-wakizashi, wide mihaba, kasane in proportion, rounded fukura, deep saki-zori.

Leading swordsmiths: The Sue-Seki (末関) school (Kanefusa [兼房], Kanehisa [兼久], Kanemura [兼村]), Sengo Muramasa (千子村正), Tsunahiro (綱広), Shimada Yoshisuke (島田義助), etc.

Hira-zukuri tanto, ha-watari of about 23–26 cm, uchi-zori, similar to the tanto of the Kamakura period.

Leading swordsmiths: The Sue-Seki (末関) school (Kanesada [兼定], Kanetsune [兼常]), Osafune Sukesada (長船祐定), Shimada Yoshisuke (島田義助), Tegai Kanekiyo (手掻包清), etc.

Hira-zukuri tanto, ha-watari of 20–23 cm, uchi-zori, extremely narrow sakihaba, very thick motokasane.

Leading swordsmiths: The Sue-Bizen (末備前) school (Sukesada [祐定], Norimitsu [法光], Tadamitsu [忠光]), etc.

Moroha-zukuri, ha-watari of 20–23 cm, shallow sori.

Leading swordsmiths: The Sue-Bizen (末備前) school, the Sue-Seki (末関) school, the Sue-Mihara (末三原) school.

7. Momoyama period (1573–1643)

Hira-zukuri ko-wakizashi, wide mihaba, kasane in proportion, saki-zori. This type is an imitation of the sugata of the Nanbokucho period, but the kasane is thicker, the saki-zori is stronger, and the fukura is much more rounded.

Leading swordsmiths: Umetada Myoju (埋忠明寿), the Horikawa (堀川) school (Kunihiro [国弘], Kuniyasu [国安], Kunimichi [国路], Kunisada [国貞]), Etchu no Kami Masatoshi (越中守正俊), Tadayoshi I (初代 忠吉), Yasutsugu I (初代 康継), Higo Daijo Sadakuni (肥後大掾貞国), Kanewaka (兼若), etc.

Katakiriha-zukuri tanto, ha-watari of about 30 cm, wide mihaba, shallow sori.

Leading swordsmiths: Umetada Myoju (埋忠明寿), the Horikawa (堀川) school, Tadayoshi I (初代 忠吉), Yasutsugu I (初代 康継), Higo Daijo Sadakuni (肥後大掾貞国).

8. Early Edo period (1644–1687)

Tanto are rare in this period, particularly among the Settsu-province (Osaka) schools.

Leading swordsmiths: Mino no Kami Masatsune (美濃守政常), Nagasone Kotetsu (長曾祢虎徹), Harima no Kami Tadakuni (播磨守忠国), etc.

9. Late Edo period to early Meiji period (1781–1876)

Hira-zukuri ko-wakizashi, ha-watari of 39 to 43 cm, wide mihaba, thick kasane, saki-zori.

Leading swordsmiths: Taikei Naotane (大慶直胤), Minamoto Kiyomaro (源清麿), Sa Yukihide (左行秀), Hoki no Kami Masayoshi (伯耆守正幸), Yamato no Kami Motohira (大和守元平), etc. Kiyomara also pro-

duced blades characterized by shobu-zukuri ko-wak-izashi, wide mihaba, and distinct saki-zori.

Hira-zukuri tanto, ha-watari of 24 to 27 cm, proportional mihaba, shallow uchi-zori.

Leading swordsmiths: Suishinshi Masahide (水心子正秀), Kiyomaro (清麿), Chikuzen no Kami Nobuhide (筑前守信秀).

Kissaki moroha-zukuri or kanmuri otoshi-zukuri tanto, ha-watari of 15 to 18 cm, thick kasane.

Leading swordsmiths: Kiyomaro (清麿), Nobuhide (信秀), Sa Yukihide (左行秀), etc.

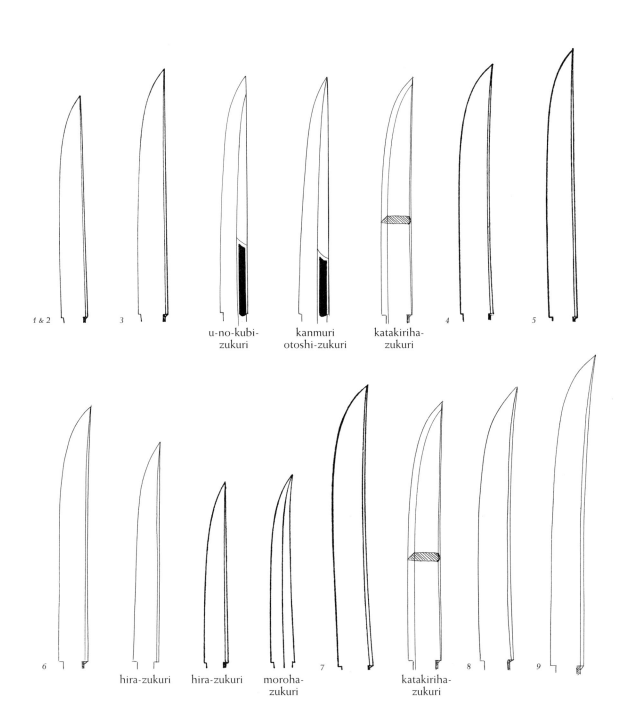

1 & 2 3

u-no-kubi-zukuri kanmuri otoshi-zukuri katakiriha-zukuri 4 5

6

hira-zukuri hira-zukuri moroha-zukuri 7 katakiriha-zukuri 8 9

DETERMINING THE CONDITION OF THE NAKAGO

The nakago, or tang, is the portion of the sword blade that extends below the hamachi and the munemachi. On it may be found such useful identifying marks as the yasurime (file marks) and the mei (signature). A special peg known as the mekugi is inserted through a peg hole (mekugi ana) to hold the nakago in the hilt (tsuka).

A small metal collar called a habaki secures the blade in the saya. The part of the blade that slips into the habaki is called the habaki-moto, and the filed section below gathers rust, which is considered a sign of a sword's age. The boundary between the habaki-moto and the yasurime is called the sabigiwa (rust border).

Ubu nakago: An original nakago, or one that is still shaped just as it was created by the swordsmith. In some cases the nakago's curvature has been altered or reshaped slightly, or peg holes have been added, but provided that the blade's shape and length are changed only slightly, the sword is still regarded as an ubu nakago.

Suriage nakago: A "shortened" nakago. When a sword is shortened, it is always shortened at the tang end; the tip of the blade is never cut down. During the shortening process, the hamachi and munemachi are moved further up the blade. Blades characterized as suriage nakago usually still bear the original mei.

O-suriage nakago: A "greatly shortened" nakago. Unlike the suriage nakago, in which the nakago is merely reshaped, the o-suriage nakago is formed from what was originally part of the blade. The original signature (mei) is usually completely lost, although it can sometimes be preserved as an orikaeshi-mei or gaku-mei.

Orikaeshi-mei: The metal on which the mei is inscribed remains attached to the nakago and is then bent around to the opposite side; the signature thus appears upside-down.

Gaku-mei: The metal on which the mei is inscribed is cut off in a rectangular section, and then reattached to the altered nakago.

Machi-okuri: Moving the machi upward. The ha-watari is shortened by moving both the munemachi and the hamachi upward on the blade without actually shortening the nakago. The sword's overall length does not change.

In a few cases, the nakago is shortened slightly without moving either the hamachi or the munemachi.

● TANGS

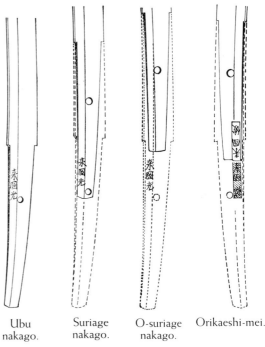

Ubu nakago. Suriage nakago. O-suriage nakago. Orikaeshi-mei.

Gaku-mei.

TYPES OF NAKAGO

The nakago varies in length and shape according to the period in which it was forged and the school of production. In addition to more usual types, there are several unique types, including:

Kijimomo-gata: "Kijimomo" is Japanese for "pheasant's leg," the curve of which lends its name to this nakago. The blade side of the tachi's nakago dips halfway, and the nakago remains narrow to the tip. This style is often seen on tachi produced in the Heian and Kamakura periods. Apparently this area was scraped away to allow rivets to reinforce the tsuka.

Furisode-gata: The word "furisode" refers to the long sleeves of a young lady's kimono. The type of nakago named after the way this sleeve drapes has a strong curvature, and is seen only on tanto produced in the Kamakura period.

Funa-gata: "Funa" (or "fune") means "boat." In the funa-gata nakago, the line of the cutting edge has a deep outward bulge. The funa-gata is associated with Masamune of Soshu and his school.

Tanagobara-gata: "Tanagobara" means "fish belly." The upper part of the tang has a bulge that tapers gently into a narrow lower section. It is seen in blades of the Muramasa school, Heianjo Nagayoshi, and the Shitahara school of the Muromachi period.

Gohei-gata: "Gohei" are the pieces of cut paper attached to the sacred straw ropes seen at Shinto shrines. In the gohei-gata, each side of the tang has an equal number of stepped notches. This style was originally used by Ise no Kami Kuniteru in the Edo period.

Sotoba-gata: "Sotoba" is another word for "stupa," the wooden grave markers seen in Buddhist cemeteries. This style of tang is about the same width from the top to the bottom, with a pointed base, resembling a stupa turned upside-down. It was used by swordsmiths of the Kongobei school during the Muromachi period.

● NAKAGO OF VARIOUS SHAPES

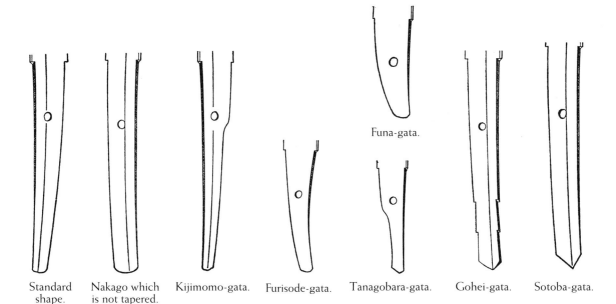

Standard shape. Nakago which is not tapered. Kijimomo-gata. Furisode-gata. Funa-gata. Tanagobara-gata. Gohei-gata. Sotoba-gata.

TYPES OF NAKAGOJIRI

The butt end of the tang is known as the nakagojiri, and its shape reflects the characteristics of each school. When a sword is shortened, the nakagojiri is usually copied from the original.

Kurijiri: "Chestnut-shaped." This style has a rounded end and is the type most commonly seen in all periods.

Ha agari kurijiri: This style has a rounded end similar to that of the kurijiri, but the cutting-edge side slants more steeply than does the back (mune) side.

Kiri (or ichimonji): In this style the end is cut off squarely in a straight line. It is often seen in swords of the Hosho school from the Kamakura period, and also on shortened swords.

Iriyama-gata: The cutting-edge side of the tang is an acute angle to the bottom end of the shinogi line, the other side runs either straight or at a slight upward angle to the mune. It is seen among Yamato-province schools, the swords produced along the Hokurikudo, and Shinto swords.

Kengyo: "Sword-shaped." The nakagojiri comes to a point at the center, and both lines of the bottom are straight. This type is seen among Masamune's works, works by other members of his school, and Shinto swords produced by Soshu-den followers.

● TYPES OF BUTT ENDS

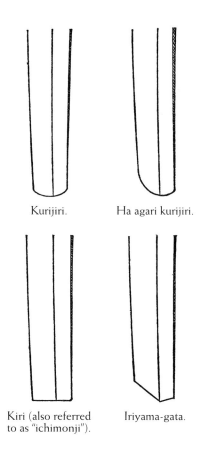

Kurijiri.　　　　Ha agari kurijiri.

Kiri (also referred　　Iriyama-gata.
to as "ichimonji").

Kengyo.

TYPES OF YASURIME

Before a signature is engraved into the tang, it is finished with a file, leaving distinctive file marks. Styles of filing differed with various periods, schools, and smiths. File marks typically vary in depth, thickness, and spacing, depending on the file used by a swordsmith. Both sides of the tang are usually finished using the same style of filing. The place where the filing begins, just below the haba-ki-moto, is known as the suri dashi (file beginning). The yasurime need to be studied carefully, as does the color of the rust.

Sen suki: Plane-drawing pattern. This style is finished with a sen, a tool similar to a plane, used for shaving iron. The resulting file marks show irregular vertical traces. This style is seen on jokoto (pre-Koto swords), early Koto blades, and occasionally on Mino-province swords of the Muromachi period, as well as on yari and naginata.

Tsuchime: Hammered marks. In this style the tang has an uneven surface entirely covered with marks, created first by leveling and then by finishing with a hammer. It is seen only on jokoto and special swords.

Kiri (or yoko yasuri): Horizontal file marks. This pattern, the most popular, is filed horizontally from the edge to the back.

Katte sagari: "Right-handed, downward-slanting" pattern. This pattern slants downward and to the right, and is the second most popular style, after kiri, throughout all periods of swordsmithing.

Katte agari: "Right-handed, upward-slanting." The opposite of the katte sagari pattern. File marks in this style slant downward to the left.

Sujikai: Diagonal. This style slants downward more steeply than does katte sagari. It is quite frequently seen.

O-sujikai: "Great," or steep, sujikai. The angle of the file marks in this pattern is much steeper than that of sujikai. The pattern was used particularly by the Aoe, Samonji, and Horikawa schools, and by the swordsmith Hankei.

● TYPES OF FILE-MARK PATTERNS

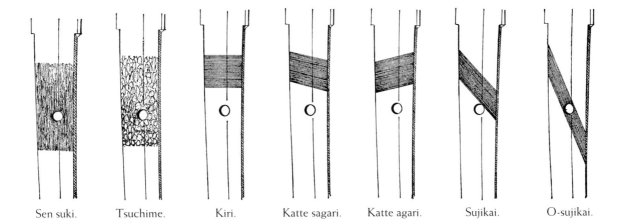

Sen suki. Tsuchime. Kiri. Katte sagari. Katte agari. Sujikai. O-sujikai.

Saka o-sujikai: In this pattern, file marks slant steeply upward from left to right. It appears only on Shinto blades, such as those forged by Horikawa Kuniyasu, Iyo no Jo Munetsugu II, etc.

Takanoha: "Hawk feather." The back portion of the tang (the shinogiji) is filed slanting downward and to the right (sujikai), while the front portion (the hiraji) is filed in the opposite direction (saka sujikai). This style can be seen on swords from Yamato province and related schools.

Saka takanoha: The shinogiji has file marks slanting upward to the right (saka sujikai), while the hiraji's file marks slant upward to the left (sujikai). This style is seen in swords from Yamato and Mino provinces. A few variations are also occasionally seen, such as shinogiji with straight file marks, or hiraji with file marks sloping gently down to the right.

Higaki: In general, this term refers to a fence made of thin, crossed Japanese cypress boards. In sword terminology, a pattern formed when sujikai and saka sujikai are crossed. It is seen on swords from Yamato province, Mino province, and the Naminohira school.

Kesho yasuri: "Cosmetic file marks." This style is a combination of the patterns previously described, and is located at the suri dashi. It appears only on Shinto or later blades, with distinct variations seen among work of specific schools and smiths.

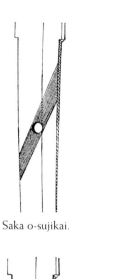

Saka o-sujikai.

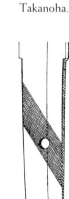

Takanoha.

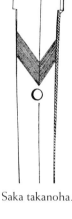

Saka takanoha.

Katte sagari in the shinogiji, kiri in the hiraji.

Kiri in the shinogiji, katte sagari in the hiraji.

Higaki.

Kesho yasuri.

TYPES OF MEI

Mei is the name, or signature, of the sword-smith that is chiseled into the tang. Blades still bearing their original signature are referred to as zaimei ("having a signature"). When there is no signature, either because the blade was not originally signed or because the signature was lost when the blade was shortened, it is known as mumei ("no signature"). Gimei ("false signature") is a copy of an authentic signature inscribed on the tang of some other (often inferior) swordsmith.

Tachi-mei: In general, signatures were carved into the side of the sword that faced outward when the sword was worn. Since tachi were worn with the cutting edge facing downward, the tachi-mei is found on the side that would face away from the body of the wearer. Swords (except for tanto and wakizashi) produced through the early part of the Muromachi period are almost all tachi-mei. There are a few exceptions, such as those by Yukihira and swordsmiths of the Ko-Aoe school, who carved their signatures on the inner side, facing the body when the sword was worn cutting edge downward.

Katana-mei: Katana-mei is the term used to describe a signature that appears on that side of a katana, wakizashi, or tanto that faces out when the blade is worn with the cutting edge facing upward. The tachi-mei appears on the opposite side. Swords produced after the Muromachi period are almost exclusively katana-mei, except for those by smiths of the Tadayoshi school and by Yamashiro no Kami Kunikiyo; these always signed their swords with tachi-mei, as the Shinshinto swordsmiths of the Suishinshi school also often did.

Omote-mei (inscription on the front) and ura-mei (inscription on the back): Omote-mei is the term used to describe the entire inscription on the front side of the blade, including the swordsmith's signature. The inscription often includes the swordsmith's address and title, particularly in the case of blades forged after the Muromachi period.

Ura-mei refers to the inscription on the side opposite the omote-mei. The ura-mei usually consists of the date, the name of the person who ordered the sword, etc.

Niji-mei and nagamei: Signatures inscribed with just two Chinese characters are known as niji-mei; these were most popular on Koto swords, and were used by smiths such as Masatsune (正恒), Nagamitsu (長光), and Masamune (正宗). Masamune-saku (正宗作) and Rai Kunimitsu (来国光) usually used sanjimei (three-character signatures).

A nagamei is a long signature, which often includes an address, a middle name, and title such as: "Bizen (no) Kuni Tomonari Zo" (備前国友成造), "Bizen (no) Kuni Osafune Ju Sakon Shogen Nagamitsu" (備前国長船住左近将監長光), "Minamoto Saemon no Jo Nobukuni "(源左衛門尉信国), "Sagami (no) Kuni Junin Hiromitsu" (相模国住人広光), or "Rakuyo Ichijo Ju Shinano (no) Kami Kunihiro" (洛陽一条住信濃守国広).

Niji-mei was particularly popular in the Heian and Kamakura periods; after the Shinto era, the nagamei becomes standard.

Zuryo-mei: Any of the titles title given to a particular swordsmith by the imperial court, such as kami (守), suke (介), daijo (大掾), and the like. Such titles frequently appear on Shinto and later swords, for example: Dewa *Daijo* Kunimichi (出羽大掾国路), Kazusa no *Suke* Kaneshige (上総介兼重), Izumi no *Kami* Kanesada (和泉守兼定), Wakasa no *Kami* Ujifusa (若狭守氏房).

Kaki-kudashi mei: This type of inscription includes the swordsmith's address, the signature, and the date, all engraved onto one side of the tang. An example is: "Bichu no Kuni Tsuguyoshi Enbun Gonen Nigatsu Hi" (備中国次吉 延文五年二月日).

Tameshi-mei: An inscription commemorating a cutting test. The tameshi-mei, usually chiseled or inlaid in gold, notes the sword's sharpness

as demonstrated in a practical cutting test; for example: "Futatsu Do Saidan Kanbun Sannen Sangatsu Juhachi-nichi Yamano Kaemon Hisahide (kao [monogram])" (二ツ胴截断 寛文三年三月十八日 山野加右衛門久英).

Kiritsuke-mei: A memorial inscription, usually consisting of the history of the sword and its owners. Such an inscription might include the name of the cutting tester, the name of the person who shortened the nakago, etc.

Daimei: When a swordsmith's signature is chiseled onto a sword by his son or student with his permission, this signature is called a daimei ("substitute signature") and regarded as equivalent to the real signature. It seems that students also often produced swords in their teachers' or fathers' style, with full permission. Production of this sort is known as daisaku ("substitute production"), and such blades were often signed by the teacher rather than the student. These signatures are also regarded as authentic.

Orikaeshi-mei: "Turned-back signature." When a nakago is shortened, the part bearing the signature is sometimes thinned down and folded up onto the opposite side. This preserves the original signature, which then appears upside-down on the opposite side of the tang. Orikaeshi-mei is seen primarily on Koto blades.

Gaku-mei (or tanzaku-mei): "Framed signature." When a blade has been shortened (o-suriage), the metal containing the signature is excised in a rectangular shape, thinned, and then attached to the reshaped tang. Gaku-mei is used as a means of retaining the original signature on the tang even after reshaping.

Hari-mei (or haritsuke-mei): This has a similar purpose to that of gaku-mei, but in this case the mei is located on the part of the nakago where the original mei would have been. Orikaeshi-mei, gaku-mei and hari-mei are valuable for their historical importance, but there are many cases in which this technique of transferring the original mei to the newly-made nakago has been exploited as a way of producing counterfeits.

Shu-mei: Red lacquer inscription made by an appraiser. The appraiser may provide the name of a swordsmith on an unaltered tang with no signature, using red lacquer to avoid inscribing directly onto the metal. Shu-mei is done primarily by members of the Hon'ami family, with a typical one reading as follows: on the front, "Sadamune" (貞宗); and on the back, "Hon'a" (monogram). The first name of the appraiser, if he is a member of one of the Hon'ami families, can be determined by the monogram.

Kinzogan-mei: An inscription in gold inlay of the name of an attributed swordsmith on a shortened tang without a signature, made by a member of the Hon'ami family. This practice started prior to the Edo period. Silver inlay (ginzogan-mei) is very rare, and Kotoku's in particular is highly prized, as he is considered the finest appraiser of the Hon'-ami family. Sometimes an inlay is seen that is not the name of a swordsmith; this is usually a sword's title, for example, "Sasa no Tsuyu" (笹の露) or "Hana Gatami" (花形見).

Kinpun-mei (fun-mei): Appraiser's inscription of the name of the attributed swordsmith, written in gold lacquer. "Kinpun" means "gold powder," in this case mixed with lacquer. This sort of inscription was fashionable during the Meiji and Taisho periods on both unaltered and altered tangs. Kinpun-mei written by Hon'ami Ringa and Hon'ami Koson are fairly common.

Mekugi ana (peg hole)

After filing and carving is completed, the swordsmith drills the mekugi ana into the tang. Sometimes part of the signature is damaged by the addition of this peg hole.

On tangs of unaltered tachi, there is quite often a second peg hole located nearer the end (nakagojiri). This is referred to as the shinobi ana.

When a sword is shortened, a new mekugi ana is made. Each time a sword is altered, the number of peg holes increases; these unused holes are frequently inlaid with gold, silver, or copper.

TYPES OF HI

The hi is a groove engraved on the shinogiji or the hiraji; such grooves are found on swords dating back to the earliest times. Originally the object was to reduce the weight and improve the cutting ability of the sword; later the grooves served as decoration. Another purpose for the hi was to restore a sword's balance after it had been shortened, or to conceal a flaw in the blade. In either of these cases, the hi was known as an ato-bi (groove added later).

Hi are classified according to shape, as follows (please note that "hi" is usually pronounced "bi" when it is preceded by other characters):

Bo-bi: A long, straight, wide groove. When engraved on tanto, it is known as katana-bi.

Bo-bi with soe-bi: A wide groove with a second, thinner groove.

Bo-bi with tsure-bi: A wide groove with a second, thinner groove that extends to the top of the bo-bi.

Futasuji-bi: Two parallel grooves.

Shobu-bi: Iris leaf–shaped groove.

Naginata-hi: A short bo-bi with the top finished in the direction opposite that of the katana-bi; the foot of the groove is rounded, and is usually accompanied by soe-bi. This type of groove is seen on naginata, sometimes on wakizashi, and on tanto made in the kanmuri-otoshi-zukuri style.

Kuichigai-bi: Two thin grooves run halfway down the blade; then the top groove ends while the bottom one continues and surrounds the shorter groove.

Koshi-bi: A short groove with a rounded top, engraved on the lower part of the blade, close to the tang. Usually such a groove is engraved only on the front of the blade.

The top of the hi is called the hisaki. A groove that ends near the ko-shinogi is known as a hisaki agaru (rising hisaki), while a groove that stops below the yokote is called a hisaki sagaru (descending hisaki).

The bottom of the groove is known as the tome ("stop"). Tome are further classified with the following terms:

● TYPES OF GROOVES

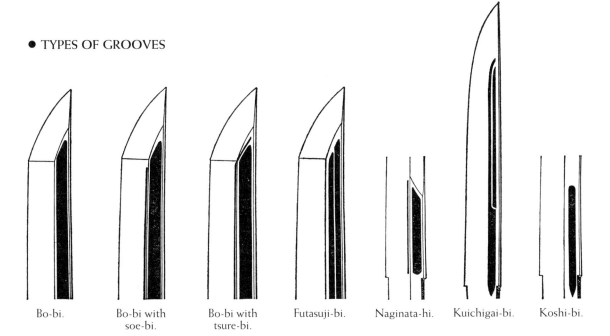

Bo-bi. Bo-bi with soe-bi. Bo-bi with tsure-bi. Futasuji-bi. Naginata-hi. Kuichigai-bi. Koshi-bi.

Kaki-toshi: "No end." The groove is engraved all the way down to the butt end of the tang.

Kaki-nagashi: "Halfway end." This is a pointed groove which tapers to an end halfway down the blade.

Kaku-dome: "Square end." This type of groove-end usually stops within 3 cm of the machi.

Maru-dome: "Rounded end." This is also positioned within about 3 cm of the machi.

When a groove is engraved into a shinogi-zukuri–style blade, a very narrow shinogiji, known as the chiri ("wall of the groove"), remains at the side of the groove. When a narrow shinogiji remains only on the mune side of the blade, this is called kata-chiri ("one wall"); when a shinogiji remains on both sides of the groove, this is known as ryo-chiri ("two walls").

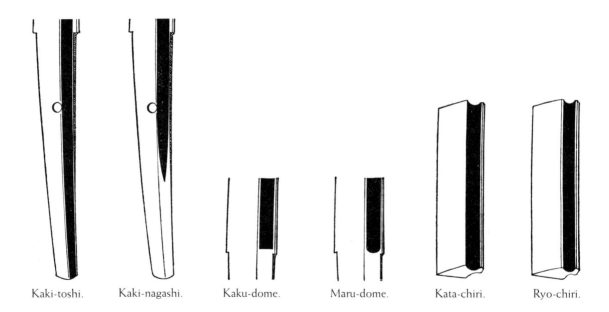

Kaki-toshi. Kaki-nagashi. Kaku-dome. Maru-dome. Kata-chiri. Ryo-chiri.

ATTRIBUTION BASED ON THE HI

Kata-chiri

Leading swordsmiths:

<Koto> Seen in and popular with all schools of Koto times; rare in Ko-Bizen Masatsune (古備前正恒), Yasutsuna (安綱), and Sanjo Munechika (三条宗近).

<Shinto> Used less often in this period than during Koto times. Seen in work by the Horikawa (堀川) school, Ogasawara Nagamune (小笠原長旨), the Tadayoshi (忠吉) school, Ichinohira Yasuyo (一平安代), Yokoyama Sukesada (横山祐定), etc. Sometimes seen in the work of Noda Hankei (野田繁慶) and Kotetsu (虎徹).

<Shinshinto> Suishinshi Masahide (水心子正秀), Taikei Naotane (大慶直胤), Yamato no Kami Motohira (大和守元平), Hoki no Kami Masayoshi (伯耆守正幸), Gassan Sadakazu (月山貞一), etc.

(Note: There are some ato-bi ("added-later") kata-chiri that were originally produced as ryo-chiri.)

Ryo-chiri

Leading swordsmiths:

<Koto> Often seen in schools other than the Gokaden (five traditions). The Aoe (青江) school, Yamato- (大和) province schools, Kashu Yukimitsu (加州行光), Kongobei Moritaka (金剛兵衛盛高), the Naminohira (波平) school, etc.
Ryo-chiri is also often found in the blades of swordsmiths of Kaga (加賀), Echizen (越前), Etchu (越中), Hoki (伯耆), and Iwami (石見) provinces.

<Shinto> Rarely seen after Koto times, but may sometimes be seen in the work of the following swordsmiths: Noda Hankei (野田繁慶), Minamoto (no) Yorisada (源頼貞), Ogasawara Nagamune (小笠原長旨), Sasaki Ippo (佐々木一峯), Higo Daijo Sadakuni (肥後大掾貞国), Yamato Daijo Masanori (大和大掾正則), Echizen Daijo Tadakuni (越前大掾忠国), later Nio (二王), etc.

Wide hi

Leading swordsmiths:

<Koto> Miike Mitsuyo (三池光世) (famous as a skilled engraver of hi), Mitsutada (光忠), etc.

<Shinto> (The tanto of) Higo Daijo Sadakuni (肥後大掾貞国).

Narrow hi

Leading swordsmiths:

<Koto> Soshu- (相州) (Sagami province) swords.

Hisaki agaru ("rising hisaki")

Leading swordsmiths:

<Koto> Popular on Koto blades and fine swords. The Rai (来) school (Kuniyuki [国行], Kunitoshi [国俊], Kunimitsu [国光]), Nobukuni (信国), the Ko-Bizen (古備前) school, the Ichimonji (一文字) school, the Ko-Osafune (古長船) school (Mitsutada [光忠], Nagamitsu [長光], Kagemitsu [景光]), Kanemitsu (兼光), Kunimune (国宗), Hatakeda Moriie (畠田守家), Ryumon Nobuyoshi (龍門延吉), Yukimitsu (行光), etc.

<Shinto> Rarely seen on Shinto blades, except occasionally on work of the following: Horikawa Kunihiro (堀川国広), Etchu no Kami Masatoshi (越中守正俊), Echizen Yasutsugu (越前康継), Higo Daijo Sadakuni (肥後大掾貞国), Noda Hankei (野田繁慶), Minamoto (no) Yorisada (源頼貞), Teruhiro (輝広), Tadayoshi (忠吉), etc.

<Shinshinto> Suishinshi Masahide (水心子正秀), Taikei Naotane (大慶直胤), Koyama Munetsugu (固山宗次), Minamoto (no) Kiyomaro (源清麿), etc.

Hisaki sagaru ("descending hisaki")

Leading swordsmiths:

<Koto> Seen primarily on swords of the Nanbokucho period. The Tegai (手掻) school, the Shikkake (尻懸) school, Go Yoshihiro (郷義弘), Tsunahiro (綱広), the Chogi (長義) school, the Kanemitsu (兼光) school, the Motoshige (元重) school, the Sue-Aoe (末青江) school, the Sue-Sa (末左) school, the Sue-Seki (末関) school, etc.

<Shinto> Dewa Daijo Kunimichi (出羽大掾国路), the Yasutsugu (康継) school, the Hojoji (法城寺) school, Tadayoshi (忠吉), Satsuma- (薩摩) province swords, etc.

<Shinshinto> Sa Yukihide (左行秀), etc.

Maru-dome

Leading swordsmiths:

<Koto> Bizen- (備前) province swords of the mid-Kamakura and Muromachi periods, Nobukuni (信国), Heianjo Nagayoshi (平安城長吉), the Sue-Tegai (手掻) school, the Kanabo (金房) school, etc.
The position of the end (tome) of work by Kagemitsu (景光) and Kanemitsu (兼光) is higher than in work of other smiths.

<Shinto> The Horikawa (堀川) school, Ikkanshi Tadatsuna (一竿子忠綱), Tsutsui Kiju (筒井紀充), Echizen Yasutsugu (越前康継), Noda Hankei (野田繁慶), Kotetsu (虎徹), Ogasawara Nagamune (小笠原長旨),

the Hojoji (法城寺) school, etc. On swords of skilled swordsmiths such as Horikawa Kunihiro (堀川国広) and Kotetsu (虎徹), the hi is deep, and the position of the tome is higher.

<Shinshinto> Suishinshi Masahide (水心子正秀), Taikei Naotane (大慶直胤), etc.

Kaku-dome

Leading swordsmiths:
<Koto> Tomonari (友成), Nagamitsu (長光), Kagemitsu (景光), the Oei-Bizen (応永備前) school, the Tegai (手搔) school, Ryumon Nobuyoshi (龍門延吉), Shimada Yoshisuke (島田義助), the Ko-Mihara (古三原) school, Akikuni (顕国), the Takada (高田) school, Inshu Kanenaga (因州景長), Kanro Toshinaga (甘露俊長), Fujishima Tomoshige (藤島友重), Zenjo Kaneyoshi (善定兼吉), etc.

<Shinto> Dewa Daijo Kunimichi (出羽大掾国路), Etchu no Kami Masatoshi (越中守正俊), Ogasawara Nagamune (小笠原長旨), the Hojoji (法城寺) school, Yokoyama Sukesada (横山祐定), the Chikuzen Nobukuni (筑前信国) school, Tadahiro (忠広), etc.

<Shinshinto> Taikei Naotane (大慶直胤), Koyama Munetsugu (固山宗次), Kiyondo (清人), Gassan Sadakazu (月山貞一), etc.

(Note: Kaki-nagashi and kaki-toshi are the most common patterns of Koto swords.)

Bo-bi with soe-bi

Leading swordsmiths:
<Koto> Rarely seen during the Kamakura period, this style of groove comes into prominence on Bizen swords of the Nanbokucho period, and is also commonly seen during the Muromachi period. The Hasebe (長谷部) school, Nobukuni (信国), Sanjo Yoshinori (三条吉則), the Sue-Tegai (末手搔) school, the Sue-Shikkake (末尻懸) school, the Kanabo (金房) school, the Sue-Seki (末関) school, the Takada (高田) school, the Sue-Mihara (末三原) school, etc.

<Shinto> Horikawa Kunihiro (堀川国広), Dewa Daijo Kunimichi (出羽大掾国路), the Hojoji (法城寺) school, Miyoshi Nagamichi (三善長道), Masanaga (政長), Yamato Daijo Masanori (大和大掾正則), Echizen Kanenori (越前兼則), Yamashiro no Kami Kunikiyo (山城守国清), the Chikuzen Nobukuni (筑前信国) school, the Tadayoshi (忠吉) school, etc.

Bo-bi with soe-bi is quite rare in swords of the Mishina (三品) school, Osaka- (Settsu) province schools, and Satsuma-province swords.

<Shinshinto> Taikei Naotane (大慶直胤), etc.

Bo-bi with tsure-bi

Leading swordsmiths:
<Koto> Seen primarily toward the end of the Muromachi period, but also found on blades of skilled smiths of the Kamakura and Nanbokucho periods. The Rai (来) school (Kuniyuki [国行] Kunitoshi [国俊]), Nobukuni (信国), Sukezane (助真), the Ko-Osafune (古長船) school (Mitsutada [光忠], Nagamitsu [長光], Kagemitsu [景光], Sanenaga [真長]), Kanemitsu (兼光), Morimitsu (盛光), Yasumitsu (康光), Norimitsu (則光), Tsunahiro (綱広), etc.

<Shinto> The Horikawa (堀川) school, Ikkanshi Tadatsuna (一竿子忠綱), the Hojoji (法城寺) school, the Chikuzen Nobukuni (筑前信国) school, etc.

Occasionally found on Mishina- (三品) school swords, as well as blades by Nanki Shigekuni (南紀重国), Kunikane (国包), the Mizuta (水田) school, and smiths of Satsuma (province).

<Shinshinto> Often seen in Bizen-style work of the following swordsmiths: Suishinshi Masahide (水心子正秀), Taikei Naotane (大慶直胤), Koyama Munetsugu (固山宗次), etc.

Futasuji-bi

Leading swordsmiths:
<Koto> Rai Kuninaga (来国長), Sadamune (貞宗), Tsunahiro (綱広), Kaneuji (兼氏), the Naoe Shizu (直江志津) school, Izumi no Kami Kanesada (和泉守兼ﾍﾞ), Wakasa no Kami Ujifusa (若狭守氏房), the Sengo (千子) school (Muramasa [村正], Masazane [正真]), Fujishima Tomoshige (藤島友重), Inshu Kanenaga (因州景長), Chogi (長義), the Chu- (中) and the Sue-Aoe (末青江) schools, etc.

<Shinto> Dewa Daijo Kunimichi (出羽大掾国路), Etchu no Kami Masatoshi (越中守正俊), the Yasutsugu (康継) school, the Hojoji (法城寺) school, Miyoshi Nagamichi (三善長道), Aizu Kanesada (会津兼定), Kanewaka (兼若), the Echizen Seki (越前関) school, the Chikuzen Nobukuni (筑前信国) school, the Takada (高田) school, the Tadayoshi (忠吉) school, Mondo no Sho Masakiyo (主水正正清), etc.

<Shinshinto> Taikei Naotane (大慶直胤), Minamoto Kiyomaro (源清麿), Yamato no Kami Motohira (大和守元平), Oku Mototake (奥元武), etc.

Shobu-bi

Leading swordsmiths:
<Koto> Seen on tanto of Yamato (大和) province and Soshu (相州) (Sagami province).

Kuichigai-bi

Leading swordsmiths:

<Koto> Nobukuni (信国), Heianjo Nagayoshi (平安城長吉), Sanjo Yoshinori (三条吉則), the Hosho (保昌) school, the Sue-Tegai (手搔) school, the Kanabo (金房) school, the Sue-Mihara (末三原) school, the Uda (宇多) school, the Koga (広賀) school, the Sue-Enju (延寿) school.

<Shinto> Dewa Daijo Kunimichi (出羽大掾国路), Etchu no Kami Masatoshi (越中守正俊), the Yasutsugu (康継) school, Echizen- (越前) (province) swords, etc.

<Shinshinto> Taikei Naotane (大慶直胤), Kurihara Nobuhide (栗原信秀), Gassan Sadakazu (月山貞一), etc.

Naginata-hi

Leading swordsmiths:

<Koto> Nobukuni (信国), Heianjo Nagayoshi (平安城長吉), Sanjo Yoshinori (三条吉則), the Sue-Tegai (手搔) school, the Kanabo (金房) school, the Sue-Seki (末関) school, the Uda (宇多) school, Hojoji Kunimitsu (法城寺国光), Koga (広賀), the Sue-Mihara (末三原) school, the Sue-Sa (末左) school, etc.

<Shinto> The Horikawa (堀川) school, Miyoshi Nagamichi (三善長道), Michitoki (道辰), etc.

<Shinshinto> Suishinshi Masahide (水心子正秀), Taikei Naotane (大慶直胤), Kurihara Nobuhide (栗原信秀), Gassan Sadakazu (月山貞一), etc.

Koshi-bi

Usually seen on tanto, but in Koto times, also seen on tachi and katana.

Leading swordsmiths:

<Koto> The Awataguchi (栗田口) school, the Rai (来) school, Nobukuni (信国), Heianjo Nagayoshi (平安城長吉), Sanjo Yoshinori (三条吉則), Shintogo Kunimitsu (新藤五国光), the Sue-Tegai (手搔) school, Soshu- and Bizen- (province) swords.

<Shinto> Umetada Myoju (埋忠明寿), the Horikawa (堀川) school, Yasutsugu (康継), Omi no Kami Tsuguhira (近江守継平), Sagami no Kami Masatsune (相模守政常), Higo Daijo Sadakuni (肥後大掾貞国), Yamato Daijo Masanori (大和大掾正則), Kanenori (兼則), Ujishige (氏重), Teruhiro (輝広), the Tadayoshi (忠吉) school, etc.

<Shinshinto> Suishinshi Masahide (水心子正秀), Taikei Naotane (大慶直胤), etc.

TYPES OF HORIMONO

The hi (groove) is but one of many types of engraving or horimono found on Japanese swords. Although horimono engravings were initially intended to serve as religious talismans, as time passed they came to be purely decorative.

The following are various types of horimono:

Goma hashi: Chopsticks used on the altars of Shinto shrines.

Ken: Sword; also, an alternative incarnation of the Buddhist deity Fudo Myoo. There are several types of swords, like the suken (straight, old-style sword), the ken with tsume (sword with claw) and the ken with sankozuka (ken with vajra thunderbolt hilt), and the ken with bonji (Sanskrit characters).

Kurikara: Dragon winding around a sword. There are some different types of kurikara, such as shin no kurikara (realistic dragon winding around a sword), gyo no kurikara (simplified dragon winding around a sword), and so no kurikara (highly simplified dragon winding around a sword).

Bonji: Sanskrit characters. Bonji may be used alone or in combination with other elements.

Fudo Myoo: The Buddhist deity framed in fire.

Other popular horimono: Plants such as plum blossoms, trees, bamboo. Also, Shinto or Buddhist deities, and Chinese characters in various styles.

● ENGRAVINGS

Goma hashi.

Suken.

Ken with tsume.

Ken with sankozuka.

Bonji and embossed suken in the groove.

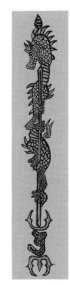

Shin no kurikara.

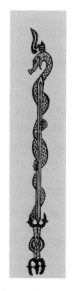

Gyo no kurikara.

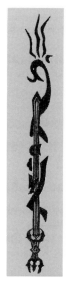

So no kurikara.

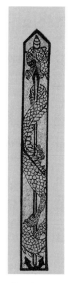

Kurikara in the groove.

Bonji, kuwagata (a W-shaped design that forms the front crest of a helmet), rendai (lotus-flower pedestals placed beneath images of the Buddha).

Yoraku, bonji, rendai, kuwagata.

Chinese characters.

Kensaku (rope held by the Buddhist deity Fudo Myoo).

Hatahoko (halberd with standard).

Kaen Fudo (the Buddhist deity framed in fire).

Kaen Fudo in the groove.

Ryu (dragon)

Leading swordsmiths:

<Koto> Nobukuni (信国), etc.

<Shinto> Umetada Myoju (埋忠明寿), Horikawa Kunihiro (堀川国広), Ikkanshi Tadatsuna (一竿子忠綱), Yasutsugu (康継), Kotetsu (虎徹), Tadayoshi (忠吉), etc.

<Shinshinto> Taikei Naotane (大慶直胤), Kurihara Nobuhide (栗原信秀), Tairyusai Sokan (泰龍斎宗寛), Gassan Sadakazu (月山貞一), etc.

Jo-ge ("ascending and descending" dragons [a ryu on one side of the tang, and a ryu with a plum tree on the other])

Seen only in swords dating from Shinto times or later.

Leading swordsmiths:

<Shinto> Umetada Myoju (埋忠明寿), Horikawa Kunihiro (堀川国広), Yasutsugu (康継), Kotetsu (虎徹), Ikkanshi Tadatsuna (一竿子忠綱), Nanki Shigekuni (南紀重国), the Tadayoshi (忠吉) school, etc.

<Shinshinto> Gassan Sadakazu (月山貞一), etc.

Bonji

Leading swordsmiths:

<Koto> Yukihira (行平), Nobukuni (信国), Heianjo Nagayoshi (平安城長吉), the Kurama (鞍馬) school, the Sue-Tegai (手掻) school, the Masamune (正宗) school (Yukimitsu [行光], Masamune [正宗], Sadamune [貞宗], Hiromitsu [広光], Akihiro [秋広]), the Sue-Soshu (末相州) school, Fujishima Tomoshige (藤島友重), the Ko-Osafune (古長船) school (Nagamitsu [長光], Kagemitsu [景光]), the Kanemitsu (兼光) school, Aoe Yoshitsugu (青江吉次), etc.

<Shinto> Umetada Myoju (埋忠明寿), the Horikawa (堀川) school, Yasutsugu (康継), Higo Daijo Sadakuni (肥後大掾貞国), Kotetsu (虎徹), the Tadayoshi (忠吉) school, etc.

<Shinshinto> Suishinshi Masahide (水心子正秀), Taikei Naotane (大慶直胤), etc.

Fudo Myoo

Leading swordsmiths:

<Koto> Yukihira (行平), Rai Kuniyuki (来国行), the Masamune (正宗) school (Yukimitsu [行光], Masamune [正宗]), the Soshu (相州) schools (Tsunahiro [綱広], Kagemitsu [景光]), etc.

<Shinto> Horikawa Kunihiro (堀川国広), Yasutsugu (康継), etc.

Names of Shinto and Buddhist deities in characters

Leading swordsmiths:

<Koto> Kagemitsu (景光), Kanemitsu (兼光), the Sue-Bizen (末備前) school, Nobukuni (信国), Heianjo Nagayoshi (平安城長吉), Sanjo Yoshinori (三条吉則), etc.

<Shinto> Horikawa Kunihiro (堀川国広), Horikawa Kuniyasu (堀川国安), Yasutsugu (康継), etc.

<Shinshinto> Kurihara Nobuhide (栗原信秀), etc.

Names of Shinto and Buddhist deities, plants and animals

Leading swordsmiths:

<Koto> Yukihira (行平), Muramasa (村正), Wakasa no Kami Ujifusa (若狭守氏房), Tsunahiro (綱広), Yamamura Yasunobu (山村安信), the Kaifu (海部) school (Ujiyoshi [氏吉], Yasuyoshi [泰吉]), etc.

<Shinto> Horikawa Kunihiro (堀川国広), Dewa Daijo Kunimichi (出羽大掾国路), Yasutsugu (康継), Higo Daijo Sadakuni (肥後大掾貞国), Echizen Sadatsugu (越前貞次), Ikkanshi Tadatsuna (一竿子忠綱), etc.

<Shinshinto> Taikei Naotane (大慶直胤), Kurihara Nobuhide (栗原信秀), etc.

JIGANE AND JIHADA

The steel from which Japanese swords are made is known as the jigane. The term jihada refers to the pattern of the surface grain produced by the swordsmith's forging. Since this pattern varies with each individual swordsmith and school, the jihada is useful for determining, with some conclusiveness, a blade's period and school. The surface grain also influences the appearance of the hamon (temper line), which occurs as a result of tempering. There are a number of basic patterns of jihada, including mokume-hada, masame-hada, itame-hada, and ayasugi-hada. (The term hada also refers to the pattern of the surface texture.)

The characteristics of the grain pattern and the features of the steel are described with the following terms:

Fine: Used for a jihada which is dense and beautiful and has high-quality jigane.

Dense: Used for a jihada which is simply dense (and not beautiful).

Coarse: Can be used to refer to a jihada (the Japanese equivalent is "hada tatsu").

Strong: Used to describe a functionally strong (tsuyoi) jigane. A strong jigane normally has a discernible grain and is accompanied by plenty of ji-nie (nie which appears on the ji, and not inside the hamon).

Weak: Again, used to refer to the jigane, weak (yowai) means functionally weak. A weak jigane has a grain which is only barely discernible. Shinshinto blades are made of steel with weak jigane, with exceptions being the work of Kiyomaro, Koyama Munetsugu, etc.

Clear: Also used to refer to the jigane. (The Japanese equivalent is "sunda.")

Cloudy: Also used to refer to the jigane. (The Japanese equivalent is "nigotta.")

Whitish: Also used to refer to the jigane. (The Japanese equivalent is "shiraketa.")

The types of grain patterns seen are as follows:

Mokume-hada: Similar to the annual growth rings of a tree trunk (although this similarity may not always be immediately evident). The grains of most Japanese swords can be said to be mokume-hada. A grain is classified, according to size, as o-mokume (large), chu-mokume (medium), or ko-mokume (small). In addition to these basic types, there are others describing the extent to which mokume is mixed with itame or masame grains, or the state of ji-nie and

● **VARIOUS SURFACE-GRAIN PATTERNS**

O-mokume hada.

Chu-mokume hada.

Ko-mokume hada.

chikei (a black, gleaming line of nie on the ji). (Note: Today the terms ko-itame and itame are often used to describe a ko-mokume or a mokume grain that has a compressed or distorted pattern that is not conspicuously round. However, in the Hon'ami school of appraisal, these varieties are simply referred to as mokume grain.)

Masame: When a tree is cut along the vertical plane, the grain is straight, and basically this same effect is what distinguishes masame blades. There are various kinds of masame grains, including the pure masame typical of Hosho-school work, masame tending toward itame grain (known as "running masame"), and partial masame, in which the masame grain is visible in just one section of the blade—for example, in the shinogiji or along the hamon.

Itame: Itame also resembles the annual rings of a tree. It is not burl (as is mokume), nor does it consist of running lines (as does masame). It is classified as o-itame (large), chu-itame (medium), or ko-itame (small), depending on the size of the grain.

Ayasugi: A pattern of curved lines that have a wave-like effect. Usually seen in blades of the Gassan school, and thus also known as gassan.

Matsukawa: A kind of o-mokume or o-itame with thick chikei. The pattern of the grain stands out exceptionally clearly, and resembles the bark of a pine tree. In blades made by Norishige, it is also known as Norishige grain, and in blades made by Hankei it is called hijiki (a variety of algae).

Nashiji: "Pear skin"; this grain resembles the flesh of a sliced pear, and is essentially a fine dense ko-mokume grain, with surface nie throughout. It is seen in the work of Sanjo Munechika, the Awataguchi school, etc.

Konuka: "Rice bran"; similar to nashiji, but a little coarser and with less ji-nie. Used only to describe swords from Hizen province, it is also known as Hizen grain.

Chirimen: "Crepe"; a distinctly visible mokume grain, with a clearer steel than is found in patterns that are similar but coarser. Used only to describe Aoe-school swords.

| Masame-hada. | Itame-hada. | Ayasugi-hada. | Matsukawa-hada. | Konuka-hada. |

Muji: Plain; unfigured; thus here, "without grain." Difficult to identify. This has a glassy look, and is often seen on Shinshinto blades. The steel is not actually grainless, of course, but until recently it was very difficult to discern the grain, even after careful polishing, because the grain is so small and the steel so tight in texture. However, details of this so-called "grainless" pattern can now be brought out with polishing, because of improved polishing techniques. To be precise, the pattern should be described as *appearing* to be without grain.

Distinctive grains: A variety of grain patterns, each of which provides definitive identification of a particular swordsmith or school.

Yakumo: "Mass of clouds." Found in the work of Mito Rekko, this appears to be a unique combination of steels. The grain is glaringly large, and has an effect like chikei.

Uzumaki: Whirlpool. Found in work of the Shitahara school, this is apparently the result of a particular technique used in forging. Distinct from mokume.

Chirimen-hada. Muji-hada.

HATARAKI IN THE JIHADA

The surface-grain patterns of blades are determined primarily by the composition of the steel and the forging pattern. With polishing, additional patterns and shapes may appear. These are called hataraki, (activity, or workings), and these features provide the connoisseur additional enjoyment. Activity in the blade is also an important point in making attributions.

Ji-nie: Ji-nie is nie found in the ji or, more specifically, in the hiraji. It is composed of the same type of particles that make up the hamon, and is seen to some extent in any sword.

Chikei: A black gleaming line of nie in the ji. It has the same construction as kinsuji and inazuma, features found in the hamon.

Sumigane: Plain dark spots on the ji that are quite different from the surrounding surface pattern in both color and grain. Frequently seen on work of the Aoe school.

Yubashiri: A spot or spots where nie is concentrated on the ji. Seen on celebrated swords with temper lines consisting of nie.

Utsuri: A misty reflection found on the ji and the shinogiji of swords of every possible type of surface grain. The purpose seems to have been to improve the sword's flexibility to prevent breakage during use. Usually made of steel that is softer than the rest of the blade's surface.

TYPES OF UTSURI
Bo utsuri: Straight pattern. Also known as sugu utsuri.

Midare utsuri: Irregular pattern.

Choji utsuri: Clove-shaped pattern.

Shirake utsuri: Whitish utsuri with an unclear, indistinct pattern. Seen mainly on blades of Mino province and related schools.

Nie utsuri: Utsuri appearing on the ji of quality blades based on nie.

Jifu utsuri: Scattered spots of utsuri. This is different from sumigane in that it is not plain, and that it is found all over the blade's surface. It is often seen on blades of the Ko-Bizen school.

Generally, utsuri is clearly evident on blades of Bizen province made in the Kamakura through the early Muromachi periods. (Note: The surface-grain patterns of blades or hamon are not immediately evident, but are largely brought out, or even added, by the sword polisher, whose skill is therefore crucial. The various traditional schools of polishing have developed an array of techniques to bring out the beauty of a particular sword. Even skilled polishers need to be careful and inventive in order to produce fine grain, chikei, and ji-nie. A sword cannot be fully appreciated unless it has first been polished by a qualified polisher.)

● ACTIVITY

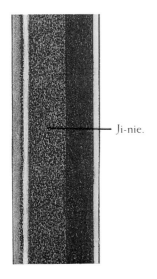
Ji-nie.

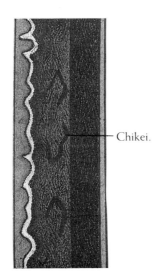
Chikei.

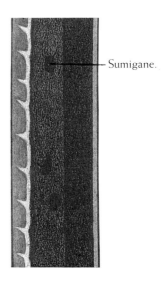
Sumigane.

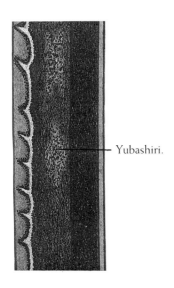
Yubashiri.

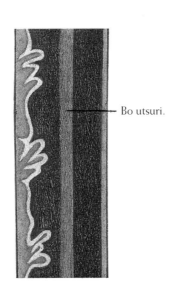
Bo utsuri.

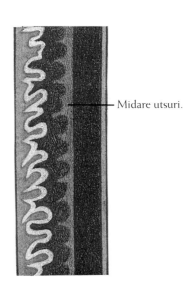
Midare utsuri.

ATTRIBUTION BASED ON THE JIHADA

Mokume-hada

Mokume grain was popular throughout all periods and in all regions. In Yamashiro-province schools, mokume is accompanied by fine, beautiful ji-nie, while in Bizen-province blades it is seen together with utsuri. In blades of Mino province, it is combined with masame and looks whitish; in blades of the Aoe (青江) school, it is combined with sumigane. In the Hokuriku district, blades were made with shirake utsuri.

In Shinto blades, masame grain is frequently seen in the shinogiji. During this period the common features of each province's grain patterns become less clear, and attributions should be made systematically, on the basis of each school's workmanship in general, rather than on the basis of the jihada alone.

O-mokume

Leading swordsmiths:
<Koto> Ichimonji Suketsuna (一文字助綱), the Oei-Bizen (応永備前) school (Morimitsu [盛光], Yasumitsu [康光], Moromitsu [師光]), Tsunahiro (綱広), etc.

O-mokume combined with o-itame and masame grain

Leading swordsmiths:
<Koto> The Yasutsuna (安綱) school (Yasutsuna [安綱], Sanemori [真守]), etc.

Chu-mokume

Leading swordsmiths:
<Koto> The Ichimonji (一文字) school, Mitsutada (光忠), Moriie (守家), Chiyozuru Kuniyasu (千代鶴国安), Koga (広賀) (or Hiroyoshi), the Shitahara (下原) school, etc.

<Shinto> Masatsune (政常), Yamato no Kami Yasusada (大和守安定), Korekazu (是一), Sukesada (祐定), the Chikuzen Nobukuni (筑前信国) school (Koretsugu [守次], Moritsugu [守次]), Masakiyo (正清), etc.

<Shinshinto> Naotane (直胤), Kiyomaro (清麿), Motohira (元平), etc.

Chu-mokume combined with masame

Leading swordsmiths:
<Koto> Motoshige (元重), the Ukai (鵜飼) school (Unjo [雲生], Unji [雲次]), Naotsuna (直綱), the Naoe

Shizu (直江志津) school, Muramasa (村正), Kanemoto II (二代 兼元) II, Izumi no Kami Kanesada (和泉守兼定), Sue-Seki (末関) school, Tsukushi Ryokai (筑紫了戒), the Kongobei (金剛兵衛) school, etc.

<Shinto> Kunisada (国貞), Kaneyasu (包保), Kuniteru (国輝), Tsutsui Kiju (筒井紀充), Shigekuni (重国), Teruhiro (輝広), Sasaki Ippo (佐々木一峯), Yasutsugu (康継) Omura Kaboku (大村加卜), Sendai Yasutomo (仙台安倫), Yamashiro no Kami Kunikiyo (山城守国清), the Echizen Seki (越前関) school, etc.

<Shinshinto> Chounsai Tsunatoshi (長運斎綱俊), Unju Korekazu (運寿是一), etc.

Ko-mokume

Leading swordsmiths:
<Koto> Sanjo Munechika (三条宗近), Gojo Kanenaga (五条兼永), Ayanokoji Sadatoshi (綾小路定利), the Awataguchi (粟田口) school, the Rai (来) school, Shintogo Kunimitsu (新藤五国光), the Masamune (正宗) school (Yukimitsu [行光], Sadamune [貞宗]), Tsunahiro (綱広), Fusamune (総宗), Go Yoshihiro (郷義弘), the Ko-Bizen (古備前) school (Tomonari [友成], Masatsune [正恒], Kanehira [包平]), the Ko-Ichimonji (古一文字) school, the Ko-Osafune (古長船) school (Mitsutada [光忠], Nagamitsu [長光], Kagemitsu [景光]), the Sue-Bizen (末備前) school (Yosozaemon Sukesada [与三左兵衛門祐定], Tadamitsu [忠光]), the Aoe (青江) school, Samonji (左文字), Bungo Yukihira (豊後行平), etc.

<Shinto> Umetada Myoju (埋忠明寿), Yoshihira (美平), Kunihiro (国広), Kunisuke (国助), Sukehiro (助広), Sukenao (助直), Shinkai (真改), Ikkanshi Tadatsuna (一竿子忠綱), Terukane (照包), Kotetsu (虎徹), etc.

<Shinshinto> Masahide (正秀), Hosokawa Masayoshi (細川正義), Ichige Tokurin (市毛徳鄰) (or Norichika), Tegarayama Masashige (手柄山正繁), Hamabe Toshinori (浜部寿格) (or Jukaku), etc.

Ko-mokume combined with masame

Leading swordsmiths:
<Koto> Heianjo Nagayoshi (平安城長吉), the Senjuin (千手院) school, the Taima (当麻) school, Shikkake Norinaga (尻懸則長), Tegai Kanenaga (手掻包永), Kaneuji (兼氏), the Naoe Shizu (直江志津) school, Nobunaga (信長), the Uda (宇多) school, the Mihara (三原) school, the Nio (二王) school, the Enju (延寿) school, the Dotanuki (同田貫) school, etc.

<Shinto> The Horikawa (堀川) school, the Mishina (三品) school, Hokuso Harukuni (北窓治国), Nobutaka (信高), Yasutsugu (康継), Hojoji Masahiro (法城寺正弘),

Kaneshige (兼重), Ogasawara Nagamune (小笠原長旨), Nagamichi (長道), Higo Daijo Sadakuni (肥後大掾貞国), etc.

<Shinshinto> Kiyomaro (清麿), Yamaura Masao (山浦真雄), Sa Yukihide (左行秀), etc.

Mokume combined with masame along the hamon

Leading swordsmiths:
<Koto> Shikkake Norinaga (尻懸則長), etc.

Mokume combined with masame along the mune

Leading swordsmiths:
<Koto> Sue-Seki (末関) school, etc.

Mokume in the hiraji and masame in the shinogiji

Leading swordsmiths:
<Shinto> The followers of the Mino- (美濃) province schools.

Masame

Seen primarily in blades of Yamato province and related schools. The most obvious masame is seen in the Hosho school and in Shinto blades by Kunikane. It is usually combined with mokume or itame.

Leading swordsmiths:
<Koto> The Hosho (保昌) school, the Taima (当麻) school, the Sue-Tegai (末手掻) school, Daido (大道), Nobunaga (信長), etc.

<Shinto> Kunimichi (国路), Etchu no Kami Masatoshi (越中守正俊), Sendai Kunikane (仙台国包), Ogasawara Nagamune (小笠原長旨), etc.

<Shinshinto> Norikatsu (徳勝), Norichika (徳鄰), Masahide (正秀), Naotane (直胤), Kiyondo (清人), Sa Yukihide (左行秀), Gassan Sadakazu (月山貞一), etc.

Itame

Itame is found primarily on blades of Soshu-province schools and their related schools, as well as swords of the late Heian period.

Leading swordsmiths:
<Koto> Norishige (則重), the Uda (宇多) school, the Masamune (正宗) school (Hiromitsu [広光], Akihiro [秋広]), Chogi (長義), the Samonji (左文字) school, etc.

<Shinto> Kunihiro (国弘), Kunimichi (国路), Hankei (繁慶), etc.

<Shinshinto> Naotane (直胤), Kiyomaro (清麿), Hosokawa Masayoshi (細川正義), Shimizu Hisayoshi (清水久義), Naganobu (長信), etc.

Itame combined with masame along the mune

Leading swordsmiths:
<Koto> The Hasebe (長谷部) school, etc.

Running itame

Leading swordsmiths:
<Koto> Kyushu- (九州) district swords, etc.

Ayasugi

Most commonly seen in the works of the Gassan school. In the work of other smiths it is usually combined with other surface-grain patterns.

Leading swordsmiths:
<Koto> The Gassan (月山) school, the Hoju (宝寿) school, Momokawa Nagayoshi (桃川長吉), the Shikkake (尻懸) school, Kaifu Morohisa (海部師久), Sairen (西蓮), Jitsua (実阿), the Naminohira (波平) school, etc.

<Shinshinto> Gassan Sadayoshi (月山貞吉), Sadakazu (貞一), etc.

Muji

Leading swordsmiths:
<Shinto> Followers of Tanba no Kami Yoshimichi (後代 丹波守吉道), Usaku Munehide (右作宗栄), Mizuta Kunishige (水田国重), etc.

<Shinshinto> The Suishinshi (水心子) school, Ozaki Suketaka (尾崎助隆), etc.

Ji-nie

Seen in swords produced in the Yamashiro, Yamato, Soshu, and Shintotoku traditions in all periods.

Chikei

Seen in swords with hamon consisting of nie, known as nie deki.

Sumigane

Leading swordsmiths:
<Koto> The Aoe (青江) school, Chiyozuru Kuniyasu (千代鶴国安), Hashizume Kunitsugu (橋詰国次), Kashu

Yukimitsu (加州行光), the Mihara (三原) school, the Enju (延寿) school, etc.

Yubashiri

Leading swordsmiths:
<Koto> Yamashiro- (山城) province and Soshu- (相州) (Sagami province) swords of the Kamakura period, etc.

Midare utsuri

Leading swordsmiths:
<Koto> Generally seen in Bizen- (備前) province swords of the Kamakura and the Nanbokucho periods; even when the temper line is suguha, the utsuri is usually midare utsuri.

<Shinto> Tsunemitsu (常光), Sukehiro I (初代 助広), Tatara Nagayuki (多々良長幸), Tameyasu (為康), Mitsuhira (光平), Korekazu (是一), Sukesada (祐定), Koretsugu (是次), Moritsugu (守次), etc.

<Shinshinto> Naotane (直胤), Naokatsu (直勝), Munetsugu (宗次), Sokan (宗寛), Tsunatoshi (綱俊), etc.

Bo utsuri

Leading swordsmiths:
<Koto> The Oei-Bizen (応永備前) school (Morimitsu [盛光], Yasumitsu [康光], Moromitsu [師光]), Tadamitsu (忠光), etc.
(Beginning in the Muromachi period, the utsuri of Bizen- (備前) province swords was bo utsuri, even when the temper line was irregular [midare].)

<Shinto> In Shinto blades, midare utsuri is usual; bo utsuri is rare.

Jifu utsuri

Leading swordsmiths:
<Koto> The Ko-Bizen (古備前) school, the Ukai (鵜飼) school, the Aoe (青江) school, etc.

<Shinto> Tameyasu (為康), but very rarely seen.

Nie utsuri

Leading swordsmiths:
<Koto> Seen on celebrated nie deki swords (in which the hamon consists of nie).
Yamashiro- (山城) province and Soshu (相州) swords of the Kamakura period, etc.

<Shinto> Kunihiro (国弘), Kunimichi (国路), etc.

<Shinshinto> Naotane (直胤), etc.

Shirake utsuri

Leading swordsmiths:
<Koto> Mino- (美濃) province swords, Kashu- (加州) (Kaga province) swords, the Mihara (三原) school, the Takada (高田) school, the Kongobei (金剛兵衛) school, etc.
The following smiths made steel with whitish utsuri: The Tsukushi Ryokai (筑紫了戒) school, Yukihira (行平), the Miike (三池) school, the Enju (延寿) school, the Naminohira (波平) school, etc. This is a distinctive characteristic of swords produced in the Kyushu area.

NIE AND NIOI

Nie and nioi are terms for two different instances of the crystalline effect known as martensite in Western metallurgical terms. Other terms such as austensite, pearlite, and troostite are also used for this phenomenon, but for our purpose these are all fundamentally the same. Nie is the term used for individual particles that look like twinkling stars and that may be discerned with the naked eye. Nioi, on the other hand, has a misty look resembling the Milky Way; no individual particles can be distinguished in it. All swords have nioi along the temper line. When there is very little nie, and the hamon consists entirely of a nioi structure, a sword is known as nioi deki or nioi hon'i. Work in which the hamon consists primarily of nie is known as nie deki or nie honi.

Nie is classified as ara-nie (large nie) and ko-nie (small nie) depending upon particle size. Other types—not considered particularly desirable—include kazunoko ("herring roe") nie (an especially large and partially scattered particle), and mura ("uneven") nie (an irregular particle much larger than other nie, which partially intrudes upon the hamon). Celebrated swords usually have small, bright nie that are accompanied by nioi.

● NIE AND NIOI

Nioi deki (or nioi hon'i).

Nie deki (or nie hon'i).

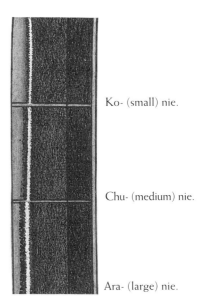

Ko- (small) nie.

Chu- (medium) nie.

Ara- (large) nie.

TYPES OF HAMON

As a result of yakiire (quenching), a blade takes on an edge which is sufficiently hard for effective cutting. When looking along a blade toward the light, the ji looks black and the ha white. The border between the ji and ha shines brightly and is quite distinct. The pattern of this border line is known as the hamon (temper line). The hamon is heavily influenced by the tsuchioki (also known as tsuchidori), an application of a clay coating. Before the blade is quenched, it is completely coated with clay, with a much thinner coating applied to the part that becomes the cutting edge than to the part that becomes the ji. Methods and patterns used in applying this coat of clay are different in each school.

Hamon can basically be classified as suguha (straight pattern), notare (undulating pattern), and gunome (zigzag pattern). To put it more simply, all hamon but suguha are midareba (irregular pattern). The category of midare can be further broken down into ko-midare (a small-patterned midareba), o-midare (large-pattern midareba), and saka-midare (midareba with a slanted pattern). There are also hamon in which these basic patterns are mixed. The various patterns of hamon were subject to the general aesthetic trends of each era, and also show characteristic features of the period, province, and school of their production. The hamon is also a good indicator of a sword-smith's level of skill.

Suguha: (Literally, "straight pattern.") This pattern became quite popular in swords produced prior to the eight century. Many famous swords, especially those of the Awataguchi and Rai schools, show this temper pattern. Suguha may be classified, according to a hamon's width, as hiro-suguha (wide), chu-suguha (medium), and hoso-suguha (narrow). (It should be noted here that in any discussion of the hamon, the terms "width" or "wide" refer not only to the width of the hamon, but to the width of the hamon and the cutting edge, since it is difficult to discern the border between these.)

Extremely narrow suguha are called ito (string) suguha. The suguha is not usually a simple straight line, but is based on a straight pattern and shows various types of activity.

Notare: An undulating pattern of gentle waves. Tani, which literally means "valley," is the term used to describe the lower point of the midare, while the terms o-notare (large) and ko-notare (small) are used to further classify notare on the basis of the amplitude of the waves. In many cases, other patterns are mixed with notare; such mixtures are called notare midare.

Gunome: A series of waves that look like similarly-sized semicircles. Depending on its size, this hamon pattern may be referred to as o-gunome (large) or ko-gunome (small). When it is mixed with midareba, it is known as gunome midare. There are also various other types of gunome referred to by their respective shapes.

Kataochi gunome: Originated by Osafune Kagemitsu and continued by Kanemitsu. The top of the gunome follows a straight line and each line slants from the peak to the valley. Also known as nokogiriba ("sawtooth pattern").

Togari gunome: Gunome in which the peaks are pointed and orderly. This pattern is found in the blades of the Sue-Seki and related schools.

Sanbon-sugi: "Three-cedar gunome." One type of togari gunome, in which the pattern resembles a cluster of three cedar trees. Originated by Kanemoto II.

Gunome choji: Gunome in which each valley is separate and clove- (choji) shaped.

Juka choji: Multiple, overlapping, clove-shaped choji midare, often gorgeous.

O-busa choji: Large clove-shaped choji midare.

Hako midare: Box-shaped, irregular pattern.

Yahazu midare: Fishtail-shaped, irregular pattern.

Uma-no-ha midare: "Horse-teeth–shaped," irregular pattern.

Fukushiki gunome: Multiple gunome. Found mixed with ordinary gunome.

Choji midare: As was noted, choji means "clove." The upper part of the midare is roundish, and the lower part constricted and narrow. This pattern has a number of variations, including: ko-choji midare (small, clove-shaped, irregular pattern); o-choji midare (large, clove-shaped, irregular pattern); juka-choji midare (bag-shaped choji); kawazuko choji midare (tadpole-shaped choji); and saka choji midare (slanting choji midare).

Choji midare is seen not only in Bizen swords, but in blades of the Aoe and Yamashiro schools. In Shinto times, this pattern is found in the work of the Ishido school; in Shinshinto it appears in Hizen swords and those of the Suishinshi school. Kunisuke II created a particular choji midare known as kobushigata choji (fist-shaped choji).

Koshi-no-hiraita midare: Similar to notare. The valleys are gentler than are the peaks. Often mixed with choji or gunome in the upper portion. Seen mainly on Bizen swords of the Muromachi period.

Hitatsura: Gunome midare or notare midare with tobiyaki (tempered spots apart from the hamon) scattered throughout the blade. Originated by swordsmiths of Soshu (Sagami province) during the Nanbokucho period, it later came to be found on blades forged throughout the country.

Toran-midare: A quite splendid pattern resembling large, surging waves. First created by Echizen no Kami Sukehiro, and later favored by some swordsmiths of Osaka (Settsu province). It was seen again in some work of the Shinshinto era. Occasionally, a roundish tempered spot, separate from the main hamon, and known as tama (jewel), may be seen within the ji.

Sudare-ba: A "sudare" is a bamboo-strip blind. Sudare-ba is based on suguha or a shallow notare. The pattern seen inside the hamon looks like a sudare. Tanba no Kami Yoshimichi originated the pattern, and his followers maintained it.

Kikusui: "Kiku" means "chrysanthemum," and "sui" means "water." Kikusui shows a chrysanthemum floating on a stream.

Yoshino: Yoshino is a locale famous for viewing cherry blossoms, and the term has come to refer indirectly to cherry blossoms. This pattern represents cherry blossoms on the Yoshino river.

Tatsuta: Tatsuta is a site famous for viewing maple leaves. This pattern depicts a maple leaf on the Tatsuta river.

Fujimi-Saigyo: "Priest Saigyo viewing Mount Fuji." This pattern shows Mount Fuji and a bamboo hat that suggests an itinerant priest.

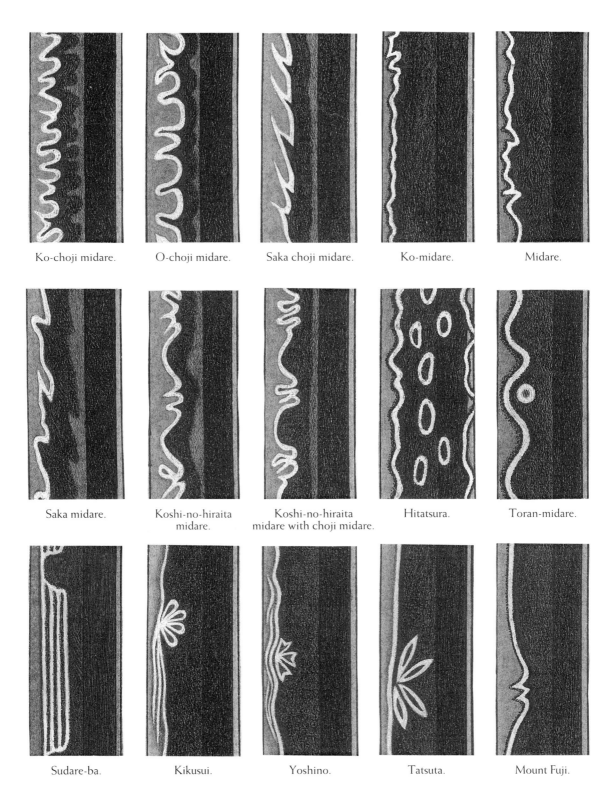

Ko-choji midare.

O-choji midare.

Saka choji midare.

Ko-midare.

Midare.

Saka midare.

Koshi-no-hiraita
midare.

Koshi-no-hiraita
midare with choji midare.

Hitatsura.

Toran-midare.

Sudare-ba.

Kikusui.

Yoshino.

Tatsuta.

Mount Fuji.

VARIOUS CONDITIONS SEEN IN PARTS OF THE HAMON

Koshiba: A partially irregular pattern (midare) seen just above the hamachi. Unlike the standard hamon, which narrows in the hamachi area, this pattern is much wider at the base than in the upper portion. Sometimes seen in Koto blades.

Yakidashi: Yakidashi refers to the very start of the hamon, beginning below the hamachi. Swords that have not been altered always have this tempering extending into the tang. In Shinto blades, the yakidashi is often tempered in a suguha pattern that extends above the hamachi, even when the rest of the hamon is midare; this is referred to as suguha yakidashi, but the expression is used only to refer to Shinto blades (and Shinto copies produced by Shinshinto smiths).

Yakiotoshi: A hamon that begins above the hamachi. Often seen on ancient swords and swords from the Kyushu district, as well as on blades that have had their edges retempered (sai ha), but rarely seen on blades forged after the Shinto era.

Osaka yakidashi: A hamon which starts in suguha or gentle notare, and then gradually widens before shifting smoothly to midare.

Kyo yakidashi: A hamon which starts in suguha and suddenly becomes midare.

Mino yakidashi: A hamon in which koshi-ba is seen in the habaki area.

Satsuma yakidashi: A hamon which starts in midare, as did blades of the Koto times.

Tobiyaki: A tempered spot within the ji, not connected to the main hamon.

Muneyaki: A tempered spot or line found on the mune.

Mizukage: A whitish reflection that appears in the machi area at an angle of 45 degrees from the edge of the nakago to the mune. It is seen only in blades of specific swordsmiths, or in blades that have been retempered (and so it can serve as conclusive evidence that a blade has been retempered).

Habuchi, or nioiguchi: The border between the ji and the hamon. (Note: The border between the ji and the ha is the hamon). This border may be described as "tight," "wide," "soft," "bright," "dull," "indistinct," etc.

TERMS FOR VARIOUS FEATURES OF THE MIDAREBA
Tani, or valley: The lower part, near the cutting edge.
Yakigashira, or top: The upper part, near the mune.
Koshi, or waist: The middle area, between the tani and the yakigashira.

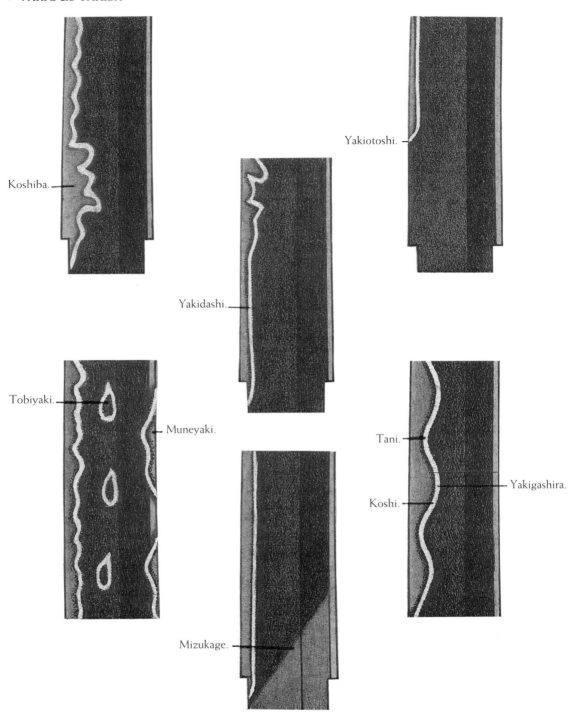

Koshiba.

Yakiotoshi.

Yakidashi.

Tobiyaki.

Muneyaki.

Tani.

Yakigashira.

Koshi.

Mizukage.

HATARAKI (ACTIVITY) WITHIN THE HAMON

Ashi: "Leg"; the thin line that runs across the hamon toward the cutting edge.

SOME CLASSIFICATIONS OF ASHI

Ko-ashi: small ashi.

Nezumi ashi: "Rat's leg"; very small ashi.

Choji ashi: Clove-shaped ashi.

Gunome ashi: Zigzag-shaped ashi.

Saka ashi: Slanting ashi.

Nioi kuzure: This may be considered a type of ashi, but it is separate from the main hamon line and appears scattered inside the hamon. It looks like tiny footprints. The term "nioi kuzure" is used after the late Sengoku period (late sixteenth century), although this feature is often seen in Sue-Bizen work. Prior to late Sengoku, the term "yo" ("leaf") is used.

Yakikuzure: A deformed part of the hamon with nie, usually seen in midareba.

Sunagashi: "Stream of sand." Consists of nie particles and resembles the marks left behind by a broom sweeping over sand. Usually appears inside the hamon near the ha-buchi, parallel to the cutting edge.

Nijuba: "Double." A second line of hamon, consisting of nie or nioi, drawn parallel to the main hamon. Triple lines of hamon are known as "sanjuba."

Uchinoke: Looks like short nijuba and resembles a crescent moon. Appears within the ji, near the habuchi.

Kuichigaiba: Lines of hamon which are not completely aligned, allowing for a gap between the tempered lines.

Kinsuji and inazuma: "Kinsuji" means "gold line," and "inazuma" means "lightning." Kinsuji is a short, straight, brilliant black line that appears inside the hamon, near the habuchi. Inazuma is a crooked line resembling a bolt of lightning. Both are comprised of nie, the only difference being in their shape. Chikei is a prominent black line appearing along the pattern of the jihada. Like kinsuji and inazuma, it is comprised of nie, but it is found on the ji.

Nie hotsure: "Frayed" nie. Nie seen along the habuchi, that looks like the edge of a frayed piece of cloth.

Nie sake: "Torn" nie. Bright, black nie are seen inside the rent, in a hamon which looks as if it has been torn apart. Similar to kuichigaiba, but shorter.

Hakikake: "Sweeping." Similar to sunagashi, but much shorter and thinner. Appears on the edge of the hamon.

● ACTIVITY IN THE YAKIBA

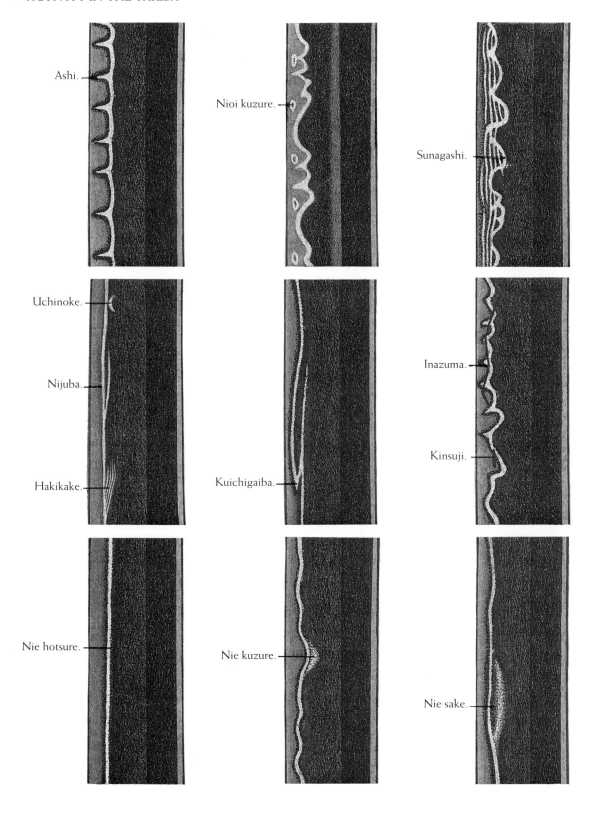

Ashi.

Nioi kuzure.

Sunagashi.

Uchinoke.

Nijuba.

Hakikake.

Kuichigaiba.

Inazuma.

Kinsuji.

Nie hotsure.

Nie kuzure.

Nie sake.

ATTRIBUTION BASED ON THE HAMON

Suguha

Suguha is the most popular type of hamon, seen in blades from every province and every period. It was especially popular with smiths of the Yamashiro and Yamato traditions.

Leading swordsmiths:
<Koto> The Awataguchi (粟田口) school produces abundant nie, with a narrow hamon; hoso suguha is relatively often seen in the tanto. Rai- (来) school (Kunitoshi [国俊], Kunimitsu [国光], Kunitsugu [国次], Kunizane [国真]) blades exhibit chu-suguha mixed with ko-midare. In Yamato- (大和) province schools, vertical hataraki, such as hakikake, nijuba, and kuichigaiba, appear in the hamon. Bizen- (備前) province schools basically tempered in nioi deki. Soshu- (相州) province schools produced abundant nie at the end of the Kamakura period, while the Sue-Soshu (末相州) school was inclined toward nioi deki. In addition, suguha is often seen in blades of the Mino- (美濃) province schools, Muramasa (村正), the Shimada (島田) school, the Uda (宇多) school, the Momokawa (桃川) school, the Mihara (三原) school, and the Enju (延寿) school. Less hataraki tends to be seen in the hamon of blades produced in later periods.

<Shinto> Suguha tempered in nie deki is seen in the work of the most famous swordsmiths (for instance, in tanto by Myoju and work by the Horikawa [堀川] school, Kotetsu [虎徹], Yasutsugu [康継], etc.). Sukehiro (助広) produced abundant ko-nie. Shinkai (真改) created larger nie with a pattern that undulates slightly. The Tadayoshi (忠吉) school tempered in a chu-suguha that is uniform in width from top to bottom. Shigekuni (重国) tempered in nijuba in the monouchi area. In blades by Kunikane (国包), hakikake is seen along the habuchi.

Suguha in nie deki

Leading swordsmiths:
<Koto> The Awataguchi (粟田口) school (Kuniyoshi [国吉], Yoshimitsu [吉光]), the Rai (来) school (Kunitoshi [国俊], Kunimitsu [国光], Mitsukane [光包], Kunizane [国真], Kuninaga [国長], Ryokai [了戒]), the Tegai (手掻) school, the Hosho (保昌) school, the Senjuin (千手院) school, the Taima (当麻) school, the Shikkake (尻懸) school, the Shintogo (新藤五) school (Kunimitsu [国光], Kunihiro [国広]), Yukimitsu (行光), the Shimada (島田) school, the Ko-Aoe (古青江) school (Yoshitsugu [吉次], Tsunetsugu [恒次], Suketsugu [助次]), the Ko-Mihara (古三原) school, the Ko-Nio (古二

王) school, Kagenaga (景長), the Miike (三池) school, the Enju (延寿) school (Kunimura [国村], Kunitoki [国時], Kuniyasu [国康], Kunisuke [国資]), the Naminohira (波平) school, etc.

<Shinto> Myoju (明寿), the Horikawa (堀川) school, Shinkai (真改), Sukehiro II (二代 助広), Shigekuni (重国), Yasutsugu (康継), Ogasawara Nagamune (小笠原長旨), Kunikane (国包), Yamashiro no Kami Kunikiyo (山城守国清), the Tadayoshi (忠吉) school, Yasuyo (安代), Naminohira Yasuchika (波平安周), Yasukuni (安国), etc.

<Shinshinto> Masahide (正秀), Naotane (直胤), Kiyondo (清人), Norikatsu (徳勝), Sadakazu (貞一), Aizu Kanesada (会津兼定), Sa Yukihide (左行秀), etc.

Suguha in nioi deki

Leading swordsmiths:
<Koto> Osafune (長船) school (Nagamitsu II [二代 長光], Kagemitsu [景光], Sanenaga [真長], Kagemasa [景政], Chikakage [近景]), the Oei-Bizen (応永備前) school (Morimitsu [盛光], Yasumitsu [康光]), the Sue-Bizen (末備前) school (Norimitsu [則光], Tadamitsu [忠光], Sukesada [祐定], Kiyomitsu [清光]), the Ukai (鵜飼) school, the Chu-Aoe (中青江) school (Tsugunao [次直], Tsuguyoshi [次吉], Moritsugu [守次]), the Sue-Tegai (末手掻) school, Zenjo Kaneyoshi (善定兼吉), the Sue-Seki (末関) school (Kanesada [兼定], Kaneyoshi [兼吉], Kanetsune [兼常]), the Sue-Mihara (末三原) school, the Sue-Nio (末二王) school, etc.

Suguha with wide nioiguchi

Leading swordsmiths:
<Koto> Go Yoshihiro (郷義弘), etc. Very rare in Koto blades.

<Shinto> Shinkai (真改), Sukehiro II (二代 助広), Sukenao (助直), Tadatsuna II (二代 忠綱), the Tadayoshi (忠吉) school.

<Shinshinto> Yukihide (行秀), etc.

Suguha with hazy nioiguchi

Leading swordsmiths:
<Koto> Bungo Yukihira (豊後行平), the Gassan (月山) school, the Hoju (宝寿) school, Sairen (西蓮), Jitsua (実阿), the Naminohira (波平) school, etc. Also found on blades of local swordsmiths.

Suguha mixed with fushi (knob) or togari-ba

Seen mainly in the work of Mino-den smiths.

Leading swordsmiths:
<Koto> The Sue-Seki (末関) school, Zenjo Kaneyoshi (善定兼吉), the Takada (高田) school, etc.

<Shinto> Ogasawara Nagamune (小笠原長旨), Onizuka Yoshikuni (鬼塚吉国), etc.

Suguha with nijuba, uchinoke, and hakikake

Seen mainly in the works of Yamato-den.

Leading swordsmiths:
<Koto> The Awataguchi (粟田口) school, the Hosho (保昌) school, the Tegai (手掻) school, the Taima (当麻) school, the Naminohira (波平) school, etc.

<Shinto> Etchu no Kami Masatoshi (越中守正俊), Shigekuni (重国), Kunikane (国包), etc.

<Shinshinto> Norichika (徳鄰), Norikatsu (徳勝), etc.

Suguha mixed with kuichigaiba

Leading swordsmiths:
<Koto> Rai Kunitsugu (来国次), the Taima (当麻) school, the Tegai (手掻) school, the Hosho (保昌) school, etc.

<Shinto> Kunikane (国包), Shigekuni (重国), the Echizen Yasutsugu (越前康継) school, Tadayoshi I (初代 忠吉), etc.

Suguha with nezumi ashi or saka ashi

Leading swordsmiths:
<Koto> The Rai (来) school (Kunimitsu [国光], Ryokai [了戒]), the Ko-Osafune (古長船) school (Kagemitsu [景光], Sanenaga [真長], Chikakage [近景]), Motoshige (元重), Yasumitsu (康光), the Ukai (鵜飼) school, the Aoe (青江) school, the Akasaka Senjuin (赤坂千手院) school, Hiromasa (広正), etc.

Suguha with gunome ashi

Found mainly on the blades of the Shinto tokuden.

Leading swordsmiths:
<Shinto> Kotetsu (虎徹), Kaneshige (兼重), the Hojoji (法城寺) school, Echizen Seki (越前関) school, etc.

<Shinshinto> Sa Yukihide (左行秀), etc.

Notare

Seen after the end of the Kamakura period, mainly on blades of Soshu-province schools and their related schools.

Ko-notare

Leading swordsmiths:
<Koto> Soshu Sadamune (相州貞宗), Nobukuni (信国), Rai Tomokuni (来倫国), the Kanemitsu (兼光) school (Kanemitsu II (二代 兼光), Tomomitsu [倫光], Masamitsu [政光], Yoshikage [義景]), Omiya Morikage (大宮盛景), the Kozori (小反) school, the Samonji (左文字) school, etc.

<Shinto> Yasutsugu (康継), Kotetsu (虎徹), Okimasa (興正), Yamato no Kami Yasusada (大和守安定), Yasutomo (安倫), Masatsune (政常), Teruhiro (輝広), Hizen Tadayoshi (肥前忠吉), Yasuyo (安代), etc.

O-notare

Leading swordsmiths:
<Koto> Heianjo Nagayoshi (平安城長吉), the Sue-Bizen (末備前) school (Norimitsu [則光], Sukesada [祐定], Kiyomitsu [清光], Izumi no Kami Kanesada (和泉守兼定), Ujifusa (氏房), Muramasa (村正), Tsunahiro (綱広), Fuyuhiro (冬広), the Shimada (島田) school, the Uda (宇多) school, etc.

<Shinto> Myoju (明寿), the Horikawa (堀川) school, Masatoshi (正俊), Shinkai (真改), Echizen no Kami Sukehiro (越前守助広), Omi no Kami Sukenao (近江守助直), Shigekuni (重国), Yasutsugu (康継), Yasusada (安定), Sadakuni (貞国), Masatsune (政常), Nobutaka (信高), Daido (大道), Teruhiro (輝広), the Tadayoshi (忠吉) school, etc.

Notare midare

Leading swordsmiths:
<Koto> The Masamune (正宗) school (Yukimitsu [行光], Masamune [正宗], Sadamune [貞宗]), Shizu Kaneuji (志津兼氏), Norishige (則重), Go Yoshihiro (郷義弘), Heianjo Nagayoshi (平安城長吉), the Samonji (左文字) school, the Kanemitsu (兼光) school, the Sue-Bizen (末備前) school (Sukesada [祐定], Kiyomitsu [清光], Tsunahiro (綱広), the Shimada (島田) school, the Sengo (千子) school (Muramasa [村正], Masashige [正重]), the Fujishima (藤島) school, the Takada (高田) school, etc.

<Shinto> The Horikawa (堀川) school, Masatoshi (正俊), Kunisada (国貞), Shinkai (真改), the Echizen Seki (越前関) school, Kanewaka (兼若), Teruhiro (輝広), the Mizuta (水田) school, Masafusa (正房), Masakiyo (正清), etc.

<Shinshinto> Naotane (直胤), Masayoshi (正幸), Motohira (元平), etc.

Gunome

Commonly seen in swords of the Mino-den and Shinto tokuden.

Ko-gunome

Leading swordsmiths:

<Koto> The Yoshii (吉井) school, the Kozori (小反) school, the Shikkake (尻懸) school, the Sue-Seki (末関) school, the Shimada (島田) school, the Fujishima (藤島) school (Yukimitsu [行光], Kiyomitsu [清光]), Akikuni (顕国), the Takada (高田) school, etc.

<Shinshinto> Tomotaka (朝尊), the Suishinshi (水心子) school, Munetsugu (宗次), Hamabe Toshinori (浜部寿格), etc.

O-gunome

Leading swordsmiths:

<Koto> Kanesada (兼定), Ujisada (氏房), the Sengo (千子) school (Muramasa [村正], Masashige [正重]), Tsunahiro (綱広), the Shimada (島田) school, etc.

<Shinto> Masatoshi (正俊), Kuniyasu (国安), Kunisada (国貞), Yasutsugu (康継), Kotetsu (虎徹), the Hojoji (法城寺) school, Yamato no Kami Yasusada (大和守安定), Kaneshige (兼重), the Mizuta (水田) school, Masafusa (正房), Masakiyo (正清), etc.

<Shinshinto> The Suishinshi (水心子) school, Suketaka (助隆), Motohira (元平), Hoki no Kami Masayoshi (伯耆守正幸), etc.

Gunome midare

Leading swordsmiths:

<Koto> Nobukuni (信国), Chogi (長義), the Samonji (左文字) school, the Shizu (志津) school, Naotsuna (直綱), Tametsugu (為継), the Uda (宇多) school, the Takada (高田) school, etc.

<Shinto> The Horikawa (堀川) school, the Mishina (三品) school, Mutsu no Kami Kaneyasu (陸奥守包保), Yasutsugu (康継), the Mizuta (水田) school, Munehide (宗栄), Tadayoshi I (初代 忠吉), Hizen Masahiro (肥前正広), Hizen Yukihiro (肥前行広), etc.

<Shinshinto> The Suishinshi (水心子) school, the Kiyomaro (清麿) school, etc.

Regularly-spaced gunome midare

Leading swordsmiths:

<Koto> The Yoshii (吉井) school, the Sue-Seki (末関) school (Kanemoto [兼元], Kanefusa [兼房]), Muramasa (村正), etc.

<Shinto> Katsukuni (勝国), Kotetsu (虎徹), Kaneshige (兼重), the Hojoji (法城寺) school, Nagamichi (長道), etc.

Gunome midare based on notare

Leading swordsmiths:

<Koto> The Masamune (正宗) school (Masamune [正宗], Sadamune [貞宗]), Shizu Kaneuji (志津兼氏), the Samonji (左文字) school, Chogi (長義), Kanemitsu (兼光), Go Yoshihiro (郷義弘), Nobukuni (信国), Naotsuna (直綱), etc.

<Shinto> The Horikawa (堀川) school, the Mishina (三品) school, Kaneyasu II (二代 包保), Yasutsugu (康継), Kotetsu (虎徹), Hankei (繁慶), Munehide (宗栄), Tadayoshi I (初代 忠吉), Tadahiro II (二代 忠広), Tadayoshi III (三代 忠吉), Hizen Masahiro (肥前正広), Hizen Yukihiro (肥前行広), etc.

<Shinshinto> Naotane (直胤), Hosokawa Masayoshi (細川正義), Kiyomaro (清麿), Nobuhide (信秀), Yukihide (行秀), etc.

Kataochi gunome

Mainly seen in swords of the Bizen-den.

Leading swordsmiths:

<Koto> The Ko-Osafune (古長船) school (Kagemitsu [景光], Chikakage [近景]), the Kanemitsu (兼光) school (Tomomitsu [倫光], Yoshimitsu [義光]), Motoshige (元重), etc.

<Shinto> Very rare in Shinto-era blades.

<Shinshinto> Masahide (正秀), Naotane (直胤), Naokatsu (直勝), Munetsugu (宗次), Sokan (宗寛), Sadakazu (貞一), etc.

Gunome mixed with togari-ba

Mainly seen in swords of the Mino-den.

Leading swordsmiths:

<Koto> Kaneuji (兼氏), the Naoe Shizu (直江志津) school, the Sue-Seki (末関) school, the Shimada (島田) school, the Sue-Soshu (末相州) school, Muramasa (村正), etc.

<Shinto> Kinmichi (金道), Masatoshi (正俊), Kunimichi (国路), the Echizen Seki (越前関) school, Aizu Kanesada (会津兼定), Masafusa (正房), Mondo no Sho Masakiyo (主水正正清), etc.

Sanbon-sugi

Mainly seen in blades of the Mino-den.

Leading swordsmiths:

<Koto> Mainly seen in the work of Kanemoto (兼元). Kanemoto II (二代 兼元) produced a less regular sanbon-sugi, with the top of the hamon inclined to be rounded. However, his followers created a more regular pattern, with the nioiguchi distinctly tightened.

This same style is also seen in the work of Muramasa (村正), the Sue-Soshu (末相州) school (Yasuharu [康春], Yasukuni [康国]), the Shitahara (下原) school, etc.

Gunome choji
Mainly seen in swords of the Mino-den.

Leading swordsmiths:
<Koto> The Sue-Seki (末関) school (Kanefusa [兼房], Kanesada [兼定], Kanetsune [兼常]), etc.

<Shinto> Jumyo (寿命), the Echizen Seki (越前関) school, Aizu Kanesada (会津兼定), Omura Kaboku (大村加卜), etc.

Gunome midare mixed with hako midare
Mainly seen in swords of the Mino-den.

Leading swordsmiths:
<Koto> The Sue-Seki (末関) school (Kanesada [兼定], Kanefusa [兼房], Ujifusa [氏房]), the Sengo (千子) school (Muramasa [村正], Masashige [正重]), the Shimada (島田) school, Tsunahiro (綱広), etc.

<Shinto> Yasutsugu (康継), Kotetsu (虎徹), Yamato no Kami Yasusada (大和守安定), Kanewaka (兼若), Takahira (高平), Masanori (正則), the Mizuta (水田) school, Masafusa (正房), etc.

Gunome midare mixed with yahazu midare
Mainly seen in swords of the Mino-den.

Leading swordsmiths:
<Koto> The Sue-Seki (末関) school (Kanesada [兼定], Kanetsune [兼常]), Muramasa (村正), Heianjo Nagayoshi (平安城長吉), Tsunahiro (綱広), etc.

<Shinto> The Echizen Seki (越前関) school, Kanewaka (兼若), Nobutaka (信高), Teruhiro (輝広), etc.

Uma-no-ha midare
Mainly seen in swords of the Soshu-den from all periods.

Leading swordsmiths:
<Koto> The Masamune (正宗) school (Yukimitsu [行光], Masamune [正宗], Hiromitsu [広光], Akihiro [秋広]), Go Yoshihiro (郷義弘), Norishige (則重), Shizu Kaneuji (志津兼氏), the Hasebe (長谷部) school, etc.

<Shinto> Hankei (繁慶), Okimasa (興正), Kunihiro (国広), Kunimichi (国路), the Mizuta (水田) school, Mondo no Sho Masakiyo (主水正正清), etc.

<Shinshinto> The Kiyomaro (清麿) school, Motohira (元平), etc.

Koshi-no-hiraita midare
Mainly seen in swords of the Bizen-den.

Leading swordsmiths:
<Koto> The Sue-Bizen (末備前) school (Norimitsu [則光], Katsumitsu [勝光], Munemitsu [宗光], Sukesada [祐定], Kiyomitsu [清光], Harumitsu [春光]), the Uda (宇多) school, the Kanabo (金房) school, Kashu Kiyomitsu (加州清光), Koga (広賀) (or Hiroyoshi), the Takada (高田) school, etc.

<Shinto> Ishido Tameyasu (石堂為康), Tatara Nagayuki (多々良長幸), Sukesada (祐定), etc.

<Shinshinto> Naotane (直胤), Munetsugu (宗次), Tsunatoshi (綱俊), Sadayoshi (貞吉), Sadakazu (貞一), etc.

Koshi-no-hiraita midare mixed with choji midare

Leading swordsmiths:
<Koto> Chogi (長義), the Oei-Bizen (応永備前) school (Morimitsu [盛光], Yasumitsu [康光], Moromitsu [師光]), Norimitsu (則光), Tsuneie (経家), Iesuke (家助), etc.

<Shinshinto> Masahide (正秀), Naotane (直胤), Hosokawa Masayoshi (細川正義), Tsunatoshi (綱俊), etc.

Choji midare
Mainly seen among swords of the Bizen-den.

Ko-choji midare

Leading swordsmiths:
<Koto> Ayanokoji Sadatoshi (綾小路定利), the Awataguchi (粟田口) school (Kunitomo [国友], Kunitsuna [国綱]), the Ko-Bizen (古備前) school (Tomonari [友成], Masatune [正恒], Kanehira [包平]), the Ko-Ichimonji (古一文字) school, the Ko-Osafune (古長船) school (Nagamitsu [長光], Chikakage [近景], Kagemitsu [景光]), Kunimune (国宗), the Ko-Aoe (古青江) school, etc.

<Shinto> Ishido Korekazu (石堂是一), Tsunemitsu (常光), Mitsuhira (光平), etc.

<Shinshinto> Masahide (正秀), Naotane (直胤), Hosokawa Masayoshi (細川正義), Nobuhide (信秀), Tomotaka (朝尊), Sadakazu (貞一), Kawamura Toshitaka (河村寿隆), Sukenaga (祐永), Sukekane (祐包), Toshinori (寿格), etc.

O-choji midare and juka-choji midare
Leading swordsmiths:
<Koto> The Awataguchi (粟田口) school (Kuniyasu [国安], Kunitsuna [国綱]), Sanjo Yoshiie (三条吉家), the Fukuoka Ichimonji (福岡一文字) school (Yoshifusa [吉

房], Sukezane [助真], Yoshihira [吉平], Norifusa [則房], Sukefusa [助房]), Moriie (守家), Kunimune (国宗), the Ko-Osafune (古長船) school (Mitsutada [光忠], Nagamitsu [長光], Kagehide [景秀]), the Rai (来) school (Kuniyuki [国行], Niji Kunitoshi [二字国俊]), Izumi no Kami Kanesada (和泉守兼･), etc.

<Shinto> Tatara Nagayuki (多々良長幸), Yamato no Kami Yoshimichi (大和守吉道), Tameyasu (為康), Korekazu (是一), Mitsuhira (光平), Tsunemitsu (常光), Koretsugu (是次), Hatakeda Moritsugu (畠田守次), etc.

<Shinshinto> Naotane (直胤), Tsunatoshi (綱俊), Munetsugu (宗次), Tomotaka (朝尊), Sadakazu (貞一), etc.

Choji midare with kawazuko choji
Leading swordsmiths:
<Koto> Mitsutada (光忠), Moriie (守家), Sukezane (助真), etc.

<Shinto> Ishido Korekazu (石堂是一), Tsunemitsu (常光), Mitsuhira (光平), Tatara Nagayuki (多々良長幸), etc.

<Shinshinto> Naotane (直胤), Tomotaka (朝尊).

Suguha-choji midare
Leading swordsmiths:
<Koto> The Rai (来) school (Kuniyuki [国行], Niji Kunitoshi [二字国俊]), the Ko-Bizen (古備前) school (Masatsune [正恒], Yoshikane [吉包], Tsunetsugu [恒次]), Kunimune (国宗), the Ko-Osafune (古長船) school (Nagamitsu [長光], Kagemitsu [景光], Chikakage [近景]), etc.

<Shinto> The Tadayoshi (忠吉) school, etc.

Saka-choji midare
Leading swordsmiths:
<Koto> The Katayama Ichimonji (片山一文字) school, the Chu-Aoe (中青江) school (Tsugunao [次直], Tsuguyoshi [次吉], Moritsugu [守次]), etc. Niji Kunitoshi (二字国俊) also sometimes mixed this into his hamon.

<Shinto> The Fukuoka Ishido (福岡石堂) school, the Kishu Ishido (紀州石堂) school, etc.

<Shinshinto> Naotane (直胤), Tsunatoshi (綱俊), Munetsugu (宗次), Tomotaka (朝尊), Sadakazu (貞一), etc.

Kobushigata-choji midare
Leading swordsmiths:
<Koto> This style did not appear until after Koto times, but a similar style can be found very occasionally in work of Katsumitsu (勝光), Sukesada (祐定), the Takada (高田) school, etc.

<Shinto> Kunisuke II (二代 国助), Kunisuke III (三代 国助), Yamato no Kami Yoshimichi (大和守吉道), Higo no Kami Kuniyasu (肥後守国康), etc.

<Shinshinto> Sukekane (祐包), Sukenaga (祐永), Toshinori (寿格), etc.

Choji midare with long ashi
Found only on Shinto blades.

Leading swordsmiths:
<Shinto> Tadatsuna I (初代 忠綱), Tadatsuna III (三代 忠綱), Nagatsuna (長綱), Tatara Nagayuki (多々良長幸), Yamato no Kami Yoshimichi (大和守吉道), Higo no Kami Kuniyasu (肥後守国康), the Tadayoshi (忠吉) school, etc.

Choji midare in nie deki
Leading swordsmiths:
<Koto> Yamashiro- (山城) province schools, the Ko-Bizen (古備前) school, the Ko-Aoe (古青江) school, etc. Choji midare tending toward nie deki is often seen in blades of the Ko-Ichimonji (古一文字) school, Sukezane (助真), Kunimune (国宗), etc.

<Shinto> The Tadayoshi (忠吉) school, etc.

<Shinshinto> Unju Korekazu (運寿是一), etc.

Ko-midare
Leading swordsmiths:
<Koto> The Sanjo (三条) school (Munechika [宗近], Kanenaga [兼永], Kuninaga [国永]), Sadayoshi (貞吉), the Awataguchi (粟田口) school (Hisakuni [久国], Kunikiyo [国清], Kuniyasu [国安], Kunitsuna [国綱]), Rai Kuniyuki (来国行), the Senjuin (千手院) school, Tegai Kanenaga (手掻包永), Shikkake Norinaga (尻懸則長), Ryumon Nobuyoshi (龍門延吉), Chikakage (近景), Kunimune (国宗), the Ukai (鵜飼) school, the Kanemitsu (兼光) school (Motomitsu [基光], Masamitsu [政光]), Hidemitsu (秀光), the Omiya (大宮) school, the Yoshii (吉井) school, Yasumitsu (康光), the Hoju (宝寿) school, the Gassan (月山) school, the Uda (宇多) school, the Fujishima (藤島) school, the Ohara (大原) school (Yasutsuna [安綱], Sanemori [真守], Aritsuna [有綱]), the Ko-Aoe (古青江) school (Moritsugu [守次], Sadatsugu [貞次], Suketsugu [助次], Yasutsugu [康継], Tsunetsugu [恒次]), Bungo Yukihira (豊後行平), Takada Tomoyuki (高田友行), the Enju (延寿) school, the Naminohira (波平) school, etc.

<Shinto> Myoju (明寿), Kunihiro (国弘), Aizu Nagakuni (会津長国), Aizu Masanaga (会津政長), etc.

<Shinshinto> Masahide (正秀), Naotane (直胤), etc.

Ko-midare based on suguha

Mainly seen on swords of the Yamashiro-den and Yamato-den.

Leading swordsmiths:
<Koto> The Sanjo (三条) school, the Awataguchi (粟田口) school, the Rai (来) school, Ryokai (了戒), Nobukuni (信国), the Tegai (手掻) school, the Shikkake (尻懸) school, the Senjuin (千手院) school, the Ko-Bizen (古備前) school, the Ko-Uda (古宇多) school, the Ukai (鵜飼) school, the Takada (高田) school, etc.

<Shinshinto> Masahide (正秀), Naotane (直胤), etc.

Ko-midare with saka ashi

Leading swordsmiths:
<Koto> The Aoe (青江) school, the Ko-Osafune (古長船) school (Kagemitsu [景光], Chikakage [近景]), the Shochu Ichimonji (正中一文字) school, the Kanemitsu (兼光) school (Tomomitsu [倫光], Masamitsu [政光], the Motomitsu [基光]), the Motoshige [元重] school (Motoshige [元重], Shigezane [重真]), the Ukai (鵜飼) school, the Oei-Bizen (応永備前) school (Morimitsu (盛光), Yasumitsu (康光), Iesuke [家助]), etc.

<Shinto> Korekazu (是一), Tsunemitsu (常光), Mitsuhira (光平), Yorisada (頼貞), etc.

<Shinshinto> Masahide (正秀), Naotane (直胤), Naokatsu (直勝), Sadakazu (貞一), etc.

O-midare

Mainly seen on swords of the Soshu-den.

Leading swordsmiths:
<Koto> The Hasebe (長谷部) school, Nobukuni (信国), the Kanabo (金房) school, the Chogi (長義) school, the Masamune (正宗) school (Masamune [正宗], Hiromitsu [広光], Akihiro [秋広]), Kaneuji (兼氏), the Naoe Shizu (直江志津) school, the Dotanuki (同田貫) school, the Uda (宇多) school, Fuyuhiro (冬広), the Samonji (左文字) school, Muramasa (村正), the Sue-Seki (末関) school, etc.

<Shinto> The Horikawa (堀川) school, the Mishina (三品) school, Terukane (照包), Kuniteru (国輝), Kaneyasu II (二代 包保), Yasutsugu (康継), Yasusada (安定), Ujifusa (氏房), Masafusa (正房), Masakiyo (正清), etc.

<Shinshinto> Masahide (正秀), Naotane (直胤), Kiyomaro (清麿), Motohira (元平), Hoki no Kami Masayoshi (伯耆守正幸), etc.

Saka midare

Leading swordsmiths:
<Koto> Motoshige (元重), the Chu-Aoe (中青江) school (Tsugunao [次直], Tsuguyoshi [次吉], Moritsu-

gu [守次]), etc. Very occasionally seen in Rai Kunimitsu (来国光).

<Shinto> Tatara Nagayuki (多々良 長幸), Korekazu (是一), Tsunemitsu (常光), Mitsuhira (光平), Sukesada (祐定), etc. Very occasionally the Chikuzen Nobukuni (筑前信国) school.

<Shinshinto> Naotane (直胤), Naokatsu (直勝), Munetsugu (宗次), Sokan (宗寛), Sadakazu (貞一), etc.

Hitatsura

Mainly seen in the blades of the Soshu-den.

Leading swordsmiths:
<Koto> The Masamune (正宗) school (Hiromitsu [広光], Akihiro [秋広]), the Sue-Soshu (末相州) school, the Hasebe (長谷部) school (Kunishige [国重], Kuninobu [国信], Kunihira [国平]), Nobukuni (信国), the Shimada (島田) school (Yoshisuke [義助], Hirosuke [広助], Sukemune [助宗]), Muramasa (村正), the Sue-Seki (末関) school, the Sue-Bizen (末備前) school, the Uda (宇多) school (Kunimune [国宗], Kunimitsu [国光]), Koga (広賀) (or Hiroyoshi), the Takada (高田) school, etc.

<Shinto> Etchu no Kami Masatoshi (越中守正俊), Yoshihira (美平), the Mizuta (水田) school, followers of Koga (広賀), followers of Tsunahiro (綱広), Yasutsugu (康継), etc.

<Shinshinto> Naotane (直胤), Masahide (正秀), Hosokawa Masayoshi (細川正義), Nobuhide (信秀), Tomotaka (朝尊), Sadakazu (貞一), etc.

Toran midare

Seen only in blades of the Shinto tokuden.

Leading swordsmiths:
<Shinto> Sukehiro II (二代 助広), Sukenao (助直), Echigo no Kami Kanesada (越後守包貞), Terukane (照包), Tadatsuna II (二代 忠綱), Tsutsui Kiju (筒井紀充), Tegarayama Ujishige (手柄山氏重), etc.

<Shinshinto> Masahide (正秀), Suketaka (助隆), Kato Tsunahide (加藤綱英), Masashige (正繁), Norichika (徳鄰) (or Tokurin), etc.

Sudare-ba

One of the patterns of the Shinto tokuden which is never seen in Koto blades.

Leading swordsmiths:
<Shinto> Followers of Tanba no Kami Yoshimichi (丹波守吉道), Yamato no Kami Yoshimichi (大和守吉道), etc.

Representational, or picturesque, hamon

Representational hamon styles include scenes of Yoshino, Tatsuta, Fuji, etc., all of which are specific to the Shinto tokuden tradition.

Leading swordsmiths:

<Shinto> Followers of Tanba no Kami Yoshimichi (丹波守吉道), followers of Yamato no Kami Yoshimichi (大和守吉道), followers of Kunisuke (国助), etc.

<Shinshinto> Hamabe Toshinori (浜部寿格), Toshizane (寿実), Tenryushi Masataka (天隆子正隆), Sadakazu (貞一), the Yokoyama Sukenaga (横山祐永) school, etc.

Hamon the two sides of which are notably different

Leading swordsmiths:

<Koto> Tegai Kanenaga (手掻包永), the Uda (宇多) school, the Takada (高田) school, etc.

<Shinto> The Mishina (三品) school, Echizen- (越前) province swords, etc.

Hamon the top and bottom of which are notably different

Leading swordsmiths:

<Koto> The Sengo (千子) school (Muramasa [村正], Masazane [正真]), the Sue-Seki (末関) school, the Sue-Bizen (末備前) school, etc.

Hamon with koshiba in the bottom area

Leading swordsmiths:

<Koto> Awataguchi Kunitsuna (粟田口国綱), the Sengo (千子) school (Muramasa [村正], Masazane [正真]), Samonji (左文字), etc. Very occasionally the Ko-Bizen (古備前) school, the Ichimonji (一文字) school, Nagamitsu (長光), Moriie (守家), etc.

Hamon with gunome in the bottom area

Leading swordsmiths:

<Koto> Awataguchi Yoshimitsu (粟田口吉光), Heian-jo Nagayoshi (平安城長吉), the Sengo (千子) school (Muramasa [村正], Masashige [正重]), the Sue-Seki (末関) school (Kanesada [兼定], Kanemoto [兼元], Kanetsune [兼常]), Sukesada (祐定), Sukemitsu (祐光), etc.

Hamon the start of which, under the hamachi, is wider than the upper area

Leading swordsmiths:

<Koto> The Shintogo (新藤五) school (Kunimitsu [国光], Kunihiro [国弘], Yukimitsu [行光]), Rai Kunitoshi (来国俊), Samonji (左文字), etc.

<Shinto> The Horikawa (堀川) school (Kunihiro [国弘], Masahiro [正広], Kuniyasu [国安]), Musashi Taro Yasukuni (武蔵太郎安国), etc.

Hamon with suguha yakidashi

Seen only in Shinto blades. The yakidashi (start of the hamon) of blades from the Koto and Shinshinto periods is almost always midare when the rest of the hamon is midare-ba, but Shinto and Shinshinto blades made in the Shinto tokuden style often have a suguha yakidashi.

Leading swordsmiths:

<Shinto> The Horikawa (堀川) school, the Mishina (三品) school, Sukehiro (助広), Echigo no Kami Kanesada (越後守包貞), Sukenao (助直), Shinkai (真改), Terukane (照包), Tadatsuna (忠綱), Kunisuke (国助), Kotetsu (虎徹), Okimasa (興正), etc.

Yakiotoshi

Leading swordsmiths:

<Koto> Sanemori (真守), the Naminohira (波平) school, the Yasutsuna (安綱) school, Yukihira (行平), Takada Tokiyuki (高田時行), Miike Denta (三池典太), etc.

Muneyaki

Leading swordsmiths:

<Koto> The Rai (来) school (Kuniyuki [国行], Niji Kunitoshi [二字国俊], Kunitoshi [国俊], Kunimitsu [国光]), the Ichimonji (一文字) school, Kagehide (景秀), Go Yoshihiro (郷義弘), the Takada (高田) school, etc.

<Shinto> The Mizuta (水田) school, Kanewaka (兼若), Ise no Daijo Tsunahiro (伊勢大掾綱広), etc.

Mizukage

Often seen on very old swords from before the start of the Kamakura period. It is usually seen on the blades of Horikawa Kunihiro (堀川国弘), and is one of the identifying characteristics of his works. In addition, it appears on swords with retempered edges.

BOSHI

The hamon of the kissaki is called the boshi (literally, "hat"). The tip of a blade is often said to have as rich a variety of expressions as a human face. The quenching of the boshi requires considerably more skill than any other part of the process, and the quality of the boshi is a clear indicator of the skill and identifying characteristics of the swordsmith.

The kaeri is the part of the hamon which extends from the tip of the boshi to the mune. There are several adjectival terms used to describe kaeri, depending on the shape—long, short, straight, irregular, and so on. The end of the kaeri is known as the tome (stop), and this is described as steep or gentle.

The boshi is also described by its shape, with the following terms. (Note: It is useful to bear in mind that the patterns of the boshi and the hamon are nearly identical in Koto and Shinshinto blades. This is not true, however, of Shinto work.)

Ko-maru: "Small circle." This boshi runs from the yokote parallel to the cutting edge of the kissaki. The top curves around and then turns back toward the mune, describing an arc.

Ko-maru agari: "Rising small circle." The top of the rounded part is close to the tip of the kissaki. The upper area of the boshi temper line is narrower than the lower part.

Ko-maru sagari: "Descending small circle." The top of the ko-maru is some distance from the tip of the kissaki. The upper area of the temper line is wider than the lower part of the boshi.

Ichimonji kaeri: a straight, horizontal turn-back. The top of the boshi is flattened off level, and the kaeri is short.

Sansaku boshi: "Sansaku" means three swordsmiths, and this term refers to the particular boshi seen in work of Osafune Nagamitsu, Kagemitsu, and Sanenaga. It is a type of ko-maru; the suguha temper line continues straight across the yokote into the boshi, the ko-maru of which starts above the yokote.

Yakitsume: Without turn-back. The boshi continues directly to the mune. There are two patterns, sugu (straight) and midare komi (irregular).

Midare komi: In this type, the irregular pattern of the hamon continues into the kissaki. The type of kaeri differs from one sword to another.

Choji midare komi: A choji midare hamon pattern which continues into the kissaki.

O-maru: Large semi-circle. The width of the boshi is much narrower than in the ko-maru style. The top sweeps around and turns back toward the mune in a large arc.

Jizo: Jizo refers to statues of the priest Jizo, whose profile this boshi resembles. The boshi is sharply constricted about halfway up, and has a rounded top.

Kaen: Flame. This boshi almost looks as if it were on fire, due to hakikake and the activity of nie.

Ichimai: A fully-tempered kissaki. In most cases, however, part of the outline of the boshi is still discernible in the kissaki.

Mishina boshi: The boshi typically produced by the Mishina school. The line of the boshi runs straight from the yokote to the top. The top inclines toward a point, and the kaeri is slightly wider than usual.

Nie kuzure: literally, "nie break." Abundant nie are scattered throughout the kissaki, and as a result, the boshi is not distinctly formed.

Notare komi: Similar in shape to a portion of the notare of the hamon. The line of the boshi sags halfway down.

● TYPES OF BOSHI

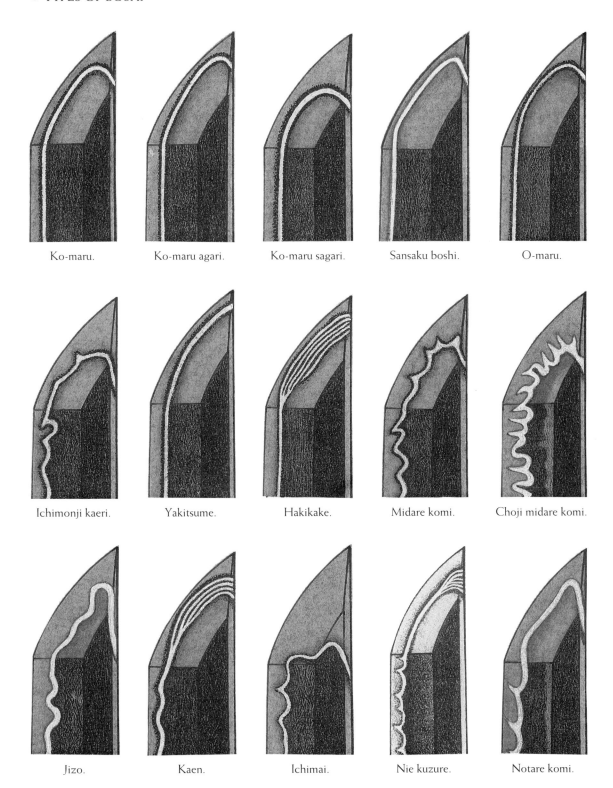

Ko-maru.

Ko-maru agari.

Ko-maru sagari.

Sansaku boshi.

O-maru.

Ichimonji kaeri.

Yakitsume.

Hakikake.

Midare komi.

Choji midare komi.

Jizo.

Kaen.

Ichimai.

Nie kuzure.

Notare komi.

 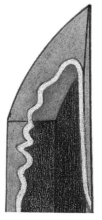

| Kaeri yoru (wide turn-back). | Kaeri katai (steep turn-back). | Kaeri fukai (long turn-back). |

ATTRIBUTION BASED ON THE BOSHI

Standard ko-maru

Leading swordsmiths:
<Koto> The Awataguchi (粟田口) school, the Rai (来) school , Ko-Bizen Masatsune (古備前正恒), the Sue-Bizen (末備前) school, Tadamitsu (忠光), Tosa Yoshimitsu (土佐吉光), the Enju (延寿) school, etc.

<Shinto> Suguha with ko-maru is seen primarily in Shinto blades. Shigekuni (重国), the Tadayoshi (忠吉) school, Kuniteru (国輝), Ishido (石堂) school (except Nagayuki [長幸]), Kotetsu (虎徹), Okimasa (興正), the Hojoji (法城寺) school, Kaneshige (兼重), Darani Katsukuni (陀羅尼勝国), Kanewaka (兼若), etc.

<Shinshinto> Tadayoshi VIII (八代 忠吉), Yukihide (行秀), Sadakazu (貞一), etc.

Ko-maru agari

Leading swordsmiths:
<Shinto> Yamashiro-province swords. Kotetsu (虎徹), etc.

Ko-maru sagari

Rarely seen in Koto blades, except at the end of the Muromachi period.

Leading swordsmiths:
<Koto> Tadamitsu (忠光), Sukesada (祐定), Ko-Bizen Masatsune (古備前正恒), etc.

<Shinto> Mainly seen in Osaka- (Settsu province) swords. Sukehiro II (二代 助広), Sukenao (助直), Tadatsuna II (二代 忠綱), Echigo no Kami Kanesada (越後守包貞), Terukane (照包), Shinkai (真改), Kuniteru (国輝),

Kuniyasu II (二代 国安), the Hojoji (法城寺) school, Kaneshige (兼重), Tsuguhira (継平), Miyoshi Nagamichi (三善長道), Sasaki Ippo (佐々木一峯), Echizen Shigetaka (越前重高), Masanori (正則), Sadatsugu (貞次), Sukesada (祐定), the Takada (高田) school, Onizuka Yoshikuni (鬼塚吉国), etc.

<Shinshinto> Tegarayama Masashige (手柄山正繁), Masahide (正秀), Suketaka (助隆), Yukihide (行秀), etc. Seen in swords produced in imitation of Osaka Shinto blades.

Sansaku boshi

Leading swordsmiths:
<Koto> Typical sansaku boshi can be seen in the work of Osafune Nagamitsu (長船長光), Kagemitsu (景光), Sanenaga (真長). A similar style is seen in the work of Chikakage (近景), Tomonari (友成) (inclined toward nijuba), and the Aoe (青江) school. In Aoe, the top tends to be pointed.

Mishina boshi

Leading swordsmiths:
<Shinto> Typical Mishina boshi can be seen in work of the Mishina (三品) school. A similar type is seen in blades by Kunimichi (国路), Kunitomo (国儔), Yasutsugu (康継), Kanewaka (兼若), etc.

O-maru

Leading swordsmiths:
<Koto> The Rai (来) school (Kuniyuki [国行], Niji Kunitoshi [二字国俊], Kunimitsu [国光], Ryokai [了戒]),

Shintogo Kunimitsu (新藤五国光), Suketsuna (助綱), Kunimune (国宗), Motoshige (元重), the Ko-Aoe (古青江) school, Kaneuji (兼氏), Kagenaga (景長), Bungo Yukihira (豊後行平), Sadahide (定秀), the Miike (三池) school, the Enju (延寿) school, Tomoyuki (友行), the Naminohira (波平) school, etc.

<Shinto> The boshi of blades produced in Shinto times was usually relatively wide, so o-maru work from this period is rare.

Ichimonji kaeri

Leading swordsmiths:
<Koto> The Aoe (青江) school, Go Yoshihiro (郷義弘), Zenjo Kaneyoshi (善定兼吉), etc.

Yakitsume

Leading swordsmiths:
<Koto> This style has been produced in every province since the earliest period of the Japanese sword, though it is found mainly among the work of Yamato smiths and related schools. It is rare among the blades of the Soshu and Bizen schools. Due to the reshaped curve, yakitsume in nagamaki naoshi (reformed or remade nagamaki) is common.

The Sanjo (三条) school, the Awataguchi (粟田口) school, the Rai (来) school, the Tegai (手掻) school, the Taima (当麻) school, the Hosho (保昌) school, the Shikkake (尻懸) school, the Ko-Bizen (古備前) school, the Ichimonji (一文字) school, the Uda (宇多) school, the Momokawa (桃川) school, the Gassan (月山) school, the Enju (延寿) school, the Naminohira (波平) school, etc.

<Shinto> Seen in the work of the Yamato-den and related schools. It is not seen in Osaka-, Hizen-, or Satsuma-province swords. Kunikane (国包), Shigekuni (重国), etc.

Hakikake

Leading swordsmiths:
<Koto> As with yakitsume, seen mainly in swords of the Yamato smiths and related schools.

The Sanjo (三条) school, the Awataguchi (粟田口) school, the Rai (来) school, the Taima (当麻) school, the Hosho (保昌) school, the Tegai (手掻) school, the Shikkake (尻懸) school, the Senjuin (千手院) school, the Uda (宇多) school, Sosho Yukimitsu (相州行光), Go Yoshihiro (郷義弘), Kanro Toshinaga (甘露俊長), the Mihara (三原) school, the Naminohira (波平) school, the Gassan (月山) school, etc.

<Shinto> Kunikane (国包), Shigekuni (重国), Hankei (繁慶), etc. This is often seen in blades by Myoju (明

寿), Kunimichi (国路), Kuniyasu II (二代 国安), the Mizuta (水田) school, etc.

<Shinshinto> Naotane (直胤), Yukihide (行秀), Kiyondo (清人), etc.

Midare komi

Leading swordsmiths:
<Koto> Munechika (宗近), Gojo Kanenaga (五条兼永), the Awataguchi (粟田口) school (Kunitsuna [国綱], Kunitomo [国友]), the Rai (来) school (Kuniyuki [国行], Niji Kunitoshi [二字国俊], Kunimitsu [国光]), the Hasebe (長谷部) school, Nobukuni (信国), Sanjo Yoshinori (三条吉則), Shikkake Norinaga (尻懸則長), Bizen- (備前) province swords, the Aoe (青江) school, the Samonji (左文字) school, etc.

<Shinto> The Hirokawa (堀川) school, Samonji (左文字), Kinmichi (金道), the Yasutsugu (康継) school, Nobutaka (信高), Masatsune (政常), Echizen Masanori (越前正則), Ujifusa (氏房), Masafusa (正房), Masakiyo (正清), etc.

<Shinshinto> The Suishinshi school, the Kiyomaro (清麿) school, Satsuma-province swords, etc.
In Shinshinto times, the boshi is usually midare komi, except in swords in suguha and in copies of Osaka (Settsu province) Shinto blades.

Choji midare komi

Choji midare komi is seen only in work that has a choji midare temper line. It is rare in Shinto and Shinshinto blades.

Leading swordsmiths:
<Koto> The Ichimonji (一文字) school, Mitsutada (光忠), the Rai (来) school (Kuniyuki [国行], Niji Kunitoshi [二字国俊]), etc.

Jizo

Leading swordsmiths:
<Koto> Kaneuji (兼氏), the Naoe Shizu (直江志津) school, the Sue-Seki (末関) school, the Hasebe (長谷部) school, Nobukuni (信国), Heianjo Nagayoshi (平安城長吉), Sanjo Yoshinori (三条吉則), Tsunahiro (綱広), Yasuharu (康春), Muramasa (村正), the Uda (宇多) school, the Takada (高田) school, etc.

Kaen

Kaen is never found in swords in nioi deki, but it is often seen in celebrated nie deki blades.

Leading swordsmiths:
<Koto> The Sanjo (三条) school, the Awataguchi (粟

田口) school, the Rai (来) school, the Taima (当麻) school, the Hosho (保昌) school, the Senjuin (千手院) school, the Shikkake (尻懸) school, the Masamune (正宗) school (Yukimitsu [行光], Masamune [正宗], Sadamune [貞宗]), Go Yoshihiro (郷義弘), Norishige (則重), Samonji (左文字), Kaneuji (兼氏), etc.

<Shinto> Kunihiro (国弘), Kunimichi (国路), Horikawa Kuniyasu (堀川国安), Yoshihira (美平), Shigekuni (重国), Hankei (繁慶), Yasutsugu (康継), Omura Kaboku (大村加卜), Kunikane (国包), the Mizuta (水田) school, Ujifusa (氏房), Masafusa (正房), Masakiyo (正清), Yasuyo (安代), etc.

<Shinshinto> Masahide (正秀), Naotane (直胤), Kiyomaro (清麿), Motohira (元平), Hoki no Kami Masayoshi (伯耆守正幸), etc.

Ichimai

Only seen in blades of the Soshu-den and in swords dating from the end of the Muromachi period.

Leading swordsmiths:
<Koto> The Masamune (正宗) school (Hiromitsu [広光], Akihiro [秋広]), Tsunahiro (綱広), the Hasebe (長谷部) school, Muramasa (村正), Yoshisuke (義助), the Sue-Seki (末関) school (Kanesada [兼定], Ujifusa [氏房], Ujisada [氏貞]), Go Yoshihiro (郷義弘), the Uda (宇多) school, the Sue-Bizen (末備前) school, (Sukesada [祐定], Kiyomitsu [清光]), Koga (広賀) (or Hiroyoshi), etc.

<Shinto> Yoshihira (美平), Horikawa Kuniyasu (堀川国安), etc.

Nie kuzure

Leading swordsmiths:
<Koto> The Sanjo (三条) school, the Awataguchi (粟田口) school, the Rai (来) school (Kunimitsu [国光], Kunitsugu [国次], Kunizane [国真]), the Hasebe (長谷部) school (Kunishige [国重], Kuninobu [国信]), Nobukuni (信国), the Taima (当麻) school, the Shikkake (尻懸) school, the Hosho (保昌) school, the Senjuin (千手院) school, the Tegai (手掻) school, the Masamune (正宗) school (Yukimitsu [行光], Masamune [正宗], Sadamune [貞宗], Hiromitsu [広光], Akihiro [秋広]), Tsunahiro (綱広), Kaneuji (兼氏), the Uda (宇多) school, Muramasa (村正), Izumi no Kami Kanesada (和泉守兼定), Kanro Toshinaga (甘露俊長), Norishige (則重), Go Yoshihiro (郷義弘), the Samonji (左文字) school, the Naminohira (波平) school, etc.
<Shinto> The Horikawa (堀川) school, Yoshihira (美平), Shigekuni (重国), Hankei (繁慶), Yasutsugu (康継), Tsuguhira (継平), Kunikane (国包), Kunishige (国重), Masakiyo (正清), Yasuyo (安代), etc.

<Shinshinto> Masahide (正秀), Naotane (直胤), Kiyomaro (清麿), Yukihide (行秀), Tomotaka (朝尊), Hoki no Kami Masayoshi (伯耆守正幸), Motohira (元平), etc.

Pointed boshi

Leading swordsmiths:
<Koto> The Samonji (左文字) school, the Kanemitsu (兼光) school, the Chogi (長義) school, the Masamune (正宗) school (Hiromitsu [広光], Akihiro [秋広]), Heianjo Nagayoshi (平安城長吉), Muramasa (村正), etc.

<Shinto> Kunihiro (国広), etc.

<Shinshinto> Kiyomaro (清麿), Kiyondo (清人), etc.

Wide kaeri

Leading swordsmiths:
<Koto> Mainly seen in swords of the Sue-Seki (末関) school, the Sue-Soshu (末相州) school, and the Mino tradition.

<Shinto> The Mishina (三品) school, Kunimichi (国路), Kunitomo (国儔), Nobutaka (信高), etc.

Steep stop

Leading swordsmiths:
<Koto> Mainly seen in blades of the Sue-Seki (末関) school, the Sue-Mihara (末三原) school, Muramasa (村正), the Sue-Bizen (末備前) school, Koga (広賀), Tadasada (忠貞) (or Chutei), Fuyuhiro (冬広), Kashu Yukimitsu (加州行光), Kashu Kiyomitsu (加州清次), etc.

<Shinto> The Mishina (三品) school, the (Osaka) Tanba no Kami Yoshimichi (丹波守吉道) school, Kunisada (国貞), Kunisuke II (二代 国助), Masatsune (政常), Ujifusa (氏房), etc.

Long kaeri

Leading swordsmiths:
<Koto> Chogi (長義), the Mihara (三原) school, Fuyuhiro (冬広), Koga (広賀), Kashu- (Kaga province) swords, the Sue-Bizen (末備前) school, the Sue-Soshu (末相州) school, the Sue-Seki (末関) school, etc.

<Shinto> The Mizuta (水田) school, Kanewaka (兼若), etc.

A different boshi on each side of the kissaki

Leading swordsmiths:
<Koto> The Sue-Bizen (末備前) school (especially Kiyomitsu [清光]), the Sue-Seki (末関) school, Hokuriku-district swords (swords of Kaga [広賀], Echizen [越前], and Etchu [越中] provinces), the Takada (高田) school, etc.

FLAWS AND DEFECTS

Flaws and defects in Japanese swords may be caused accidentally during the forging or tempering processes. Poor preservation may also lead to rust that must be removed by repeated grinding. Finally, damage may have resulted from a sword's use in battle. Swords that remain flawless after many years are naturally regarded as quite valuable.

Hagire: A crack in the edge that continues from the cutting edge toward the hamon, at a 90 degree angle. Caused by faulty tempering or by actual contact in fighting.

Karasuguchi: "Crow's beak." A crack that runs from the cutting edge toward the boshi in the kissaki.

Tsuki-no-wa: A crescent-shaped crack inside the boshi.

Hagarami: An oblique crack in the cutting edge.

Hadaware: A crack running lengthwise through the ji that indicates a swordsmith's lack of skill. When this sort of crack appears in the mune, it is called muneware.

Shinae: Cracks or wrinkles running crosswise through the ji or shinogiji.

Nioigire: Part of a hamon that is missing, as if it had been left out. This is caused by faulty tempering or by the blade's having been burned. The term nioigire is also used for hamon in nie deki.

Kakedashi: A part of the hamon that extends all the way to the cutting edge.

Kirikomi: A cutting mark on the blade caused by use in actual fighting.

Fukure: A pocket of air in the steel that was not forced out during the forging process. A fukure appears as a blister-like swelling on the surface of the blade; when this bubble breaks, it is known as fukure yabure (broken fukure). When the cavity left by a broken fukure or a hadaware is filled or repaired using steel from another blade, this is called umegane.

● FLAWS

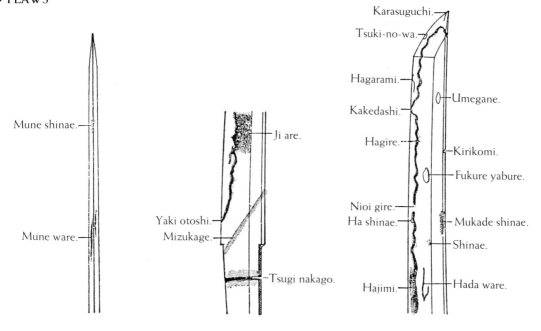

Mune shinae. Mune ware. Ji are. Yaki otoshi. Mizukage. Tsugi nakago. Karasuguchi. Tsuki-no-wa. Hagarami. Kakedashi. Hagire. Nioi gire. Ha shinae. Hajimi. Umegane. Kirikomi. Fukure yabure. Mukade shinae. Shinae. Hada ware.

Ji zukare: A blade the steel of which has worn out as a result of repeated grinding. Generally, in these cases, the steel becomes rougher and coarser, and changes color.

Ha jimi: In another effect of repeated grinding, the hamon becomes less clear and loses its original brightness. This defect may also be caused by faulty tempering.

Ji are: A rough and coarse part of the jihada caused by tiredness or by unskilled forging.

Tsugi nakago: A patched nakago in which the original nakago has been removed, and replaced with one from another blade (usually inscribed).

Sabitsuke nakago: A rusted nakago. This does not refer to natural rust that develops over time, but to a nakago into which rust has deliberately been introduced, in order to make the look blade older.

Sai ha: A retempered blade. In the past, swords that were burned or worn out were often retempered. With retempering, the original characteristics of the blade are usually almost completely lost, particularly in the hamon, since the work is generally done by another swordsmith. (Note: The peculiarities of retempered blades are as follows: The overall form is unnatural. The curvature may be deeper than usual. The steel is coarse. Activity within the hamon is rare. Tobiyaki, muneyaki, mizukage and yakiotoshi are frequently seen.)

THE WORKMANSHIP
OF THE LEADING
SWORDSMITHS

BASIC CLASSIFICATION OF THE GOKADEN IN KOTO TIMES

Today the term Gokaden is frequently used in the appreciation and attribution of the Japanese sword. During Koto times, the term referred to the style of work produced specifically in the five provinces of Yamashiro, Yamato, Bizen, Soshu (or Sagami) and Mino. Later, as these styles grew in importance and were no longer associated simply with particular regions, the term came to refer more generally to the five basic styles of sword production by which blades are now classified. "Goka" means five, and "den" means "tradition," here referring to the style of sword production. "Den" is often used by itself to class a smith's workmanship within a particular tradition.

Simply speaking, typical workmanship of the Gokaden is as follows:

a) Yamashiro (山城) tradition is mokume, with suguha in nie deki.

b) Yamato (大和) tradition is masame-hada, with suguha in nie deki.

c) Bizen (備前) tradition is utsuri and choji midare in nioi deki.

d) Soshu (相州) tradition is midareba in nie deki.

e) Mino (美濃) tradition is midareba mixed with togari-ba, in nioi deki.

The Gokaden were closely followed in Shinto times, but during this period, another style of swordmaking, called the Shinto Tokuden tradition, also arose. Japanese swords can, for the most part, be classified into one of these six styles.

Naturally there are exceptions in any time period. For instance, if one were to take one of the traditional styles of the Gokaden and add local color, then mix in another style, the result would be what is known as majiwari-mono or wakimono. If the appraiser understands all these elements sufficiently well, it becomes possible to judge the period, province, and school, even upon first viewing of a particular smith's work.

It should be noted that a swordsmith may exhibit more than one tradition—often two, or even three—in his work. One would then say that he works in the Yamashiro, Bizen, and Mino traditions.

YAMASHIRO (山城) TRADITION

Jihada: Composed mainly of mokume-hada. Ko-mokume, chu-mokume, and o-mokume hada are seen. Yubashiri appears in the ji, and resembles the Milky Way.

Hamon: This is based on suguha in nie deki, with hataraki like niju-ba, uchinoke, and hakikake appearing inside the hamon.

Boshi: According to the pattern of the hamon, ko-maru, nie kuzure, and kaen are seen.

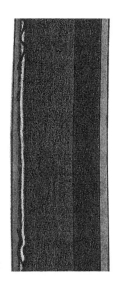 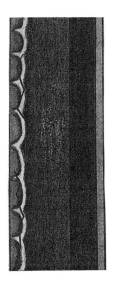 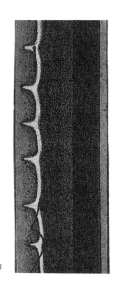 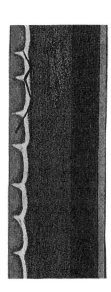

1. The ko-mokume is fine, the suguha is in nie deki, and very small hataraki are seen in the hamon.

2. Chu-mokume hada, based on suguha. Abundant hataraki are seen along and within the hamon.

3. O-mokume hada. The hataraki become larger in accordance with the composition of the jihada.

4. Mokume hada with ji-nie and chikei. Yubashiri appears.

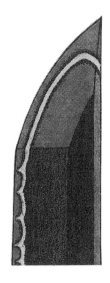 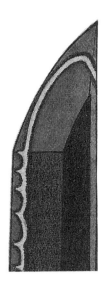 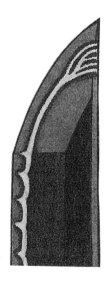 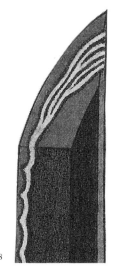

5. In accordance with the suguha of the hamon, the boshi is suguha and ko-maru.

6. The boshi is suguha and o-maru, and turns back.

7. Nie kuzure with abundant nie.

8. Kaen, seen mainly in cases in which the pattern composing the jihada is large.

YAMATO (大和) TRADITION

Sugata: Shinogi is especially high.

Jihada: Composed mainly of masame-hada. Mokume-hada and itame-hada may sometimes be seen, but a more usual combination is nagare-hada (running pattern) and masame-hada.

Hamon: As in the Yamashiro tradition, this has a basis of suguha in nie deki, but vertical hataraki such as nijuba, uchinoke, hakikake, etc, appear frequently in the habuchi.

Boshi: Mainly ko-maru, o-maru, nie kuzure, kaen, and yakitsume are seen.

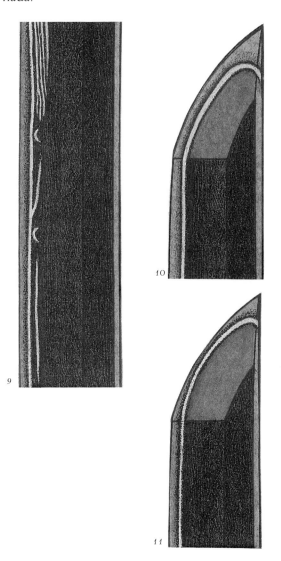

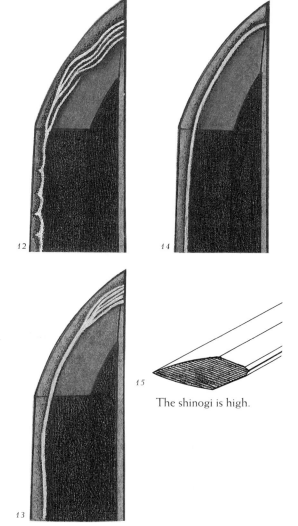

The shinogi is high.

9. The jigane is composed mainly of masame hada. The hamon is based on suguha, with nijuba, uchinoke, and hakikake in nie deki.

10. Ko-maru is sometimes seen in the Yamato tradition, as in the Yamashiro.

11. The boshi is suguha and o-maru. Mokume hada with running hada.

12. In the case of pure masame hada, the boshi generally becomes kaen.

13. The boshi becomes nie kuzure in the Yamato school, and the reflectiveness of the nie is generally greater than that of other schools.

14. Yakitsume is particularly common in the Yamato tradition.

BIZEN (備前) TRADITION

Jihada: Jigane is relatively soft and well forged. Jihada is composed mainly of mokume-hada, although ko-mokume, chu-mokume, and o-mokume are also seen, usually combined with o-hada. Utsuri is nearly always seen in the ji.

Hamon: This is composed mainly of midareba in nioi deki. Choji midare, gunome midare, koshi-no-hiraita midare, and others are sometimes present.

Boshi: The boshi is a continuation of the hamon. There are choji midare komi, midare komi, and midare komi with choji ashi.

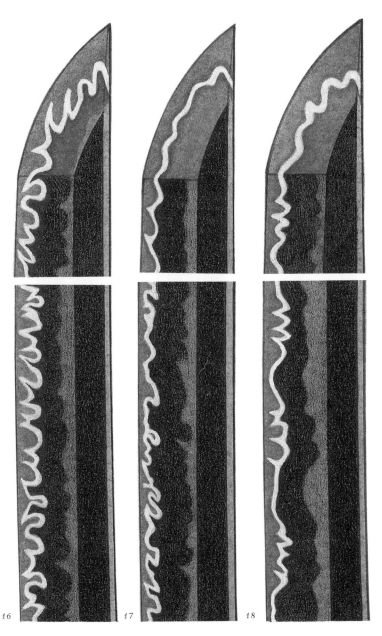

Illustrations from left to right (Note: The upper and lower illustrations show parts of the same sword).

16. (Above): In accordance with the pattern of the hamon, the boshi becomes choji midare komi. (Below): The jihada is composed mainly of mokume hada, with utsuri readily visible. The hamon is choji midare in nioi deki.

17. (Above): The boshi is always midare komi, but the pattern of the midare is smaller than that on the hamon. (Below): The hamon of the Bizen tradition is composed of midareba in nioi deki, and utsuri is seen.

18. (Above): The boshi is midare komi, but here its pattern is different from that of the hamon. (Below): The hamon is koshi-no-hiraita midare. After the start of the Muromachi period, the utsuri usually becomes bo-utsuri, even if the hamon is midareba.

There are also a few styles of sword production in Bizen province in which Bizen tradition is mixed with another tradition, as follows:

Bizen tradition mixed with Yamashiro tradition

Swordsmiths who originally belonged to the Bizen tradition but who also worked in Yamashiro tradition, for example, a smith of the Bizen school whose hamon varies in width (in the Bizen tradition the hamon is usually uniform in width at the top and bottom).

Bizen tradition mixed with Soshu tradition

Swordsmiths originally trained in the Bizen tradition who also work in the Soshu tradition. Their work is usually referred to as "So-den Bizen."

19. Bizen tradition mixed with Yamashiro tradition. The hamon is based on suguha in nioi deki, and utsuri is seen.

20. An example of a work in the Bizen tradition with a hamon of uneven width. In the Bizen tradition, the hamon's width is usually uniform from top to bottom.

21. So-den Bizen, with a jihada forged in the Soshu tradition. The hamon is inclined to be in nie deki rather than nioi, and utsuri is not necessarily seen.

19 20 21

SOSHU (相州) TRADITION

Jihada: Mokume-hada combined with o-hada, itame-hada, etc.

Hamon: Based on midareba in nie deki.

Boshi: Mainly in midare komi.

The Soshu tradition's style of workmanship has been quick to change, and may be further classed into subcategories of early, mid-, and late Soshu.

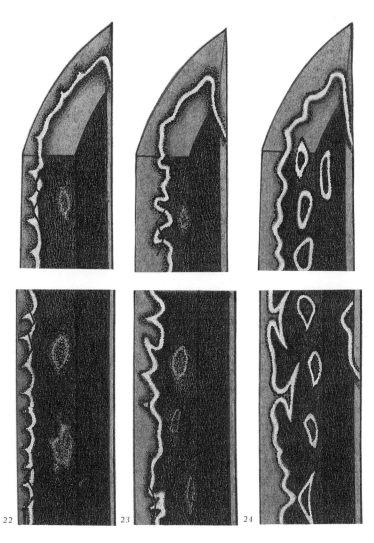

22. Early Soshu tradition: Mokume hada. The hamon is midareba based on suguha, in nie deki. The yubashiri becomes roundish. At this time, the Soshu tradition is similar to the Yamashiro, but the nie is brighter in Soshu work.

23. Mid-Soshu tradition: The yubashiri becomes dense and looks as if it has been tempered. Many hataraki are seen. The boshi is midare komi.

24. Late Soshu tradition: Tobiyaki are distinctly visible on the ji, and the hamon becomes hitatsura. Different materials are used, and the work shows less skill.

MINO (美濃) TRADITION

Jihada: Jigane is generally hard. Jihada is based on mokume-hada and combined with o-hada, and looks rather coarse; the whitish pattern stands out distinctly. Masame-hada is always present along the mune. Shirake utsuri is seen.

Hamon: Based on midareba and definitely mixed with togari-ba, with scattered nie. When swordsmiths originally trained in the Mino tradition temper in the Yamashiro, Yamato, or Soshu styles, the hamon is invariably mixed with togari-ba.

Boshi: Long and wide kaeri, steep tome. Jizo boshi is often seen.

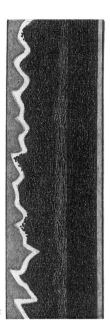
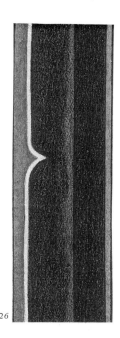

25

26

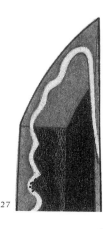

27

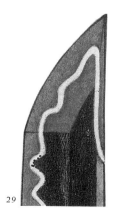

29

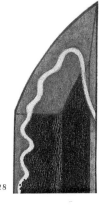

28

25. The jihada is based on mokume hada and is combined with masame hada along the mune. The hamon is based on midare in nioi deki.

26. Even in suguha in the Yamashiro or the Yamato traditions, togari-ba appears.

27. The kaeri is long.

28. The head of the boshi leans toward the fukura.

29. The kaeri has a steep stop.

WAKIMONO (MAJIWARIMONO)

In Koto times there were several schools whose workmanship did not belong to the Gokaden, as well as others that mixed two or three Gokaden. These were chiefly seen in regions outside the provinces of Yamashiro, Yamato, Bizen, Soshu, and Mino, and are referred to as wakimono or majiwarimono (unorthodox schools).

The leading schools of this kind include:

Takada (Bungo province), Uda (Etchu province), Mihara (Bingo province), Shimada (Suruga province), Shitahara (Musashi province), Kanabo (Yamato province), Fujishima (Kaga province), Dotanuki (Higo province), Nio (Suo province), Gassan (Dewa province), Hoju (Mutsu province), Kaifu (Awa province), Kongobei (Chikuzen province), Iruka (Kii province), Sudo (Kii province), Chiyozuru (Echizen province), Hashizume (Kaga province), Yamamura (Echigo province), and Momokawa (Echigo province).

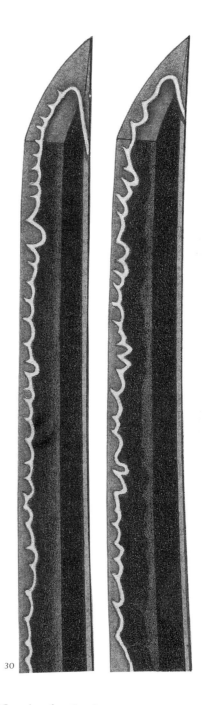

30

Samples of majiwarimono.

THE MAIN SCHOOLS AND WORK-MANSHIP OF EARLY JAPANESE SWORDS

The Japanese sword as we know it today first appeared in about the mid-Heian period. Blades made before that time, when the unique style of the Japanese sword, or nihonto, had not yet been established, are known as jokoto (ancient swords). By the middle to the end of the Heian period, we can say that the major traditions in the production of swords were well on the way to becoming established. Some examples of Gokaden blades survive from about the start of the Kamakura period, and can be quite easily classed into one of the five traditions. However, there are not a great number of swords that survive from this very early period.

In the early Kamakura period, the sword-smiths of the Sanjo school were more advanced than any others. These smiths lived in Yamashiro province—at that time home to Japan's largest city—and we can recognize

31. Suguha hotsure.

32. Choji midare based on suguha.

33. Ko-choji midare mixed with ko-midare, with abundant nie.

34. Suguha mixed with choji midare.

the Yamashiro tradition in their workmanship. Their work does not always follow the Yamashiro tradition, however; it sometimes resembles majiwarimono or the Bizen tradition. Other schools and smiths active in this period included the Yasutsuna school, the Ko-Bizen school, the Ko-Aoe school, and some smiths in Kyushu.

THE SANJO (三条) SCHOOL

The founder of the Sanjo school was Sanjo Munechika (三条宗近), who is said to have lived in the Eien era (987–989). He was followed by Sanjo Yoshiie (三条吉家), Gojo Kanenaga (五条兼永), Gojo Kuninaga (五条国永), and others. Examples survive of their signed works, or zaimei. Each of these swordsmiths' blades shows slightly different characteristics, because the period in which they lived spanned many years.

Sugata: Shows features common to this period. The upper area is much more narrow than the bottom. Ko-kissaki, torii-zori and deep koshi-zori appear; the blade is graceful overall. Yoshiie's blade shapes look strong in comparison to those of Sanjo Munechika, but the monouchi area never becomes as narrow as it does in Sanjo Munechika's work.

Jihada: Good-quality steel, well forged, with abundant fine ji-nie and chikei. Ko-mokume hada, mixed with wavy, large hada; but in later generations this large hada is not as obvious.

Hamon: Consists of nie structure. The bright hamon line is covered with thick nioi and looks soft. The hamon is based on suguha mixed with ko-choji midare and ko-midare. Hataraki appear along the hamon line. Other swordsmiths' blades are similar to those of Munechika, but their work shows greater technical skill and is more gorgeous.

Boshi: Nie kuzure, kaen o-maru are seen. The kaeri is short and turns back gently; sometimes it is nearly yakitsume. The monouchi-area hamon occasionally becomes nijuba or sanjuba.

Horimono: Bo-bi and koshi-bi are seen.

Nakago: The nakago has a degree of sori and is long. The tip becomes thin.

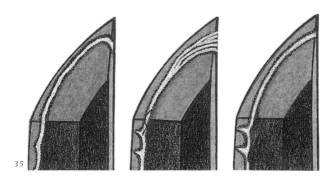

35

(From left to right): Midare komi inclined to be ko-maru, nie kuzure, and yakitsume.

THE YASUTSUNA (安綱) SCHOOL

One old account says that Hoki Yasutsuna (伯耆安綱) lived in the Daido era (806–810). This period is still part of the Jokoto period, but those Yasutsuna swords that we can see today satisfy all the conditions of the fully developed Japanese sword. It is obvious that Yasutsuna must have lived and worked sometime after the Daido era. His work appears to pre-date that of the Ko-Bizen school, and it is reasonable to assume that he was a contemporary of Sanjo Munechika.

Yasutsuna's greatest work, the "Dojigiri Yasutsuna," has a blade length of 80 cm, a curvature of 2.7 cm, torii-zori (the koshi-zori is still strong), distinct funbari, and ko-kissaki. Jihada is mokume-hada with abundant ji-nie and chikei, and nie utsuri is present. Hamon is ko-midare consisting of thick nioi and abundant ko-nie. Many vivid ashi, yo, and kinsuji appear inside the hamon. It is said that Soshu Masamune tried to imitate Yasutsuna's workmanship, which indeed shows magnificent activity.

Ohara Sanemori (大原真守) (who is said to be Yasutsuna's son), Yasuie (安家), Aritsuna (有綱), and Kunimune (国宗) belong to this school, and examples of their works are extant today. Common points in their workmanship are a coarse mokume-hada, a jigane that looks black, and the presence of both ji-nie and chikei. The hamon is ko-midare, consisting of a nie structure with kinsuji and sunagashi.

THE KO-BIZEN (古備前) SCHOOL

During the Heian period, most swordsmiths in Bizen province belonged to the Ko-Bizen school. During the Kamakura period this was succeeded by the Ichimonji school, which had many swordsmiths. These included Tomonare (友成) (said to have been a contemporary of Sanjo Munechika), Masatsune (正恒) (who left many extant works), Nobufusa (信房), Sanetsune (真恒), Toshitsune (利恒), Sukekane (助包), and Yoshikane (吉包). Of the so-called "Three Hira" smiths—Takahira (高平), Kanehira (包平), and Sukehira (助平)—only Takahira's work is no longer extant. The names Tomonari and Masatsune seem to have been used by various smiths over several generations. But another Masatsune also lived during this same period, belonging to the Ko-Aoe school in the neighboring province of Bitchu, and among the Ichimonji swordsmiths there are many whose names are also associated with other schools, such as Mitsutada (光忠), Norishige (則重), and Yukimitsu (行光); all this clearly suggests that one needs to take great care in order to avoid confusion.

Sugata: Shows the characteristic features of this period. The blade has torii-zori but koshi-zori is still strong, with distinct funbari and ko-kissaki. The yokote area becomes considerably thinner, but it shows strength rather than elegance, particularly in comparison to the Sanjo school. Some blades, like the noted "O-Kanehira" and "Sanetsune," owned by the Kunosan Toshogu shrine, show grand sugata. These are the so-called ikubi kissaki tachi, seen from the mid-Kamakura period.

Jihada: Generally speaking, this is not as soft as in Yamashiro blades. Occasionally, it is a little coarse and mixed with large patterns, but usually the jihada is dense ko-mokume, with ji-nie and chikei. Jifu utsuri is also an important feature of the jihada of the Ko-Bizen school.

Hamon: Ko-choji midare and ko-midare based on suguha. The hamon appears active, and contains many ashi, yo, kinsuji, and inazuma. The nioi-guchi is not bright. Abundant ko-nie and nie kogori (lumps of nie) are seen. The hamon consists of a nie structure, but no purely nioi deki hamon are seen.

Boshi: Midare komi in proportion to hamon, slight notare komi or ko-maru, with a short turn-back.

Horimono: Bo-bi. This is seen rarely in Hoki-province blades, but often in those from Yamashiro.

Nakago: Has sori, and the tip (nakagojiri) usually becomes kurijiri.

The Ko-Aoe school will be discussed on p. 141.

THE SWORDSMITHS OF THE SAIKAIDO

As the southernmost island of the Japanese archipelago, Kyushu enjoyed rich cultural exchanges with China and Korea since ancient times. Some of Japan's very earliest swordsmiths may in fact have emerged there. As the island is located far from the central area of Yamato and Yamashiro provinces, smiths tended to maintain old traditions and to shun innovation. As a result, their workmanship did not change much over time, in contrast with that of the main schools. In early times, influence of the Yamato smithing tradition is evident in work produced throughout Kyushu.

Sugata: Looks comparatively old; the shinogiji is wide.

Jihada: Mokume-hada tends to be masame-hada or to become ayasugi-hada. Nashiji-hada is sometimes seen. The jigane is soft. Ji-nie and chikei are seen.

Hamon: Ko-midare, consisting of nie, based on suguha; nioi-guchi is neither bright nor clear. There is yakiotoshi. The yakidashi (the edge of the hamon) starts just above the hamachi.

Denta Mitsuyo (典太光世), who lived at Miike in Chikugo province and whose Buddhist name was Genshin, is said to have been active in the Shoho era (1074–1077). We can see several of his extant works, among them the noted "O-Denta Mitsuyo" and a mumei tachi owned by Kunosan Toshogu shrine, which is dedicated to Tokugawa Ieyasu.

Both examples display jihada and hamon that resemble the "Kogarasu-maru" in the Imperial collection. These blades have been confirmed to date back to the end of the Heian period. They show unusual grandeur in their shape, as does the noted "O-Kanehira." The mihaba (blade width) is wide, as is the

shinogiji. They have torii-zori, but there is still deep koshi-zori and the kissaki becomes ikubi. This sugata may exemplify the style of workmanship seen in swords of an earlier period.

The names Mitsuyo and Denta were used by successive generations of swordsmiths through the Muromachi period.

Shinsoku (神息) and Choen (長円) are said to have lived in Buzen province in the Wado era (708–715) and the Eien era (987–988) respectively, but the Japanese sword was not yet fully developed at that time. Their extant works show completed tachi and tanto sugata, and are reminiscent of blades of the early Kamakura through the Nanbokucho periods. It appears that their names were also used by several successive generations.

We can see some tachi bearing the signature "Bungo no kuni ju so Sadahide (定秀) saku" (Made by the priest Sadahide, resident in Bungo). Incidentally, Sadahide's student, or perhaps teacher, is said to be the well-known Bungo Yukihira, who lived in the early Kamakura period and is one of the goban kaji (swordsmiths honored with appointments by the retired emperor Gotoba).

In the Naminohira school, it is believed that Masakuni moved from Yamato province to Naminohira in Satsuma province during the Eien era, but we have no extant examples of his work. Masakuni's son, and thus the main family, succeeded to the name of Yukiyasu (行安) in the Muromachi period. The Naminohira school was also active during the Shinto and Shinshinto periods. The oldest extant work in this school is a tachi by Yukimasa (行正) dated in the first year of the Heiji era (1159), and the second-oldest is a Yukiyasu tachi owned by Sanage shrine. Both these blades are graceful and show very old, Yamato-style workmanship.

LEADING SWORDSMITHS OF THE EARLIEST TIMES

(Smiths for whom no era or province is indicated are from the same era and province as the smith noted above.)

ERA	PROVINCE	SWORDSMITH(S)	PATTERN
Taiho (701–704)	Yamato	Amakuni (天国)	The "Kogarasu-maru" in the Imperial collection is said to have been made by Amakuni.
		Amakura/Amaza (天座)	No extant works.
Wado (708–715)	Buzen	Shinsoku (神息)	Extant work is scarce. Blades that bear his signature seem to have been produced by later generations, after the beginning of the Kamakura period. His work shows characteristics of the Yamashiro tradition. The blade is well forged, and in mokume hada mixed with a little masame hada. The hamon is hoso-suguha, inclined toward ko-midare, with ko-nie and ashi. The boshi is yakitsume, nie kuzure, or kaen.
Daido (806–810)	Hoki	Yasutsuna (安綱)	Majiwarimono. Sugata resembles that of Sanjo Munechika (of the late Heian period) and the blade has deep torii-zori with funbari and tapering sugata with ko-kissaki. Jihada is fine mokume combined with o-hada or relatively coarse o-itame. Hamon is based on sugu-ha mixed with ko-choji-midare, and consists of thick nioi and relatively rough nie. Many activities are seen inside the hamon, such as nie-kogori (lumps of nie), ashi, inazuma, kinsuji, nie-zake, and sunagashi. Ha-hada is visible inside the hamon. Up and down is recognized in the formation of the hamon. Boshi is midare-komi with yakitsume or notarekomi, nie-kuzure or kaen (flame).
Kasho (848–851)	Hoki	Ohara Sanemori (大原真守)	This smith's swords have much the same workmanship as those of Yasutsuna.
Owa (961–964)	Bizen	Ko-Bizen Takahira (古備前高平)	No extant works.
Eien (987–989)	Yamashiro	Sanjo Munechika (三条宗近)	Yamashiro-tradition characteristics. The jigane is fine and extremely beautiful, and appears very active, with abundant ji-nie and chikei. The jihada is ko-mokume hada, mixed with a large, wavy pattern. A narrow hamon, consisting of ko-choji midare, is mixed with ko-midare and nie kuzure. The nie are very bright and there is a lot of activity, with nie, nioi kogori, fine kinsuji and inazuma, and numerous vigorous, gorgeous uchinoke appearing. The hamon sometimes becomes nijuba from the monouchi area to the boshi. The boshi is nie kuzure, kaen, o-maru, and others. The kaeri (turn-back) is usually either short or yakitsume.
	Bizen	Ko-Bizen Tomonari (古備前友成)	These swords have characteristics of the Yamashiro tradition. The jigane is well forged and soft. The jihada is ko-mokume hada, mixed with large patterns, and contains utsuri. The hamon is narrow ko-choji midare, mixed with ko-midare and based on suguha. Abundant nie, nie and nioi kogori, ashi, kinsuji, and inazuma are seen. Suguha choji midare with nioi is also seen. The boshi is either ko-midare or yakitsume.
		Ko-Bizen Kanehira (古備前包平)	Bizen-tradition characteristics. There are two different sugata. One is a little stronger than the normal sugata of this period. The other one is more magnificent, like the noted "O-Kanehira," and similar to those of the mid-Kamakura period. The jigane is well forged and an example of fine mokume hada mixed with o-hada. Chikei also appear. When the jihada is forged in a large pattern, the abundant

ERA	PROVINCE	SWORDSMITH(S)	PATTERN
			ji-nie become yubashiri. The hamon is narrow ko-choji midare or ko-midare, based on suguha. The nie and nioi kogori, long ashi, fine kinsuji, and inazuma are extremely beautiful. A large koshiba is seen. Suguha choji midare and o-choji midare, resembling those of the Bizen tradition and consisting of nioi and nie, are sometimes seen. The ha hada (grain pattern on the inside of the hamon) is visible. Thick nie, nioi kogori, and long ashi are seen. The large kinsuji and inazuma are vigorous. The boshi is large midare or ko-midare, or ko-maru with short kaeri, or yakitsume, all in proportion to the hamon.
Eien (987–989)	Buzen	Choen (長円)	These swords have Yamashiro- and Yamato-tradition characteristics. The jigane is well forged and oily. The jihada is ko-mokume hada mixed with masame hada and ji-nie. Chikei appear. The hamon is chu-suguha, the nie are rather rough, and there is gentle hataraki inside the hamon. The boshi is yakitsume, with thick nie.
Chotoku (995–999)	Bizen	Ko-Bizen Masatsume (古備前正恒)	His swords have Yamashiro-tradition characteristics. The sugata looks graceful but the mihaba (blade width) is usually narrow. The sori is not deep. The width of the blade does not vary greatly from top to bottom. The jigane is well forged and appears strong. The jihada is ko-mokume hada mixed with o-hada. Chikei and utsuri appear. The hamon is wide suguha choji midare, with thick nie, nioi kogori, and long ashi. The kinsuji and inazuma are vigorous. Usually the hamon is ko-midare at the bottom and becomes suguha choji midare in the upper area. The boshi is ko-maru sagari (this is often the case in Osaka shinto blades) or ko-midare.
Kanko (1004–1012)		Ko-Bizen Sukehira (古備前助平)	Bizen-tradition characteristics; extant works are very rare. The hamon is a narrow suguha choji midare, nie are scarce, and small kinsuji and inazuma appear. Other aspects of his workmanship are similar to those of Kanehira.
	Yamashiro	Sanjo Yoshiie (三条吉家)	These swords have Yamashiro- and Bizen-tradition characteristics. The jigane is well forged and the jihada is fine mokume hada mixed with o-hada and chikei. The hamon is usually o-choji midare with a great deal of nie. Nie, nioi kogori, ashi, kinsuji, and inazuma are seen. In some cases the hamon may be suguha choji midare with abundant nie. A large koshiba is sometimes seen, which looks like o-choji or juka-choji midare. The boshi is o-maru and midare komi, with either short kaeri or yakitsume.
Chogen (1028–1037)		Gojo Kanenaga (五条兼永)	These swords have Yamashiro- and Bizen-tradition characteristics. The jigane is well forged and the jihada is fine mokume hada, mixed with o-hada. Ji-nie, nie utsuri, and chikei appear. The hamon is of proper width and is ko-choji midare, mixed with ko-midare. Thick nioi, a little rough nie, nie, nioi kogori, and ashi are seen. Suguha choji midare and o-choji midare are also seen. The boshi is nie kuzure and o-maru, with short kaeri.
Chokyu (1040–1044)	Bizen	Ko-Bizen Tsunetsugu (古備前恒次)	His swords have Yamashiro-tradition characteristics; extant works are very rare.
Tengi (1053–1058)	Yamashiro	Gojo Kuninaga (五条国永)	Yamashiro- and Bizen-tradition characteristics. The jigane looks strong. A fine ko-mokume hada is relatively coarse. Nie utsuri and chikei appear. The hamon is ko-choji midare based on either chu-suguha or suguha choji. The hamon is also characterized by midare with nie, nioi kogori, long ashi, kinsuji, and inazuma. The pattern of

ERA	PROVINCE	SWORDSMITH(S)	PATTERN
			the yakidashi area becomes small. The boshi is ko-maru or midare komi, with short kaeri, occasionally yakitsume.
Joho (1074–1077)	Chikugo	Miike Mitsuyo (三池光世)	These swords have Yamashiro-tradition characteristics. At first glance they resemble the sugata of the mid-Kamakura period. This smith is an excellent hi engraver. They are wide and shallow, and there is no unevenness inside the groove. The hamon is chu-suguha, mixed with ko-midare. A lot of activity, ashi, kinsuji, and inazuma are seen. The blades also show features of Yamato tradition such as hakikake and nijuba. The boshi is ko-midare.
Joryaku (1077–1081)	Bizen	Ko-Bizen Sanetsune (古備前真恒)	These have Yamashiro-tradition characteristics. Extant work is rare but includes an ikubi kissaki tachi sugata that resembles the famous "O-Kanehira."
Jotoku (1097–1099)		Ko-Bizen Tsunemitsu (古備前恒光)	This smith's swords have Yamashiro-tradition characteristics. Extant work is rare.
Hoan (1120–1124)	Bitchu	Ko-Aoe Yasutsugu (古青江安次)	These swords have Yamashiro-tradition characteristics. Refer to page 141.
Ninpyo (1151–1154)		Ko-Aoe Moritsugu (古青江守次)	These swords have Yamashiro-tradition characteristics. Refer to page 141.
	Yamato	Ko-Senjuin Yukinobu (古千手院行信)	There are no extant works. Refer to page 157.
Eiryaku (1160–1161)	Bungo	Sadahide (古千手院定秀)	These swords have Yamashiro-tradition characteristics. The blade has distinct funbari. One blade by this smith has a cherry blossom engraved at the bottom. In Sadahide's work, the jihada is fine mokume hada, mixed with o-hada, ji-nie, and chikei. The hamon is narrow suguha hotsure mixed with ko-midare. Fine kinsuji and inazuma appear. The boshi is ko-maru, yakitsume, and nie kuzure.
Nin'an (1166–1169)	Yamato	Ko-Senjuin Shigehiro (古千手院重弘)	None of Shigehiro's work is extant. Refer to page 157.
Joan (1171–1175)		Ko-Senjuin Shigenaga (古千手院重永)	None of Shigenaga's work is extant. Refer to page 157.

THE MAIN SCHOOLS AND EVOLUTION OF THE YAMASHIRO (山城) TRADITION

During the early development of the Japanese sword in the late Heian period, the most refined workmanship was seen in Kyoto, the major cultural center and metropolitan area of the period. Sanjo Munechika's work is representative of late-Heian Kyoto.

In the Kamakura period, the Awataguchi school took over the style of workmanship of the Sanjo school and established the Yamashiro tradition. The Ayanokoji and Rai schools appear after the Awataguchi school, followed by the Ryokai and Enju schools. As a result, the Yamashiro tradition reached the height of its prosperity in the Kamakura period. The Soshu tradition, which flourished beginning at the end of the Kamakura period, was developed by a swordsmith who originally belonged to the Awataguchi school. This was Awataguchi Kunitsuna, one of the pioneers of the tradition. Afterward, workmanship related to, or inclined toward, the Yamashiro tradition, may be seen in many different districts and schools.

Throughout the Kamakura period, the workmanship of Yamashiro-style blades is characterized by a jihada of very good quality and a fine ko-mokume that is clear and soft. Yubashiri, chikei, and abundant ji-nie are also evident.

There are two patterns of hamon seen in Yamashiro work of the Kamakura period:

a) Ko-choji midare based on suguha, mixed with ko-nie, and displaying splendid activity;

b) A wide suguha choji midare (choji midare based on suguha), with ashi and nie. There is also a similar Kyo (Yamashiro) choji midare. The Bizen tradition is known to have influenced the Yamashiro tradition during the Kamakura period.

The boshi generally has the same width as the hamon, with abundant nie. Occasionally, however, it contains only a very small amount of nie. O-maru and ko-maru are the main patterns, though other patterns are often seen.

Many tanto masterpieces were made in the Yamashiro tradition during the mid-Kamakura period. They are generally made in hira-zukuri and are josun (standard length, about 26 cm), with slight uchi-zori, normal mihaba, a small amount of thick kasane, high iori- or mitsu-mune, full hira-niku, and normal fukura. The sugata is very refined and wholly dignified. The nakago is long and plump. Furisode-gata is sometimes also seen. In this tradition, tanto frequently have engravings such as bonji, suken, goma-hashi and koshibi. The horimono is usually centered on the mihaba. The top lines of the suken tend to be rounded; the angles of the sides are not very sharp. The suken horimono has a regular depth from top to bottom, called Kyo-bori (Yamashiro-style engraving).

The jihada on the tanto is finer than that on the tachi, and ji-nie, yubashiri, and chikei are seen on it. The hamon is a narrow chu-suguha with hotsure and small activity, sometimes mixed with ko-choji midare. The boshi is nie kuzure, yakitsume, or kaen. Naturally,

TANTO OF THE YAMASHIRO TRADITION

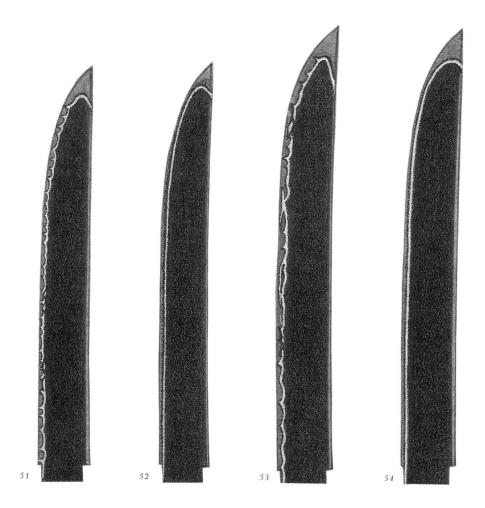

51 52 53 54

51. Early to mid-Kamakura period: Blades are hira-zukuri (with a standard length [josun] of about 26 cm) and uchi-zori. The jihada is very fine. The hamon is based on suguha and shows a great deal of activity.

52. Early and mid-Kamakura period: The width of the hamon is narrow, with abundant hotsure and nie. Horimono are common. Overall, this style is very gentle and refined.

53. Late Kamakura period: The blade is a little longer than that of the preceding period, and has very little sori. The jihada is a fine mokume hada. The hamon is based on suguha with nie, and shows a great deal of activity.

54. Late Kamakura period: The tanto jihada is finer than that of the tachi. Ji-nie, chikei, and yubashiri are seen. The boshi is ko-maru, nie kuzure, yakitsume, or kaen.

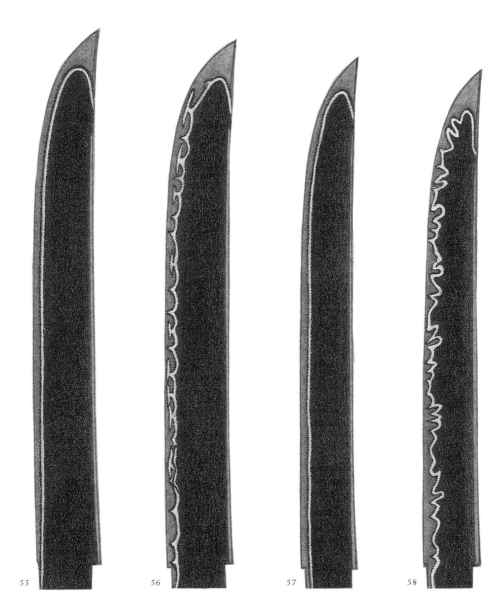

55. Nanbokucho period: Blade length increases. The tanto is also called ko-wakizashi in hira-zukuri, and is characterized by sori and a wide mihaba. The hamon is chu-suguha in nie deki.

56. Nanbokucho period: The hamon is suguha-choji midare with many ashi. Kinsuji, inazuma, nie kogori, and nioi kogori are also seen.

57. Muromachi period: Sanjo Yoshinori, (Oei-era) Nobukuni, etc. The jigane is beautiful, but the suguha lacks activity, and the habuchi is tightened. The kaeri has a steep stop.

58. Muromachi period: Nobukuni of the Oei era and other smiths. The koshi-no-hiraita midare is tempered, in keeping with the Bizen tradition, which is the most influential style of this time. Nie-ji and nie are more common than in work of the original Bizen tradition.

THE AWATAGUCHI (粟田口) SCHOOL

A group of excellent swordsmiths known as the Awataguchi school lived in Awataguchi, Yamashiro province, from the early through the mid-Kamakura period. Kuniyori (国頼)'s son, Kuniie (国家), is said to have founded the school. It included six brothers—Kunitomo (国友) (Kuniie's son), Hisakuni (久国), Kuniyasu (国安), Kunikiyo (国清), Arikuni (有国), and Kunitsuna (国綱)—as well as Kunitomo's son Norikuni (則国), his grandsons Kuniyoshi (国吉) and Kunimitsu (国光), and Toshiro Yoshimitsu (吉光), who is said to have been either a son or student of Kuniyoshi. The work of all these smiths, except Kuniyori and Kuniie, is extant, and shares a number of characteristics in common.

Awataguchi Kunitsuna moved from Yamashiro province to Soshu, in Sagami province. His son is said to have been Shintogo Kunimitsu (新藤五国光). Kunihiro (国広), Yukimitsu (行光), and Masamune (正宗) belong to Kunimitsu's school. The work of Yukimitsu and Masamune shows characteristics of the Soshu tradition, but it is also clear that the Awataguchi school's Yamashiro tradition was one of the basic influences in founding the Soshu tradition. No significant Awataguchi smiths are recognized after Yoshimitsu, and the Rai school eventually replaced the Awataguchi as the foremost swordsmithing school in Yamashiro province.

Sugata: During the early Kamakura period, the Awataguchi sugata did not differ greatly from that of the Sanjo school, but in the mid-Kamakura period it became an ikubi kissaki tachi, with a mihaba that was wide even in the yokote area. The school's tanto was normal in length and width, and showed slight uchi-zori.

Jihada: The Awataguchi jihada is called nashiji-hada, and is generally recognized as being of the finest quality, surpassed only by the jihada of the Sanjo school. It is a dense ko-mokume hada, mixed with chikei. Yubashiri appear and thick ji-nie are seen all over the ji.

Hamon: Originally, the narrow hamon tends to become even narrower toward the top. The hamon consists of suguha hotsure, a suguha mixed with ko-choji midare, or, occasionally, rather wide suguha choji midare, with nie. Thick, bright ko-nie, which reflect light brilliantly, are called Awataguchi nie. This hamon has a good deal of nie, nioi kogori, fine kinsuji, and inazuma activity.

Boshi: The nie in the boshi are rougher than those in the hamon. The boshi are ko-maru and o-maru, with short kaeri. Yakitsume, nie kuzure, and kaen are also seen.

Horimono: Bo-bi, soe-bi, koshibi, and ken are the usual horimono seen with this school. Bo-bi are quite common; the top of the hi is close to the ko-shinogi line and resembles a straight line, rather than a rounded shape. The bottom of the groove is usually stopped with a kaku-dome just below the machi, but maru-dome, kaki-nagashi, and kaki-toshi are also seen. In tanto, simple horimono like suken, bonji, and goma-hashi can be seen. Characteristic of the Awataguchi school is that goma-hashi are engraved near the mune. Generally speaking, the pattern of horimono is different on either side, but in this school the same pattern is often engraved on both sides.

Nakago: Awataguchi tachi nakago are long and slender. They feature sori and hira-niku, as well as a slightly curved, but flat, surface. The kijimomo nakago is seen. The tanto can take either of two nakago shapes, one without sori, and the other a furisode nakago. The nakagosaki is a shallow kurijiri. The yasurime is kiri, or a gentle katte sagari. Signatures usually have two characters.

THE RAI (来) SCHOOL

The Rai school, which, with the Awataguchi school, is representative of Yamashiro blades, was active from the latter mid-Kamakura period through the Nanbokucho period. The reason that this school is known as the Rai school is that they precede their signatures with the character "Rai" (来). One old account gives Kuniyoshi (国吉) of the Awataguchi style

as the founder of the Rai school, but this is difficult to confirm since none of his work is extant; others suggest that his son Kuniyuki (国行) is the actual founder of the school. Kuniyuki was followed by Kunitoshi (国俊), Ryokai (了戒), Kunimitsu (国光), Kunitsugu (国次), and Chudo Rai Mitsukane (中島来国長). During the Nanbokucho period, Kunisue (国末), Kunizane (国真), Tomokuni (倫国), Kuniyasu (国安), and Nakajima Rai Kuninaga (中島来国長) were all active.

Rai Kunimitsu's workmanship shows a few characteristics of what would become known as the Soshu tradition. Afterward, the Soshu tradition is clearly recognizable in the workmanship of the Rai school, particularly in that of Kunitsugu, but quality of workmanship declined quite markedly during the Nanbokucho period.

There are a number of blades with the two-character signature, namely, "Kunitoshi," and others bearing the three-character signature "Rai Kunitoshi." There is some controversy about whether these are the work of the same swordsmith, or of two different people. Those who say that they are the same explain the difference in the names by saying that the two-character signature is Kunitoshi's way of signing his early work, and that he began to use the three-character signature later in life. Nowadays, however, it is widely believed that different smiths named Kunitoshi were working at the same time.

Sugata: Kuniyuki's work resembles sugata of the late Heian to the early Kamakura period, in that it is both gentle and graceful, but the difference in width at the bottom and the top of his blades is not as great as that generally seen in swords of that period. His work gradually becomes an ikubi kissaki tachi sugata with a wide mihaba. Meanwhile, swords of Kunitoshi (with the three-character signature), and of Ryokai, and, occasionally, Kunimitsu, have the old sugata seen in the late Heian period through the early Kamakura period. However, these blades generally look grander and show rather vigorous workmanship. The

kissaki of Kunimitsu and later swordsmiths becomes larger. Regardless of the workmanship, the sugata exhibits features characteristic of the Nanbokucho period. Tanto sugata underwent remarkable changes from about the time in which Kunimitsu worked.

Jihada: The ko-mokume hada is dense and has ji-nie, yubashiri, and chikei. The quality of the jigane is slightly inferior to work of the Awataguchi school. Usually, Rai-hada (or gane), which refers to a weak jigane with a color and pattern different from that of ordinary jihada, appears somewhere on the blade. The Rai-hada is a very important feature to look for when appraising swords of the Rai school. Nie utsuri and muneyaki are visible. Masame-hada is also sometimes seen, and is especially noticeable in the work of Rai Kunitoshi and Ryokai.

Hamon: Chu-suguha mixed with ko-choji midare, o-choji midare, and choji midare based on suguha, with ko-nie. Nie nioi kogori, ashi, yo, kinsuji, and inazuma are seen. Gorgeous choji midare is seen on the work of the two-character Kunitoshi, and choji midare is seen on blades by Kuniyuki and Kunimitsu. Kunitsugu's nie has a highly reflective quality and, this workmanship shows prominent characteristics of the Soshu tradition, even though he made swords with suguha.

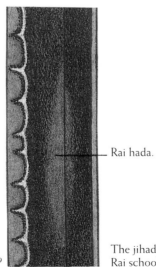

— Rai hada.

The jihada and hamon of the Rai school.

Boshi: In proportion to the hamon, the boshi becomes yakitsume, ko-maru, nie kuzure, and kaen, with abundant nie in all cases. The kaeri turns back short, with a gentle curve. Slightly longer kaeri are sometimes seen in the blades of Rai Kunitoshi, Kunimitsu, and Kuninaga.

Horimono: Bo-bi with kaki-toshi are common, as are ken and bonji. A wide hi, without any unevenness, is skillfully engraved. In tanto, one will often see suken, bonji, and goma-hashi.

Nakago: In tachi, the nakago features hira-niku and a little sori, and the tip becomes narrow. Tanto nakago are without sori or become the furisode type. The tip is a shallow kurijiri. The yasurime is kiri or gentle katte sagari. The signature usually has three characters and the dates of forging can sometimes be seen on the tang.

THE AYANOKOJI (綾小路) SCHOOL

Sadatoshi (定利), Sadayoshi (定吉), and others who lived at Ayanokoji in Yamashiro province during the middle to late Kamakura period are grouped together into the Ayanokoji school. Nagamasa (永昌) is said to have been the founder. Also included in the Ayanokoji school are: Sukesada (介定), Sadaie (定家), Sadatoshi (定俊), Sueyuki (末行), and Tadaie (忠家), but none of their works are extant. Sadatoshi is said to

60

The jihada and hamon of Ayanokoji Sadatoshi.

have been a friend of Rai Kuniyuki's, but his work appears older in that it resembles that of the Sanjo school rather than that of Rai Kunitoshi.

Sugata: Tachi are slender, with ko-kissaki. A wide mihaba at the bottom of the blade and in the yokote area is sometimes seen, and the kissaki resembles ikubi.

Jihada: The jigane is soft and the ko-mokume hada is mixed with some masame-hada. Abundant ji-nie, yubashiri, and chikei are seen.

Hamon: The temper line is ko-choji midare of proper width and has nie with a lot of activity such as fine kinsuji and inazuma. The pattern of the hamon is inclined to be regular; the top is small and rounded.

Boshi: The boshi are ko-maru, nie kuzure, yakitsume, kaen.

Horimono: Common carvings are bo-bi, futa-suji-bi, and similar designs.

Nakago: The nakago is long and has a little niku. The two-character signature looks classical.

THE UKAI (鵜飼) (OR UKAN [宇甘]) SCHOOL

The smiths who lived at Ukai, Bizen province, show a style of workmanship quite distinct from that of other swordsmiths of this province. The differences are Yamashiro characteristics that are easily recognizable in their work. This is said to be because the founder of the school originally started his career in Yamashiro province and afterward moved to Bizen. The school's leading smiths are Unjo (雲生), Unji (雲次), and Unju (雲重). They are also called the Unrui (Un family), because each uses the character "Un" (雲) as the first syllable of his name. There seem to have been later generations who succeeded to their names, and these smiths were active from the end of the Kamakura period through the Nanbokucho period.

Sugata: The sugata reflects the features of the

period. These are a gentle tachi sugata, inclined toward ikubi kissaki tachi.

Jihada: This is a mokume-hada mixed with masame-hada. Jifu utsuri appears.

Hamon: The hamon is chu-suguha, mixed with ko-choji midare, ko-midare, and saka ashi. There are fewer ashi and less activity in the upper than in the lower area of the temper line. Nijuba can at times be seen. The hamon consists of tight nioi and very fine nie.

Boshi: The boshi is midare komi in proportion to the hamon, or a very gentle notare komi.

Nakago: The yasurime is o-sujikai. Signatures usually have two characters, but there are occasional cho mei, or signatures with many characters.

THE AOE (青江) SCHOOL

Iron manufacture began in Bitchu, Bizen, and Hoki provinces, as well as on the island of Kyushu, in the earliest times, and we find swordsmiths in these locales from the Heian period to the Muromachi period. The mainstream in Bitchu province is the Aoe school, which is classed, on the basis of its workmanship, into further subheadings of the Ko-Aoe, Chu-Aoe, and Sue-Aoe schools. Ko-Aoe spans the late Heian period through the mid-Kamakura period's Ryakunin era (1238–1239); Chu-Aoe continues through the Meitoku era (1390–1393) in the late Nanbokucho period, while the term Sue-Aoe refers to all blades produced during the Muromachi period.

The Ko-Aoe (古青江) school

There were two families in the Ko-Aoe school. The first is represented by Yasutsugu (安次), who was active in the late Heian period, and by his son Moritsugu (守次). These were followed by Sadatsugu (貞次), Tsunetsugu (恒次), and Tsuguie (次家), all of whom were goban kaji, or smiths appointed by the retired emperor, Gotoba. Other smiths of this school included Norizane (則実), Tsunezane (恒真), Kanetsugu (包次), Tametsugu (為次), Yasutsugu (康次),

Toshitsugu (俊次), Suketsugu (助次), Naotsugu (直次), Tsugutoshi (次俊), Tsugutada (次忠), and Moritoshi (守利).

The other family group was called Senoo. The first generation of this family was Noritaka (則高). He was followed by Masatsune (正恒), Tsuneto (常遠), Morito (守遠), and others. There are no particular differences in the workmanship of the two families, and neither family changed its characteristic style very much over time. Both of the Masatsune were very good smiths. Two very famous blades made by smiths of this school were the "Juzumaru Tsunetsugu" and the "Kitsunegasaki Tametsugu."

Sugata: Slender tachi with ko-kissaki show a sugata to be from this period. The curvature of the Aoe-school sword is distinguished by its very deep koshi-zori. The center point of the sori is in the bottom part of the blade, just above the habaki area. The sori in the upper part of the blade, however, is very shallow.

Jihada: Aoe blades have a rather visible distinctive feature called chirimen-hada, and sumigane (dark and plain steel) is also seen occasionally. When the temper line consists of nie, the jihada becomes o-mokume hada, with ji-nie and chikei. When a hamon looks like the Yamashiro tradition mixed with the Bizen tradition, and the hamon also shows nioi, the jihada is a fine mokume-hada mixed with o-hada, and both utsuri and chikei appear.

Hamon: Midare based on suguha, with ashi and yo. Hamon may be mixed with recognizable saka ashi and kumo-no-iwata, but a choji midare hamon is rather unusual. The hamon is chu-suguha with nezumi ashi, but much activity is also seen. The temper line shows the basic workmanship of the Yamashiro tradition of each period. In the early Ko-Aoe, a lot of activity, including abundant nie, kinsuji, and inazuma, is seen, and the ha-hada (forging pattern inside the hamon) is visible. In the late Ko-Aoe, nie become less apparent and the hamon is inclined to have more nioi, showing considerable influence of Bizen-tradition workmanship.

Boshi: In proportion to the hamon, boshi become midare komi or suguha, with a short kaeri, yakitsume, and, occasionally, ichimonji kaeri.

Horimono: Bo-bi are common. The hi usually has katachiri, but the original presumably had ryo-chiri and was reshaped later.

Nakago: The nakago is long and has a little niku (meat). Kijimomo nakago are occasionally seen. The yasurime is o-sujikai. Aoe-school swords bear a unique two-character signature, which is inscribed on the side opposite that of the usual tachi.

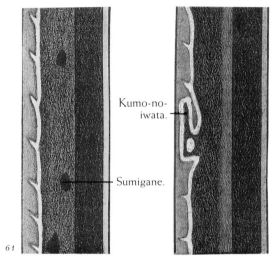

Kumo-no-iwata.

Sumigane.

The jihada and hamon of the Ko-Aoe school.

The Chu-Aoe (中青江) school

There is a rather large difference between the sugata of the Kamakura and Nanbokucho periods. In the early Chu-Aoe school, smiths focused on producing a considerable number of tanto and ko-wakizashi which were hira-zukuri in type. Nagamaki naoshi can seen throughout these periods. The leading swordsmiths of this school are Chikatsugu (親次), Hidetsugu (秀次), Yoshitsugu (吉次), Naotsugu (直次), Tsuguyoshi (次吉), Tsugunao (次直), Moritsugu (守次), Ietsugu (家次), Tamenori (為則), Kunitsugu (国次), Tsunetsugu (恒次), Nagatsugu (長次), and Shigetsugu (重次). Many others later succeeded to the names of the Ko-Aoe swordsmiths.

Sugata: The sugata shows features typical of this period. Many blades were shortened and the nagamaki were reshaped into nagamaki naoshi, since the original length was very long. There are two tanto sugata. One is the standard length of approximately 26 cm, and has uchi-zori, thick kasane, and a narrow mihaba. The other is a ko-wakizashi with saki-zori, a wide mihaba, and thin kasane, and which is hira-zukuri in its construction.

Jihada: Fine mokume-hada mixed with o-hada. Utsuri appears and sumigane are noticeable.

Hamon: Temper lines are similar to those of the Ko-Aoe hamon, but look vigorous, and have a pattern which becomes larger in proportion to the sugata. There are Bizen-tradition characteristics, mixed with those of the Yamashiro tradition, including saka-choji midare, suguha with nezumi ashi, and saka ashi. Ko-Aoe–style yaki kuzure is seen as well. The distinctive feature of Aoe-school blades is a hamon inclined to a slanting pattern, but the width is never as great as in the Katayama Ichimonji school's saka-choji midare.

Boshi: Known as the Aoe boshi, this draws the line against the bulk of the kissaki. The top is inclined to be pointed, and the nioi-guchi is tight. The boshi becomes midare komi and ko-maru in proportion to the hamon.

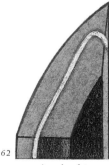

Aoe boshi.

Nakago: Two-character signatures are common and the date is occasionally carved on the tang.

The Sue-Aoe (末青江) school

Some swordsmiths of the Aoe school were still active during the Muromachi period, and we

find examples of their work on occasion. The jigane is hard, while the hamon is suguha, gunome midare, or koshi-no-hiraita midare. Yaki kuzure is usually seen somewhere on the blade. The quality of manufacture is inferior to the swords of the preceding period.

Few Aoe-school swords made during the Muromachi period are extant, so some people employ a different system of classification for this school's subgroupings. In this system, smiths active from the middle to the end of the Kamakura period are called Chu-Aoe and swordsmiths during the Nanbokucho period are called the Sue-Aoe school.

THE ENJU (延寿) SCHOOL

The Enju school, which produced swords in the Kikuchi area in Higo province, has certain features that are unique among Kyushu swordsmiths. Hiromura (弘村), who came from Yamato province, is generally known as the founder of the school, but in fact his son, Kunimura (国村), is thought to be the actual founder of the style. The name of this school originated from Enju Taro, a name that Kunimura used. Hiromura is said to have been Rai Kuniyuki's grandson or son-in-law, and there are some similarities between his workmanship and that of the Rai school. Examples of this school's work date from the mid-Kamakura through the Muromachi periods. The Enju school is divided into three periods: Ko-Enju, which includes swordsmiths from the middle through the late Kamakura period; Chu-Enju, smiths active in the Nanbokucho period; and Sue-Enju, smiths of the Muromachi period.

The Ko-Enju (古延寿) school
Works by Kuniyasu (国泰), Kunisuke (国資), Kunitoki (国時), and Kunitomo (国友) are extant. The names of a number of smiths of this school seem to have been handed down through the generations.

Jihada: Fine ko-mokume hada mixed with a little masame-hada and chikei appears. Enju gane, a type of dark, detailed, plain jigane, is seen in the ji.

The sugata and the jihada are similar to the work of Rai Kunimitsu, but this school's jihada appears whitish and is mixed with masame-hada. Enju gane is very similar to Rai gane, but looks darker and stronger.

Hamon: Chu-suguha mixed with hotsure, ko-midare, and ko-choji midare. Activity resembling the nie-nioi kogori, ashi, kinsuji, and inazuma of work by Rai Kunimitsu is seen.

Boshi: Ko-maru boshi with abundant nie is the normal type for this school.

The Chu-Enju (中延寿) school
Chu-Enju smiths include Kuniyoshi (国吉), Kunikiyo (国清), Kunitsuna (国綱), Kunifusa (国房), and Kunishige (国重).

Sugata: The sugata shows features typical of the period, but there are no blades with wide mihaba or o-kissaki. The tanto have two sugata, both uchi-zori and mu-zori, and blades without any curvature. The mihaba becomes a little wider than that of the tanto produced in the preceding period. Hi and horimono are not commonly seen.

Jihada: There is hardly any difference between the Chu-Enju jihada and that of Ko-Enju.

Hamon: Chu-Enju hamon are similar to the work of Rai Kunitoshi and Rai Kunimitsu but have less nie as well as less activity.

Boshi: Normal ko-maru or ko-midare.

The Sue-Enju (末延寿) school
The Sue-Enju jigane is hard. The hamon is chu-suguha, but the blade does not show characteristics of the original Yamashiro tradition. The workmanship shows features in common with Sue-Koto (blades produced in the late Muromachi period). Further, it is very difficult to distinguish Sue-Enju workmanship from that of the Yamato tradition. Sometimes Sue-Enju work is also very similar to that of Dotanuki-school smiths who lived in the same province.

LEADING SWORDSMITHS OF THE YAMASHIRO TRADITION

ERA	PROVINCE	SWORDSMITH(S)	PATTERN
Genryaku (1184–1185)	Bungo	Yukihira (行平)	Horimono are common and the design is simple, including short ken-maki-ryu in the hitsu (groove), bonji, deities, and personages. The jihada is ko-mokume and looks like cotton floss; it is sometimes mixed with o-hada. Yakiotoshi is seen and the yakidashi (the beginning of the hamon) is located 3 to 6 cm above the hamachi. The name inscribed in the nakago is a cho mei (a long signature, of more than four characters). Some tanto can be seen.
	Bitchu	Ko-Aoe Sadatsugu (古青江貞次)	Refer to page 141.
Bunji (1185–1190)		Ko-Aoe Tsunetsugu (古青江恒次)	Refer to page 141.
Kenkyu (1190–1199)	Yamashiro	Awataguchi Kunitomo (粟田口国友)	Suguha hotsure and rather gentle nie activity. Refer to page 92.
		Awataguchi Hisakuni (粟田口久国)	An excellent, skillful swordsmith. The blade shows vigorous workmanship. The hamon is chu-suguha hotsure and ko-choji midare. The ko-maru boshi is inclined to be notare. Tanto are also seen. Refer to page 138.
	Bitchu	Ko-Aoe Norizane (古青江則実)	Refer to page 141.
		Ko-Aoe Tsunezane (古青江恒真)	Refer to page 141.
Shoji (1199–1201)	Yamashiro	Awataguchi Kuniyasu (粟田口国安)	The sori is comparatively shallow. The hamon is wide, with flamboyant choji midare or sugu choji midare. Refer to page 138.
Genkyu (1204–1205)		Awataguchi Kunitsuna (粟田口国綱)	After moving to Sagami province, Kunitsuna became one of the first Kamakura swordsmiths. His blades still show signs of the Yamashiro tradition and his work represents some of the most vigorous of the Awataguchi-school smiths. The hamon is suguha choji midare with ashi and nie-nioi kogori. The nie are rather rough. The boshi is midare komi, in proportion to the hamon. The activity of nie in the boshi is brilliant. There are some extant ko-dachi (short tachi, 60–70 cm long). In tanto, the kasane is thick, with such horimono as suken, goma-hashi, and koshibi. Tanto hamon are chu-suguha hotsure, with many active nie. Tanto boshi are ko-maru, with slightly long kaeri.
		Awataguchi Kunikiyo (粟田口国清)	Refer to page 138.
		Awataguchi Arikuni (粟田口有国)	Rather gorgeous ko-choji midare. Refer to page 138.
Ken'ei (1206–1207)	Bitchu	Ko-Aoe Masatsune (古青江正恒)	Refer to page 141.
Jogen (1207–1211)		Ko-Aoe Ietsugu (古青江次家)	Refer to page 141.
		Ko-Aoe Tsunesugu (古青江恒次)	Refer to page 141.
Kenryaku (1211–1213)		Ko-Aoe Naotsugu (古青江直次)	Refer to page 141.

ERA	PROVINCE	SWORDSMITH(S)	PATTERN
		Ko-Aoe Toshitsugu (古青江俊次)	Refer to page 141.
		Ko-Aoe Tametsugu (古青江為次)	Refer to page 141.
Kenryaku (1211–1213)	Bitchu	Ko-Aoe Yasutsugu (古青江康次)	Refer to page 141.
Jokyu (1219–1222)	Yamashiro	Awataguchi Norikuni (粟田口則国)	Refer to page 138.
	Bitchu	Ko-Aoe Suketsugu (古青江助次)	Refer to page 141.
Joo (1222–1224)	Dewa	Gassan (月山)	A number of old accounts tell of Gassan's living in the Heian period, but work of his predating the Muromachi period is very rare. His work is majiwarimono.
Joei (1232–1233)	Bizen	Saburo Kunimune (三郎国宗)	Kunimune's work includes Bizen tradition mixed with Yamashiro tradition, as well as pure Bizen tradition. The jihada is a dense ko-mokume hada, with distinct utsuri. The hamon is nioi, choji midare based on suguha, and a good deal of nioi ashi. In the monouchi area, activity becomes less apparent and the hamon becomes a simple suguha with some ashi. The boshi is ko-maru and yakitsume.
Ryakunin (1238–1239)	Bitchu	Ko-Aoe Tsugutoshi (古青江次俊)	Refer to page 141.
Ninji (1240–1243)	Yamashiro	Awataguchi Kuniyoshi (粟田口国吉)	Kuniyoshi's swords have a strong sugata with steep sori. He was a master not of tachi, but of tanto. His hamon tend to have nioi, with tight nioi-guchi. Niju-ba can often be seen. Refer to page 138.
Hoji (1247–1249)	Bitchu	Chu-Aoe Tamenori (中青江為則)	Bizen-tradition characteristics are also seen in his work. Refer to page 142.
		Chu-Aoe Kunitsugu (中青江国次)	Refer to page 142.
Kencho (1249–1256)		Chu-Aoe Tsunetsugu (中青江恒次)	Refer to page 142.
		Chu-Aoe Ietsugu (中青江家次)	Refer to page 142.
Kogen (1256–1257)	Bizen	Osafune Kagehide (長船景秀)	Kagehide's work is Bizen tradition mixed with Yamashiro tradition, as well as pure Bizen tradition. Grooves are common and horimono are seen in the tanto. The hamon consists of nioi, is choji midare based on suguha, and has long nioi ashi. In the monouchi area, the hamon becomes a simple suguha without much activity, through the yokote line. The boshi is midare komi. Many tanto made by Kagehide are extant.
Shogen (1259–1260)	Yamashiro	Awataguchi Yoshimitsu (粟田口吉光)	Yoshimitsu tachi are rarely seen. Other than a few tachi and nagamaki naoshi, his extant works are all tanto. The jihada is a typical nashiji hada and the highest quality of any in the Awataguchi school. The hamon consists of nie and is chu-suguha hotsure, with five or six waves of ko-gunome with

63

Toshihiro
Yoshimitsu's tanto.

			ashi in the yakidashi. The hamon is narrower but more active in the fukura area. Nie are rougher in the boshi, and some clusters of nie appear in the ji in the kissaki. Refer to page 138.
Bun'ei (1264–1275)		Rai Kuniyuki (来国行)	The sugata shows features of the early Kamakura period. The hamon is inclined to have a small pattern, and is generally choji midare mixed with ko-midare based on suguha, with long nie and nioi ashi. Warabite choji (bracken-shaped choji) are a common feature of his blades, especially in the monouchi area through the yokote line. His work also displays o-choji midare, with koshiba in the bottom area. Inazuma is often seen in the yokote area. There are few tanto.
		Ayanokoji Sadatoshi (綾小路定利)	The sugata shows features typical of the early Kamakura period. Horimono are rare. The hamon is ko-choji midare, with a lot of nioi ashi. The top of each midare is rounded, and the pattern is rather small and repeated regularly from bottom to top. The jigane is somewhat weak and the jihada is slightly coarse.
	Bizen	Osafune Nagamitsu (1st generation) (長船 初代 長光)	Some people suggest that Nagamitsu is actually the same person as Jinkei. His work shows elements of Bizen tradition mixed with Yamashiro tradition, as well as of pure Bizen tradition. Some of his blades have a sugata with features of the late Heian period. The shinogi is slightly high. The blade has noticeable funbari and the yokote area is narrow. Hi and horimono are rare in his work. The jihada is a dense ko-mokume hada with utsuri. The hamon consists of nioi ko-choji midare with ko-midare. The pattern is inclined to be slanted and based on suguha, or chu-suguha with slanted ashi. The nioi-guchi is tight. The width of the hamon narrows just above the yokote line and finally becomes o-maru or ko-midare.
	Bitchu	Chu-Aoe Tsuguyoshi (中青江次吉)	Tsuguyoshi's work also shows signs of Bizen tradition. Refer to page 142.
Kenji (1275–1278)	Higo	Ko-Enju Kunimura (古延寿国村)	Kunimura's blades have a deep sori and a distinct funbari. The jihada is mixed with a wavy o-hada. The width of the hamon is narrow. Refer to page 143.
Koan (1278–1288)	Sagami	Shintogo Kunimitsu (新藤五国光)	Kunimitsu is said to have been the son of Awataguchi Kunitsuna, and to have lived in the Bunpo era (1317–1318). He seems to have been mainly a maker of tanto, and his extant tachi are rare. His tanto are a bit shorter than those of other smiths of the period, with a fukura that is not round. Horimono such as su ken, goma-hashi, and koshibi are common. Occasionally, his work is in the kanmuri-otoshi-zukuri style.

The jihada is ko-mokume hada, with abundant ji-nie, chikei, and yubashiri. There are nie utsuri. The yubashiri of swords of the Awataguchi school and those of Shintogo Kunimitsu differ in that the former look like the Milky Way, while Kunimitsu's tend to be round.

The hamon is chu-suguha or hoso-suguha with very bright, highly reflective

Okina-no-hige.

Yubashiri.

64

The workmanship of Shintogo Kunimitsu.

ERA	PROVINCE	SWORDSMITH(S)	PATTERN
			nie. There is a lot of kinsuji and inazuma activity inside the hamon. In the hamachi area, the hamon widens toward the nakago. Examples of midareba are very rare. The famous blade "Midare Shinto-go" is unusual in that it shows a midareba. Nie in the boshi are rougher than in the lower part of the blade. Nie spilling from the boshi to the ji create brush lines that are referred to as okina-no-hige (old man's beard). The boshi is ko-maru, with nie kuzure to yakitsume.
Koan (1278–1288)	Bitchu	Chu-Aoe school (中青江派)	Several swordsmiths are known to have existed. Refer to page 142.
	Yamashiro	Niji Kunitoshi (二字国俊)	Few of his tanto are extant. His work is similar to that of Rai Kunitoshi, but is more flamboyant and grander.
	Bizen	Yoshioka Ichimonji Sukeyoshi (吉岡一文字助吉)	Sukeyoshi blades show Bizen tradition mixed with Yamashiro tradition, as well as pure Bizen tradition. The hamon is suguha choji midare or ko-midare based on suguha, with a tendency toward slanted patterns. Refer to page 179.
	Yamashiro	Rai Kunitoshi (来国俊)	Kunitoshi's work has a gentle sugata with features of the late Heian period. Bo-bi and futasujibi are evident. The jigane is well forged and the jihada is a fine ko-mokume hada, mixed with masame hada, that shows ji-nie and chikei. The hamon is a narrow suguha, with nie-nioi kogori, and gentle-looking ashi, kinsuji and inazuma. The boshi is o-maru or maru with a short kaeri. Kunitoshi is known as a tanto expert and made many shorter blades representative of the Yamashiro tradition.
		Ryokai (了戒)	Ryokai is said to have been the son of Rai Kunitoshi. His sugata show features similar to those of the late Heian period. A famous sword of his, the "Ataki Ryokai," is made in the u-no-kubi-zukuri style. Generally speaking, his workmanship is similar to that of Rai Kunitoshi, but is a bit inferior in quality. With the exception of blades by Ryokai, extant work of the Rai school is rare. His successors moved to Bungo province during the Muromachi period and prospered as the Tsukushi Ryokai school.
Shoan (1299–1302)	Bizen	Osafune Nagamitsu (2nd generation) (長船 二代 長光)	Nagamitsu worked under the honorary title of Sakon Shogen. His work includes Bizen tradition mixed with Yamashiro tradition, as well as pure Bizen. The jigane is soft, and utsuri with fine ko-mokume hada appears. His work is similar in all aspects to that of the first-generation Nagamitsu. The hamon is suguha choji midare with long nioi ashi, or a chu-suguha with choji ashi that are slightly slanted. The boshi becomes sansaku boshi.
		Osafune Kagemitsu (長船景光)	Kagemitsu's work includes Bizen tradition mixed with Yamashiro tradition, as well as pure Bizen. The jigane is soft. The jihada is ko-mokume hada. One can observe utsuri and, occasionally, bo-utsuri. Fine nie are also seen inside the hamon, although it contains nioi. The hamon is suguha choji midare with ashi, inclining toward a slanted pattern. A chu-suguha is also seen. The boshi is typically a sansaku boshi, but in tanto the o-maru boshi is more common.
		Osafune Sanenaga (長船真長)	Sanenaga's workmanship is very similar to that of Nagamitsu and Kagemitsu.

ERA	PROVINCE	SWORDSMITH(S)	PATTERN
Kengen (1302–1303)		Ukai Unjo (鵜飼雲生)	The jihada is a weak mokume hada and is sometimes mixed with masame hada. The hamon is a narrow suguha mixed with ko-midare and saka ashi, of nioi and a little nie. Nie kogori are visible in some spots. The boshi is midare komi, in proportion to the hamon.
Kagen (1303–1306)		Osafune Motoshige (1st generation) (長船 初代 元重)	Called Ko-Motoshige. His work includes Bizen tradition mixed with Yamashiro tradition, as well as pure Bizen. The jihada is a fine mokume hada. The jigane looks weak and has jifu utsuri. The hamon is suguha, showing nioi and ko-midare with ashi in a slanted pattern. The boshi is shallow notare with a short kaeri that looks like chikakage boshi.
	Mikawa	Nakahara Kunimune (中原国宗)	Kunimune's work is majiwarimono. The hamon is suguha choji midare and nioi. Nie is seen occasionally.
	Yamashiro	Rai Kunimitsu (来国光)	Many of Kunimitsu's extant works have a sugata reflecting characteristics of the mid- and late Kamakura period and the Nanbokucho periods; the workmanship of his Yamashiro tradition changes, depending on the sugata. Many of his tanto are masterpieces. The jigane is well forged, with fine jihada. Ji-nie, yubashiri, and chikei are seen. In his works of the Nambokucho period, independent midare, inclined to be box-shaped, are commonly seen in the monouchi area.
Tokuji (1306–1308)	Inaba	Kokaji Kagenaga (小鍛冶景長)	Kagenaga is said to have been a student of Awataguchi Yoshimasa. His extant work is rare. The blades that do remain are slender and look rather graceful, reminding one of the Awataguchi school.
Enkyo (1308–1311)	Higo	Ko-Enju Kuniyasu (古延寿国泰)	His tanto are without sori, and have brilliant nie activity. Refer to page 143.
Showa (1312–1317)	Yamashiro	Rai Kunizane (来国真)	Kunizane is said to have been either the son or the student of Rai Kunitoshi. His work looks similar to that of Kunitoshi but is inferior to it in quality.
	Omi	Rai Mitsukane (来光包)	Also called Chudo Rai, he is said to have been a student of Osafune Nagamitsu's or Rai Kunitoshi's. His tachi are no longer extant, but some of his tanto remain. His work is similar to that of Toshiro Yoshimitsu. Mitsukane's midareba occasionally resemble the blades of Nagamitsu or Kagemitsu. His famous "Midare Mitsukane" is one of these swords.
	Sagami	Ichimonji Suketsuna (一文字助綱)	Son of Kamakura Ichimonji Sukezane. His work is Bizen tradition mixed with Yamashiro tradition, as well as pure Bizen. The hamon is a bit narrow and is suguha choji midare, with nie rather than nioi. There are many ashi, consisting of thick nioi, and the hada stands out quite distinctly.
Bunpo (1317–1319)	Bizen	Ukai Unji (鵜飼雲次)	The jigane is a bit hard. The jihada is mokume hada mixed with masame hada, and jifu utsuri appears. The yaki hada is inclined to be wide. The hamon contains nioi and ko-midare, and is based on suguha or notare with saka ashi. The nijuba looks a little like the foggy, overcast slope of a mountain. The boshi is notare with a slight turn-back.

ERA	PROVINCE	SWORDSMITH(S)	PATTERN
Shochu (1324–1326)	Yamashiro	Heianjo Mitsunaga (平安城光長)	Little of his work is extant.
Karyaku (1326–1329)	Higo	Ko-Enju Kunisuke (古延寿国資)	Kunisuke's workmanship is similar to that of Kuniyasu. Refer to page 143.
Gentoku (1329–1331)	Yamashiro	Heianjo Yoshinaga (平安城吉長)	Few examples of Yoshinaga's work are extant.
		Rai Kuninaga (来国長)	A student of Rai Kunitoshi's. He is also known as Nakajima Rai since he lived at Nakajima in Settsu province. Bo-bi are common. The jigane is a little hard. The jihada is a coarse mokume hada. The hamon is chu-suguha mixed with small, regular gunome. The boshi is ko-maru.
	Bizen	Kokubunji Sukekuni (国分寺助国)	Sukekuni is said to have been a son of Fukuoka Ichimonji Nobukane. His blades show Bizen-tradition characteristics mixed with Yamashiro tradition, as well as pure Bizen. There are few pieces extant. The jihada is mokume hada, slightly mixed with masame hada. The hamon is suguha choji midare with a little nie and nioi, and is of reasonable width. The boshi is ko-maru and has a slight turn-back.
	Sagami	Shintogo Kunihiro (新藤五国広)	Kunihiro's tachi are rarely seen, but his tanto remain. The workmanship is very similar to that of Kunimitsu but the temper line tends to be wider.
	Bitchu	Chu-Aoe Naotsugu (中青江直次)	The hamon is chu-suguha mixed with ko-midare and saka ashi, or suguha choji midare with ashi that tend to slant. Refer to page 142.

THE NANBOKUCHO PERIOD

SOUTHERN COURTS	NORTHERN COURTS	PROVINCE	SWORDSMITH(S)	PATTERN
Kenmu (1334–1336)	Kenmu (1334–1338)	Yamashiro	Nobukuni I (初代 信国)	Also works in the Soshu tradition. His work is similar to that of Sadamune, but the quality is not as good. Excellent, sometimes very elaborate horimono such as bo-bi, bo-bi with futasuji-bi, ken-maki-ryu, and bonji are seen. The head of the ken is rather pointed and looks very sharp. The upper part of the ken is cut more deeply and more widely than the lower. This feature of Soshu-style horimono differentiates it from carving of the Yamashiro style. The jihada is mokume hada with ji-nie. The hamon is chu-suguha mixed with ko-midare. The boshi is in proportion to the hamon and the top of the boshi tends to creep up to the line of the mune. Tanto produced by Nobukuni at times resemble those of Rai Kunitoshi, but not many of his pieces are extant.
			Sanjo Yoshinori (三条吉則)	Later generations of smiths using this name were active during the Muromachi period.
		Kaga	Fujishima Tomoshige (藤島友重)	Said to be Rai Kunitoshi's student. Not many of his works are extant, but those that are show some characteristics common to the Rai school. Later generations of smiths also used this name.

SOUTHERN COURTS	NORTHERN COURTS	PROVINCE	SWORDSMITH(S)	PATTERN
Engen (1336–1340)		Inada	Kagenaga II (小鍛冶 二代 景長)	Kagenaga's extant work is rare.
		Bitchu	Chu-Aoe Hidetsugu (中青江秀次)	Refer to page 142.
			Chu-Aoe Sadatsugu (中青江貞次)	Refer to page 142.
	Ryakuo (1338–1342)	Yanashiro	Heianjo Nagayoshi (平安城長吉)	Work from the Engen era is rare, but a considerable number of blades from the later Oei era remain. Nagayoshi is said to have been the teacher of Muramasa, the famous smith from Ise.
Shohei (1346–1370)	Jowa (1345–1350)	Higo	Chu-Enju Kuniyoshi (中延寿国吉)	The yaki hada, or width of the hamon, in Kuniyoshi's swords is narrow. Refer to page 143.
			Chu-Enju Kunikiyo (中延寿国清)	Kunikiyo's work shows a wide yaki hada. Refer to page 143.
			Chu-Enju Kunitsuna (中延寿国綱)	The hamon is chu-suguha, and nie is scarce. The quality of Kunitsuna's work is not as high as that of others of the Chu-Enju school during this period. Refer to page 143.
			Chu-Enju Kunifusa (中延寿国房)	The yaki hada in Kunifusa's work is wide. Refer to page 143.
		Echizen	Chiyozuru Kuniyasu (千代鶴国安)	Blades made by Kuniyasu resemble those of the Rai school. The jihada is mokume hada with sumigane. Muneyaki are visible. The hamon is chu-suguha, hiro-suguha and ko-choji midare, mixed with ko-gunome midare based on suguha; the pattern tends to slant occasionally.
		Bitchu	Chu-Aoe Moritsugu (中青江守次)	Refer to page 142.
Shohei	Bunwa (1352–1356)	Yamashiro	Daruma Shigemitsu (達磨重光)	Extant work by Shigemitsu is rare. He moved from Yamato to Yamashiro province and founded the Daruma school. Masamitsu, who was his second-generation successor, moved to Hachiya in Mino province, after which he was called Hachiya Masamitsu.
	Enbun (1356–1361)	Bitchu	Chu-Aoe Yoshitsugu (中青江吉次)	Refer to page 142.

While there are some extant examples of swords by the later-generation smiths of the Enju, Chu-Aoe, Chiyozuru, Fujishima, Daruma, and Jumyo (of Mino province) schools, produced toward the end of the Nanbokucho period, after the Shohei and Enbun eras, these smiths were not very active, however, and their works are not numerous.

THE MUROMACHI PERIOD

Beginning in the Muromachi period, the general quality of swordsmithing deteriorated markedly. Nie and hataraki are scarce in blades with suguha, and it is difficult to differentiate the workmanship of the Yamato tradition from that of the Yamashiro. It was not unusual for a smith to work in both the Yamashiro and the Yamato traditions, or sometimes even in three traditions. Many swordsmiths are seen in this period but here we mention only prominent smiths, focusing primarily instead on their schools.

ERA	PROVINCE	SWORDSMITH(S)	PATTERN
Oei (1394–1428)	Yamato	Sue-Tegai school (末手掻派)	Refer to page 158.
		Sue-Shikkake school (末尻懸派)	Refer to page 159.
	Higo	Sue-Enju school (末延寿派)	Refer to page 143.
	Yamashiro	Nobukuni (信国)	Nobukuni also worked in the Soshu tradition. Horimono, sometimes ukibori in hitsu (embossing in a groove), are elaborate and found frequently.
Shocho (1428–1429)		Sanjo Yoshinori (2nd generation) (三条 二代 吉則)	Yoshinori's suguha appear to be nijuba.
		Heianjo Nagayoshi (平安城長吉)	Nagayoshi also works in the Soshu and the Mino traditions, in addition to the Yamashiro style. His horimono are longer than those of other smiths, and occasionally include elaborate examples. The jihada is ko-mokume hada mixed with masame hada and is not very visible; in short, the jigane is weak. The hamon is a tight chu-suguha, with a little nie.
	Tosa	Yoshimitsu (吉光)	Yoshimitsu produced mainly tanto. The kasane is very thick and looks like a triangle. The jihada is a weak mokume hada mixed with masame hada. The hamon is hoso-suguha with hotsure. Several generations of smiths used this name.
	Mino	Zenjo Kaneyoshi (善定兼吉)	Kaneyoshi was originally from the Tegai school in Yamato province. He moved to Mino and afterward became the founder of the Zenjo school. The jigane is a little hard and is ko-mokume hada mixed with masame hada. Shirake utsuri appears. His distinctive jihada is called Zenjo hada, and contains masame hada scattered from the bottom to the top. The hamon is a narrow and tight suguha and consists of nioi, with a little nie, partially mixed with ko-gunome that resembles small beans. The boshi is inclined to be ichimonji and is called Zenjo boshi.
Eikyo (1429–1441)	Izumi	Kaga Shiro school (加賀四郎派)	Mitsumasa (光正) was a smith of the Joji era (1362–1367). No examples of his work exist today, although extant work of the school from the Muromachi period is seen. The Mino tradition is more common than the Yamashiro. The hamon is a wide suguha with ko-ashi and nie.
	Dewa	Gassan school (月山派)	Some old texts state that smiths of the Gassan school may be found in the Heian period, but the existence of any such swords has never been confirmed. Many swordsmiths used Gassan as their family name during the Muromachi period. The jigane is soft and is aya-sugi hada. The hamon is a narrow suguha hotsure with nioi or regular ko-gunome midare. The nioi-guchi is not tight and there are numerous hajimi (obscured parts). The boshi is yakitsume or has a short kaeri.
Kakitsu (1441–1444)	Suruga	Shimada Yoshisuke (島田義助)	Yoshisuke worked in both the Soshu tradition and the Bizen tradition and was known as an excellent maker of yari.
	Wakasa	Fuyuhiro (冬広)	This swordsmith most commonly worked in the Soshu tradition. His tanto have a hoso-suguha and a jihada mixed with ayasugi hada.

ERA	PROVINCE	SWORDSMITH(S)	PATTERN
Bun'an (1444–1449)	Bizen	Osafune Tadamitsu (長船忠光)	Most of Tadamitsu's work is in the Bizen tradition. When he worked in this style, his pieces have a fine mokume hada. The chu-suguha gradually widens from the bottom to the top, and his sug-uha is inclined to have a shallow notare. All his tanto are shorter than the standard length of 25–26 cm. In his blades with moroha-zukuri, the kaeri is suguha, and turns back toward the munemachi.
		Osafune Norimitsu (長船則光)	The major part of his work was in the Bizen tradition.
		Osafune Morimitsu (長船盛光)	Morimitsu worked mainly in the Bizen tradition. His blades are occasionally made with a suguha that has small, pointed "knobs" of nioi in spots toward the ji.
	Satsuma	Sue-Naminohira school (末波平派)	Refer to page 163.
Hotoku (1449–1452)	Bizen	Osafune Yasumitsu (長船康光)	Yasumitsu's work is mostly in the Bizen tradition and is similar to that of Moromitsu.
	Kaga	Fujishima Yukimitsu (藤島行光)	The sori is shallow. Both the shinogi and kasane are thick. The jigane is hard, with coarse mokume hada and shirake utsuri. The hamon consists of tight nioi, either chu-suguha mixed with ko-midare or chu-suguha mixed with ko-gunome. Nie and hataraki are scarce. The boshi is ko-maru with a long kaeri.
Kosho (1455–1457)	Bitchu	Sue-Aoe school (末青江派)	Refer to page 142.
	Etchu	Uda school (宇多派)	Smiths of this school worked in both the Soshu and Bizen traditions. The jigane is weak and the jihada is coarse, with shirake utsuri. The chu-suguha shows some resemblance to temper lines of both the Tegai and the Shikkake schools.
Choroku (1457–1460)	Bingo	Sue-Mihara school (末三原派)	Refer to page 161.
Kansho (1460–66)	Su-oh	Nio school (仁王派)	Refer to page 161.
Bunsho (1466–1467)	Chikuzen	Kongobei school (金剛兵衛派)	Refer to page 163.
	Bungo	Tsukushi Ryokai school (筑紫了戒派)	This school began to be called the Tsukushi Ryokai school after the Yamashiro Ryokai school moved to this province. The school's leading smith was Yoshizane (能真), who was followed by Hideyoshi (秀能), Iemitsu (家光), Nobumitsu (信光), Yasumitsu (安光), and Yukizane (行真). The jigane is weak and whitish. The jihada is mokume hada mixed with masame hada. The hamon is a narrow chu-suguha hot-sure, mixed with ko-midare and nijuba, with nie. The boshi is either a small, patterned midare komi, or ko-maru.
		Taira Takada school (平高田派)	This school was active from the Nanbokucho period through the Edo period. Its swordsmiths of the Muromachi period are all known as Taira Takada. The school had many smiths and was, numerical-ly, one of the largest. Nagamori (長盛), the founder of the school, was followed by Nagayuki (長行), Munekage (統景), Akimori (鑑盛), Shizumori (鎮盛), Shizunori (鎮教), Shizuhisa (鎮久), and others. This school worked in both the Bizen and Mino traditions. The jihada is a coarse ko-mokume hada mixed with o-hada. Most hamon are

ERA	PROVINCE	SWORDSMITH(S)	PATTERN
			hiro-suguha with nioi kuzure and yaki kuzure, but some chu-suguha were also made.
Bunmei (1469–1487)	Bizen	Shurinosuke Tadamitsu (修理亮忠光)	Tadamitsu's sugata show typical characteristics of the period and are relatively elegant. In addition to other features of the Bizen tradition, hi and horimono are seen. The jihada is a beautiful ko-mokume hada. The hamon is a tight chu-suguha and the temper line gradually widens from the bottom to the top. The suguha tends to be notare in the upper part. The boshi is ko-maru sagari, with a long kaeri. Tadamitsu's tanto are shorter than the standard of about 25 cm. He also made some moroha-zukuri blades.
	Mino	Kanesada (1st generation) (初代 兼定)	Kanesada's work was in the Mino tradition. The sugata is elegant and at a glance sometimes resembles a tachi's sugata. The jihada is a mokume hada mixed with masame hada, and the masame hada appears very distinctly in the shinogiji. The hamon is a tight hoso-suguha or chu-suguha with a little nie and some small pointed midare. The boshi is o-maru, with a wide kaeri. Yakitsume is also visible. Tanto are made in the standard length of 25–26 cm. These are hira-zukuri, with an elegant sugata and uchi-zori. Some of Kanesada's tanto appear to be copies of blades made by Rai Kunitoshi.
Meio (1492–1501)		Kanesada II (二代 兼定)	Son of the first-generation Kanesada and the second smith to take the name, he worked in the Mino and Soshu traditions. He held the title Izumi no Kami, and is popularly called "No Sada" because the character which he used for "Sada" (㞀) in his signature resembled the character for "No" (之). The jihada is well forged, of better and finer quality than other Mino blades. Masame hada appears along the line of the mune. Shirake utsuri is also visible. The hamon is hoso-suguha mixed with small and pointed "knobs" here and there, with some (but not very much) nie. The boshi is ko-maru with a wide kaeri and small, patterned midare komi. This Kanesada did very good copies of work by Rai Kunitoshi.
Eisho (1504–1521)	Bizen	Sukesada (祐定)	There were many swordsmiths named Sukesada, mainly working in the Bizen tradition. The jigane is a little hard and the jihada is a dense mokume hada. Utsuri is rarely seen. The hamon is hiro-suguha and o-notare, with a little nie. The numerous yaki kuzure on the hamon line make the hamon look like ko-midare. Nioi kuzure can be seen within the hamon. The boshi is ko-maru, with a long kaeri and with yaki kuzure that look like a small patterned midare komi. Tanto are often in suguha.
Tenbun (1532–1555)	Mino	Kanesada III (三代 兼定)	The third-generation smith of this name is popularly known as "Hiki Sada," because of the peculiar chiselling of the character "Sada" in his signature. Not many examples of his work remain.

During this period, the Sanjo, Rai, Hachiya (Mino), Fujishima (Kaga), Sue-Aoe, Kongobei (Chikuzen) and other schools all worked in the Yamashiro tradition, but their work shows features common to all Sue-Koto blades (blades produced in the late Muromachi period). By this time, most smiths' blades had lost their own school's or tradition's peculiar characteristics.

THE MAIN SCHOOLS AND EVOLUTION OF THE YAMATO (大和) TRADITION

During the Nara period, before the capital was transferred to Kyoto in Yamashiro province, the province of Yamato was the center of Japanese culture. Naturally, the area has a long and rich history of producing swords. According to legend, Amakuni (天国) and Amakura (天座) were the earliest Japanese swordsmiths, though no blades with their signatures remain extant; Yamato is said to have been their home. After that, the Senjuin (千手院) smiths Yukinobu (行信) and Shigenobu (重信) are believed to have worked in Yamato at the end of the Heian period. The earliest confirmed time of manufacture for a sword with a signature from this province, however, is the middle of the Kamakura period.

The development of the swordsmith's trade in Yamato was closely linked to the area's proximity to the capital at Nara. Furthermore, swordsmiths' prosperity depended on their relationship with the temples with which they were affiliated. From the end of the Heian period, temples in Yamato province acquired vast manors and many branch temples, and strove to arm themselves in order to guard their rights and property. The five major Yamato schools—the Senjuin, Tegai, Taima, Hosho, and Shikkake—were groups of swordsmiths who supplied the temples, and the Yamato tradition thus became known over a wide area through the nationwide organizations of these temples. The Yamato tradition exercised great influence on the Shizu, Akasaka Senjuin, Ino, Uda, Asako Taima, Iruka, Sudo, Mihara, and

other schools. In addition, direct exchange seems to have taken place between individual smiths from Yamato province and smiths throughout Kyushu in the early days of the Yamato tradition.

The Yamato tradition of the middle Kamakura period has the following characteristics:

a) The sugata is in accord with the basic shape of the period, but the shinogi is remarkably high. Horimono are rare. The jihada is composed mainly of masame-hada, but even when the jihada is mokume-hada, it tends to be a nagare-hada combined with a masame-hada of a certain fineness.

b) The jigane in Yamato-tradition workmanship is generally inferior to that of the Yamashiro tradition, in terms of both quality and fineness of detail.

c) The hamon is based on suguha in nie deki, as it is in the Yamashiro tradition, but vertical activities such as nijuba, uchinoke, and hakikake appear along the hamon. Nie are larger than in the Yamashiro tradition, and more highly reflective. The nie of an individual sword may be either abundant or scarce. The boshi is ko-maru, o-maru, or yakitsume, usually with hakikake. The kaeri is generally short. On the yasurime, both higaki and takanoha are frequently seen.

d) The jihada and the hamon of tanto are similar to those of tachi. The sugata is slightly longer than the standard of about

25 cm. The mihaba is wider, and the kasane is thick. Both shobu-zukuri and u-no-kubi-zukuri are common. The Yamato tradition declined in the same way as did the Yamashiro tradition after the Nanbokucho period. During the early Muromachi period, as was stated above, it becomes rather difficult to distinguish between Yamato-tradition and Yamashiro-tradition workmanship.

Mid- to late Kamakura period

Swordsmiths are known to have worked in Yamato province even before the final and unique characteristics of the Japanese sword had been fully established. It is only during the period in which these characteristics begin to be established, however, that the work of individual smiths can first be confirmed through extant signed swords.

Typical workmanship has a hamon based on suguha in nie deki. The jihada is formed mainly in a masame-hada which is different from the style of the Yamashiro tradition. Vertical hataraki (activity), therefore, appears along the hamon. The boshi becomes hakikake, kaen, or yakitsume. The kaeri is usually short. Midareba are also present, indicating that the Yamato tradition was affected by the Soshu tradition, which was to become the dominant style after the close of the Kamakura period.

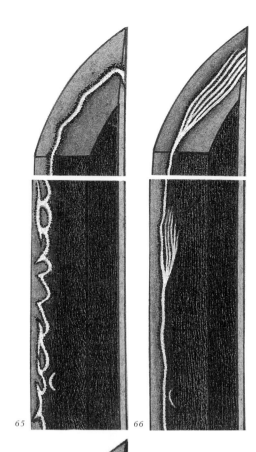

65. In the work of Taima-school smiths like Tegai Kaneuji (known as Yamato Shizu) and others, the shinogi is high. The mokume hada is combined with masame hada along the hamon. The nie is highly reflective. The hamon is midareba. The boshi is midare komi, and the kaeri is short.

66. Smiths of the Hosho school show pure Yamato-tradition characteristics. The jihada is masame hada. The hamon is chu-suguha with both hakikake and uchinoke, and the boshi is either nie kuzure or kaen.

67. Work of the Shikkake-school smiths has a jihada in mokume hada, combined with masame hada along both the hamon and mune. The hamon is chu-suguha, with vertical activity such as nijuba. The boshi is yakitsume, with abundant nie.

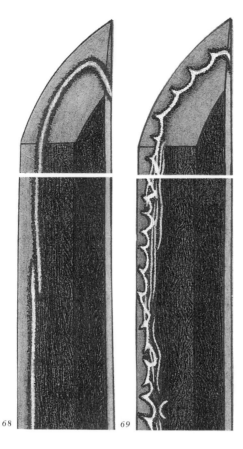

The Muromachi period

Yamato-tradition swords dating from the Nanbokucho period are very rare. From the beginning of the Muromachi period, the Yamato tradition is revived by some schools but for the most part loses its distinct characteristics, with the sole exception being the Hosho school. It is thought that the workmanship of the Hosho school was influenced by the Bizen, Soshu, and Mino traditions.

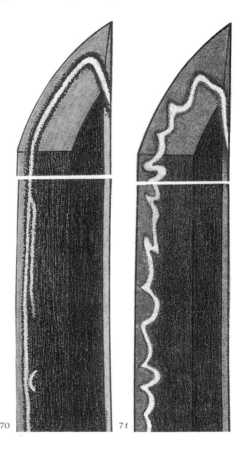

68. Throughout this period, Tegai-school smiths maintained the style developed in the early Kamakura period. The jihada is mokume hada combined with masame hada along the hamon. The boshi is generally ko-maru, and abundant ji-nie is scattered over the entire blade.

69. Blades made by Tegai Kaneuji (also called Yamato Shizu) had a refined sugata, similar to that of the preceding period. The jihada is mokume hada combined with masame hada. The hamon is midareba mixed with ko-gunome and togariba. Hotsure is also evident.

70. Late Hoshu school: The shinogi is high. The hamon is suguha with nijuba and uchinoke nie deki. The masame hada is arranged in a more orderly manner than was seen in late Kamakura. The boshi is mainly ko-maru with kaeri.

71. Kanabo-school swordsmiths tempered in the Bizen tradition, but their shinogi is high. The combination of the jihada with masame hada is immediately noticeable, and the hamon is inclined to be in nie deki; these points distinguish this from work in the pure Bizen tradition.

TANTO OF THE YAMATO TRADITION

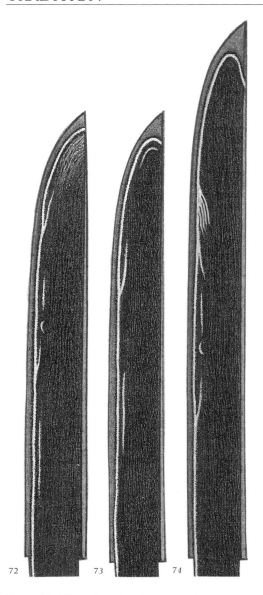

72 73 74

Tanto: **Middle to late Kamakura period:**

72. The Hosho-school tanto has a pure masame hada. The suguha has abundant nie, nijuba, uchinoke, and hakikake. The boshi is yakitsume. 73. In the Tegai- and Shikkake-school tanto, the jihada is mokume-hada combined with masame hada along the hamon. Vertical activity is visible along the hamon.

74. **Muromachi period:** Late Hosho-school ko-wakizashi are made in hira-zukuri with saki-zori. In early Hosho-school work, the lines of the masame hada pass through toward the mune, while these same lines usually turn back along the boshi in work of the late Hosho school.

THE SENJUIN (千手院) SCHOOL

Senjuin is the oldest of the five main Yamato schools, and it seems that workmanship in this school was not particularly uniform. The school's smiths were active from the late Heian period to the Nanbokucho period. Sword-smiths active through the early Kamakura period are known as Ko-Senjuin; those working from the middle Kamakura period to the Nanbokucho period are called Chu-Senjuin. Ryumon Nobuyoshi (龍門延吉), active during the later Kamakura period, is sometimes said to have come from this school but is generally recognized as an independent smith. Akasaka Senjuin, who moved to Mino province, comes from this school.

The Ko-Senjuin (古千手院) school

Yukinobu (行信) is said to have been the founder of the Senjuin school and was followed by Shigehiro (重弘), Shigenaga (重永), Yukiyoshi (行吉), Yukimasa (行正), and Rikinao (力直). Zai mei katana (blades with signatures) are rare.

The characteristics of the Ko-Senjuin school are:

a) The jigane is well forged and beautiful. The mokume-hada is mixed with ji-nie and chikei. Yubashiri appear.

b) The hamon is suguha hotsure, mixed with ko-choji and ko-midare. The nie are highly reflective and rather rough. Activity such as uchinoke, kuichigaiba, kinsuji, and inazuma are attractive and readily visible. The nijuba looks like yubashiri.

c) The boshi is yakitsume, nie kuzure, and kaen. The nie is highly reflective and tends to become rougher from the yokote toward the top.

The Chu-Senjuin (中千手院) school

Sadashige (定重), Rikio (力王), Kuniyoshi (国吉), Yoshihiro (義弘), Yoshihiro (吉広), and Kiyomune (清宗) were active during this period. Workmanship is generally similar to that of the Ko-Senjuin, but inferior in grace and quality. The sugata is stout and shows features typical of this period. Tanto are rare. There are some

tachi with signatures and dates of manufacture, such as the "Senjuin Yashihiro, Bunwa 2-nen 8-gatsu hi" or "Joji 5-nen, Hinoe Uma, Senjuin Nagayoshi."

THE HOSHO (保昌) SCHOOL

The work of this school shows a typical masame-hada, which is the main distinctive feature of Yamato blades. Kunimitsu (国光), who lived in the mid-Kamakura period, is said to have been the school's founder, but none of his works are extant. Practically speaking, Sadamune (貞宗) should be considered the founder of this school, followed by Sadayoshi (貞吉), Sadatsugu (貞継), Sadazane (貞真), Sadakiyo (貞清), Sadaoki (貞興), Sadayuki (貞行), and Sadamitsu (貞光). These smiths produced swords up through the Nanbokucho period.

Jihada: The jihada is a pure masame-hada, with abundant nie. The work of later generations is inclined to become wavy and rougher. Hadaware (crevices along the forging pattern) are quite common.

Hamon: The narrow chu-suguha hotsure consists of nie. Vertical uchinoke activity is seen. There are prominent nijuba and kuichigaiba. Chu-suguha mixed with regular ko-gunome midare or ko-midare are also found.

Boshi: Boshi are hakikake and yakitsume, with a great deal of nie.

Nakago: The yasurime is higaki.

THE TEGAI (手掻) SCHOOL

The name of this school originated from the Tegaimon (gate) of Todaiji temple in Nara. The smiths lived in the temple town. The Tegai school was founded in the late Kamakura period by Kanenaga (包永), and several generations of smiths used his name. The smiths of this school all use the character "Kane" (包) in their names, as in Kanekiyo (包清), Kanetsugu (包次), Kanetoshi (包俊), Kanemitsu (包光), Kanezane (包真), and so on.

Kaneuji (包氏), Kanetomo (包友), and Kaneyoshi (包吉) are said to have moved later to Mino province and changed the first character of their names to a different Chinese character for "Kane" (兼), which was commonly used in Mino province.

At the end of the Nanbokucho period, the school ceased to be active, but with the start of the Muromachi period, it revived and began to prosper. The school was called "Sue-Tegai" during the Muromachi period.

Jihada: During the Kamakura period, the ko-mokume hada is well forged and fine. Masame-hada is less distinct than in later generations. Ji-nie are more abundant than in other Yamato swords, and occasionally become yubashiri.

Hamon: The temper line is a relatively narrow chu-suguha hotsure, with uchinoke and nijuba consisting of nie. One also sees o-midare temper lines with abundant nie, kinsuji, and inazuma, that have rather different patterns on each side. In succeeding generations, the hamon becomes rather calm.

Boshi: Yakitsume, kaen, nie kuzure, midare komi are the most common boshi. In any case, the kaeri is short.

Nakago: A common pattern for filing marks is takanoha yasurime.

The Sue-Tegai (末手掻) school

The production of many schools in Yamato province declined in the Muromachi period, but the Sue-Tegai and Kanabo schools remained active, and many of their works are extant today. The workmanship of the Kanabo school is unique, while Sue-Tegai school blades are difficult to distinguish from those of other schools. It might be said that swords made by Sue-Tegai smiths show features generally common to late Yamato swords. The following are details of the workmanship of not only the Sue-Tegai school, but of the average late Yamato sword as well.

Sugata: Blades show the features common to the period. They still retain a high shinogi and a wide shinogiji. Shinogi-zukuri and shobu-zukuri are both seen in wakizashi. In tanto,

there is a narrow mihaba, a shortened nagasa, and a slightly rounded fukura. The sugata looks sharp. The kasane is thick, in spite of the narrow mihaba.

Jihada: The jihada mixed with masame-hada is fine, but has little ji-nie. The jigane is a bit hard and whitish in color.

Hamon: The temper line is narrow and tight. The hamon consists of nioi with some nie, but with little activity. O-midare, which looks similar to that of the Soshu tradition, is seen on occasion.

Boshi: Hakikake and yakitsume become rare. The standard ko-maru boshi is commonly seen. The kaeri becomes longer.

Horimono: Unusual and elaborate horimono are sometimes seen on sunnobi tanto (blades a bit longer than 30 cm). Skillful ukibori (embossing) is also seen in the hitsu (groove).

THE SHIKKAKE (尻懸) SCHOOL

Norihiro (則弘) is said to be the founder of the school, but none of his works are extant. As a matter of fact, Norinaga (則長), said to be his son or his student, should be considered the founder. There is a sword by the first Norinaga which bears the signature "Ryakuo san-nen roku-gatsu hi rokujukyu-sai" (a day in June, 1341, 69 years old). Swords with his signature are not particularly rare, although most other Yamato swords produced during the period are unsigned. The name Norinaga seems to have been passed down through several generations. Besides making tachi, the first Norinaga also produced nagamaki and tanto, notably in the kanmuri-otoshi-zukuri style. Norinari (則成), Norizane (則真), and other smiths also belong to this school, but their extant work is scarce.

Jihada: A ko-mokume hada mixed with masame-hada is typical. A particular type of jihada, in which mokume-hada appears along the shinogi with masame-hada near the hamon, is known as shikkake-hada. The jiha-

da of later generations became loose and appeared whitish.

Hamon: Narrower chu-suguha hotsure mixed with ko-midare and ko-gunome midare consisting of nie, as well as regular ko-gunome midare, are seen. There is a great deal of activity, such as nijuba, uchinoke, hakikake, small kinsuji, inazuma, nie, nioi, and kogori.

Boshi: Yakitsume, hakikake, and ko-maru are common. The kaeri is short.

Nakago: The nakagojiri, or tip, is iriyamagata. Filing patterns, yasurime, are kiri or a gentle katte sagari.

75

Shikkake hada.

THE TAIMA (当麻) SCHOOL

The Taima school seems to have been retained by the Taimaji Temple of Yamato province. Kuniyuki (国行) founded the school. He lived in the Shoo era (1288–1293); his son was Tomokiyo (友清). A sword by Cho Aritoshi (長有俊) is dated "Einin roku-nen" (1298). In addition, the names of such smiths as Toshiyuki (俊行), Kunikiyo (国清), Tomotsuna (友綱), Tomonaga (友長), Tomoyuki (友行), and Arihoshi (有法師) may be seen on some lists, but their extant works are rare.

Jihada: A well-forged fine mokume-hada, mixed with itame-hada, chikei, and yubashiri,

appears. In the yokote area, an itame-hada is seen which tends to become masame-hada toward the munesaki of the tip; this is called a "Taima-hada." The jigane looks blackish, and has abundant ji-nie. At a casual glance, one might mistake this for a Soshu blade.

Hamon: Taima-school hamon are a narrower chu-suguha hotsure consisting of nie; also seen is choji midare, based on a slightly wavy suguha. The nie are rather rough. Nijuba, kuichigaiba, uchinoke, fine kinsuji, and inazuma, in particular, appear from the monouchi area to the yokote. The workmanship resembles that of Yukimitsu from Soshu.

Boshi: The boshi are mainly yakitsume.

Nakago: The tanto nakagojiri of the Taima, like those of the Shikkake school, are iriyamagata. Filing patterns are kiri or a gentle katte sagari.

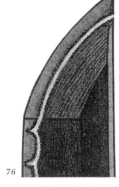

76

Taima hada.

THE KANABO (金房) SCHOOL

The Kanabo school is said to have begun producing swords in the Daiei era (1521–1528), and its smiths seem to have used "Kanabo" as their family name. They used either of two different Chinese characters, both pronounced "Masa (正／政)," in signing their names, which included Masashige (正重), Masasada (政定), Masakiyo (正清), and Masatsugu (政次). Features characteristic of Sue-Koto may be found in their workmanship, but features which differentiate them from other Yamato schools of the late Muromachi period may also be seen. These smiths also worked in the Bizen and

Mino traditions. One branch, the Masazane (正真) family, moved to Mikawa province, and is referred to as the "Mikawa Monju."

Sugata: Kanabo-school blades have a shallow sori, wide mihaba, thick kasane, relatively low shinogi, large kissaki, and full hira-niku. They look stout, rather than smart or elegant. There are two styles of tanto, one of which—the so-called ko-wakizashi—is more than 30 cm in length. The other is shorter than the standard tanto length of 25–26 cm, and is reminiscent of Sue-Bizen tanto. The Kanabo smiths have a reputation for being expert makers of spears, including the jumonji yari.

Jihada: The jihada is a coarse mokume or masame-hada, with distinct masame-hada in the shinogiji.

Hamon: Wide hamon consisting of nioi and koshi-no-hiraita midare with yaki-kuzure which resemble the temper lines of the Eisho-era Sue-Bizen school. The Kanabo school also made sanbon-sugi midare resembling the work of Kanemoto. Hiro-suguha and o-notare with many nioi kuzure and yaki-kuzure are also seen.

Boshi: Boshi is wide, with a different pattern on each side, and is occasionally ichimai. The kaeri is long.

Horimono: Horimono include bo-bi, bo-bi with soe-bi, or tsurebi. These are stopped above the munemachi by maru-dome. Elaborate carvings which look almost squeezed or compressed, are skillfully engraved in the bottom of the shinogiji. In some cases, horimono are embossed in the hitsu.

Nakago: Kanabo nakago are shorter. The nakagojiri is a gentle iriyamagata or kaku-mune, and the yasurime is katte sagari.

THE MIHARA (三原) SCHOOL

The Mihara school, in Bingo province, was founded by Masaie (正家). Swordsmiths of this school were active beginning in the Showa era (1312–1317), at the end of the Kamakura

period, through the end of the Muromachi period, and the Yamato tradition is distinctly recognizable in their workmanship. The school is divided into three terms: smiths active through to the Nanbokucho period are called Ko-Mihara; early Muromachi-period work is called Chu-Mihara; and the late Muromachi period is called Sue-Mihara. Of the swords of all these periods, the Chu-Mihara alone are rarely seen.

The Ko-Mihara (古三原) school

Masaie and Masahiro (正広) produced master-pieces. Others who belonged to this school include the smiths Masamitsu (正光), Masakiyo (正清), Masanobu (正信), and Masahiro (政広).

Sugata: The shinogi is high, with a wide shinogiji.

Jihada: The jigane is whitish, and the jihada is ko-mokume hada, mixed with o-hada.

Hamon: Temper lines are a narrow chu-suguha, mixed with ko-midare, consisting of nioi. The hamon is tight, with some nie. Ko-midare in nie deki and hoso-suguha are also seen.

Boshi: The boshi is ko-maru, with a long kaeri.

The Sue-Mihara (末三原) school

Masachika (正近), Masaoku (正奥), Masazane (正真), Masamori (正盛), Masayoshi (正賀), Masamune (正宗), Masanobu (正信), and Masanori (正則) carried on the Ko- and Chu-Mihara traditions. Some of these smiths inscribed their signatures with the phrase "Bungo no kuni Mihara ju kai" (Resident of Mihara, Bungo province); these are referred to as the "Kai Mihara" (貝三原) smiths. On the other hand, some other schools stemming from Mihara appeared during the Muromachi period; the Hokke Ichijo (法華一乗), Tomo (鞆), and Tatsubo (辰房) were a few such related schools.

The Hokke Ichijo school (法華一乗) smiths signed their work "Hokke Saku" (法華作), "Hokke Ichijo," or, occasionally, with just the character for the number one, "ichi" (一). Saneyuki (実行), Kaneyuki (兼行), Kanemori (兼守), Kaneyasu (兼安), and Nobukane (信兼) were members of this school.

Among the Tomo (鞆) school smiths were Sadaie (貞家), Sadatsugu (貞次), Munesada (宗貞), and Ietsugu (家次).

Shigemitsu (重光), Shigemichi (重道), Shigeyoshi (重吉), and Shigetoshi (重俊) are some of the smiths of the Tatsubo (辰房) school.

Sugata: Sugata have a shallow sori, a thin mune kasane, and a high shinogi.

Jihada: The jigane is relatively hard. The jihada is a coarse ko-mokume hada, with a plain hada (sumigane) appearing in some places.

Hamon: Temper lines are relatively narrow chu-suguha, consisting of a tight nioi line. At times, small gunome are seen in places. Also seen is koshi-no-hiraita midare, similar to the work of the Sue-Bizen smiths, or yahazu midare resembling Sue-Seki blades. Irregularities of the bumps in the temper line are not as pronounced as in Sue-Bizen or Sue-Seki work. The pattern of the hamon is inclined to be box-shaped and regular from top to the bottom.

Boshi: The boshi is ko-maru with a long kaeri. The boshi has two distinctive kaeri, called "takiotoshi" (waterfall) and "tora-no-o" (tiger's tail).

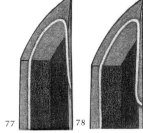

(Left): Takiotoshi kaeri.
(Right): Tora no o kaeri.

THE NIO (二王) SCHOOL

Kiyozane (清真) of Suo province is said to have founded the Nio school, but none of his blades can be seen today. Work dating from the mid-Kamakura period is extant. Nio smiths were active through the end of the Edo period. The workmanship of the Ko-Nio (Kamakura period)

and Sue-Nio (Muromachi period) are explained below.

The Ko-Nio (古二王) school

Smiths such as Kiyonaga (清永), Kiyomitsu (清光), Kiyoharu (清春), and Kiyotada (清忠), who used the character "Kiyo (清)" in signing their work, are mentioned in lists of swordsmiths, but the only blades of this school now extant are some of those produced by Kiyotsuna (清綱) and Kiyohisa (清久). The name Kiyotsuna was also used over several successive generations.

Sugata: Nio blades display the features characteristic of the period, but their shinogi is high, with a thick kasane.

Jihada: The jigane is beautiful, but weak. Mokume-hada is mixed with masame-hada, and ji-nie can be seen. A unique utsuri called hera-kage appears between the hamon and the shinogi. Some tanto look like work by Soshu Yukimitsu or Chu-Aoe.

Hamon: The narrow hamon consists of fine nie that are not very bright, and is either a hoso-suguha hotsure or a chu-suguha hotsure with nijuba. A ko-midare temper line is also seen.

Boshi: Boshi is ko-maru, o-maru with a short kaeri, and yakitsume.

The Sue-Nio (末二王) school

The smiths Kiyotsuna (清綱), Kiyonaga (清永), Kiyokage (清景), Kiyotane (清種), Kiyosada (清貞), Kiyozane (清真), Masayuki (正清), and Kiyofusa (清房) belong to the later Sue-Nio school. Workmanship, based on the suguha of the Yamato-den, is similar to that of Ko-Nio and bears a close resemblance to Sue-Tegai and Sue-Mihara as well. Tanto blades are made in both shobu-zukuri and u-no-kubi-zukuri styles.

Jihada: The jihada is a weak mokume-hada mixed with masame-hada and is not very visible. Muneyaki and hera-kage are seen at times.

Hamon: The temper line is a chu-suguha mixed with ko-midare. Nie is scarce and looks like nioi deki. Koshi-no-hiraita midare hamon with yaki-kuzure resemble work done by Sukesada.

Boshi: Boshi is ko-maru and midare komi. Often the patterns on the two sides are different.

Nakago: The nakagojiri is an exaggerated iriyamagata. The two characters for "Nio" (二王; Benevolent Guardian Kings of Buddhism) are usually inscribed before the smith's signatures.

SWORDSMITHS OF CHIKUZEN PROVINCE PREDATING SAMONJI (左文字)

Samonji (左文字), one of Masamune's Juttetsu (Ten excellent students of Masamune), was active in the early Nanbokucho period, when he broke away from the conventional workmanship of smiths in Kyushu. Characteristics of the Soshu tradition are obvious in his work. Before Samonji, the smiths seen in Chikuzen province are: Ryosai (良西), considered the founder of the school; Nyusai (入西), Ryosai's brother; Sairen (西蓮), said to have been Nyusai's son; and Jitsua (実阿), believed to have been the son of Sairen and the father of Samonji. Their workmanship shows signs of the Yamato tradition and shares features in common with the swordsmiths in Kyushu.

Sugata: Sugata is slender, with ko-kissaki and a wide shinogiji. It is very conservative and resembles early Kamakura blades rather than blades of this period, but the mihaba is slightly wider. Tanto have no sori, and the length of the tanto is less than the standard 25–26 cm (10 inches).

Jihada: The hada is large and mixed with masame-hada; it sometimes becomes ayasugi-hada. Fine ji-nie and active chikei are seen occasionally.

Hamon: The chu-suguha is relatively narrow, consisting of nie, with ashi, nie kuzure, hakikake, and considerable nijuba. This activity shows a distinct relationship to the Yamato tradition.

Boshi: Boshi are kaen, hakikake, and yaki-tsume.

THE KONGOBEI (金剛兵衛) SCHOOL

The Kongobei school, like the Samonji school, was from Chikuzen province, but consistently maintained a unique style of workmanship. The founder, Moritaka (盛高), is said to date back to the Kamakura period, and the name Moritaka was used by several generations. The smiths of this school, such as Moritoshi (盛利), Morikane (盛包), Moriyoshi (盛吉), and Morikuni (盛国), all used the character "Mori" (盛) in their signatures. One tanto produced by Reizei Sadamori (冷泉貞盛), who seems to be of this school, is dated "Shoei nijugo-nen" (1370). Most of the extant Kongobei work was made during the Muromachi period, and its workmanship is invariably conservative; it is quite difficult to say whether the style is in the Yamato or the Yamashiro tradition; it should be called majiwarimono.

Sugata: The sugata is usually stout and rustic, but a gentler shape is occasionally seen. The sugata has a wide shinogiji, a high shinogi and thick kasane. Ohira-zukuri, u-no-kubi-zukuri wakizashi and shobu-zukuri wakizashi also exist.

Jihada: The jigane is a harder mokume-hada, mixed with masame-hada, and is inclined to be coarse. Shirake utsuri appears.

Hamon: The temper line is a wide suguha with scarce activity. The rather tight nioi-guchi (nioi line) is not bright. The hamon is either gunome midare, hako midare, or notare midare, and has uneven nie.

Boshi: Boshi are ichimai midare komi, with steep kaeri.

Horimono: Bo-bi chiri on the shinogiji between the hi and the line of the shinogi, or between the lines of the shinogi and the mune, are wide. Other horimono are rarely seen.

Nakago: The nakagojiri is sotoba, while the yasurime are kiri or a gentle katte sagari. Blades are signed "Kongobei Mori," "Minamoto (no) Mori," and the like.

THE NAMINOHIRA (波平) SCHOOL

The school is said to have been founded by Masakuni (正国), who moved from Yamato province. It followed the Yamato tradition for many generations. The smiths who were active through the Nanbokucho period are known as Ko-Naminohara (古波平); those of the Muromachi period are the Sue-Naminohira (末波平).

The Ko-Naminohira (古波平) school
Smiths of the Ko-Naminohira school are: Yukiyasu (行安) (a name used by several generations), Yasuyuki (安行), Ieyasu (家安), Yasuie (安家), Tomoyasu (友安), Yasutsuna (安綱), Yasumitsu (安光), and Yukitsugu (行次).

Jihada: The jigane is soft. The jihada is a fine masame-hada with ayasugi-hada.

Hamon: The chu-suguha hotsure is relatively narrow and consists of nie, with ko-ashi, uchinoke, and hakikake.

Boshi: Boshi is yakitsume with nie kuzure and other activity.

Nakago: In earlier work of this school, the file patterns (yasurime) are kiri or katte sagari. Higaki yasuri became common from the end of the Kamakura period.

The Sue-Naminohira (末波平) school
The quality of Sue-Naminohira swords is inferior to Ko-Naminohira work. Sue-Naminohira smiths did not use only the Yamato style, but also mixed Yamato tradition with characteristics of Yamashiro-den and Bizen-den. Sue-Naminohira smiths include Yoshiyuki (吉行), Yoshimune (吉宗), Yasutomo (安朝), Kiyosuke (清左) (who studied under Osafune Kiyomitsu), Kiyosuke (清右), Kiyoyoshi (清吉), Kiyohide (清秀), and others.

Jihada: Ayasugi-hada or ko-mokume hada, inclined to become masame-hada, is not quite visible. Naminohira's jihada does not have standard and well-formed ayasugi-hada, unlike that of the Gassan school.

Hamon: Narrow chu-suguha, at times mixed with ko-midare or ko-gunome. Few hataraki are seen, but there are some kakikake in the habuchi (the border between the hamon and ji). Choji midare and hitatsura are occasionally seen.

Boshi: Standard ko-maru. As the period progresses, the kaeri becomes longer. Yakitsume is also seen.

Nakago: Higaki yasuri is common. The signature is inscribed "Naminohira."

LEADING SWORDSMITHS OF THE YAMATO TRADITION

ERA	PROVINCE	SWORDSMITH(S)	PATTERN
Genryaku (1184–1185)	Yamato	Ko-Senjuin school (古千手院派)	Refer to page 157.
Kenkyu (1190–1199)	Dewa	Gassan (月山)	Smiths using the name Gassan were active in each period, but work from this period is almost never seen now. During the Muromachi period, smiths seem to have used Gassan as their family name.
Genkyu (1204–1206)	Suo	Ko-Nio Kiyotsuna (古仁王清綱)	Refer to page 162.
Shogen (1207–1211)	Yamato	Ko-Senjuin Rikinao (古千手院力直)	Refer to page 157.
Joei (1232–1233)	Suo	Ko-Nio Kiyotsuna (古仁王清綱)	Refer to page 162.
Kenji (1275–1278)		Ko-Nio Kiyonaga (古仁王清永)	Refer to page 162.
Shoo (1288–1293)	Yamato	Tegai Kanenaga I (手掻 初代 包永)	The jihada shows features of the Yamashiro, rather than the Yamato, tradition. There are two hamon patterns—one gentle and based on suguha, and the other a flamboyant midareba—but in any case, the pattern is gentle and calm from the bottom through the middle of the blade. Nie become rougher nearer the top. Each nie looks independent and is highly reflective. Hamon that have a different pattern on each side of the blade are seen occasionally. The boshi commonly has an ichimonji kaeri.
Einin (1293–1299)	Yamato	Taima Kuniyuki (当麻国行)	Work of Taima Kuniyuki also displays a mid-Kamakura sugata. Hi are commonly engraved on the tachi. There are both wide and narrow hamon. The wide hamon look as if they were from the Soshu tradition. The nie are highly reflective. The hamon contains a lot of activity, including kinsuji, inazuma, and sunagashi. Narrow hamon show more signs of Yamato tradition, and Taima hada (an itame hada that becomes masame hada toward the mune side of the kissaki) is recognizable in the kissaki area.
Shoan (1299–1302)	Suo	Ko-Nio Kiyomitsu (古仁王清光)	Refer to page 162.
Kagen (1303–1306)	Yamato	Chu-Senjuin Kuniyoshi (中千手院国吉)	Refer to page 157.
Engyo (1308–1311)	Suo	Ko-Nio Kiyoharu (古仁王清春)	Refer to page 162.

ERA	PROVINCE	SWORDSMITH(S)	PATTERN
Ocho (1311–1312)	Yamato	Tegai Kaneuji (手掻包氏)	Kaneuji moved to Mino province, where he was known as Shizu Saburo Kaneuji. In Yamato province his work is generally known as Yamato Shizu. Abundant ji-nie and chikei are seen in the ji. The hamon is ko-notare midare mixed with ko-midare and togariba. Some nioi ashi reach the hasaki. The hamon is active and vigorous. Boshi are sometimes inclined to be constricted; the Jizo boshi is recognized as having originated in Kaneuji's boshi.
	Suo	Ko-Nio Kiyotada (古仁王清忠)	Refer to page 162.
Showa (1312–1317)	Yamato	Shikkake Norinari (尻懸則成)	Almost none of Norinari's work is extant today.
	Satsuma	Naminohira Yukiyasu (波平行安)	Refer to page 163.
		Naominohira Yasuyuki (波平安行)	Refer to page 163.
		Naminohira Ieyasu (波平家安)	Refer to page 163.
Bunpo (1317–1319)	Yamato	Hosho Sadamune (保昌貞宗)	Horimono are rare. The jihada is pure masame hada from the bottom to the top and, in the kissaki area, the masame hada becomes parallel to the fukura and reaches the mune.
		Hosho Sadayoshi (保昌貞吉)	Sadayoshi's workmanship is identical to that of Sadamune.
		Ryumon Nobuyoshi (龍門延吉)	The jihada is ko-mokume, mixed with o-hada and with ji-nie and chikei. Yubashiri are visible. The suguha is inclined to be o-notare. Much activity can be seen in the hamon, and the nie are highly reflective.
	Satsuma	Naminohira Yasutsuna (波平安綱)	Extant works are few.
Gen'o (1319–1321)	Yamato	Taima Tomokiyo (当麻友清)	Refer to page 159.
		Tegai Kanenaga II (手掻 二代 包永)	Kanenaga's workmanship is identical to that of the first-generation Kanenaga.
		Hosho Sadakiyo (保昌貞清)	Refer to page 158.
Shochu (1324–1326)	Bingo	Ko-Mihara Masaike (古三原正家)	Refer to page 161.
Karyaku (1326–1329)	Yamato	Taima Kunikiyo (当麻国清)	Refer to page 159.
Gentoku (1329–1331)		Shikkake Norinaga (尻懸則長)	Norinaga's sori are not as deep as those seen in work by other swordsmiths of this period. The jihada is shikkake hada—in other words, mokume hada along the shinogi and masame hada along the hamon. The hamon is ko-midare based on suguha, mixed with uniform, continuous gunome. The boshi is accompanied by hakikake.
Genko (1331–1334)	Satsuma	Naminohira Yasumitsu (波平安光)	Refer to page 163.

characteristics. The workmanship of the tanto is similar to that of tachi but, in kataochi gunome, nioi rise toward the ji and look like smoke. The top of the boshi is pointed and looks like a candle flame, and the kaeri is generally long.

The workmanship of the Muromachi period may be roughly divided into the early Oei-Bizen and the later Sue-Bizen schools. The Oei-Bizen jigane is soft. The jihada is most often a large mokume-hada with bo-utsuri.

The hamon is of standard width. A koshi-no-hiraita midare suguha, mixed with choji midare in nioi deki, is seen at times. The boshi is chiefly midare komi, in proportion to the hamon, but sometimes has a different pattern on each side.

The Sue-Bizen–school jigane is hard. The jihada is a dense mokume-hada; bo-utsuri is hardly ever seen. A number of swords have mokume-hada combined with o-hada.

The hamon becomes wider and is basically in nioi deki, although nie are occasionally seen in some parts of the blade. One characteristic of Sue-Bizen blades is that yo is certain to appear inside the hamon. During the later part of the Muromachi period, in particular, yo was referred to as "nioi kuzure," meaning "scattered nioi."

Hamon of the early Muromachi period are usually koshi-no-hiraita midare mixed with choji midare, but this late period shows pure koshi-no-hiraita midare. The boshi is wide and its pattern is frequently scattered. Ichimai boshi are sometimes seen. The boshi's pattern is often remarkably different on each side.

Late Heian and early Kamakura periods

The illustrations on p. 169 show how the Ko-Bizen hamon changed to a gorgeous choji midare in nioi deki. The illustrations in the row at the top are details of the surfaces of the blades; the corresponding jihada and boshi of each are shown below. At first, the Yamashiro tradition is recognizable, and the hamon is based on suguha mixed with ko-midare, or ko-choji in nie deki. Choji midare then becomes partially recognizable, but it is mainly based on suguha and nioi kogori, or a mass of nie characteristic of Ko-Bizen, seen in certain spots on the hamon. Later the hamon is based on midareba. The jihada is a ko-mokume, chu-mokume, or ko-mokume hada. Jifu utsuri is often seen, and choji midare, continuous from top to bottom in nioi deki, is completed by the Fukuoka Ichimonji school.

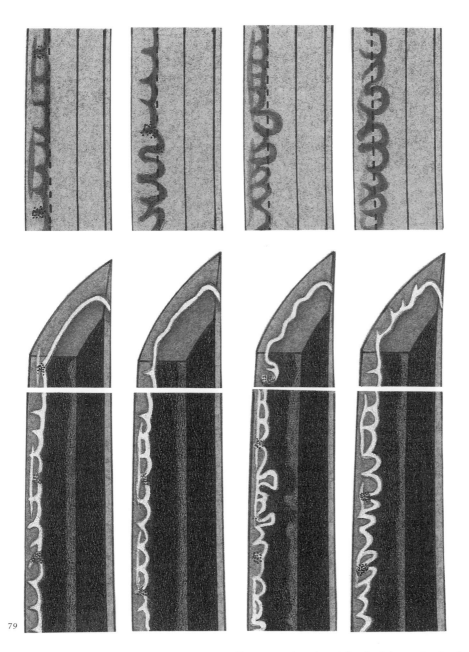

79. Four examples of work by the Ichimonji school, showing the way that choji-midare of the Ko-Bizen tradition developed from a relatively simple to a much more lively pattern. In each case, the hamon is shown above, while the corresponding boshi and jihada are presented below. Note that the sword at extreme right is an example of continuous choji-midare nioi-deki.

Middle and late Kamakura period

The brilliant Bizen tradition is established by
the Ichimonji and Ko-Osafune schools. Choji
midare is continuous from top to bottom. The
jihada is a mokume-hada mixed with o-hada,
and various midare utsuri may be seen. The
sugata becomes grander than those of earlier
periods, and there is sometimes an ikubi
kissaki. Workmanship is varied, in accordance
with the sugata. But gentle sugata, similar to
those of earlier times, are also seen during
this period, and usually show signs of the
Yamashiro-den.

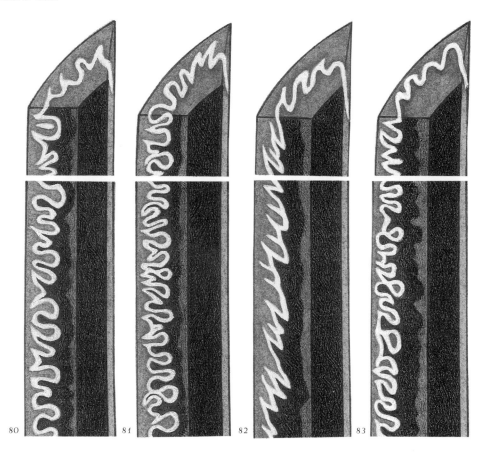

80. Fukuoka Ichimonji school. The jihada is a mokume hada
with utsuri. The hamon, from top to bottom, is o-busa
choji midare, in nioi. The pattern seen on the boshi
is the same as, but smaller than, that of the hamon.

81. Fukuoka Ichimonji school. The jihada is an o-mokume
or a ko-mokume hada, combined with o-hada. The
hamon is choji midare or juka choji midare. Botan
(peony-shaped) utsuri, choji utsuri, or jifu utsuri appear.

82. Katayama Ichimonji school. The jihada is similar to
that of the Fukuoka Ichimonji school, but the hamon
becomes a saka-choji midare, and the boshi takes on
an oblique pattern in accordance with the hamon. In
most cases, the pattern of the boshi is similar to that
of the hamon.

83. Swordsmiths who combined choji midare with
kawazuko choji are Ichimonji Sukezane, Osafune
Mitsutada, Hatada Moriie, and their successors.

84. Yoshioka Ichimonji and Nagamitsu, their students, and others: The width of the hamon is narrower than in blades made by either the Fukuoka Ichimonji or the Mitsutada. The pattern, therefore, naturally becomes a smaller midare. Gunome midare becomes noticeable in the choji midare temper lines.

85. Kagemitsu and other smiths: The hamon changes from choji midare to kataochi gunome. Toward the end of the Kamakura period, the kissaki becomes a little longer.

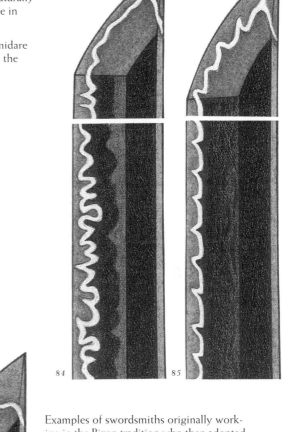

84 85

Examples of swordsmiths originally working in the Bizen tradition who then adopted the Yamashiro tradition. 86. Mid- to late Kamakura period: In swords produced by Nagamitsu, Sanenaga, and other smiths, the hamon is suguha, as it is in the Yamashiro tradition, but here it consists of a nioi structure with utsuri. This is seen mainly among swordsmiths who continued making swords featuring the gentle sugata of the early Kamakura period. 87. Mid- to late Kamakura period: Swords by Sanenaga and others have a suguha hamon with ko-ashi. The hamon is adopted from the Yamashiro-den, but the jigane shows characteristics of the Bizen tradition.

Examples of swordsmiths originally working in other styles who went on to adopt the Bizen tradition. 88. Mid- to late Kamakura period: Blades made by Rai Kuniyuki, Niji Kunitoshi, and other smiths have utsuri, but are constructed in nie. The jigane shows characteristics of the Yamashiro tradition. The hamon is Kyo-choji midare: the top line becomes rather flattened and consists of a nie structure.

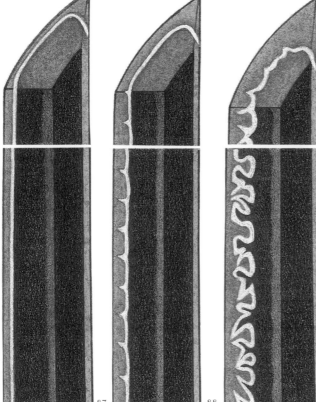

86 87 88

Nanbokucho period

The late Kamakura sugata is extremely exaggerated during this period, with the kissaki and the blade very much lengthened. The jihada and the hamon also change in accordance with the sugata. The popularity of choji midare, which was formerly at the height of its popularity, declines; instead, kataochi gunome, notare midare, and koshi-no-hiraita midare become more common. Hamon patterns generally become larger, and the boshi's kaeri lengthens. At this time, the Soshu-den has already become the most popular style, and the So-den Bizen style arises, as a result of Bizen-province smiths in the Nanbokucho period having adopted the Soshu-den tradition in their sword production; such smiths include those from the Kanemitsu, Chogi, and Motoshige schools.

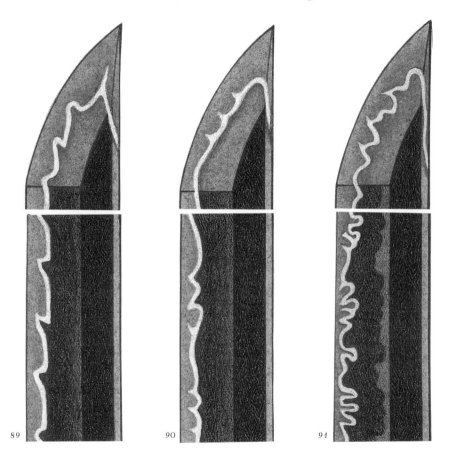

89. Kanemitsu and others: The hamon is becoming kataochi gunome but is in proportion to the relatively long, wide sugata. The pattern of the hamon becomes rather large; the jihada is o-mokume, and utsuri appears.

90. Kanemitsu, Motomitsu, and others: The hamon is based on notare, mixed with small midare. In cases in which the yakihaba widens, the utsuri is less clearly visible.

91. Chogi and others: The hamon shows various patterns, gradually changing into the increasingly popular koshi-no-hiraita midare. Jihada and hamon in the Soshu style, with considerable nie, become more common.

Early Muromachi period

The blade length is shorter than during the Nanbokucho period, and the sugata has returned to the style of the early Kamakura period. The curvature, though, is inclined to be saki-zori, which is different from what it was in early Kamakura times. In the Momoyama period, the koshi-no-hiraita midare temper line, which was sometimes seen in earlier smiths' work, is finally completely developed. The hamon is characteristically koshi-no-hiraita midare, which is invariably mixed with choji midare. The two sides of the midare komi boshi are considerably different. Otherwise, utsuri usually becomes bo-utsuri, even if the hamon is midareba. When the sword has a suguha, bo-utsuri is natural.

92

93

92. Midare komi boshi with different patterns on each side.

93. Morimitsu, Yasumitsu, Moromitsu, and other smiths: The hamon is koshi-no-hiraita midare, mixed with choji midare; bo-utsuri is visible.

Late Muromachi period (Sengoku period)

Just as the Oei Bizen school can be said to have been representative of swordsmithing in general at the beginning of the Muromachi period, the Sue-Bizen school is representative of the latter part of Muromachi. The jigane loses the characteristic that was unique to Bizen-province swords—that is to say, its oiliness. Also, utsuri become rare, and when they are seen, are not distinct. The hamon is typically koshi-no-hiraita midare, and since it resembles the claws of a crab, it is known as "kani-no-hasami." Nie is usually very visible in the hamon. Another feature invariably seen is nioi kuzure. (This expression is limited in its application to Sue-Bizen blades or occasionally to Sue-Koto work. It literally means "scattered nioi," but is basically the same type of activity as yo.) Swords called uchigatana, about 60 cm long and used with one hand, become very popular during this period.

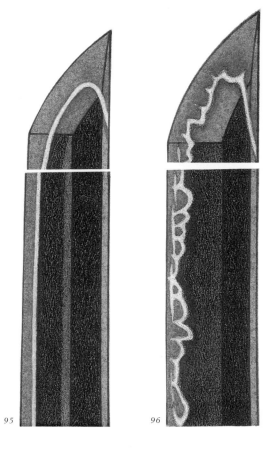

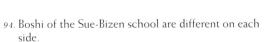

94. Boshi of the Sue-Bizen school are different on each side.

95. An example of a suguha hamon in the Yamashiro tradition by Tadamitsu of the Sue-Bizen school. Bo-utsuri and nioi-deki place the sword within the Sue-Bizen tradition of the period. In addition, the boshi has a long kaeri, a popular feature of the swords of the period.

96. Yozaemon Sukesada and others: The hamon is usually koshi-no-hiraita midare, without choji midare. Nioi kuzure are quite common. The boshi has a long kaeri.

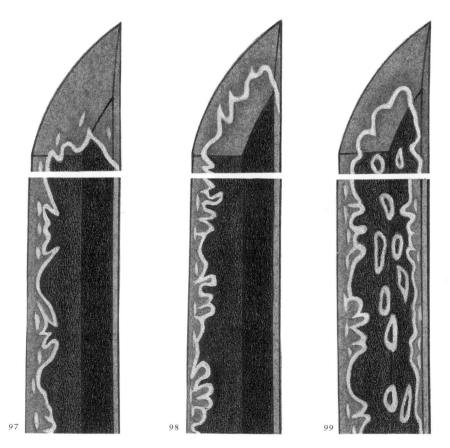

97. Sukesada, Munemitsu, Katsumitsu, and others: The koshi-no-hiraita midare resembles the claws of a crab. Nioi kuzure are often seen. The boshi has a long kaeri, and ichimai boshi are also seen.

98. Kiyomitsu and others: The hamon is koshi-no-hiraita, with abundant nie. Utsuri is rare.

99. Sukesada, Munemitsu, Katsumitsu, and others: The hamon is koshi-no-hiraita midare, mixed with tobiyaki. As a result, it becomes hitatsura. The jigane of this period differs little in quality from that of work by smiths from other parts of the country, and lacks the oiliness traditional to the jigane of Bizen province.

TANTO OF THE BIZEN TRADITION

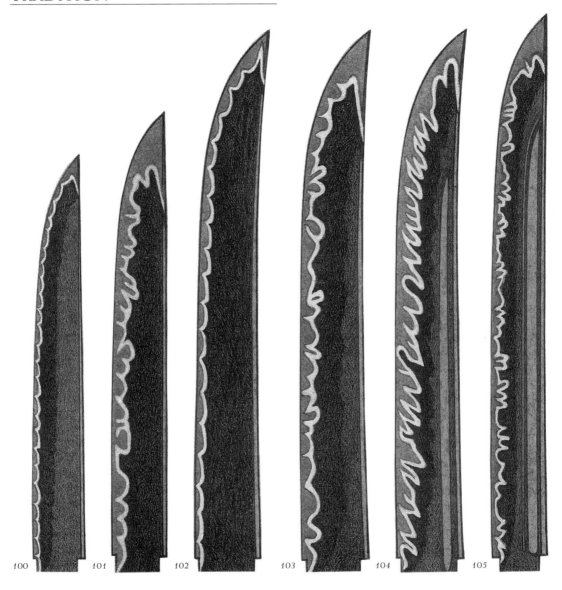

100 101 102 103 104 105

Mid- to late Kamakura period: *100.* Kagemitsu, etc. The nagasa is about 26 cm. Blades are uchi-zori, and have ko-mokume hada with utsuri. The hamon is composed of kataochi gunome. *101.* Mid- to late Kamakura period: Chogi, etc. The hamon is midareba mixed at intervals with choji, and with considerable nie. Among tanto, pure choji midare is rarely seen.

Nanbokucho period: *102.* Kanemitsu, etc. In this period, the blade becomes long and wide (about 30 cm in length), and has sori. *103.* Chogi, etc. The workmanship shows characteristics of So-den Bizen. The jihada is itame-hada combined with mokume-hada. The hamon

is gunome midare, and nie is seen in the ji and the ha. *104.* Chu-Aoe school: The mihaba is wide, and the kasane thin. The blade has sori. The jihada is mokume-hada mixed with sumigane (plain, dark spots) and with utsuri. The hamon is saka-choji midare.

Early Muromachi period: *105.* Morimitsu, Yasumitsu, etc. This illustration shows the wakizashi developed from the tanto; there is also another type that developed from the shortened katana in shinogi-zukuri. Both types originated at this time. The sugata of the wakizashi shown here is not well balanced, because the nagasa is too long in comparison with the mihaba.

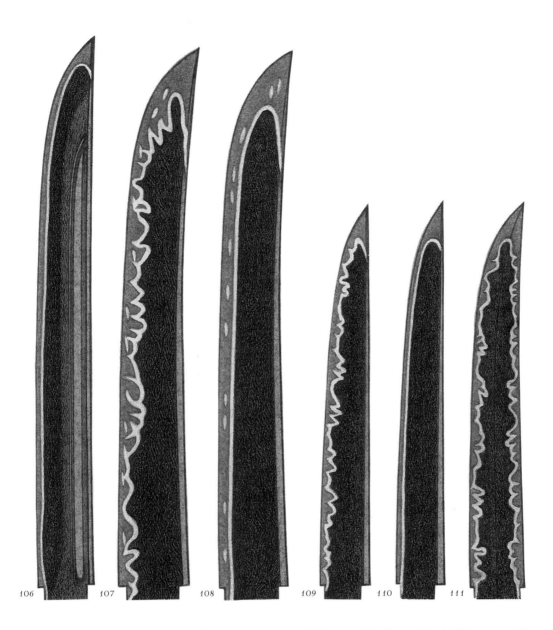

106 107 108 109 110 111

106. Morimitsu, Yasumitsu, etc. The Yamashiro tradition is adopted, but the blade is nioi deki. Bo-utsuri is usually seen. The jihada is a fine mokume-hada.

Late Muromachi period: 107. Kiyomitsu and other Sue-Bizen smiths: Hira-zukuri ko-wakizashi with a relatively great nagasa, wide mihaba, and deep saki-zori is seen in this period, as are yoroidoshi. 108. Sukesada, Kiyomitsu, etc. The suguha at this time is different from the Oei-Bizen school's in terms of both the sugata and the hataraki. Nioi kuzure is always seen inside the hamon.

Late Muromachi period (Three examples of yoroi-doshi):

109. The entire Sue-Bizen school: When viewed from the mune side, the blade looks a triangle. The blade and the sugata are very sharp, which distinguishes this from Kamakura-period tanto with uchi-zori. 110. Sukesada, Kiyomitsu, and others: The Yamashiro tradition is adapted for yoroidoshi (armor-piercing tanto). Nioi kuzure is seen within the hamon. The jigane is hard. 111. The entire Sue-Bizen school: This type of moroha-zukuri tanto is widely produced at this time, but in the case of Sue Bizen, the hamon usually becomes koshi-no-hiraita midare.

THE KO-ICHIMONJI (古一文字) SCHOOL

Swordsmiths of the Ichimonji school inscribed either their names or just the Chinese character "ichi" ("one") on the nakago. Among these smiths, the Fukuoka Ichimonji school, active in Fukuoka in Bizen province, and the Yoshioka Ichimonji school, active in Yoshioka in Bizen province, are well known. In the early Kamakura period, workmanship of the Ichimonji smiths was classical and subdued, but different in certain respects from that of the Ko-Bizen school; smiths of this period are known as the Ko-Ichimonji. Ichimonji workmanship of the mid-Kamakura period is extremely flamboyant.

Sadanori (定則) is said to have founded the Fukuoka Ichimonji school. He was followed by Norimune (則宗), Nobufusa (信房), Sukeyuki (助行), Yasunori (安則), Sukemune (助宗), Sukenori (助則), Narimune (成宗), Sukenari (助成), Sukemura (助村), Sukeshige (助茂), Muneie (宗家), Nobumasa (延正), Muneyoshi (宗吉), Munetada (宗忠), Sadazane (貞真), and others.

The fact that half of the Gotoba-in Goban Kaji (the smiths employed each month by retired emperor Gotoba) was selected from this school indicates the level of recognition accorded the school at the time. Norimune is sometimes called Kiku Ichimonji, and Sukemune is referred to O-Ichimonji.

Sugata: Slender, deep koshi-zori and ko-kissaki. The tachi sugata is elegant and graceful.

Jihada: Well-forged and fine ko-mokume mixed with o-hada. Jifu utsuri occasionally appears.

Hamon: Narrow ko-choji midare, sometimes based on suguha mixed with ko-choji midare. Nie kogori and many hataraki are seen. Wide choji midare may also be seen; when it is, ha-hada is visible. Koshiba is occasionally seen toward the bottom.

Boshi: Ko-maru or ko-midare; the kaeri is short.

Horimono: Bo-bi are sometimes engraved. No other horimono are seen.

THE FUKUOKA ICHIMONJI (福岡一文字) SCHOOL

As stated above, the early Ichimonji school is called Ko-Ichimonji. During the mid-Kamakura period, the Fukuoka Ichimonji was at the height of its prosperity and produced gorgeous, magnificent blades with choji midare of nioi deki. The leading smiths' names include Yoshifusa (吉房), Sukezane (助真), Norifusa (則房), Sukefusa (助房), Nobufusa (延房), Yoshihira (吉平), Yoshimune (吉宗), Yoshimochi (吉用), Yoshimoto (吉元), Sukeyoshi (助吉), Sukemori (助守), Nobukane (信包), Nobumasa (信正), Yoshikane (吉包), Yoshiie (吉家), Naomune (尚宗), and Yoshizane (吉真). Some of the Ichimonji smiths simply inscribed their swords with "ichi" (一), the character for the word "one." Sukezane later moved to Kamakura and is said to have become the leader of a group of smiths there; he is thus called Kamakura Ichimonji. Likewise, Norifusa further expanded the school's geographic reach by founding the Katayama Ichimonji school.

112

The hamon of the Fukuoka Ichimonji school (from left to right): O-busa choji midare; juka-choji midare; and o-choji midare.

Sugata: The tachi (太刀) sugata is grand but not excessive, and remains elegant. The difference in its width at the bottom and the top is not great. Ikubi kissaki is also seen. Some ko-dachi (short tachi) exist, but there are no tanto.

Jihada: The jigane is soft and well forged. It is composed of mokume-hada mixed with o-hada and with chikei. Choji utsuri, midare utsuri, jifu utsuri or botan utsuri appears.

Hamon: Narrow ko-choji midare is rare; more typical are Bizen-tradition choji midare such as o-choji midare, juka-choji midare, o-busa choji midare, etc. Splendid hataraki is seen.

Boshi: The boshi is midare komi in proportion to the hamon and either is yakitsume or has short kaeri. Occasionally the boshi does not become midare komi, but looks like o-maru.

Horimono: No horimono are seen, but bo-bi and futasuji-bi do appear. The top of the hi is sharp and well shaped. The bottom of the hi becomes maru-dome, kaku-dome, or kaki-nagashi.

THE YOSHIOKA ICHIMONJI (吉岡一文字) SCHOOL

The founder of this school, Sukeyoshi (助吉), is said to be the grandson of Sukemune of the Fukuoka Ichimonji school. The smiths of this school lived at Yoshioka in Bizen province and were active from the late Kamakura period through the Nanbokucho period. Most of them inscribe their swords' tangs with the character "ichi," followed by their names. Smiths who did so include Sukemitsu (助光), Sukeshige (助茂), Sukeyoshi (助義), and Sukeshige (助重). As with the Fukuoka Ichimonji school, Yoshioka Ichimonji workmanship is magnificent and flamboyant. They follow the fashion of the period in terms of their sugata and hamon.

Sugata: Grand tachi sugata with ikubi kissaki, shallower sori. The width at top and bottom does not vary greatly. Kodachi, nagamaki, and tanto are occasionally seen.

Jihada: Visible mokume-hada, mixed with o-hada and chikei. Choji utsuri or jifu utsuri appear.

Hamon: The nioi line is tighter than that of the Fukuoka Ichimonji school. O-choji midare are mixed with koshi-no-hiraita midare. Some midare are tapered by nioi or in ko-midare which is inclined to be oblique. Suguha-choji midare is also seen. Koshiba is sometimes tempered at the bottom.

Boshi: The boshi is midare komi, and the kaeri is relatively long.

Horimono: Bo-bi, soe-bi, futasuji-bi, etc. The top of the hi descends slightly from the ko-shinogi. The end of the hi becomes maru-dome or kaki-nagashi.

THE IWATO ICHIMONJI (岩戸一文字) SCHOOL (ALSO KNOWN AS SHOCHU ICHIMONJI [正中一文字])

The swordsmiths who lived at Iwato in Bizen province were called the Iwato Ichimonji. This school was also known as the Shochu Ichimonji, since its members often inscribed the dates of the Shochu era (1324–1326) on their nakago.

The leading swordsmiths of the Iwato Ichimonji school were Yoshitake (吉武), Shigeyoshi (重吉), Yoshiuji (吉氏), Yoshimori (吉守), Yoshitoshi (吉利), Yoshisada (吉定), and Yoshihisa (吉久). Their work does not have the glamorous qualities of other Ichimonji schools, but does show some traces of the Yamashiro tradition. Extant works are comparatively rare.

Sugata: Shallow sori, wide mihaba, slightly larger kissaki, and only scarce hira-niku. Nagamaki are also seen.

Jihada: Relatively rough jihada mixed with o-hada. The utsuri is not distinct.

Hamon: Narrow hamon consisting of nioi. Ko-choji midare, or suguha mixed with ko-choji midare.

Boshi: Ko-midare.

Horimono: Bo-bi, futasuji-bi, etc.

THE KATAYAMA ICHIMONJI (片山一文字) SCHOOL

The Katayama Ichimonji school is said to have been founded by Norifusa (則房), who moved to Bitchu from Bizen province. The school's leading smiths include Sanetoshi (真利), Yorizane (依真), Noritsune (則常), and Norizane (則真). They seem to have been active from the mid-Kamakura period to the Nanbokucho period. Due to geographic proximity, it is natural that there were technical exchanges between the provinces of Bitchu and Bizen, and indeed

similarities are readily evident in the workmanship of smiths from these two areas.

Sugata: Grand, graceful tachi sugata with ikubi kissaki. Examples of tachi with larger kissaki, displaying the characteristic features of the Nanbokucho period, are also seen.

Jihada: Mokume-hada mixed with o-hada. Utsuri appear.

Hamon: The yakihaba is not uniform from bottom to top. Saka-choji midare consists of thick nioi.

Boshi: The ko-midare is inclined to be oblique.

Horimono: The top of the bo-bi ascends toward the ko-shinogi, the end of the hi is usually kaki-nagashi.

THE OSAFUNE (長船) SCHOOL

All of the production sites of the Bizen schools are located along the lower reaches of the Yoshii river. Of these, the Osafune school was for a long time the most prosperous. This school produced master swordsmiths in great numbers, from the middle of the Kamakura period through the end of the Muromachi period. The main families that lived in Osafune are referred to as the Osafune school here. Osafune smiths are classified into several schools for the sake of convenience, including Ko-Osafune, Kanemitsu, Oei-Bizen, and Sue-Bizen.

The founder is thought to have been Mitsutada (光忠). His son was Nagamitsu (長光), a name which was used by a smith of the generation which followed his as well. The first-generation Nagamitsu was long thought to have used the name Junkei after his retirement, and is known as Junkei Nagamitsu. Recent research has revealed, however, that Junkei and Nagamitsu were in fact two different smiths. Although it is yet to be fully confirmed, the two-character signature for Nagamitsu is said to been that of the first-generation smith, and the signature Sakon Shogen Nagamitsu that used by his successor.

Kagemitsu (景光) represents the school's third generation, and Kanemitsu (兼光) the fourth.

Kanemitsu then seems to have been followed by another smith who used his name. The second-generation Kanemitsu, known as Enbun Kanemitsu, lived during the Nanboku-cho period, and his work shows characteristics quite different from those of his predecessor.

This school included many other master smiths as well, such as Kagehide (景秀), Kageyori (景依), Sanenaga (真長), Nagamoto (長元), Kagemasa (景政), Sanemitsu (真光), and Chikakage (近景).

Sugata: The sugata exhibits the features characteristic of the period, and is similar to the work of the Ichimonji school of the same period. It is a tachi sugata typical of the mid-Kamakura period, with wide mihaba and ikubi kissaki. Occasionally among Nagamitsu's work an unusual sugata may be seen, resembling sugata of the early Kamakura period, or with shallow sori and a mihaba which does not vary greatly from the bottom to the top.

Hamon: Mitsutada adopted the Ichimonji-style o-choji midare mixed with juka choji, and a unique kawazuko choji which consists of nioi. Nagamitsu also produced gorgeous choji midare, but the pattern is different from the conspicuous rise and fall seen in that of the Ichimonji school, and is mixed with considerable gunome midare. Suguha-choji midare and chu-suguha with ko-ashi are also seen. Hamon based on suguha and gunome midare were common from the time of Kagemitsu. Kagemitsu also originated kataochi gunome.

Boshi: Mitsutada's boshi is midare komi in proportion to the hamon, and the kaeri is short or yakitsume. Nagamitsu's becomes a sansaku boshi. In fact the term "sansaku" generally refers to the boshi of Nagamitsu, Kagemitsu, and Sanenaga.

Horimono: Bo-bi are commonly seen, and the top of the hi looks pointed and sharp. Futasuji-bi are also seen. Kagemitsu engraves harami-ryu (an image of a pregnant dragon) and bonji, or the names of various gods and deities. Ukibori (embossing) is seen in the hitsu (groove) or the

hi. Kagemitsu is one of the finest engravers. One of his masterpieces, "Koryu Kagemitsu," is very famous for its horimono.

THE SABURO KUNIMUNE (三郎国宗) SCHOOL

In Osafune, another school was also started, by Kunimune (国宗). This smith's father was Naomune (直宗), while Kunizane (国真), Kunisada (国貞), and Kuniyasu (国安) are said to have been his brothers. Kunimune moved to Kamakura in Soshu, along with Ichimonji Sukezane, and became one of the pioneer Soshu swordsmiths. Two generations of smiths appear to have used the name Kunimune.

The Saburo Kunimune school's workmanship is similar to that of other smiths of the period, although the jihada is slightly coarse and hajimi can be seen in places where the hamon does not form a proper pattern and appears misty. The pattern of the choji midare is smaller, and tends to be suguha-choji midare with nie, making it reminiscent of Yamashiro-den workmanship. On occasion, the hamon becomes calmer and flatter as it ascends up the blade toward the tip.

Nakahara Kunimune (中原国宗), who lived in Mikawa province, seems to have belonged to this school. Some of his extant works show influence of the Yamashiro tradition, in that the hamon is a suguha-choji midare that consists of nioi.

THE HATAKEDA (畠田) SCHOOL

The founder of the Hatakeda school is said to be a smith called Morichika (守近), but few of his blades are extant. Moriie (守家), who it is believed to have lived in Hatakeda and to have belonged originally to the Fukuoka Ichimonji school, produced swords during the mid-Kamakura period.

The name Moriie was used by more than two generations. As the second Moriie inscribed the phrase "Osafune ju" (resident of Osafune) on his nakago, it is clear that he moved to Osafune, and there is a possibility that he later joined the Osafune school. Sanemori (真守), Iesuke (家助),

and Morishige (守重) belong to this school.

Hatakeda workmanship is similar to that of Mitsutada, but the jihada is loose and rough. The hamon is a rather flamboyant o-choji midare mixed with kawazuko choji, as is Mitsutada's, but in Hatakeda work, the hahada is visible and the hamon is inclined to consist of nie.

Swords made in Bizen and other areas became enormous in size with the start of the Nanbokucho period (90 cm was not unusual); these swords had a wide mihaba and an o-kissaki. Very long tachi, called nodachi or seoi-dachi, more than 100 cm long, were also made. Tanto, too, became ko-wakizashi, reaching more than 30 cm in length, and had a wide mihaba and a pronounced sori.

Osafune was still the main area of sword production during this period, but even in Kanemitsu's school (the main branch of the Osafune school), there was a movement away from the original Bizen tradition's hamon consisting of choji midare in nioi deki; his school's work shows some influence of the Soshu-den. In the work of Kanemitsu and Chogi (長義) (both of whom are counted among Masamune's Juttetsu, or ten excellent students), and Motoshige (元重) (said to be one of Sadamune's Santetsu, or three excellent students), the influence of the Soshu-den is clearly recognizable. The question of just who were Masamune's ten students or Sadamune's three students aside, it is quite interesting to note that the Soshu tradition came into vogue even in the famous sword-producing region of Bizen province and that smiths there actually incorporated several Soshu elements into their sword production; this amalgamated Nanbokucho-period workmanship is known as the So-den Bizen.

In addition to those listed above, two other schools were active in Bizen province, the Omiya and the Yoshii. Work by their smiths is extant.

THE KANEMITSU (兼光) SCHOOL

Kanemitsu is said to have been the name used by two generations of smiths in the main family of the Osafune school. The first generation

was Kagemitsu's son, and a blade dated 1331 is the oldest dated extant example of his work. Workmanship characteristic of Kagemitsu, whose sugata shows features typical of the late Kamakura period, with hamon that are uniformly kataochi gunome consisting of nioi, continued into the Nanbokucho period.

Beginning in the Bunna era (1352–1356), the workmanship of Kanemitsu changed remarkably. In this period, the smith known by that name is called Enbun Kanemitsu (延文兼光), and because of the change in the style of workmanship, is said to be of a second generation. Tomomitsu (倫光), Yoshimitsu (義光), Yoshikage (義景), Hidemitsu (秀光), Motomitsu (基光), Masamitsu (政光), Toshimitsu (利光), Shigemitsu (重光), and other smiths belonged to the school headed by this second-generation smith. The work of each member of this school had some distinctive features, but the basic characteristics of the second Kanemitsu's work are outlined below.

Sugata: The ubu (original, or untouched) swords of this period came to have the longest nagasa in Japanese history, but most of the extant works are o-suriage (shortened at some point in their history) and mu mei (unsigned now, as a result of reshaping). The mihaba is wide, with almost no difference in width at the bottom and the top. The kissaki is large, with a fukura which is not rounded. Hira-niku is scarce. The shinogi is high and the shinogiji narrow. Later (toward the Muromachi period) this school's nagasa becomes shorter and the sugata gradually takes on a greater resemblance to the katana sugata.

In the tanto, the nagasa ranges from 30 cm to 35 cm, the mihaba is relatively wide, hira-niku is scarce, and the kasane is thin; the blade also has saki-zori. As is true of the tachi sugata as well, the tanto becomes gentle and slender with the approach of the Muromachi period.

Jihada: The jigane is well forged and soft. Utsuri appears in the pattern of namazu-hada with thick chikei.

Hamon: The hamon is narrow, but when kataochi gunome is present, the pattern is larger than Kagemitsu's. O-midare with nie and mixed with kataochi gunome, and notare midare with small hataraki are also seen. In work by later smiths of this school there are ko-midare, ko-gunome midare, and koshi-no-hiraita midare.

Boshi: His distinctive boshi, called "Kanemitsu boshi," is midare komi and is tapered with nioi at the top, resembling a candle flame.

Horimono: In addition to the hi, such horimono as ken-maki-ryu (a dragon winding around a sword), bonji, tsume-tsuki-ken (a sword hilt with claws), dokko-tsuki-ken (a sword with a handle), and the names of gods and deities are skillfully engraved. Tomomitsu (Rin Tomomitsu) engraved a simplified ken-maki-ryu which looks like kara kusa (arabesque pattern).

Some of the swordsmiths in Bizen province were referred to as Kozorimono (the Kozori group). The defining features of the group are unclear, but it appears that smiths who did not belong to the main school and who were active at the end of the Nanbokucho and beginning of the Muromachi periods were called Kozorimono. Smiths belonging to this group were Tsunehiro (恒弘), Yoshikiyo (義清), Yoshihiro (吉弘), Hidemitsu (秀光), Nariie (成家), Moritsuke (守助), Morihiro (守弘), Shigetsuna (重綱), Sadayasu (貞安), Morihisa (守久), and Mitsuhiro (光弘). The work of the smiths active at this time illustrates the process by which tachi were gradually changing to katana. Even in the Kanemitsu school, at the end of the Nanbokucho period, a general decline in workmanship is very obvious. The hamon pattern generally becomes smaller. But some of the swords produced by the Kozorimono are as excellent as Morimitsu's or Yoshimitsu's.

THE CHOGI (長義) SCHOOL

Generally, Bizen swords made during the Nanbokucho period are called So-den Bizen. Among these, those by Chogi and his school show the most distinct features of the Soshu tradition. Some of their hamon and jihada are

reminiscent of work by masters of Soshu province. Their work, dating from the Kenmu through the Enbun eras (1334–1360), has been confirmed as extant. Nagashige (長重), Kanenaga (兼重) (or Kencho) and Nagamori (長守) belong to this school.

Sugata: Shallow sori, thick kasane, wide mihaba, plenty of hira-niku, and large kissaki. In the tanto, the nagasa is extended to around 30 or more cm; the nagasa has a little thick kasane and slight sori.

Jihada: The jigane is soft and the jihada is itame-hada mixed with mokume-hada with nie and chikei.

Hamon: The hamon is wide and gorgeous; it is basically nioi deki but is inclined to be nie deki. Gunome midare is seen, mixed with the so-called "mimigata midare" (ear-shaped gunome). O-hada is visible inside the hamon. There are hataraki associated with nie, such as nie sake and sunagashi, all features of the Soshu tradition. Workmanship is similar to that of Soshu Hiromitsu. Hajimi (misty spots) are seen inside the hamon at times. Tanto by Nagashige sometimes have a narrow hamon, and are ko-midare, or ko-gunome midare with abundant nie.

Boshi: Midare komi and long kaeri with hataraki, but the end of the kaeri is smooth, which distinguishes this work from the Mino tradition.

Horimono: Bo-bi are occasionally seen, sometimes with soe-bi.

THE MOTOSHIGE (元重) SCHOOL

Motoshige (元重) is said to be the son of Morizane (守真) of the Hatakeda school. He produced swords for a relatively long time, from the end of the Kamakura period and into the Nanbokucho period; a considerable number of his works are extant today. It is highly probable that more than one generation of smiths worked under the name Motoshige. A second Motoshige, whose chiseled signature and workmanship are completely different from that of the earlier smith, is called "Ko" ("Old") Motoshige.

Ko Motoshige's work has a sugata that shows features of the early Kamakura-period Yamashiro tradition. The jihada is fine, the suguha consists of tight nioi, the ashi are inclined to be oblique, the yasurime is o-sujikai, and the signature appears to be chiselled in the manner of katana mei of the Aoe school.

Smiths of the Motoshige school include Shigezane (重真), said to have been the son of the first Motoshige, and Motozane (元真), who is thought to have been the son of Ko Motoshige. The work done by these smiths during the Nanbokucho period is described below.

Sugata: As does the work of the second Kanemitsu, shows the characteristic features of the Nanbokucho period.

Jihada: Weak mokume-hada mixed with masame-hada. The weakness of the ji and the ha is one distinguishing feature. The utsuri tends to be shirake utsuri.

Hamon: Based on suguha in proper width with saka (oblique) ashi which look like kataochi gunome, or mixed with ko-midare which is inclined to be oblique. Uniform ko-gunome are customarily formed in the middle of the hamon. The hamon is dull. Unique oikakeba that are gunome inclined to be notare and look very much like rolling waves are seen occasionally.

Boshi: Similar to Chikakage's, but with a boshi that is less pointed at the top than his.

Horimono: Bo-bi and futasuji-bi on tachi, and suken and bonji on ko-wakizashi, are seen.

THE OMIYA (大宮) SCHOOL

Kunimori (国盛), the founder of this school, is said to have moved from Inokuma Omiya, Yamashiro province, to Bizen province at the end of the Kamakura period. Kunimori was followed by Sukemori (助盛), Morishige (盛重), Moritoshi (盛利), Morikage (盛景), and Morokage (師景). All these names were used over several

generations, until the Muromachi period. It is difficult to distinguish between blades made by this school and those made by the Osafune school during the Muromachi period.

Sugata: Similar to the Kanemitsu school, but less refined. Thick kasane, plenty of hira-niku, and shallow sori.

Jihada: The jigane is slightly hard, and the jihada is mokume-hada mixed with o-hada.

Hamon: Narrow ko-midare of nioi deki mixed with ko-choji, with plenty of hataraki. Similar to the Kanemitsu school, but technically inferior on the whole. Among Morikage's blades there is a hamon which is a mixture of o-midare and choji midare.

Boshi: The boshi is ko-midare and turns back.

Horimono: Bo-bi with soe-bi or tsure-bi, futasuji-bi, etc.

THE YOSHII (吉井) SCHOOL

The Yoshii school was active in Yoshii, near Osafune, beginning in the Nanbokucho period. Tamenori (為則) is said to have been the founder, followed by Kagenori (景則), Sanenori (真則), Ujinori (氏則), Yoshinori (吉則), Mitsunori (光則), Morinori (盛則), Kiyonori (清則), Naganori (永則), and Kanenori (兼則). Later generations of smiths also used the same names; those who moved to Izumo province are known as the Unshu Yoshii. Most of their work was produced in the Muromachi period. Their workmanship shows its own distinctive traits and is an unorthodox variation of the Bizen tradition. The following explanation describes the workmanship of the Yoshii school of the Muromachi period.

Sugata: The swords have neither o-kissaki nor wide mihaba, but gentle sugata of standard length or just a bit shorter. The school produced mainly katana and wakizashi, although hira-zukuri wakizashi are occasionally seen.

Jihada: Narrow and uniform ko-gunome midare with nie in the tani (bottom) of each

gunome. Chu-suguha with nie ashi at regular intervals.

Boshi: Ko-midare and short kaeri.

Horimono: Bo-bi with soe-bi or tsure-bi, futasuji-bi, etc.

THE OEI-BIZEN (応永備前) SCHOOL

By about the start of the Muromachi period, most of the different schools in Bizen province were virtually absorbed by the Osafune school, which had long been the main school in the area. The various schools gradually lost any distinctive qualities they may have had, and began to display the characteristic features of Bizen workmanship of this period. Oei-Bizen is a general term for the Osafune smiths who inscribed the dates of the Oei era (1394–1428) on their nakago. The school's predecessors are said to date back to the Nanbokucho period, but their work had changed greatly by the end of the period, and it may be said that they were superseded, and their style developed further, by the Oei-Bizen smiths. Morimitsu (盛光), Yasumitsu (康光), Moromitsu (師光), Iesuke (家助), and Tsuneie (経家) were the leading smiths of the school. The first three of these are known as the "Oei no San Mitsu (応永の三光)" (Three Mitsu of the Oei era) and are very famous and excellent.

Sugata: There are tachi, katana and wakizashi of both shinogi-zukuri and hira-zukuri, but tanto of less than 30 cm in length are rare. There are no extant examples of nagamaki. The exaggerated and ostentatious sugata which was in fashion in the preceding period disappeared completely. These smiths seem to have set out to copy the tachi sugata of the Kamakura period, but theirs is differentiated by a shallow saki-zori. Generally the nagasa is about 70 cm in tachi, and 50 cm in wakizashi. The production of katana and wakizashi was begun in this period. Katana are similar to tachi, but the saki-zori is deeper and the nagasa shorter than is seen in tachi. Wakizashi generally have

narrow mihaba, small kissaki and saki-zori. Nagasa of hira-zukuri ko-wakizashi became longer than in the preceding period, but the mihaba grew narrower and the sori is very shallow, or blades may sometimes be mu-zori.

Jihada: The jigane is soft and the jihada is mokume-hada mixed with o-hada. Clear bo-utsuri appears. Even when the hamon is midareba, the utsuri tends to be bo- (straight) utsuri. But midare utsuri is still sometimes seen.

Hamon: The hamon has a proper yakihaba and consists of nioi. It is koshi-no-hiraita midare mixed with choji midare. The thick nioi line is very soft and hajimi are seen inside the hamon at times. Alternatively, suguha mixed with ko-midare is also seen.

Horimono: Bo-bi with soe-bi or tsure-bi are quite common. The top of the hi is located just above the yokote. The bottom of the hi is finished around the machi. Horimono are often seen on the wakizashi, with the same design appearing on both sides of the blade. Ken-maki-ryu or the names of gods and deities are engraved on the omote (front) and ken with dokko, tsume or bonji on the ura (back); while bo-bi with soe-bi or tsure-bi whose bottoms are maru-dome (rounded end) are usually engraved above the horimono.

Nakago: Shorter and less tapered nakago with kurijiri. Cho mei (long signature) including the date is common. It is natural that katana-mei became common instead of tachi-mei, as production of katana increased.

Some smiths who were active between the years 1429 and 1465 could not readily be classed into either the Oei- or Sue-Bizen schools and, as their work shows qualities slightly different from either of these schools, they are referred to as the Eikyo Bizen (永享備前). The leading smiths are Norimitsu (則光), Sukemitsu (祐光), and Toshimitsu (利光). Their work is described below.

Sugata: The nagasa is comparatively short, the blade is slender, and the kasane is relatively thick. The blade is compact and handy. It is here that the uchigatana intended for single-handed use made its first appearance.

Jihada: The mokume-hada is dense in comparison with Oei-Bizen. Midare-utsuri or bo-utsuri appears.

Hamon: Wide koshi-no-hiraita midare mixed with choji midare but uniform pattern is not regularly repeated, unlike Sue-Bizen. Ha-hada is visible and there are few hataraki.

Horimono: Bo-bi, futasuji-bi, tsure-bi, bonji, elaborate ken-maki-ryu (dragon winding itself around a sword) with another horimono on the same side. They were skillful engravers.

THE SUE-BIZEN (末備前) SCHOOL

In the later Muromachi period (and the Sengoku period) there were relatively few good swordsmiths working in Bizen province. The Sue-Bizen smiths produced numerous kazu-uchi-mono (mass-produced swords), as did the Sue-Seki smiths. Nevertheless, high-quality swords were also produced, the workmanship of which is clearly distinct from that of the Oei-Bizen swordsmiths. Leading smiths were Katsumitsu (勝光), Munemitsu (宗光), Tadamitsu (忠光), Sukesada (祐定), Kiyomitsu (清光), Harumitsu (春光), Yukimitsu (幸光), Yoshimitsu (賀光), Nagamitsu (永光), Norimitsu (法光), Koremitsu (是光), and two smiths named Arimitsu (在光・有光), whose names had different first characters. Some of these names were used over several generations, and there was sometimes more than one smith working at the same time with the same name. Sukesada was the most prominent figure of the Sue-Bizen school, but more than forty smiths who also went by this name are listed in old records. Of these, Yosozaemon no Jo Sukesada seems to have been the most skillful, followed by Hikobei no Jo Sukesada and Genbei no Jo Sukesada.

Sugata: Uchigatana were the main swords produced in this period, followed by hira-zukuri wakizashi, tanto of either hira-zukuri

or moroha-zukuri, and naginata. Uchigatana generally have a length of 63–66 cm, deep saki-zori, wide mihaba, thick kasane, full hira-niku, relatively small kissaki, and stout sugata. The nakago is short, to allow for single-handed use.

Just before the start of the Shinto era, during the Koji and Tensho eras (1555–1592), swords became longer, ranging from 72 to 75 cm. At this time, the saki-zori is relatively shallow. There appears to have been a change in the way swords were used, with the nakago becoming longer than it had been in the uchigatana of the preceding period; this made it possible to use the katana with two hands.

There are two sizes of tanto. The longer was around 30 cm, and the other was very short, under 20 cm in length. The nakago is long in proportion to the length of the blade. Yoroi-doshi have thick kasane and exaggerated uchi-zori. Moroha-zukuri tanto are common, not only in work by Sue-Bizen smiths, but also in that of other schools such as the Sue-Mihara, Sue-Seki, Sue-Yamato, Sue-Soshu, and Hakushu-Koga.

Jihada: Fine ko-mokume hada with jinie; the utsuri is neither clear nor distinct.

Hamon: Wide hamon of nioi deki but sometimes inclined toward nie deki. One of the most common hamon is koshi-no-hiraita midare which is based on a wavy pattern and which is consistent in its width from bottom to top. Each top of the midare has a peculiar shape which is called "kani-no-hasami" (crab's claw). O-midare, nie kuzure, and hitatsura in Soshu-tradition style are also seen. There are ashi, a lot of nioi kuzure, and sometimes koshiba, in the case of a suguha or o-notare hamon. Nioi kuzure is seen on most Sue-Bizen swords. In the case of a moroha-zukuri tanto which is midareba, the kaeri is in proportion to the hamon, or becomes suguha and extends right down to the bottom.

Boshi: Ko-maru sagari (descending) when the hamon is suguha. When the boshi is midare-ba, it is in proportion to the hamon, but the patterns on each side are different. The kaeri

does not form a proper pattern, and it looks like hitatsura in the monouchi area (beginning at the ko-shinogi and extending downward 6 to 9 cm).

Horimono: Above the machi, bo-bi with tsure-bi, and maru-dome are common. The horimono are deeply and elaborately engraved. The width of the horimono is a bit narrow. Kasane bo-bi (more than two kinds of hori-mono on the same side) of ken-maki-ryu, bonji, ken with tsume or dokko, the names of gods and deities, and the combination of horimono and hi with tsure-bi and with maru-dome are seen. The distinctive bonji, whose top looks like a flame, is called "kaen bonji."

Nakago: Short and relatively less tapered nakago. Cho mei (long signature) is standard in the case of elaborate works or custom-made swords; also included are dates, second names and sometimes the owner's name.

Kazuuchi-mono (mass-produced blades)
It is clear that mass-produced blades, or kazu-uchi-mono, are inferior in quality to elaborate, custom-made swords. Yet it may be useful to know something about the details of kazu-uchi-mono workmanship.

Sugata: The nagasa is generally from 65 to 70 cm, and the sugata resembles Oei-Bizen but is a little more slender in the upper part.

Jihada: Shingane often appears on the surface as a result of the attempt to economize on valuable materials (tamahagane) and of the use of more shingane in the core. Rough masame-hada and tsukare utsuri ("tired jiha-da," or a jihada worn down from repeated polishing) also appear. When the shingane comes out into the hamon, the pattern of the hamon becomes obscured.

Hamon: There are many yaki-kuzure, and the size of the various midare is not at all regular. At a glance, the yaki-kuzure look like the claws of a crab.

Boshi: Generally has yaki-kuzure, and is different on each side of the blade.

Nakago: Kazuuchi-mono usually have the same style of signature, such as Bishu Osafune (備州長船) or Bizen no kuni Osafune (備前国長船) followed by the smith's name, but without any zokumyo (second name).

LEADING SWORDSMITHS OF THE BIZEN TRADITION

ERA	PROVINCE	SWORDSMITH(S)	PATTERN
Genryaku (1184–1185)	Bizen	Fukuoka Ichimonji Norimune (福岡一文字則宗)	The hamon is ko-choji midare, ko-midare, and suguha choji midare in regular width. There is a great deal of hataraki inside the hamon. O-choji midare is almost never seen, and workmanship in general is similar to that of the Ko-Bizen school.
		Fukuoka Ichimonji Nobufusa (福岡一文字信房)	In addition to the typical workmanship of Ko-Ichimonji, there is wide choji midare and a visible hada.
		Fukuoka Ichimonji Sukeyuki (福岡一文字助行)	Refer to page 178.
Kenkyu (1190–1199)		Hatakeda Morichika (畠田守近)	Founder of the Hatakeda school. Extant works are rarely seen and, as a matter of fact, Moriie is regarded as having the greater influence on later smiths of this school.
Shoji (1199–1201)		Fukuoka Ichimonji Yasunori (福岡一文字安則)	Refer to page 178.
		Fukuoka Ichimonji Muneyoshi (福岡一文字宗吉)	The sugata is gentle and the hamon is suguha choji midare.
	Yamashiro	Awataguchi Kuniyasu (粟田口国安)	Work in the Yamashiro tradition is common, but choji midare with nie kogori is also seen.
Jogen (1207–1211)	Bizen	Fukuoka Ichimonji Sukemune (福岡一文字助宗)	Norimune's son; his workmanship is similar to his father's.
		Fukuoka Ichimonji Narimune (福岡一文字成宗)	Refer to page 178.
		Fukuoka Ichimonji Sukenari (福岡一文字助成)	Refer to page 178.
		Fukuoka Ichimonji Sukemura (福岡一文字助村)	Refer to page 178.
Kenpo (1213–1219)		Fukuoka Ichimonji Sukefusa (福岡一文字助房)	The sugata is grand and the hamon is choji midare with a great many gorgeous choji ashi.
		Fukuoka Ichimonji Nabukane (福岡一文字信包)	Features identical to those of Nobufusa.
		Fukuoka Ichimonji Nobufusa (福岡一文字延房)	Features identical to those of Nobufusa.
		Fukuoka Ichimonji Yoshifusa (福岡一文字吉房)	One of the representative smiths of the Fukuoka Ichimonji school through the Kamakura period. The sugata is grand. The hamon is a gorgeous juka-choji midare, and the choji utsuri are splendid.

SOUTHERN COURTS	NORTHERN COURTS	PROVINCE	SWORDSMITH(S)	PATTERN
	Enbun (1356–1361)		Osafune Kanemitsu II (長船 二代 兼光)	Typical sugata of the Nanbokucho period, with wide mihaba and large kissaki. Hi and horimono are commonly engraved on the blade. The jihada is fine. Namazu hada, utsuri, and thick chikei appear. In the case of kataochi gunome, the pattern is larger than Kagemitsu's. Also there is notare midare which is inclined to be oblique and mixed with kataochi gunome. The nioi line is tight, but there are many hataraki inside the hamon. Occasionally the nioi line is not bright, and the hamon appears dull. The boshi is midare komi and the top is tapered, resembling a candle flame.

116

Two examples of the workmanship of Kanemitsu II.

| | | | Osafune Tomomitsu (長船倫光) | (Also known as Rin Tomomitsu.) Kanemitsu school. The sugata is typical of the time. Hi and horimono are commonly engraved. This smith favoured a unique ken-maki-ryu which is called "Karakusa bori" because it looks like an arabesque pattern. The hamon is a large-patterned kataochi gunome and o-midare whose pattern is inclined to be oblique, like that of Kanemitsu II. The jihada, boshi, and workmanship of the tanto are all similar to those of Kanemitsu II. |
| Shohei (1346–1370) | | | Osafune Motomitsu (長船基光) | Kanemitsu school. Hi are commonly seen. The jigane is a little hard, the jihada is coarse mokume hada, and utsuri appears. The hamon is narrow ko-gunome midare mixed with kataochi gunome. The nioi is tight. The boshi is midare komi and the kaeri is short. |

117

Tomomitsu's horimono.

SOUTHERN COURTS	NORTHERN COURTS	PROVINCE	SWORDSMITH(S)	PATTERN
	Joji (1362–1368)		Osafune Masamitsu (長船政光)	Kanemitsu school. Hi are commonly seen. The hamon is wide o-midare or choji midare mixed with koshi-no-hiraita midare. The hamon tends to be ko-midare in nie deki.
			Omiya Morikage (大宮盛景)	Refer to page 183.
			Osafune Kanenaga (長船兼長)	(Commonly called, in another pronunciation of the same characters, Kencho.) Chogi school. The workmanship bears a resemblance to Chogi's but is not equal to it in quality.
			Osafune Nagamori (長船長守)	Chogi school. The workmanship bears a resemblance to Chogi's but is not equal to it in quality.
		Echigo	Yamamura Masanobu (山村正信)	Tachi are rare. His production is mainly in tanto and ko-wakizashi with saki-zori. Horimono are similar to those of Nobukuni. The hamon is nioi deki and ko-midare with mura (uneven) nie.

THE MUROMACHI PERIOD

ERA	PROVINCE	SWORDSMITH(S)	PATTERN
Oei (1394–1428)	Bizen	Omiya school (大宮派)	Several smiths are recognized. Refer to page 183.
		Yoshii school (吉井派)	Several smiths are recognized. Refer to page 184.
		Osafune Moromitsu (長船師光)	The workmanship is similar to that of Yasumitsu and Morimitsu as a whole, but is less elegant and features a jihada mixed with masame-hada.
		Osafune Yasumitsu (長船康光)	Katana and hira-zukuri wakizashi are the main areas of production. There are a few tanto. Hi and horimono are commonly seen. The jihada is a dense mokume hada mixed with o-hada, and bo-utsuri appear. The hamon has a proper width which gradually expands from the bottom toward the top; also, the beginning of the hamon starts with a small pattern, which becomes larger as it progresses upward. The yakigashira (top of each midare) is tapered with nioi, and winds its way like smoke up toward the ji. There is also ko-midare. The boshi is midare komi, and the kaeri is short. Occasionally the pattern of the boshi is different on the two sides.
		Osafune Morimitsu (長船盛光)	Hi is common but horimono are rare. The jihada is a dense mokume-hada mixed with o-hada, and bo-utsuri appear. The pattern of the hamon is inclined to be larger at the bottom and smaller toward the top. The nioi line is tight and the yakigashira has a round shape, unlike Yasumitsu. The boshi is midare komi and the kaeri is short. Occasionally the pattern of the boshi is different on the two sides.

118

Comparison of hamon by Yasumitsu (left) and Morimitsu.

ERA	PROVINCE	SWORDSMITH(S)	PATTERN
Shocho (1428–1429)		Hatakeda Iesuke (畠田家助)	Workmanship shows general features of Oei-Bizen swords, but the blade is somewhat lacking in elegance.
		Osafune Morimistu II (長船 二代 盛光)	Hi and horimono are commonly engraved. The jigane is weak and the jihada is mokume hada mixed with masame hada. The hamon is koshi-no-hiraita midare, with mura nie seen here and there. The boshi is midare komi.
Eikyo (1429–1441)		Osafune Norimitsu (長船則光)	Gentle sugata with shallow sori; occasionally, stout sugata can be seen. Hi and horimono are commonly engraved. The jihada is a fine mokume hada mixed with wavy o-hada, and bo-utsuri appear. The hamon is koshi-no-hiraita midare in a large pattern. There are not many hataraki inside the hamon. Nioijimi (the part of the hamon whose nioi line is indefinite and looks misty) can be seen in places. Also there is a type of hamon which is inclined to be nie deki; in this case, the size of midare is irregular. The boshi is midare komi and the kaeri is short.
		Yoshii school (吉井派)	Several smiths are recognized.
		Osafune Moromitsu II (長船 二代 師光)	Features identical to those of the first generation Morimitsu.
		Osafune Sukemitsu III (長船 三代 祐光)	There are no extant works by either the first or the second generations. There are a few blades with hi and horimono. The jihada is dense mokume hada mixed with wavy o-hada, and bo-utsuri appears. The hamon is koshi-no-hiraita midare, like the ones produced between the Oei and the Eikyo eras, but here yaki-kuzure and haji-mi can be seen. In the case of ko-midare, the hamon tends to be nie deki. The boshi is midare komi.
Bunmei (1469–1487)		Ukyo no Suke Katsumitsu (右京亮勝光)	There were several generations of smiths who worked under this name. Hi and horimono are common. The horimono are deeply and skillfully engraved and the design and the chiseling are elaborate. The jihada is dense mokume hada mixed with o-hada. In cases where the hamon tends to be nie deki, ji-nie can be seen. The hamon is koshi-no-hiraita midare with nie and many hataraki. The size of the midare is not regular. Boshi midare komi, occasionally with different patterns on each side.
		Sakyo no Shin Munemitsu (左京進宗光)	This smith often collaborated with Katsumitsu. There are several generations. Workmanship is the same as Katsumitsu's, but the hamon is mainly a relatively narrow ko-midare with nie and hataraki.
		Shuri no Suke Tadamitsu (修理亮忠光)	Katana and wakizashi are the main areas of production. The sugata is gentle, and hi and horimono are commonly engraved. The jihada is beautiful, and a dense mokume hada mixed with o-hada. The hamon is koshi-no-hiraita midare. The boshi is midare komi and the kaeri is long.
Eisho (1504–1521)		Osafune Sukesada (長船祐定)	There were many smiths working under the name Sukesada at this time. The sugata is typical Sue-Bizen style, but there is also a sugata which looks like a ko-dachi with ikubi kissaki. The tanto is mainly sunzumari (short tanto, under 20 cm in length) or moroha-zukuri. Hi and horimono are commonly engraved. The outlines of the horimono are deeply engraved, and the designs are elaborate. The slightly hard jigane is well forged, and the jihada is a dense mokume

ERA	PROVINCE	SWORDSMITH(S)	PATTERN
			hada mixed with o-hada. When it is present, the utsuri is not distinct; often there is no utsuri. The hamon is a wide koshi-no-hiraita midare, with a repeated, uniform pattern. The yakigashira looks like a crab's claws. The boshi is midare komi with a long or short kaeri. There is also hitatsura, which consists of yaki-kuzure and has a different pattern on each side.
		Osafune Kiyomitsu (長船清光)	There were many smiths working under the name Kiyomitsu at this time. The sugata is typical Sue-Bizen style; there is also a long katana of about 75 cm. The saki-zori is deep. Hira-zukuri wakizashi can be seen, but shinogi-zukuri wakizashi cannot. There are sunzumari and moroha-zukuri tanto, but the sugata looks rustic and lacks any elegance. Hi and horimono are both rare. The jigane is slightly hard, and the jihada is coarse mokume hada mixed with o-hada. The hamon is koshi-no-hiraita midare with a busy, crowded pattern. Many yaki kuzure and nioi kuzure can be seen. The boshi is either midare komi with a different pattern on each side, or an ichimai boshi with a long kaeri.

In addition, the following schools produced swords in the Bizen tradition during this period: the Kanabo school (Yamato), the Mizuta school (Bitchu), the Hokke school (Bingo), the Unshu Yoshii school (Izumo), the Dotanuki school (Higo), the Takada school (Bungo), the Chiyozuru school (Echizen), the Yamamura school (Echigo), the Shimada school (Suruga), and others.

THE MAIN SCHOOLS AND EVOLU-TION OF THE SOSHU (相州) TRADITION

The Soshu tradition includes swords that were made in Kamakura, in Soshu (or Sagami province), where the Kamakura shogunate was located. Awataguchi Kunitsuna (粟田口国綱), Ichimonji Sukezane (一文字助真), and Saburo Kunimune (三郎国宗), all of whom were from Yamashiro and Bizen provinces, are the recognized founders of the Kamakura swordsmiths. However, it seems likely that many other swordsmiths, whose work no longer exists, also visited Kamakura and the local swordsmiths, and that their work had an influence on the development of the Soshu tradition.

Kunitsuna, Sukezane, and Kunimune are generally believed to have been the founders of the Soshu tradition, but it is difficult to discern the style's distinct characteristics in their work. The first blade that may truly be regarded as being produced in the Soshu-den was by Shintogo Kunimitsu; this is the blade known as the "Midare Shintogo." This sword has an exceptional midareba hamon, which took a full one hundred years, from the start of the Kamakura shogunate, to develop. Kunimitsu's workmanship usually shows signs of the Yamashiro tradition and is similar to blades of the Awataguchi school. The "Midare Shintogo" is exceptional. This section describes changes in the Soshu tradition in Sagami province after the time of Shintogo Kunimitsu (新藤五国光).

The workmanship of the Soshu tradition may be roughly classified into three periods: early (late Kamakura period through the beginning of the Nanbokucho period), middle (Nanbokucho period) and later (Muromachi period).

EARLY PERIOD SOSHU-TRADITION WORKMANSHIP —Yukimitsu (行光), Masamune (正宗), Sadamune (貞宗)

During this early period, swordsmiths set out to produce swords that exhibited splendor and toughness at the same time. The earlier Yamashiro and Bizen traditions certainly had such properties, but following the experience of the Mongol invasions of 1274 and 1281, functional improvements were demanded; when these improvements were made, naturally, some of the characteristics of the period were incorporated. The Soshu tradition produced more durable swords by incorporating some of the best features of the Yamashiro-den and Bizen-den. The beginning of this early period is a transitional phase, in which swordsmiths were influenced by the Yamashiro tradition. The most representative smiths of this period were Yukimitsu, Masamune, and Sadamune. Sadamune's work usually looks modest when compared to Masamune's, who is considered to be the actual founder of the Soshu tradition.

During this period, the jihada is a fine mokume with ji-nie, as is also true of Yamashiro work of the same period, but the Soshu blades are different from the Yamashiro in that the Soshu-den's jihada is combined with o-hada. Nie gathered together in the ji becomes

yubashiri, and abundant ji-nie are seen all over the length of the blade. The Soshu hamon's composition does not always adhere to a pattern, but hamon of this type have certain features in common, as follows: the nie is large; the hamon is inclined to be nie kuzure; kinsuji, inazuma, and sunagashi are frequently seen within the hamon; and, in wide hamon, kinsuji, inazuma, and sunagashi are larger. Even if the hamon is wide and has a large pattern, the monouchi area usually becomes narrower. In addition, the boshi's nie tend to be larger than the hamon's, and to be nie kuzure. The boshi is wide.

Yukimitsu, Masamune, and Sadamune were active mainly in the later part of the Kamakura period. However, Masamune and Sadamune were also producing swords at the beginning of the Nanbokucho period, and consequently they used two distinctive types of sugata in their work: one typical of the late Kamakura period, and the other common to the Nanbokucho period, with a longer point, or an o-kissaki. A sugata often seen in Sadamune's work has a long kissaki, a wide mihaba, and shallow sori. The tanto and tachi also have sugata characteristic of the two periods.

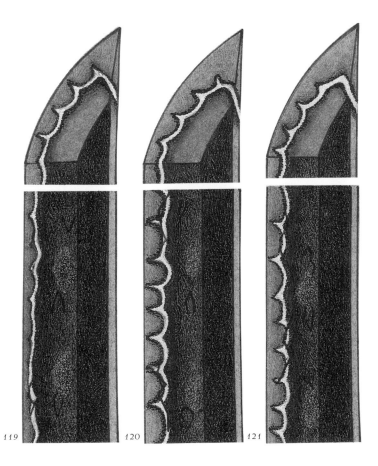

119. The workmanship here shows heavy influence of the Yamashiro tradition. The jihada is mokume hada with abundant ji-nie and a rounded yubashiri. The hamon is relatively narrow and based on suguha. Large and abundant nie are seen within the hamon.

120. The hamon is a bit wide and based on suguha, but mixed with midare and nie kuzure. Hataraki (activi-

ty) such as kinsuji, inazuma, and sunagashi appear within the hamon. The boshi is midare komi and inclined to be nie kuzure.

121. The hamon is narrow, and a good deal of hataraki appears in the ji. The nie are relatively large. When the hamon is wide, the pattern of the activity becomes larger.

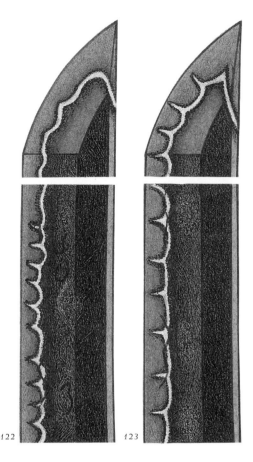

122 123

122. The jihada is mainly mokume hada and is mixed
with itame hada. The hamon becomes midareba
based on notare. The nie is larger and brighter. Nie
kuzure is seen in both the hamon and the boshi.

123. The jihada is mokume hada combined with itame
hada. The hamon is a wide uma-no-ha midare. The
nie seen in the boshi is larger than that within the
hamon. The hamon usually becomes narrow from
the monouchi upward.

MIDDLE-PERIOD SOSHU-TRADITION WORKMANSHIP
—**Hiromitsu** (広光), **Akihiro** (秋広)

Hiromitsu and Akihiro are representative sword-
smiths of the middle period of the Soshu tra-
dition. Their work became more flamboyant
and began clearly to show Soshu-den charac-
teristics. Influence of the Soshu tradition spread
everywhere during the Nanbokucho period,
and the So-den Bizen style developed as a result,
even in Bizen, the "capital" of Japanese sword-
making. Tachi sugata had an o-kissaki, a wide
mihaba, a thin kasane, and a shallow sori.

Tanto were made with a distinct sori, a wide

mihaba, and a longer blade, for example, hira-
zukuri ko-wakizashi over 30 cm in length.

The jihada is an itame-hada that was
roughly forged, with a relatively large pattern.
The hamon, accordingly, becomes hitatsura.
Yubashiri, described in the section on the
preceding period, turns into tobiyaki. In other
words, gathered nie becomes perfect spots of
tempering at this time. Mokume-hada com-
bined with o-hada is also seen.

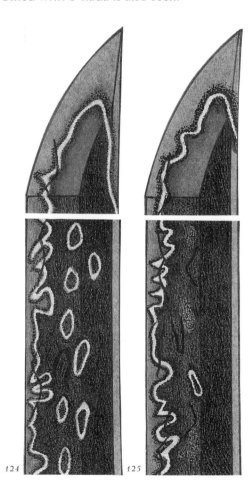

124 125

124. The jihada is itame hada or mokume hada, com-
bined with o-hada. The yubashiri changes into
tobiyaki. Both ji-nie and chikei are visible.

125. The hamon is based on notare, and is mixed with
gunome midare, tobiyaki, and nie kuzure. Kinsuji,
inazuma, and sunagashi are frequently seen within
the hamon. The boshi becomes midare komi in
accordance with the hamon.

The hamon, the lower part of which is narrow and has a small pattern, gradually becomes larger as it proceeds up the blade, and has rough nie. O-midare, notare midare, and uma-no-ha midare, with sunagashi, kinsuji, and inazuma, are the main patterns. Nie kuzure and nie sake are frequently seen on the hamon. The boshi is midare komi and has a long kaeri. Ichimai boshi are sometimes seen.

126. The hamon in the lower area of the blade is narrow and has a small pattern, which becomes larger as it moves up toward the tip. The boshi is midare komi and has a long kaeri; alternatively, it is sometimes ichimai.

127. In this work dating from the time when the Soshu-den's popularity was at its height, the hitatsura is showy, which is well-suited to the very long swords of the Nanbokucho period. The jigane and the hamon show various types of activity. Workmanship is very high-spirited.

LATE-PERIOD SOSHU-TRADITION WORKMANSHIP
—Hiromasa (広正), Masahiro (正広), Tsunahiro (綱広)

Muromachi-period Soshu-den work is known as Sue-Soshu. At this time, the Bizen tradition had been restored to its former popularity, and the Mino tradition was at the height of its popularity, but the Soshu tradition was on the decline.

After the capital of the shogunate was transferred from Kamakura to Kyoto, it appears that Kyoto again became the center of politics and culture. This is probably the main reason for the decline of the Soshu-den. At the beginning of the Muromachi period, the successors of both Hiromitsu and Akihiro become well known, as do Hiromasa (広正), Masahiro (正広), Yoshihiro (吉広), Hirotsugu (広次), and Sukehiro (助広).

Blade length is a bit shorter than in earlier periods, and there is a pronounced saki-zori. Tanto also become shorter. The jigane is hard, small, and densely grained. Itame-hada, a pattern unique to Soshu-den work, is not usually seen. The hamon is o-midare, inclined to be hitatsura, and looks flamboyant, but activity resulting from nie is rare, since nie are scarce. A temper line often adopted is the pattern of the Bizen tradition of the same period, since the Bizen-den is once again in vogue. The boshi is midare komi, inclined to be nie kuzure or yaki-kuzure, which refers to a "crumbled" pattern, or a pattern that is losing its shape.

At the end of the Muromachi period, another group of smiths gathered in Odawara, another city in Soshu province ruled by the Hojo clan. This group was called the Odawara Soshu, and was one of the Sue-Soshu schools. Masahiro, Hiromasa, and Sukehiro were local swordsmiths and the descendants of this group. The Odawara Soshu combined its own methods with those of the Shimada school, to form a distinct style. In Tsunahiro's line, Takahiro (隆広), Tsunamune (綱広), Sadahiro (定広), Tsuguhiro (次広), Hiroshige (広重), Tsunaie (綱家), Hirotsugu (広次), and Fuyuhiro (冬広) comprise one branch

of the Odawara Soshu school. The smiths Yasuharu (康春), Yasukuni (康国), and Fusamune (総宗) belong to another line. Fuyuhiro later moved to Wakasa province. The Soshu tradition's characteristics were gradually lost during this period, and workmanship of the Soshu schools often resembled blades of the Sue-Bizen and Sue-Seki schools.

The jigane is hard and does not differ significantly from Soshu-tradition work of earlier periods. Mokume-hada, combined with o-hada, is inclined to be coarse. The hamon is o-midare, hitatsura, and notare midare, but nie, which is traditionally the most definitive characteristic of the Soshu-den, is rarely seen. Even if nie is visible, it is detached and uneven, and activity is scarce. The boshi is midare komi, with a long kaeri.

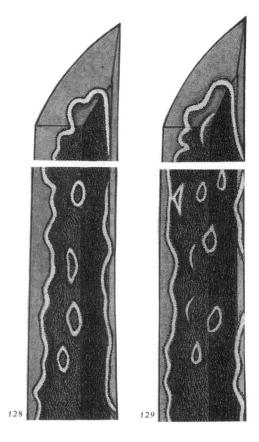

128

129

128. The jihada is dense and the jigane is hard. The hamon is a flamboyant hitatsura, but lacks both nie and activity. The boshi is midare komi, and has a long kaeri.

129. Odawara Soshu hamon lack nie, and consist predominantly of nioi. Hitatsura, o-midare, notare midare, and the like are seen, usually in combination with a yahazu-ba.

TANTO OF THE SOSHU TRADITION

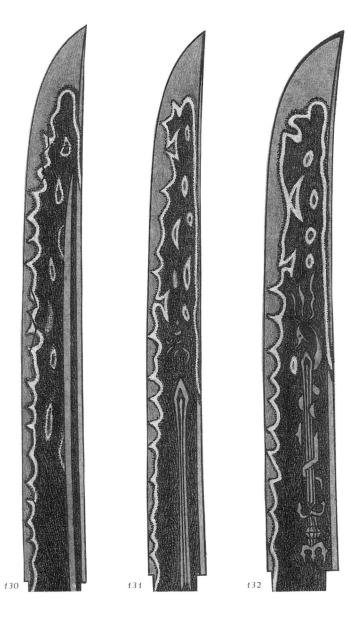

130 131 132

Nanbokucho period: *130.* Hiromitsu, Akihiro, and others: Ko-wakizashi, or blades over 30 cm long, with sori, are produced in hira-zukuri. There is much activity in the ji, and the hamon has abundant nie. Blades of this sort look very colorful.

Early Muromachi period: *131.* Hiromasa, Masahiro, and others: Production of the hitatsura blade continues, but the blade lacks both nie and the characteristic features of the Soshu-den. The hamon's composition begins to look a little awkward, and the habuchi (nioi line) is inclined to be tightened.

Late Muromachi period: *132.* Tsunahiro and others: Crescent-shaped tobiyaki characterize hitatsura blades of this period, and usually appear on the yakigashira (head of the midare). The jigane is hard and the jihada is inclined to be coarse.

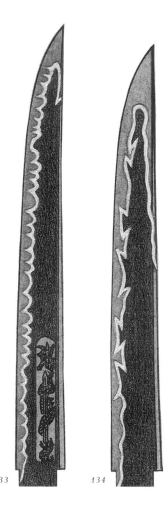

133.

134.

133. Odawara Soshu: Blades bear little resemblance to the Soshu tradition. The hamon is usually in nioi deki. Workmanship is considerably influenced by the Mino tradition, which is at the height of its prosperity.

134. Odawara Soshu: The hamon is mixed with yahazu midare and looks exactly like work of the Mino tradition, but closer examination reveals that its composition is in fact a little different. The upper part of the hamon is more gorgeous than the lower, which is true too of the Soshu tradition.

HORIMONO OF THE SOSHU TRADITION

Soshu swords often have skillful horimono that share certain features in common. In the early Soshu-den, hi, bonji, and suken were engraved on the tanto and tachi, and occasionally carved into the hi or hitsu. One excellent engraver named Daishinbo Yukei is said to have engraved blades made by Yuki-mitsu and Masamune.

In the middle Soshu-den, various types of horimono were carved in the ko-wakizashi and tanto. These designs included katana-bi, soe-bi, tsure-bi, kuichigai-bi, koshi-bi, dokko-tsuki-ken, tsume-tsuki-ken, goma-hashi, and bonji. These horimono are located slightly toward the mune side, and are relatively tall. The head of the ken is sharp, the neck is constricted, and the upper area is wider and deeper than the bottom. Gyo-no-kurikara (or ken-maki-ryu) are occasionally engraved in the tachi, but there are no elaborate shin-no-kurikara.

In the late Soshu-den, the horimono of the preceding period remained popular. Shin-no-kurikara are also found, and one popular horimono was an elaborate shin-no-kurikara carved in the hitsu. During this period, Fusamune was known as an excellent engraver of horimono.

The following section is an explanation of the work of the leading schools and smiths directly influenced by the Soshu-den after the end of the Kamakura period.

GO YOSHIHIRO (郷義弘) AND NORISHIGE (則重)

Go Yoshihiro and Norishige, who are said to have been among Masamune's Juttetsu (Ten excellent students), lived at the end of the Kamakura period in Etchu province. Go Yoshihiro's work had the following characteristics:

Sugata: There are various sugata with ko-kissaki and narrow mihaba, as well as wider mihaba with larger kissaki, but no o-kissaki. There is full hira-niku and a thick kasane. Tanto are rarely seen.

this time, have a narrow mihaba, a fukura which is not rounded, and slight sori. But in the Nanbokucho period, his followers adopted the standard Nanbokucho style.

Jihada: Fine, beautiful ko-mokume mixed with nenrin-hada (hada shaped like the annual rings of a tree). Ji-nie and chikei can be seen, but tobiyaki are not. Bo-utsuri appears in blades by Yasuyoshi. Other members of this school produce jigane that are darker than O-Sa's, and coarse jihada.

Hamon: The yakihaba is not regular. The hamon is in nie deki and is based on notare mixed with gunome. The nioi line is thick and bright. There are plenty of hataraki, such as kinsuji and inazuma. The kuichigaiba and ashi are inclined to be oblique. The hamon starts with a small pattern mixed with a distinguishing midare called "Samonji Koshiba," and the width gradually increases toward the top. In his students' work, a wide hamon consisting of rough nie, o-midare and gunome midare whose patterns are inclined to be notare can be seen, and the ha-hada is visible; these blades also have plenty of hataraki, including nie zake. His students' hamon is not as bright or active as his own.

Boshi: The boshi is referred to as "Sa boshi." It has a distinguishing midare with saka ashi which is shaped like a Jizo in the fukura area; the top becomes tapered and creeps up toward the munesaki, and the kaeri is long.

Horimono: Bo-bi, soe-bi, and futasuji-bi can be seen.

Nakago: The yasurime are mostly sujikai or, occasionally, katte sagari. This school included the phrase "Nancho era" in their engravings, to indicate when swords were made.

SENGO MURAMASA (千子村正) AND HIS SCHOOL

Muramasa (村正) is the first swordsmith from Ise province. Several generations of smiths used this name, and their works seem to have been produced beginning in the middle of the Muromachi period. Muramasa is said to have been a student of Heianjo Nagayoshi's, but the distinctive characteristics of his work bear a resemblance to work of Seki Kanesada and also show signs of influence of the Mino tradition mixed with Soshu-den. A relatively large number of his works are still extant. The smiths Masashige (正重) and Masazane (正真) belong to this school as well.

Sugata: Deep koshi-zori; mihaba of a proper width or, perhaps, slightly wide for the blade; narrow shinogiji; and high shinogi. The kissaki is slightly long, and the fukura is not rounded. The tanto is about 18 cm in length, the mihaba is wide even though the blade is not long, the kasane is thin, and the blade has sori. There are also tanto between 24 cm and 27 cm in length, and hira-zukuri ko-wakizashi which have the same features as the tanto.

Jihada: The jigane is slightly hard and usually whitish. The jihada is a coarse mokume-hada. Masame-hada appears on both the ha and the mune sides.

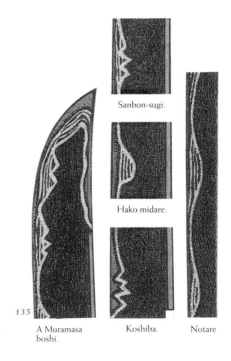

Sanbon-sugi.

Hako midare.

135

A Muramasa boshi.

Koshiba.

Notare

Workmanship of Muramasa.

Hamon: In nioi deki and of irregular width. The hamon tends to have the same pattern on both sides; this is especially obvious near the start of the hamon. There are hako midare, o-notare, yahazu midare, etc. The tani (valley) of the midare is deep or close to the hasaki (fine edge), and nioi ashi sometimes go through the hasaki. In the case of sanbon-sugi, the groups of three tapered gunome are connected by notare. Koshiba with rugged hako midare can be seen. Even in work in the Soshu tradition, the hamon is lacking in nie, and the pattern is stiff and awkward-looking.

Boshi: Jizo boshi creeps upward toward the munesaki, and the kaeri is long and takes on an irregular pattern.

Nakago: The distinctive nakago is known as the "Muramasa nakago," and has a short tanagobara. The relatively wide nakago is ha agari kurijiri. The yasurime are kiri.

THE SHIMADA (島田) SCHOOL

The founder of the Shimada school is said to have been Yoshisuke (義助), who lived in Suruga province in the mid-fifteenth century. Like that of his younger brother, his name seems to have been carried on by several generations of smiths of this school, and work of these later smiths has been attributed dating from the mid-Muromachi period. The school's other smiths include Hirosuke (広助), Yoshitsuna (義綱), and Motosuke (元助).

The school maintained a close relationship with the Sue-Soshu school, and seems to have had technical exchanges with the Shitahara and Sengo schools and with the smiths of Mino province.

Sugata: Deep saki-zori, a wide mihaba, a slightly narrow kasane, and a low shinogi. On the whole, the sugata resembles that of the Sue-Soshu. There are longer and shorter tanto, but both have thick kasane. One of the "Tenka san mei so" (Ten great spears), known as "Otekine," was made by Yoshisuke, but was later lost in a fire. There is also a well-known, distinctive tanto by Sukemune, on which four Japanese letters from the hiragana syllabary, "O So Ra Ku" (おそらく), are engraved. The versatile smiths of this school also produced various types of tanto and naginata.

Jihada: Coarse mokume-hada mixed with masame-hada. The jigane is a little weak, and whitish.

Hamon: O-midare mixed with notare midare, which recalls the Soshu tradition, except that the nie are not bright and are sometimes scattered about sporadically. There are also examples of koshi-no-hiraita midare and hoso-suguha.

Boshi: Midare komi, with a kaeri that becomes midare and that has a relatively large pattern and is very long. The pattern of the boshi is usually different on each of the two sides.

Horimono: Katana-bi is engraved near the mune, or the design of the hi is engraved in a manner similar to that of the Sue Soshu.

Nakago: In katana, the cutting-edge side is swollen; in the tanto it becomes almost tanagobara-gata. The tip is kurijiri or ha agari kurijiri. The yasurime is kiri or katte sagari.

THE SHITAHARA (下原) SCHOOL

The Shitahara school was located in the Hachioji area of what is now Tokyo. The founder of this school is said to have been Chikashige (周重), active in the early part of the sixteenth century; smiths of this school continued to produce swords through the end of the Edo period. They seem to have been employed by the Hojo clan, and influence of the Soshu tradition is evident in their workmanship. Terushige (照重), Yasushige (康重), Hiroshige (広重), and other smiths belong to this school.

Sugata: The katana has a shallow sori, a wide mihaba, and a thin kasane. The blade feels heavy because it is not well-balanced. Ko-wakizashi and sunnobi (longer tanto) may be seen.

Jihada: The jigane is hard, dark, and cloudy.

The jihada is a coarse mokume-hada mixed with shitahara-hada that eddy in a continuous line of whirlpool shapes through its center.

Hamon: In nioi deki, but mura nie can also be seen here and there. There are gunome midare, o-midare, o-notare, notare midare, hiro-suguha, chu-suguha, sanbon-sugi which resemble the work of Kanemoto, etc. The hamon is dull, not bright.

Boshi: Midare komi, ichimai, etc.

Horimono: Bo-bi, ken, so no kurikara (or ken-maki-ryu), etc.

Nakago: Tanagobara-gata. The tip is kurijiri. The yasurime are kiri or katte sagari.

LEADING SWORDSMITHS OF THE SOSHU TRADITION

ERA	PROVINCE	SWORDSMITH(S)	PATTERN
Kagen (1303–1306)	Sagami	Yukimitsu (行光)	In addition to ordinary sugata, there are tachi with larger kissaki. Hi are common. The jigane is well forged and "oily," like Awataguchi's. Plenty of hataraki appear in the ji, such as ji-nie, yubashiri, and chikei. There are both wide and narrow hamon, based variously in chu-suguha, notare midare, o-gunome midare, suguha choji midare, etc. The nie is rough and bright. Abundant hataraki appear vigorously inside the hamon and on the border between the ji and ha; these include nie kuzure, nie nioi kogori, kinsuji, and inazuma. The boshi is ko-maru, o-maru, midare komi, kaen, or yakitsume, in proportion to the hamon.
Showa (1312–1317)		Masamune (正宗)	Ordinary sugata, or a sugata in which the kissaki is relatively large. The tanto has a gentle sugata and is mu-zori (without curvature); exceptions to this, however, are the three noted "Hocho Masamune." Bo-bi are common in the tachi. Katana-bi, bonji, goma-hashi, etc., are skillfully engraved on the tanto. The jigane is similar to that of Yukimitsu, but is stronger, and ji-nie, yubashiri and chikei appear vigorously. The hamon is wide and becomes more gorgeous and larger-patterned than Yukimitsu's. The nie is brilliant, kinsuji and inazuma are noticeable, and an incredible variety of hataraki can be seen inside the hamon as well as on the border between the ji and the ha. The boshi is usually midare komi in proportion to the hamon, and the kaeri is generally short.
	Yamashiro	Rai Tomokuni (来倫国)	Extant works are rare. The hamon is o-midare and the nie are rough.
Gen'o (1319–1321)	Etchu	Norishige (則重)	Ordinary tachi sugata; the kissaki never becomes larger. The tanto has a fukura which is not rounded, and uchi- (inward) zori. The jihada is a distinctive matsukawa hada. The hamon is gunome midare with nie kuzure, ashi, and sunagashi. Ha hada is visible. Many vigorous inazuma cross the habuchi (the border between the ji and the ha) and finally become chikei. The boshi is midare komi and nie kuzure or yakitsume, in proportion to the hamon.

136

Workmanship of Norishige.

ERA	PROVINCE	SWORDSMITH(S)	PATTERN
	Chikuzen	Samonji (左文字)	Tachi are rare and the bulk of production is in tanto. The tanto's sugata is called "Samonji sugata" because of its distinctiveness. The nagasa is slightly shorter than josun (25–26 cm), and the mihaba is narrow. The fukura is not rounded, and the blade has saki-zori. Hi and horimono are both rare. The jigane is beautiful and the jihada fine. Ji-nie, chikei and nenrin (annual tree rings) hada appear. The hamon is midareba based on notare and inclined to be oblique. Kuichigaiba and koshiba of midare can be seen. In the upper area the pattern becomes smaller; kinsuji and inazuma appear there. The distinctive boshi is called "Sa boshi." Just above the fukura the pattern suddenly changes: it creeps upward toward the munesaki, and the top of the boshi either resembles a Jizo or is tapered.
	Mino	Shizu Kaneuji (志津兼氏)	This smith moved from Yamato province and is the founder of the Mino tradition. There are sugata dating from the end of the Kamakura period and from the Nanbokucho period which have o-kissaki. Bo-bi are commonly engraved, and the hisaki is descended; futasuji-bi can also be seen. The jigane is well forged, and the jihada is mokume hada mixed with masame hada; masame hada which are especially distinct appear in the shinogiji. Ji-nie, yubashiri, and chikei can be seen. There are wide and narrow hamon. It is a characteristic feature of the Mino tradition that togari-ba can be seen somewhere. Kinsuji, inazuma and sunagashi appear vigorously. The boshi is midare komi in proportion to the hamon, and the kaeri is short.
	Mino	Kinju (金重)	Extant works are rare and similar to those of Kaneuji. The hamon is ko-gunome midare mixed with togariba.
	Etchu	Go Yoshihiro (郷義弘)	A little larger kissaki, but no o-kissaki, can be seen; tanto are rare. The jigane is beautiful, oily, and well forged. The jihada is mokume hada mixed with o-hada, or occasionally mixed with masame hada. Abundant ji-nie, chikei and yubashiri appear. Brilliant nie can be seen in the ji and the ha. The hamon is based in wide o-notare; the bottom area starts with a smaller pattern which becomes larger in the monouchi area; choji ashi can also be seen, although these are not plentiful. Abundant nie form long ashi in places. Gentle kinsuji and inazuma appear. The boshi is ichimai, ichimonji, etc.
Karyaku (1326–1329)	Yamashiro	Rai Kunitsugu (来国次)	This smith is also called "Kamakura Rai," and he produced many masterful tanto. These have josun and uchi-zori or sunnobi, wide mihaba and sori. The hi is wide, shallow, and skillfully engraved. The jigane is well forged and the jihada is fine. Ji-nie appear, as do chikei and yubashiri. The pattern of the boshi is not ko-maru, and it tends to be midare; the kaeri is usually yakitsume. Occasionally the hamon and the boshi become o-midare.

137

Workmanship
of Samonji.

138

An ichimai boshi of Go Yoshihiro.

THE NANBOKUCHO PERIOD

SOUTHERN COURTS	NORTHERN COURTS	PROVINCE	SWORDSMITH(S)	PATTERN
Kenmu (1334–1336)	Kenmu (1334–1338)	Sagami	Sadamune (貞宗)	The tachi has shallow sori, relatively wide or narrow mihaba, and relatively large kissaki. Tanto and hira-zukuri ko-wakizashi measure about 30 cm in length. The mihaba is wide and the blade sometimes has sori. The horimono are commonly and skillfully engraved. The jigane is very beautiful and well forged. Ji-nie, chikei, and yubashiri appear. The hamon is calm and gentle, narrow ko-notare mixed with gunome midare and with kinsuji and inazuma. The boshi is a gentle midare that becomes ko-maru. There are also nie kuzure and kaen.
		Yamashiro	Nobukuni I (初代 信国)	On the whole workmanship is similar to that of Sada-mune, but of an inferior quality.
		Omi	Takagi Sadamune (高木貞宗)	This smith is sometimes said to be the same smith as Soshu Sadamune. Tachi are rare; the main areas of production are tanto and ko-wakizashi. Workmanship is similar to that of Soshu Sadamune but of an inferior quality. Horimono are common. The jihada is mokume hada, and masame hada appears along the mune side. The hamon is a narrow ko-notare mixed with midare, or ko-midare mixed with o-midare. There are many sunagashi, kinsuji, and inazuma. The boshi is inclined to be ko-maru, and the kaeri may be short or long.
		Kaga	Sanekage (真景)	Norishige's student. Tanto is the main area of produc-tion. Workmanship is similar to that of Norishige, but of an inferior quality.
		Yamashiro	Hasebe Kunishige (長谷部国重)	Wide mihaba, thin kasane, longer kissaki, and shallow sori. This smith produced many hira-zukuri tanto or ko-wakizashi of about 30 cm in length. Bo-bi, futasuji-bi, katana-bi (near the mune side of the tanto), and simple horimono can be seen. The jihada is mokume hada mixed with itame hada and masame hada, and has a striped pattern. The hamon is o-midare with nie kuzure, and becomes hitatsura. The nie are rough; sunagashi and muneyaki can be seen. The boshi is midare komi and the kaeri is long. There is also an ichimai boshi.
		Bungo	Takada Tomokuni (高田友行)	Saki-zori is noticeable. Horimono can be seen, but are not especially skillful. The jihada is a coarse mokume hada mixed with o-hada. The jigane is whitish.
Kokoku (1340–1346)	Ryakuo (1338–1342)	Chikuzen	Sa Yoshisada, Yoshihiro, (左吉貞) (吉弘) Kunihiro and Hiroyasu (国弘) (弘安)	All show influence of the Soshu tradition, but tobiyaki can rarely be seen in their work. The hamon becomes more gorgeous from the monouchi to the boshi, and shows the characteristic features of the Sa school there. There are nie zake, sunagashi and nenrin hada.
Shohei (1346–1370)	Jowa (1345–1350)	Tajima	Hojoji Kunimitsu (法城寺国光)	This smith is a master of nagamaki; most of his nagamaki were reworked, and are extant today as nagamaki naoshi. The jihada is mokume hada mixed with wavy o-hada and with chikei. The workmanship is in the Soshu tradition mixed with Bizen tradition. The o-choji midare resembles the work of Fukuoka Ichimonji but

SOUTHERN COURTS	NORTHERN COURTS	PROVINCE	SWORDSMITH(S)	PATTERN
				is in nie deki. There are nie nioi kogori, long ashi, long kinsuji, and sunagashi, chabana (tea flower shaped) midare can be seen. The boshi is midare komi in proportion to the hamon, and turns back.
		Sagami	Hiromitsu (広光)	Tachi are rare. The main production is in hira-zukuri ko-wakizashi with nagasa over 30 cm and with a wide mihaba, thin kasane, and sori. The horimono are commonly engraved in the Soshu style. Hiromitsu's works show the typical workmanship of the Soshu tradition of this time. Most of his hamon are hitatsura. Refer to page 200.
		Chikuzen	Sa Yukihiro (左行弘)	Refer to page 206.
	Bunna (1352–1356)	Yamashiro	Hasebe Kunishige II (長谷部 二代 国重)	Similar to the work of the first-generation Kunishige, but inferior in quality. The mihaba is wider, and the nagasa longer, than those of the first-generation Kunishige.
			Hasebe Kuninobu (長谷部国信)	Features identical to those of the second-generation Kunishige.
	Enbun (1356–1361)	Sagami	Akihiro (秋広)	Features identical to those of Hiromitsu.
	Oan (1368–1375)	Etchu	Tametsugu (為継)	A student of either Norishige or Go Yoshihiro. The jihada is coarse, and the hamon is gunome midare with many sunagashi.

THE MUROMACHI PERIOD

ERA	PROVINCE	SWORDSMITH(S)	PATTERN
Oei (1394–1428)	Yamashiro	Nobukuni (信国)	The elaborately-designed horimono are skillfully engraved. The jigane is weak and the jihada is mokume hada mixed with masame hada. The hamon is koshi-no-hiraita midare, mixed with choji midare, which was in fashion at this time, but it is in nie deki. There are yaki-kuzure, sunagashi, and muneyaki. The boshi is midare komi and the patterns on each side are different.
		Heianjo Nagayoshi (平安城長吉)	In addition to the Soshu tradition, Nagayoshi also worked in the Yamashiro and Mino traditions. The nagasa of his katana and wakizashi is comparatively short, while the blade has deep saki-zori. There are many tanto shobu-zukuri and u-no-kubi-zukuri, as well as hira-zukuri. He also produced yari and naginata. Tall and elaborately-designed horimono may also be seen. The jigane is somewhat hard, and the jihada is mokume hada mixed with o-hada. The hamon is o-midare, notare midare, or o-gunome midare, all of which tend to be nie deki. The boshi is midare komi and creeps upward toward the munesaki. Long kaeri can be seen.
	Ise	Sengo Muramasa (千子村正)	There are several generations and the sugata shows the characteristic features of each period, but generally speaking the blades have relatively large kissaki and high shinogi. The katana and the tanto have fukura which are not rounded, and look very sharp. Hi and horimono are both rare. The jigane is hard and the jihada is inclined to be coarse. The hamon is nioi deki but with some nie and o-notare, hako midare, yahazu midare, and sanbon-sugi, whose patterns look

ERA	PROVINCE	SWORDSMITH(S)	PATTERN
			dynamic and acute, and the hamon has the same pattern on both sides. Stiff koshiba can be seen. The boshi resembles Jizo and the kaeri becomes midare.
	Sagami	Hiromasa, Masahiro, (広正)(正広) Yoshihiro, Hirotsugu, (吉広)(広次) and Sukehiro (助広)	High shinogi, thin kasane and deep saki-zori. The horimono are common types such as gyo or so no kurikara (ken-maki-ryu), ken with dokko or tsume, bonji, etc. The boshi is based on hitatsura, but lacks in nie, which is seen only sporadically. The tanto are similar to those of Hiromitsu, but of a lesser quality.
Kosho (1455–1457)	Suruga	Shimada Yoshisuke (島田義助)	There are several generations. Shallow sori and wide mihaba. There are various tsukuri-komi (types) of tanto. The jigane is hard and the jihada is coarse. The hamon is in the Soshu tradition, but the tani (valley or bottom) of each midare becomes suguha; there are also cases in which the hamon tends to be yahazu midare.
	Wakasa	Fuyuhiro (冬広)	This smith moved to the area from Sagami province. Several generations of smiths worked under the name Fuyuhiro. Workmanship is similar to that of the Sue-Soshu school.
Bunmei (1469–1487)	Sagami	Takahiro and Tsunamune (隆広)(綱宗) Fusamune (総宗)	Features identical to those of Tsunahiro.

The main area of production is in katana, wakizashi and tanto that are comparatively short in length. Shin no kurikara is skillfully engraved in the hitsu (groove) at the bottom of the shinogiji. The jihada is a dense ko-mokume hada. The hamon is nioi deki and ko-midare with some nie. |
Chokyo (1487–1489)	Wakasa	Later Fuyuhiro (後代 冬広)	Features identical to those of the preceding generation.
Meio (1492–1501)	Sagami	Later Hiromasa (後代 広正) and Later Hirotsugu (後代 広次)	Features identical to those of Tsunahiro.
Eisho (1504–1521)		Sadahiro, Hiroshige (定広)(広重) and Tsuguhiro (次広)	Features identical to those of Tsunahiro.
Kyoroku (1528–1532)	Musashi	Shitahara Chikashige (下原周重)	Practical, stout sugata which lacks sophistication. The jihada is known as "shitahara hada," which means that it is mokume and is shaped like whirlpools running continuously along the center of the ji. The hamon is in Soshu tradition but is in nioi deki. Mura nie can be seen here and there.
Tenbun (1532–1555)	Sagami	Tsunahiro (綱広)	During the Meio era, many swordsmiths moved to Odawara, where swordsmiths enjoyed the patronage of the warlord Hojo Soun and where they eventually formed the Odawara Soshu school. The fourth Masahiro was given the character "Tsuna" from Hojo Ujitsuna, and changed his name to Tsunahiro. This smith is considered the founder of the Odawara Soshu school. The name Tsunahiro was succeeded to by many generations, up through Shinshinto times. The work-

Workmanship of Shitahara Chikashige.

ERA	PROVINCE	SWORDSMITH(S)	PATTERN
Koji (1555–1558)	Hoki	Koga (or Hiroyoshi) (広賀)	manship of the Odawara-Soshu school is represented by Tsunahiro. The sori is shallow. There are shinogi-zukuri, o-hira-zukuri, u-no-kubi-zukuri, shobu-zukuri, etc. Hi and horimono are usually seen, and include bo-bi with soe-bi or tsure-bi, futasuji-bi, elaborately designed shin-no-kurikara, kurikara in hitsu, etc. The jigane is rather hard and the jihada is rough ko-mokume hada or o-mokume hada. The hamon is o-midare, notare midare, o-gunome midare, hitatsura, etc., and shows the characteristic features of the time. In the case of hitatsura, half-moon– and crescent-shaped tobiyaki can be seen. The hamon is in sparse nie deki. Nie appear in the hamon, but are not abundant. The boshi is a wide midare komi or ichimai, and the kaeri is long. This smith is said to have been a student of Tsunahiro's; there are many smiths who went by the name "Koga." There are various tsukuri-komi (types). The jigane is hard and whitish. The jihada is coarse mokume hada. Muneyaki can be seen. The hamon is o-notare, notare midare, hiro-suguha, etc. The hamon is in sparse nie deki.

In addition, there are extant works in the Soshu tradition by the Kaifu school (Awa province), the Oishi Sa school (Chikugo province), etc.

THE MAIN SCHOOLS AND EVOLUTION OF THE MINO (美濃) TRADITION

The existence of swordsmiths in Mino province has been confirmed with various documents to date back to the Hogen era (1156–1159). However, almost none of these works are extant today. The oldest confirmed swords from Mino are by Kaneuji (兼氏) and Kinju (金重), and date from the end of the Kamakura period. Workmanship of Mino-province swordsmiths after Kaneuji and Kinju is generally called Mino-den, but this tradition reached the height of its prosperity only in late Muromachi. It was, therefore, the last of the Gokaden to be established. Mino swords produced in the late Muromachi period, the so-called Sue-Seki blades, are well known because swordsmiths from both Mino and Bizen provinces produced large quantities of swords used in the civil wars that continued throughout the Sengoku period.

The Sengoku smiths developed new methods of producing swords in order to meet increasing public demand not only for quantity but for efficiency. At the end of the Muromachi period, and just prior to the start of the Edo period, many Mino swordsmiths moved to other provinces, where they formed new schools and established the basis of the Shinto sword period.

EARLY MINO-TRADITION WORKMANSHIP
—Kaneuji (兼氏) and Kinju (金重)

The leading swordsmith of this early term is Kaneuji. According to tradition, he moved

from Yamato province and studied under Masamune. Kinju (or Kaneshige) is another leading Mino swordsmith, who moved from Echizen province.

Their workmanship shows more conspicuous signs of influence of the Soshu than the Mino tradition, since the Mino-den is in a developmental stage at this time. Their workmanship is considered to be in the Yamato tradition mixed with the Soshu tradition. It is difficult to find any blades with Mino-den characteristics that do not have some togari-ba (tapered midarc).

Sugata: Standard for the end of the Kamakura period. The mihaba is not very wide, and the kissaki is generally relatively large—chu-kissaki at most. O-kissaki may be seen after the start of the Nanbokucho period. The tanto are not very long at the very beginning of the Nanbokucho period, but after a time they generally become wide and long, and have sori.

Jihada: O-mokume hada combine with some masame-hada with chikei and with abundant ji-nie. The jihada is clear and does not appear whitish; only later does a whitish jigane become characteristic of the Mino tradition.

Hamon: In nie deki, with abundant nie and thick nioi; the nie and the nioi are bright, and large nie are sometimes seen. Widths vary greatly. The pattern is o-midare, o-gunome midare, notare midare, etc., and includes nie kuzure, sunagashi, kinsuji, and inazuma. The

hamon is basically similar to that of the Soshu tradition, but different from it in that togari-ba is usually seen somewhere.

Boshi: Midare komi, with hakikake in proportion to the hamon. The top of the boshi becomes ko-maru with a short kaeri, yakitsume, or is tapered and turns back.

Horimono: Simple horimono like suken and bonji are commonly seen, as are various hi. Kinju's work includes some complicated and unusual horimono.

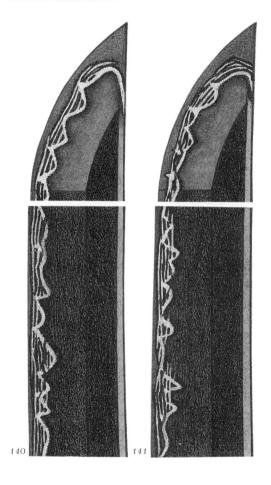

140

141

140. Refined o-mokume hada. The hamon is o-gunome midare in nie deki; within the hamon are abundant nie and a good deal of activity. Workmanship is definitely influenced by the Soshu tradition.

141. Mokume hada, with masame hada around the hamon. Gunome midare is here mixed with togari-ba. The workmanship is by Kaneuji, and remains within the Yamato-den tradition.

Nakago: Kurijiri; among the tanto, furisode with deep sori is sometimes seen. Yasurime are kiri or shallow katte sagari.

Unsigned swords attributed to Kaneuji are known as Yamato Shizu (with "Shizu" meaning "Kaneuji"), because their workmanship shows more characteristics of Yamato-den than of the Soshu or Mino traditions. Mino-den swords made in this early period always show signs of influence of the Soshu style, and remain within the tradition of the Yamato-den. At any rate, the Mino-den had not yet established a distinctive style of workmanship in this early period.

MIDDLE-PERIOD MINO-TRADITION WORKMANSHIP —The Naoe Shizu (直江志津) school

The middle period of the Mino-den continues from the middle of the Nanbokucho period through early Muromachi. Students of the Naoe Shizu school, and smiths of the O-Shizu school (founded by Kaneuji) took the place name, Naoe, (located in the same province), in order to distinguish their school. Also representing the Naoe Shizu school were Kaneyuki (金行) (son of Kaneshige; his name may also be read "Kinju"), Tametsugu (為継), a disciple of either Go Yoshihiro or Norishige, the later Kaneuji (兼氏), Kanetoshi (兼俊), Kanetoshi (兼利), Kanetsugu (兼次), Kanetomo (兼友), Kanehisa (兼久), Kanenobu (兼信), and Kanenobu (兼延).

Naoe Shizu–school workmanship is different from that of Kaneuji in that the sugata is grander than Kaneuji's, the jihada has more masame combined within it, the jigane is whitish, and the hamon is mixed with considerable togari gunome.

Sugata: Wide mihaba and o-kissaki, both of which lend a grand appearance. Tanto are rare. Hira-zukuri ko-wakizashi with wide mihaba and sori are popular.

Jihada: Mokume-hada combined with masame-hada which especially stands out near the

hamon or in the shinogiji. The jigane looks somewhat whitish and hard.

Hamon: The hamon is wide and o-midare or gunome-midare, with nie. The hamon has a deformed area, which produces sunagashi and togari-ba.

Boshi: Shaped like a Jizo, midare komi, and sometimes hakikake. The kaeri is usually long.

Horimono: In the case of the bo-bi, the hisa-ki (top of the hi) is lower than usual. Bonji and suken are seen among the hira-zukuri ko-wakizashi (tanto whose nagasa is more than 30 cm).

Nakago: The yasurime are kiri, katte sagari, or sometimes higaki.

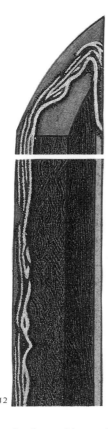

142.Naoe Shizu school, etc.: Masame hada stands out near the hamon and in the shinogiji; as a result, sunagashi appears along the masame hada, within the hamon. O-midare and gunome midare are mixed with togari-ba and are in nie deki.

LATER MINO-TRADITION WORKMANSHIP
—The Sue-Seki (末関) school

The Mino tradition was finally established, and its productivity began to increase rapidly, as the swordsmiths of Mino province entered the Muromachi period. To meet the demand for the large quantity of swords needed for the ongoing warfare, new methods of swordmaking were developed, and these seem to have attached greater importance to tactical use and functionality than to aesthetic concerns. Mino-province swords were, from the start, famous for their sharpness. Smiths centered in the town of Seki are representative of the Mino tradition of the time just after the middle of the Muromachi period. Generally, Mino-province swords of this period are known as Sue-Seki swords, because of the prosperity of the town of Seki. In this book, for the sake of convenience, the term "Sue-Seki" is also used to refer to a school of smiths.

Sugata: There are two katana sugata. One has a wider shinogiji than usual, despite its relatively narrow mihaba. The other has a wider mihaba, narrower shinogiji, deep saki-zori, and is the standard sugata of the time; shobu-zukuri, yari, and naginata are often seen. In tanto there were three nagasa: one of about 20 cm, one called the Jo Sun (about 26 cm.), and one over 30 cm.

Jihada: The jigane is hard, and not very high-quality. The color is black without being bluish black (generally, a clear bluish-black jigane like that of the Awaguchi school is admired). The ji is coarse mokume-hada and the shinogiji is definitely masame-hada. In the tanto, masame-hada appears near and along the mune, and shirake utsuri is also a conspicuous characteristic.

Hamon: Togari (tapered) gunome (in other words, sanbon-sugi). O-notare, yahazu midare, hako midare, gunome choji, etc. Hitatsura resembling work of the Soshu tradition is also sometimes seen. Hitatsura is often seen in hira-zukuri ko-wakizashi of the Soshu tradition during the Nanbokucho period. In the Soshu's

hitatsura, however, the lower part of the hamon is usually small-patterned while the upper part is larger-patterned; the Mino hitatsura, however, is tempered in equal width. In the Mino tradition, koshiba is sometimes seen above the hamachi. With suguha tempering, this looks like work of the Tegai school, but the hamon in nioi deki is tightened, and togari-ba or fushi (knob) are seen in places.

Boshi: The nioi-guchi (nioi line) is tightened, and the top of the boshi is inclined to be tapered. Midare komi, the top of which is shaped like a Jizo, is common. Long kaeri, steep tome and wide kaeri (the top of the boshi appearing nearer the hasaki than the mune side) are generally seen.

Horimono: In addition to hi, so no ken-maki-ryu (a simplified dragon wound around a sword) is seen on the tanto. Elaborate horimono are seldom seen. The tanto's katana-bi is engraved closer to the mune side than is usual.

Nakago: Kurijiri is popular. The yasurime are generally higaki or takanoha.

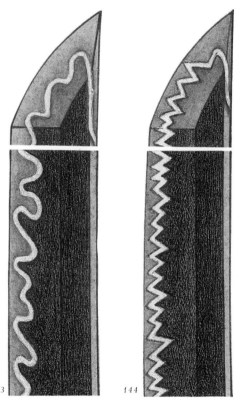
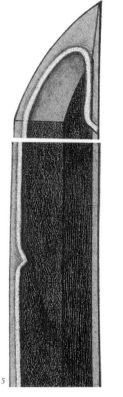

143. Kanesada, etc.: The shinogiji is a pronounced masame hada. The ji is mokume hada. The border between the ji and ha is very distinct. Shirake utsuri is seen, and nie is attached unevenly to the hamon in nioi deki.

144. Kanemoto, etc. The Mino tradition is based on gunome midare, with the hamon varying significantly from one swordsmith to another. Sanbon-sugi is composed of continuous togariba, a feature peculiar to the Mino tradition. The sanbon-sugi of the first- and second-generation Kanemoto are not typical, nor as regular as those of their followers.

145. Kanesada, Kanetsune, etc.: Even if a suguha blade is tempered in Yamashiro-den or Yamato tradition, togari-ba is certain to be mixed in somewhere. The nioi-guchi is tightened. A wide kaeri and steep stop are seen.

146. Sue-seki school: The koshi-ba has a distinctive pattern, and the so-called "Mino koshi-ba" is sometimes seen. In the Mino koshi-ba, the hamon runs straight along the edge of the nakago (tang), with a little space left between. From the hamachi toward the top of the sword, the hamon becomes midareba.

TANTO OF THE MINO TRADITION

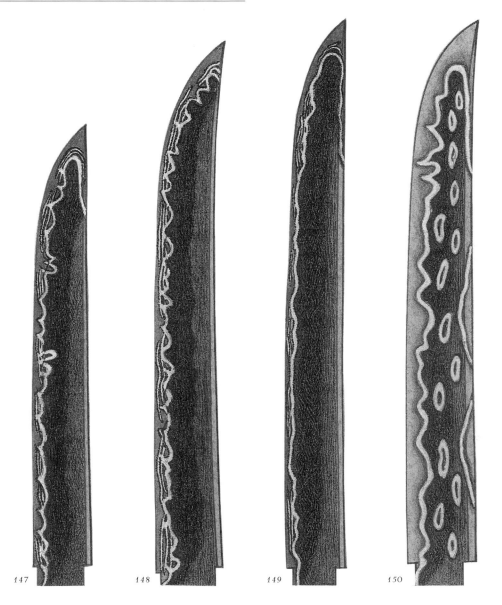

147 148 149 150

Tanto of various periods. End of the Kamakura period through the beginning of the Nanbokucho period: *147.* The work of Kaneuji, the Naoe Shizu school, and other smiths shows a mixture of the Yamato and Soshu traditions.

End of the Kamakura period through Nanbokucho period: *148.* The work of Kaneuji, the Naoe Shizu school, and other smiths. Masame hada comes out along the mune side and along the hamon. The hamon is in nie deki and gunome-midare, mixed with togari-ba.

End of the Nanbokucho period through the beginning of the Muromachi period: *149.* In the Naoe Shizu school, masame hada comes out along the hamon. The hamon is still in nie deki and gunome midare, with sunagashi.

Late Muromachi period: *150.* Smiths in Mino province sometimes tempered blades in Soshu-den hitatsura. A basic hamon, of approximately equal width all along the blade; tobiyaki is scattered evenly from top to bottom.

THE ZENJO (善定) SCHOOL

Kaneyoshi (包吉), a smith of the Yamato-province Tegai school, moved to Mino province and changed the first character of his name to a different "Kane (兼)" from the one he had formerly used. The name of this school originates from his Buddhist name. His name is listed among the Oei-era swordsmiths, but extant works from before the middle of the Muromachi period are rarely seen. Other smiths of this school include Kaneyoshi (兼善) (the character for "Yoshi [善]" is different from that of the school's founder), Kanemitsu (兼光), and Kanetsune (兼常). The workmanship of the Zenjo school is similar to that of the Sue-Tegai school and, in comparison with other Mino schools, has a distinctive sugata and hamon.

Sugata: The katana is relatively short, the mihaba is narrow, the shinogi is high, and the shinogiji is wide.

Jihada: The jigane is somewhat hard, the jihada is ko-mokume hada mixed with masame-hada, and shirake utsuri appears. Masame-hada appears regularly in the center of ji from the bottom to the top, in a pattern known as "zenjo-hada."

Hamon: A narrow hamon, consisting of tight nioi with some nie. A hoso-suguha is mixed with small midare that look like red beans in both their size and shape.

Boshi: A zenjo boshi with ichimonji-gaeri.

THE KANEMOTO (兼元) SCHOOL

Magoroku Kanemoto (孫六兼元), whose swords were very well known as o-wazamono ("very sharp blades"), was the second-generation smith to work under that name; he lived from the end of the fifteenth through the beginning of the sixteenth centuries. A number of generations of smiths succeeded to the name of Kanemoto; they are well known for a unique sanbon-sugi hamon.

Sugata: The katana is relatively short; yari, naginata, and tanto may be seen.

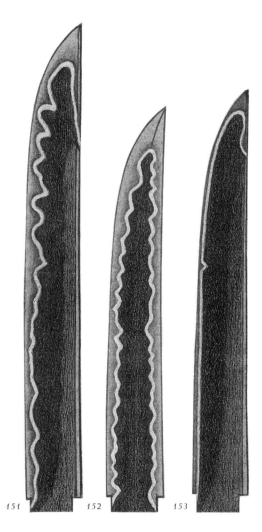

151 152 153

Late Muromachi period: *151.* Kanesada and other smiths adopted the Soshu-den style, but the basis of the hamon is still regarded as being Mino-den. Nie and sunagashi are frequently seen.

Late Muromachi period: *152.* Moroha-zukuri was produced by smiths of various schools at this time. The jigane is whitish. The jihada is inclined to be masame hada. The hamon shows characteristics of the Mino-den—namely, it is gunome midare mixed with togari-ba.

Late Muromachi period: *153.* Kanesada and other smiths copied the Yamashiro tradition. Masame appears along the side of the mune, and the jigane is whitish. Togari-ba or fushi (knobs) are seen in some spots.

Jihada: The jigane is soft, the jihada is mixed with o-hada, and masame-hada is noticeable in the shinogiji.

Hamon: The hamon is nioi deki and togari (tapered) gunome. A group of three togari-ba, of which the third is taller than the others, is regularly repeated and looks like a stand of cedars. In the work of Magoroku Kanemoto, unlike that of later generations, the pattern of sanbon-sugi is not uniformly repeated, and the top of each midare is not sharply crested. In the narrow part of the hamon, nioi ashi goes through the hasaki (fine edge), and the hamon. In later generations, the zigzagging hamon becomes regular.

Boshi: The zigzagging hamon forms a Jizo. In later generations, the boshi is ko-maru and komidare, and turns back.

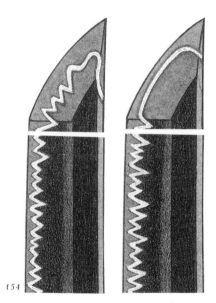

154

Comparison of the sanbon-sugi of the second Kanemoto (left) and that of later generations (right).

THE KANESADA (兼定) SCHOOL

The first three generations of the Kanesada line—Oya Kanesada (親兼定), Izumi no Kami Kanesada (和泉守兼㝎) (or No Sada [之定]), and Izumi no Kami Kanesada (和泉守兼定) (or Hiki Sada [疋定])—are well known. In a pattern

similar to that seen in the Kanemoto school, several generations of smiths used the name Kanesada, and their blades are famous for their extreme sharpness and are known as o-wazamono.

Sugata: Relatively short katana, high shinogi, and thin kasane. Wakizashi are rarely seen. Shobu-zukuri and nagamaki naoshi-zukuri can be seen. There are tanto that have uchi-zori, show Yamashiro-den, and seem to have been copied from Rai Kunitoshi.

Jihada: The jigane is better forged and finer than other Sue-Seki blades, but shares in common with them a whitish coloring. The jihada is mokume-hada mixed with masame-hada; masame-hada is especially noticeable in the shinogiji.

Hamon: There are various types. One is o-midare in the Soshu tradition, and similar to the work of the Naoe Shizu school, one has nie kuzure, one is o-choji midare and looks like the work of the Fukuoka Ichimonji school, and one has deep nie and hataraki.

Boshi: Midare komi, Jizo or ko-maru, with a long kaeri.

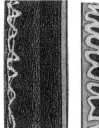

155

Soshu tradition in the Mino style (left) and Bizen tradition in the Mino style (right) by Kanesada.

THE HACHIYA KANESADA (蜂屋兼貞) SCHOOL

Kanesada (兼貞) is said to have come from the Daruma school of Yamashiro province. His name is found on lists of smiths of the early Oei era, but most of his extant works seem to have been produced at the end of the Muro-

machi period, and several generations of smiths likely used this same name.

Jihada: A well-forged jigane and mokume-hada mixed with masame-hada; occasionally, fine jihada with ji-nie.

Hamon: Suguha notare of nioi deki. Hitatsura in the Soshu tradition can be seen among the tanto at times.

THE KANEFUSA (兼房) SCHOOL

Several generations of smiths used the name Kanefusa (兼房) during the Koto period. Later generations, after the start of the Shinto period, changed their name to Ujifusa (氏房). A great many fine pieces, dating from Koto through Shinto times, can be seen in the workmanship of Wakasa no Kami Ujifusa, who moved to Owari, and Maruta Bingo no Kami Ujifusa, who moved to Satsuma. Both these families flourished in those provinces throughout the Edo period.

Jihada: As in other Sue-Seki blades, the jihada is a coarse mokume-hada mixed with masame-hada.

156

Kenbo midare
(gunome choji).

Hamon: The hamon is nioi deki and wide gunome midare. Kanefusa's distinctive gunome midare is called "Kenbo midare" (Kenbo is an alternative reading of Kanefusa) and consists of uniform midare with round yakigashira (the top of the midareba) repeated at regular intervals. There are also gorgeous hamon like o-midare and o-gunome midare with nie.

Boshi: The boshi commonly resembles a Jizo, and the kaeri is long.

THE DAIDO (OR OMICHI) (大道) SCHOOL

The Daido school was active from the very end of the Muromachi period through Shinto times. Compared with the work of other schools, the jihada is dense. The hamon is stiff, not a smooth notare, and is mixed with gunome in the bottom and upper areas of the blade.

THE SAKURA SEKI (坂倉関) SCHOOL

Masatoshi (正利), who lived in Sakura, Mino province, produced swords with temper lines and signatures that resembled the work of Sengo Muramasa.

THE AKASAKA SENJUIN (赤坂千手院) SCHOOL

Early in Japanese history, technical exchanges in sword production methods took place between Yamato and Mino provinces. This school seems to have come from the Yamato-province Senjuin school, but extant work from before the Muromachi period is seldom seen. The workmanship shows features in common with other Sue-Seki blades. Blades by Jumyo were particularly numerous. The jihada is ko-mokume-hada. The hamon is chu-suguha; the boshi is ko-maru and, occasionally, inclined to be in the Bizen tradition.

THE GANMAKU (岩捲) SCHOOL

The lineage of Ganmaku (岩捲), Ujinobu (氏信), Ujisada (氏貞), and the other smiths of this school is not very clear, but it is known that they produced good blades in the Soshu-den as well as in the Mino tradition. The famous blade called "Ikkoku Ujisada" is one of Ujisada's masterpieces, and its o-notare midare resembles work of Nosada (the second-generation Kanesada).

In addition to the smiths mentioned above, there are hundreds of smiths of the Sue-Seki school who used the character "Kane" in their signatures. Their work is not described here, as it displays the common features of Sue-Seki workmanship. The names of this school's leading smiths are:

Ietsugu (家次), Tomohira (具衡), Kaneie (兼舎), Kaneie (兼家), Kaneiwa (兼岩), Kaneharu (兼春), Kaneharu (兼治), Kaneharu (兼晴), Kanetomo (兼知), Kanekore (兼伊), Kanetsuki (兼付), Kanetoki (兼時), Kanetoki (兼辰), Kanechika (兼近), Kaneyoshi (兼女), Kanehiro (兼涌), Kanekatsu (兼勝), Kanekage (兼景), Kanekado (兼門), Kanetaka (兼高), Kanetsuna (兼綱), Kanetoku (兼得), Kanenaga (兼長), Kanenaga (兼永), Kanemune (兼宗), Kanemura (兼村), Kanenobu (兼宣), Kanenori (兼則), Kanenori (兼法), Kaneoto (兼音), Kanekuni (兼国), Kaneyasu (兼安), Kanemasu (兼舛), Kanemaki (兼巻), Kanemachi (兼町), Kanefune (兼舟), Kaneari (兼在), Kanesaki (兼先), Kanekiyo (兼清), Kaneyuki (兼行), Kaneaki (兼見), Kaneshige (兼茂), Kanehira (兼平), Kanemori (兼守), Kaneyuki (包行), Kanetaka (金高), Nagakatsu (長勝), and Kunitsugu (国次).

LEADING SWORDSMITHS OF THE MINO TRADITION

THE NANBOKUCHO PERIOD

SOUTHERN COURTS	NORTHERN COURTS	PROVINCE	SWORDSMITH(S)	PATTERN
Kokoku (1340–1346)	Koei (1342–1345)	Mino	Naoe Shizu Kanetsugu (直江志津兼次) and Kanetomo (兼友)	The sori is shallow. Hi are commonly seen, and the hisaki is descended, or located at a lower position than usual. The jigane is somewhat hard, and the jihada is mokume hada mixed with masame hada. The hamon is o-midare and gunome midare in nie deki. Nie kuzure, sunagashi and togari-ba can be seen.
Shohei (1346–1370)	Koan (1361–1362)		Naoe Shizu Kanenobu (直江志津兼信)	Features identical to those of Kanetsugu and Kanemoto.
	Joji (1362–1368)	Izumi	Kaga Shiro Mitsutada (加賀四郎光正)	Extant works of this period are rare.

THE MUROMACHI PERIOD

ERA	PROVINCE	SWORDSMITH(S)	PATTERN
Oei (1394–1428)	Izumi	Kaga Shiro Yoshimasa, (加賀四郎賀正) Suketsugu, Suketoshi, (次) (資利) and Sukemasa (資正)	The katana is relatively short. These smiths produced many tanto and wakizashi. Shobu-zukuri and u-no-kubi-zukuri can be seen. The jigane is hard, and the jihada is coarse mokume hada mixed with masame hada. The hamon is o-midare, yahazu midare, ko-midare, chu-suguha, etc., and has mura-nie. The hamon tends to be stiff and awkward in its patterning. The boshi is midare komi, ko-maru, or o-maru, in continuation of the hamon, and the kaeri is always long.
	Ise	Muramasa (村正)	Refer to page 207.
	Yamashiro	Heianjo Nagayoshi (平安城長吉)	Tanto is the main area of preduction. Shobu-zukuri and u-no-kubi-zukuri can be seen. This smith also produced yari and naginata. The horimono are always tall. Some are elaborate. The jigane is rather hard. The jihada is mokume hada mixed with masame hada. The hamon is hako midare and yahazu midare with o-koshiba. The hamon has the same pattern on both sides, and the pattern is stiff and awkward-looking. The boshi is also stiff midare komi, and the kaeri is long.

ERA	PROVINCE	SWORDSMITH(S)	PATTERN
		Sanjo Yoshinori (三条吉則)	Hi and horimono are commonly seen, and elaborately-designed horimono can occasionally be seen. The jigane is weak and the jihada is mokume hada mixed with masame hada. The hamon is yahazu midare with mura-nie, gunome choji or hitatsura. Muneyaki can be seen at times. The boshi is Jizo, ichimai, etc.
	Mikawa	Yakuoji Kaneharu (薬王寺兼春)	The founder is said to be Kunimori. There are many smiths in this school, but their extant works are rare. The hamon is nioi deki and koshi-no-hiraita midare with mura-nie that resembles that of Bizen swords of this time.
	Totomi	Takatenjin Kaneaki (高天神兼明)	This smith moved from Mino province. Extant examples of work are rare. The jihada is mokume hada mixed with masame hada. The hamon is o-notare, o-midare, yahazu midare, hitatsura, etc., and is of nioi deki. Among the tanto there is a hoso-suguha which resembles the Yamashiro tradition. The boshi is midare komi, Jizo or yaki-kuzure (crumbled pattern), and the kaeri is long.
	Mino	Naoe Shizu Kanenobu (直江志津兼信) and Kanehisa (兼久)	A considerable number of works by the Naoe Shizu school are extant. The workmanship does not differ greatly from Kaneuji's, but the jigane is harder and is not oily, and the jihada is coarse. In later generations mura-nie, thick sunagashi, and a greater number of togari-ba can be seen; the kaeri of the boshi also becomes long. This work is a mixture of the Mino and Soshu traditions.
		Hachiya Kanesada (蜂屋兼貞)	There are several generations of smiths by this name, but extant works by the early generations are rarely seen. Refer to page 221.
		Kanetsune (兼常)	There are several generations of smiths by this name, but extant works by the early generations are rarely seen. Workmanship becomes more vigorous than that of the first-generation Zenjo Kaneyoshi. In Shinto times, a descendant of Kanetsune's moved to Owari province and changed his name to Masatsune.
Eikyo (1429–1441)	Ise	Masashige (正重)	The son of Muramasa. His workmanship is similar to that of his father.
Bun'an (1444–1449)	Mino	Kanemoto (兼基) also known as Kanemoto I (初代 兼元)	This smith did not produce many tanto. Hi and horimono are both seen only rarely. The jigane is hard and the jihada is mokume hada mixed with masame hada that is noticeable along the mune side. The hamon is ko-midare mixed with ko-gunome, and occasionally sanbon-sugi. The boshi is midare komi in proportion to the hamon, and the kaeri is long.
Bunmei (1469–1487)		Kanesada I (初代 兼定)	Also known as Oya Kanesada. Pure Mino tradition is rare. The workmanship generally shows Mino tradition mixed with Yamashiro-den.
Meio (1492–1501)		Kanesada II (二代 兼⌒)	Also known as Nosada. This smith was referred to by the title "Izumi no Kami." The katana is from 63 cm to 66 cm in length, and has high shinogi and thin mune kasane; it looks practical. Shobu-zukuri and nagamaki-naoshi-zukuri can be seen. Hi and horimono are both seen only rarely. The jigane is well forged and the jihada is a dense mokume hada mixed with masame hada that is noticeable along the mune side. Shirake utsuri appear. The hamon is o-choji midare of thick nioi with a lot of hataraki, and looks like Fukuoka Ichimonji's but tends to be gunome choji midare, and is also invari-

ERA	PROVINCE	SWORDSMITH(S)	PATTERN
			ably mixed with togari-ba or yahazu ba. There are also yahazu midare and hako midare. The boshi is midare komi or Jizo, and the kaeri is invariably long. The tanto has no sori, while the hamon is o-notare, gunome choji, o-midare, etc. In addition to work based in suguha, there is also Yamashiro tradition.
Bunki (1501–1504)	Ise	Masazane (正真)	Workmanship is similar to that of Muramasa, but becomes gentle or calm.
Eisho (1504–1521)	Mino	Kanemoto II (二代 兼元)	Also known as Magoroku Kanemoto. The jigane is relatively soft and the jihada is a coarse mokume hada mixed with masame hada. Utsuri appear. The hamon is sanbon-sugi but does not show the uniformity of later generations. The boshi is midare komi and becomes Jizo.
Daiei (1521–1528)		Kanefusa (兼房)	Workmanship shows the characteristic features of Sue-Seki swords but in tanto his peculiar hamon, namely kenbo midare (a kind of gunome choji midare) is commonly seen. There are many smiths who belong to this school.
Tenbun (1532–1555)		Hida no Kami Ujifusa (飛騨守氏房)	Features identical to those of Kanefusa.
		Kanemoto III (三代 兼元)	Features identical to those of the first and second generations, except that the jigane is harder and the jihada is ko-mokume hada mixed with masame hada that is noticeable along the mune side. The hamon becomes a uniform sanbon-sugi. The boshi is ko-maru; alternatively, it is inclined to be irregular, and its top becomes round and turns back.
Tensho (1573–1592)		Wakasa no Kami Ujifusa (若狭守氏房)	Features identical to those of Kanefusa.

WORKMANSHIP OF SHINTO TIMES

Swords made during the Heian period (794–1185) through the Keicho Era (1596–1615) are called Koto. Shinto (literally, "new swords") were made from the Keicho era through the An'ei era (1772–1781). Shinshinto (literally, "new-new swords") are those made between An'ei era and the ninth year of the Meiji period (1876), when the Meiji government issued an edict prohibiting the wearing of swords. These classifications refer not only to "old" and "new" sword periods, but also to the rather different character of the workmanship of each period. The differences may be described easily.

Swords made in the Koto period are still classified in terms of the Gokaden, the schools that developed in the provinces of Yamashiro, Yamato, Bizen, Soshu, and Mino. During the Shinto period, some swordsmiths continued with the five traditions and also developed a new forging style not known in Koto times. This is called the Shinto tokuden tradition, and the majority of swordsmiths of the Shinto period adopted this forging style. Even if a Shinto swordsmith used one of the Gokaden forging methods, the sword would not look as if it had been produced during the Koto period, but would show definite characteristics of the Shinto style, incorporating into this elements of the Gokaden.

After the Muromachi period, great strides were made in the manufacture of iron, and smiths were easily able to produce plenty of consistently high-quality steel. The Shinto period led to improvements in transportation as well, allowing smiths better access to steel. During the Koto period, the features of the jigane had varied significantly because of the different material used in each province, but during Shinto times, since all swordsmiths used material of the same quality, the jigane became very similar. Although one can recognize the tradition of the Koto-era swordsmiths based on the material used in the jigane, swords made during Shinto times cannot be recognized on the basis of jigane material alone. It is possible, however, to recognize a particular smith's school from the forging style.

Shinto-period swordsmiths did not always follow the style of their predecessors, but often tried to learn from famous smiths. Well-known smiths, therefore, had many students. The character of Shinto schools was thus quite different from that of earlier periods.

Famous swordsmiths gathered and prospered in the towns that developed around the principal castles. Major centers for swordsmiths were: Kyoto (Yamashiro), Osaka (Settsu), Edo (Musashi), Saga (Hizen), Kagoshima (Satsuma), Fukui (Echizen), and Kanazawa (Kaga).

FEATURES OF THE SWORDS OF SHINTO TIMES

1) The length of the swords of Shinto times is about 70 cm for katana, and 45–48 cm for wakizashi. The sori is shallow. The mihaba is wide, the kasane is thick, and the iori-mune

(gyo-no-mune) is relatively low. There is full hira-niku, and the kissaki is a bit longer than the ordinary chu-kissaki. The Koto blade fits comfortably in the hand, and feels lighter than it actually is. Shinto blades, by contrast, feel heavy.

2) The top of the hi stops at the yokote area, and the bottom is rounded at the end (maru-dome) and usually stops at the machi area.

3) Generally speaking, Shinto blades have few horimono, although a few smiths and

schools specialized in them. Designs are often intricate, and chiseling is elaborate.

4) The steel is hard. It looks black in color and is highly reflective, particularly in the shinogiji, which is polished by burnishing.

5) Wide choji midare and o-midare hamon show activity near the temper line, but little activity from the middle of the hamon to the ha. The nie are larger than those seen in the Koto period. The Koto-period midare starts abruptly as an irregular shape from the yakidashi area (the start of the hamon), and the boshi becomes midare komi. Many Shinto blades, however, have suguha yakidashi and a boshi that is ko-maru.

6) The finishing of the nakago is very elaborate. The shape becomes tapered and well balanced. Yasurime are filed minutely and carefully, and decorative filing, or kesho yasuri, are often seen. The ana are made by a lathe and form a perfect circle. Lengthy signatures, dates of manufacture, and smiths' titles are other common features of Shinto swords.

157

An example of an Osaka Shinto.

SHINTO TOKUDEN AND THE GOKADEN

Shinto tokuden

In Koto times, it was natural that swords with a rough jihada also had a wide hamon, while swords with a fine jihada had a narrow hamon. In the Shinto tokuden, however, swords with fine jigane have a wide hamon in nie deki. At first glance these may bear some resemblance to swords in the Soshu tradition, but original Soshu work has a larger itame-hada and a wide midareba of nie deki, so sunagashi, kinsuji, inazuma, and nie sake also appear. Since swords made in the Shinto tokuden tradition are often in ko-mokume, sunagashi, kinsuji, inazuma, and nie sake are rarely seen.

The main hamon of the Shinto tokuden are toran-midare, a gunome-midare resembling toran-midare, hiro-suguha with gunome ashi, o-midare, notare and notare-midare, all wide and with abundant nie. In addition, new temper lines, never seen in Koto times, appeared, as did picturesque patterns such as kikusui, Yoshino, Tatsuta, Fujimi Saigyo, and Mount Fuji.

158. Toran-midare: Sukehiro, Sukenao. 159. Midareba like toran-midare: Echigo no Kami Kanesada, Gonnoshin Terukane, etc. 160. Hiro-suguha with gunome ashi: Kotetsu, the Hojoji school. 161. Midareba: Osaka shinto swords, etc. 162. Notare: Kunihiro, Shinkai, Teruhiro. 163. Notare-midare: Yasutsugu, Hizen Masahiro, Yasutomo.

Yamashiro (山城) tradition

The jihada is ko-mokume. The hamon is chu-suguha with hotsure in nie deki, and the boshi is ko-maru. Nie is either abundant or scarce, and is sometimes large in size. Smiths tried to copy the style of work that had been done in the Yamashiro tradition during Koto times, but masame is usually seen in the shinogiji, and there is little activity in the hamon.

164. Kikusui: Works by later generations of smiths working under the name Kunisuke, etc. 165. Yoshino: Tanba no Kami Yoshimichi school, etc. 166. Tatsuta: Tanba no Kami Yoshimichi school, etc. 167. Mount Fuji: Tanba no Kami Yoshimichi school, etc.

168. Chu-suguha in nie deki: Tsuda Sukehiro, Tadatsuna II, etc. 169. Chu-suguha with abundant nie. The shinogiji is inclined to become masame. Kunikiyo (Yamashiro), Shigekuni (Kii), etc. 170. This is an example of the chu-suguha swords with ko-mokume which are commonly seen in Hizen province.

Yamato (大和) tradition

There are two patterns in the jihada, one purely masame-hada and the other consisting mainly of mokume-hada. Vertical activities particular to the Yamato tradition are seen along the hamon. The hamon is usually wider than that of smiths working in the Yamato tradition in Koto times. The hamon is chu-suguha with hotsure in nie deki. The boshi is suguha and ko-maru, and turns back, as in other Shinto styles.

Chu-suguha in nie deki. The jihada is masame. The Kuni-kane school.

171

Bizen (備前) tradition

The jigane is relatively soft and looks weak, while the jihada is mokume-hada mixed with masame-hada; utsuri sometimes appears. The hamon is in nioi deki and choji midare, o-choji midare, choji midare the top of which is leveled, and saka choji midare the top of which resembles a squid's head. In addition, kobushigata choji midare appeared for the first time in Shinto times. Generally these resemble the Ichimonji school of Koto times, but sometimes have partial nie. Specific characteristics of each school may be distinguished, but it is difficult to recognize the patterns of the hamon of individual swordsmiths. Koshi-no-hiraita midare, which was very popular in the Muromachi period, is not very often seen in Shinto. The boshi in Koto blades is usually midare komi continuing the pattern of the hamon, but in the Shinto Bizen tradition it becomes ko-maru or midare komi inclined to become ko-maru.

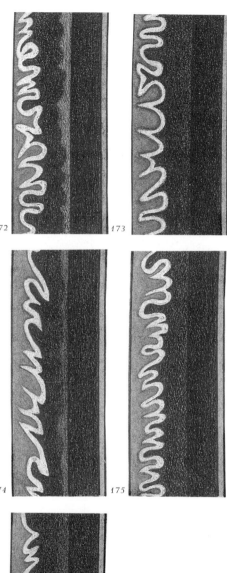

172 173

174 175

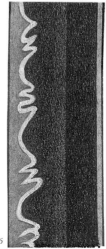

176

172. Choji midare in nioi deki. Ishido school. 173. Choji midare, the top of which is always the same height, or which looks like suguha-choji midare (Hizen swords have a good deal of nie at the bottom of the hamon). 174. Saka-choji midare resembling the head of a squid. Fukuoka Ishido school. 175. Kobushigata choji midare. Kunisuke II, etc. 176. Koshi-no-hiraita midare. Yokoyama Sukesada, the Osaka Ishido school.

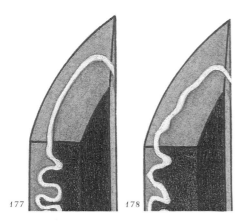

177. The hamon is choji midare in nie deki; the boshi is ko-maru and has kaeri. 178. Midare komi inclined to become ko-maru boshi.

Soshu (相州) tradition

Shinto swordsmiths tried to copy the Soshu tradition of the later Kamakura and Nanbokucho periods. Jihada is o-mokume hada, itame-hada, and ko-mokume hada with a relatively large pattern. The hamon is o-midare, and nie kuzure are popular, as they were in the Koto Soshu tradition, but the nie becomes larger and rougher. The following is a typical Shinto Soshu-tradition hamon: hako midare with a good deal of deep midare komi inclined to become nie-kuzure. Slightly tapered ko-maru boshi may also be seen.

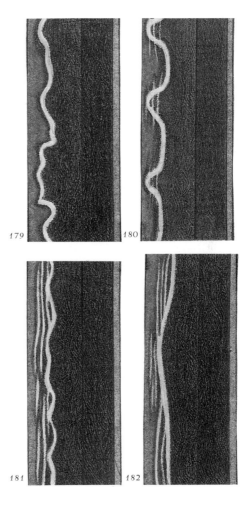

179. O-midare with nie kuzure. 180. Hako midare with a good deal of sunagashi. Kanewaka, etc. 181. Gunome midare with nie kuzure and sunagashi. 182. Notare with nie and sunagashi.

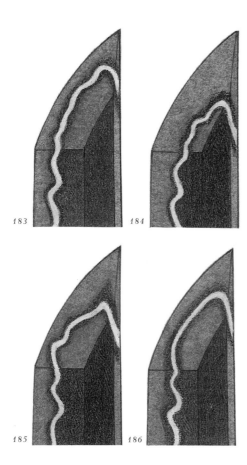

183 184

185 186

Mino (美濃) tradition

Shinto swordsmiths of the Mino-den suc-
ceeded those of the late Muromachi period
without a great deal of change. The jigane
looks black and clean. The Shinto jigane is
highly reflective. The hamon is midareba,
with togari-ba in nioi deki, but partial nie is
also seen. A standard sanbon-sugi is also seen.

183. Shallow midare komi with turn-back. *184.* Deep
midare komi with turn-back. *185.* Midare komi with nie
kuzure. *186.* Ko-maru, slightly tapered, turns back.

PROVINCES AND SCHOOLS OF SHINTO TIMES

YAMASHIRO (山城) PROVINCE

For centuries after the transfer of the capital from Nara at the end of the eighth century, Kyoto in Yamashiro was home to Japan's emperors. This was true despite the fact that the center of Japan's political administration was transferred to Kamakura at the time of the establishment of the Minamoto shogunate government in 1182. Kyoto was burned to the ground during the Honin war, and Oda Nobunaga and Toyotomi Hideyoshi made great efforts to rebuild the city in their campaigns to unify all Japan. Hideyoshi, for example, built the gorgeous Juraku Pavilion and magnificent Fushimi Castle. The city did indeed emerge from the ruins of the war to become the center of political administration and the economy. Naturally, many smiths moved there and began producing swords there at the beginning of Shinto times. Keicho Shinto, which adopted some aspects of the o-suriage sugata of the Kamakura and Nanbokucho periods, and which infused many Shinto swordsmiths with a new spirit, was established in Kyoto.

The jigane of Yamashiro swords differs slightly from one school to another although, generally speaking, it is inclined to be coarse, and masame-hada appears in the shinogiji. The yakidashi starts with suguha, or with suguha mixed with ko-midare. It is called Kyo-yaki-dashi and is not smoothly connected with the start of the main hamon, or has a connection that looks stiff; nie can also be seen there.

The boshi is ko-maru agari but is inclined to be notare, and the yakihaba is relatively narrow. This is the so-called "Kyo-boshi." The boshi of the Mishina school is inclined to be Jizo, and creeps upward toward the munesaki.

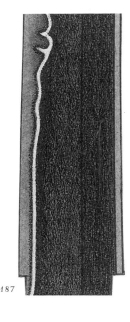

187

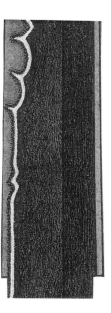

188

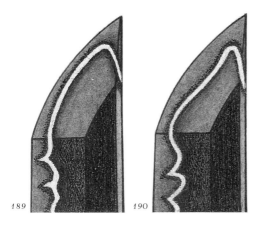

187. Kyo-yakidashi. The yakidashi is suguha inclined to be notare. 188. Kyo-yakidashi mixed with ko-midare, with a rugged connection to the main hamon. 189. Kyo-boshi. Ko-maru agari, with a relatively narrow yakihaba and nie. 190. Mishina boshi which is inclined to be Jizo and which creeps upward toward the munesaki.

The Umetada Myoju (埋忠明寿) school

Myoju (明寿) is said to be the pioneer of the Shinto period. He was born to a distinguished family of metalworkers. They made sword fittings such as tsuba, habaki, and other pieces, and did professional suriage (shortening) of good Koto blades and zogan (inlaying). Myoju was the only one in his family to produce swords. His extant works that have been authenticated are a katana, a shinogi-zukuri wakizashi, a ken, and some tanto. Most of his tanto are katakiriha-zukuri.

The school includes Hizen Tadayoshi (忠吉) (founder of the Tadayoshi school), Harima no Kami Teruhiro [輝広] (founder of the Teruhiro school), Umetada Shigeyoshi (重義) (who succeeded Myoju), and Yamato Daijo Yoshinobu (大和大掾吉信) and Higashiyama Yoshihira (Shigeyoshi's students). Their work is described in the chart at the end of this chapter, "Leading Swordsmiths of Shinto Times." Tadayoshi's and Teruhiro's workmanship will also be explained in the paragraphs on their provinces.

The Horikawa Kunihiro (堀川国広) school

It is said that Kunihiro (国広) was originally a retainer of the Ito family (in Obi, Hyuga province). He traveled around the country and became devoted to sword production after the clan's downfall. It has been confirmed, from the dates inscribed on his swords, that his sword production ranged from 1576 to 1613. At the beginning of the Keicho era, in 1596, he moved to Horikawa in Kyoto, where he taught many students while producing masterpieces himself.

The school includes Kuniyasu (国安), Dewa Daijo Kunimichi (出羽大掾国路), Osumi no Jo Masahiro (大隅掾正弘), Fujiwara Hirozane (藤原広実), Echigo no Kami Kunitomo (越後守国儔), Heianjo Hiroyuki (平安城弘幸), Yamashiro no Kami Kunikiyo (山城守国清), Awa no Kami Ariyoshi (阿波守在吉), Izumi no Kami Kunisada (和泉守国貞), and Kawachi no Kami Kunisuke (河内守国助). All were skillful smiths. Both Kunisada and Kunisuke later moved to Osaka and became the pioneers of Osaka Shinto workmanship.

Sugata: The blade has a wide mihaba, shallow sori, and relatively large kissaki; a Keicho Shinto sugata, it is a copy of the suriage (shortened blade) of the Nanbokucho period. Many hira-zukuri and sunnobi tanto (longer than josun) were also produced, and these have a wide mihaba, slight sori and a sugata similar to that of the tanto of the Enbun and Joji eras of the Nambokucho period, but their kasane is thick.

Jihada: Generally, coarse and larger-grain; some swords, however, have fine mokume-hada. In any case, ji-nie, yubashiri, and chikei are seen.

Hamon: Consisting of abundant nie. Chu-suguha hotsure in Yamashiro tradition, o-midare or o-gunome in Soshu tradition with nie kuzure. Sunagashi and nie sake, hiro-sugu-ha with gunome ashi in the Shinto tokuden tradition which is inclined to be notare, sugu-ha choji, etc. There are many hataraki such as kinsuji and inazuma. The yakidashi usually has standard yakihaba in the hamachi area, as does that of Koto blades. In work that is o-gunome midare or o-midare, the hamon occasionally becomes small-patterned in the monouchi area.

Boshi: Midare komi, ko-midare with nie kuzure, or o-midare; the upper part is ko-maru agari.

The boshi of Dewa Daijo Kunimichi often becomes Mishina boshi.

Nakago: Relatively long funagata; the tip becomes narrow. The nakagojiri is kurijiri. The yasurime is o-sujikai, but Kuniyasu adopts gyaku sujikai, while Ariyoshi and Hiroyuki adopt kiri.

The Mishina (三品) **school**
The founder of the Mishina school was Kanemichi (兼道), who lived in Seki, Mino province, at the close of the Muromachi period. He had four sons. Iga no Kami Kinmichi (伊賀守金道) was the eldest, and the second-eldest was Rai Kinmichi (来金道). His third son was Tanba no Kami Yoshimichi (丹波守吉道), and his fourth, Etchu no Kami Masatoshi (越中守正俊). The four brothers later moved to Kyoto, where they played an important part in the manufacture of blades in the Keicho Shinto period.

The second-generation Iga no Kami Kanemichi (二代金道) titled himself "Nihon Kaji Sosho" (Master swordsmith of Japan). His important position allowed him to use his influence at the Imperial Court to help determine which smiths would be given honorific titles. Later generations, as a distinguished family, succeeded to this exclusive business through the end of the Edo period.

Rai Kinmichi was the least prolific of the four brothers. His son, Daihoshi Hokyo Rai Kinmichi, was also known by his priestly name, Daihoshi Hokyo Rai Eisen.

Tamba no Kami Yoshimichi is well known as the creator of the sudare-ba. The main branch of his family is known as the Kyo Tanba. The family remained in Kyoto for generations, though the second son of the first generation moved to Osaka and was also given the title Tanba no Kami. The branch of the family that he started is known as the Osaka Tanba.

Meanwhile, the second son of the first Osaka Tanba no Kami Yoshimichi started a branch family of his own, and called himself Yamato no Kami Yoshimichi (大和守吉道). Tsutsui Kiju (筒井紀充), the son of Etchu no Kami Kanekuni (越中守包国), who was Osaka

Tanba no Kami Yoshimichi's student, is famous for his toran-midare, which is similar to that of Sukehiro. The name Etchu no Kami Masatoshi was used over three generations. These include Omi no Kami Hisamichi (近江守久道) of the Mishina school and are called the Kyo go-kaji (Five excellent smiths of Kyoto).

Sugata: There are katana, shinogi-zukuri wakizashi, hira-zukuri, and sunnobi tanto. Tanto with josun are rare. Katana and wakizashi have a wide mihaba, shallow sori, and relatively large chu-kissaki. Sunnobi tanto have wide mihaba, sori, and thick kasane.

Jihada: The jigane is somewhat hard, and the jihada is a coarse ko-mokume hada. Masame-hada in the shinogiji recalls the family's origins in Mino province. The work of Etchu no Kami Masatoshi includes some pure masame-hada. The jihada of later generations becomes clear, but is not very attractive because it has few hataraki.

Hamon: Kyo yakidashi is occasionally mixed with midare. Wide hamon consists of nie and is mixed in many cases with yahazu midare and hako midare. In addition, gunome midare reminiscent of the work of Kanesada or san-bon-sugi like that made by Kanemoto can be seen. O-midare in nie deki by Yoshimichi has a good deal of sunagashi, which indicates that the sudare-ba is from sunagashi. Deliberate production of representational sudare-ba originated with Yoshimichi II and Kinmichi II. In addition, later generations introduced other picturesque hamon such as Yoshino, Tatsuta, kikusui, Fujimi Saigyo, etc.

Boshi: Mishina boshi which starts with a shallow notare and has a slightly tapered tip which creeps upward toward the munesaki.

Horimono: Bo-bi and futasuji-bi can be seen at times.

Nakago: Iriyamagata which looks like ken gyo is generally seen. In the case of Etchu no Kami Masatoshi, this is inclined to be kurijiri. Kurijiri is very rarely seen in the work of

Kinmichi; ha agari kurijiri is similarly rare in Yoshimichi's work. The yasurime are katte sagari or sujikai. The first Masatoshi's yasurime is mainly sujikai but becomes kiri in later years. The second generation also adopts kiri. Yoshimichi's chiseling of his signature is very skillful, and he is called Hokake Tanba because the first character, "Tan (丹)," in Tanba no Kami Yoshimichi looks like a sail. Hokake means hoisting a sail.

OSAKA, OR SETTSU (摂津) PROVINCE

Osaka was a thriving city and a key point for transport by water to Kyoto; it also developed, at the end of the Muromachi period, into a prosperous temple town of the Ishiyama Honganji temple. Toyotomi Hideyoshi, Japan's supreme ruler, built a great castle there in 1583, attracting many lords and merchants to Osaka. The castle town then became the center of administration and commerce.

After the start of the Edo period, the governor of Osaka Castle, who was directly appointed by the shogun, was stationed in Osaka, where he oversaw the building by many of the major feudal lords of trading offices and storehouses for rice paid as land taxes. By the Genroku era (1688–1704), Osaka had established itself as the country's major distribution center for the most unusual and sought-after products from all over the country. The city enjoyed great prosperity and was known as the "kitchen of the country."

Osaka Shinto was founded by Kawachi no Kami Kunisuke (河内守国助) and Izumi no Kami Kunisada (和泉守国貞), both of whom had studied with Horikawa Kunihiro. They established a style of flamboyant workmanship that accurately reflected the unique culture of Osaka. It is interesting that the school produced many shinogi-zukuri wakizashi.

The jigane is extremely beautiful. The fine ko-mokume hada is not readily visible, sometimes resembling muji-hada. The burnished surface of the shinogiji is dark and looks like the surface of a mirror; this feature is called Osaka tetsu or Osaka gane. The start of the

Osaka yakidashi hamon is a suguha that becomes notare. The main hamon and yakidashi are smoothly connected, which distinguishes this style from Kyo-yakidashi. In o-midare, the dynamic, active pattern is carried on through the yokote line. The boshi is ko-maru sagari, or Osaka boshi, with the top located lower than in other styles. The nakago is elaborately finished, and is often done in kesho (decorative) yasuri.

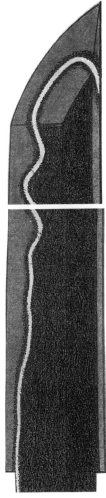

191

Osaka boshi (top) and Osaka yakidashi.

The Izumi no Kami Kunisada (和泉守国貞) school

Izumi no Kami Kunisada and Kunihiro came from Hyuga province. At the time of the

death of his teacher Kunihiro, Kunisada was still just twenty-five years old. Given the extent to which his early signature resembles that of Echigo no Kami Kunitomo, the likelihood is that he learned techniques of swordsmithing from Kunitomo. His workmanship shows features in common with that of the Kunihiro school. After moving to Osaka, Kunisada established his own style, seen in most Osaka Shinto work and described above. His successor to the Osaka Shinto school was Inoue Izumi no Kami Kunisada, who later changed his name to Shinkai (真改). This second Kunisada (or Shinkai) left many fine blades that clearly suggest his great admiration for Go Yoshihiro, and which enhanced his renown as the "Masamune of Osaka." The first-generation smith is usually called Oya Kunisada; his successor in the second generation is referred to as Shinkai Kunisada, in order to avoid confusion. The lineage of smiths includes Suzuki Kaga no Kami Sadanori (鈴木加賀守貞則), Doi Shinryo (土肥真了), and Hokuso Harukuni (北窓治国), all of whom were actually students of Shinkai.

Sugata: Keicho Shinto sugata can be seen among the work of Oya Kunisada, but the Kanbun Shinto sugata is common to Shinkai and to his students, since they were active from the time of the Kanbun era. The sori of Shinkai and his students is shallow, and also Keicho Shinto, but the sakihaba (width of the yokote area) is relatively narrow. In other words, the blade has tapering mihaba, the kissaki is a relatively small chu-kissaki, and the blade is well balanced and practical. Shinogi-zukuri wakizashi exceed katana in quantity but tanto are rare, for unknown reasons. This phenomenon can be seen not only in this school, but in other Osaka Shinto schools as well.

Jihada: A most beautiful jihada, of fine komokume hada with chikei and abundant ji-nie.

Hamon: In later works of Oya Kunisada, the number of gunome commonly seen on Osaka Shinto increases, and he comes close to establishing a style of workmanship unique to Osaka Shinto. In addition to gunome midare, o-notare, hiro-suguha and o-midare are seen from the time of Shinkai. The nie and nioi are thick. The hamon is in nie deki and the habuchi (border between the ji and the ha) looks gorgeous. A lot of nie spill over from the habuchi to the ji. The wide hamon becomes still wider in the monouchi area, and the thick nie and nioi occasionally reach the shinogi.

Boshi: In continuation of the hamon, and ko-maru with short kaeri. The boshi has wide yakihaba and sometimes looks like ichimai with rather rough nie.

Horimono: There is one blade by Oya Kunisada on which shin-no-kurikara is engraved in the hitsu. But horimono is rarely seen, and hi are rare after Oya Kunisada.

Nakago: The tip is ha agari kurijiri and yasurime are o-sujikai with kesho yasuri. Everything is done skillfully.

The Kawachi no Kami Kunisuke (河内守国助) school

Kunisuke studied under Kunihiro, along with Izumi no Kami Kunisada, but it is said that he learned swordmaking mainly from Echigo no Kami Kunitomo. He later moved to Osaka, where he founded his own school. Traces of the Horikawa school's characteristics were still evident in his work at first, but his workmanship gradually changed to the unique Osaka Shinto style, adopting gunome midare and suguha choji. There were several generations. The smith of the second generation is as well known as Nakakawachi. The school includes Higo no Kami Kuniyasu (肥後守国康), Musashi no Kami Kunitsugu (武蔵守国次), Ise no Kami Kuniteru (伊勢守国輝) and Soboro Sukehiro (そぼろ助広).

Sugata: Keicho Shinto sugata can be seen among the work of the first Kunisuke but generally shinogi-zukuri katana and wakizashi are the main area of production; these have shallow sori, narrow mihaba in the yokote and relatively small kissaki and are known as Kanbun Shinto.

Jihada: The ko-mokume hada is not readily visible, and sometimes looks like muji-hada; alternatively, the jigane is hard and the jihada a coarse mokume-hada mixed with masame-hada.

Hamon: Kobushigata (fist-shaped) choji midare originated with the second Kunisuke. On the whole, choji midare is common. Notare midare, hiro-suguha, o-midare, and o-gunome midare in nie deki can all be seen among the work of Ise no Kami Kuniteru. In any case, the hamon has Osaka yakidashi.

Boshi: Kyo-boshi can be seen in the work of the first Kunisuke, but generally the boshi is ko-maru sagari.

Horimono: Bo-bi can be seen at times, and maru-dome ends just above the machi.

Nakago: The nakagojiri is ha agari kurijiri. The filing mark pattern (yasurime) is o-sujikai, occasionally with kesho yasuri. Kuniteru's nakago have a rather unusual shape, called goheigata.

The Sukehiro (助広) school

Sukehiro studied under Kawachi no Kami Kunisuke and was a native of Harima province. He is referred to as Soboro Sukehiro (そぼろ 助広), while the second-generation successor to his name, Tsuda Echizen no Kami Sukehiro (津田越前守助広), was a distinguished sword-smith and creator of the famous toran-midare hamon that represents large surging waves. His signature was done in two ways. His early work is called Kaku ("square") Tsuda, because the signature was done in the block style. His later work is called Maru Tsuda because the signature is written in a running, cursive style. Tsuda Omi no Kami Sukenao (津田近江守助直) was a skillful smith, and succeeded his teacher, the second Sukehiro.

Sugata: The sugata is in the Kanbun Shinto style, as is that of this school's contemporaries in the Kunisuke school.

Jihada: The jigane of the first Sukehiro and of the early work of the second Sukehiro is slightly weak. The jihada is mokume-hada, but generally the jigane is oily and well forged, and the jihada is a fine ko-mokume hada, with chikei and abundant fine ji-nie.

Hamon: Choji midare in nioi can be seen in the work of the first and the early work of the second Sukehiro. The toran-midare of the second Sukehiro and that of Sukenao stand out conspicuously from that of others. The hamon starts out in Osaka yakidashi, changes to toran-midare which has a wide hamon and continues in a regular pattern to the yokote. The even, round nie are brilliant and most beautiful. The chu-suguha has thick and brilliant nie as well.

Boshi: Ko-maru sagari with abundant nie.

Horimono: Rarely seen, but occasionally bo-bi.

Nakago: The tip is ha agari kurijiri or iriyama-gata. The yasurime are sujikai with well-ordered kesho yasuri.

The Tadatsuna (忠綱) school

Asai Omi no Kami Tadatsuna (浅井近江守忠綱) moved to Osaka from Himeji, in Harima, where he taught many disciples. Awataguchi Ikkanshi Tadatsuna (粟田口一竿子忠綱), who succeeded him, was also given the title of Omi no Kami. The first-generation Tadatsuna is sometimes called Oya Tadatsuna, as a way of differentiating him from his successor. Ikkanshi Tadatsuna is well known not only as a skillful smith but also as a masterful carver of horimono. He was active around the end of the seventeenth century and represents Osaka Shinto after Inoue Shinkai and Tsuda Echizen no Kami Sukehiro. The school includes Tadayuki (忠行), Nagatsuna (長綱), Munetsuna (宗綱), Kanetsuna (包綱), and Hirotsuna (広綱).

Sugata: Generally Kanbun Shinto sugata but in the case of Ikkanshi Tadatsuna, the blade has hira-niku, a mihaba which is not tapered, relatively deep sori and slightly large chu-kissaki.

Jihada: The jigane is very beautiful, but the ko-mokume hada is not readily visible.

Hamon: Choji midare, with wide yakihaba and long ashi whose yakigashira (top of each midare) tends to be round and to consist of nioi. Ikkanshi Tadatsuna is very good at o-notare with Osaka yakidashi and gunome ashi which lie along the habuchi and are sprinkled evenly with nie.

Boshi: Ko-maru sagari.

Horimono: Rarely seen except in the work of Ikkanshi Tadatsuna. Fine chiseling and elaborate design are characteristic features of the work of Ikkanshi Tadatsuna. He engraves the omote (front) with fine ken-maki-ryu (or kurikara) which harmonize well with the blade, and, on the ura (back), bonji above dokko or ken with tsume. Ume ryu (plum tree and dragon), hai ryu (a crawling dragon), koi no taki nobori (carp swimming up the waterfall), etc. Occasionally, bo-bi and soe-bi with maru-dome are engraved above the horimono mentioned above.

Nakago: Generally slender and relatively long nakago, ha agari kurijiri and sujikai yasuri.

The Kaneyasu (包保) school

Mutsu no Kami Kaneyasu (陸奥守包保) is said to have been a student of the Tegai school and a native of Yamato province. His work suggests the Yamato tradition in some ways. He is called Hidari Mutsu (Left-handed Mutsu), as his signature is written in the opposite direction from normal, a mirror image. Iga no Kami Kanemichi (伊賀守包道) was his student. The school includes Kanemichi's student, Echigo no Kami Kanesada (越後守包貞), and that smith's son, Sakakura Gonnoshin Terukane (坂倉言之進照包). Terukane later succeeded his father as the second Echigo no Kami Kanesada.

Sugata: High shinogi, shallow sori and chu-kissaki, occasionally chu-kissaki that are a bit larger than usual.

Jihada: The jigane is somewhat hard, and the jihada is a slightly coarse mokume-hada mixed with masame-hada, which is especially noticeable in the shinogiji. A dense mokume-hada mixed with o-hada can also be seen among Terukane's blades.

Hamon: The wide hamon consists of uneven nie. There are o-midare, gunome midare, notare midare, etc. Rough or tapered midare can be seen in some spots. There are also hiro-suguha and chu-suguha with hataraki in the Yamato style including nijuba, uchinoke, etc. Terukane is good at toran-midare, but his patterns are not orderly, and his nie are rough and uneven, unlike work by Sukehiro. His toran-midare is mixed with choji, togari-ba, and yahazu-ba, as well as with a good deal of sunagashi.

Boshi: Ko-maru sagari or ichimai.

Horimono: Bo-bi can be seen at times. The maru-dome (rounded bottom of the hi) ends above the machi.

Nakago: Relatively somewhat long, with a tapering nakago. Nakagojiri is gentle kurijiri, ha agari kurijiri, or iriyamagata. Yasurime are gyaku sujikai or sujikai. Kesho yasuri can be seen in the work of Kanesada.

The Kishu (or Osaka) Ishido (紀州石堂) school

A group of smiths that lived in Omi province are said to be descendants of the Bizen-province Ichimonji school, and called themselves Ishido. They moved to Edo, Wakayama (Kii province), and Fukuoka (Chikuzen province), to start new branches, and prospered in these locales throughout the Shinto period. During the Kan'ei era (1624–1644), the group moved first to Wakayama, and later to Osaka. The leader of this school was called Tameyasu (為康). The second-generation head was given a title, and then began to call himself Mutsu no Kami Tameyasu. The brother of the second-generation head was Bitchu no Kami Yasuhiro (備中守康広). The school includes smiths Kawachi no Kami Yasunaga (河内守康永) and Bizen no Kami Sukekuni (備前守祐国). Tatara Nagayuki (多々良長幸) was Yasunaga's student and one of the finest Bizen-style smiths to work during the Shinto period.

Sugata: The katana has a relatively short

nagasa, and the mihaba becomes narrow in the upper area. The Ishido school produced many shinogi-zukuri wakizashi. But Nagayuki produced few wakizashi; the katana has a high shinogi, a shallow sori, and thick kasane.

Jihada: Mokume-hada mixed with o-hada which is inclined to be masame-hada. Utsuri is seen at times.

Hamon: The hamon of choji midare mixed with koshi-no-hiraita midare consists of nioi and is wide. This school's choji midare is different from the Koto in its yakidashi and the size of its choji. O-choji midare and koshi-no-hiraita midare can both be seen among Nagayuki's works, but there are not many hataraki inside his hamon.

Boshi: Ko-maru sagari or midare komi in a small pattern, with short kaeri.

Nakago: Nagayuki's nakago is wider but shorter than others', and it has a stout, somewhat rustic appearance.

MUSASHI (武蔵) PROVINCE

In the Koto period, the Shitahara school was the only one producing swords in Musashi province. Musashi had been a rural province of eastern Japan until warlord Ota Dokan built Edo Castle at the start of the Choroku era, in 1457. Tokugawa Ieyasu established residence in the castle in 1590. With the transfer there of the government of the Tokugawa shogunate, Edo immediately became the center of administration, and the city developed rapidly. At the end of the Edo period, it was the biggest city in the world, with a population of more than one million.

Some Edo Shinto schools moved there, following Tokugawa Ieyasu. Other schools were founded as the city developed. All flourished and began to display individual styles of workmanship, in contrast with the Osaka Shinto smiths.

The Shitahara school's jihada is ko-mokume hada, but coarser and with more masame-hada in the shinogiji than Kyo mono, or Yamashiro blades. Kyo yakidashi is seen at times, but the

yakidashi generally becomes a midare similar to that of Koto blades. The pattern of the yakidashi is smaller and less busy than that of Koto swords. The hamon tends to have a small pattern in the area from the upper part of the monouchi to the yokote. The boshi is similar to a Kyo-boshi, and is referred to as an Edo-boshi.

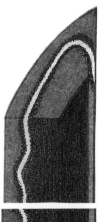

192

The boshi is ko-maru agari. The yakidashi has a small, gentle pattern characteristic of Edo Shinto.

The Yasutsugu (康継) school

Yasutsugu (康継) was a native of Omi province and used Shimosaka as his swordsmithing name in his early years, before moving to Echizen province. When he was given the character "Yasu" (康) from Tokugawa Ieyasu's name, he changed his name to Yasutsugu, and

was allowed to use the Aoi Mon, the family crest of the Tokugawa clan, on his blades. This honor was granted in 1507 by Tokugawa Ieyasu himself. Yasutsugu alternatively produced swords in Edo and Echizen provinces after being employed by Tokugawa Ieyasu. A struggle over family succession, following the death of the second Yasutsugu, caused a split within the school. As a result, the eldest son came to head the Edo Yasutsugu line of the family, and the third son succeeded to the Echizen Yasutsugu branch. Both used Yasutsugu as their smithing name for generation after generation, but no smiths equal in skill to the first-generation Yasutsugu appeared at any time in the Edo period.

The Yasutsugu school of Echizen province includes Higo Daijo Sadakuni (肥後大掾貞国) and Shimosaka Sadatsugu (下坂貞次). Yamato Daijo Masanori (大和大掾正則) seems to have had some connection with this school, as his work bears a resemblance to that of Yasutsugu. For the sake of convenience, the following description of Yasutsugu's work also outlines the work of Masanori.

Sugata: There are many hira-zukuri wakizashi, as well as shinogi-zukuri katana and wakizashi. Tanto are rare. Katakiriha-zukuri with shinogi-zukuri or hira-zukuri on one side and kiriha-zukuri on the other are seen. The first-generation Yasutsugu produced many copies of Sadamune and Masamune; in these he copied the original horimono exactly, but adopted his own hamon.

Jihada: The jigane is dark and rather hard. The jihada is a coarse mokume-hada mixed with masame-hada; masame-hada is especially noticeable in the shinogiji. Often, an inscription on the nakago states that the smith used nanban tetsu (imported iron).

Hamon: In nie deki and with wide hamon, o-notare, o-midare, o-gunome midare, hiro-suguha inclined to be notare, hitatsura, chu-suguha hotsure, etc. A good deal of kinsuji and sunagashi can be seen, but the nioi-guchi is neither tight nor bright.

Boshi: Ko-midare with narrow or wide hamon, occasionally similar to Mishina boshi.

Horimono: In addition to various types of hi, there are various designs, as follows: suken with sanko, gomahashi, bonji, ken-maki-ryu, Fudo Myoo, Bishamonten, Santai Butsu (Three Buddhas), plum tree, and bamboo. The horimono are skillfully engraved, and look powerful and vigorous. Most were done by the Echizen Kinai school.

Nakago: The nakagojiri is a tapered ken-gyo or iriyamagata, or occasionally kurijiri. The yasurime is usually sujikai, but katte sagari or kiri can also be seen. The correct generation of Yasutsugu can be determined on the basis of the style of writing of the second character, "Tsugu."

The Hankei (繁慶) school
Hankei (繁慶) was originally a gunsmith employed by Tokugawa Ieyasu, during which time he studied swordmaking. It is said that he moved from Edo to Suruga province, where Ieyasu lived out the remainder of his life after retiring as shogun, and that he became a full-time swordsmith upon Ieyasu's death in 1616. Some of the swords that he produced in Suruga province are extant. In those early days he used Kiyotaka (清堯) as his smithing name. The school's lineage also includes Hanjo (繁昌) and Masayoshi (正慶).

Sugata: Katana and wakizashi are always in shinogi-zukuri and no other tsukuri-komi (type). In his early work, produced under the name Kiyotaka, the katana has a relatively short nagasa, a relatively small chu-kissaki, and extremely shallow sori. After the smith changed his name to Hankei, his katana came to have a longer nagasa, wider mihaba and larger chu-kissaki. His hira-zukuri tanto has a wide mihaba and slight sori; there are also tanto with shorter nagasa, uchi-zori, mitsumune with steep oroshi (slope of the mune), and thick kasane.

Jihada: Coarse o-itame hada mixed with masame-hada looks like the Koto jihada; in

some cases the jihada tends to be masame-hada. Hankei's unusual jihada is called matsukawa (bark of pine tree) hada or hijiki (a kind of brown algae) hada which is roughly forged and which has abundant ji-nie and thick chikei. It somewhat resembles Norishige's jihada, but is not as clear as that of Norishige.

Hamon: In nie deki, based on hiro-suguha or notare with gunome ashi. The nie are thick but not bright. There are a lot of sunagashi, and the hamon looks as though it is composed of sunagashi. The border between the hamon and the ji (in other words, the nioi-guchi) is not distinctly exposed.

Boshi: In continuation of the hamon, and yakitsume or with short kaeri.

Horimono: The bo-bi ends with kaku-dome or maru-dome above the machi or the kaki-nagashi. Horimono are rare. One exception is the crane eating pine needles which is engraved on a tanto that has been designated an Important Asset (juyo bijutsu hin).

Nakago: The distinctively-shaped Hankei nakago. Since the hamachi and the munemachi are extremely deep, the nakago naturally becomes slender. The nakagojiri is a unique ha agari kurijiri. The yasurime are o-sujikai on the omote, and gyaku sujikai on the ura. The mune is kaku (square) or maru (round) with higaki yasuri. The engraving of the signature is unlike the chiseling used by other smiths.

The Kaneshige (兼重) school
Izumi no Kami Kaneshige (和泉守兼重) and Kazusa no Suke Kaneshige (上総介兼重), his son (or perhaps his student), show characteristics in common with Nagasone Kotetsu and Yamato no Kami Yasusada, but they are referred to here as an independent school. The first-generation Kaneshige came from Echizen province and is said to have been an arrowhead smith in his early years. His first title was Izumi no Daijo; he was later accorded the more honorific title of Izumi no Kami. The second-generation head of the school was Kazusa no Suke Kaneshige.

Sugata: There are Keicho Shinto sugata with relatively large kissaki among the first work of the generation, but later the sugata generally becomes a rather stout Kanbun Shinto sugata.

Jihada: The jigane is slightly hard, and the jihada is a ko-mokume hada mixed with masame-hada; masame-hada is especially noticeable in the shinogiji.

Hamon: The hamon is in nie deki, hiro-suguha, or notare with gunome ashi. Second-generation work sometimes bears a strong resemblance to Kotetsu, but is not equal to his work in brightness. There are also o-midare and yahazu midare with gunome ashi which look like the work of Izumi no Kami Kanesada (No Sada).

Boshi: Ko-midare, with the tip inclined to be tapered and turn-back. Mishina boshi can be seen in the work of first-generation Kaneshige.

Horimono: Bo-bi can be seen at times.

Nakago: A relatively long and tapering nakago, ha agari kurijiri. The yasurime are kiri at the start and then become sujikai as they move downward. There are blades which have the tameshi- (cutting test) mei of Yamano Kanjuro Hisahide and Yamano Kaemon Nagahisa in kin zogan (gold inlay) on the nakago.

The Kotetsu (虎徹) school
Nagasone Okisato Nyudo Kotetsu (長曾禰興里入道虎徹) was a native of Echizen province who started his career as an armorer, but became a swordsmith when he was more than fifty years old. Several swords of his which actually note his age on the nakago are extant. He moved to Edo and eventually made a name for himself as a great swordsmith. He appears to have studied with Kazusa no Suke Kaneshige. The second generation was Okimasa (興正), his adopted son and a rather skillful smith. Okinao (興直) and Okihisa (興久) were two smiths of the same school, but few of their swords now exist.

Sugata: In the early years of Kotetsu, the blade has a shallow sori and a wide mihaba; high shinogi and o-kissaki can also sometimes be seen. In his later years, the sugata becomes a standard Kanbun Shinto sugata with a shallow sori, a tapering mihaba, high shinogi, thick kasane, and relatively small kissaki. Occasionally, unusual tsukuri-komi can be seen.

Jihada: Well-forged ko-mokume hada with fine ji-nie or a little coarse jihada with ji-nie and mixed with masame-hada. In any case, the shinogiji becomes masame-hada. O-hada known as "tekogane" usually appears in the area 6 to 9 cm above the habaki area. The tekogane looks dark and plain. In the part of hamon where the tekogane appears, the hamon is sometimes partly obscured.

Hamon: Yakidashi starts with suguha or ko-midare. The hamon is wide and consists of vigorous nie. Continuous gunome known as "juzuba" is characteristic of Kotetsu; this is based on hiro-suguha or o-notare, and has thick gunome ashi. The hamon consists of thick and very bright nie nioi. Among Kotetsu's early works there is o-gunome which is inclined to be hako midare, or in which the hamon is mixed with togari-ba and oriented toward the Mino tradition.

Boshi: Ko-midare with gunome ashi and, at the top, ko-maru agari (Kyo-boshi) or a slightly tapered tip. This is called the "Kotetsu boshi"; its yakihaba suddenly becomes narrow just above the yokote, then shifts to ko-maru agari boshi and turns back beautifully.

Horimono: Hi and horimono are comparatively few, but are very skillfully engraved. When a blade has horimono, there is usually an inscription on the nakago such as "Hori do saku" (彫同作) (Engraved by the swordsmith). Kotetsu favored engraving ryu (dragon), as well as, Fudo Myoo, Horaisan, ken with sanko, suken, bonji, etc. Also ukibori (embossing) in the hi or the hitsu and ranma sukashi (pierced horimono) can be seen.

Nakago: In his early years, steep ha agari kurijiri like ken-gyo; it becomes gentle kurijiri in later years. The shinogi line is very crisp and the yasurime are well-ordered katte sagari. The signature is skillfully chiseled in different styles in different periods; "hako (block style) tora" (or "kaku tora") and "hane (jumping) tora". (Tora [虎] is an alternate reading of the first character of Kotetsu's name, and means "tiger.")

The Hojoji (法城寺) school

The Hojoji school is thought to have descended from the smith Hojoji Kunimitsu, one of the Sadamune Santetsu (Sadamune's three excellent students). Masahiro (正弘) moved from Tajima province to Edo and founded the school, which was one of the most prosperous during Shinto times. The school includes Sadakuni (貞国), Yoshitsugu (吉次), Masanori (正則), Masateru (正照), Kunimitsu (国光), and Kunimasa (国正). It is difficult to discern any individual characteristics in their work. Their style of workmanship suggests that these smiths may have had some connection with the Kotetsu school.

Sugata: The blade has a shallow sori, a tapering mihaba and a relatively gentle Kanbun Shinto sugata.

Jihada: The jigane is clear but somewhat hard. The jihada is a ko-mokume hada mixed with masame-hada with ji-nie. Masame-hada appears in the shinogiji. Muneyaki can be seen at times.

Hamon: Consists of slightly sparse nie. Hiro-suguha or o-notare with gunome ashi. In this school the amount of gunome ashi far exceeds that of the Kotetsu school, and gives the hamon a crowded look. There are also examples of chu-suguha mixed with gunome, gunome midare, and notare midare.

Boshi: Midare komi in a small pattern shifts to ko-maru and turns back, or is suguha which changes to ko-maru and turns back.

Horimono: Bo-bi and futasuji-bi can be seen, but horimono are rarely seen.

Nakago: Gentle iriyamagata, katte sagari.

Many blades have saidan kiritsuke mei in kin zogan on the nakago.

The Yasusada (安定) school

Yamato no Kami Yasusada (大和守安定) is thought to have been from Echizen province and to have learned swordmaking from Yasutsugu, but this has not been confirmed. He was most active between the years 1658 and 1672. His workmanship is similar in some ways to that of Kotetsu, Kaneshige, and Masahiro. Other smiths of this school include Yasunao (安直) and Yasutomo (安倫), who collaborated on making swords with the lord of Rikuzen province, Date Tsunamune (伊達綱宗).

Sugata: A shallow sori, a wide and tapering mihaba, and chu-kissaki. Occasionally the nagasa is longer than those of other smiths working at this same time.

Jihada: The jigane is hard and the jihada is a coarse mokume-hada with ji-nie. Masame-hada is noticeable in the shinogiji.

Hamon: In nie deki, but the nie is not as bright, even, or round as that of Kotetsu. There are not many gunome ashi. O-midare mixed with choji midare, togari-ba, and stiff midare. Suguha consisting of tight nioi can be seen among the work of Yasutomo.

Boshi: Suguha and ko-maru; it occasionally looks like Kotetsu boshi.

Horimono: In addition to bo-bi, there are ken-maki-ryu (kurikara) and bonji.

Nakago: A tapering nakago, very gentle ha agari kurijiri and sujikai yasuri.

The Edo Ishido (江戸石堂) school

The smiths of the Ishido school who lived in Omi province moved to and prospered in various locales during the early Shinto period. Among these, one group, led by Musashi Daijo Korekazu, moved to Edo and was called the Edo Ishido school. It includes the following smiths: Tsushima no Kami Tsunemitsu (対馬守常光), Heki Dewa no Kami Mitsuhira (日置出羽守光平), and Echizen no Kami Munehiro (越前守宗弘). This group was good at choji midare in the Bizen tradition, and its masterpieces remind one of Ichimonji blades. Their style of workmanship was handed down to later generations through the end of the Edo period.

Sugata: Tanto are rare, and shinogi-zukuri katana and wakizashi are the main areas of production. The elegant sugata is often reminiscent of old Koto work.

Jihada: The jigane is slightly weak. The jihada is mokume-hada mixed with o-hada which tends to be masame-hada, and is not readily visible. The utsuri looks like early Bizen at a glance, but the jigane is whitish on the whole and masame-hada appears in the shinogiji, differentiating it from early Bizen blades.

Hamon: The width of the hamon varies, and there is no Shinto yakidashi. O-choji midare or saka choji midare with long nioi ashi in nioi deki; some midare occasionally reach the shinogi as the width increases from the middle through the monouchi area. The pattern is smaller, and the nioi-guchi tighter, than in the Ichimonji or the early Osafune schools.

Boshi: Midare komi and ko-maru; turns back. Inferior in terms of skill to the Ichimonji and the early Osafune schools.

Nakago: The tip is ha agari kurijiri or kurijiri, and the yasurime are katte sagari or sujikai.

The Shitahara (下原) school

Founded at the end of the Muromachi period, the Shitahara school did not produce any very distinguished smiths, but seems to have produced large numbers of swords during the Edo period. Yasushige (康重), Terushige (照重), and Musashi Taro Yasukuni (武蔵太郎安国) are relatively well-known members of the school who, on the whole, continued working in the Koto style. Picturesque hamon like Mino-den Kanemoto-style sanbon-sugi from the mid-Edo period, or sudare-ba and Mount Fuji, can be seen in their work. They were skillful at engraving horimono. The nakago is a tanagobara-gata

similar to that of Muramasa, with a kurijiri tip and kiri or katte sagari yasurime.

ECHIZEN (越前) PROVINCE

Fukui, the center of Echizen province, was called Kitanosho until 1624, when Matsudaira Tadamasa became lord of Echizen province. After Oda Nobunaga conquered Echizen province, he sent Shibata Katsuie, one of his direct retainers, there to build a castle and construct a castle town around it. Fukui soon became the most prosperous city of the Hokuriku district. No smiths worked there in the Koto period except Chiyozuru Kuniyasu and his school. During Shinto times, however, many smiths moved there from Omi, Yamashiro, Mino, and other areas, producing enough swords to meet the increasing demand.

The Yasutsugu (康継) and Echizen Seki schools are the major groups of the region. The Yasutsugu school split into two family branches, centered in Edo and in Echizen province, but there are few noticeable differences in their work. The following smiths are also relatively well known: Yamashiro no Kami Kunikiyo (山城守国清) of the Horikawa Kunihiro school, Yamato Daijo Masanori (大和大掾正則) (descended from Sanjo Yoshinori, of Yamashiro), and Harima Daijo Shigetaka (播磨大掾重高) (there were many generations of smiths using this name up to the Shinshin-to period).

The Echizen Seki (越前関) school

Many swordsmiths moved to Echizen from Seki, in Mino province, and they were very active during the years 1658 through 1680. Their work reflects the Shinto tokuden tradition that was in fashion at the time, as well as their original Mino tradition. These smiths include Kanetane (兼植), Kanenori (兼則), Kanenori (兼法), Kanemasa (兼正), Kanetoshi (兼利), Kanetaka (兼高), Tsuguhiro (継広), Hirotaka (汎隆), Yoshitane (義植), and Kanenori (包則).

Sugata: The blade has a rustic sugata. Hirazukuri sunnobi tanto in the Enbun-Joji style of the mid-Nanbokucho period are seen.

Jihada: The jigane is hard, and the jihada is mokume-hada mixed with masame-hada. Masame-hada is noticeable in the shinogiji. Muneyaki can be seen at times.

Hamon: The hamon is wide and consists of uneven nie, but is inclined to be nioi deki. There are o-midare, notare midare, o-gunome midare, hiro-suguha with ashi, chu-suguha consisting of tight nioi, hitatsura, etc. Midareba is invariably mixed with rough midare.

Boshi: The tip is inclined to be tapered and the kaeri is long.

Horimono: Often engraved on sunnobi tanto. Skillful ranma sukashi (pierced carving) may be seen.

Nakago: Features of the nakago are identical to those of the Yasutsugu school in general.

KAGA (加賀) PROVINCE

Kanazawa no Sho, the economic, political, and cultural center of Kaga province, developed during the Azuchi Momoyama period as the main temple town of the Ikko-shu (an aggressively evangelistic sect of Buddhism), and was taken over by Oda Nobunaga in 1580. Three years later, Maeda Toshiie, who was one of Oda Nobunaga's direct retainers, moved there and began to build a castle town. The Fujishima school had already started to produce swords in the area in Koto times. Two schools, the Darani and the Kiyomitsu (清光), both of which are related to the Fujishima school, were active during Shinto times. The Kaga Seki school, represented by Kanewaka (兼若), is still another school from the area that should not be overlooked.

The Kanewaka (兼若) school

The first Kanewaka was a son of Yomosuke Kanewaka of Seki, in Mino, and moved to Kaga from Inuyama in Owari province. He was active from the late 1590s until about 1625. Early on, he used the name Kanewaka, changing it later to Takahira after he was

given the title Etchu no Kami. By mid-Edo, several generations had succeeded to the name Kanehira. Other smiths of this school are Kagehira (景平), Arihira (有平), and Hachimanyama Kiyohira (八幡山清平) (who later moved to Odawara, in Sagami province).

Sugata: The katana of the first-generation Kanewaka has a shallow sori, a wide mihaba and o-kissaki, and the tanto is in the Enbun-Joji style and has a relatively long nagasa or sunnobi, saki-zori, a wide mihaba, and thick kasane. There are also more standard tanto which have josun, uchi-zori, and thick kasane. The katana of Takahira has chu-kissaki and standard, tapering mihaba; this sugata was also adopted by his followers.

Jihada: Mokume-hada mixed with masame-hada with ji-nie.

Hamon: O-notare midare and o-gunome midare with wide hamon and whose gunome tend to be hako midare. Thick sunagashi can be seen in the tani, and the hamon is occasionally mixed with rough and pointed midare. There is also a hamon of suguha-choji midare with gunome ashi and a good deal of hataraki.

Boshi: The boshi is midare komi in a small pattern, ko-maru and turn-back. Mishina boshi can be seen at times. Standard ko-maru boshi becomes common beginning with the second generation.

Horimono: Bo-bi and futasugibi can be seen. The first generation skillfully engraves such horimono as ken, goma-hashi, ken-maki-ryu in the hitsu, sho chiku bai (pine tree, bamboo, and plum tree), Santai Butsu (Three Buddhas), etc. But the later generations rarely produce horimono.

Nakago: A relatively gentle kurijiri. The yasurime are sujikai or katte sagari.

HIZEN (肥前) PROVINCE

Hizen province was more or less under the control of Todaiji temple after the Kamakura period. In the Sengoku period, the Ryuzoji clan of Saga tried to expand its influence, but the province was divided and given to the Nabeshima, Omura, Matsuura, and Goto domains by Toyotomi Hideyoshi following his conquest of Kyushu. Of these, the Nabeshima family domain was the biggest and most powerful, and, even under the reign of the Tokugawas, was able to maintain its huge landholdings assessed at 350,000 koku of annual rice production (the koku was a unit of dry measure equivalent to about five US bushels). The clan played a very important part in the Meiji Restoration as one of the country's richest feudal families, their wealth being the result of their tremendously successful participation in the industrial and financial innovations of the late Edo period.

During Koto times, only the Hirado Sa school, dating from the Nanbokucho period was active in the province. But the importance of Hizen blades was established in early Shinto times, with the appearance of Tadayoshi (忠吉). Hizen blades of this period display a unique style of workmanship; a number of swords, including many masterpieces, are extant.

The jihada is a dense ko-mokume hada known as konuka-hada. Plain, dark spots called sumigane, resembling those seen in the work of Enju and Aoe, appear here and there, and are one of the characteristic features of Hizen swords.

Although there are some blades with an o-midare hamon, the chu-suguha temper line, consisting of Yamashiro-tradition nie, is undoubtedly a Hizen speciality. It is often noted in sword appraisal meetings that a sword might possibly be an example of the work of the Hizen Tadayoshi school with a Shinto blade of chu-suguha consisting of ko-nie. The so-called "Hizen boshi" has a uniform width from the yokote to the tip, and is a standard ko-maru boshi.

The Tadayoshi (忠吉) school
Hashimoto Shinzaemon Tadayoshi (橋本新左衛門忠吉), the first generation of this family of swordsmiths, went to Kyoto in 1596, where he studied under Umetada Myoju. He returned

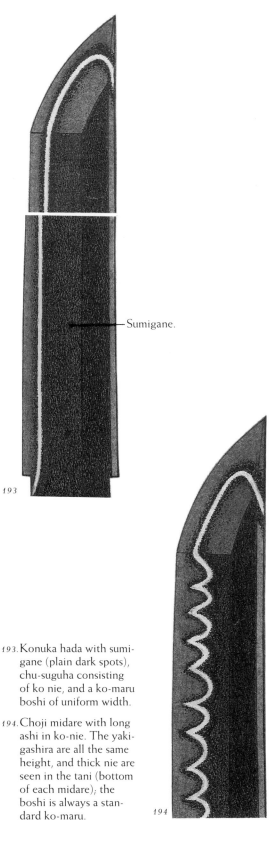

—Sumigane.

193

193. Konuka hada with sumi-
gane (plain dark spots),
chu-suguha consisting
of ko nie, and a ko-maru
boshi of uniform width.

194. Choji midare with long
ashi in ko-nie. The yaki-
gashira are all the same
height, and thick nie are
seen in the tani (bottom
of each midare); the
boshi is always a stan-
dard ko-maru.

194

to Hizen after completing as a three-year
apprenticeship, and lived in the castle town
of Saga, where he was employed by the
Nabeshima clan. He was later awarded the
title of Musashi Daijo and changed his name
to Tadahiro.

The Tadayoshi family prospered through-
out the Edo period. Omi Daijo Tadahiro (近江
大掾忠広) was the second generation. The
third, Mutsu Daijo Tadayoshi (忠吉), was later
awarded the title of Mutsu no Kami. The fourth
was Omi Daijo Tadayoshi (近江大掾忠吉); the
fifth-, sixth- and seventh-generation smiths
were all named Omi no Kami Tadayoshi (近江
守忠吉), while the eighth received no title of
any sort. Ninth-generation Tadayoshi (忠吉)
had to face the problems caused by the Impe-
rial Ordinance of 1876, which banned the
wearing of swords by anyone but police and
servicemen, and in fact had no choice but to
give up swordmaking. The Tadayoshi are clas-
sified from the sixth generation as Shinshinto
smiths. In addition, Tosa no Kami Tadayoshi
(土佐守忠吉), Kawachi Daijo Masahiro (河内大
掾正広), Dewa no Kami Yukihiro (出羽守行広),
Iyo no Jo Munetsugu (伊予掾宗次), and Hari-
ma Daijo Tadakuni (播磨大掾忠国) were well-
known, skillful smiths of the Tadayoshi school.

Sugata: Among the early works of the first-
generation Tadayoshi, o-suriage sugata mod-
eled on the Nanbokucho style can be seen. But
other Hizen-to generally have a deep sori that
is very unusual in Shinto times, as well as a
wide mihaba and grand sugata. Wakizashi
have relatively wide mihaba also.

Jihada: In the early years of the first-genera-
tion Tadayoshi, the jihada is slightly coarse
and loose ko-mokume hada mixed with o-hada,
but it becomes dense and fine ko-mokume
hada with ji-nie and chikei from the end of
the Keicho era. This later jihada is called
konuka-hada, and is characteristic of Hizen-to.

Hamon: O-midare, gunome midare, and
notare midare in nie deki in the early years of
the first Tadayoshi tend to be similar to the
Mino tradition; at times in these early years,

he models his work after that of Shizu Kaneuji. Later, the hamon becomes chu-suguha in nie deki, nioi-guchi is bright, and decent, relatively fine nie can be seen in the habuchi (the border between the ji and the ha). After receiving the title Musashi Daijo Tadahiro (武蔵大掾忠広), he favoured o-midare and o-choji midare. He has several unusual hamon, one of which is called "ashi naga choji" (choji midare with long ashi and nie), and the other of which consists of notare and twined gunome choji whose yakigashira is inclined to be square. Whenever midaraeba are present, many sunagashi can be seen in the tani. Other smiths of this school also favor chu-suguha followed by o-midare, notare midare, choji midare, and gunome midare; but these smiths are not equal to the first-, second- or third-generation Tadayoshi in terms of quality or quantity of nie.

Boshi: The yakihaba is regular, from the yokote to the tip, and the boshi is a standard ko-maru boshi.

Horimono: In this school, horimono is usually engraved by experts like Munenaga, Yoshinaga, and Tadanaga. There are various designs, including ryu, bonji, suken, Fudo Myoo, etc.

Nakago: The tip is a relatively narrow kurijiri, ken-gyo, or iriyamagata. The yasurime of the main family of the Tadayoshi school (excluding the first generation) are kiri, but they also tend to slope downward to the left (in a very gentle katte agari). Others' yasurime generally become sujikai. The yasurime of the second Iyo no Jo Munetsugu are exceptionally sake sujikai. The first Tadayoshi's signature "Hizen (no) kuni Tadayoshi (肥前国忠吉)" is called "Goji ("five characters") Tadayoshi" because the signature is written in five characters; he is also alternatively called "Shugan Mei" because a Zen priest named Shugan is said to have instructed him in writing style. Signatures inscribed with phrases like "Hizen (no) kuni junin Tadayoshi (肥前国住人忠吉; resident of Hizen, Tadayoshi)" are known as "Junin Tadayoshi" (resident Tadayoshi). It must also be noted that some later generations used the name Tadayoshi in their signatures, such as Tosa no kami Tadayoshi (土佐守忠吉; Tadayoshi of Tosa), the fourth, fifth, sixth, and ninth Tadayoshi. Hizen smiths always inscribe their signature in the tachi mei (in the case of katana) except for Iyo no Jo Munetsugu.

SATSUMA (薩摩) PROVINCE

Satsuma province was under the reign of the Shimazu clan. The clan was originally appointed as lords of the area by Minamoto Yoritomo, head of the first shogunate government of Japan, and its members served in that capacity from the end of the twelfth century through the Meiji Restoration in 1867. During the Sengoku period, they extended their influence over the island of Kyushu, and more than half the island was in their hands when they reached the height of their powers. They finally yielded to Toyotomi Hideyoshi, however, when he sent his invincible forces to the island. As a result, their vast estate was reduced to Satsuma province. In the battle of Sekigahara, they were on the side of the Toyotomi family against the Tokugawa, and they were fortunate in being allowed to keep their previous holdings despite their defeat. In 1604, the clan built a castle at Kagoshima, the capital of the province. Satsuma province is located at the extreme southern end of the Japanese archipelago. Though far from the country's administrative and political center, the people of the Satsuma area played an important role in the Meiji Restoration by fostering economic and military growth through foreign trade (illegal in the days of the Tokugawa shogunate, and strictly controlled by the government), and by making many different kinds of domestic and political innovations.

In Koto times, the Naminohira school had a long history of sword production. In Shinto times, however, Maruta Bingo no Kami Ujifusa (丸田備後守氏房), a student of Wakasa no Kami Ujifusa of Mino province, moved to the area and became the founder of the Satsuma Shinto smiths. His second son was Izu no Kami Masafusa (伊豆守正房), known as a skillful smith, as was also the third head of the family,

Maruta Sozaemon Masafusa (丸田惣左衛門正房). Mondo no Sho Masakiyo (主水正正清) was the third of Masafusa's students. Ichinohira Yasusada (一平安貞) was a student of Izu no Kami Masafusa, and Ichinohira Yasuyo (主馬首一平安代) was Yasusada's son. Meanwhile, Yasuchika (安周) and Yasukuni (安国) of the Naminohira school were also active during the mid-Edo period. Generally speaking, there was little demand for swords in mid-Edo, which was a long period of peace. But Satsuma smiths remained active and continued to hand down their traditions, even through this relatively dark time for swordsmiths. Their prosperity continued through the Shinshinto period, at which time they established a unique Soshu tradition.

The grand sugata of the Keicho Shinto style remained an integral part of the Satsuma tradition throughout the Edo period, despite rapidly changing fashions. The Keicho-Shinto–style jigane is densely forged, but weak. Black lines similar to chikei, but thicker and longer, appear in the ji. A snaking line sometimes runs continuously from the bottom to the top of the blade; this is known as Satsuma gane.

Satsuma yakidashi, like Koto blades, start with midare. Some Mino influence is also retained. The hamon is the beautiful and flamboyant Soshu-den o-midare, and consists of ara- (rough) nie mixed with togari-ba that is inclined to be nie kuzure. Even when temper lines are notare midare and hiro-suguha, there are many ara-nie. There is no clear nioi-guchi in the border between the ji and the ha because the nie in the hamon is ji-nie, so that it is hard to distinguish between the ha-nie and the ji-nie. Thick inazuma appear in the habuchi and inside the hamon. These are known as "imozuru" (potato runners), and this is an important feature in determining which are Satsuma blades.

Sugata: The blade has a shallow sori, a wide mihaba, relatively large kissaki, and grand sugata. Occasionally, very long swords may be seen. Shinogi-zukuri wakizashi also have a grand sugata with wide mihaba. There are a few tanto, which have full hira-niku and thick kasane.

Jihada: The jigane is densely forged and clear. The jihada is mokume-hada with Satsuma gane and abundant ji-nie, but is not readily visible.

Hamon: The width of the hamon varies. Yakidashi starts with ko-midare, and the width increases toward the top. Togari-ba consisting of nie can be seen in some spots. Nie in the habuchi are rougher than those inside the hamon. There are many hataraki, including sunagashi, kinsuji, inazuma, and, of course, imozuru. There are gunome midare, o-midare, chu-suguha, and hiro-suguha. The Masakiyo school is good at midareba, and the Yasuyo school favors hiro-suguha.

195

The jigane is mixed with dark lines known as Satsuma gane. The yakidashi starts with midare, and the hamon is o-midare of rough nie mixed with togari-ba inclined to be nie kuzure. The boshi is ko-midare, kaen with nie kuzure, or hakikake with a rounded tip.

Imozuru. —

Satsuma gane. —

196. The jigane is weak and not readily visible. Ji-nie and nie in the habuchi are rough. *197.* The hamon is mixed with togari-ba consisting of nie, because of the influence of the Mino tradition. *198.* Satsuma gane in the ji and imozuru in the habuchi are the most distinctive features of Satsuma blades.

Boshi: Midare komi in a small pattern. Kaen with nie kuzure or hakikake with a round tip. The yakihaba is narrow in comparison to the hamon.

Horimono: Bo-bi can be seen but horimono are rare.

Nakago: Funagata with a bulging edge. Nakagojiri is generally iriyamagata, and yasurime sujikai or katte sagari. In the Ichinohira Yasuyo school, the nakago has a standard shape

but the bulge on the edge makes the tip become rounded kurijiri, and the yasurime are katte sagari. Yasuyo and Masakiyo were selected to take part in a swordmaking contest sponsored by the eighth shogun, Tokugawa Yoshimune, and they were allowed to use the Ichi-yo-Aoi Mon (a single leaf of hollyhock; the aoi mon is the Tokugawa family's crest) on their blades, followed by their signatures.

In addition to the seven main Japanese castle towns, there were many other locales to which swordsmiths moved during the Shinto period, founding new schools and establishing their own styles. The leading schools are described below.

OSHU (奥州) DISTRICT

(Mutsu, Rikuchu, Rikuzen, Ugo, Uzen, Iwashiro, and Iwaki provinces)
The Kunikane school of Sendai, in Rikuchu province, was the largest school in Oshu. Another school in Sendai was founded by Yasutomo (仙台安倫), who studied with Yamato no Kami Yasusada and was employed by the Date clan. The Miyoshi Nagamichi and Kanesada schools were in Aizu, Iwashiro province.

The Sendai Kunikane (仙台国包) school
The first generation of this school called himself a successor of the Hosho Sadayoshi school of Yamato province. He was employed by the Date family, who were the lords of Rikuzen province. By order of Date Masamune, he studied swordsmithing twice under Etchu no Kami Masatoshi of Kyoto, once during the Keicho era and once more during the Genna era. Accorded the title of Yamashiro Daijo, he changed his name to Nintaku Yoe (also read Yokei) upon Masamune's death and, after that time, signed his blades Yoe (or Yokei) Kunikane (用恵国包). The second-generation smith's name was Yamashiro no Kami Kunikane (山城守国包), and his name was used by successive generations through the end of the Edo period. These successors followed the first-generation Kunikane's example in making masame-hada

jihada and suguha hamon in the style of the Yamato-den, but later-generation smiths never equaled the skill of the school's founder.

Sugata: Adopting the Yamato style of Koto blades, the blade has high shinogi, wide shinogiji, a tapering mihaba, and ko-kissaki or chu-kissaki, but shallow sori.

Jihada: The uniform, dense masame-hada with ji-nie is beautiful. In later generations, the jigane loses its oiliness and the masame hada becomes more readily visible.

Hamon: Chu-suguha hotsure with relatively narrow yakihaba in nie deki. There are many hataraki, such as uchinoke and nijuba. Gunome midare consisting of abundant nie with hataraki can be seen at times.

Boshi: Hakikake and yakitsume, but in later generations the boshi has kaeri.

Horimono: Bo-bi and futasuji-bi; horimono are rare, although bonji are occasionally seen.

Nakago: Relatively long, and tapering nakago with gentle kurijiri. The yasurime is sujikai.

The Miyoshi Nagamichi (三善長道) school

Nagamichi (長道) was the grandson of Nagakuni (長国) of Matsuyama (Iyo province); his father Masanaga (政長) moved to Aizu (Iwashiro province), where Nagamichi was born. In his early years he referred to himself as Michinaga, then changed his smith name to Nagamichi when he was accorded the title Mutsu Daijo in 1658. The name Nagamichi was then handed down to subsequent generations until the end of the Edo period. Of this school, Michitoki (道辰) was one of the best known and most skillful smiths.

Sugata: A stout sugata, a shallow sori, a relatively short nagasa, and a tapering mihaba. Tanto and wakizashi of shobu-zukuri and kanmuri-otoshi-zukuri can be seen at times among the blades of Nagakuni and Masanaga.

Jihada: The jigane is clear but hard. The jihada is ko-mokume hada mixed with masame-hada and with ji-nie; masame-hada is especially noticeable in the shinogiji.

Hamon: The yakihaba is wide. Gunome midare or o-midare with gunome ashi are nie deki. There is o-midare with abundant nie that resembles toran-midare, but some of the midare are inclined to be tapered. Nie are not distributed evenly from the bottom to the top. Choji midare in nioi deki tends to be slanted, and is mixed with togari-ba. Chu-suguha consisting of tight nioi is also found.

Boshi: Ko-midare and ko-maru. The tip creeps up toward the munesaki.

Horimono: Bo-bi with kaku-dome or maru-dome can be seen above the machi.

Nakago: Generally the tip is kurijiri, and the yasurime is kiri or katte sagari. The nakagojiri of Masanaga becomes iriyamagata, and that of Michitoki is an unusual ha agari kurijiri.

The Aizu Kanesada (会津兼定) school

In early Shinto times, Kanesada (兼定) of Mino province moved to Aizu (in Iwashiro province), where he was employed by the Gamo clan. His family was prosperous, and lasted for eleven generations, through Izumi no Kami Kanesada of Shinshinto times. The jihada is mokume-hada mixed with masame-hada. The hamon is suguha and gunome midare in nie deki, but the nioi-guchi is not very bright. The boshi is ko-maru. The nakagojiri is iriyamagata that resembles kengyo, and the yasurime is kiri.

SAGAMI (相模) PROVINCE

Sagami province was the birthplace of the Soshu tradition and home to many master smiths from the late Kamakura through the Nanbokucho periods. Even during the Muromachi period, many smiths were still active in Sagami, but by the beginning of the Edo period, the Tsunahiro school was the only group still recognized in the province.

The Tsunahiro (綱広) school

It is said that Masahiro, who was active at the end of the Muromachi period, was given the

character "tsuna" (綱) by the daimyo Hoji Ujiyasu; he changed his name to Tsunahiro, and founded the school that bears his name. The name Tsunahiro was used by successive generations of smiths through the end of the Edo period. Among these, Tsunahiro of the Keicho era and Ise Daijo Tsunahiro (伊勢大掾綱広) of the Manji era were considered skillful. The Soshu tradition is not particularly evident in their workmanship.

Sugata: Blades produced prior to the Kan'ei era (1624–44) have wide mihaba and larger kissaki, while blades made after this period have shallow sori, shorter nagasa, and smaller kissaki.

Jihada: The jigane is somewhat hard. The jihada is dense mokume-hada, or occasionally mokume-hada mixed with black, shiny o-hada.

Hamon: A wide hamon, in nie deki but with few nie. Notare based on hiro-suguha or o-midare with thick sunagashi in the habuchi. Hitatsura in nioi deki appears in blades of the Keicho era.

Boshi: Ko-maru is common, and occasionally midare komi or ichimai is seen. The kaeri is usually long.

Horimono: Occasionally Fudo Myoo, bonji, etc.

Nakago: The tip is a gentle kurijiri or iriyama-gata. The yasurime are usually kiri.

MINO (美濃) PROVINCE

This province, together with Bizen, was pre-eminent in sword production during Koto times. In the Nanbokucho period, Shizu Kaneuji was active in the province, and at the end of the Muromachi period, works of Kanesada, Magoroku Kanemoto, and others helped to enhance the reputation of Mino blades. But the work of their followers centered in the province during Shinto times is surprisingly dull. The Kanesada (兼定) and the Kanemoto (兼元) families continued to produce swords in the area until the end of the

Edo period. The leading Mino smiths were Kaneari (兼住), Shinano no Kami Daido (信濃守大道) (or Omichi), Tashiro Gen'ichi Kanenobu (田代源一兼信), Gen'ichi Kanemoto (源一兼元), Sanami Kanetaka (三阿弥兼高), Omi no Kami Kiyonobu (近江守清宣), Suruga no Kami Morimichi (駿河守盛道), Jumyo (寿命), Tanba no Kami Terukado (丹波守照門), Musashi no Kami Yoshikado (武蔵守吉門) (who later moved to Mito in Hitachi province), and others. They succeeded to the workmanship of Sue-Seki smiths, but were not equal to either Kanesada or Kanemoto of Koto times. Mutsu no Kami Daido was a relatively skillful smith, and his workmanship is reminiscent of that of Naoe Shizu.

Nonetheless, the tradition of the province was highly esteemed, and many Mino smiths moved to various other locales, where they established new Shinto schools. Founders and schools in this tradition include Masatsune, Nobutaka, and Ujifusa of Owari province; the Mishina school of Yamashiro province; Kanesada of Iwashiro province; Kanewaka of Kaga province; Kanenori, Kanenori, and Kanetaka of Echizen province; Takatenjin Kaneaki of Totomi province; and Hachiya Kanesada of Suruga province.

OWARI (尾張) PROVINCE

Early in Shinto times, a number of smiths moved to Owari province from neighboring Mino, and began to produce swords under the patronage of the daimyo there. These smiths are known as Owari Seki, and adopted a style of workmanship slightly different from that of their native province. Of these, Sagami no Kami Masatsune (相模守政常), Hida no Kami Ujifusa (飛騨守氏房) and Hoki no Kami Nobutaka (伯耆守信高) were skillful, and their families flourished through generation after generation.

During the Daiei era (1521–1527), the Imagawa clan built a castle in Nagoya, but the castle was abandoned by Oda Nobunaga after his defeat of the Imagawa clan. Afterward Tokugawa Ieyasu began building a new castle there, completing it in 1614. From that time

on, Nagoya continued to develop both as a castle town and as the capital city of Owari province.

The Sagami no Kami Masatsune (相模守政常) school

Masatsune (政常) learned swordmaking from Seki Kanetsune. In his early years he used the name Kanetsune, and changed it later to Masatsune. He was accorded the title Sagami no Kami at the end of the Tensho era. He resumed sword production following the untimely death of his successor, who had also used the name Sagami no Kami Masatsune (相模守政常), at that time adding the word "Nyudo" (入道) (lay priest) to his signature. He had moved from Seki to Komaki and Kiyosu, and finally settled in Nagoya in 1610. The third-generation successor was Mino no Kami Masatsune (美濃守政常), who was the son of Mutsu no Kami Daido, and was later adopted by Masatsune I. The fourth-generation smith was also called Mino no Kami. The name of Masatsune was used in successive generations until the end of the Edo period.

Sugata: The katana has a small, slender mihaba and relatively small chu-kissaki. The shinogi-zukuri wakizashi has a wide mihaba, a relatively deep sori, and relatively large chu-kissaki. There are hira-zukuri ko-wakizashi with wide mihaba, and tanto without sori and with a nagasa of about 27 cm. In later generations, the kasane becomes thicker, and kanmuri-otoshi-zukuri are seen. These smiths also produced many fine yari, naginata, and kogatana.

Jihada: The jigane is clear, and the jihada a dense ko-mokume hada with ji-nie. The jigane is sometimes a little hard, and the jihada a coarse mokume-hada mixed with masame-hada.

Hamon: Each generation was good at suguha; some of these resemble those of the Rai school. The first and second generations usually mixed suguha with notare. There are also hiro-suguha in nie deki, chu-suguha consisting of tight nioi, squarish notare mixed with togari-ba, and sanbon-sugi.

Boshi: The tip of the ko-maru boshi is inclined to be tapered.

Horimono: There are various hi and elaborate horimono.

Nakago: The mune usually becomes kaku (square, or flat) and the tip is kurijiri. The yasurime of the first generation is a fine, gentle sujikai, and becomes a crisp sujikai with later generations.

The Hida no Kami Ujifusa (飛驒守氏房) school

Ujifusa (氏房) was the son of Kawamura Wakasa no Kami Ujifusa of Mino province. He went to Kyoto with Masatsune to receive the title Hida no Kami. He was employed by Fukushima Masanori, Matsudaira Tadayoshi, and Tokugawa Yoshinao, and finally moved to Nagoya. The second generation of this school was Bizen no Kami Ujifusa (備前守氏房), who was succeeded by his son, Hida no Kami Ujifusa (飛驒守氏房). The name of Ujifusa was used through generation after generation.

Sugata: Keicho Shinto sugata with a wide mihaba and shallow sori is common; occasionally blades have noticeable saki-zori. Tanto are rare.

Jihada: Coarse mokume-hada mixed with masame-hada, or a relatively dense jihada that has slightly whitish jigane.

Hamon: Notare mixed with gunome similar to Shizu Kaneuji, or gunome choji and o-notare reminiscent of Kanesada of the Sue-Seki school. The hamon consists of bright nie and has hataraki.

Boshi: Midare komi and ko-maru with hakikake and long kaeri, midare komi with a tapered tip, or a descended boshi with a very wide yakihaba that looks like ichimai, etc.

Horimono: Bo-bi or futasuji-bi can sometimes be seen.

Nakago: The tip is a gentle kurijiri which looks like iriyamagata. The yasurime is sujikai or katte sagari. The shape and file marks are skillfully done.

The Hoki no Kami Nobutaka (伯耆守信高) school

The first generation of this school was a member of the San-Ami Kanenori school of Mino province, was accorded the title Hoki no Kami, and then moved to Nagoya from Kiyosu at the end of the Keicho era (1596–1615). The second and third generations were also titled Hoki no Kami. The name Nobutaka (信高) was used by successive generations through the end of the Edo period and throughout Edo enjoyed the patronage of the Tokugawa clan of Owari province. In later generations, their workmanship became less attractive and their skill declined.

Sugata: Blades have a wide mihaba, shallow sori, and relatively large kissaki or a Keicho Shinto sugata with o-kissaki. In later generations, blades are a standard Shinto sugata with chu-kissaki.

Jihada: The jigane is hard, and the jihada a coarse ko-mokume hada mixed with masame-hada. Jihada of the later generations became clear and dense, but had few hataraki.

Hamon: O-midare, notare midare or gunome midare in nie deki mixed with ragged togari-ba. In later generations, gunome midare and suguha were common, but the nioi-guchi was dull.

Boshi: Midare komi with ko-maru toward the top, or a tapered tip and long kaeri. Ko-maru boshi are commonly seen after the first generation.

Horimono: Bo-bi may be seen on occasion.

Nakago: In the first generation, the tapered funagata with kurijiri and yasurime is katte sagari or sujikai. In contrast with that of the first generation, the nakago of later generations has a standard shape with ha agari kurijiri, and its yasurime is sujikai with kesho yasuri.

KII (紀伊) PROVINCE

In Koto times, the Iruka school and Sudo Kunitsugu engaged in sword production in this province, but by Shinto times their followers were no longer active. Several new schools appeared in the province, however, including the Nanki Shigekuni and Kishu Ishido schools.

The Nanki Shigekuni (南紀重国) school

It is said that Shigekuni (重国) originally came from the Tegai school of Yamato province. He worked for Tokugawa Ieyasu during the Keicho era, and then moved to Wakayama in Kii province, where he was employed by the Kii Tokugawa clan. He was one of the finest swordsmiths of Shinto times. Several generations of smiths of this school went by the name Shigekuni, and later generations added "Monju (文珠)" to their signatures, but the name Monju Shigekuni is customarily used to refer only to the second-generation smith.

Sugata: Blades have a proper mihaba, a shallow sori, and relatively large kissaki. High shinogi and wide shinogiji characterize his native Yamato tradition. In addition to shinogi-zukuri wakizashi, there are many hira-zukuri and katakiriha-zukuri and some u-no-kubi-zukuri, all of which have a wide mihaba, relatively thick kasane, saki-zori, and relatively long nagasa. A slightly unusual sugata can be seen in the tanto and wakizashi. Standard tanto with slender mihaba and uchi-zori are rarely seen.

Jihada: A dense mokume-hada mixed with masame-hada and with thick chikei and abundant ji-nie; coarse jihada can occasionally be seen. His jigane and jihada are more similar in quality and appearance to old Koto blades than are those of any other Shinto smiths.

Hamon: There are Yamato-tradition hamon produced in imitation of Shikkake Norinaga and others of the Soshu tradition which imitate Go Yoshihiro. The former are chu-suguha hotsure in nie deki with many hataraki such as uchinoke, hakikake, and nijuba, while the latter are o-gunome midare, o-midare, notare midare, etc., with a wide hamon, nie zake, sunagashi, and kinsuji consisting of rough nie. Among the latter, there are also o-midare and hiro-suguha with gunome ashi.

Boshi: Yakitsume or midare komi with hakikake and, toward the top, ko-maru with short kaeri.

Horimono: In addition to bo-bi and futasuji-bi, there are suken, ryu, ken-maki-ryu, etc. These horimono are very skillfully engraved, and seem to have been done by Ikeda Gonsuke Yoshiteru.

Nakago: The nakagojiri of the first-generation smith is a narrow, gentle kurijiri. Work of later generations is iriyamagata, kengyo, or kurijiri, and inclined to be tapered. The yasurime are kiri or katte sagari. Sujikai can be seen in the work of later generations. In particular, the large mekugi ana (peg hole) should be noted.

The Kishu Ishido (紀州石堂) school

The smiths of the Ishido school, which originated in Omi province, moved to Kii province during Shinto times. The founder is Tosa Shogen Tachibana Tameyasu (土佐将監橘為康), and the school includes Tameyasu II (二代為康), Bitchu no Kami Yasuhiro (備中守康広), and Yasutsuna (康綱). After the school moved to Osaka, there were no notable smiths in the province, and sword production there declined.

BIZEN (備前) PROVINCE

There is no doubt that Bizen was the most successful sword-producing province, creating the finest blades from the very earliest period through Koto times. But from the beginning of Shinto times, the number of Bizen smiths dropped off sharply, as did the number of swords produced in this tradition. There may have been several reasons for this, including the fact that Bizen smiths in general were not inclined to pay much attention to trends in public taste. But more significantly, Bizen smiths were centered in Osafune village, an area hit hard by flooding several times during the Tensho era, leveling the village; many smiths were among the casualities. The fate of Bizen smiths stands in sharp contrast to the Sue-Seki, who had dispersed over a much greater geographic area. It can be said that

dominance of what remained of the Bizen tradition shifted from the Osafune school to the Ishido school, which then spread to various locales.

The Osafune (長船) school

During the Keicho era, only a few swordsmiths, including Hikobei Sukesada (彦兵衛祐定), are recognized in Bizen province. But in the Kan'ei era Shichibei Sukesada (七兵衛祐定), who called himself the fifth-generation smith to follow Yosozaemon Sukesada, and his son Yokoyama Daijo Sukesada (横山上野大掾祐定), appeared and produced a considerable number of swords. Yosozaemon Sukesada (与三右衛門祐定) was also a skillful smith, who styled himself the descendant of Sukesada IX of the Eisho era. The workmanship of these smiths changed little for generations, until the appearance of Sukenaga and Sukekane, who created a unique kobushigata choji midare in Shinshinto times.

Sugata: Blades of the Keicho era have Keicho Shinto sugata. After the time of Kozuke Daijo Sukesada the blade has thick kasane and chu-kissaki or relatively large chu-kissaki; there are also blades with either relatively deep or shallow sori.

Jihada: The jigane is somewhat weak, and the jihada is mokume-hada mixed with o-hada. In the case of more elaborate work, the jigane is beautiful and well forged.

Hamon: Koshi-no-hiraita midare in nioi deki was produced by Koto Sukesada, but the pattern looks stiff and awkward; gunome choji and suguha can also be seen.

Boshi: Ko-midare or suguha, with ko-maru toward the top.

Horimono: Bo-bi can be seen, as can bo-bi with tsure-bi.

Nakago: Similar to that of Sue-Bizen, but longer. The tip is ha agari kurijiri. The yasurime are either kiri or katte sagari. The hira-niku is not full; in other words, the surfaces of the hiraji are almost flat.

BITCHU (備中) PROVINCE

The Aoe school, one of the largest schools active during the Kamakura and the Nanbokucho periods and famed for its Yamashiro- and Bizen-tradition blades showing unique characteristics, had almost completely disappeared by the beginning of the Oei era. It was succeeded by the Mizuta school, which adopted the Soshu Shinto tokuden traditions in its swordmaking.

The Mizuta (水田) school

A group of swordsmiths who lived in Mizuta in Bitchu province is known as the Mizuta school. Members of this school are said to be the descendants of Ko-Aoe Tametsugu and the smith Kunishige, who appeared in the Kyoroku era. Kunishige was also known as Ko-Mizuta. In Shinto times this group changed completely their style of workmanship, which had earlier resembled the styles of the Sue-Bizen and Sue-Mihara school to some extent. The leading smith of this school was Otsuki Yogoro Kunishige, also known as Oyogo Kunishige (大与五国重). The school consisted of two families; one was the Otsuki family, who used the name Kunishige for generations, while the other was Asai Mizuta, founded by Kono Rihei Tameie (河野理兵衛為家), who went by the name of Tameie. Both families flourished from the beginning of the Edo period through the Genroku era (1688–1704).

Sugata: Kanbun Shinto sugata with a tapering mihaba and shallow sori; alternatively, a grand sugata with saki-zori, a wide mihaba, and relatively large kissaki.

Jihada: Very dense ko-mokume hada which looks like muji-hada, occasionally with rough ji-nie. Muneyaki can be seen.

Hamon: The width of the hamon is not uniform. There are abundant nie in the ji and ha. The hataraki of the nie is vigorous, but the nie's size is uneven. Hitatsura and o-midare in nie deki are commonly seen, as is gunome midare mixed with togari-ba and suguha.

There are many hataraki such as sunagashi. Ha-hada (the grain inside the hamon) is visible.

Boshi: Ichimai, ko-maru, or midare komi. The kaeri usually is very long.

Horimono: Occasionally suken and bonji.

Nakago: The nakagojiri of Kunishige is katayamagata, and that of Tameie is iriyamagata. The yasurime are sujikai, but Kunishige adopts a steeper sujikai yasuri.

AKI (安芸) PROVINCE

In Koto times no important smiths were active in this province. But beginning in the Shinto era, Teruhiro (輝広) of the Umetada Myoju school moved to Aki and produced swords there.

The Teruhiro (輝広) school

It is said that Teruhiro was a follower of Kanetsune (the Sue-Seki school) of Mino province, and used two versions of the name Kanetomo (each with a different character for "tomo") during his early years. After he studied under Umetada Myoju, who is regarded as the founder of Shinto, he was employed by daimyo Fukushima Masanori and lived in Kiyosu, Owari province. He changed his name to Teruhiro when he received the title Higo no Kami. When Fukushima Masanori relocated to Hiroshima in Aki province in 1600, Kanetomo accompanied him there. After Fukushima Masanori lost his status as daimyo, Teruhiro returned to the employ of the Asano clan and continued sword production in Hiroshima. Teruhiro's successor was Harima no Kami Teruhiro (播磨守輝広), who was much more prolific than his eponym had been. Both are considered skilled smiths of the Keicho Shinto era. The name and title Harima no Kami Teruhiro (播磨守輝広) appear to have been passed down to successive generations through the end of the Edo period, but details are not known.

Sugata: A wide mihaba, somewhat thin kasane with iori-mune, a shallow sori with slight saki-zori, and relatively large chu-kissaki.

Ko-wakizashi in hira-zukuri usually has mitsu-mune, a wide mihaba, relatively thin kasane, and a sori. There are no shinogi-zukuri wakizashi by the first generation. Tanto, yari, and naginata are found.

Jihada: Mokume-hada mixed with masame-hada and with abundant ji-nie. Muneyaki can be seen at times.

Hamon: The hamon is in nie deki and of irregular width. The narrow area of the hamon is ko-gunome, and the wide area o-gunome. There is narrow ko-midare mixed with midare that is inclined to be crested. The hamon consists of vigorous and rough nie. O-notare, hiro-suguha, and chu-suguha can also be seen.

Boshi: Midare komi in a small pattern, with ko-maru near the top; the kaeri tends to creep upward toward the munesaki.

Horimono: Rarely seen among the work of the first generation. Koshibi, futasuji-bi, suken and bonji can be seen on the hira-zukuri ko-wakizashi of the second generation.

Nakago: Funagata with kurijiri. The yasurime of the first generation are sujikai or gentle katte sagari, and that of the second generation are sujikai.

CHIKUZEN (筑前) PROVINCE

Sword production in this province began relatively early in the history of the Japanese sword, and the Sa school, the Kongobei school, and the Nobukuni school were all active in the Koto era. Immediately after moving to this province in 1600, the Kuroda clan began to build a castle town in Fukuoka, and many swordsmiths gathered there under the patronage and encouragement of this clan. The Chikuzen Nobukuni school and Fukuoka Ishido school were the two major groups of this province.

The Chikuzen Nobukuni (筑前信国) school
Nobukuni Yoshisada (信国吉貞), founder of this school, is regarded as a descendant of Yamashiro Nobukuni and Tsukushi Nobukuni of the Koto era. In the Muromachi period,

smiths of the Nobukuni school lived in various locales throughout Kyushu island. Kuroda Nagamasa sent for Yoshisada, who was then living in Bizen province, and employed him; this event is considered the school's founding. Heishiro Yoshimasa (平四郎吉政), eldest son of Yoshisada, was this school's most skillful smith; he also has gained a reputation as an expert yari maker. Shigekane (重包) forged a blade in the presence of the eighth shogun, Yoshimune, at his palace, and earned the right to use a leaf of the Aoi Mon (the family crest of the Tokugawa clan) on his blades, which he subsequently added above his signature, as did Mondo no Sho Masakiyo and Ichinohira Yasuyo. The school includes Yoshitsugu (吉次), Yoshikane (吉包), Yoshisuke (吉助), Shigemune (重宗), Yoshikatsu (吉勝), and Yoshishige (吉重).

Sugata: A shallow sori, relatively thick kasane, chu-kissaki, or relatively large chu-kissaki. Tanto are rarely seen.

Jihada: The jigane is strong and the jihada is a dense mokume-hada; occasionally the jihada may be slightly coarse or o-hada mixed with mokume-hada. Muneyaki can be seen.

Hamon: The yakihaba is wide. There are o-notare, notare midare, o-midare, and hiro-suguha in nie-deki with gunome ashi and tiny sunagashi. Stiff, awkward midare are usually mixed in somewhere. Ha-hada is visible. There are tiny sunagashi. Tobiyaki can be seen just above the habuchi. In the case of Yamashiro-tradition blades in nioi deki, there are chu-suguha consisting of tight nioi and choji midare mixed with koshi-no-hiraita midare.

Boshi: Midare komi in a small pattern, with ko-maru near the top, or suguha with ko-maru near the top.

Horimono: Bo-bi, or bo-bi with tsurebi that ends in a marudome above the machi, are found. Shigekane skillfully engraved Fudo Myoo, and ken-maki-ryu (kurikara).

Nakago: Shorter nakago with kurijiri that are relatively wide or not tapered. The yasurime are kiri.

The Fukuoka Ishido (福岡石堂) **school**

It is said that Toshihide (利英), who was a descendant of the Ichimonji school of Bizen province, moved to Fukuoka with his son Koretsugu (是次) and founded this school, which became very successful. Koretsugu went to Edo and studied there under Ishido Musashi Daijo Sakon Koretsugu. He appears to have been employed by the Kuroda clan following his return from Edo. Koretsugu is the most skillful smith to work in the Bizen tradition during Shinto times, and he left many masterpieces in which clear utsuri appear. Moritsugu (守次) was also a skillful smith. Toshitsugu (利次) belongs to this school, but extant works of his are rare.

Sugata: Blades have a gentle sugata reminiscent of old Koto blades, but with a shallow sori, relatively thick kasane, and chu-kissaki. Tanto are rarely seen.

Jihada: The jigane is relatively soft. The jihada is mokume-hada mixed with o-hada, and the shinogiji is masame-hada. Utsuri appear.

Hamon: Choji midare which somewhat resembles that of the Ichimonji school, but which then becomes saka-choji midare mixed with an unusual midare shaped like a squid's head. The width of the hamon is not regular. In the narrow area, the hamon becomes ko-choji midare with ashi, and in wider areas some yakigashira (the top part of each midare) of the choji midare reach the shinogi. There are hataraki such as ashi and yo. The main differences between the Fukuoka Ishido and the Ichimonji schools are that the choji midare of the Fukuoka Ishido school is not in pure nioi deki, but tends to consist of nioi and ko-nie, the yakigashira is hard, the hamon is mixed with togari-ba, and masame-hada is noticeable in the ji.

Boshi: Midare komi, with the tip inclined to be pointed and turns back.

Horimono: Only simple horimono such as suken and bonji.

Nakago: A slightly longer nakago with roundish kurijiri. The yasurime are sujikai. The signature is very unique for its rounded writing style.

CHIKUGO (筑後) PROVINCE

Onizuka Yoshikuni (鬼塚吉国) is relatively well known among Shinto smiths from this province. In the early Edo period there were three generations of smiths working under the name Yoshikuni, and their followers revived the school at the end of the Edo period. Their work has earned a reputation for

199

Saka-choji midare of the Fukuoka Ishido school.

200

Workmanship of Onizuka Yoshikuni.

sharpness, as they emphasized practical use of the blade as a weapon in their swordmaking. Their workmanship bears some similarity to Hizen swords, but it is not their equal, particularly from an artistic point of view. The blades have a rustic sugata, a shallow sori, and thick kasane. The jigane is hard, and the jihada is ko-hada mixed with masame-hada. The hamon is chu-suguha, like that of Hizen Tadayoshi, but with fewer and lower-quality nie. The suguha usually has a knot-shaped midare in the monouchi area.

BUNGO (豊後) PROVINCE

This province produced such excellent swordsmiths as Yukihira during Koto times. In Shinto times the Takada school, founded by Tomoyuki in the Nanbokucho period, still had a good number of smiths and was thriving. Members of the school are also known as the Fujiwara Takada because most used Fujiwara (藤原) as a family name in their signatures. The school includes Yukinaga (行長), Muneyuki (統行), Munekage (統景), Shigeyuki (重行), Sadayuki (貞行), Tadayuki (忠行), Teruyuki (輝行), Yukimitsu (行光), Masayuki (正行), Kuniyuki (国行), and Toyomasa (豊政). Kawachi no Kami Motoyuki (河内守本行), who moved to Hizen province, is also known as Matsuba Motoyuki because the character "Moto" (本) which he used in later years resembles pine needles (matsuba).

Members of this school worked in a variety of traditions, from the Gokaden to the Shinto tokuden, but their blades appear to satisfy practical rather than artistic needs. The blades have a shallow sori, thick kasane and relatively small chu-kissaki. The jihada is rough and coarse mokume-hada. The hamon is in nioi deki and koshi-no-hiraita midare mixed with stiff midare and yaki-kuzure (crumbled pattern). Nie are seen sporadically. Blades are similar to those of Sue-Bizen in some ways. There are also gunome midare mixed with stiff and awkward midare in the Mino style, and chu-suguha in Yamashiro style, such as those by Hizen Tadayoshi.

ERA	PROVINCE	SWORDSMITH(S)	PATTERN
Keicho (1596–1615)	Yamashiro	Umetada Myoju (埋忠明寿)	This smith is said to have been the founder of Shinto, but extant works of his are few. Myoju has a greater reputation as a metal-worker than as a swordsmith.
			Yamashiro tradition and Shinto tokuden tradition: Very elaborate horimono are usually engraved on the blade. The jihada is ko-mokume hada with ji-nie. The hamon with narrow yakihaba consists of nie. There are chu-suguha hotsure, ko-midare, gunome midare, etc., which have many hataraki, including nie kuzure. The boshi is ko-maru.
		Horikawa Kunihiro (堀川国広)	A native of Hyuga province, he moved to Yamashiro province in his later years and spent his last days there. His career as a sword-smith began at the close of the Koto era and spanned many years. His later work includes daisaku daimei—blades made and signed by other family members or students, with the signature of their father or teacher on the nakago. Blades of this type are regarded as genuine. The workmanship is in various styles.
			Shinto tokuden tradition: The sugata is grand and elegant. The jihada is ko-mokume hada with abundant ji-nie and the shinogiji or mune side of hira-zukuri blades tends to be masame-hada. The hamon is o-gunome midare with Kyo-yakidashi, and uniform o-gunome can be seen extending from the monouchi area to the yokote line. The boshi is ko-maru agari with abundant nie.
			Yamashiro tradition: The jihada is a dense mokume-hada with hataraki. The hamon is a relatively narrow chu-sug-uha hotsure with ashi and many other hataraki. Abundant nie can be seen in the ji and the ha. The boshi is ko-maru agari.
			Soshu tradition: Keicho Shinto sugata; the ji and the ha are similar to those of Soshu Hiromitsu, Soshu Akihiro, the Samonji school, and Shizu Kaneuji. Masterpieces are reminiscent of works by master Koto smiths from Soshu province such as Yukimitsu, Masamune, and Sadamune.
			Mino tradition: This tradition can be seen in many blades made in Hyuga province in early Shinto times. The jigane is hard, and the jihada a coarse mokume-hada mixed with masame-hada. The hamon is yahazu midare, with sporadic, uneven nie. The boshi is midare komi, with a tapered tip and long kaeri.
		Dewa Daijo Kunimichi (出羽大掾国路)	A student of Kunihiro, and a skillful smith. Hi and horimono are commonly engraved on the tanto but are rarely seen on katana.
			Shinto tokuden tradition: The jihada is a dense ko-mokume hada. The hamon is based on o-notare mixed with o-gunome midare. O-gunome midare and gunome midare are also found. Pairs of gunome

201

Workmanship of Kunihiro of Horikawa, Yamashiro province (left), and Kunihiro of Hyuga province (right).

tend to meet very closely and look like a single midare. The boshi is ko-maru agari inclined to be midare komi.

Yamato tradition: The jihada is mokume-hada mixed with distinct masame-hada. The hamon is chu-suguha with uchinoke, and consists of ko-nie. The boshi is ko-maru or ko-maru agari.

Soshu tradition: Workmanship is similar to that of Kunihiro, and not at all inferior to his in quality. Dewa Daijo Kunimichi should be rated as more highly skilled than Kunihiro.

Horikawa Kuniyasu
(堀川国安)

Shinto tokuden tradition and Soshu tradition: This smith is said to be Kunihiro's younger brother. Workmanship differs little from that of Kunihiro.

202

Workmanship of Kunimichi.

Echigo no Kami Kunitomo
(越後守国儔)

Shinto tokuden tradition: A student of Kunihiro. The hamon is o-notare, hiro-suguha mixed with gunome midare or gunome midare with plentiful ashi and other hataraki. The sugata, jihada, and boshi are all very similar to Kunihiro's.

Osumi Daijo Masahiro
(大隅掾正弘)

This smith is a student of Kunihiro, and said to be the son of Kuniyasu.

Shinto tokuden tradition and Soshu tradition: The sugata resembles that seen in old Koto blades, and the nagasa is longer than that of other Keicho Shinto blades. Workmanship is in some ways similar to that of Yoshisada and Sadayoshi of the Samonji school. The jigane is beautiful, and the jihada is a mokume-hada mixed with masame-hada. The mokume-hada resembles a whirlpool. The hamon is ko-midare and tends to be tapered; its width is regular.

Heianjo Hiroyuki
(平安城弘幸)

Shinto tokuden tradition and Soshu tradition: A student of Kunihiro, he produced mainly tanto. The hamon is calm and based on suguha.

Musashi

Yasutsugu I
(初代 康継)

This smith worked in all traditions, and was skilled at copying famous Koto blades. Echizen Kinai engraved horimono expertly on his blades.

Shinto tokuden tradition: The jihada is ko-mokume hada, and masame-hada appears in the shinogiji or the mune side of a hira-zukuri blade. The hamon is o-notare or o-midare with abundant nie, but the nie tend to be uneven. Something resembling nijuba consisting of nie appears somewhere on the blade. The boshi is ko-midare, and there are wide and narrow yakihaba in

203

Yasutsugu I's suguha (left) and hitatsura (right).

ERA	PROVINCE	SWORDSMITH(S)	PATTERN
			the boshi. Occasionally a boshi is midare komi, with kaeri that creeps upward toward the munesaki.
			Yamato tradition: The jihada is coarse and masame-hada is noticeable. The hamon is hiro-suguha or suguha mixed with ko-gunome. There are many hataraki such as hakikake, uchinoke, kuichigai, and something similar to nijuba consisting of nie. The boshi is ko-maru.
			Soshu tradition: The jihada is a coarse o-mokume hada mixed with masame-hada; masame-hada is particularly evident toward the back of the blade. The hamon is o-midare, o-gunome midare, or hitatsura with sunagashi. Nie tend to be uneven. The boshi is ko-midare, and the kaeri is usually long.
	Echizen	Higo Daijo Sadakuni (肥後大掾貞国)	Said to be a student, or possibly the younger brother, of Yasutsugu I.
			Shinto tokuden tradition: Features identical to those of Yasutsugu I.
			Yamashiro tradition: The jihada is a dense ko-mokume hada mixed with masame-hada. Muneyaki can at times be seen. The hamon is chu-suguha hotsure with abundant nie. The boshi is ko-midare, with ko-maru near the top.
	Owari	Sagami no Kami Masatsune (相模守政常)	Blades with a substantial sugata, a shallow sori, wide mihaba and relatively large chu-kissaki.
			Shinto tokuden tradition: The jihada is a dense ko-mokume hada with ji-nie, and masame-hada appears toward the back of the blade. The hamon is o-notare or notare midare mixed with slightly tapered midare. The boshi is ko-maru and tends to be slightly tapered; the kaeri is long.
			Yamashiro tradition: The jihada is relatively dense, but visible ko-mokume hada and masame-hada appear toward the mune side. The hamon is a tight chu-suguha. The boshi is ko-maru and inclined to be slightly tapered; the kaeri is long.
			Yamato tradition: The jihada is ko-mokume hada mixed with masame-hada. The hamon is a tight chu-suguha, and hataraki run lengthwise along the blade.
			Mino tradition: The jigane is hard, and the jihada a coarse ko-mokume hada mixed with masame-hada. The hamon is ko-midare inclined to be tapered, and occasionally sanbon-sugi. Boshi is ko-maru but inclined to be pointed, and the kaeri is long.
		Hoki no Kami Nobutaka (伯耆守信高)	Several generations of smiths used the name Hoki no Kami Nobutaka. During this period, the blade has little sori. The jigane is hard and the jihada is a coarse ko-mokume hada mixed with masame-hada.
			Shinto tokuden tradition: The wide hamon is o-midare, and mixed with togari-ba and awkward, stiff midare. The hamon tends to be in nioi deki. The boshi is ko-maru but with a tendency toward midare, and the kaeri is long.
			Mino tradition: The hamon is o-midare mixed with stiff, awkward midare. The boshi is ko-maru or has a pointed tip, and the kaeri is long.
	Aki	Higo no Kami Teruhiro (肥後守輝広)	Blades have a stout sugata, a shallow sori, and high shinogi. There are many hira-zukuri ko-wakizashi and tanto, but few shinogi-zukuri wakizashi.

ERA	PROVINCE	SWORDSMITH(S)	PATTERN

Shinto tokuden tradition: The jihada is ko-mokume hada mixed with masame-hada with ji-nie. The width of the hamon is not regular. Gunome midare consists of tight nioi, and the pattern as a whole appears stiff and awkward. The boshi is a small-patterned midare komi, with ko-maru at the top, and the kaeri creeps up toward the munesaki.

Mino tradition: The jigane is hard, and the jihada is ko-mokume hada mixed with o-hada and masame-hada. Muneyaki can be seen. The narrow hamon is narrow ko-midare mixed with togariba. The boshi is a small-patterned midare komi, with kaeri that creeps up toward the munesaki.

	Hizen	Tadayoshi I (初代 忠吉)	This smith signed his blades with a variety of signatures, including Goji Tadayoshi, Shugan Mei, Junin Tadayoshi, Musashi Daijo Tadahiro, etc. There are slight differences in sugata of blades which he made in different periods. The horimono are engraved by Munenaga, Yoshinaga, and others of the Umetada Myoju school. The jihada is a dense ko-mokume hada known as konuka-hada, and tiny Hizen gane appear here and there.

Shinto tokuden tradition: The hamon is o-notare, o-midare, gunome midare or gunome choji, occasionally with long nioi ashi. Abundant nie can be seen in the ji and the ha. The boshi is suguha with regular yakihaba, with standard ko-maru at the top, and the kaeri tends to creep upward toward the munesaki.

Yamashiro tradition: The hamon is chu-suguha consisting of abundant nie and thick nioi. The boshi is standard ko-maru, or Hizen-boshi.

204

The kuichigai-ba and suguha with nie of Tadayoshi I.

	Kii	Nanki Shigekuni (南紀重国)	Blades have grand and elegant sugata with high shinogi that resemble those of old Koto blades. There are unusual structures in Shigekuni's tanto and ko-wakizashi. Horimono with unusual designs, and larger than those of other smiths, are typical.

Shinto tokuden tradition: The jihada is a dense mokume-hada mixed with masame-hada. The hamon is a wide o-midare consisting of slightly rough nie. The boshi is ko-midare with short kaeri, or with long kaeri and nie zake.

Yamato tradition: The jigane is beautiful, and the jihada is a dense mokume-hada mixed with considerable masame-hada and chikei. The hamon is chu-suguha hotsure with uchinoke, hakikake, nijuba, etc. The boshi is basically yakitsume, or slightly turn-back.

205

Workmanship of Nanki Shigekuni.

ERA	PROVINCE	SWORDSMITH(S)	PATTERN
			Soshu tradition: The jigane is oily and reminiscent of old Koto blades. The jihada is o-mokume hada with chikei, inclined toward masame-hada. The wide hamon is o-midare, o-gunome midare, or notare midare consisting of rough nie. Nie sake appear in the habuchi. The boshi is midare komi with short kaeri, or occasionally yakitsume.
	Bitchu	Mizuta Kunishige (水田国重)	There were several generations of smiths who worked under the name Kunishige. Of these, Otsuki Yogoro Kunishige was the most skillful. His blades have a deep sori, and a mihaba which is not tapered.
			Shinto tokuden tradition: The jihada is ko-mokume hada with ji-nie mixed with masame-hada. The hamon is a vigorous o-midare with abundant nie. The boshi is ichimai, or ko-maru sagari with long kaeri and abundant nie.
			Soshu tradition: The jihada is o-mokume-hada or itame-hada. The hamon consists of uneven nie and vigorous o-midare with sunagashi, and its width is not regular. Ha-hada is visible. There are examples of o-notare whose hamon is narrow at the start and grows wider nearer the top. The boshi is midare komi, or occasionally ichimai.
	Mutsu	Kunikane I (初代 国包)	**Yamato tradition:** Workmanship is reminiscent of Ko-Hosho blades. Blades have a high shinogi and a wide shinogiji. The jihada is a dense, uniform masame-hada. The hamon is chu-suguha hotsure with uchinoke and nijuba. The boshi is yakitsume, or has short kaeri.
	Inaba	Kanesaki (兼先)	This smith is said to be a descendant of Kanesaki of Mino province.
			Mino tradition: The sugata is rustic. There are a few tanto. Workmanship is similar to that seen in Sue-Seki blades. His zigzagging hamon resembles that of Kanemoto I.
Genna (1615–1624)	Settsu	Izumi no Kami Kunisada (和泉守国貞) Kunisada I (初代 国貞)	A student of Kunihiro, and the founder, together with Kawachi no Kami Kunisuke, of Osaka Shinto. This smith is called Oya (father) Kunisada to differentiate him from Shinkai Kunisada.
			Shinto tokuden tradition: Blades have a slightly tapering sugata. Horimono are occasionally seen. The jigane is somewhat hard but its quality is good. The jihada is ko-mokume hada mixed with masame-hada. The hamon is wide and Kyo-yakidashi. Ragged, slightly tapered midare are mixed with gunome midare with ashi. The boshi is ko-maru sagari, with kaeri that becomes a small-patterned midare. Muneyaki can sometimes be seen just below the end of the kaeri. Horimono are often engraved on the tanto and wakizashi; the hamon is gunome midare based on notare, or hiro-suguha with gunome ashi tending toward notare.
	Echizen	Yamato Daijo Masanori (大和大掾正則)	This smith is said to be a descendant of Sanjo Yoshinori of Yamashiro province.
			Shinto tokuden tradition: The jigane is hard, and the jihada is mokume-hada mixed with masame-hada. Muneyaki can be seen at times. The hamon is o-midare.
			Yamato tradition: The jigane is hard, and the jihada is coarse mokume-hada mixed with masame-hada. The hamon is based on suguha mixed with uniform ko-gunome. Sunagashi and nijuba can be seen.

ERA	PROVINCE	SWORDSMITH(S)	PATTERN	
	Musashi	Noda Hankei (野田繁慶)	**Soshu tradition:** Blades have high shinogi and relatively large kissaki with a fukura which is not full, and which is usually mitsu-mune. Hi and horimono are sometimes seen. The jihada is coarse o-itame hada mixed with masame-hada, with rough ji-nie and something resembling thick, long chikei, known as hijiki-hada. The hamon is o-midare or o-gunome midare with nie kuzure and sunagashi. The hiro-suguha resembles o-notare because of the quantity of sunagashi. The hamon is dull, and the nie are not bright. The boshi is midare komi with nie kuzure and sunagashi; the turn-back has nie kuzure.	 *206*
	Kaga	Tsujimura Kanewaka (辻村兼若)	Blades have a standard sugata. The kasane is thick and the shinogi is high. Hi and horimono are rare. **Shinto tokuden tradition:** The jigane is hard, and the jihada is a mokume-hada mixed with masame-hada and with ji-nie. The wide hamon is o-gunome midare and tends toward hako midare. There are fewer nie in some of the valleys, where thick kinsuji appear. The pattern is rather stiff and awkward. The boshi is ko-maru, with long kaeri. **Soshu tradition:** The jihada is coarse o-mokume hada mixed with masame-hada. The hamon is o-notare midare or o-gunome midare with wide yakihaba. The gunome is o-notare midare or o-gunome midare with wide yakihaba. The gunome is squarish, and thick sunagashi are seen in the valleys. The boshi is ko-maru with a small-patterned midare komi, or similar to the Mishina boshi. **Mino tradition:** The hamon has slightly crested and rugged midare along its habuchi, or is gunome with some tapered ashi such as choji midare.	 *207* Workmanship of Kanewaka.
Kan'ei (1624–1644)	Yamashiro	Iga no Kami Kinmichi (伊賀守金道) Kinmichi I (初代 金道)	Blades have saki-zori, and the mihaba is uniformly wide, extending all the way to the yokote without tapering. The jigane is hard, and the jihada a coarse ko-mokume hada, with masame-hada appearing on the mune side. The boshi is a ko-maru agari known as Mishina boshi. **Shinto tokuden tradition:** The hamon consists of slightly uneven nie and is a stiff and awkward pattern of o-midare mixed with togari-ba and with wide yakihaba. **Mino tradition:** The work of the Mino tradition is distinct from that of other traditions. The hamon is o-midare mixed with yahazu midare or hako midare with uneven nie in a stiff and awkward pattern.	

Workmanship of Hankei.

| --- | --- | --- | --- |
| | | Etchu no Kami Masatoshi (越中守正俊) Masatoshi I (初代 正俊) | The most expert member of the Mishina school. He was skilled in all the Gokaden as well as the Shinto tokuden tradition. There are grand sugata, as well as gentle sugata resembling old Koto blades. The boshi is midare komi, ko-maru agari inclined toward Jizo, or Mishina boshi, with kaeri that creeps upward toward the munesaki.

Shinto tokuden tradition: The jigane is hard, and the jihada is ko-mokume hada mixed with masame-hada that is particularly noticeable on the mune side. The hamon is o-midare or o-notare mixed with togariba.

Yamato tradition: The jihada is a dense ko-mokume hada mixed with masame-hada. The hamon is chu-suguha hotsure with uchinoke and hakikake. |
| | | Tanba no Kami Yoshimichi (丹波守吉道) Yoshimichi I (初代 吉道) | **Shinto tokuden tradition:** This smith invented the sudare-ba hamon, characteristic of this family of smiths; it resembles a bamboo screen composed of sunagashi.

Soshu tradition: The jihada is o-mokume hada mixed with masame-hada along the mune side. Nie kuzure and sunagashi are found. The boshi is a slightly disorganized Mishina boshi. |
| | Settsu | Kawachi no Kami Kunisuke I (初代 河内守国助) | Kunihiro's student and, together with Oya Kunisada, the founder of Osaka Shinto. Blades have a substantial sugata with thick kasane. The jihada is dense ko-itame hada. The boshi is ko-maru sagari or ko-maru agari.

Shinto tokuden tradition: A wide hamon and Kyo-yakidashi; the hamon is gunome midare with ashi based on o-notare and consisting of uneven nie.

Yamashiro tradition: The hamon is chu-suguha hotsure. |
| | Musashi | Yasutsugu II (二代 康継) | **Shinto tokuden tradition and Soshu tradition:** Workmanship is similar to that of Yasutsugu I, but the jigane is clear, and the jihada dense. |
| | | Shitahara Yasushige (下原康重) | This school had been prosperous since the Koto era. The jihada is dense or coarse ko-mokume hada. The boshi is ko-maru agari with long kaeri.

Shinto tokuden tradition: The hamon is a stiff, awkward midareba inclined toward yahazu midare with few hataraki.

Mino tradition: The sanbon-sugi is similar to that of Kanemoto. |
| | Echizen | Yamashiro no Kami Kunikiyo (山城守国清) | Kunihiro's student. Blades have a gentle sugata with a shallow sori. Horimono are common. The jigane is somewhat hard, and the jihada is mokume-hada mixed with masame-hada, with ji-nie. Muneyaki is sometimes seen.

Shinto tokuden tradition: The wide hamon is o-gunome midare. The boshi is ko-maru.

Yamashiro tradition: The hamon is chu-suguha hotsure with abundant nie. The boshi is ko-maru agari or inclined toward a small-patterned midare. |
| | | Harima Daijo Shigetaka (播磨大掾重高) | This smith is said to have been Seki Kanenori's student. His family continued sword production through the end of the Edo period. |

ERA	PROVINCE	SWORDSMITH(S)	PATTERN
	Hizen	Omi Daijo Tadahiro (近江大掾忠広)	**Shinto tokuden tradition:** Blades have a rustic sugata and, occasionally, elaborate horimono. The jigane is hard, the jihada is coarse mokume-hada, and masame-hada is noticeable in the shinogiji. The hamon consists of nie and is o-notare midare or o-midare mixed with a stiff and awkward midare. The boshi is ko-maru inclined to be tapered and the kaeri is long.
			Tadayoshi I's son. Workmanship is quite similar to the works of the first generation, but hi and horimono are rare.
			Shinto tokuden tradition: The jigane is soft Hizen-gane, and the jihada is ko-mokume hada. The hamon is o-midare or choji midare with long ashi based on suguha. The boshi is a standard ko-maru, but the kaeri tends to creep upward toward the munesaki.
			Yamashiro tradition: The jihada is ko-mokume hada or, more specifically, konuka-hada. Tiny sumigane appear here and there. The hamon is chu-suguha hotsure with abundant nie, or occasionally a gorgeous hiro-suguha. The boshi is standard ko-maru (Hizen boshi).
	Settsu	Ishido Tameyasu (石堂為康)	**Bizen tradition:** This smith produced many wakizashi. The katana are relatively short, with tapering mihaba and gentle sugata. The jihada is mokume-hada mixed with o-hada with a tendency toward masame-hada. The hamon is wide along the habuchi, but there is little hataraki inside the hamon. The boshi is ko-maru sagari tending toward ko-midare.
	Inaba	Shinano Daijo Tadakuni (信濃大掾忠国)	This smith is said to have been Dewa Daijo Kunimichi's student. His family continued to produce swords through the end of the Edo period.
			Shinto tokuden tradition: Features identical to those of Kunimichi.
	Mutsu	Miyoshi Nagakuni (三善長国) and Masanaga (三善政長)	Miyoshi Nagamichi is the grandson of Nagakuni and the son of Masanaga.
			Yamashiro tradition: The jigane is hard, and the jihada is a coarse ko-mokume hada mixed with masame-hada. The hamon is chu-suguha consisting of tight nioi.
	Musashi	Ogasawara Nagamune (小笠原長旨)	A retainer of the Hosokawa clan of Higo province, Ogasawara is said to have been active during the Kan'ei Era, but his works appear to be slightly more recent.
			Yamato tradition: Blades have a gentle sugata, a shallow sori, a high shinogi, and a narrow shinogiji. The jihada is mokume-hada with partial masame-hada in the center of the ji. The hamon is chu-suguha consisting of tight nioi. Nie is scarce. The boshi is ko-maru.
Shoho (1644–1648)	Settsu	Mutsu no Kami Kaneyasu (陸奥守包保)	A descendant of the Tegai school of Yamato province. This smith is called Hidari ("left") Mutsu because the strokes of the characters of his signature are written as if viewed in a mirror. The blades have a wide mihaba up to the yokote, saki-zori and a relatively large kissaki. The jigane is hard, and the jihada is a coarse mokume-hada mixed with masame-hada.
			Shinto tokuden tradition: The hamon consists of slightly uneven nie, and there are o-midare, o-gunome midare, and notare midare mixed with slightly pointed midare. The boshi is ko-maru sagari or ichimai.

ERA	PROVINCE	SWORDSMITH(S)	PATTERN
Keian (1648–1652)	Musashi	Yamato no Kami Yasusada (大和守安定)	**Yamato tradition:** Masame-hada is noticeable along the mune side. The hamon is chu-suguha or hiro-suguha; hataraki run lengthwise along the blade.
			Shinto tokuden tradition: Blades have a sugata consistent with the period, with a shallow sori and a tapering mihaba. This smith has a reputation for producing excellent, sharp blades. "O-wazamono" here means "very famous for sharpness" or "very sharp sword." Many of his blades bear inscriptions describing test cuttings in gold on the nakago. The jigane is hard; the jihada is coarse mokume-hada and masame-hada is noticeable in the shinogiji and the mune side. The hamon is a stiff, awkward o-midare based on notare. The boshi is a slightly tapered ko-maru, and kaeri creeps up toward the munesaki.
Joo (1652–1655)		Omura Kaboku (大村加卜)	This smith was a native of Suruga province. He served the Matsudaira clan of Echigo province as a surgeon before becoming a retainer of the Tokugawa clan (Mito Tokugawa family) of Hitachi province. He appears to have learned swordmaking from a smith of the Shitahara school who was a relative. Musashi Taro Yasukuni was Kaboku's son. Kaboku wrote a study of Koto, entitled *Kento Hiho* (Hidden Treasures), and attempted to produce various kinds of hamon, probably in imitation of Koto blades.
			Shinto tokuden tradition: His blades have a rugged, stout sugata, a shallow sori, hira-niku, thick kasane, and a relatively large kissaki. The jihada is a coarse ko-mokume hada mixed with masame-hada. The hamon is generally gorgeous o-midare with uneven nie. The boshi is ko-maru with long kaeri.
	Mutsu	Sendai Yasutomo (仙台安倫)	A student of Yamato no Kami Yasusada, in the employ of the Date clan of Rikuzen province.
			Shinto tokuden tradition: Yasutomo's blades have a shallow sori and thick kasane. The jigane is hard, and the jihada is a coarse mokume-hada mixed with masame hada. The hamon is o-midare and gunome-midare with uneven nie, ashi, and togariba. The boshi is ko-maru with long kaeri, and the tip tends to be tapered.
Manji (1658–1661)	Settsu	Omi no Kami Tadatsuna (近江守忠綱)	The father of Ikkanshi Tadatsuna. His blades usually have a gentle sugata with a tapering mihaba.
			Shinto tokuden tradition: The jihada is a dense ko-mokume hada. The hamon is o-midare consisting of thin nie. The boshi is ko-maru or ko-maru sagari.
			Bizen tradition: The hamon is wide choji midare with long ashi in nioi deki. The yakigashira is rounded. The ko-maru boshi tends to be midare.
		Kawachi no Kami Kunisuke II (二代 河内守国助)	This smith was known as Naka Kawachi.
			Bizen tradition: His work includes substantial sugata and gentle sugata with slightly tapering mihaba, as well as sugata similar to those of the first generation. The jihada is barely noticeable mokume-hada which looks like muji-hada. The hamon is kobushigata choji midare. The boshi is ko-maru sagari.
	Musashi	Nagasone Kotetsu (長曽祢虎徹)	His blades have a shallow sori, a wide mihaba, and a substantial sugata. The jigane is hard and strong.

ERA	PROVINCE	SWORDSMITH(S)	PATTERN
	Mutsu	Miyoshi Nagamichi (三善長道)	**Shinto tokuden tradition:** In his early work, the jihada is ko-mokume hada mixed with o-hada, masame-hada is noticeable in the shinogiji or along the mune side, and coarse, roughly forged o-hada, or tekogane, appears in the bottom area. The wide hamon is a squarish gunome. The yakidashi is a small pattern. The boshi is a small-patterned midare komi, or ko-maru agari with long kaeri. In later works, the jihada is a well-forged ko-mokume hada with ji-nie, and o-hada can be seen in the bottom area on both sides. The hamon is a unique juzuba gunome with plenty of ashi consisting of thick nie and nioi; it is crystal clear and a brilliant white . **Yamashiro tradition:** The jihada is a well-forged, slightly coarse ko-mokume hada with ji-nie, and masame-hada is noticeable in the shinogiji and along the mune side. Tekogane appears in the bottom area. The hamon is a crystal-clear, brilliant white hiro-suguha consisting of thick nioi and nie. The boshi is ko-maru agari with long kaeri. This smith is sometimes called Aizu Kotetsu. His blades have a gentle sugata with a tapering mihaba. **Shinto tokuden tradition:** The jigane is hard and the jihada is mokume-hada mixed with masame-hada. The wide hamon is gunome midare or o-midare mixed with slightly tapered midare. Workmanship is similar to that seen in early works of Kotetsu. The boshi is ko-maru and the kaeri creeps upward toward the munesaki. **Yamato tradition:** The jigane is hard, and the jihada is mokume-hada mixed with masame-hada; masame-hada is particularly noticeable along the mune side. The hamon is chu-suguha with tight habuchi. The boshi is ko-maru, and the kaeri creeps up toward the munesaki. **Mino tradition:** This tradition is usually mixed with the Shinto tokuden tradition. The hamon is a stiff, tapered midare.
	Bizen	Yokoyama Sukesada (横山祐定)	**Bizen tradition:** Bo-bi with tsurebi or soe-bi are common. The jihada is mokume-hada mixed with o-hada. The hamon is koshi-no-hiraita midare consisting of tight nioi, which tends towards gunome midare. The boshi is ko-maru or gentle midare komi based on ko-maru.
Kanbun (1661–1673)	Yamashiro	Omi no Kami Hisamichi (近江守久道)	A smith of the Mishina school and one of the Kyo Go Kaji (Five outstanding smiths of Kyoto). **Yamashiro tradition:** The hamon is chu-suguha consisting of tight nioi with a few nie. **Mino tradition:** Features identical to those of Iga no Kami Kinmichi I.

208

Workmanship of Kotetsu.

ERA	PROVINCE	SWORDSMITH(S)	PATTERN
	Settsu	Nagatsuna and Tadayuki (長綱) (忠行)	Both smiths are students of Tadatsuna I. **Shinto tokuden tradition:** Similar to Tadatsuna I, but not as skillful. The habuchi is tight and nie are scarce. **Yamashiro tradition:** The hamon is chu-suguha with few nie.
		Tanba no Kami Yoshimichi (丹波守吉道)	The second son of Tanba no Kami Yoshimichi of Yamashiro province (Yoshimichi I). This smith moved from Yamashiro to Osaka, where he established the Osaka Tanba family. His blades have a gentle sugata with a tapering mihaba. **Shinto tokuden tradition:** Features identical to those of Yoshimichi I. **Yamashiro tradition:** The hamon is hiro-suguha tending toward sudareba.
	Musashi	Yasutsugu III (三代 康継)	**Shinto tokuden tradition:** Blades have a somewhat deep sori, thick kasane, and a stout sugata. Hi and horimono are rare. The jigane is hard, and the jihada is coarse ko-mokume mixed with masame-hada. The hamon is wide o-gunome midare mixed with togariba, with uneven nie; the pattern is stiff and awkward. The ko-maru boshi tends toward midare komi and the kaeri is long.
		Hojoji Masahiro (法城寺正弘)	His blades have a shallow sori and a slightly tapering mihaba. **Shinto tokuden tradition:** The jigane is somewhat hard, and the jihada is coarse mokume-hada mixed with masame-hada. The hamon is o-notare, gunome midare, or notare midare with few hataraki. Partial yaki-kuzure can be seen. The boshi is midare komi with long kaeri, and the tip of the boshi tends to be tapered. **Yamashiro tradition:** The jihada is ko-mokume hada, and coarse masame-hada appears along the mune side. The hamon is hiro-suguha or chu-suguha with few hataraki. The boshi is ko-maru agari.
		Shitahara Chikashige (下原周重)	**Shinto tokuden tradition and Mino tradition:** Features identical to those of Yasushige.
		Ishido Korekazu (石堂是一)	A leading smith of the Edo Ishido school, he was titled Musashi Daijo. **Bizen tradition:** The sugata is reminiscent of old Koto blades. The jihada is mokume-hada mixed with o-hada inclined toward masame-hada. Utsuri appears. The hamon is o-choji midare or saka choji midare with long nioi ashi, and the width is not regular. Some crests of the saka-choji midare between the monouchi area and the middle of the blade extend as far as the shinogi. The boshi is ko-midare with short kaeri.

209

Workmanship of Hojoji Masahiro.

ERA	PROVINCE	SWORDSMITH(S)	PATTERN
		Tsushima no Kami Tsunemitsu and (対馬守常光) Heki Mitsuhira (日置光平)	These smiths, native to Omi province and members of the Edo Ishido school, were brothers. They also produced swords in Matsushiro, Shinano province. **Bizen tradition:** Generally similar to Ishido Korekazu.
		Tsunamune (綱宗)	Lord of the Date clan and daimyo of Rikuzen province. Yasutomo assisted him in swordmaking. **Shinto tokuden tradition, Bizen tradition, and Soshu tradition:** Produced mainly wakizashi. The jigane is weak and the jihada is mokume-hada. The hamon is in nie deki and o-midare, o-gunome midare, or hiro-suguha with sunagashi and rough nie. Tsunamune also made hamon that are choji midare mixed with koshi-no-hiraita midare, but that have few hataraki.
		Minamoto (no) Yorisada (源頼貞)	The lord of Moriyama in Oshu. Tsushima no Kami Tsunemitsu assisted him in swordmaking. Yorisada also employed the master metalworker Yasuchika I. **Shinto tokuden tradition and Soshu tradition:** The hamon is o-midare mixed with ko-midare in nie deki. Thick inazuma can be seen on the habuchi.
	Kaga	Darani Katsukuni (陀羅尼勝国)	This smith is a later-generation Katsukuni belonging to the Chiyozuru Kuniyasu school (Echizen province). **Mino tradition:** The hamon is similar to Kanemoto's sanbon-sugi, but lumps of nie can be seen in each valley; the nie is shaped like the webbed feet of a water bird.
	Chikuzen	Ishido Korekazu (石堂是次) and Moritsugu (石堂守次)	These are the leading smiths of the Fukuoka Ishido school. **Bizen tradition:** a gentle sugata reminiscent of old Koto blades. The jigane is relatively soft, and the jihada is a mokume-hada mixed with o-hada with a tendency towards masame-hada. Utsuri appear. The wide hamon is saka choji midare with wide yakihaba and the width is regular. The masterpieces of these two smiths are reminiscent of blades by Katayama Ichimonji. The shape of their unique choji resembles the head of a squid. The boshi is midare komi with short kaeri.
	Chikugo	Onizuka Yoshikuni (鬼塚吉国)	**Yamashiro tradition:** This smith's lineage is uncertain. Workmanship is similar to that of Hizen Tadayoshi. The hamon is chu-suguha and often mixed with midare that looks much like a knot in the monouchi area.
	Hizen	Mutsu no Kami Tadayoshi (陸奥守忠吉)	**Shinto tokuden tradition and Yamashiro tradition:** The son of Tadahiro II. His blades have a relatively grand sugata. The jigane is strong, and the jihada is ko-mokume hada with ji-nie and chikei. The hamon is similar to that of the first generation, but is more gorgeous and vigorous. The boshi is ko-maru and has a long, steep stop, but retains its elegance.

210
Sanbon-sugi
by Darani
Katsukuni.

ERA	PROVINCE	SWORDSMITH(S)	PATTERN
Enpo (1673–1681)	Settsu	Echizen no Kami Sukehiro (越前守助広) Sukehiro II (二代 助広)	Blades have a well-proportioned sugata typical of this era. Tanto are rare. **Shinto tokuden tradition:** The jigane is dark-bluish and beautiful. The jihada is ko-mokume hada with chikei and abundant ji-nie. His hamon is a distinguished, original toran-midare. Nie inside the hamon are finer than those in the habuchi. Osaka yaki-dashi and tama are seen between the midare. The boshi is ko-maru sagari. **Yamashiro tradition:** The jigane is oily and dark-bluish. The jihada is ko-mokume hada with chikei and ji-nie, and finer than that of his Shinto tokuden tradition blades. The hamon is a relatively wide chu-suguha consisting of thick nie and nioi. The nie becomes finer (i.e., midare nie) toward the hasaki, as Sukehiro was originally a maker of midareba. (This is unusual, since the nie of suguha typically become rougher toward the hasaki, in which case they are known as suguha nie.) Hizen Tadayoshi, who originally made suguha, did precisely the opposite, and his midareba were suguha nie even when a hamon was midareba. The boshi is ko-maru sagari with abundant nie.
		Inoue Shinkai (井上真改)	Izumi no Kami Kunisada II (二代 和泉守国貞). Blades have a sugata which is typical of this period. Tanto are rare. The jihada is a beautiful ko-mokume hada with abundant ji-nie. The boshi is ko-maru sagari or ichimai. **Shinto tokuden tradition:** The hamon is o-midare or o-notare consisting of rough and thick nie. Osaka yakidashi is seen. The hamon gradually becomes wider toward the top of the blade. **Yamashiro tradition:** The hamon is chu-suguha consisting of abundant nie with rather tight nioi-guchi.
		Suzuki Sadanori (鈴木貞則)	A student of Inoue Shinkai. This smith was employed by the lord of the Naito clan after having received the title Kaga no Kami. **Shinto tokuden tradition:** Workmanship differs little from that of Shinkai, but not as skillful.
		Sakakura Gonnoshin Terukane (坂倉言之進照包)	This smith succeeded Echigo no Kami Kanesada, and later changed his name to Sakakura Gonnoshin Terukane. **Shinto tokuden tradition:** Blades have a shallow sori and a tapering mihaba. The jihada is ko-mokume hada mixed with o-hada. The hamon is toran-midare consisting of abundant nie, similar to that of Sukehiro. There are different sizes of midare in the toran-midare, which is usually mixed with yahazu midare in the monouchi area. The boshi is ko-maru sagari.

211 Sukehiro's midare nie.

212 Workmanship of Inoue Shinkai.

ERA	PROVINCE	SWORDSMITH(S)	PATTERN
Tenna (1681–1684)	Musashi	Higo no Kami Kuniyasu (肥後守国康)	The son of Kunisuke I. (初代 国助) **Bizen tradition**: Blades have a gentle sugata. The hamon is a wide choji midare mixed with stiff and awkward midare, consisting of nioi.
		Nagasone Okimasa (長曾禰興正)	A student of Kotetsu. This smith was later adopted, and became the second generation of the Kotetsu school. **Shinto tokuden tradition**: Workmanship is similar to that of Kotetsu, but inferior in skill.
	Yamashiro	Kazusa no Suke Kaneshige (上総介兼重)	Kaneshige II and this smith are said to have been Kotetsu's teachers. **Shinto tokuden tradition**: Blades have a shallow sori and a tapering mihaba. The jigane is strong. The jihada is mokume-hada mixed with masame-hada appearing along the mune side. The hamon is notare with uniform gunome ashi, some of which extend to the hasaki. The boshi is ko-maru with plentiful nie and the tip tends to be tapered.
		Higashiyama Yoshihira (東山美平)	This smith is said to have been Umetada Shigeyoshi's son or student. He later changed his name to Oe Yoshitaka. His blades have a slightly tapering mihaba, relatively large kissaki, and a slight saki-zori. The boshi is ichimai or ko-maru sagari. **Shinto tokuden tradition**: The jihada is ko-mokume hada mixed with masame-hada, with abundant ji-nie. The hamon is o-notare mixed with yahazu midare, and widens gradually toward the top. **Yamashiro tradition**: The jihada is a dense ko-mokume hada with abundant ji-nie. The hamon is hiro-suguha or o-notare, generally consisting of rough nie. The hamon is narrow toward the bottom, and widens toward the top.
	Settsu	Omi no Kami Sukenao (近江守助直)	**Shinto tokuden tradition**: Workmanship is similar on the whole to Sukehiro's, but the nie are rougher, and the size of the midare is irregular. Another difference is that Sukenao's tama are not located precisely at the spot between two midare.
		Kawachi no Kami Kunisuke III (三代 河内守国助)	**Shinto tokuden tradition and Bizen tradition**: This smith is not as skillful as either the first or second generation. His hamon is choji midare and kobushigata choji midare consisting of nioi, with level yakigashira and Osaka yakidashi. Picturesque hamon are sometimes seen.
		Tatara Nagayuki (多々良長幸)	This smith belongs to the Osaka Ishido school and is one of the best Bizen-tradition smiths of Shinto times. **Bizen-tradition**: Blades have a shallow sori, a high shinogi, and thick kasane. The jihada is mokume-hada mixed with o-hada with a tendency toward masame-hada. Utsuri appear. The hamon is o-choji midare mixed with koshi-no-hiraita midare; likewise, pure

213

Kata yahazu-ba of Higashiyama Yoshihira.

ERA	PROVINCE	SWORDSMITH(S)	PATTERN
			koshi-no-hiraita midare are found. The boshi is a small-patterned midare komi and turns back.
	Musashi	Omi no Kami Tsuguhira (近江守継平)	This smith, a native of Echizen province, is said to have studied under Yasatsugu III; there are six generations in his line. "Tsuguhira Oshigata" is reported to be Tsuguhira II's work.
			Shinto tokuden tradition: Blades have little sori and are generally shin-no-mune (or mitsu-mune). The jigane is a bit shiny and has a mirrorlike surface. The jihada is dense ko-mokume hada, and do-tetsu-hada (literally, mixed iron and copper) or o-gon gitae (literally, forged with gold and iron) can be seen; mixed with its dark, thick, snaking lines, this resembles muji-hada. The hamon is o-midare or o-notare. The boshi is ko-maru with a slightly tapered tip, and the kaeri is long.
	Omi	Sasaki Ippo II (二代 佐々木一峯)	This smith, whose real name was Sasaki Zenshiro, was a member of the Ishido school. His predecessor lived in the Kan'ei era (1624–1644), but extant works are rare.
			Shinto tokuden tradition: The sugata is stout but rustic. Katakiriha-zukuri is sometimes found. Jigane is hard and jihada is coarse ko-mokume hada mixed with masame-hada. The hamon is o-notare, or notare midare with uneven nie in a stiff and awkward pattern. The boshi is ko-maru with long kaeri.
	Satsuma	Izu no Kami Masafusa (伊豆守正房)	**Soshu tradition:** Keicho Shinto sugata; hi and horimono are rare. The jihada is a clean and dense mokume-hada, but is not very visible. Satsuma-gane and ji-nie can be seen. The width is not regular, the hamon is wide, and the size of the midare is irregular. Togari-ba consisting of nie is reminiscent of blades from his native province of Mino. Nie in the habuchi are relatively rough, and imozuru appear there. The boshi is midare komi, similar to old Koto blades.
			Mino tradition: A mixture of the Mino and Soshu traditions.
Jokyo (1684–1688)	Settsu	Ise no Kami Kuniteru (伊勢守国輝)	The fourth son of Kunisuke I.
			Shinto tokuden tradition: Blades have the stout sugata typical of the period. The jigane is hard, and the jihada is a slightly coarse ko-mokume hada mixed with masame-hada. The hamon is notare midare or o-midare with uneven nie in a stiff and awkward pattern, occasionally mixed with togariba. The boshi is ko-maru sagari.
Genroku (1688–1704)		Ikkanshi Tadatsuna (一竿子忠綱) Tadatsuna II (二代 忠綱)	A master of horimono who engraved many elaborate dragons.
			Shinto tokuden tradition: The jihada is a beautiful and dense ko-mokume hada. The hamon is based on o-notare with uniform gunome ashi from the base of the blade to the yokote, with Osaka yakidashi. Occasionally, tama can be seen above the valleys in the midare. The boshi is ko-maru sagari.
	Harima	Usaku Munehide (右作宗栄)	This smith was originally a retainer of the lord of Himeji, and afterward was employed by the Ikeda clan of Okayama. It is said that he was permitted to use the character "U" (右) (also pronounced migi, and meaning "right") because he was very good at copying the work of Samonji. In Japanese, the right side ("u"or "migi"; in this case indicating Munehide) is considered to be superior to the left ("sa," indicating Samonji). Several generations used this name.

ERA	PROVINCE	SWORDSMITH(S)	PATTERN
Hoei (1704–1711)	Satsuma	Tegarayama Ujishige (手柄山氏重)	**Shinto tokuden tradition:** Blades have thick kasane, full hira-niku, saki-zori, and relatively large kissaki. Ko-mokume hada is not very visible. The hamon starts with narrow yakihaba and gradually widens toward the tip of the blade. The boshi tends to be ichimai, with rougher nie than that of the hamon.
			This family adopted Tegarayama as their surname because they lived at the foot of Mt. Tegara (yama means "mountain"). During his later years, the third generation of this line changed the character "Shige" (繁) into a different character that is also read "Shige" (重). The fourth generation was Masashige who was employed by the Matsudaira clan of Shirakawa.
			Shinto tokuden tradition: Workmanship similar to that of Munehide; gorgeous toran-midare consisting of thick, rough nie is found.
		Naminohira Yasuchika (波平安周)	This smith is a direct descendant of the Naminohira school, founded in the late Heian period.
Kyoho (1716–1736)	Yamato	Yamato no Kami Kiju (大和守紀充)	**Yamato tradition:** Blades have a gentle sugata with shallow sori. The jihada is a beautiful ko-mokume hada inclined toward masame-hada mixed with o-hada; it is worth noting that ayasugi-hada can be seen. The hamon is a chu-suguha hotsure mixed with ko-gunome or gentle midare based on suguha, or occasionally hiro-suguha. Uchinoke, hakikake, and nijuba appear. The boshi is ko-maru with hakikake and plentiful nie.
			A student of (Osaka) Tanba no Kami Yoshimichi and son of Etchu no Kami Kanekuni, a descendant of the Tegai school of Yamato province. His name in his early years was Terukuni, but he later changed it to Kiju (a lay priest's name).
			Shinto tokuden tradition: At first glance, the sugata resembles Koto blades. The jigane is hard, and the jihada is a coarse mokume-hada mixed with masame-hada. The hamon is toran-midare, but the nie are uneven, and the pattern looks a little stiff and awkward. The boshi is ko-maru or ichimai.
	Musashi	Musashi Taro Yasukuni (武蔵太郎安国)	This smith is believed to have belonged to the Shitahara school, as a student of Omura Kaboku.
			Shinto tokuden tradition and Mino tradition: Blades have a shallow sori, thick kasane, and slightly tapering mihaba. The jigane is hard, and the jihada is a little coarse. The hamon is o-notare, notare midare, o-gunome midare, with scarce nie. The hamon is wide in the kissaki; ichimai boshi are seen.
	Chikuzen	Nobukuni Shigekuni (信国重包)	Nobukuni Yoshikane's son. This smith was granted the right to engrave a leaf of the aoi mon (family crest of the Tokugawa clan) on his nakago by the eighth shogun, Yoshimune; other smiths awarded this honor were Masakiyo, Yasuyo, and Nanki Shigekuni IV.
			Shinto tokuden tradition and Soshu tradition: Blades have a shallow sori, thick kasane, and relatively large kissaki. The jihada is a visible mokume-hada. The hamon is o-notare or o-midare, in nie deki mixed with a stiff, awkward midare. The boshi is a small patterned midare komi, and ko-maru near the top.
			Yamashiro tradition: Hiro-suguha with gunome ashi or chu-suguha consisting of tight nioi.

ERA	PROVINCE	SWORDSMITH(S)	PATTERN
Enkyo (1744–1748)	Satsuma	Mondo no Sho Masakiyo (主人水正正清)	**Bizen tradition**: Choji midare mixed with koshi-no-hiraita midare in nioi deki, occasionally nie deki. **Soshu tradition**: Keicho shinto sugata; bo-bi are seen, but horimono are not. The jihada and the boshi are little different from those of Izu no Kami Masafusa. The hamon is o-midare mixed with togari-ba and a square midare consisting of rough nie. The width is not regular. The blade shows all the typical features of Satsuma blades.
		Ichinohira Yasuyo (一平安代)	**Mino tradition**: A mixture of the Mino and Shoshu traditions. **Shinto tokuden tradition and Yamashiro tradition**: Blades are long, with thick kasane and stout sugata. The jigane is strong and the jihada is dense mokume-hada, unlike other Satsuma blades. The hamon is hiro-suguha inclining toward notare, consisting of rough nie. There is a lot of activity inside the hamon. Yasuyo's nie are midare nie even though his hamon is suguha, similar to Sukehiro. Kuichigaiba consisting of nie is found. The boshi is ko-maru with abundant nie.
		Naminohira Yasukuni (波平安国)	**Yamato tradition**: Features identical to those of Yasuchika.
	Settsu	Doi Shinryo (土肥真了)	A student of Inoue Shinkai. Shinryo lived in Hirado, Hizen province, and was employed by the lord of the Matsuura clan. **Shinto tokuden tradition**: Katana are rare, and production was mainly in wakizashi. In general the workmanship is similar, but inferior to, that of Inoue Shinkai.

WORKMANSHIP OF SHINSHINTO TIMES

Shinto production began in the Keicho era (1596–1615), reached its height in the Kan'ei (1624–1644) and Kanbun eras (1661–1673), and gradually declined in the Genroku (1688–1704) and the Hoei eras (1704–1711), when it became difficult to find good swordsmiths. This was due to a reduced demand for swords as a result of long-standing peace. In the Kyoho era (1716–1736), the shogun Yoshimune encouraged swordmaking, and held a swordmaking contest at the palace. But this was only a temporary revival. From the Genbun (1736–1741) through the Horeki eras (1751–1764) very little swordsmithing was done.

The art of sword production began to make a comeback with the appearance of the smith Suishinshi Masahide. By this time, methods and techniques of sword appreciation and appraisal had been firmly established, and the publication of *Arami Mei Zukushi* by Kanda Hakuryushi in 1721 and *Shinto Bengi* (two books that introduced and ranked various swords and smiths of the day) by Kamata Natae in 1777 further encouraged renewed interest. *Shinto Bengi* had high praise for the workmanship of Osaka Shinto.

Japan was faced with turmoil in its domestic and foreign affairs. Foreign ships had forced the shogun's government to open the country's long-closed doors and enter into diplomatic relationships. The government had already lost control of the political situation, causing social unrest. The study of classical Japanese literature gained popularity and support for the Emperor grew, leading to reactionary tendencies in many aspects of life and culture.

Blades made at this time, specifically from the Tenmei era (1781–1789) through the early Meiji period (1867–1876), are known as Shinshinto; smiths working during the preceding Meiwa era (1764–1772) are also regarded as Shinshinto smiths. The social situation, as outlined above, strongly influenced swordmaking. During early Shinshinto times, copying the Osaka Shinto style was in vogue, but before long the main trend turned to the restoration of pre–Nanbokucho-period methods, and many swordsmiths attempted to recreate Koto traditions.

Suishinshi Masahide had enormous influence—both theoretical and technical—on other swordsmiths. His school expanded quickly and listed over one hundred swordsmiths as its members. Of these, Taikei Naotane (大慶直胤) and Hosokawa Masayoshi (細川正義) in particular are considered to be outstanding. Also his "grand-students," Kato Tsunahide (加藤綱英), Tsunatoshi (加藤綱俊), and Koyama Munetsugu (固山宗次) produced fine blades.

In Shinano province (Nagano Prefecture) the brothers Yamaura Masao (山浦真雄) and Kiyomaro (源清麿) established their own style of workmanship. After Kiyomaro had relocated to Edo, Nobuhide (栗原信秀), Kiyondo (斎藤清人), and Suzuki Masao (鈴木正雄) entered his school. Sa Yukihide (左行秀) in Tosa province (Kochi Prefecture), Gassan Sadakazu (月山貞一) in

Osaka, Yamato no Kami Motohira (大和守元平), and Hoki no Kami Masayoshi (伯耆守正幸) in Satsuma province (Kagoshima Prefecture), where the Soshu tradition had been practiced since Shinto times, were also active at this time. The following are the common points that characterize Shinshinto workmanship:

1) There is a sugata with a shallow sori and a hawatari about 80–85 cm long that is particular to this period, but most swordsmiths copied Koto and Shinto styles.

2) Hi and horimono are often seen. Horimono have a variety of designs that tend to be quite dense, with minute, precise engraving. They are skillfully and realistically done, but lack grace and elegance. Yoshitane, Nobuhide, and Gassan Sadakazu were particularly adept engravers.

3) Many swordsmiths successfully practiced more than one tradition, which was not true of Koto or Shinto times. Swordsmiths were also able to make good copies of the hamon, boshi, nie, and nioi of both Koto and Shinto blades.

4) With the exception of the Kiyomaro school and those smiths who created tsukuri-hada (mixing other materials into steel to make the surface-grain pattern stand out), most smiths' jihada is a very fine ko-mokume and appears to be muji-hada. Generally the steel is weak.

5) Regardless of the tradition of any particular blade, the hamon is a milky color, rather than being bright or clear white.

6) Hard black spots are frequently seen near the top of the hamon line.

7) The hamon does not consist of bright nie or nioi. The inside of the hamon is hazy, so it is difficult to precisely discern the patterns of the hamon.

8) The hamon of Shinto blades are usually suguha yakidashi with ko-maru boshi, even when midareba, but in Shinshinto suguha, yakidashi is never seen, and the

boshi becomes midareba in proportion to the hamon, as it was in Koto blades.

214. There are hard black spots near the top of the hamon, and the hamon stands out in bold relief against the jihada. 215. The nioi-guchi is hazy or misty, and the border between the ji and ha is indistinct.

216. Sa Yukihide, etc. Katana with little sori, about 80–85 cm in length, are sometimes seen. These are called "kinnoto" (imperialist swords) and were not produced during Shinto times. Royalists are said to have preferred to carry swords of this type.

PROVINCES AND SCHOOLS OF SHIN-SHINTO TIMES

During Koto times, the traditions of each school were carefully preserved over the generations, and the characteristics common to a swordsmith's school were clearly evident in his blades. When several schools existed in one province, it was possible to discern specific provincial characteristics. During Shinto times, however, the uniqueness of the steel from each province diminished as a result of the introduction of mass production and standardization of raw materials. Swordsmiths also began to gather around new large castle towns, and the very process of forming schools changed.

During Shinshinto times, this tendency became more marked, so much so that it became almost meaningless to speak of provincial characteristics except in regard to the Hizen and Satsuma smiths, who had succeeded in establishing and maintaining unique styles of workmanship. More than half the leading smiths lived and worked in Edo, while others returned to their hometowns or relocated to various other places after they had finished studying under such famous smiths as Suishinshi Masahide. Based on the evidence of the extant works, there is little doubt that Shinshinto smiths not only continued to produce blades in the styles they had learned from their teachers, but also experimented with other methods of swordmaking.

Thus, references to Shinshinto smiths emphasize their individual style rather their school or province. The following is a detailed description of the characteristic elements of the individual styles of the leading Shinshinto smiths, which also locates them within the provincial classification scheme.

THE SUISHINSHI MASAHIDE (水心子正秀) SCHOOL

Suishinshi Masahide was a native of Dewa province; he first used the name Suzuki Saburo Fujiwara (no) Iehide, later changing Iehide to Hidekuni. In 1774 he went to Edo and was employed by the Akimoto clan. At this time he began to use Kawabe Gihachiro Fujiwara (no) Masahide as his smith's name and took the title Suishinshi. In later years he varied the characters used to write Masahide (正日出), then changed his name to Amahide (天秀), and finally used Suishin Roo Amahide (水心老翁天秀). He died in 1826 at the age of seventy-six.

It is said that Suishinshi Masahide learned his craft from Shitahara Yoshihide, Soshu Tsunahiro, and Ishido Korekazu, but his great achievement seems primarily a result of his own genius. In his books *Token Jitsuyo Ron* (Theories on practical use of swords [a technical study of Koto of the Heian and Kamakura periods]) and *Kenko Hiden Shi* (Secret techniques of sword production), he proved himself not only a skillful smith but also a distinguished theorist. He also taught more than one hundred students, which was in itself an enormous contribution to the future of the Japanese sword. His leading students include Sadahide (貞秀) (Masahide II), Suishinshi Masatsugu

(水心子正次), Hyoshinshi Hideyo (氷心子秀世), Mutsu no Suke Hiromoto (陸奥介弘元), Ikeda Isshu (池田一秀), Taikei Naotane (大慶直胤), and Hosokawa Masayoshi (細川正義).

In his early works, he used a toran-midare consisting of thick nie and nioi as created by Sukehiro and a notare midare modeled after that of Inoue Shinkai (see Fig. 162 on page 228). These gorgeous styles can also be seen in the blades of Ozaki Suketaka, Tegarayama Masashige, Chounsai Tsunatoshi, and others. Evidently, Kamata Natae's book *Shinto Bengi*, with its glowing appraisal of the work of Sukehiro and Inoue Shinkai, had a considerable influence on the style of the times. Afterward, he began to create a notare midare with nie kazure and hitatsura of the Soshu tradition. In his later years, he changed to choji midare and suguha in a Bizen style, deliberately avoiding the wide hamon consisting of thick nie that took into account the practical requirements of the sword as a weapon.

Suishinshi Masahide advocated a return to the Heian- and Kamakura-period methods of sword forging; his theory was known as "fukkoto," and had a significant impact on Shinshinto smiths. As a result, Bizen and Soshu traditions replaced the Shinto tokuden tradition as the mainstream, from the middle of Shinshinto times.

The workmanship of Suishinshi Masahide is described below.

Yamashiro tradition
His blades have elegant sugata with funbari, in imitation of Koto blades. The jihada is a beautiful ko-mokume hada. The hamon is chu-suguha hotsure consisting of nie, but there are few hataraki. The boshi is ko-maru. Occasionally masame-hada in the Yamato tradition is seen.

Bizen tradition
Copies of various sugata from Koto times as well as from the Yamashiro tradition. The hamon is in nioi deki and ko-choji midare with long nioi ashi, with a tendency to slant, or in koshi-no-hiraita midare mixed with choji midare in the Oei-Bizen style. Hard

dark spots can be seen inside the hamon, and the nioi-guchi is neither bright nor tight.

Soshu tradition
O-midare, notare midare with nie kuzure and hitatsura, or an o-gunome midare that Masahide himself referred to as Kamakura or Masamune traditions.

Shinto tokuden tradition
In imitation of Sukehiro and Shinkai, the jigane and the jihada are beautiful and the hamon consists of thick nioi and nie. But Masahide's blades have little hira-niku, and neither the pattern of the toran-midare nor the size of each midare is uniform. Uneven, rough nie are seen in the habuchi and hard, dark spots appear in the yakigashira. The jigane is weak, and the jihada hardly visible; the ji-nie is not equal to that of Sukehiro in either quality or quantity.

Tanto: There are hira-zukuri ko-wakizashi in the Enbun Joji, or mid-Nanbokucho style, or in the gorgeous Soshu tradition; otherwise tanto are of standard length, uchi-zori, with dense, beautiful jihada and chu-suguha hotsure in nie deki and in the Yamashiro tradition; katakiriha-zukuri and osoraku-zukuri can occasionally be seen.

Horimono: The inscription "Hori do saku" (Horimono engraved by the smith himself) is seen at times, but most horimono seem to have been engraved by one of Masahide's students, Honjo Yoshitane. Suken, dokko, and ken-maki-ryu in the groove are skillfully engraved. The scales of Yoshitane's dragons resemble overlapping coins.

Nakago: The blade generally has a long nakago. The nakagojiri is steep ha agari kurijiri in the smith's early years, and becomes gentle ha agari kurijiri later. The yasurime are sujikai with kesho yasuri. When Masahide copies Osaka Shinto, the nakago is also done in the style of the Osaka Shinto smith. Masahide often used a hallmark design made of the two characters "Hi Ten (日天)."

Masahide II (二代 正秀)

This smith was the eldest son of Masahide I; he succeeded his father and changed his name from Sadahide to Masahide when his father began to work under the name Amahide. He also used his lay priest's name, "Suikanshi Nyudo Shirokuma" (水寒子入道白熊), in his signature, so that the entire signature read, "Suishinshi Shirokuma Nyudo Masahide" (水心子白熊入道正秀). Extant works are few, because he died the same year that his father did.

Suishinshi Masatsugu (水心子正次)

This smith is said to be the son of Masahide II, and to have been Taikei Naotane's student; he took over as the head of Masahide's Kawabe family after marrying a daughter of Naotane. He was proficient in all traditions of swordsmithing. He made ko-choji midare with narrow yakihaba in the Bizen tradition, chu-suguha hotsure in the Yamashiro tradition, etc. Honjo Yoshitane sometimes engraved horimono on his blades. Kijimomo-gata nakago can be seen. The yasurime are sujikai. A kao, or monogram, appears with his signature.

Hyoshinshi Hideyo (水心子秀世)

This smith was a student of Suishinshi Masahide's; he also studied under Ishido Unju Korekazu. He married Masahide's daughter and then took the title Hyoshinshi. He forged ko-dachi with kijimomo-gata nakago that he appears to have copied from Koto blades. Hideyo's hamon is hoso-suguha consisting of tight nioi, uniform gunome midare, or notare midare mixed with gunome midare consisting of rough nie. The jigane is weak and the jihada is hardly visible.

Mutsu no Suke Hiromoto (陸奥介弘元)

This smith was a native of Nihonmatsu, Iwashiro province, and studied under Masahide. He used Munetsugu as his smith's name during his early years, then changed it to Hiromoto when he received the title Mutsu no Suke. He was employed by the lord of the Nihonmatsu clan. His jigane is weak and his jihada hardly visible. The hamon is hoso-suguha, ko-choji midare with ashi and tight nioi-guchi or midareba. The yasurime is an unusual gyaku sujikai.

Ikeda Isshu (池田一秀)

This smith was a native of Shonai, Dewa province. He was employed by the lord of the Shonai clan (Lord Sakai), after studying under Masahide. Naokazu (直一) was his student. His jihada is hardly visible and appears to be muji-hada; the hamon is a uniform gunome midare with ashi or suguha with tight nioi-guchi.

THE TAIKEI NAOTANE (大慶直胤) SCHOOL

Naotane (直胤) was born in Yamagata, Uzen province, in 1778, and his birth name was Shoji Minobei. He called himself Taikei. He was not only one of the most talented students of the Suishinshi Masahide school, but also one of the finest swordsmiths of Shinshinto times. His first title was Chikuzen Daijo, and he later received the title Mino no Suke. He was in the employ of Lord Akimoto, and died in 1857, at the age of 79. His school includes Suishinshi Masatsugu, Jiro Taro Naokatsu (次郎太郎直勝), and Yamon Naokatsu (弥門直勝) and Katsuya Naohide (勝弥直秀) (Jiro Taro Naokatsu's sons); Hosoda Naomitsu (細田直光), or Kaji Hei, the well-known forger, was also Naokatsu's student.

Like his teacher Masahide, Naotane favored the reintroduction of old methods of swordmaking over modern practicality, and he put this theory of fukkoto into practice. He started with toran-midare, then began to make choji midare in the Bizen tradition, masame-hada in the Yamato tradition, gunome midare mixed with togari-ba in the Mino tradition, o-midare in the Soshu tradition, and chu-suguha in the Yamashiro tradition. He was quite successful in all traditions and styles, and especially in the Bizen and Soshu. He does not appear to have attempted the o-choji midare of the Ichimonji school, but there is no doubt that he studied Koto

blades closely, as clear utsuri appears on blades in which he imitates Nagamitsu, Kagemitsu, and Oei Bizen. He was clearly the most outstanding Shinshinto swordsmith to work in the Bizen tradition.

The workmanship of Naotane is described below:

Bizen tradition

The hamon is in nioi deki and ko-choji midare with a tendency to slant; it resembles the work of Nagamitsu and Kagemitsu. Utsuri appear. There are also kataochi gunome resembling the work of Kanemitsu, and copies of Morimitsu and Yasumitsu. But Naotane's nioi-guchi is not tight, and hard, dark spots can be seen in the yakigashira. The jigane is weak.

Yamashiro tradition

The hamon is chu-suguha with tight habuchi and few nie.

Soshu tradition

Imitations of late-Kamakura blades and of the suriage sugata of the Nanbokucho period. The jihada is itame-hada mixed with o-hada and unique uzumaki-hada. The nie kuzure, sunagashi, kinsuji, and inazuma are vigorous. The nie are rough and the nioi guchi is not tight. The inside of the hamon is misty and there are not a lot of nie. The patterns of the hamon and the boshi correspond to those of old Koto blades, but the hamon is mixed with koshi-no-hiraita midare, and there are hard, dark spots in the yakigashira.

Tanto: There are hira-zukuri ko-wakizashi in the Enbun–Joji (1356–1368) style, similar to those seen in Dewa Daijo Kunimichi, as well as tanto in a standard style, similar to those of the Masamune school; tanto in the Rai Kunitoshi style (standard length uchi-zori) with chu-suguha or hoso-suguha are occasionally found. The jihada is generally mixed with masame-hada.

Horimono: Honjo Yoshitane is said to have engraved Naotane's blades. Various kinds of horimono can often be seen, including dragons, ken-maki-ryu, suken, dokko, bonji, and the names or figures of Shinto gods and Buddhist deities. Horimono embossed in the groove are also common. The engraving is very elaborate and precise, and matches the blades well.

Nakago: A plump nakago; kurijiri, and sujikai yasuri with kesho yasuri. The signature is skillfully and smoothly done, but the thickness of the characters varies during Naotane's lifetime. Tachi-mei are found. A monogram and a hallmark (stylized rendering of the name of the place in which he actually made the blade) are often added to the signature.

Jiro Taro Naokatsu (次郎太郎直勝)

This smith called himself Kazusa Shiro and became Naotane's student. He married a daughter of Naotane and was then employed by Lord Akimoto. He died just a year after Naotane's death, at the age of 54. His main style was Soshu- and Bizen-tradition blades and he was a skilled smith. Unlike other smiths of the Suishinshi school, his jigane is not weak. The hamon is a midareba consisting of thick nie in the Soshu tradition, kataochi gunome imitating Kanemitsu in nioi deki, saka-choji midare, ko-choji midare, chu-suguha in the Yamashiro tradition, etc. He always signed his katana with tachi-mei.

Yamon Naokatsu (弥門直勝)

The eldest son of Jiro Taro Naokatsu, he died in 1884 at the age of 50. His blades have a wide mihaba and relatively large kissaki. The jigane is weak. The hamon is kata-ochi gunome, ko-choji midare with a tendency to slant, or suguha in the Yamashiro tradition.

HOSOKAWA MASAYOSHI (細川正義) AND THE SA YUKIHIDE (左行秀) SCHOOL

Masayoshi (正義) was the son of Hosokawa Ryosuke of Kanuma, Shimotsuke province. It is said that during his early years he was employed by Lord Toda of Utsunomiya and that he used a different character for "yoshi"

in his name at that time. After having studied under Suishinshi Masahide, he succeeded his father as Masayoshi; prior to this he also used Morihide as a smith's name. He was later employed by Lord Matsudaira of the Tsuyama clan of Mimasaka province, and often added the phrase "Sakuyo Bakka Shi" (Retainer of the Tsuyama clan of Mimasaka) to his signature, but he did most of his work for Matsudaira while resident in Edo. After Naotane, he was the best of the Suishinshi smiths; he died in 1858 at the age of 75. His school includes Hosokawa Masamori (細川正守), Hosokawa Masanaga (細川正長), Jokeishi Masaaki (城慶子正明), Kishinmaro Masatoshi (鬼晋麿正俊), Fujieda Taro Teruyoshi (藤枝太郎英義), Ikkansai Yoshihiro (一貫斎義弘), Shimizu Hisayoshi (清水久義), Fuji Yoshimune (富士義宗), Tada Masatoshi (多田正利), Iwai Yukihide (岩井行秀), and Hasebe Yoshishige (長谷部義重). His second son Tadayoshi (忠義) and nephew Yoshinori (義規) were employed by the Sakura clan in Shimofusa province. Sa Yukihide (左行秀) was Shimizu Hisayoshi's student.

In his early years he favored copying the Osaka Shinto style, such as toran-midare, and he occasionally collaborated with his teacher Masahide (using the name Morihide), but during his later years he was attached to the Bizen and Soshu traditions. He produced mainly tachi and katana, but tanto are occasionally found.

The workmanship of Hosokawa Masayoshi is described below:

Bizen tradition
Blades are long, with a deep sori and funbari. Bo-bi with soe-bi or tsurebi are common. The jihada is a dense ko-mokume hada. The hamon is choji midare with wide yakihaba and long, crowded ashi, and consists of tight nioi. Dark, hard spots can at times be seen in the yakigashira.

Soshu tradition
Blades imitated the o-suriage sugata of the Nanbokucho period and have relatively large kissaki, fukura that are not rounded, thick kasane, and full hira-niku. Bo-bi with soe-bi are also seen. The jihada is coarse o-itame hada with plentiful ji-nie and glittering chikei. The hamon is o-midare consisting of rough nie, but the habuchi is loose. Dark, hard spots can be seen here and there. Hahada is visible, and sunagashi and inazuma are vigorous inside the hamon. The boshi is a small-patterned midare komi.

Nakago: A long nakago with sori. The signature is tachi-mei. The yasurime are orderly, thick, and crisp sujikai with kesho yasuri; in other words, each stroke of the file results in only one file mark (rather than the usual several marks). He generally added a hallmark to his signature, as had his teacher Masahide.

Hosokawa Masamori (細川正守)
This smith is Masayoshi's eldest son. Like his father, he was employed by the lord of the Tsuyama clan of Mimasaka province. He favored the Bizen tradition and his workmanship is similar to his father's, but unequal to it in skill.

Jokeishi Masaaki (城慶子正明)
This smith was also employed by the lord of the Tsuyama clan. He was skilled at the Bizen tradition, adopting the methods of his teacher, and utsuri can be seen. The jigane is relatively strong.

Fujieda Taro Teruyoshi (藤枝太郎英義)
This smith was the son of Gyokurinshi Terukazu (玉麟子英一), and his real name was Fujieda Taro. In his early years he used Haruhiro as his smith's name. After studying under Masayoshi, he was employed by Lord Matsudaira of the Kawagoe clan. When Lord Matsudaira relocated to Maebashi in Kozuke province, he accompanied him. He died in 1876 at the age of 54. Bizen and Soshu traditions can be seen in his work. He produced many tanto. The nakago is relatively slender. Futatsudomoe (two huge commas united so as to make a perfect circle) or oka (cherry blossom) crests are engraved on the nakago.

Sa (no) Yukihide (左行秀)

This smith was born in 1813 in Chikuzen province. His real name was Toyonaga Kyubei and he called himself "the 39th-generation Samonji." He went to Edo in the early Tenpo era and studied under Shimizu Hisayoshi, who was a student of Hosokawa Masayoshi. He moved to Tosa province when he was employed by Lord Yamanouchi. Sekita Shinpei Katsuhiro also worked for Lord Yamanouchi as a swordsmith, and was in charge of the arsenal. He admired Yukihide's work very much, and Yukihide was able to succeed Sekita as the head of the arsenal after his death.

In 1860 Yukihide returned to Edo and began making swords at the branch office of the Yamanouchi clan. In 1868 he returned to Tosa province and changed his name to Toko. He seems to have engaged in swordmaking from 1840 to 1871, based on the dates on his blades.

After the Haitorei decree, which banned the carrying of swords by anyone but policemen and servicemen, his whereabouts are uncertain, but some say that he died in Yokohama or Osaka in 1891 at the age of 79. His students include Yukinao (行直), Hidemasa (秀方), Hidehiro (秀弘), Hidechika (秀近), and Hidetaka (秀隆). But there are few examples of his students' works, because there was so little demand for the Japanese sword after the Haitorei.

In Sa Yukihide's early works the hamon is choji midare consisting of tight nioi with a tendency to slant, and differs little from that of his teacher Shimizu Hisayoshi. But the smith totally transformed his style after his move to Tosa province in 1847.

In this new style, the hamon is notare with o-gunome ashi and consists of very bright and very thick nie (see Figs 160 and 162 on page 228). He seems to attempt to imitate Go Yoshihiro of Koto times, and Inoue Shinkai and Nagasone Kotetsu of Shinto times. He is unrivaled in this style among smiths of Shinshinto times, and is now gaining a fine reputation for the quality of his work.

Sugata: The blades are long, with a shallow sori, a wide mihaba, thick kasane, o-kissaki, and a magnificent sugata. Mitsu-mune is common, and iori-mune and maru-mune can be seen. In addition, there are blades about 70 cm long, with a shallow sori that is slightly saki-zori, and chu-kissaki; these long, uncurved blades are referred to as kinnoto.

Jihada: The jihada is a clear and dense ko-mokume hada with ji-nie, while the jigane is somewhat weak. The jihada is mixed with o-hada and not very visible; alternatively, the jihada is dense and a uniform masame-hada.

Hamon: The hamon consists of thick nioi and nie, and is based on hiro-suguha or wide notare with thick and long gunome ashi. It is beautiful, and there are many vigorous hataraki. There is also o-midare with nie kuzure and sunagashi in the Soshu tradition, but the nie tend to be uneven, and stiff, awkward midare can occasionally be seen.

Boshi: Ko-maru with abundant nie and gunome ashi. The kaeri is long or, occasionally, ichimai boshi.

Horimono: Very rare.

Nakago: A long nakago with kurijiri. The yasurime is sujikai with kesho yasuri.

KATO TSUNAHIDE (加藤綱英) AND THE KOYAMA MUNETSUGU (固山宗次) SCHOOL

Tsunahide (綱英) was born to Kato Kanshiro Kunihide (加藤勘四郎国秀) of the Suishinshi school and employed by Lord Uesugi of the Yonezawa clan. He went to Edo with his younger brother Chounsai Tsunatoshi (長運斎綱俊) and established his own school there. He sometimes used an alternate character for "Hide" in his signature. The brothers were somewhat similar in style, but Tsunahide excelled at toran-midare, while Tsunatoshi was good at choji midare. There are fewer extant works by Tsunahide than by Tsunatoshi.

The school includes Akama Tsunanobu (赤間綱信), who was good at toran-midare, and Koyama Munetsugu (固山宗次), famed for his

Bizen-tradition blades. Tairyusai Sokan (泰龍斎宗寛), Koyama Munehira (固山宗平), Koyama Munetoshi (固山宗俊), Kubota Muneaki (久保田宗明), and Seisosai Muneari (精壮斎宗有) were students of Koyama Munetsugu's.

Tsunahide's workmanship is characterized by hard jigane and jihada that is barely visible. The hamon is toran-midare consisting of thick nioi and nie, which is inclined toward gunome midare. Tama can be seen. The pattern of the toran-midare is regular.

Koyama Munetsugu was born in Shirakawa, Oshu district, in 1803, and his real name was Koyama Sobei. He also called himself at various times Issensai or Seiryosai. He is said to have been a student of Kato Tsunahide's, but his style of workmanship suggests that he learned a great deal from Chounsai Tsunatoshi. He moved to Kuwana with Lord Matsudaira, for whom he worked. Later he also made swords in Owari province. Finally he settled down in Yotsuya Samon-cho in Edo, after frequent trips between Kuwana and Edo. Munetsugu was accorded the title Bizen no Suke in 1845, and died in 1872 in his seventies.

Munetsugu is distinctive in every respect from Minamoto (no) Kiyomaro, who was active during the same period. He had an established reputation as an excellent smith, and made swords for many prominent customers, including Lord Furukawa, the popular sumo wrestler Inazuma Raigoro, master metalworker Goto Hokyo Ichijo, and expert test cutter Yamada Asaemon Yoshitoshi.

Munetsugu was very good at Bizen tradition, and his unique hamon is called Munetsugu choji. He is by no means inferior in skill to Suishinshi Masahide, Taikei Naotane, Hosokawa Masayoshi, Chounsai Tsunatoshi, or Unju Korekazu. Many of his blades bear tameshi-mei describing the results of test cutting, clearly showing that his blades were not only gorgeous, but that their outstanding practicality had been officially acknowledged.

The workmanship of Koyama Munetsugu is described below:

Sugata: There are Osaka Shinto sugata with thick kasane and grand sugata with a shallow sori, a wide mihaba, and relatively large kissaki. There are also many copies of Koto blades.

Jihada: A dense mokume-hada with ji-nie, occasionally mixed with o-hada; the jigane is clear.

Hamon: There are ko-choji midare, kataochi gunome, and small-patterned koshi-no-hiraita midare consisting of thick nioi. In the case of koshi-no-hiraita midare, the yakigashira tends to become choji midare, and the hamon appears crowded.

Boshi: Small-patterned midare komi.

Horimono: Relatively rare. This smith sometimes engraved his own, but his student Sokan usually did the carvings on his blades.

Nakago: The nakago has proper niku, and the nakagojiri is gentle kengyo. The yasurime are sujikai with kesho yasuri in the smith's early years; later they become, first, katte sagari, and then finally kiri. Tachi-mei are occasionally found.

Tairyusai Sokan (泰龍斎宗寛)

One of Koyama Munetsugu's best students. At first he used the name Abukumagawa Sokan, but changed it to Tairyusai Sokan in 1854. His blades have a shallow sori, relatively thick kasane, and a rough sugata. The beautiful and dense jihada looks like muji-hada, and clear utsuri appear. His early hamon are similar to those of his teacher Munetsugu, but afterward the nioi-guchi becomes tighter and the hamon is ko-gunome choji with yakigashira in a level line. Suguha are sometimes seen. He is a skillful engraver, and is said to have done the horimono on the "Koryu Kagemitsu Utsushi" by Munetsugu. Beginning in 1857 he changed the style of his signature from the square style (kaisho-mei) to a classical Chinese writing style (reisho-mei). He died in 1883.

KATO TSUNATOSHI (加藤綱俊) AND THE UNJU KOREKAZU (運寿是一) SCHOOL

Tsunatoshi (綱俊) was a native of Yonezawa, Uzen province, and his real name was Kato Hachiro. He went to Edo with his elder brother Kato Tsunahide and was employed by Lord Uesugi. He called himself Chounsai, and this title was passed on to his son Koretoshi. Later, Tsunatoshi called himself Chojusai Tsunatoshi. Beginning in the Ansei era (1854–1860), he often collaborated with his son. He died in 1862 at the age of 66.

The school includes Tsunatoshi II (二代 綱俊), Ishido Unju Korekazu (石堂運寿是一), Takahashi Naganobu (高橋長信), and Seiryuken Moritoshi (青龍軒盛俊). Sumi Moto'oki II (二代 角元興), Katsumura Norikatsu (勝村徳勝) (or Tokkatsu), Unju Nobukazu (運寿信一), and Unju Toshikazu (運寿俊一) were students of Unju Korekazu's.

Tsunatoshi does toran-midare similar to that of his brother Tsunahide, but he shows himself at his best working in the Bizen tradition. His hamon is ko-choji midare or ko-midare consisting of tight nioi, and hard, dark spots can be seen in the yakigashira. The boshi is a small-patterned midare komi, the jihada is a dense mokume-hada mixed with o-hada and is hardly visible, and the blade is long, with a deep sori, and thick kasane.

Tsunatoshi II (二代 綱俊)

This smith is the second son of Tsunatoshi I; he studied under Seiryuken Moritoshi of Suo province, a student of Tsunatoshi I. In his early years he used Koretoshi as his smith's name, then took over his father's title of Chounsai, and finally took the name of Tsunatoshi after his father's death. He often worked in collaboration with his father, and also made daisaku daimei for his father. He favored toran-midare, as well as the Bizen tradition. On the whole, his work is not equal to his father's.

Unju Korekazu (運寿是一)

This smith was Tsunatoshi I's nephew and the seventh-generation head of the Edo Ishido family; he called himself Unjusai. He was in the employ of the Tokugawa government and seems to have been of high social standing, as was Koyama Munetsugu; among his extant works are blades made for the Ise Shrine and for the famous Edo magistrate Toyama Saemon no Jo. He ranks high among the Shinshinto smiths of the Bizen tradition, and died in 1891 at the age of 75.

Sugata: Blades have a relatively shallow sori, relatively high shinogi, narrow shinogiji, and relatively large kissaki.

Jihada: A dense ko-mokume hada that looks like muji-hada, or ko-mokume hada mixed with o-hada. Jihada, reminiscent of Kiyomaro's, with many chikei can be seen at times.

Hamon: In his early years, produced choji midare consisting of tight nioi similar to Tsunatoshi, and then choji midare consisting of abundant ko-nie with a good deal of hataraki. Soshu tradition may also be seen.

Boshi: Ko-maru or midare komi that turns back. In Soshu-tradition blades, midare komi with hakikake and plentiful nie.

Horimono: Elaborate horimono are occasionally seen.

Nakago: The plump nakago has kurijiri and is skillfully finished. Kijimomo-gata can be seen. The yasurime are o-sujikai with kesho yasuri and with each file stroke making only a single mark.

Takahashi Naganobu (高橋長信)

The real name of this smith was Takahashi Rihei. He was the student of the fifteenth Fuyuhiro of Wakasa province, and was later adopted as the seventeenth Fuyuhiro. After studying under Chounsai Tsunatoshi, he was employed by Lord Matsudaira of Izumo province and worked in Edo. Late in life he returned to his hometown of Matsue, where he died in 1869 at the age of 64. His work-

manship is similar to that of his teacher Tsunatoshi. His blades have a grand sugata, and he favored the Bizen tradition. The jigane is weak and the jihada hardly visible; occasionally the jihada tends toward masame-hada. The hamon is ko-choji midare inclined to be oblique, and hard, dark spots can be seen in the yakigashira. He also made blades with suguha and toran-midare. He is thought to have been left-handed, because his yasurime is gyaku sujikai. He sometimes signed his blades in the square style (kaisho-mei) on the omote (front), and also in the cursive style (gyosho-mei) on the ura (back).

Seiryuken Moritoshi (青龍軒盛俊)

This smith's real name was Iwamoto Seizaemon. He was in the employ of Lord Kikkawa of the Iwakuni clan, but left Iwakuni for Edo to study under Chounsai Tsunatoshi. At first he called himself Seiryusai, then changed his name to Seiryuken. After his return to Iwakuni, he taught Koretoshi, who later became Tsunatoshi II. Most of his works are in the Bizen tradition, but the hamon is gunome midare rather than choji midare. The pattern is relatively small, and the hamon has little hataraki. Suguha and Mino-tradition blades in imitation of Kanemoto can be seen at times. The nakago of his early years has a gentle kurijiri and kesho yasuri. Later, the nakagojiri becomes a steep ha agari kengyo, and the yasurime are generally kiri. Senryushi Morihide (潜龍子盛秀), who produced a large-patterned gunome midare, was his student.

THE MINAMOTO (NO) KIYOMARO (源清麿) SCHOOL

Kiyomaro (清麿) was a native of Komoro, Shinano province, and born the second son of the Yamaura family. He was called Tamaki in his childhood and his real name was Yamaura Kuranosuke. He changed his smith's name many times, as follows: first to Ikkansai Masayuki, then to Hidetoshi, then to Tamaki, back to Masayuki, and finally to Kiyomaro. After learning swordsmithing from his elder brother Saneo (or Masao) (山浦真雄), he apprenticed himself to Kawamura Toshitaka (河村寿隆), who was in the employ of the Ueda clan of Shinano province.

In about 1835, he went to Edo and began swordmaking with the support of Kubota Sugane, a direct retainer of the shogun. Even at that time, Masayuki was already bringing his genius into full play. In 1840 Kubota Sugane secured one hundred orders on his behalf, but only one of the blades, to be called "Buki Ko," seems to have been completed—just one blade inscribed "Buki Ko Ichi Hyaku No Ichi" (The first blade of one hundred Buki Ko) has been found thus far. The next year he ran away to Nagato province. The reason for his hasty departure is unknown, but it is believed that he had realized the impossibility of fulfilling the contract for the Buki Ko within the specified time, and believed that he had disappointed and betrayed his patron Kubota Sugane. In 1845 he returned to Edo and settled down in Yotsuya Iga-cho. The following year he changed his name to Kiyomaro. Following his time in Choshu (or Nagato province), his style changed completely, and he was given the name Yotsuya Masamune, because of his vigorous, gorgeous workmanship. In 1854 he committed suicide at the age of 42.

Kiyomaro is reputed to be the greatest smith of Shinshinto times, and ranks with Kotetsu of Shinto times. It is obvious that he was influenced by Shizu Kaneuji and Samonji, and he made a few faithful copies of the blades of these smiths. He took great pains to develop his own style. His students were also skilled smiths and can be recognized from common features in their blades. This school includes Kurihara Nobuhide (栗原信秀), Saito Kiyondo (斎藤清人), Suzuki Masao (鈴木正雄), his elder brother Yamaura Masao (or Saneo), and Kanetora (兼虎) (Yamaura Masao's son) of Shinano province. Hayama Enshin (羽山円真) was Suzuki Masao's student, and was active until about 1910.

Sugata: Apart from his early works, which have a standard sugata similar to that of other smiths of the period, his blades are relatively long, over 72 cm, with shallow saki-zori, relatively thin kasane, a wide mihaba, and o-kissaki with a fukura that is not full; overall, the blade appears very sharp. Among the tanto which he forged are a copy of a Samonji blade with a relatively short nagasa, and longer tanto, of about 27 cm, with a little sori, a relatively narrow mihaba which is not in proportion to the length, and thick kasane. There are also shobu-zukuri, u-no-kubi zukuri, osoraku-zukuri, nagamaki, nagamaki naoshi zukuri, and yaki.

Jihada: In his early works, the jihada is a beautiful ko-mokume hada; afterward, it becomes mokume-hada or mokume-hada mixed with masame-hada with ji-nie and chikei. The later jigane is relatively soft but still strong, and similar in its vigor to Koto blades.

Hamon: Ko-choji midare in nioi deki, and a hamon similar to that of his teacher Kawamura Toshitaka is to be found in his early works. After the change of his name to Masayuki, gunome midare becomes a common feature of his work; this consists of rough nie, looks gorgeous, and has a good deal of hataraki such as nie kuzure, sunagashi, and thick kinsuji. Beginning in 1844, his work includes o-gunome midare and o-midare with wide yakihaba consisting of thick nioi, which at a glance look as though they are based on suguha or notare, since the pattern is crowded and the midare are very close to each other. Small lumps of ara-nie can be seen scattered in the yakigashira. There are many long nioi ashi, some of which extend to the cutting edge. Thick, shiny, and snaking lines which look like kinsuji appear from the habuchi, extending to inside the hamon. There is also gunome midare mixed with choji midare, with ashi and yo, consisting of bright and thick nioi; some are by no means inferior to old Koto blades.

Boshi: Ko-maru with gunome ashi and proper turn-back, occasionally with a tapered boshi that creeps up toward the munesaki in imitation of Samonji, or Shizu Kaneuji.

Horimono: Occasionally, bo-bi or futasuji-bi are seen.

Nakago: The carefully finished nakago has kurijiri and sujikai yasuri. The signature is chiseled thickly, powerfully, and skillfully.

Kurihara Nobuhide (栗原信秀)

Nobuhide was born in Echigo province. He went to Kyoto and became a mirror-maker. In 1850, at the age of 35, he became one of Kiyomaro's students. After a two-year apprenticeship, he went into business on his own. His skill at forging steel was probably acquired before he met his teacher, and made it possible for him to leave Kiyomaro's workshop so quickly. In 1865 he received the title Chikuzen no Kami in Kyoto. It is known that he made some blades in Osaka two years later, as he left signed and dated blades. Early in the Meiji period, he also worked in his hometown of Sanjo in Echigo province. It is reported that he resumed his previous business as a mirror-maker after the decree of the Haitorei in 1876. He died in 1881, at the age of 66.

Blades of Nobuhide's have been found that date from 1855 through 1878. He was the most proficient of Kiyomaro's students, and his skill was equal to that of his teacher. He is sometimes superior to his master in the quality of the hataraki inside the hamon, but is not his teacher's equal in jigane. He is without doubt one of the best horimono engravers of Shinshinto times.

Sugata: Blades have a relatively wide mihaba, slight saki-zori, and relatively large kissaki with a fukura that is not full. In addition to shinogi-zukuri katana, shinogi-zukuri wakizashi, hira-zukuri ko-wakizashi, and hira-zukuri tanto, his work includes kiriha-zukuri katana, shobu-zukuri tanto, and osoraku-zukuri tanto.

Jihada: A dense ko-mokume hada with ji-nie and chikei. The jigane is relatively soft but strong, and is second in quality only to Kiyomaro's.

Hamon: Gunome midare in nioi deki. His koshi-no-hiraita midare with squarish yaki-

gashira is very similar to that of Kiyomaro. In his early work, the gunome midare is inclined to be crowded in a small pattern; later it becomes a larger pattern with a good deal of nie. There are many hataraki such as suna-gashi and kinsuji. Suguha can be seen at times.

Boshi: Small-patterned midare komi with turn-back. The tip tends to be tapered.

Horimono: In addition to traditional designs, there are various new designs reflective of the times, such as Ame-no-Uzume no Mikoto (a female Shinto deity), cherry blossoms, and Japanese poems. In particular, designs become more elaborate early in the Meiji period. After that time, deep engraving and embossing can be seen.

Nakago: His relatively long nakago is carefully finished. The nakagojiri is a relatively wide kurijiri. The yasurime is katte sagari without kesho yasuri.

Saito Kiyondo (斎藤清人)

Kiyondo was a native of Shonai in Dewa province, and his real name was Saito Ichiro or Koichiro. In 1852 he went to Edo and became one of Kiyomaro's students. He had studied under Kiyomaro just one-and-a-half years before his teacher committed suicide. But despite his short apprenticeship, he successfully mastered his teacher's techniques and art. He applied the proceeds from thirty of his own blades to clear the debts left by his teacher. He was given the title Buzen no Kami in 1867, and retired in 1871. He returned to his hometown and worked in the hotel business, which had been run by his father-in-law. Kiyondo died in 1902, at the age of 75.

Sugata: Blades are long, with shallow sori, relatively wide mihaba, and o-kissaki. Kanmuri-otoshi-zukuri tanto can be seen at times.

Jihada: The dense mokume-hada is not readily visible. The jigane is weaker than that of Kiyomaro and Nobuhide. Masame-hada of the Yamato tradition can be found in his later works.

Hamon: Generally, uniform gunome midare consisting of fine nie, but nie and mura nie can be seen sporadically. There are few hataraki inside the hamon. Hiro-suguha, chu-suguha, and o-notare are also found.

Boshi: Bo-bi are rarely seen. Occasionally suken and bonji can be seen on the tanto.

Nakago: The relatively long nakago has a rather wide kurijiri. The yasurime are katte sagari.

Suzuki Masao (鈴木正雄)

Masao was a native of Mino province whose real name was Suzuki Jiro. He seems to have been a senior student in the Kiyomaro school and to have started sword production around 1853, according to the earliest dates given on his blades. He worked briefly in Hokkaido (Japan's northernmost island), and then returned to Edo and retired in 1865. His blades have a wide mihaba and a stout sugata. The jihada is a dense mokume-hada mixed with masame-hada. The hamon is gunome choji midare with uneven nie and many kinsuji, and the valleys of the midare are generally close to the cutting edge. He signed his blades with a three-character signature in the square style, "Minamoto Masa O" (源正雄), like Yamaura Masao. He also wrote a two character signature in a very rounded, cursive style.

Yamaura Masao (or Saneo) (山浦真雄)

Masao was nine years older than his brother Kiyomaro, and worked full-time producing blades in Shinano province. His changed his first name several times, as did other smiths including Masatoshi, Zendayu, and Noboru. Like his brother, he began his study under Kawamura Toshitaka, but left after two years and traveled widely in search of his own approach to swordmaking. He changed his smith's name several times beginning in 1851, from Tennenshi Masatoshi to Toshimasa, to Masao (正雄), and to Masao/Saneo (真雄), finally calling himself Toshinaga in his later years. He took as titles Yushaken and Yu-unsai, and sometimes added "Shin Yo Shi" (Native of

Shinano province) to his signature. Masao was employed by Lord Sanada of the Matsushiro clan, and is said to have had seventeen students, including his heir Kanetora (兼虎). The solid reputation of his swords was established when he passed a unique and merciless cutting test done by the Sanada clan. He died in 1875, at the age of 71.

Sugata: His katana are between 69 and 72 cm in length, with the occasional longer blade. Blades have a shallow sori, a wide mihaba, o-kissaki, and thick or thin kasane. Masao is also said to have produced many naginata, but these are quite rare today.

Jihada: Dense ko-mokume hada mixed with o-hada and with fine ji-nie. The jigane is rather strong.

Hamon: Ko-choji midare and ko-gunome midare can be seen among his early works. Afterward, he shifted to gunome midare in nie deki, which is similar to Kiyomaro's, though Masao's is mixed with notare. In later works, notare midare is common, and this is occasionally mixed with stiff, tapered midare.

Boshi: Small-patterned midare komi or, occasionally, ko-maru. The tip of the boshi tends to be tapered.

Horimono: Bo-bi are rarely seen.

Nakago: Well-finished nakago has gentle ha agari kurijiri and sujikai yasuri. In general, the signature on the omote is written in a square style, while additional inscriptions and the date on the ura is done in a cursive style.

Yamaura Kanetora (山浦兼虎)
Kanetora was born the eldest son of Yamaura Masao in 1824. While a student of kenjutsu in the Jikishinkage tradition in Edo, he decided to become a swordsmith, and apprenticed himself to his uncle Kiyomaro. After returning to his hometown, he was employed by Lord Sanada and became a retainer of the Matsushiro clan. Kanetora took the title Jikishinsai, and frequently collaborated with his father, but he was not equal to Masao in skill.

The jihada is a mokume-hada mixed with slight masame-hada. The hamon is gunome midare or suguha with ara-nie.

SWORDSMITHS OF OSHU (奥州) DISTRICT
(Iwaki, Iwashiro, Uzen, Ugo, Rikuzen, Rikuchu, and Mutsu provinces)

Tegarayama Masashige (手柄山正繁)
Masashige was the fourth-generation Tegarayama Ujishige, who lived at the bottom of Mount Tegara in Settsu province. He used Ujishige as his smith's name in his early years, then changed this to Masashige when he was employed by Lord Matsudaira of the Shirakawa clan in 1788. He took the title Tangasai when he became a monk (his father, Tanga Nyudo II, was also a monk). The third-generation Ujishige (氏繁) was his elder brother. Masashige was given the title Kai no Kami in 1801, and presented at that time with the two characters "Shin Myo" (神妙) (Highest Admiration) by Lord Matsudaira Rakuo. It is said that he added these two characters to the signature only to blades which met his own rigorous standards.

He was active from 1789 through 1831, when he was 71 years old. Although most of his sword production was done in Edo, for convenience he is classified here as an Oshu smith. He is also said to have studied under Suishinshi Masahide. Toran-midare, one of the most popular hamon in early Shinshinto times, was his favorite hamon.

Sugata: Katana and wakizashi are the main areas of production. Tanto are rare. His blades have thick kasane, hira-niku which is not full, and relatively large chu-kissaki. There are both gentle sugata with a narrow mihaba and grand sugata with a wider mihaba.

Jihada: Beautiful and fine jihada that is barely visible. The jigane is somewhat weak.

Hamon: Toran-midare with abundant, bright nie, in imitation of Sukehiro. Dark, hard spots can be seen in the yakigashira, similar to those seen in blades of other Shinshinto smiths; the

nie are rougher in the yakigashira, and spill over into the ji. His toran-midare does not have as smooth and rhythmical a pattern as that of Sukehiro, and it is mixed with hard togari-ba and square midare. Some sunagashi can be seen in his work. There are also o-gunome midare, notare midare, and suguha.

Boshi: Generally ko-maru.

Horimono: Various designs are elaborately and skillfully engraved.

Nakago: As in the work of Sukehiro, the nakago has no sori, and it is gentle ha agari kengyo. The yasurime are sujikai with unique kesho yasuri.

Later Kunikane (後代国包)

This school has a long tradition which began with the founder Yamashiro Daijo Kunikane, but there are few extant works of any of the first eleven generations, active between 1688 and 1780. The real name of the twelfth Kunikane was Hongo Genbei. He went to Edo and apprenticed himself there to Taikei Naotane. Thus far, blades produced between 1816 and 1849 have been authenticated. The real name of the thirteenth Kunikane was Hongo Eisuke; he succeeded as head of the family in 1848, and died in 1871 at the age of 61. These smiths forged masame-hada and adopted the Yamato as their tradition, but were inferior to the first and second generations in skill.

Toryo Nagamichi (棟梁長道)

This smith is either the sixth or the ninth generation to follow Miyoshi Nagamichi I. Nagamichi is generally referred to as Toryo Nagamichi, because he usually signed his blades "Mutsu Aizu Ju Katana Kaji Toryo Nagamichi" (陸奥会津住刀鍛冶棟梁長道), which means "Nagamichi, the master of swordsmiths living in Aizu in Mutsu." He died in 1889 at the age of 70. He primarily produced shinogi-zukuri katana with normal sugata. The jigane is strong and the jihada is a dense mokume-hada, occasionally mixed with masame-hada. The hamon is gunome midare or suguha with ashi and sunagashi in nie deki. The yasurime on the nakago are kiri.

Izumi no Kami Kanesada (和泉守兼定)

The eleventh- and twelfth-generation Kanesadas, whose ancestor moved from Mino province to Aizu in Iwashiro province at the close of the Sengoku period, were active in this period. The twelfth generation (Izumi No Kami Kanesada) was a better smith than the eleventh (Omi No Kami Kanesada) had been. The twelfth received the title Izumi no Kami in 1863, and then changed his name from Kanemoto to Kanesada. He used the same choice of character for "Sada" (定) as had the Koto smith Izumi no Kami Kanesada. He also worked briefly in Echigo province, and died in 1904, at the age of 67. His jigane is ko-mokume hada, masame-hada, or o-hada gitae; masame-hada is noticeable in the shinogiji. The hamon is gunome midare or suguha in nie deki. Kanetomo (兼友), who was supposedly Unju Korekazu's student, also comes from this family.

Sumi Moto'oki (角元興)

Moto'oki was born in Aizu, Iwashiro province, and his real name was Sumi Daihachi. He first learned swordsmithing from the fourth Michitoki (四代 道辰) of the Nagamichi school, using Hidekuni or Michinobu as his name. Afterward, he went to Edo to study under Suishinshi Masahide. In 1792 he traveled to Satsuma province to learn the Soshu tradition from Yamato no Kami Motohira, and changed his name to Moto'oki. He was employed by Lord Matsudaira of the Aizu clan and then accorded the title Kaji Toryo (master smith) by him; he died in 1824 at the age of 71. In his early works, the sugata is similar to that of Suishinshi Masahide, but after his return from Satsuma, his blades could be seen to have a grander, stout sugata similar to that of Satsuma blades, with a long nagasa, a shallow sori, a wide mihaba that is not tapered, and relatively large kissaki. The jigane is weak and the jihada is barely visible. The hamon is gunome midare, notare midare, or hiro-suguha in nie deki.

Shoken Moto'oki (松軒元興)

Moto'oki was a grandson of Sumi (Daihachi) Moto'oki, and his real name was Sumi Daisuke. He is called Shoken Moto'oki because he adds his lay priest's name, Shoken, to his signature in order to distinguish himself from Sumi Moto'oki. He learned swordmaking from his grandfather and from Michitoki, because his own father, Hidekuni (秀国), died when he was still young. In about 1860 he went to Edo to study under Unju Korekazu, and a few collaborations by those two smiths have survived. Moto'oki received the title Yamato no Kami in 1867, and changed his name to Hidekuni (秀国), the name his grandfather used early in his career. He died in 1892.

Shoken Moto'oki was the finest of the Shinshinto Aizu smiths. He created a sugata that was similar to that of his teacher Korekazu, and his blades have a wide mihaba, relatively large kissaki, and a well-balanced sugata. The jigane is not as strong as Korekazu's, but he reproduces his teacher's style even here, as the hamon is choji midare consisting of nie. In addition, there are notare midare and suguha. He is competent in both the Bizen and Soshu traditions.

SWORDSMITHS OF MITO (水戸) (HITACHI PROVINCE)

Ichige Norichika (or Tokurin) (市毛徳鄰)

Norichika was born in 1777, and his real name was Ichige Genzaemon. He began to study swordsmithing under Kume Naganori, a retainer of the Mito clan, when he was eighteen years old, and later founded his own school. He also studied under Ozaki Suketaka of Osaka. In 1809 he was employed by the Mito clan, and he was given the title Omi no Kami in 1830. He died in 1836 at the age of 59.

He was the best of the Mito smiths. Examples of his tanto are rare. His sugata and nakago are similar to those of his teacher Suketaka. The jihada is a dense ko-mokume hada with ji-nie, but is barely visible. The hamon is toran-midare, o-gunome midare, or suguha with gunome ashi consisting of thick, bright nie. This smith is superior to his teacher Suketaka

in toran-midare, and occasionally rivals that of Sukehiro in the degree of perfection. His boshi is ko-maru. He was followed by a second generation, and Norimune was his student.

Naoe Sukemasa (直江助政)

Sukemasa was born in 1765, and his real name was Naoe Shinpachi or Shinzo. He studied under Ozaki Suketaka and was later employed by the Mito clan, from whom he received the title Omi no Kami in 1830. He died in 1835 at the age of 70. He ranks second, after Norichika, in skill among the Mito smiths. His blades have a sugata which is similar to Suketaka's. His jigane is strong and his jihada is a dense mokume-hada with ji-nie. The hamon is notare midare or chu-suguha consisting of thick, even nie, and is reminiscent of the Shinto smith Inoue Shinkai. The family was continued by Suketomo (助共), Suketoshi (助俊), and Sukenobu (助信).

Katsumura Norikatsu (or Tokkatsu) (勝村徳勝)

Norikatsu was born in Mito, Hitachi province, in 1809 and his real name was Katsumura Hikoroku. He first learned swordmaking from Kannai Norimune, and then went to Edo to study under Unju Korekazu and Hosokawa Masayoshi. In 1817 he moved, together with his students, to a branch office of the Mito clan in Edo, where he worked producing swords. He died in 1872 at the age of 64. The school includes Norikatsu Masakatsu (正勝), Nagakatsu (長勝), and Yoshikatsu (義勝).

Blades have a shallow sori, thick kasane, larger kissaki, and a grand sugata. The jihada is visible masame-hada of the Yamato tradition with ji-nie. The hamon is in nie deki and ko-midare, notare midare, or suguha with nijuba and uneven nie. The boshi is midare komi, hakikake, etc.

Rekko (Mito Nariaki) (烈公)

Tokugawa Nariaki, who was the ninth lord of the Mito clan, engaged in swordsmithing assisted by Katsumura Norikatsu, Naoe Sukemasa, and Sukemasa's son Suketomo. The jihada is the so-called yakumo-hada, in which

the wavy, large grain is quite visible, and composed of a dark, shiny steel. The unique forging style is known as yakumo gitae. Nariaki did not sign his blades but instead inscribed them with a decorative design of a chrysanthemum and a clock.

In addition, Chikanori (近則) (who studied under Taikei Naotane and was in the employ of the Mito clan), Yokoyama Sukemitsu (横山祐光), and Kannai Norikane (関内徳兼) were active in the province during this period.

SWORDSMITHS OF OSAKA (大坂) (SETTSU PROVINCE)

Ozaki Suketaka (尾崎助隆)
Suketaka was born in Harima province in 1753, and his real name was Ozaki Gengoemon. He studied under Kuroda Takanobu (黒田鷹諶), who moved from Harima province to Osaka. In 1798 he received the title Nagato no Kami, and he died in 1805 at the age of 53. The school includes his son Takashige (隆繁), his grandson Masataka (正隆), Ichige Norichika (or Tokurin), Naoe Sukemasa, and others. Suketaka consistently produced traditional Osaka Shinto toran-midare. This was at just the time that Suishinshi Masahide and Tegarayama Masashige were working with toran-midare, and there is evidence to suggest, as an interesting historical note, that these two smiths were influenced by Kamata Matae's great admiration of Sukehiro.

Sugata: Blades have a shallow sori, thick kasane, full hira-niku, and relatively large chu-kissaki. The sugata is not as refined as Sukehiro's.

Jihada: Dense but barely visible—in other words, muji-hada.

Hamon: There are toran-midare, gunome midare, and suguha. Toran-midare consists of rough and uneven nie; hard, dark spots can be seen in the yakigashira, and the tama are not uniform in shape. There is long suguha yakidashi.

Boshi: Standard ko-maru.

Horimono: Occasionally dragons, plum blossoms, and a spray of plum leaves.

Nakago: The tip is iriyamagata. The yasurime is o-sujikai with kesho yasuri.

Ozaki Masataka (尾崎正隆)
Masataka was Takashige's son and Suketaka's grandson, and took the name Tenryushi. In his early years he worked in Osaka and later moved to Kyoto; he also assisted Chigusa Arikoto (千種有功) in swordmaking. Among his work there are toran-midare and Fujimi Saigyo. Hayami Chikukansai Yoshitaka (逸見竹貫斎義隆) was one of his students. Unfortunately, Yoshitaka's career began after the Haitorei decree, so that there are not many extant works. Incidentally, his jigane is strong and his hamon is gunome midare or suguha in ko-nie deki, and he is a skillful engraver.

Gassan Sadayoshi (月山貞吉)
Sadayoshi was a native of Dewa province and a descendant the Gassan school of Koto times. He went to Edo to study under Suishinshi Masahide, then moved to Osaka around 1833, and died in 1870 at the age of 90. His jihada include the ayasugi-hada of the Gassan school, masame-hada of the Yamato tradition, and dense mokume-hada. His hamon include chu-suguha in nie deki, small-patterned choji midare, koshi-no-hiraita midare, etc. It is said that his son Sadakazu created a number of daisaku daimei for him in later years—in other words, Sadakazu produced swords himself but signed the blades with his father's name.

Gassan Sadakazu (月山貞一)
Sadakazu was born in Omi province in 1836 and his real name was Yagoro. He was adopted as Gassan Sadayoshi's heir when he was seven years old. At various times he took the names Unjusai, Kokensai, and Suiyushi. In 1907 he was nominated as Teishitsu Gigei In (Craftsman authorized by the Imperial court; a title equivalent to today's Living National Treasure), and he died in 1918 at the age of 84.

One blade which he made at the age of fourteen has been confirmed. His career as a

swordsmith spanned more than seventy years, including even the ill-starred years after the Haitorei. He was familiar with all sword-smithing traditions and was especially good at the Soshu and Bizen traditions. He was also one of the best engravers of Shinshinto times, and his horimono are admired as much as those of Honjo Yoshitane and Kurihara Nobuhide. If Suishinshi Masahide was the forerunner of Shinshinto times, then Gassan Sadakazu can be said to be the period's last smith. His role was to hand down the traditional methods of swordmaking to gendaito smiths.

Sugata: His blades have a long nagasa, a shallow sori, a wide mihaba, chu-kissaki or o-kissaki, and a grand sugata. There are also sugata in the style of the early Muromachi period. Around the Keio era, his sugata tends to become very grand. He made many copies of Koto blades.

Jihada: Ayasugi-hada of his own school's tradition, masame-hada of the Yamato tradition, mokume-hada, ko-mokume hada, itame-hada, etc. Various jihada can be seen, each appropriate to the tradition of a particular blade.

Hamon: Skillful choji midare consisting of nioi with narrow yakihaba and long nioi ashi, copied from Oei-Bizen smiths; ko-choji midare consisting of ko-nie; chu-suguha hotsure of the Yamashiro tradition; or gunome midare of the Soshu tradition consisting of thick nioi and nie with a good deal of hataraki.

Boshi: Ko-maru, midare komi, yakitsume, etc.

Horimono: These include various designs such as dragons, plums and dragons, ken-maki-ryu, waterfalls, and Fudo Myoo, bonji, etc. All are engraved elaborately and skillfully, and occasionally resemble work of Ikkanshi Tadatsuna.

Nakago: His long nakago has kurijiri, and the yasurime are sujikai with kesho yasuri. The nakago is carefully finished with ippon yasuri. A unique hallmark was added to his signature between the Keio and the Meiji eras.

THE BIZEN YOKOYAMA (備前横山) SCHOOL

The Shinshinto Yokoyama family began with Sukehira (祐平). He was the fifth generation after Sazaemon Sukesada, and the younger brother of the fourth-generation Gengoro Sukesada. In his early years he used the name Sukesada, changed it later to Sukehira, and still later received the title Ise no Kami. It is unusual that, as a Bizen smith, Sukehira learned the Soshu tradition from Motohira of Satsuma province. Sukehira's work in the Soshu tradition is thus similar to his teacher's, with abundant nie seen at times.

Sukehira's second son, Sukenaga, succeeded as head of the Sukehira family because the eldest son became head of the Sukemori (祐盛) family. Sukenaga received the title Kaga no Suke, and was the finest smith of this school. Sukenaga added to his signature on the nakago the Chinese character "Ichi" (one [一]) and the phrase "Tomonari 56 Dai Mago" (友成五十六代孫) (56th generation from Tomonari). Sukesada, Sukenari, and Sukenori also added this same inscription to their signatures. There is another Sukenaga as well, who added the phrase "Tomonari 57 Dai" to his signature.

Sukekane and Sukeyoshi added "Tomonari 58 Dai Mago" (友成五十八代孫) to their signatures; a number of works by the former are extant. Sukekane (祐包) was adopted by Sukeyoshi (祐義), Sukenaga's elder brother, whose real name was either Shunkichi or Shunzaemon. Sukekane was a relatively skillful smith, who at times forged suguha. Miyamoto Kanenori (宮本包則) was his student, and was nominated as Teishitsu Gigei In (equivalent to the present Living National Treasure) in 1907, along with Gassan Sadakazu.

This school also includes among its members Sukakane II (二代 祐包), Sukeyoshi (祐芳), Suketaka (祐高), Sukenao (祐直) (Sukehira's younger brother), Sukenobu (祐信), and Sukesada (祐定) of the main family. There were many smiths who used the character "Suke" (祐) in their smith's name, since this was a tradition of the Osafune school.

The workmanship of the school is described below:

Sugata: Blades have a narrow and tapering mihaba, relatively small kissaki, scarce hiraniku, thick kasane, and an Oei-Bizen sugata.

Jihada: Dense ko-mokume hada is barely visible, but is mixed with o-hada.

Hamon: Consisting of tight nioi, a kobushigata choji midare similar to that of Naka Kawachi Kunisuke; or a unique choji midare composed of crowded blossoms. The yakihaba is narrower, and the pattern smaller, than those of Kunisuke II. Yakidashi similar to Osaka yakidashi can be seen.

Boshi: Small-patterned midare komi, with short kaeri.

Horimono: Bo-bi with tsurebi is seen occasionally.

Nakago: The tip is ha agari kurijiri and the yasurime is katte sagari.

THE HAMABE (浜部) SCHOOL

Hamabe Toshinori (or Jukaku) (浜部寿格)
Toshinori lived in Tottori, Inaba province, and used Kaneyoshi as his smith name during his early years. He received the title Mino no Kami in 1785 and died in 1810 at the age of 66. His jihada looks like muji-hada. His hamon is gunome midare, which looks like toran-midare, mixed with choji or kobushigata choji midare, in imitation of Naka Kawachi Kunisuke. His nioi-guchi is tight.

Hamabe Toshizane (浜部寿実)
Toshizane was Toshinori's son; he used the name Toshikuni during his early years. He took the name Minryushi and is said to have engaged in sword production with his father, at about the time of the Kansei era (1789–1800). His workmanship is similar to his father's, but his hamon is more picturesque.

Hamabe Toshiyuki (浜部寿幸)
Toshiyuki was Toshizane's son and the third

generation of the Hamabe school. He took the name Kenyushi. His jihada is barely visible, or looks like muji-hada. The hamon is choji midare consisting of tight nioi. The fourth generation is Toshihide (寿秀), who engaged in sword production in Edo, and Takenaka Kunihiko (竹中邦彦), who was Toshiyuki's student.

Kawamura Toshitaka (河村寿隆)
Toshitaka was a native of Inaba province and studied under Minryushi Toshizane. He was later employed by the Uweda clan of Shinano province and is known for having taught Yamaura Masao (or Saneo) and Minamoto Kiyomaro. Jihada is hardly visible and hamon is ko-choji midare consisting of tight nioi.

In addition to the Hamabe school in Inaba province, there was also the Kanesaki school, which had been active there since Shinto times; the ninth generation of this school continued working during Shinshinto times. It is said that beginning in the third generation, smiths of this school used the name Kanetsugu during their early years. Heki Kanetsugu (日置兼次) is one of their followers.

THE HIZEN TADAYOSHI (肥前忠吉) SCHOOL

Tadayoshi VI (六代 忠吉)
The sixth generation was the fifth Tadayoshi's son, who used Tadahiro as a smith name during his early years, as his father had. He then succeeded to the name of Tadayoshi and signed his blades Hizen (no) Kuni Tadayoshi (肥前国忠吉) (Hizen province Tadayoshi) after his father's death. He received the title Omi no Kami in 1800 and died in 1815. The jihada is a dense ko-mokume hada, and the hamon is a suguha with ko-nie, kuichigaiba, and occasional ashi. The nakago holds to the tradition of Hizen blades; therefore, the signature is done in tachi-mei, but the nakago is slightly longer than that of early generations of Shinto times.

Tadayoshi VIII (八代 忠吉)
The demand for swords was quite limited during the lifetime of the seventh Omi no Kami

Tadahiro (七代近江守忠広), and his works are very rare despite the fact that he was the head of a distinguished family. Tadayoshi VIII, who was adopted by Tadayoshi VII, was a skillful smith; he left many extant works which display traditional workmanship. Tadayoshi VIII's real name was the same as the first Tadayoshi's, Hashimoto Shinzaemon, and he died in 1859 at the age of 59. His blades have a substantial, traditional Hizen sugata, but a shallower sori. His is the strongest jigane among the later generations, and his jihada is ko-mokume hada. The hamon is chu-suguha or hiro-suguha in nie deki but the unique Hizen choji midare is rarely seen in Shinshinto times.

SWORDSMITHS OF SATSUMA (薩摩) PROVINCE

In later years of the Shinto times there were few major smiths outside of Satsuma, where swordsmiths maintained their traditions and continued to thrive. The two masters Mondo no Sho Masakiyo and Ichinohira Yasuyo, who were active in about the Kyoho era (1716–1736), made remarkable contributions toward enhancing the reputation of Satsuma blades, while Oku Yamato no Kami Motohira (奥大和守元平) and Hoki no Kami Masayoshi (伯耆守正幸) at the end of the Edo period secured an undisputed position for Satsuma smiths during Shinshinto times.

It appears that Suishinshi Masahide's theory of fukkoto had no direct influence on these smiths or on their Soshu tradition, since the styles and methods of Shinto times had been maintained. Some smiths, such as Sumi Moto'oki of Aizu, Aoki Terunoshin Motonaga (青木照之進元長) of Owari province, and Yokoyama Sukehira of Bizen province came to Satsuma to learn Soshu tradition from them, and their workmanship spread rapidly as these students returned to their homelands. In addition to Satsuma, a few smiths of the Naminohira school were still active and their family names, which go back to the early Koto era, were still being used.

It is meaningless to classify Satsuma blades as Shinto or Shinshinto on the basis of the sugata or the workmanship; they are therefore classified according to chronology, for the sake of convenience.

Oku Yamato no Kami Motohira (奥大和守元平) Motohira was born the heir of Oku Motonao in 1744. His real name was Oku Kozaemon or Jirobei, and he took the name Tennenshi. He learned swordmaking from his father, and was authorized by Lord Shimazu to add "Sappan Shi" (薩藩臣) (Retainer to the Satsuma clan) to his signature in 1785. Motohira received the title Yamato no Kami in 1789, at the same time as did Masayoshi, and died in 1826 at the age of 83. The school includes his younger brother Mototake (元武) and Motoyasu (元安), his son Motohira (元寛), his grandson Motohira II (二代 元平), Motomitsu (元光), Motofusa (元房), Motoyoshi (元珍), and Motoaki (元全). He generally worked in the Soshu tradition, which had been the school's tradition since Shinto times, but he also experimented with other traditions, demonstrating his enthusiasm and ambitions for swordmaking. A considerable number of his blades are extant.

Sugata: The gentle sugata of his early and later years is an exception, but his blades generally have a shallow sori, a wide mihaba which is not tapered, thick kasane, full hiraniku, and a grand sugata. The shinogi is narrow, despite the wide mihaba.

Jihada: The dense mokume-hada is barely visible but is mixed with o-hada or Satsuma-gane. The ji-nie are rough, and yubashiri appears at times. The shinogiji looks like muji-hada.

Hamon: Consisting of very rough nie, the hamon starts with narrow yakihaba in the yakidashi, then gradually widens upward. The nie become rougher toward the top. In the monouchi area the roughest nie can be seen, and they spill over into the ji and become ji-nie. He used calm and gentle hamon like suguha and notare midare in his early works (see Fig. 163 on page 228), but after the Tenmei era established a typical Satsuma style of gorgeous

gunome midare consisting of thick nie and nioi with many hataraki, such as sunagashi and imozuru, mixed with togari-ba consisting of nie.

Boshi: Ko-maru, midare komi, or ichimai, in all cases with abundant nie.

Horimono: Various hi can be seen, in addition to the occasional horimono.

Nakago: Relatively long and tanagobara-gata nakago, kengyo nakagojiri, and sujikai yasuri. Tachi-mei can often be seen.

Hoki no Kami Masayoshi (伯耆守正幸)
Masayoshi (正幸) was born in 1733, the son of Masayoshi (正良) II (the characters used in their names for "Yoshi" are different). Masayoshi's family name was Ichiji, and he had three first names: Jiemon, Nakazo, and Shohei. He learned swordmaking from his father, and succeeded to his father's name after the latter's death. Masayoshi was employed by the Satsuma clan, and used the inscription "Satsuma Kanko" (薩摩官工) (Official smith of the Satsuma clan) in his signature in 1793. When he received the title Hoki no Kami at the same time as did Motohira, he changed the character "Yoshi" used in his name to a different character with the same pronounciation. He died in 1818 at the age of 86. Motohira and Masayoshi were the twin master smiths of Satsuma province in Shinshinto times. It is said that more than forty students studied under him. The school includes his son Masakuni (正国) and Yoshimoto (良元). In this school the characters "Yoshi" (良) or "Masa" (正) are commonly used by students as part of their smith names.

Sugata: Blades have a wide mihaba, thick kasane, full hira-niku, a shallow sori, and a grand sugata.

Jihada: Beautiful mokume-hada is mixed with masame-hada in his early years; afterward itame-hada is mixed with o-hada; in all cases, abundant ji-nie are seen. The jihada is more visible than is that of Motohira.

Hamon: Vigorous notare midare and gunome midare with a wide yakihaba. Occasionally, in his early years, suguha hotsure can be seen. The yakigashira tend to be tapered with nie. There are numerous hataraki, such as sunagashi, nijuba, imozuru, etc.

Boshi: Ko-maru, hakikake, nie kuzure, etc.

Horimono: Bo-bi with kakinagashi is commonly seen.

Nakago: The cutting-edge side of the nakago bulges, and resembles funagata. The nakago-jiri is kengyo of a narrow width. The yasurime is kiri.

OTHER LEADING SMITHS

Kawai Hisayuki (川井久幸) (**Musashi province**)
Hisayuki was born in 1785 and his real name was Kawai Kametaro. As a member of a bushi, or samurai-class, family, he was entitled to inscribe the phrase "Bakufu Shi" (幕府士) (Direct retainer of the shogun) on his blades. His swords do not display features particular to the school to which he belongs, but many of his works are extant. The jihada is masame, or ko-mokume which is so dense that it is barely visible. The hamon is mainly suguha, and there are also gunome midare and hitatsura. Hisayuki favored yari, and fine jumonji yari are found among his work.

Maizuru Tomohide (舞鶴友英) (**Kawachi province**)
Tomohide lived in Kawachi province, and later moved to Edo. He is said to have conducted a technical exchange with Koyama Munetsugu. His blades have a shallow sori, a wide mihaba, a high shinogi, and a wide shinogiji; they are also a bit unusual in appearance. The hamon is hiro-suguha, notare midare, ko-gunome midare, or choji midare based on suguha.

Aoki Motonaga (青木元長) (**Owari province**)
His early smith's name was Nobunao, and his real name was Aoki Terunoshin. He studied under Hoki no Kami Nobutaka, and it is said that he later went to Satsuma province to learn the Soshu tradition from Oku Yamato no Kami

Motohira. The jihada is dense ko-mokume hada. The hamon is midareba consisting of very rough nie, evidence of Motohira's influence. Skillful horimono can be seen. The yasurime is higaki.

Okachiyama Nagasada (御勝山永貞) (Mino province)

Nagasada was born in 1824 and his real name was Matsui Jiichiro. It is said that he first learned swordmaking from Akasaka Senjuin Michinaga (赤坂千手院道永) before going to Edo and asking to be allowed to study under Taikei Naotane. In the meantime, he was employed by Lord Tokugawa of the Kishu clan. Nagasada produced blades in Edo, Ise province, and Kyoto, as well as in his native province of Mino. He died in 1869 at the age of 51.

Nagasada's main areas of production were katana and hira-zukuri sunnobi tanto. His blades have a mihaba which is not tapered, relatively large kissaki, a shallow sori, and a grand sugata. The jigane is strong, and the jihada is a dense mokume-hada with chikei. The hamon is o-midare, gunome midare, or ko-choji midare consisting of bright but slightly uneven nie with ashi and sunagashi, or occasionally of suguha with tight habuchi. The boshi is midare komi or ko-maru with hakikake. The nakago is long and has ha agari kurijiri. The yasurime is sujikai with kesho yasuri.

Nankai Taro Tomotaka (南海太郎朝尊) (Yamashiro province)

Tomotaka was a native of Tosa province and his family name was Morioka. He went to Kyoto during the Bunsei era and argued for the theory of fukkoto; he also wrote *Token Gogyo Ron*, and *Zoto Shinki Ho* (both works discussing swordsmithing from a philosophical point of view), as well as *Shinto Meishu Roku* (a collection of the oshigata of Shinto swords). Tomotaka was Suishinshi Masahide's equal as a theorist, and he attracted many students, including Komai Yoshitomo (駒井慶任). He also assisted Chigusa Arikoto (千種正三位有功) (a noble at the Imperial court) in making swords. He died in 1865 at the age of 61. His hamon is mainly ko-choji midare in nioi deki; occasionally, o-midare, hitatsura, and suguha in nie deki are seen.

LEADING SWORDSMITHS OF SHINSHINTO TIMES

ERA	PROVINCE	SWORDSMITH(S)	PATTERN
Tenmei (1781–1789)	Settsu	Kuroda Takanobu (黒田鷹諶)	This smith is a native of Harima province who later moved to Osaka. In his early years he worked under the name Masatsugu. **Shinto tokuden tradition and Yamashiro tradition:** The jihada is dense but barely visible. The hamon is gunome midare or suguha.
	Rikuzen	Gennosuke Kunikane (源之助国包)	The tenth generation of the Sendai Kunikane family; he belonged to the Suishinshi school but few of his works are extant. **Yamato tradition:** On the whole, workmanship is similar to the Shinto smith Kunikane, but the jigane is mixed with kawari gane (a distinctly different steel) in order to emphasize the masame hada grain. The hamon is mainly chu-suguha. Ara-nie can be seen in the ji at times. This style continued through the thirteenth generation.
	Iwashiro	Aizu Kanesada (会津兼定)	This smith is a descendant of Shinto smith Aizu Kanesada. There have been several smiths since Shinto times who called themselves Izumi no Kami Kanesada. **Mino tradition:** The pure Mino tradition of this school is still practiced.
	Sagami	Yamamura Tsunahiro (山村綱広)	This smith is the sixth generation of the Koto smith Tsunahiro. He is said to have been the teacher of Suishinshi Masahide and Matsumura Masanao. The ninth generation studied under Masahide. Few works are extant.
	Hizen	Tadayoshi VI (六代 忠吉)	**Yamashiro tradition:** In early years, his smith's name was Tadahiro; he later used Omi no Kami Tadayoshi. The eighth Tadayoshi was the most skilled smith of the later generations of this school.
Kansei (1789–1801)	Settsu	Ozaki Suketaka (尾崎助隆)	**Shinto tokuden tradition:** His blades have a shallow sori and a rugged sugata. The jihada is dense but barely visible. The hamon is toran-midare with uneven nie and stiff, awkward midare. His blades are not equal in skill to Sukehiro's.
	Bizen	Yokoyama Sukehira (横山祐平)	**Bizen tradition:** The hamon is kobushigata choji midare consisting of tight nioi with proper yakihaba. Workmanship is similar to that of Naka Kawachi Kunisuke but the pattern is smaller. **Soshu tradition:** The similarity in workmanship to that of Yamato no Kami Motohira is readily understandable, since Sukehira studied briefly under Motohira. Sukehira produced mainly katana and wakizashi with a narrow mihaba and relatively short nagasa.
	Inaba	Hamabe Toshinori (浜部寿格)	**Shinto tokuden tradition, Yamashiro tradition and Bizen tradition:** The jihada is barely visible, or looks like muji hada. The hamon is a standard suguha or ko-choji midare consisting of tight nioi. There are picturesque hamon as well.
Kyowa (1801–1804)	Iwaki (Shirakawa)	Tegarayama Masashige (手柄山正繁)	The fourth generation of the Tegarayama family of Harima province. His smith's name was Ujishige during his early years. **Shinto tokuden tradition:** The hamon resembles that of Sukehiro (see Fig. 158 on page 228). Horimono are seen at times. The jigane is weak, and the jihada is dense and beautiful, but barely visible.

ERA	PROVINCE	SWORDSMITH(S)	PATTERN
Bunka (1804–1818)	Musashi	Suishinshi Masahide (水心子正秀)	There are toran-midare, but the size of the midare is not uniform and the nie are rough, unlike Sukehiro's; there are also suguha made in imitation of Shinkai. Masashige was relatively successful at copying Sukehiro and Shinkai. **Shinto tokuden tradition:** The jigane is beautiful. The hamon is toran-midare, after Sukehiro, but Masahide's work is unlike Sukehiro's in that it incorporates mura nie and sunagashi. **Yamashiro tradition:** Elegant sugata, beautiful ko-mokume hada, chu-suguha hotsure with few hataraki and ko-maru boshi. **Bizen tradition:** The hamon is ko-choji midare inclined to slant, consisting of thick nioi and with ashi. Masahide was very successful in copying old Bizen blades. There is also koshi-no-hiraita mixed with choji midare.
	Satsuma	Oku Motohira (奥元平)	**Soshu tradition and Shinto tokuden tradition:** Blades have the Keicho Shinto sugata. The jihada is mokume hada mixed with o-hada and with chikei, but the mokume hada is barely visible. The hamon consists of ara-nie, and starts with a narrow yakidashi that gradually widens toward the top, while the nie become rougher nearer the top. Boshi is small-patterned midare komi.
		Hoki no Kami Masayoshi (伯耆守正幸)	**Soshu tradition and Shinto tokuden tradition:** His early smith's name was Masayoshi (with a different character for "yoshi" than he used later). His blades have a Keicho Shinto sugata. The jihada is a beautiful mokume hada mixed with o-hada and with chikei. The hamon is o-midare or ko-midare consisting of rough nie and with sunagashi and togari-ba consisting of nie. The boshi is a small-patterned ko-midare.
Bunsei (1818–1830)	Yamashiro	Nankai Taro Tomotaka (南海太郎朝尊)	**Shinto tokuden tradition:** The hamon is o-midare with nie kuzure and sunagashi, occasionally hitatsura. **Yamashiro tradition and Yamato tradition:** The hamon is chu-suguha consisting of ko-nie. The jihada is a beautiful masame hada mixed with ko-mokume hada. **Bizen tradition:** Katana and wakizashi have a gentle sugata with a relatively short nagasa. Elaborate horimono can be seen. The hamon is ko-choji midare with hataraki. There is also a hamon reminscent of Oei-Bizen blades.
		Chigusa Arikoto (千種有功)	Nankai Taro Tomotaka's student, and a court noble. **Yamashiro tradition and Shinto tokuden tradition:** Slender wakizashi of about 45 cm in length is this smith's main area of production. He favors engraving Japanese poems on both sides of his blades. The hamon is mainly hoso-suguha, or occasionally midare-ba. Midare shaped like Mount Fuji can be seen in the bottom area at times. The boshi is ko-maru; tama can sometimes be seen there.
	Settsu	Ozaki Masataka (尾崎正隆)	**Shinto tokuden tradition:** Suketaka's grandson. His workmanship differs little from that of his grandfather. He also did picturesque hamon.
	Musashi	Fujieda Taro Teruyoshi (藤枝太郎英義)	**Shinto tokuden tradition, Bizen and Soshu traditions:** The hamon is toran-midare, gunome midare consisting of thick nie and nioi and with plentiful ashi, uniform gunome midare in nioi deki, or hitatsura.

ERA	PROVINCE	SWORDSMITH(S)	PATTERN
Tenpo (1830–1844)	Mutsu	Sumi Moto'oki (角元興)	This smith studied under Suishinshi Masahide and Motohira of Satsuma province. **Shinto tokuden tradition:** The jihada is ko-mokume hada with rough ji-nie. The hamon is notare or hiro-suguha with gunome ashi consisting of rough nie. **Soshu tradition:** Workmanship is similar to that of his teacher Motohira.
	Hitachi	Ichige Norichika (Tokurin) (市毛徳鄰)	This smith was in the employ of the Mito clan and studied under Ozaki Suketaka. **Shinto tokuden tradition:** The jihada is a beautiful ko-mokume hada. The hamon is toran-midare, similar to Sukehiro's (see Fig. 158 on page 228).
	Musashi	Taikei Naotane (大慶直胤)	Honjo Yoshitane often engraved horimono on this smith's tanto and ko-wakizashi. He was familiar with all traditions, and his masterpieces are equal to good Koto blades. **Yamashiro tradition:** The hamon is a calm chu-suguha, in imitation of mid-Kamakura blades. **Bizen tradition:** There are many copies of Koto blades, including those by Kanemitsu, Kagemitsu, Nagamitsu, Katayama Ichimonji, Choji, Morimitsu, and Yasumitsu. The nioi-guchi is not tight. Alternatively, hard, dark spots can be seen in the yakigashira. **Soshu tradition:** There are many imitations of the o-suriage sugata of the late Kamakura and the Nanbokucho periods. The jihada is itame-hada mixed with o-hada and unique uzumaki hada. The hamon is mixed with koshi-no-hiraita midare, and hard, dark spots can be seen in the yakigashira. The nie are rough, and the habuchi is not distinct. Many large hataraki such as nie kuzure, kinsuji, and inazuma are vigorous inside the hamon. 217 Work by Taikei Naotane in the Soshu (left) and Bizen traditions.
		Hosokawa Masayoshi (細川正義)	**Bizen tradition:** Blades are relatively long, and bo-bi with tsure-bi or soe-bi can often be seen. The jihada is a dense ko-mokume hada. The hamon is choji midare consisting of tight nioi with crowded ashi, and the yakihaba tends to be regular in its width from the bottom to the top. 218 Work by Hosokawa Masayoshi in the Soshu (left) and Bizen traditions.

ERA	PROVINCE	SWORDSMITH(S)	PATTERN
			Soshu tradition: The blades have o-suriage sugata, thick kasane, and full hira-niku. Workmanship is somewhat reminiscent of the work of Soshu Akihiro or the Sa school. Sunagashi and inazuma are vigorous. The jihada is a coarse o-itame hada with ji-nie and glittering chikei.
		Kato Tsunahide (加藤綱英)	**Shinto tokuden tradition:** The jihada looks like muji hada. The hamon is toran-midare mixed with togari-ba and tobiyaki.
		Chounsai Tsunatoshi (長運斎綱俊)	**Bizen tradition:** The blades have long nagasa, a deep sori, and thick kasane. Bo-bi with tsure-bi or soe-bi are often seen. The jihada is a dense mokume hada mixed with o-hada. The hamon is ko-choji midare or ko-midare consisting of tight nioi. The boshi is a small-patterned midare komi.
	Hitachi	Rekko (烈公)	The lord of the Mito clan. He was assisted by Norikatsu in his production of swords. **Yamashiro tradition and Shoshu tradition:** The jihada is the so-called yakumo hada, or a unique and snaking grain that resembles chikei. The hamon is mainly suguha, occasionally gunome midare, or hitatsura.
	Bizen	Yokoyama Sukenaga (横山祐永)	**Bizen tradition:** Features identical to those of Sukehira.
		Yokoyama Sukekane (横山祐包)	**Bizen tradition:** Features identical to those of Sukehira.
Koka (1844–1848)	Tosa	Sa Yukihide (左行秀)	The blades are long, with a shallow sori, relatively large kissaki, and a grand sugata. There are few tanto or ko-wakizashi. **Shinto Tokuden tradition:** The jihada is a dense ko-mokume hada mixed with masame hada. The hamon is wide, and suguha or notare with gunome ashi, which consists of thick nie and nioi. The nie are white and bright. The boshi is ko-maru with gunome ashi, or occasionally ichimai. **Soshu tradition:** The jihada is mokume hada mixed with o-hada, occasionally mixed with masame hada. The hamon is wide and based on notare, or gunome with ashi. Nie are very rough, and nie kuzure with sunagashi appear. The hamon is sometimes mixed here and there with crested and rugged midare-ba. The boshi is ko-maru sagari with gunome ashi, or occasionally ichimai.
Kaei (1848–1854)	Musashi	Koyama Munetsugu (固山宗次)	**Bizen tradition:** The blades have Keicho Shinto sugata, and hi or horimono are seen at times. There are copies of Koto blades. The jigane is beautiful and strong, unlike that of other Shinshinto smiths of the Bizen tradition. The jihada is a dense mokume hada mixed with o-hada.

219 Yakumo gitae by Rekko.

220 Workmanship of Sa Yukihide.

ERA	PROVINCE	SWORDSMITH(S)	PATTERN
			The hamon is ko-choji midare, or a small-patterned koshi-no-hiraita midare consisting of thick nioi. The midare with round yakigashira are close to one another and the pattern appears quite crowded. Mura nie can be seen in places. There is a masterful copy of Koryu Kagemitsu in saka-choji midare. The boshi is a small-patterned midare komi.
		Minamoto Kiyomaro (源清麿)	The blades have Keicho Shinto sugata. Hi and horimono alike are rare. 221 Workmanship of Koyama Munetsugu.
			Shinto tokuden tradition: The jihada is ko-mokume hada. The hamon is wide and o-gunome midare or o-midare which tends toward koshi-no-hiraita midare; it looks as though it is based on suguha or notare because the midare are close together. The hamon consists of very fine nie that look like nioi, and mura nie are seen sporadically. Thick, long inazuma are clear and vivid. The boshi is midare komi in proportion to the hamon.
			Soshu tradition: The jihada is o-mokume hada or itame hada with ji-nie and chikei. The hamon is o-gunome midare or o-midare with nie kuzure, ashi consisting of thick nioi and a good deal of sunagashi. The boshi is mainly midare komi.
			Mino tradition: The hamon is gunome midare mixed with togari-ba and yahazuba consisting of tight nioi. Some work is reminscent of Kanesada (Mino province) of Koto times.
	Shinano	Yamaura Masao (or Saneo) (山浦真雄)	**Shinto tokuden tradition and Mino tradition:** The workmanship differs little from that of his younger brother Kiyomaro. 222 Workmanship of Minamoto Kiyomaro.
	Inaba	Hamabe Toshizane (浜部寿実)	**Bizen and Yamashiro traditions:** Workmanship differs little from that of his father Toshinori.
		Hamabe Toshiyuki (浜部寿幸)	**Bizen and Yamashiro traditions:** Toshizane's son. Workmanship differs little from that of Toshinori.
Ansei (1854–1860)	Settsu	Gassan Sadayoshi (月山貞吉)	The blades have a shallow sori and chu-kissaki. This smith is known as a master of horimono.
			Yamashiro tradition: The jihada is ko-mokume hada, occasionally mixed with ayasugi hada. The hamon is chu-suguha consisting of ko-nie. The boshi is ko-maru.
			Yamato tradition: The jihada is masame hada mixed with mokume hada, occasionally mixed with ayasugi hada. The hamon is chu-suguha consisting of ko-nie.

ERA	PROVINCE	SWORDSMITH(S)	PATTERN
	Musashi	Kurihara Nobuhide (栗原信秀)	**Bizen tradition:** The hamon is narrow choji midare with long nioi ashi, occasionally with ko-nie. **Soshu tradition:** The hamon is o-midare consisting of thick nie. The blades have a Keicho Shinto sugata. This smith shows a unique, most excellent skill in horimono; his engraving of Chinese and Japanese characters is particularly superb.
		Saito Kiyondo and (斎藤清人) Suzuki Masao (鈴木正英)	**Shinto tokuden tradition:** Workmanship differs little from that of Kiyomaro. **Soshu tradition:** The jihada is o-mokume hada or itame-hada with ji-nie, which is not as readily visible as Kiyomaro's. Like Kiyomaro's hamon, the gunome midare tends to be koshi-no-hiraita midare, and sunagashi can be seen. The boshi is a small-patterned midare komi with a slightly tapered tip. **Soshu tradition and Shinto tokuden tradition:** Kiyomaro's students. On the whole, workmanship is similar to that of Kiyomaro, but these smiths are not their teacher's equal in skill.
		Suishinshi Masatsugu (水心子正次)	**Yamashiro tradition:** Workmanship on the whole is similar to that of Masahide. **Bizen tradition:** Similar to the workmanship of Masahide. The hamon is ko-choji midare inclined to slant. In tanto, ko-choji midare can also be seen.
		Jiro Taro Naokatsu (次郎太郎直勝)	**Yamashiro tradition and Bizen tradition:** Naotane's son-in-law. Workmanship differs little from that of Naotane.
		Unju Korekazu (運寿是一)	Chounsai Tsunatoshi's nephew, who succeeded to the seventh generation of the Edo Ishido family. **Bizen tradition:** The hamon is choji midare produced in imitation of Bizen Kanemitsu, but with abundant nie. **Soshu tradition:** Workmanship is somewhat similar to that of the Kiyomaro school, but the midare tends to be notare, and the suna-gashi is less noticeable.
	Shinano	Yamaura Kanetora (山浦兼虎)	Masao's son. **Shinto tokuden tradition:** Similar to, but of lesser quality than, Minamoto (no) Kiyomaro's.
Bunkyu (1861–1864)	Musashi	Hosokawa Masamori (細川正守) and Hosokawa Tadayoshi (細川忠義)	Both these smiths were students of Hosokawa Masayoshi. **Bizen tradition:** The blades have shorter nagasa. Hi and horimono can be seen at times. The mokume hada is beautiful. The hamon is ko-choji midare. **Soshu tradition:** Features identical to those of Masayoshi.

ERA	PROVINCE	SWORDSMITH(S)	PATTERN
Genji (1864–1865)		Tairyusai Sokan (泰龍斎宗寛)	**Bizen tradition:** The jihada is a dense mokume hada mixed with o-hada. In his early works, the hamon resembles that of his teacher Koyoma Munetsugu, but later it becomes uniform ko-gunome choji with long nioi ashi. The boshi is midare komi.
	Hitachi	Katsumura Norikatsu (勝村徳勝)	**Yamato tradition:** The blades have a shallow sori, chu-kissaki, and a rough sugata. The jihada is noticeable masame hada with ji-nie. The hamon is ko-midare based on suguha, or notare midare with uneven nie and nijuba. All hataraki run lengthwise along the blade. The boshi is midare komi or hakikake.
Keio (1865–1868)	Settsu	Gassan Sadakazu (月山貞一)	**Yamashiro, Yamato, Bizen, and Soshu traditions:** Features are the same as those of his father-in-law Sadayoshi, but this smith is superior to Sadayoshi in skill.

223

Workmanship of Tairyusai Sokan.

GUIDE TO JAPANESE SWORD APPRECIATION

APPRECIATION

The Japanese sword has been carefully preserved through the ages, in all its undeniable power, to delight the viewer. A number of swords have histories spanning nearly one thousand years and countless reversals in human fortune; time has done nothing to diminish their splendor, but has only confirmed their status as priceless art objects.

Accordingly, when examining a sword, it is customary first of all to thank the previous owners for having treasured the blade and handed it down to the succeeding generations. It is also proper to bow in a sign of respect for both the sword and its owners.

There is no need to dress particularly formally, but clothing should be neat and reflect your appreciation. Clear the area of any unnecessary items and keep at hand only the tools you'll need, such as the fukusa, nugui-gami, uchiko, mekugi nuke, and choji oil. These tools are usually set out in advance at sword-appreciation gatherings, but nevertheless it is customary for each participant to prepare his or her own fukusa (the handkerchief used in tea ceremonies).

The bow in respect to sword and owners should be done at the appropriate time, when permission has been granted to examine the blade. In order to open the cloth case (katana-bukuro), hold the sword with the end of the hilt (tsuka) facing to the right, then untie it carefully with your right hand. Hold the scabbard (saya) in the middle with your left hand to steady it.

To draw the blade, hold it with the mune (back) side of the scabbard pointing down and away from you, with the hilt facing to the right. Place your right hand on the hilt, while your left hand holds the scabbard from underneath, near the koiguchi (scabbard mouth). Stretch your left hand forward, holding the scabbard out, and draw the blade out along the mune. It is considered rude to stop the draw halfway. After drawing the blade, cover the scabbard with its cloth case, to keep it free from dust.

Never talk or laugh while examining a blade. In the past, rules of proper etiquette required viewers to hold a piece of paper between their closed lips while looking at a sword. While this precaution is no longer consistently taken, it is still important to keep moisture from the mouth away from the blade, as it is certain to cause it to rust.

Appreciation of the sword should begin with the shape of the blade. With your arm outstretched, hold the sword vertically by the hilt at arm's length.

Carefully look over each part in the following sequence: first the shape as a whole, then the length (nagasa), curvature (sori), the size of the kissaki, the height of the shinogiji, the type of mune, the thickness (kasane), the nikudori (relative fullness of the hira-niku), and any carvings (horimono). All these usually reflect the period of a blade's production. As appraisers gain confidence, they sometimes show increased interest in the steel (jigane), surface-grain pattern (jihada) and temper line

(hamon), and fail to evaluate the shape first. But in fact this general inspection is crucial to achieving a deep appreciation of swords.

To evaluate the jigane and jihada, bring the blade closer and hold it horizontally beneath your line of sight. Look at the jigane and jihada with a light shining brightly and directly on the surface; it is best to hold either a fukusa or a piece of softened Japanese paper (washi) in your left hand, and support the blade on this.

Good lighting conditions are a must for sword appreciation. The best light in which to evaluate a hamon is a naked electric bulb; fluorescent lighting does not work at all.

To appreciate the hamon, look down along the blade, toward the light. Beginners tend to mistake the hadori (whitening resulting from the final polish) for the hamon. Unless you are looking along the blade toward a light positioned such that it reflects off the part that you are inspecting, it is difficult to confirm the shape of the hamon, any activity (hataraki) that may be present inside the hamon, or the conditions of nie, nioi, and utsuri. The hamon of a blade shows great variety and is fascinating; it faithfully incorporates the features of its school, while also displaying a particular swordsmith's techniques and style. While examining the hamon, make careful note too of the yakidashi and the presence of muneyaki.

It is said that creating the boshi—which is as distinctive and individual as a human face—is the most difficult part of the swordsmith's task. Accordingly, the boshi is considered a direct reflection of the swordsmith who produced it. Generally, Koto (blades made prior to 1596) have more activity in the boshi than do Shinto (swords made after 1596), so it is possible to classify a blade as either Koto or Shinto on the basis of the boshi alone. If a boshi is particularly unusual, it may even be possible to determine the swordsmith from the boshi.

An essential point to keep in mind is the importance of the polishing techniques and the skill of the polisher. Swords cannot be appreciated properly without good polishing. Poor polishing reduces the artistic value of a sword, making proper appraisal more difficult. Sword appreciation requires, first, good polishing, and then ongoing careful treatment.

The nakago (tang) is also important to sword appreciation. Its shape, type of nakago-jiri (bottom end of the nakago), yasurime (file marks), mekugi ana (peg hole), and rust color should all be carefully inspected, regardless of whether or not a blade is signed. Never grind or polish a nakago indiscriminately, as its rust provides clues to the sword's age.

To remove the nakago from the tsuka: replace the blade in the scabbard, then remove the mekugi (peg) with the mekugi nuki (be careful not to misplace the mekugi while examining the nakago). Then draw the blade again, as described above. Hold the blade on a slight diagonal, with the kissaki up. With your left hand, grasp the sword tightly toward the top of the tsuka from the mune side, then hit your left wrist sharply with your right hand. If this blow is delivered sharply enough, it should cause the nakago to loosen within the tsuka. While holding the habaki, separate the tsuka from the nakago and carefully pull off the habaki. When you have finished examining the nakago, wipe it with a piece of Japanese paper and replace the habaki.

To reassemble, hold the blade upright and slide the tsuka back onto the blade. Hit the tip of the tsuka from below with the palm of your left hand, in order to fix it securely. Do not forget to replace the mekugi. Replace the sword in the scabbard in a motion precisely opposite to that in which first you drew the sword, being careful not to scratch the kissaki or other parts.

When handing an exposed blade to someone else, hold it vertically with the tip upward, grasping the upper part of the tsuka. Always turn the back edge of the blade toward the other person.

After evaluating swords, it is always interesting to discuss them with other enthusiasts, but do bear in mind that to question the authenticity of blades just examined would constitute a breach in etiquette.

CARE OF THE BLADE

TOOLS FOR TREATMENT

uchiko (powder for removing oil, wrapped into a cloth container)

nugui-gami (Japanese paper)
(Note that one piece of paper is used for wiping off the oil, and another for removing the residue of the uchiko powder. White flannel may be used as a substitute, but this must be washed first and softened.)

mekugi nuki (tool for removing mekugi)

piece of soft cotton cloth (for wiping off oil)

choji abura (clove oil)

Yoshino-gami (very thin sheet of Japanese paper used to spread oil over the blade, to prevent rust.)

Care of the blade

1. Draw the blade and remove the tsuka and the habaki, following the steps outlined above. Hold the nakago in your left hand and remove any oil from the blade with the nugui-gami. Always wipe the sword from the bottom toward the top.

2. Powder the blade by hitting it lightly with the uchiko all over, then wipe it clean again with the nugui-gami. Repeat this hitting and wiping process two or three times. New nugui-gami should be softened, and all traces of dust carefully removed, before they are used, as dust can harm the blade's surface. Change to a new nugui-gami when the one you are using gets dirty. Always keep these tools free of dust.

3. The blade is best appreciated only after these steps have been taken. Afterward, it is wise to use the uchiko again to clean the blade thoroughly.

4. Oil the entire blade evenly, using the Yoshino-gami soaked in choji oil. Wipe the nakago with a soft cotton cloth, occasionally oiling it lightly again with the Yoshino-gami. Wipe the blade to remove any excess oil.

5. Replace the habaki, tsuka, and mekugi. Replace the sword in its scabbard, and finally cover it again with a cloth case. This case is essential for protecting the scabbard.

6. Store the sword in a dry place, away from direct sunlight. Normally, swords need to be cleaned every two months, although a newly-polished sword should be cleaned every two weeks at first. This helps to prevent rust and keep the blade in top condition.

PREPARATION FOR NYUSATSU KANTEI

Generally speaking, the term "kantei" is usually used with regard to the process of judging whether or not an object is authentic, but in token (sword appreciation) societies, it is also used in regard to attributing blades without signatures. The word "nyusatsu" means "bidding." Nyusatsu kantei is a unique form of competition intended to aid in cultivating an eye for the Japanese sword, in which participants attempt to specify the swordsmith who forged a particular blade solely on the basis of close examination of the workmanship.

(Please note that the following explanation of nyusatsu kantei competitions does not refer to the process by which a blade is officially judged and certified by the Hon'ami family or by the Nihon Bijutsu Token Hozon Kyokai, or NBTHK [日本美術刀剣保存協会].)

Nyusatsu kantei is not only enjoyable, but also provides an ideal chance to create friendships based on a mutual interest, while at the same time providing an opportunity for hands-on study of excellent examples of the Japanese sword.

At these gatherings, five swords are usually prepared, with the nakago left in the tsuka in order to conceal the signatures from view. Participants then take up a blade and attempt to deduce the swordsmith on the basis of the workmanship alone. Needless to say, participants are required to observe proper etiquette when examining and handling the swords. Participants are provided beforehand with five sheets of paper, one for bidding on each sword. After a period of deliberation, answers are submitted to a judge, who then assesses each person's

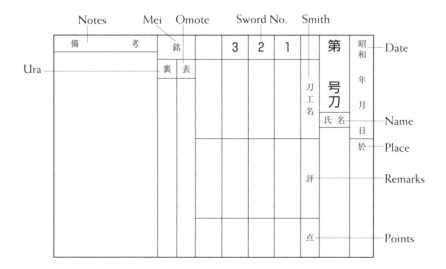

responses with one of the following eleven terms: atari, dozen, kuni iri yoku, tori yoku, iya, jidai chigai, jidai chigai yoku, jidai chigai iya, jidai chigai tori yoku, hongoku nite yoku, and desaki nite yoku.

1) Atari: Correct identification of the swordsmith.

2) Dozen: Correct identification of the family, by naming of a teacher or student of the swordsmith, or another member of his school (for example, a bid of Mitsutada or Kagemitsu for a Nagamitsu blade.)

3) Kuni iri yoku: Correct identification of the period (Koto, Shinto, or Shinshinto) and the kuni (province) but not the family, of the swordsmith. For example, if you bid Suishinshi Masahide for Kiyomaro, the judge will remark, "Kuni iri." You then have another opportunity, and should bid a swordsmith from the same kuni but a different school.

4) Tori yoku: Correct identification of the swordsmith's kaido group (main roads) and period, but not family, province, or school. For example, in response to a bid of Muramasa for Shimada Yoshisuke, the judge will remark, "Tori." You then bid again, naming a swordsmith from the same kaido but a different province.

5) Iya: A bid which does not correspond to any of the categories 1) through 4).

6) Jidai chigai: Bid of an incorrect period.

7) Jidai chigai yoku: Bid of the correct province but the wrong period.

8) Jidai chigai iya: Bid of an incorrect period, province, and school (this is regarded as the worst possible answer).

9) Jidai chigai tori yoku: Bid of the correct kaido group but the wrong period.

10) Hongoku nite yoku: Correct identification of the province alone, in a bid which does not correspond to any of the categories 1) through 4).

11) Desaki nite yoku: Correct identification of only the province where the sword-

smith temporarily lived and worked, in a bid which does not correspond to any of the categories 1) through 4).

Remarks 8) through 11) are made only in response to bids which are far afield of the correct answer and which clearly indicate that a participant is still quite unfamiliar with the work of particular swordsmiths, and has only chanced upon a bid which has some correct element. Thus these are generally not heard in high-level nyusatsu kantei competitions.

In addition, there are a few supplementary remarks which a judge may make when he assesses a participant to have sufficient knowledge of the field to make use of them in forming alternative answers. These are:

1) Jun dozen/sakugara dozen: A bid of a smith who is not a member of the correct smith's family (dozen) but whose blades show remarkably similar workmanship and belong to the same period, a judge may respond with "jun dozen" (near-dozen), or "sakugara dozen" (dozen in regard to workmanship).

2) Iya suji: The remark "iya suji" means "incorrect, but somehow related." For example, if the swordsmith is Masamune or Sadamune, a bid of Masamune Juttetsu (Masamune's ten excellent students) or Sadamune Santetsu (Sadamune's three excellent students) will be scored a dozen (correct family). If the swordsmith is Masamune Juttetsu or Sadamune Santetsu, a bid of Masamune or Sadamune will receive a dozen, but bids of other students of Masamune's or Sadamune's will receive only the remark "iya suji" (incorrect, but somehow related). Masamune and Sadamune are each, of course, dozen to their students, but the students of the two different smiths are not dozen to one another.

3) Iya en: A bid of a smith who is related but not dozen will get an "iya en" ("incorrect, but there is a relation"). For example, if the swordsmith is Horikawa Kunihiro, a bid of Inoue Shinkai will get an "iya en" because Shinkai's father, Izumi

no Kami Kunisada, was Kunihiro's student and later moved to Osaka.

There are two types of nyusatsu kantei—one in which just one bid is allowed (ippon nyusatsu), and the more common form, known as sanbon nyusatsu (described here), in which three bids are made, the last two in response to the judge's remarks. In sanbon nyusatsu, one naturally attempts to identify the swordsmith in as few bids as possible; upon successful identification of the swordsmith or his immediate "family," the bidding is completed. Atari on a first bid earns 20 points, on a second bid 15 points, and on a third bid 10 points. Dozen on a first bid scores 15 points, on a second bid 10 points, and on a third bid 5 points. After the completion of all the nyusatsu (bidding), the judge calculates the bidders' points and announces the first, second, and third prizes (ten'i, chii, jin'i).

Identifying the swordsmith is not the sole purpose of kantei, and it is unwise to lose interest after achieving this result. For instance, if you throw away your bidding paper as soon as a round is finished, you cannot expect to improve your appraisal and attribution skills. It is far better to participate actively, checking your knowledge against the actual swords, listening carefully to the judge's explanations, and asking any questions that come to mind. It is also important to reconsider your bids, and to study the swords in your own collection again, after the gathering.

I recommend that you keep your bidding papers and record your impression of each sword. It is a good idea to make a notebook and to take notes on swords that you have seen. This will help you progress rapidly in appraisal and attribution.

Participation in nyusatsu kantei contests is highly recommended, even for enthusiasts whose knowledge and experience in sword appreciation may be somewhat limited. These competitions are invaluable learning opportunities. The single most important factor in sword appreciation is simple respect for swords. Everything else follows from an attitude of respect.

KOTO DOZEN LIST

Dozen: This response is given when your bid is not "atari" but names a swordsmith listed in the same paragraph in this chart.

Kuni iri yoku: Given when your bid is not "dozen" but names a swordsmith listed in the same province in this chart.

Tori yoku: Given when your bid does not fall into the categories described above but names a swordsmith listed in the same kaido (main road) in this chart.

MAIN ROAD	PROVINCE	SWORDSMITH(S)
Kinai (畿内)	Yamashiro (山城)	The Sanjo (三条) school (Munechika [宗近], Yoshiie [吉家], Gojo Kanenaga [五条兼永], Kuninaga [国永]), the Ayanokoji Sadatoshi school (綾小路定利).
		The Rai (来) school (Kuniyuki [国行], Kunitoshi [国俊], Kunimitsu [国光], Kunitsugu [国次], Kunizane [国真], Kuninaga [Settsu prov.] 国長 [摂津], Tomokuni (倫国), Mitsukane (Omi prov.) 光包 [近江], Ryokai (了戒), the Enju school (Higo prov.) 延寿 (肥後).
		Awataguchi Norikuni (栗田口則国), Kunitsuna (Soshu) (国綱 [相州]), Kunitomo (国友), Hisakuni (久国), Kuniyasu (国安), Kunikiyo (国清), Arikuni (有国), Kunimitsu (国光), Kuniyoshi (国吉), Yoshimitsu (吉光).
		Nobukuni (信国), Ryokai (了戒), Ryo Hisanobu (了久信).
		Nobukuni (信国), Tsukushi Nobukuni (筑紫信国), the Rai (来) school (Kunizane [国真], Kuninaga (Settsu prov.) 国長 (摂津).
		The Hasebe (長谷部) school (Kunishige [国重], Kuninobu [国信], Kunihira [国平]).
		Ryokai (了戒), the Tsukushi Ryokai school (筑紫了戒).
		Later Nobukuni (後代信国), Heianjo Nagayoshi (平安城長吉), Sanjo Yoshinori (三条吉則), the Daruma (達磨) school (Shigemitsu (重光), Masamitsu (正光)), the Kurama Seki school (鞍馬関).
	Yamato (大和)	The Taima (当麻) school (Kuniyuki [国行], Tomokiyo [友清]).
		The Shikkake Norinaga school (尻懸則長).
		The Tegai (手掻) school (Kanenaga [包永], Kaneuji [包氏], Kanekiyo [包清], Kanezane [包真]).
		Ryumon Nobuyoshi (龍門延吉).
		Members of the Senjuin (千手院) school (from the same period).
		The Hosho (保昌) school (Sadayoshi [貞吉], Sadamune [貞宗], Sadaoki [貞興], and later generations [後代保昌]).
		The Kanabo (金房) school (Masatsugu [政次], Masazane [政実]).
Tokaido (東海道)	Sagami (相模)	Shintogo Kunimitsu (新藤五国光), Kunihiro (国広), Yukimitsu (行光), Masamune (正宗).
		Yukimitsu (行光), Masamune (正宗), Sadamune (貞宗).
		Masamune (正宗), Masamune Juttetsu (Masamune's ten excellent students) (正宗十哲).
		Sadamune (貞宗), Sadamune Santetsu (Sadamune's three excellent students) (貞宗三哲).
		Sadamune (貞宗), Takagi Sadamune (Omi prov.) 高木貞宗 (近江) Hiromitsu (広光), Akihiro (秋広).
		Akihiro (秋広), Hiromitsu (広光), Hiromasa (広正), Masahiro (正広).
		Tsunahiro (綱広), Fusamune (総宗), Yasuharu (康春), Tsunaie (綱家), Hirotsugu (広次), the entire Sue-Soshu school (末相州全般), Fuyuhiro (Wakasa prov.) 冬広 (若狭), Koga (Hoki prov.) 広賀 (伯耆).

MAIN ROAD	PROVINCE	SWORDSMITH(S)
Tokaido (東海道)	Ise (伊勢)	The Sengo (千子) school (Muramasa [村正], Masashige [正重], Masazane [正真]), Heianjo Nagayoshi (Yamashiro prov.) 平安城長吉 (山城).
	Mikawa (三河)	The Yakuoji school (薬王寺).
	Suruga (駿河)	The Shimada (島田) school (Yoshisuke [義助], Sukemune [助宗], Hirosuke [広助]).
	Musashi (武蔵)	The Shitahara school (下原).
Tosando (東山道)	Mino (美濃)	Shizu Kaneuji (志津兼氏), the Naoe Shizu (直江志津) school (Kanetsugu [兼次], Kanetomo [兼友], Kanetoshi [兼俊], Kanenobu [兼信]), Yamato Shizu (大和志津).
		Kanemoto (兼基), Kanemoto (兼元), Kanesada/Nosada (兼宅), Kanesada (兼定).
		Kanetsune (兼常), Kaneyoshi (兼吉), Kanefusa (兼房), Kanesada (兼貞), Kaneaki (兼明), Kanenori (兼法), the entire Sue-Seki school (末関全般).
		Omichi (or Daido) (大道), Ujifusa (氏房), Ujisada (氏貞), Ujinobu (氏信), the Akasaka Senjuin school (赤坂千手院).
		Kaneshige (or Kinju) (金重), Kaneyuki (金行), and their later generations (後代).
		The Sakakura Seki (坂倉関) school (Masatoshi [正利], Masatsugu [正次]).
	Dewa (出羽)	Gassan (月山).
	Mutsu (陸奥)	Hoju (宝寿), Mogusa (舞草).
Hokurikudo (北陸道)	Etchu (越中)	Yoshihiro (義弘), Norishige (則重), Tametsugu (為継), Sanekage (Kaga prov.) 真景 (加賀), the Uda (宇多) school (Kunifusa [国房], Kunimune [国宗], Kunihisa [国久], etc.).
	Echizen (越前)	The Chiyozuru (千代鶴) school.
	Kaga (加賀)	Fujishima Tomoshige (藤島友重), Yukimitsu (行光), Nobunaga (信長), Kiyomitsu (清光), Katsuie (勝家), Kagemitsu (景光).
		Sanekage (真景).
	Echigo (越後)	Momokawa Nagayoshi (桃川長吉), the Yamamura (山村) school (Masanobu [正信], Yasunobu [安信], Hata Chogi, Nagayoshi [秦長義]).
San'indo (山陰道)	Hoki (伯耆)	The Ohara (大原) school (Yasutsuna [安綱], Sanemori [真守], Aritsuna [有綱]). The Koga/Hiroyoshi school (広賀).
	Izumo (出雲)	The Yoshii (吉井) school (Yoshinori [Bizen] 吉則 [備前], Morinori [盛則], Kiyonori [清則], etc.).

MAIN ROAD	PROVINCE	SWORDSMITH(S)
San'indo (山陰道)	Iwami (石見)	Naotsuna (直綱), Sadatsuna (貞綱). Yoshisada (祥貞), Yoshisue (祥末), Sadasue (貞末), Suetsugu (末継), Masahiro (正弘).
	Inaba (因幡)	Kagenaga (景長), Yukikage (行景).
	Tajima (但馬)	Hojoji Kunimitsu (国光).
	Bizen (備前)	The Ko-Bizen (古備前) school (Tomonari [友成], Masatsune [正恒], Sanetsune [真恒], Kanehira [包平]). The Ko-Ichimonji (古一文字) school (Norimune [則宗], Sukemune [助宗], Narimune [成宗]). The Ichimonji (一文字) school (Yoshifusa [吉房], Sukezane [助真], Norifusa [則房], Yoshihira [吉平], Yoshimochi [吉用], Sukeyoshi [助吉]), the Yoshioka-Ichimonji (吉岡一文字) school, the Katayama-Ichimonji (片山一文字) school, the Shochu-Ichimonji (正中一文字) school. The Hatakeda school (Moriie [畠田守家], Sanemori [真守]). Saburo Kunimune (三郎国宗), Jiro Kunisada (二郎国貞). Mitsutada (光忠), Moriie (守家). The Ko-Osafune (古長船) school (Mitsutada [光忠], Nagamitsu [長光], Sanenaga [真長], Kagemitsu [景光], Nagamoto [長元], Chikakage [近景]). Kagemitsu (景光), Kagemasa (景政), Kanemitsu (兼光). The Kanemitsu (兼光) school (Kanemitsu [兼光], Tomomitsu [倫光], Yoshimitsu [義光]), Motomitsu (基光), Masamitsu (政光), Yoshikage (義景). The Chogi (長義) school (Chogi [長義], Kencho (or Kanenaga) [兼長], Nagashige [長重], Nagamori [長守], Nagatsuna [長綱]). The Omiya (大宮) school (Morokage [師景], Morikage [盛景], Kunimori [国盛]). Iesuke (家助), Tsuneie (経家). The Yoshii (吉井) school (Kagenori [景則], Yoshinori [吉則], Kiyonori [清則], Naganori [永則]). Morimitsu (盛光), Yasumitsu (康光), Toshimitsu (利光), Moromitsu (師光), Sukemitsu (祐光), Norimitsu (則光). Katsumitsu (勝光), Munemitsu (宗光), Kiyomitsu (清光), Tadamitsu (忠光), Norimitsu (法光), Sukesada (祐定), the entire Sue-Bizen school (末備前全般). The Motoshige (元重) school (Motoshige [元重], Shigezane [重真]). The Ukai (鵜飼) school (Unsho [雲生], Unji [雲次], Unju [雲重]).
	Bitchu (備中)	The Ko-Aoe (古青江) school (Moritsugu [守次], Yasutsugu [安次], Sadatsugu [貞次], Tsunetsugu [恒次], Yasutsugu [康次], Suketsugu [助次], Masatune [正恒]). The Chu-Aoe (中青江) school (Tsuguyoshi [次吉], Yoshitsugu [吉次], Naotsugu [直次], Tsugunao [次直]), the Sue-Aoe school (末青江).

MAIN ROAD	PROVINCE	SWORDSMITH(S)
San'yodo (山陽道)	Bingo (備後)	The Ko-Mihara (古三原) school (Masaie [正家], Masahiro [正広]). The Kai-Mihara (貝三原) (or the Sue-Mihara) school (Masashige [正重], Masaoki [正興]). The Hokke-Ichijo school (法華一乗).
	Suo (周防)	The Nio (二王) school (Kiyotsuna [清綱], Kiyokage [清景]).
	Nagato (長門)	Sa Yasuyoshi (左安吉), Akikuni (顕国).
Nankaido (南海道)	Kii (紀伊)	The Iruka (入鹿) school, Sudo Kunitsugu (簀戸国次).
	Awa (阿波)	The Kaifu (海部) school (Ujiyoshi [氏吉], Yasuyoshi [泰吉]).
	Tosa (土佐)	Yoshimitsu (吉光).
Saikaido (西海道)	Chikuzen (筑前)	The Ko-Chikuzen (古筑前) school (Ryosai [良西], Sairen [西蓮], Nyusai [入西], Jitsua [実阿]). The Samonji (左文字) school (Sa Yasuyoshi [Nagato] 左安吉 [長門], Sadayuki [定行], Yoshisada [吉貞], Kunihiro [国弘], Yukihiro [行弘]). The Kongobei (金剛兵衛) school (Moritaka [盛高], Moriyasu [盛安], Morimasa [盛匡]).
	Chikugo (筑後)	Miike Mitsuyo (三池光世) The Oishi-Sa (大石左) school (Ienaga [家永], Norinaga [教永], Sukenaga [資永]).
	Buzen (豊前)	Shinsoku (神息), Choen (長円). Nobukuni (信国), Yoshisuke (吉助), Yoshisada (吉定).
	Bungo (豊後)	So Sadahide (僧定秀), Yukihira (行平). The Takada (高田) school (Tomoyuki [友行], Tokiyuki [時行], Nagamori [長盛], Shizumori [鎮盛]). Tsukushi Ryokai (筑紫了戒), Yoshisada (能定), Yoshizane (能真).
	Hizen (肥前)	The Hirado-Sa (平戸左) school (Morihiro [盛広], Moriyoshi [盛吉]).
	Higo (肥後)	The Enju (延寿) school (Kunimura [国村], Kunisuke [国資], Kunitoki [国時], Kuniyoshi [国吉]). The Dotanuki (同田貫) school.
	Satsuma (薩摩)	Naminohira (波平) school.

SHINTO AND SHINSHINTO DOZEN LIST

NOTE: Occasionally you may receive a response of 'dozen' instead of 'jidai chigai iya' even though you bid a smith from the wrong period (e.g., a bid of a Shinto Satsuma smith for a Shinshinto Satsuma swordsmith, but not for a Koto smith.). Dotted lines connecting smiths show very similar workmanship.

MAIN ROAD	PROVINCE	SHINTO SWORDSMITH(S)	SHINSHINTO SWORDSMITH(S)
Kinai (畿内)	Yamashiro (山城)	The Umetada (埋忠) school (Myoju [明寿], Shigeyoshi [重義], Yoshinobu [吉信], Tadayoshi [Hizen prov.] 忠吉 [肥前]), Higo no Kami Teruhiro [Aki prov.] 肥後守輝広 [安芸], Higashiyama Yoshihira (東山美平), Nagamasa (Aizu) (会津正長). The Horikawa (堀川) school (Kunihiro [国広], Kuniyasu [国安], Masahiro [正弘], Kunimichi [国路], Kunitomo [国儔], Kunisada I [moved to Settsu prov.] 初代 国貞 [後に摂津], Kunisuke I [moved to Settsu prov.] 初代 国助 [後に摂津], Yukihiro [弘幸], Kunikiyo (Echizen prov.) 国清 [越前], Kunitake [国武], Yoshitake [吉武], Hirozane [広実], Kuniyuki (Settsu prov.) 国幸 [摂津]). The Mishina (三品) school (Kinmichi [金道], Yoshimichi [吉道], Masatoshi [正俊], Rai Kinmichi [来金道], Hisamichi [久道], Nobuyoshi [信吉]. Etchu no Kami Masatoshi (越中守正俊), Sendai Kunikane (Rikuzen prov.) 仙台国包 (陸前).	Tomotaka (朝尊), Arikoto (有功), Yoshitomo (慶任).
	Yamato (大和)	Tsutsui Kiju (筒井紀充)	
	Settsu (摂津)	Kunisada I (初代 国貞), Shinkai (真改), Harukuni (治国), Kunitora (Iwaki prov.) 国虎 (磐城), Sadanori (Iwaki prov.) 貞則 (磐城), Shinryo (真了), Kiho (奇峯). Kunisuke I and II (初代と二代 国助), Sukehiro I (初代 助広), Kuniyasu (国康), Kuniteru (国輝), Kunitsugu (国次). Sukehiro I and II (初代と二代 助広), Sukenao (助直), Teruhiro (照広). Tatara Nagayuki (多々良長幸), Tameyasu (為康), Yasunaga (康永), Yasumichi (康道), Yasukuni (祐国), the Osaka Ishido school (大坂石堂). Tadatsuna I (初代 忠綱), Ikkanshi Tadatsuna (一竿子 忠綱), Nagatsuna (長綱), Tadayuki (忠行). The Osaka Tanba Yoshimichi (大坂丹波吉道) school. Kaneyasu I and II (初代と二代 包保), Kanesada (包貞), Terukane (照包).	Takanobu (鷹誯), Suketaka (助隆), Masataka (正隆), Norichika (Hitachi prov.) 徳鄰 (常陸), Sukemasa (Hitachi prov.) 助政 (常陸). The Gassan (月山) school.

MAIN ROAD	PROVINCE	SHINTO SWORDSMITH(S)	SHINSHINTO SWORDSMITH(S)
Tokaido (東海道)	Owari (尾張)	Masatsune I (初代 政常), Mino no Kami Masatsune (美濃政常), Nobutaka (信高), Ujifusa (氏房).	
	Suruga (駿河)	Yoshisuke (義助).	
	Sagami (相模)	The later Tsunahiro school (後代 綱広).	
	Musashi (武蔵)	Yasutsugu (康継), Tsuguhira (継平), Yasusada (安定), Yasutomo (安倫), Tsunamune (綱宗), Senjuin Morikuni (千手院盛国). Kotetsu (虎徹), Okimasa (興正), Okihisa (興久). Kozuke no Suke Kaneshige (上総介兼重), Izumi no Kami Kaneshige (和泉守兼重), Kotetsu (虎徹). Hankei (繁慶), Hanjo (or Shigemasa) (繁昌). Omura Kaboku (大村加卜), Bando Bokuden (板東卜伝), Yasukuni (安国). The Hojoji (法城寺) school (Masahiro [正弘], Sadakuni [貞国], Kunimitsu [国光], Kunimasa [国正], Masateru [正照]). Tsunemitsu (江戸石堂常光), Mitsuhira (光平), Korekazu (是一), Yorisada (頼貞), Mitsuyo (Owari prov.) 光代 (尾張). The Shitahara (下原) school (Yasushige [康重], Terushige [照重]), Ogasawara Nagamune (小笠原長旨), Nagamune (長宗).	Kiyomaro (清麿), Saneo (Shinano prov.) 真雄 (信濃), Nobuhide (信秀), Kiyondo (清人), Masao (正雄). Masahide (正秀), Naotane (直胤), Masayoshi (正義), Tsunatoshi (綱俊). Naotane (直胤), Naokatsu (直勝), Yoshitane (義胤). Masayoshi (正義), Teruyoshi (英義), Masamori (正守). Tsunahide (綱英), Tsunatoshi (綱俊), Korekazu (是一), Munetsugu (宗次).
	Hitachi (常陸)	Mito Nariaki (水戸斉昭), Norichika (徳鄰), Norikatsu (徳勝), Sukemasa (助政).	

MAIN ROAD	PROVINCE	SHINTO SWORDSMITH(S)	SHINSHINTO SWORDSMITH(S)
Tosando (東山道)	Omi (近江)	Sasaki Ippo I (佐々木一峯), Ippo II (二代 一峯).	
	Mino (美濃)	Omichi (or Daido) (大道), Kanenobu (兼信), Kanetaka (兼高), Ujifusa (氏房), Terukado (照門), Jumyo (寿命).	Okachiyama Nagasada (御勝山永貞).
	Shinano (信濃)		Kawamura Toshitaka (河村寿隆), Masao (or Saneo) (真雄), Kiyomaro (moved to Musashi prov.) 清麿(後に武蔵へ).
	Rikuzen (陸前)	Yamashiro Daijo Kunikane (山城大掾国包), Kunikane II (二代 国包), Yasutomo (安倫).	Later Kunikane (後代 国包).
	Dewa (出羽)		Kato Tsunahide (加藤綱英), Tsunatoshi (綱俊), Tsunanobu (綱信).
	Iwaki (磐城)	Suzuki Sadanori (鈴木貞則), Izumi no Kami Kunitora (和泉守国虎).	
	Iwashiro (岩代)	Aizu Nagakuni (会津長国), Masanaga (政長), Nagamichi (長道), Michitoki (道辰) ⋯⋯⋯⋯⋯⋯	Later Nagamichi (後代 長道), Later Michitoki (後代 道辰), Kanesada (兼定).
Hokurikudo (北陸道)	Echizen (越前)	Yasutsugu (康継), Sadakuni (貞国), Tsuguhira (継平), Kanenori (兼法), Hirotaka (汎隆), Shigetaka (重高), Masanori (正則), Kanetane (兼植), the Shimosaka (下坂) school. Yamashiro no Kami Kunikiyo (山城守国清), Kunikiyo II (二代 国清).	Later Yasutsugu (後代 康継).
	Kaga (加賀)	Kanewaka (兼若), Takahira (高平), Kiyohira (moved to Sagami prov.) 清平 (後に相模). The Kiyomitsu (清光) school. Darani Katsukuni (陀羅尼勝国) ⋯⋯⋯⋯⋯⋯⋯	Later Katsukuni (後代 勝国).
San'indo (山陰道)	Inaba (因幡)	Kanesaki (兼先代々) and later generations. Shinano Daijo Tadakuni (信濃大掾忠国), Tadakuni II (二代 忠国), Dewa Daijo Kunimichi (Yamashiro prov.) 出羽大掾国路 (山城).	Hamabe Toshinori (浜部寿格), Toshizane (寿実), Toshitaka (寿隆).

MAIN ROAD	PROVINCE	SHINTO SWORDSMITH(S)	SHINSHINTO SWORDSMITH(S)
San'yodo (山陽道)	Harima (播磨)	Ujishige (氏重) ··············	Tegarayama Masashige (手柄山正繁), Ujishige (氏繁).
	Bizen (備前)	Yokoyama Sukesada (横山祐定), Kouzuke Daijo Sukesada (上野大掾祐定) ······	Sukenaga (祐永), Sukekane (祐包).
	Bichu (備中)	Mizuta Kunishige (水田国重代々) and later generations.	
	Aki (安芸)	Teruhiro I and II (初代と二代 輝広).	
Nankaido (南海道)	Kii (紀伊)	Nanki Shigekuni (南紀重国), Monju Shigekuni (文珠重国).	
	Tosa (土佐)	Mutsu no Kami Yoshiyuki (陸奥守吉行), Yoshikuni (吉国).	Sa Yukihide (左行秀), Hiroshige (弘秀). Tomotaka (Yamashiro prov.) 朝尊 (山城).
Saikaido (西海道)	Chikuzen (筑前)	The Nobukuni (信国) school (Yoshimasa [吉政], Yoshisuke [吉助], Yoshikane [吉包], Shigekane [重包]). The Fukuoka Ishido (福岡石堂) school (Koretsugu [是次], Moritsugu [守次]).	
	Chikugo (筑後)	Onizuka Yoshikuni (鬼塚吉国)l	
	Hizen (肥前)	Tadayoshi (忠吉), Tadahiro (忠広), Masahiro (正広), Yukihiro (行広), Tadakuni (忠国), Munetsugu (宗次), Munenaga (宗長), Tadanaga (忠長) ·············	Later Tadayoshi (後代 忠吉).
	Bungo (豊後)	The Takada (高田) school (Muneyuki [統行], Teruyuki [輝行], Matsuba Motoyuki [松葉本行]).	
	Satsuma (薩摩)	Bingo no Kami Ujifusa (備後守氏房), Masafusa (正房) ··· Mondo no Sho Masakiyo (主水正正清), Masafusa (正房). Ichinohira Yasuyo (一平安代) ······ The Naminohira (波平) school ······	Later Masafusa (後代 正房). Yasuari (安在) The Later Naminohira (後代 波平) school. Yamato no Kami Motohira (大和守元平), Motooki (Aizu prov.) 元興 (会津), Motoyasu (元安), Mototake (元武). Masayoshi (正良), Hoki no Kami Masayoshi (正幸).

LIST OF SWORDSMITHS OFTEN FEATURED IN KANTEI-KAI

This list shows swordsmiths who are often featured in kantei kai, classified by their hamons. It also notes important points about each swordsmith that are key to correct attribution, and lists the names of smiths whose work is similar. The letters A–E are used to show the frequency with which smiths are featured in kantei-kai, with "A" representing the greatest frequency.

	SWORDSMITH(S)	CHARACTERISTICS	PAGE	SIMILAR SMITH(S)
Hoso-suguha				
C	Shintogo Kunimitsu 新藤五国光	Hamon narrows at the fukura.	146	Awataguchi Yoshimitsu 粟田口吉光
C	Ryokai 了戒	Jigane is whitish. Hamon is dull, with little nie. Boshi is ko-maru.	147	The Enju 延寿 and the Ko-Mihara 古三原 schools
D	The Ko-Mihara 古三原 school	The jihada is basically ko-mokume, mixed with some masame-hada. Kaeri is long, shinogiji is wide.	161	The Ko-Nio 古二王 and the Tegai 手掻 schools
E	Inshu Kagenaga 因州景長	Jihada is ko-mokume, and jigane is whitish, weak, and slender.	148	The Awataguchi 粟田口, Ko-Nio 古二王, and Ko-Mihara 古三原 schools
E	The Ko-Nio 古二王 school	Hera-kage (a type of utsuri) appears. Muneyaki is seen.	162	The Ko-Mihara 古三原, Tegai 手掻 and Aoe 青江 schools
Suguha in nioi-deki				
A	Nagamitsu 長光	Suguha with ashi, little activity inside hamon, sansaku boshi.	146	The Chu-Aoe 中青江 and the Ukai 鵜飼 schools
A	Kagemitsu 景光	Suguha with ashi, ashi inclined to be oblique, sansaku boshi.	148	The Chu-Aoe 中青江 and the Ukai 鵜飼 schools
E	Sanenaga 真長	Suguha with ashi, sansaku boshi.	147	The Chu-Aoe 中青江 and the Ukai 鵜飼 schools
C	The Ukai 鵜飼 school	Suguha with oblique ashi. Small mass of nie seen in the hamon, masame-hada is mixed. Torii-zori (or Kyo-zori).	140	Motoshige 元重, Sanenaga 真長, and the Aoe 青江 and the Rai 来 schools
A	Morimitsu 盛光	Bo-utsuri. Top of boshi is inclined to become pointed.	152	
A	Yasumitsu 康光	Features largely the same as Morimitsu's, but ashi inclined to be more oblique.	152	
D	Tadamitsu 忠光	Fine ko-mokume hada, ko-kissaki. Hamon gradually grows wider, from the lower to the upper part of the blade.	152	
B	Kiyomitsu 清光	Heavy blade, thick kasane. The patterns of the boshi are different on each side. A good deal of nie kuzure.	197	
A	Sukesada 祐定	Nie and fine jihada are seen in the work of Genbei no Jo Sukesada.	153	
B	The Chu-Aoe 中青江 school	Suguha with saka ashi. Sumigane is seen.	142	The Ukai 鵜飼 school, Chikakage 近景, Motoshige 元重
D	Heianjo Nagayoshi 平安城長吉	Dense ko-mokume hada. Horimono are common.	151	

	SWORDSMITH(S)	CHARACTERISTICS	PAGE	SIMILAR SMITH(S)
E	Zenjo Kaneyoshi 善定兼吉	Masame-hada appears at intervals in the jihada, the nioi line is tight.	151	
A	Izumi no Kami Kanesada 和泉守兼〜	Among his tanto are many copies of work of Rai Kunitoshi. Boshi is not typical ko-maru. Togari-ba or fushi (knots) are usually seen in hamon.	153	Rai Kunitoshi 来国俊
C	The Sue-Tegai 末手掻 school	Dense ko-mokume. Jigane is whitish.	158	The Sue-Seki 末関 school
E	Gassan 月山	Ayasugi-hada appears, hamon is not clear.	151	The Naminohira 波平 and the Hoju 宝寿 schools

Suguha in nie-deki

	SWORDSMITH(S)	CHARACTERISTICS	PAGE	SIMILAR SMITH(S)
C	The Awataguchi 粟田口 school	Nashiji-hada with o-hada, nijuba is seen, hamon narrows in the upper area.	138	Tomonari 友成, Masatsune 正恒, and the Ko-Aoe 古青江 school
C	Awataguchi Yoshimitsu 藤四郎吉光	Some gunome are seen at start of hamon. A few nie lines in boshi.	145	Shintogo Kunimitsu 新藤五国光
B	Rai Kunitoshi 来国俊	Mokume-hada mixed with itame-hada. Mihaba is narrow and graceful. Rai hada.	147	The Enju 延寿 school, Nobukuni 信国, Hizen Tadayoshi 肥前忠吉
A	Rai Kunimitsu 来国光	Rai hada and running hada are seen. Hamon with fine nie and hotsure.	148	Hizen Tadayoshi 肥前忠吉, the Ukai 鵜飼 school
C	Nobukuni I 初代 信国	A little coarse mokume-hada is mixed with masame-hada. Horimono in the Soshu tradition are often seen. Kaeri is wide.	149	Rai Kunimitsu 来国光
C	The Taima 当麻 school	Taima-hada is seen, shinogi is high, a good deal of vertical activity seen along hamon.	159	
B	Shikkake Noringa 尻懸則長	Shikkake-hada is seen, shinogi is high, ko-gunome midare is seen in suguha.	159	
A	Tegai Kanenaga 手掻包永	Ko-mokume hada is visible, masame-hada is conspicuous. The hamon on one side is sometimes different from that on the other (eg., the front is suguha, and the back notare midare).	158	
C	The Hosho 保昌 school	Wavy masame hada, high shinogi. Masame-hada that is poorly welded is seen here and there.	158	Sendai Kunikane 仙台国包, Mito Norikatsu 水戸徳勝, Gassan Sadakazu 月山貞一
C	Soshu Yukimitsu 相州行光	Fine ko-itame hada. Inazuma and kinsuji are seen.	209	The Awataguchi 粟田口 school
B	The Enju 延寿 school	Jihada mixed with with running hada, and whitish. Boshi is o-maru, suguha with round-headed gunome.	143	The Rai 来 school
D	Bungo Yukihira 豊後行平	Narrow mihaba, small kissaki, hamon not bright. Yakiotoshi is seen, as are horimono.	144	
A	Tsuda Sukehiro 助広	Nie particles becomes larger toward ji (whereas they usually becomes smaller).	272	Shinkai 真改, Tadayoshi 忠吉, and Sa Yukihide 左行秀

	SWORDSMITH(S)	CHARACTERISTICS	PAGE	SIMILAR SMITH(S)
A	Shinkai 真改	Hamon line is sometimes tight. Boshi is ko-maru sagari. Osaka yakidashi. Suguha is based on notare. Slightly smaller kissaki than seen in work of other Osaka Shinto smiths.	272	Go Yoshihiro 郷義弘, Tadayoshi 忠吉, Sa Yukihide 左行秀, Yasuyo 安代
A	The Tadayoshi 忠吉 school	Konuka-hada. Tadayoshi I's hamon is inclined to be notare. Width of hamon is uniform. Hizen boshi (typically ko-maru).	263	Rai Kunitoshi 来国俊, Rai Kunimitsu 来国光, Sukehiro 助広, Shinkai 真改
C	Ichinohira Yasuyo 一平安代	Hiro-suguha with kuichigaiba, shallow sori, thick kasane.	276	Go 郷, Shinkai 真改, Sukehiro 助広, Sa Yukihide 左行秀
A	Yasutsugu 康継	Jihada is running and coarse, hamon is not bright. Horimono are often seen. Many swords copied from famous Koto blades.	261	
D	Yamashiro no Kami Kunikiyo 山城守国清	Fine mokume-hada, habuchi is somewhat tight.	266	Omi Daijo Tadahiro 近江大掾忠広
B	Nanki Shigekuni 南紀重国	Mokume-hada mixed with masame-hada. Shinogi is high. Slope of mune is steep. Deep sori.	263	Tegai Kanenaga 手掻包永, Kunikane 国包
B	Sendai Kunikane 仙台国包	Distinct masame-hada. Sugata is similar to that of tachi of the Kamakura period. Boshi is usually yakitsume.	264	The Hosho 保昌 school, Nanki Shigekuni 南紀重国, Katsumura Norikatsu 勝村徳勝
C	Masatsune 政常 (Owari)	Chu-suguha. Width of hamon increases from bottom toward top. Boshi tends to be pointed, but o-maru is sometimes seen.	262	Rai Mitsukane 来光包
B	Suishinshi Masahide 水心子正秀	Looks like muji-hada. Black ara- (large) nie glitter in places.	300	Shinkai 真改
B	Sa Yukihide 左行秀	Hiro-suguha, shinogiji is masame. Boshi is ko-maru sagari, kissaki is relatively long.	302	Go 郷, Shinkai 真改
C	Kiyondo 清人	Distinct masame-hada, usually o-kissaki.	304	Katsumura Norikatsu 勝村徳勝
D	Katsumura Norikatsu 勝村徳勝	Rough masame-hada. Sunagashi are seen in the ji.	305	Kunikane 国包, Gassan Sadakazu 月山貞一
C	Gassan Sadakazu 月山貞一	Looks like muji-hada or ayasugi-hada. Horimono are often seen.	305	Rai Kunimitsu 来国光, Hizen Tadayoshi 肥前忠吉

Ko-midare

A	The Ko-Bizen 古備前 school	Fine ko-mokume hada or coarse o-mokume hada. Jifu utsuri is seen.	128	Yasutsuna 安綱, the Ko-Ichimonji 古一文字 school
E	Yasutsuna 安綱, Ohara Sanemori 大原真守	Coarse o-mokume hada mixed with o-itame hada. Width of the hamon is not uniform.	128	The Ko-Bizen 古備前 school
C	The Ko-Aoe 古青江 school	Chirimen-hada with sumi-hada. Deep sori. Slanted patterns seen in the hamon.	141	The Ko-Bizen 古備前 school

	SWORDSMITH(S)	CHARACTERISTICS	PAGE	SIMILAR SMITH(S)
Midareba				
D	Masamune 正宗	Hamon consists of nie but becomes nioi in places. Various hamon patterns.	209	Norishige 則重, Shizu 志津, Kunimichi 国路, Naotane 直胤, Satsuma swords 薩摩刀
C	Norishige 則重	Matsukawa-hada. The border between ji and hamon is unclear. Large kissaki are rare. In tanto, fukura is not rounded.	209	Ko-Uda 古宇多, Sanekage 真景, Hankei 繁慶, Naotane 直胤
C	Yukimitsu 行光	Running hada which looks like Yamato-den is seen in ji. Somewhat disproportionately wide.	209	The Taima 当麻 school, Norishige 則重, Satsuma swords 薩摩刀
C	Rai Kunitsugu 来国次	When this smith works in Soshu tradition, hamon resembles that of Masamune, but boshi is ko-maru (typical Rai boshi). His tanto is relatively wide.	210	Masamune 正宗
B	Tametsugu 為継	Jihada is rough. Jigane and hamon are dull. Many sunagashi are seen.	212	Norishige 則重, Sanekage 真景
E	Taima Kuniyuki 当麻国行	Taima-hada is seen. Mumei and attributed Taima blades alike often show influence of the Soshu-den.	164	Yukimitsu 行光
D	Mizuta Kunishige 水田国重	Hamon is o-midare with abundant nie, and becomes wider in the monouchi area. Muneyaki are seen.	264	The Masamune 正宗 school
A	Taikei Naotane 大慶直胤	Uzumaki-hada is seen. There are hard black spots inside the hamon.	301	The Masamune 正宗 school
C	Gassan Sadakazu 月山貞一	Readily visible o-hada is mixed. Horimono are often seen.	305	The Masamune 正宗 school
Hitatsura				
C	Hiromitsu 広光	Itame-hada is coarse and readily visible. In the upper area, the pattern of hamon becomes large.	212	The Hasebe 長谷部 school, Akihiro 秋広
C	Akihiro 秋広	Similar to work of Hiromitsu, though the total shape is smaller.	212	Hiromitsu 広光, the Hasebe 長谷部 school
B	Hasebe Kunishige 長谷部国重	Masame-hada appears along mune. Boshi is inclined to be round. Sunagashi are seen inside tobiyaki, forming a striped pattern.	211	Akihiro 秋広, Hiromitsu 広光
D	Hiromasa 広正	Length is greater than in work of Hiromitsu. Nie is less abundant than in earlier Soshu swords.	213	Akihiro 秋広, Hiromitsu 広光
C	Tsunahiro 綱広	Hamon usually consists of nioi. Crescent-shaped tobiyaki are seen.	213	The Shimada 島田 school, Muramasa 村正, Koga 広賀
C	The Shimada 島田 school	The bottom of midare is suguha, togari-ba are seen. Thick kasane.	208	The Sue-Soshu 末相州 school
C	The Sue-Tegai 末手搔 school	Fine ko-mokume hada. Hamon is tight.	158	The Sue-Seki 末関 school

	SWORDSMITH(S)	CHARACTERISTICS	PAGE	SIMILAR SMITH(S)
E	Koga 広賀	Similar to work of Sukesada.	214	Sukesada 祐定
Notare				
B	Sadamune 貞宗	Narrow ko-notare mixed with gunome. Chikei and yubashiri are seen, as are hori-mono.	211	Takagi Sadamune 高木貞宗, Nobukuni 信国, Teruhiro 輝広
B	Nobukuni I 初代 信国	Jihada is a little coarse, and masame-hada is seen. Boshi is rounded and has kaeri. Soshu-style horimono.	211	Sadamune 貞宗
E	Takagi Sadamune 高木貞宗	Jihada is coarse and mixed with masame-hada. Hamon is not bright. A great deal of sunagashi.	211	Sadamune 貞宗
D	Ujifusa 氏房 and Daido (Omichi) 大道	O-notare in nioi-deki with uneven nie, Jizo-style boshi, masame-hada in shinogiji.	253	Go Yoshihiro 郷義弘 (in terms of sugata only)
C	Masatsune (Owari) 政常	O-notare which widens toward the boshi. Boshi is inclined to be pointed or deep o-maru.	262	The Sue-Seki 末関 school
A	Yasutsugu 康継	O-notare of nie-deki. Hamon is not bright, jihada is mixed with masame-hada. Work of later generations is tight ko-itame.	261	
E	Higashiyama Yoshihira 東山美平	Ko-mokume hada looks like muji-hada. Kata (half-cut) yahazu-ba is seen.	273	
D	Osumi no Jo Masahiro 大隅掾正弘	Ko-notare of thick nie, masame-hada appears along the hamon, long swords (about 80 cm) are often seen.	261	The Samonji 左文字 school
C	Teruhiro 輝広	Ko-notare resembling work of Sadamune. Masame-hada is seen. In the habuchi area, the hamon is faint in places.	262	Sadamune 貞宗, Nobukuni 信国
E	Sadakuni 貞国	Narrow ko-notare. Katakiriha-zukuri and elaborate horimono are seen. Hi is wider than is standard.	262	Yasutsugu I 初代 康継
A	Tadayoshi I 初代 忠吉	In early work the jihada is coarse and mixed with o-hada. In later work suguha or shallow ko-notare is seen.	263	The Sue-Seki 末関 school
B	The Kanemitsu 兼光 school	Notare mixed with gunome. Considerable nie is seen although blades are in nioi-deki. Kanemitsu boshi.	181	
Midareba based on notare				
B	Sadamune 貞宗	Calm, gentle midareba. Yubashiri, chikei, kinsuji and inazuma appear.	211	Horikawa Kunihiro 堀川国広, Yasutsugu 康継, Kunimichi 国路, Echigo no Kami Kunitomo 越後守国儔
C	Yukimitsu 行光	Running hada appears. Hamon is more gorgeous than in work of Sadamune.	209	The Taima 当麻 school

	SWORDSMITH(S)	CHARACTERISTICS	PAGE	SIMILAR SMITH(S)
E	Go Yoshihiro 郷義弘	Ko-mokume hada looks like nashiji-hada, hamon has wide nioiguchi and thick ashi. Boshi is ichimai or ichimonji.	210	Kotetsu 虎徹, Sa Yukihide 左行秀
C	The Samonji 左文字 school	Nenrin-hada (pattern similar to annual rings of a tree) appears. Sometimes koshiba is seen.	210	Chogi 長義, Kiyomaro 清麿
B	Nanki Shigekuni 南紀重国	Masame-hada mixed with itame-hada. Boshi is yakitsume or has very short kaeri.	263	The Taima 当麻 school, Yukimitsu 行光
Choji midare				
A	The Ichimonji 一文字 school	Various choji midare are seen. Choji utsuri appears. Mokume-hada mixed with o-hada.	178	The Ishido 石堂 school (Shinto)
D	Yoshifusa 吉房	O-choji midare. Choji utsuri.	187	
D	Norifusa 則房	O-choji midare, mixed with some saka-choji midare. Choji utsuri.	188	
D	Sukezane 助真	O-choji midare with nie and mixed with small kawazuko choji. Choji utsuri.	189	
D	Yoshioka Ichimonji Sukemitsu 吉岡一文字助光	O-choji midare, sometimes based on sugu-ha. Choji utsuri.	191	The Ishido 石堂 school (Shinto)
C	Kunimune 国宗	O-choji midare. The top of each choji is inclined to be the same height, and looks like suguha-choji midare. Hajimi (misty white spots) are seen somewhere on the blade.	188	
C	Mitsutada 光忠	O-choji midare mixed with kawazuko choji and gunome midare.	188	Moriie 守家
D	Moriie 守家	O-choji midare mixed with kawazuko choji and gunome midare. Jihada is coarser, and the hamon and jihada less clear, than in work of Mitsutada.	188	Mitsutada 光忠
A	Nagamitsu 長光	O-choji midare mixed with a considerable amount of kawazuko choji and gunome midare. Utsuri is very clear.	189	
D	Hojoji Kunimitsu 法城寺国光	Choji midare in nie-deki and mixed with ehabana- (tea flower) midare. O-mokume hada. Many blades in the nagamaki naoshi style.	211	The Ichimonji 一文字 school
B	The Chu-Aoe 中青江 school	Nioi line is tight. Saka choji midare. Sumi-hada is seen.	142	The Katayama Ichimonji 片山一文字 school
B	Rai Kuniyuki 来国行	Hamon consists of nie. Rai hada is seen. Kyo-choji midare.	189	
B	Niji Kunitoshi 二字国俊	Same as in work of Rai Kuniyuki.	189	Ichimonji 一文字 school
A	Izumi no Kami Kanesada 和泉守兼定	Shinogiji is masame-hada. Hamon mixes togari-ba and gunome choji. Midare.	224	The Yoshioka Ichimonji 吉岡一文字 school

	SWORDSMITH(S)	CHARACTERISTICS	PAGE	SIMILAR SMITH(S)
C	Tatara Nagayuki 多々良長幸	O-choji midare mixed with gunome midare. The peaks of the hamon are tapered. Boshi is midare komi.	273	The Yoshioka Ichimonji 吉岡一文字 school
D	Ishido Korekazu 石堂是一	O-choji midare or saka choji midare. Shinogiji is masame-hada. Utsuri is seen.	270	The Fukuoka Ichimonji 福岡一文字 school, the Katayama Ichimonji 片山一文字 school
C	Kunisuke II 二代国助	Kobushi-gata choji midare. Osaka yakidashi is seen. Narrow ko-maru, long kaeri.	268	Hamabe Toshinori 浜部寿格, Yokoyama Sukenaga 横山祐永
B	Koretsugu 是次	Saka choji midare, some parts of the hamon reach the shinogi line. The width of the hamon is not uniform. Jihada is mixed with masame-hada. Utsuri appears.	271	
C	Mitsuhira 光平 and Tsunemitsu 常光	Shinogiji is masame-hada. Jihada is coarse and utsuri is seen.	271	
A	Koyama Munetsugu 固山宗次	The same hamon patterns are repeated, and nie is seen in places.	302	The Ichimonji 一文字 school
D	Yokoyama Sukenaga 横山祐永, Sukekane 祐包	Jihada looks like muji- (plain) hada. Picturesque choji midare.	302	Hamabe Toshinori 浜部寿格, the Suishinshi 水心子 school

Ko-choji midare

	SWORDSMITH(S)	CHARACTERISTICS	PAGE	SIMILAR SMITH(S)
E	The Ko-Ichimonji 古一文字 school	Ko-mokume hada. Midare utsuri appears. Considerable nie is seen in the hamon. Graceful tachi sugata.	178	The Ko-Bizen 古備前 school
C	The Ko-Aoe 古青江 school	Oblique choji is seen in the hamon. Chirimen hada, sumigane appears.	141	The Ko-Bizen 古備前 school
A	The Ko-Bizen 古備前 school	Ko-midare mixed with ko-choji. Jifu utsuri appears.	126	The Ko-Aoe 古青江 and Ko-Ichimonji 古一文字 schools
E	Ayanokoji Sadatoshi 綾小路定利	Jihada mixed with masame-hada. Pairs of square choji are seen here and there. The pattern of the hamon is small.	146	Rai Kuniyuki 来国行, the Ko-Bizen 古備前 school
A	The Suishinshi 水心子 school	Jihada looks like muji- (plain) hada. Hamon is not bright, and the nioi line is not tight. Hard black spots are seen inside the hamon. Ashi are very leggy and reach the cutting edge.	279	

Suguha choji midare

	SWORDSMITH(S)	CHARACTERISTICS	PAGE	SIMILAR SMITH(S)
C	Rai Kuniyuki 来国行	Hamon consists of ko-nie. Jihada mixes nagare-hada and Rai hada.	146	Nagamitsu 長光, Sadatoshi 定利, Kunimune 国宗, the Ukai 鵜飼 school
B	Niji Kunitoshi 二字国俊	Hamon consists of ko-nie. Jihada mixes nagare-hada and Rai hada. Pattern of hamon is larger than in work of Rai Kuniyuki.	147	As above.
A	Nagamitsu 長光	Hamon is in nioi-deki. Nioi rises from the peaks of the hamon (softly, unlike that of the Mino school) to join the utsuri. Sansaku boshi.	146	Rai Kuniyuki 来国行, Niji Kunitoshi 二字国俊, Kunimune 国宗

	SWORDSMITH(S)	CHARACTERISTICS	PAGE	SIMILAR SMITH(S)
A	Kagemitsu 景光	Hamon is inclined to be kataochi gunome or oblique. Sansaku boshi.	147	The Chu-Aoe 中青江 and Ukai 鵜飼 schools, Naotane 直胤
C	Chikakage 近景	Hamon is inclined to be oblique. Boshi is notare komi, and the top looks pointed.	190	The Chu-Aoe 中青江 school
C	Kunimune 国宗	From the monouchi area to the tip, the hamon becomes suguha without ashi. Hajimi (misty white spots) are seen inside hamon.	146	Rai Kuniyuki 来国行, Niji Kunitoshi 二字国俊, Nagamitsu 長光
A	The Suishinshi 水心子 school	Jihada looks like muji- (plain) hada. Nioi line is neither tight nor bright. The top of the hamon is hard, and black spots are seen.	279	
A	Naotane 直胤	Hamon is inclined to be oblique.	301	Kagemitsu 景光, the Chu-Aoe 中青江 school
C	Naokatsu 直勝	As above.	304	As above.

Ashi-naga choji midare (choji midare with long ashi)

	SWORDSMITH(S)	CHARACTERISTICS	PAGE	SIMILAR SMITH(S)
C	Tadatsuna I 初代 忠綱	Hamon is in nioi-deki. Boshi is ko-maru sagari (Osaka boshi).	268	
A	Tadayoshi 忠吉	Hamon is in nie-deki. Abundant nie are seen in the valleys (tani) of the hamon. Hizen boshi (standard ko-maru boshi).	263	
A	Hizen swords 肥前刀	Konuka-hada.	246	
D	Tairyusai Sokan 泰龍斎宗寛	Jihada looks like muji-hada. Hamon is in nioi-deki. Boshi is midare komi. Nie is seen in a few places.	305	

Koshi-no-hiraita midare mixed with choji midare

	SWORDSMITH(S)	CHARACTERISTICS	PAGE	SIMILAR SMITH(S)
A	Morimitsu 盛光	Hamon is in nioi-deki. O-mokume hada is visible. Rounded gunome. Bo utsuri appears.	195	
A	Yasumitsu 康光	Hamon is in nioi-deki. O-mokume is visible. The top of gunome is pointed.	195	
B	Chogi 長義	Jihada is mixed with itame-hada. The pattern of hamon is large. Considerable nie is seen, as is an ear-shaped pattern.	191	The Samonji 左文字 school (in terms of the boshi)
B	Oei (era) Nobukuni 応永信国	Hamon is in nie-deki. Horimono are usually seen.	212	
D	Fujishima Tomoshige 藤島友重	Hako midare (box-shaped irregular pattern) is seen, as is muneyaki.	192	The Oei-Bizen 応永備前 school
C	Tatara Nagayuki 多々良長幸	Hamon is sometimes tapered. Ko-mokume hada, bo-utsuri is seen.	273	The Oei-Bizen 応永備前 school
A	The Suishinshi 水心子 school	Jihada looks like muji- (plain) hada. Nioi line is not tight. Hard black spots are seen inside the hamon.	279	

	SWORDSMITH(S)	CHARACTERISTICS	PAGE	SIMILAR SMITH(S)
B	Sukenao 助直	Differently-sized gunome are seen. More gunome ashi are seen than in the work of Sukehiro. Boshi is ko-maru sagari and has long kaeri.	273	Sukehiro 助広
B	Tadatsuna II 二代 忠綱	The pattern of the hamon is complicated by the presence of several gunome between each peak. Horimono are usually seen. Boshi has a short kaeri.	274	
B	Terukane 照包	Gunome of different sizes are seen. Box-shaped and yahazu- (dove-tail) shaped patterns are also seen.	272	Sukenao 助直
E	Tsutsui Kiju 筒井紀充	Jihada mixed with masame-hada. Toran-midare consists of an uneven gunome pattern. Many sunagashi are seen.	275	Terukane 照包, Sukenao 助直
C	Masahide 正秀	Toran-midare consists of uneven gunome patterns, and ara- (large) nie are seen. Hard black spots are seen inside the hamon. Jihada looks like muji- (plain) hada.	300	
C	Suketaka 助隆	Jihada looks like muji-hada. Gunome are inclined to be square.	299	
B	Masashige 正繁	Jihada looks like muji-hada. Gunome midare mixed with large gunome and long ashi. Hamon is bright.	301	
D	Norichika 徳鄰	Jihada looks like muji-hada. Regular gunome midare.	301	
D	Tsunahide 綱英	Many tobiyaki are seen. Some togari-ba are seen in the hamon.	302	
Kataochi gunome				
A	Kagemitsu 景光	Fine ko-mokume hada. Midare utsuri is seen. Ashi are inclined to be oblique. A good deal of activity is seen in hamon.	190	
A	Kanemitsu 兼光	Mokume-hada is coarse and namazu-hada appears. Pattern of hamon becomes a little larger than in the work of Kagemitsu.	192	
C	Motoshige 元重	Jihada is mixed with masame-hada. Utsuri is not clear. Jihada is rougher. Hamon is not bright.	190	
A	Naotane 直胤	Utsuri appears intermittently. Pattern of hamon lacks variety, and the hamon is loose.	301	
B	Naokatsu 直勝	Utsuri appears. Hamon pattern is rather large.	304	

	SWORDSMITH(S)	CHARACTERISTICS	PAGE	SIMILAR SMITH(S)
Gunome midare mixed with togari-ba				
A	Shizu Kaneuji 志津兼氏	The peaks of the hamon are not sharply tapered. Jihada is clear, unlike that of other Mino blades.	210	The Naoe Shizu 直江志津 and the Horikawa 堀川 schools, Satsuma swords 薩摩刀
B	The Naoe Shizu 直江志津 school	Similar to work of Kaneuji, but with less nie. Hamon pattern looks clumsy (not smooth). Jihada is whitish.	216	O-Shizu Tomomitsu (Rinmitsu) 大志津倫光, Masamitsu 政光, Kinmichi 金道, Masatoshi 正俊
B	The Sue-Seki 末関 school	Mokume-hada is mixed with masame-hada, and is coarse and whitish. Hamon usually consists of nioi, and the habuchi is dull. Hako midare and yahazu midare are seen.	217	
C	Tomomitsu (Rin Tomo) 倫光, Masamitsu 政光	Hamon consists mainly of nioi, but nie is also seen. Masame-hada is not seen. Togari-ba consists of nioi and looks like a candle flame.	194	The Naoe Shizu 直江志津 school
A	Kunihiro 国広, Kunimichi 国路	Blades appear to copy the work of Shizu Kaneuji. Coarse mokume-hada is mixed with masame-hada.	260	The Naoe Shizu 直江志津 school, Shizu Kaneuji 志津兼氏
C	Kuniyasu 国安	Same as work of Kunihiro and Kunimichi.	261	As above.
C	Kinmichi 金道	Kyo-yakidashi and yahazu-ba are seen.	265	As above.
A	Masatoshi 正俊	Mishina boshi.	266	As above.
A	Satsuma swords 薩摩刀	Very fine jihada mixed with o-hada.	248	
B	Masafusa 正房, Masakiyo 正清	Imozuru appear in the ji and the ha. Nie is quite large.	274, 276	Shizu Kaneuji 志津兼氏, Masamune 正宗, Sadamune 貞宗
B	Motohira 元平, Masayoshi 正幸	Togari-ba consists of nie and looks like a candle flame.	300	As above.
Gunome midare based on notare				
D	Masamune 正宗	The width of the habuchi is not regular from the top to bottom. Nie is only barely visible in some places. Hamon is mixed with uma-no-ha midare.	209	The Horikawa 堀川 school, Satsuma swords 薩摩刀
B	Sadamune 貞宗	Very dense mokume-hada. The workmanship is gentler than that of Masamune.	211	Nobukuni 信国
A	Shizu Kaneuji 志津	Shinogiji is masame-hada. Togari-ba are seen.	210	The Horikawa 堀川 school, Kinmichi 金道, Masatoshi 正俊
C	Samonji 左文字	Nenrin-hada and koshi-ba are seen. Samonji boshi.	210	Chogi 長義, Kiyomaro 清麿, Masatoshi 正俊
C	Sa Yasuyoshi 安吉	Jihada is not as clean, and the hamon not as bright, as in work of Samonji. Bo-utsuri is seen.	193	Kanemitsu 兼光, Takada Tomoyuki 高田友行
B	Chogi 長義	Jihada is mixed with itame-hada. Utsuri is almost never seen. Mimi-gata (ear-shaped) midare are seen.	191	Samonji 左文字, Naotsuna 直綱

	SWORDSMITH(S)	CHARACTERISTICS	PAGE	SIMILAR SMITH(S)
A	Kanemitsu 兼光	Namazu- (catfish) hada appear. The top of the boshi is pointed and resembles a candle flame.	194	Sa Yasuyoshi 左安吉, Takada Tomoyuki 高田友行
E	Naotsuna 直綱	Relatively large gunome tend to appear regularly. Many sunagashi are seen.	192	Chogi 長義
E	Go Yoshihiro 郷義弘	Jihada looks like nashiji-hada. The nioi line is wide, and thick ashi are seen. Boshi is ichimai or ichimonji kaeri.	210	Kotetsu 虎徹, Sa Yukihide 左行秀
B	Nobukuni 信国	Jihada is coarse and mixed with masame-hada. Boshi is round and has kaeri. Hori-mono are often seen.	212	Sadamune 貞宗
A	Kunihiro 国広	Horikawa hada (pattern of jihada is coarse and visible). Gunome midare is inclined to be notare. This pattern is often seen in his work from the Keicho era. Mizukage is seen.	260	Shizu Kaneuji 志津兼氏, the Naoe Shizu 直江志津 school
A	Kunimichi 国路	Horikawa hada. Hamon is mixed with a rugged pattern, and is the most gorgeous in the Horikawa school. Boshi often becomes a Mishina boshi.	260	Shizu Kaneuji 志津兼氏, Masamune 正宗
C	Kuniyasu 国安	Jihada and nie are rough. O-kissaki is standard.	261	
C	Echigo no Kami Kunitomo 越後守国儔	Hamon line is tight, with a gentle pattern. Mishina boshi.	261	
C	Osumi no Jo Masahiro 大隅掾正弘	Nagasa of katana is usually more than 75 cm. Kissaki is a relatively small chu-kissaki. Midareba looks like suguha.	261	
D	Heianjo Hiroyuki 平安城弘幸	Tanto are common but some katana are extant. Workmanship shows influence of Yamato-den and is similar to work of Masahiro.	261	
B	Kunisada I 初代 国貞	Fine ko-mokume hada. Gunome are round and appear in series of three to five. Ko-maru boshi, relatively long kaeri, near which muneyaki are seen.	264	
C	Kunisuke I 初代 国助	Hamon consists of thick nie and has a wide nioi line. Some choji midare are seen.	266	
C	Kinmichi I 初代 金道	Kyo-yakidashi is seen. Mishina boshi. Many sunagashi are seen.	265	The Naoe Shizu 直江志津 school, Izumi no Kami Kanesada 和泉守兼定
C	Yoshimichi I 初代 吉道	Same as work of Kinmichi. Hamon is inclined to be sudare-ba.	266	
A	Masatoshi I 初代 正俊	Same as work of Kinmichi. Jihada is mixed with considerable itame-hada. Togari-ba and yahazu-ba are seen.	266	Shizu Kaneuji 志津兼氏, Samonji 左文字
D	Hidari Mutsu Kaneyasu 左陸奥包保	Jihada is mixed with masame-hada, particularly around the shinogi. Many sunagashi	267	

	SWORDSMITH(S)	CHARACTERISTICS	PAGE	SIMILAR SMITH(S)
		are seen, as is rugged patterning. Workmanship looks rather like that of Yamato-den.		
A	Yasutsugu 康継	Jihada is coarse. Many copies of famous Koto are seen. Horimono are frequently seen. Workmanship shows influence of the Yamato-den.	261	The Masamune 正宗 school
B	Kotetsu 虎徹	Hamon mixed with hyotan-ba (bottle gourd- or guitar-shaped ha). The thick ashi are composed of nie. Kotetsu boshi.	268	Go Yoshihiro 郷義弘, Sa Yukihide 左行秀
C	Hankei 繁慶	Hijiki hada. The border between the ji and the ha is indistinct. The hamon is not bright. Considerable hadaware are seen.	265	Norishige 則重
E	Munehide 宗栄	Jihada looks like muji-hada. Suguha yaki-dashi are seen. Hamon widens in the monouchi area.	274	Shinkai 真改, Yoshihira 美平
A	The Tadayoshi 忠吉 school	Konuka hada. Hizen boshi (typical ko-maru boshi). This hamon is rarely seen in work of later generations.	263	
A	Naotane 直胤	Uzumaki (whirlpool) hada is seen, as are rough, large nie. There are hard black spots inside the hamon. The hamon is not tight.	301	The Masamune 正宗 school
C	Hosokawa Masayoshi 細川正義	Glittering hada appears in o-itame hada. Sunagashi becomes a large pattern.	301	The Masamune 正宗 school
A	Kiyomaro 清麿	Mokume-hada mixed with running hada. Jihada is rather visible and contains a good deal of nie. Hamon is in uma-no-ha midare or looks like choji midare. There are many kinsuji, inazuma and sunagashi.	303	Samonji 左文字, Shizu Kaneuji 志津兼氏
A	Nobuhide 信秀	Uma-no-ha midare consisting of nioi. Similar to work of Kiyomaro, but has less sunagashi and a gentler pattern. Elaborate horimono often seen.	304	
B	Sa Yukihide 左行秀	Shinogiji is masame-hada. In the hamon, nie is thick and nioi is wide. Long, thick ashi are seen, as are shallow sori and large kissaki. Boshi is ichimai or ko-maru sagari.	302	Go Yoshihiro 郷義弘, Kotetsu 虎徹
Picturesque hamon				
D	Tanba no Kami Yoshimichi 丹波守吉道	Sudare-ba appears, and becomes more standard with later generations.	266	
D	The Later Mishina 三品 school	Kikusui, Fujimi Saigyo.	235	
E	Toshinori 寿格	Tatsuta, Yoshino, Fujimi Saigyo.	299	

GLOSSARY

A

ara-nie Large particles of nie.

ashi (Lit., "leg.") A form of hataraki; thin lines that run across the hamon toward the cutting edge.

ashi naga choji Choji midare with long ashi and nie.

atari A judge's response given in nyusatsu kantei to the correct answer (identification of the swordsmith).

ato-bi ("Added-later groove.") A groove (hi) carved to restore a sword's balance after the blade has been shortened, or to hide a flaw.

ayasugi-hada A surface-grain pattern of curved lines with a wave-like effect; also known as Gassan-hada.

B

Bizen-zori *See* koshi-zori.

bo-bi ("Stick groove.") A long straight wide groove (hi) engraved into a blade.

bonji A form of horimono featuring Sanskrit characters that refer to Buddhist deities.

boshi ("Hat," "cap.") The hamon (temper line) of the kissaki.

bo-utsuri A straight pattern of utsuri; also known as sugu utsuri.

bushi Members of the Japanese warrior class; in the West, often referred to as samurai.

C

chii Second prize in a kantei-kai.

chikei A gleaming black line of nie seen on the ji; of the same composition as kinsuji and inazuma (which are seen on the hamon).

chiri The very narrow wall that remains on one or both sides of a groove engraved into shinogi-zukuri blades. (*See also* kata-chiri; ryo-chiri.)

chirimen-hada Crepe grain pattern; a distinctly visible mokume grain with a clearer steel than is found in patterns that are similar but coarser.

choji abura Clove oil (used in caring for blades).

choji ashi Clove-shaped ashi.

choji midare "Choji" means "clove," and so this term refers to a clove-shaped irregular hamon pattern. The upper part of the midare is somewhat rounded, while the lower part is constricted and narrow.

choji midare komi A choji midare hamon pattern that continues into the kissaki.

choji utsuri Utsuri with a clove-shaped pattern.

chokuto A straight, uncurved sword greater than 60 cm in length; a precursor to the classic Japanese blade. Also known as tachi.

chu-itame Medium-sized itame-hada surface-grain pattern.

chukan-zori *See* mu-zori.

chu-kissaki Medium-sized kissaki; the most prevalent kissaki size.

chu-mokume Medium-sized mokume surface-grain pattern.

chumon-uchi Custom-made swords.

chu-suguha Medium-sized, straight hamon.

D

daimei Substitute signature. A swordsmith's signature chiseled on a sword, with his permission, by his son or students and regarded as equivalent to the real signature.

daisaku Substitute production. Blades produced by students in their teachers' or fathers' style, with full permission, these are often signed by the teacher rather than the student

daisho A pair of swords (specifically, the longer katana and shorter wakizashi) worn by warriors of the Edo period.

desaki nite yoku A judge's response given in nyusatsu kantei to a bid which identifies only a province in which the smith temporarily stayed and worked.

dozen A judge's response given in nyusatsu kantei to a bid which correctly identifies the smith's family (naming a closely-related smith such as a father, son, teacher, or student).

E

eto Ancient calendar based on the Chinese zodiac; often used in the dates inscribed on the nakago.

F

Fudo Myoo Buddhist deity whose image is often featured in horimono, framed in fire.

Fujimi Saigyo ([Priest] Saigyo gazing at Mt. Fuji.) A picturesque hamon depicting Mt. Fuji together with a bamboo hat that suggests an itinerant priest.

fukkoto Shinshinto blades produced using the methods of the Kamakura and Nanbokucho periods.

fukura Bulge of the cutting edge of the kissaki.

fukure A pocket of air in the steel that was not forced out during the forging process and that appears as a blisterlike swelling on the surface of the blade.

fukure yabure Broken fukure; a cavity left in the blade when a blister (fukure) in the steel, formed by a pocket of air during forging, breaks.

fukuro yari ("Bag spear.") A spear with a tang that slips over the haft.

fukusa The handkerchief used to handle blades in sword appraisal.

fukushiki gunome Multiple-gunome hamon pattern, usually mixed with ordinary gunome.

funa-gata ('Boat type.") A type of nakago that bulges strongly outward on the cutting-edge side.

funbari Used to describe a blade which is relatively wide at the bottom, or in which the cutting edge and the back edge curve in opposite directions (both of these cases are more distinctly visible in ubu (blades which have not been shortened). To say that a blade has "no funbari" means that the cutting edge is nearly parallel to the back edge at the bottom area; this is often seen in suriage (shortened) swords.

furisode-gata A type of nakago with strong curvature, seen only on tanto produced during the Kamakura period.

futasuji-bi Two parallel grooves engraved on a blade.

G

gaku-mei Framed signature; in this process, the metal on which a blade's signature is inscribed is excised in a rectangular section, thinned, and then reattached to the reshaped nakago.

Gassan-hada *See* ayasugi-hada.

Gendaito Swords produced after 1876.

gimei False signature; a copy of an authentic signature inscribed on the tang of a blade by another (often inferior) swordsmith.

ginzogan-mei An inscription inlaid in silver by a member of the Honami family of the name of the attributed swordsmith on the shortened tang of a mumei blade.

Goban Kaji Swordsmiths summoned to the palace by retired emperor Gotoba during the Kamakura period to produce swords.

gohei-gata A type of nakago with an equal number of stepped notches on each side.

Goki Shichido (Five home provinces and seven circuits.) The term has historically been used to refer to units of governmental admistration, and to classify swordsmiths by region.

goma-hashi A form of horimono in the shape of the chopsticks which are used on Shinto altars.

gunome A hamon pattern consisting of a series of mounds that look like similarly-sized semi-circles.

gunome ashi Zigzagging ashi.

gunome choji A gunome hamon pattern in which each valley of the gunome is separate and resembles a clove (choji).

gunome midare Irregular gunome.

gyo no kurikara *See* kurikara.

gyo no mune *See* iori-mune.

H

ha The tempered cutting edge of a blade.

ha agari kurijiri A type of nakagojiri with a rounded end like that of kurijiri, but the cutting-edge side of which slants more steeply than the mune side.

habaki The small metal collar that secures the blade in the saya.

habaki-moto The part of the blade that slips into the habaki.

habuchi The border between the ji and the hamon; also known as nioiguchi.

hada *See* jihada.

hada tatsu Jihada is rough or coarse.

hadaware A type of flaw; a crack running length-

wise through the ji that indicates a swordsmith's lack of skill.

hadori The whitening that results from the final polishing of a blade.

hagarami Type of flaw; an oblique crack in the cutting edge.

hagire Type of flaw; a crack that runs at a right angle from the cutting edge toward the hamon.

Haitorei Meiji government's decree in 1876 prohibiting the wearing of swords in public.

hajimi Misty spots in the hamon that can result from repeated grinding or faulty tempering.

hakikake A type of ashi similar to sunagashi, but much shorter and thinner; it appears on the edge of the hamon.

hako midare Box-shaped, irregular hamon pattern.

hamachi See machi.

hamaguri-ba Particularly full hira-niku between the habuchi and the cutting edge; swords with hamaguri-ba were popular in the mid-Kamakura period.

hamon The temper line; the border separating the ha and the hiraji.

ha niku The "meat" (curved surface of the hiraji) between the hamon and the cutting edge.

hasaki The razor-sharp cutting edge of a blade.

hataraki Activities, or workings; distinctive features of the steel seen inside the hamon and the ji.

ha-watari See nagasa.

hi A groove engraved on the shinogiji or the hiraji.

higaki yasuri A file-mark pattern formed when sujikai and saka sujikai cross.

hijiki hada See matsukawa hada.

hira See hiraji.

hiraji Surface of the blade between the shinogi and the hamon; also known as the hira.

hira mune See kaku mune.

hira-niku The amount of "meat" seen in the hiraji—in other words, the fullness of the curve of the hiraji; this decreases after a sword has been polished many times.

hira-zukuri A sword structured without shinogi or yokote; a sword which is nearly flat on both sides.

hiro-suguha Wide, straight hamon.

hisaki Top of the hi.

hisaki agaru ("Rising hisaki.") A groove (hi) that ends near the ko-shinogi.

hisaki sagaru ("Descending hisaki.") A groove (hi) that ends below the yokote.

hitatsura A type of midare; gunome or notare midare with tobiyaki scattered throughout the blade.

Hizen boshi Standard ko-maru boshi, uniform in width from yokote to tip.

Hizen hada See konuka hada.

hoko A type of spear thought to be the forerunner of the yari.

Hokurikudo See Goki Shichido.

hongoku nite yoku A judge's response given in nyusatsu kantei to a bid which correct identifies the swordsmith's province alone, and does not correspond to any of the categories atari, dozen, kuni iri yoko, or tori yoku.

hon-zukuri See shinogi-zukuri.

horimono Blade engraving.

hoso-suguha Narrow, straight hamon.

hyotan-ba Bottle gourd–or guitar-shaped hamon.

hyotantetsu See nanbantetsu.

I

ichimai A fully-tempered kissaki; usually, however, the outline of a boshi is still discernible in the kissaki.

ichimonji See kiri.

ichimonji kaeri A straight, horizontal turn-back; a type of boshi in which the top is flattened off and the kaeri is short.

ikubi kissaki ("Wild boar–neck kissaki.") A kissaki that is shorter than it is wide.

imozuru ("Potato runners.") Thick inazuma appearing in the habuchi and inside the hamon; a form of activity often seen in Satsuma swords.

inazuma ("Lightning.") A brightly shining crooked black line that resembles a flash of lightning, appearing inside the hamon near the habuchi, and composed of nie. (See also kinsuji.)

iorimune "Iori" means "roof," and this type of mune resembles an A-frame house, with two surfaces. Also known as gyo no mune.

ippon nyusatsu A nonstandard type of nyusatsu kantei in which only one bid may be made in an effort to identify the swordsmith.

iriyama-gata A type of nakago in which the cutting-edge side forms an acute angle with the bottom end of the shinogi line, while the other side goes straight, or at a slight upward angle, to the mune.

itame-hada Surface-grain pattern which resembles the annual rings of a tree.

ito suguha String-like, straight hamon.

iya A judge's response given in nyusatsu kantei to a bid which does not correspond to any of the categories atari, dozen, kuni iri yoku, or tori yoku.

iya en A judge's response given in nyusatsu kantei, meaning that a smith is somehow related to the correct smith, but works in a different style.

iya suji A judge's response given in nyusatsu kantei, meaning that an answer is incorrect, but that the smiths are somehow related.

J

ji The area between the shinogi and hamon, also known as the hira or jihada. With polishing, this area becomes blue-black. Its surface is cured, and referred to as "niku" (lit., "meat"), a term which can be modified by the adjectives "full," "scarce," or "not full."

ji zukare A type of flaw; steel which is worn out, usually as a result of repeated polishing; typically the steel has become rougher, coarser, and discolored.

jidai chigai A judge's response given in nyusatsu kantei to a bid of an incorrect period.

jidai chigai iya A judge's response given in nyusatsu kantei to a bid of an incorrect period, province, and school; regarded as the worst possible response a participant may receive.

jidai chigai tori yoku A judge's response given in nyusatsu kantei to a bid of the correct kaido group but an incorrect period.

jidai chigai yoku A judge's response given in nyusatsu kantei to a bid of the correct province but an incorrect period.

jifu utsuri Scattered spots of utsuri; differs from sumigane in that it is not plain, and that it is found all over the blade's surface.

jigane The steel from which Japanese swords are made.

jihada The surface-grain pattern; the pattern of the surface texture of the steel produced in the forging process.

jin'i Third prize in a kantei-kai.

ji-nie Nie seen in the ji, and composed of the same type of particles that make up the hamon. Seen to some extent in all swords.

Jizo A boshi that resembles the profile of a statue of the priest Jizo; this boshi is sharply constricted about halfway up, and has a rounded top.

jo-ge ryu A form of horimono featuring "ascending and descending" dragons.

Jokoto Ancient swords; straight swords produced prior to the development of the curved blade known as the nihonto.

josun Standard length. In the case of swords, about 70 cm. In the case of tanto, about 26 cm.

juka-choji midare Multiple, bag-shaped choji hamon pattern.

jumonji yari A cross-shaped spear.

juyo bunkazai Art works and antiquities that have been designated as Important Cultural Assets, in keeping with the Cultural Properties Law (bunkazai hogoho) enacted in 1950.

K

kaen ("Flame.") A type of boshi that looks as if it is on fire, due to the presence of hakikake and nie kuzure.

kaeri The part of the boshi that turns back toward the blade's mune side.

kaido The Goki Shichido (main roads) grouping to which a smith belongs.

kaiken A small dagger kept concealed in one's clothing.

kakedashi Type of flaw; a hamon that extends all the way to the cutting edge.

kakikudashi-mei An inscription that includes the swordsmith's address and signature, and the date of forging, all engraved on one side of the tang.

kakinagashi A tapered groove that extends past the machi, but not as far as the butt end of the tang.

kakitoshi A groove that has no end, and that extends all the way to the butt end of the tang.

kakudome A square groove end; usually located within 3 cm of the machi.

kaku mune A completely flat back edge seen only on ancient swords; also known as hira mune.

kamasu kissaki A kissaki with a fukura which is hardly rounded at all, resembling the head of a saury pike.

kama yari A spear with a sickle-like branch off the blade.

kanmuri-otoshi-zukuri A type of sword structure in which the lower half of the blade is in a standard shinogi-zukuri style, but the shinogiji is cut at a slant, making the blade similar to those in the shobu-zukuri style.

kantei Sword appreciation; authentication and

attribution of blades based on the study of their physical characteristics.

kantei-kai Sword appreciation gatherings; a unique form of competition in which participants attempt to determine the swordsmith who produced a blade merely by studying the blade's visible characteristics; the nakago is kept covered.

karakusa Arabesque pattern.

karakusa bori Engraving done in an arabesque pattern.

karasuguchi Type of flaw; a crack in the kissaki that runs from the cutting edge toward the boshi.

kasane Thickness; specifically, the thickness of the mune. (*See also* motokasane; sakikasane.)

kata-chiri Chiri that remains only on the mune side of a groove.

katakiriha-zukuri A type of sword structure in which one side is hira-zukuri or shinogi-zukuri, and the other is kiriha-zukuri.

katana Curved blades longer than 60 cm, worn thrust through the belt with the cutting-edge side facing upward; also frequently used to refer to the Japanese sword in general.

katana-bi A long, straight, wide groove (hi) engraved on a blade in hira-zukuri.

katana-bukuro The cloth case in which a sword is stored.

katana-mei A signature that appears on the outer side of the tang of a katana, wakizashi, or tanto when the blade is worn in the katana style (with the cutting-edge side facing upward). (*See also* tachi mei.)

katanagari Programs of weapon confiscation implemented by Toyotomi Hideyoshi during the sixteenth century.

kataochi gunome A gunome hamon pattern in which the top of the gunome follows a straight horizontal line and then slants down from the peak to the valley; also known as nokogiriba (sawtooth pattern).

katte agari yasuri A pattern of filing marks that slants downward to the left.

katte sagari yasuri A pattern of filing marks that slants downward to the right.

kawazuko choji midare A tadpole-shaped choji hamon pattern.

kazunoko nie ("Herring roe nie.") Large, somewhat scattered nie.

kazu-uchimono Mass-produced blades.

ken The term means "sword," and is also used to

refer to a horimono which is carved in the form of a sword. Several different types of such horimono are seen: the suken (straight, old-style sword), the ken with tsume (claw), the ken with sankozuka (vajra thunderbolt hilt), and the ken with bonji (Sanskrit characters).

ken A straight, double-edged blade used as an implement of esoteric Buddhism rather than as a weapon.

kengyo A sword-shaped nakagojiri; this type comes to a point at the center, and both of its bottom lines are straight.

ken-maki-ryu *See* kurikara.

kenukigata tachi A sword the blade and handle of which are made of a single piece of steel; the center of the hilt is pierced.

kesho yasuri Cosmetic file marks; a combination of patterns located at the suridashi.

kijimomo-gata A type of nakago in which the cutting-edge side of the nakago slopes inward at the halfway-point, and the nakago remains narrow to the tip.

kikusui A decorative hamon pattern that resembles a chrysanthemum floating on a stream.

kinnoto Royalist's sword; these were used or owned by samurai who supported a doctrine of revering the emperor and expelling foreigners which was developed during the late Edo period. Has a wide mihaba, large kissaki, and thick kasane. Its nagasa is as great as 90 cm, and its sori is very shallow. This type of sword, however, was too large and heavy to be effective as a weapon, and soon disappeared.

kinpun mei Appraiser's inscription in gold lacquer of the name of the attributed swordsmith.

kinsuji ("Gold stripe.") Short, straight, shiny black line appearing inside the hamon near the habuchi, composed of nie. (*See also* inazuma.)

kinzogan-mei An inscription inlaid in gold by a member of the Honami family of the name of the attributed swordsmith on the shortened tang of a mumei blade.

kiri A type of nakago whose end is cut off squarely in a straight line; also known as ichimonji.

kiriha-zukuri A sword structured with a line (essentially equivalent to the shinogi) running quite close to the cutting edge, and with a very wide shinogiji. Apart from later imitations, this structure is seen only in ancient blades.

kiritsuke mei A memorial inscription, usually noting the owner and the history of the sword.

kiri yasuri Horizontal file marks, filed from the

cutting-edge side toward the back side; the style most commonly used in filing the tang.

kissaki Tip of the sword; the fan-shaped part of the blade above the yokote and ko-shinogi.

kissaki-moroha-zukuri A sword structured with the kissaki sharpened on both edges, and with the lower portion of the blade shaped differently from the kissaki; also known as Kogarasu-maru-zukuri.

ko-ashi Small ashi.

kobuse A type of blade construction in which shingane (core steel) is sandwiched between kawagane (jacket steel), or kawagane is worked around shingane. The most common type of blade construction.

kobushigata choji Fist-shaped choji hamon pattern.

ko-choji midare Small, clove-shaped, irregular hamon pattern.

ko-dachi Short tachi; blades of 60 cm or less.

kogarasu-maru-zukuri See kissaki-moroha-zukuri.

ko-gunome Small gunome hamon pattern.

koiguchi Scabbard mouth.

ko-itame Small itame hada.

ko-kissaki Small kissaki.

kokuho Art works and antiquities that have been designated as National Treasures, in keeping with the Cultural Properties Law (bunkazai hogoho) enacted in 1950.

ko-maru agari ("Ascending small circle.") Type of ko-maru boshi in which the top of the rounded part is close to the kissaki. The upper area of the boshi temper line is narrower than the lower.

ko-maru sagari ("Descending small circle.") a type of ko-maru boshi in which the top of the rounded part is some distance from the kissaki. The upper area of the boshi temper line is wider than the lower.

ko-maru ("Small circle.") A type of boshi that runs from the yokote parallel to the kissaki. The top curves around and turns back toward the mune, describing an arc.

ko-midare Small-patterned, irregular hamon.

ko-mokume Small mokume grain pattern.

ko-nie Small particles of nie.

konohatetsu See nanbantetsu.

ko-notare Notare hamon with waves of small amplitude.

konuka-hada Rice bran surface grain pattern; similar to nashiji but a little coarser and with less ji nie. Only used to describe swords from Hizen province; also known as Hizen hada.

koshi ("Waist.") The point halfway between the valley (tani) and the yakigashira in an irregular hamon pattern.

koshiba A partially irregular pattern (midare) located just above the hamachi, and much wider at the base than in the upper area.

koshibi A short groove (hi) with a rounded top which is engraved on the lower part of the blade, close to the tang, usually seen only on the front side of a blade (the side which faces out when the blade is worn).

ko-shinogi Diagonal line that separates the kissaki from the shinogiji; also extends the shinogi to the mune in the kissaki area.

koshi-no-hiraita midare A hamon pattern similar to notare; the valleys are gentler than the peaks. Often mixed, in the upper area, with choji or gunome.

koshi-zori ("Waist curvature.") Type of curvature in which the deepest point of the blade's curve is near the munemachi; also called Bizen-zori.

Koto Old swords; used to refer to blades forged between the mid-Heian and Muromachi periods (through 1595). During Koto times, five distinctive styles of sword production arose in the five provinces of Yamashiro, Yamato, Bizen, Soshu, and Mino. As these styles were adopted in other areas of the country and grew in importance, the term "Gokaden" came to indicate the five traditions, becoming an alternative term for "Koto swords."

ko-wakizashi Short wakizashi.

kuichigaiba Lines in a hamon which are not completely aligned, and where the nie or the nioi appears to have been nibbled away.

kuichigai-bi Two thin grooves (hi) running halfway down the blade; the top groove ends first, while the bottom one continues and then surrounds the shorter one.

kuni iri yoku A judge's response given in nyusatsu kantei to a bid which correctly identifies the period and province, but not the family, of the swordsmith.

kurijiri ("Chestnut end.") A type of nakago with a rounded end; the style most commonly seen in all periods.

kurikara Form of horimono featuring a dragon winding around a sword. There are three different types of kurikara: shin (realistic), gyo (simplified), and so (stylized). Also known as ken maki ryu.

kuwagata A type of horimono carved in a shape like that of the letter *W* and representing the front crest of a helmet.

Kyo-choji midare Choji midare based on suguha, with yakigashira that are inclined to be flat.

Kyo-zori *See* torii-zori.

M

machi Notches that divide the blade proper from the tang. The notch on the cutting-edge side is called the hamachi; that on the mune side is the munemachi.

machi-okuri Moving the machi upward; the length of the blade is shortened by moving both the munemachi and the hamachi upward on the blade without actually shortening the nakago. The sword's overall length does not change.

majiwarimono *See* wakimono.

makuri A type of blade construction in which a block of shingane (core steel) is placed on a block of kawagane (jacket steel), and the two blocks are then folded in half, to form a total of four layers.

marudome Rounded groove end; usually located within about 3 cm of the machi.

maru mune Rounded back edge; quite rare.

masame-hada Straight surface-grain pattern.

Masamune Juttetsu Masamune's Ten excellent students. Go Yoshihiro, Norishige, Kaneuji, Kinju, Rai Kunitsugu, Hasebe Kunishige, Osafune Kanemitsu, Chogi, Samonji, and Sekishu Naotsuna.

matsubasaki *See* munesaki.

matsukawa hada Readily visible surface-grain pattern resembling the bark of a pine tree; a type of o-mokume or o-itame with thick chikei. Also known as hijiki- (a variety of algae) hada.

mei Signature, usually engraved on the tang.

meibutsu Swords designated as masterpieces. Examples include the Three great swords (Tenka Go Ken), the Three great spears (Tenka San So), and works of the Ten excellent students of Masamune (Masamune Juttetsu). The term Kyoho Meibutsu refers to swords that were designated as such by Shogun Yoshimune (this category does not include the works of the ten students of Masamune).

mekugi Retaining peg used to hold the tang of a sword in the hilt.

mekugi ana Hole in the nakago for the retaining peg used to hold the tang of a sword in the hilt.

mekugi nuki Hammer-like tool used to remove the mekugi.

midare komi Boshi pattern in which the irregular pattern of the hamon continues into the kissaki.

midareba Irregular hamon; all hamon but suguha are midareba.

midare utsuri Irregular utsuri.

mihaba Width of the blade; the distance from the back ridge to the cutting edge. (*See also* motohaba; sakihaba.)

Mishina boshi A boshi typical of the Mishina school; the line of the boshi runs straight from the yokote to the top, which inclines towards a point. The kaeri is a little wider than usual.

mitsukado The point at which the yokote, shinogi, and ko-shinogi meet.

mitsumune A mune with three surfaces; typical of Soshu blades and Yamashiro tanto.

mizukage A whitish reflection that appears in the machi area, running at an angle of 45 degrees from the edge of the nakago to the mune; often regarded as conclusive evidence that a blade has been retempered.

mokume-hada Surface-grain pattern similar to the annual growth rings visible in a cross-section of a tree. The grain of most Japanese swords can be said to be mokume-hada.

monouchi The part of the sword used to hit or cut. In tachi and katana, this is an area approximately 9 cm long, beginning just below the yokote. In wakizashi and tanto, the location of the mono-uchi is proportionate to blade length.

moroha-zukuri A double-edged sword; unlike the ken, each side is different.

motohaba Bottom width; the width of the blade at the machi.

motokasane Thickness at the munemachi.

muji hada Plain, or grainless, surface. In this type, the grain is difficult to discern, but in fact it can be brought out with polishing; blades only *appear* to be without grain. Often seen on Shinshinto blades.

mukansa The most skilled smiths or polishers may be awarded this designation, which means that they are officially above the regular ranking systems.

mumei Without signature, either because a blade was not originally signed, or because the signature was lost when the blade was shortened.

mune Back edge of the blade, opposite the cutting edge, extending from the tip of the kissaki to the beginning of the nakago.

munemachi *See* machi.

munesaki Tip of the mune at the kissaki; also known as matsubasaki ("pine needle tip").

muneware Type of flaw; a lengthwise crack in the mune, reflective of a swordsmith's lack of skill.

muneyaki A tempered spot or line seen on the mune.

mura nie Uneven nie; irregular particles, much larger than most nie, that partially intrude upon the hamon.

mu-zori ("No curvature.") Used only to describe tanto that have no curvature; also known as chukan-zori.

N

nagamaki Similar to naginata blades, but more standard in shape. Most nagamaki were shortened, and it is rare to find one in its original condition.

nagamaki (or naginata) naoshi A nagamaki or naginata blade that has been reshaped for use as a katana or wakizashi.

naga-mei A lengthy signature; often includes an address, middle name, and title.

nagasa Blade length; a straight line measured from the munemachi to the tip of the kissaki. Also known as ha-watari or hacho.

naginata A long-hafted sword wielded in large, sweeping strokes. Typically has a wide blade with a large point, a long tang, and no yokote. Often has a distinctive carved groove.

naginata-hi A short bo-bi with the top finished in the direction opposite that of katana-bi; the groove has a rounded foot and is usually accompanied by soe-bi.

nakago The tang or portion of a sword blade that extends below the hamachi and munemachi.

nakagojiri The butt end of the tang.

nanbantetsu A Western-style steel introduced to Japan by the Dutch and Portuguese in the sixteenth century which later proved to be inferior to the native steel for use in sword production; also known as hyotantetsu or konohatetsu.

Nankaido One of the Goki Shichido.

nashiji-hada A surface-grain pattern similar in appearance to the flesh of a sliced pear; essentially a fine, dense ko-mokume grain with surface nie throughout.

nenrin-hada Pattern similar to the annual rings of a tree.

nezumi ashi ("Rat's feet.") Very small ashi.

nie Small, distinct particles of the crystalline effect known as martensite (or austenite, pearlite, or troostite) in Western metallurgical terms; visible to the naked eye, they look like twinkling stars.

nie-deki A hamon consisting primarily of nie; also known as nie-hon'i.

nie-hon'i See nie-deki.

nie hotsure Frayed nie; nie seen along the habuchi that resemble the frayed edge of a piece of cloth.

nie kogori The term "kogori" means to "gel" or "coagulate." "Nie kogori" refers to nie that have massed together and look like white clouds or nebulae.

nie kuzure Abundant nie that are scattered throughout the kissaki, with the result that the boshi is not distinctly formed.

nie sake Torn nie; bright black nie seen inside the hamon close to the habuchi, in a part of the hamon that looks like a tear or rip.

nie utsuri Utsuri consisting of nie.

Nihon Bijutsu Token Hozon Kyokai Japanese Art Sword Conservation Association (abbreviated as NBTHK).

nihonto Japanese sword; a curved blade with shinogi.

niji-mei Signatures consisting of just two kanji characters.

nijuba A second line of hamon, consisting of nie or nioi and appearing parallel to the main hamon.

nikudori Shape, or fullness of the curve, of the surface of the hiraji.

nioi Particles of the crystalline effect known as martensite (or austenite, pearlite, or troostite) in Western metallurgical terms; no individual particles can be distinguished, and the entire effect is like a wash of stars.

nioi-deki A hamon consisting primarily of nioi; also known as nioi-hon'i.

nioigire A hamon that is incomplete, as if part of it has been left out; usually caused by faulty tempering or damage to a blade by fire.

nioiguchi See habuchi.

nioi-hon'i See nioi-deki.

nioi kogori Lumps of nioi.

nioi kuzure May be considered a type of ashi, but is separate from the main hamon line, and scattered inside the hamon.

nokogiriba See kataochi gunome.

notare Gently waving hamon pattern.

notare komi Type of boshi similar in shape to a portion of the notare of the hamon; the line of the boshi sags halfway down.

notare midare Irregular notare.

nugui-gami Japanese paper used in caring for blades.

nyusatsu A bid made at a kantei-kai.

nyusatsu kantei *See* kantei-kai.

O

o-choji midare Large, clove-shaped, irregular hamon pattern.

o-dachi Long tachi; blades longer than 90 cm.

o-gunome Large gunome hamon pattern.

o-hada A jihada with an enlarged pattern; this term is used for any enlarged jihada, no matter what the surface-grain pattern. Thus, "mokume-hada with o-hada" means that the jihada is mokume-hada, and that at least some of the grain is enlarged.

o-itame Large itame grain pattern.

o-kissaki Large kissaki.

o-maru A boshi in the shape of a large semicircle; much narrower than the ko-maru style. The top sweeps around and turns back toward the mune in a large arc.

o-midare Large-patterned irregular hamon.

omiyari Long spear.

o-mokume Large mokume grain pattern.

omote-mei Inscription appearing on the front of a blade (the side which faces out when the blade is worn). Often includes not only the swordsmith's signature, but also his address and title.

o-notare Notare hamon with waves of large amplitude.

orikaeshi-mei Turned-back signature; in this type, the metal on which the blade's signature is inscribed is left attached to the nakago, and is thinned, and then bent down and folded around to the opposite side; the signature thus appears to be upside-down.

oroshi Slope of the mune, from the iori to the start of the shinogiji.

Osaka boshi Ko-maru sagari boshi.

osoraku-zukuri A sword structured with a very large kissaki, longer than the lower part of the blade.

o-sujikai yasuri A pattern of diagonal file marks which slant even more steeply than those of su-jikai.

o-suriage nakago A "greatly shortened" nakago whose signature has been lost; in distinction to the suriage nakago, in which the nakago is merely reshaped, this type is formed from steel that was originally part of the blade.

o-wakizashi Long wakizashi.

R

rendai Type of horimono featuring a lotus-flower dais for an image of Buddha.

ritsuryo Codes of laws and ethics based on a Chinese model, used by the imperial court prior to the Kamakura period.

ryo-chiri Chiri that remain on both sides of a groove.

ryu Form of horimono featuring a dragon.

S

sabigiwa ("Rust border.") The boundary between the habaki-moto and the file marks.

sabitsuke nakago An artificially rusted nakago.

Sadamune Santetsu Sadamune's Three excellent students. Nobukuni, Osafune Motoshige, and Hojoji Kunimitsu.

sai ha A retempered blade; the blade's original characteristics are usually completely lost with retempering.

Saikaido One of the Goki Shichido.

saka ashi Oblique ashi.

saka choji midare Oblique choji midare hamon pattern.

saka-midare An irregular hamon with an oblique pattern.

saka o-sujikai yasuri A pattern of filing marks that slant steeply upward to the right.

sakihaba Top width; the width of the blade at the yokote.

sakikasane ("Tip thickness.") The thickness of the blade at the yokote.

saki-zori ("Upper curvature.") Type of curvature in which the deepest point of the curve is in the upper area.

sanbon nyusatsu Standard type of nyusatsu kantei, in which three bids may be made, the latter two incorporating the information given in the judge's responses.

sanbon-sugi A type of togari gunome hamon pattern resembling a stand of three cedar trees.

San'indo One of the Goki Shichido.

sanjimei Signatures consisting of three kanji characters.

sanjuba Triple lines of hamon, consisting of nie or nioi; two slighter lines appear parallel to the main hamon.

sankin kotai Regular, formal, and compulsory visits made to Edo by each daimyo and his retinue,

in a custom instituted by Tokugawa Ieyasu as a means of keeping the power of provincial warlords in check.

sankozuka *See* ken.

sansaku boshi ("Three swordsmiths boshi.") The particular boshi seen in work by Osafune Nagamitsu, Kagemitsu, and Sanenaga; a type of ko-maru with a suguha temper line that continues straight across the yokote into the boshi; the boshi then starts its ko-maru above the yokote.

San'yodo One of the Goki Shichido.

sasaho yari A spear whose head is shaped like a bamboo leaf.

saya Scabbard.

Seii tai shogun ("Barbarian-quelling general.") More familiarly, simply "shogun." Prior to the establishment of military government in the Kamakura era, the title was essentially a temporary commission, assigned when it became necessary to lead an army against some specific military threat.

Sengoku daimyo General term used for the powerful local lords who displaced the military governors appointed by the Muromachi shogunate in the mid-fourteenth century. As these lords increased in political power, they began to fight amongst themselves for regional control, but they were unable to establish a centralized power structure, and were eventually subdued by the two military leaders who unified the country, Oda Nobunaga and Toyotomi Hideyoshi.

sensuki yasuri Plane-drawing pattern; a style of filing that is finished with a sen (a tool similar to the plane used to shave iron). The resulting file marks show irregular, vertical traces.

Shikkake-hada A pattern in which mokume-hada appears along the shinogi, and masame-hada near the hamon.

shinae Type of flaw; cracks or wrinkles running crosswise through the ji or the shinogiji.

shin no kurikara *See* kurikara.

shinobi ana A second peg hole, located nearer the nakagojiri, often seen on the tangs of unaltered tachi.

shinogi The ridge along the side of the blade, between the cutting edge and the mune, that extends from the yokote to the nakagojiri.

shinogiji The flat surface between the shinogi and the mune.

shinogi-zukuri A sword structured with the shinogi quite close to the mune, and having yokote and sori; also known as hon-zukuri.

Shinsakuto Contemporary swords, forged by smiths who are still living.

Shinshinto ("New new sword.") Blades produced from the late eighteenth century through the time of the Haitorei decree in 1876.

Shinto ("New sword.") Blades produced between 1596 and 1781. During Shinto times, some swordsmiths carried on the traditions of the Koto-times' Gokaden while also developing a new forging style known as the Shinto tokuden tradition. As the period progressed, most smiths adopted the Shinto tokuden tradition.

shirake utsuri Whitish utsuri, with an indistinct pattern.

shobu-hi Iris leaf–shaped groove (hi) engraved into a blade.

shobu-zukuri A sword structured similarly to the shinogi-zukuri, but without yokote.

Showato Blades produced between 1926 and the end of World War II.

shumei Red lacquer inscription made by an appraiser.

soe-bi A second smaller groove engraved alongside the bo-bi.

so no kurikara *See* kurikara.

sori Curvature of the blade; the longest horizontal distance from the back ridge to the line of the nagasa.

sotoba-gata A type of tang that is approximately uniform in width from top to bottom, with a pointed base.

sudare-ba A hamon pattern based on suguha or shallow notare that looks like the sweeping strokes of a broom.

sugata Shape of the sword as a whole; the sugata is a good indicator of the period in which the blade was produced.

suguha A straight hamon.

sugu utsuri *See* bo utsuri.

sugu yakitsume A straight yakitsume boshi pattern.

sugu yari *See* suyari.

sujikai yasuri A pattern of diagonal file marks on the tang that slants more steeply than does katte sagari yasuri.

suken *See* ken.

sumigane Plain dark spots seen on the ji that are quite different from the surrounding surface pattern in terms of both color and grain.

sunagashi ("Stream of sand.") Nie particles that sometimes appear inside the hamon, near the habuchi and parallel to the cutting edge, resem-

bling the traces left behind by a broom swept over sand.

sunnobi tanto Tanto of a greater length than is standard. (*See also* josun.)

suriage nakago A shortened nakago.

suridashi The point at which file marks begin.

suyari A straight, double-edged spear.

T

tabagatana ("Bundled swords.") Mass-produced blades sold in bundles.

tachi (大刀) A straight sword produced in ancient times, this precursor to the classic Japanese blade is over 60 cm in length, and is not curved.

tachi (太刀) A curved sword with a blade longer than 60 cm. It was worn hanging suspended from the belt with the cutting edge facing the ground, and produced primarily in Koto times (prior to 1596).

tachi-mei A signature carved on the side of the tang that faces away from the wearer when the blade is worn in the tachi style (with the cutting edge facing downward). (*See also* katana-mei.)

Taima-hada Itame-hada which tends to become masame-hada toward the kissaki.

takanoha yasuri ("Hawk feather filing.") A filing pattern in which the back portion of the tang is filed slanting downward and to the right, while the front is filed in the opposite direction.

takenoko-zori ("Bamboo-shoot curvature.") A term used to describe uchi-zori tanto whose fukura is virtually not rounded at all.

tama A roundish tempered spot separate from the main hamon, occasionally seen within the ji.

tamahagane Native Japanese steel. (*See also* nanbantetsu.)

tameshi-mei Inscription commemorating the results a cutting test; usually chiseled or inlaid with gold.

tanagobara-gata A type of nakago in which the upper part bulges and then gently tapers into the narrow lower section.

tani ("Valley.") The lowest point of the midare.

tanto Blades shorter than 30 cm, with a standard length of about 26 cm.

Tatsuta A picturesque hamon that depicts a maple leaf floating on the Tatsuta River.

te-hoko A hand-held spear.

ten'i First prize in a kantei-kai.

Tenka Go Ken (Five swords famous throughout the country.) These are the Juzumaru Tsunetsugu,

Mikazuki Munechika, Dojigiri Yasutsuna, Odenta Mitsuyo, and Onimaru Kunitsuna.

tobiyaki Tempered spots within the ji that are separate from the hamon.

togari-ba Tapered midareba.

togari gunome A gunome hamon pattern in which the peaks of the gunome are tapered and orderly.

Tokaido One of the Goki Shichido.

token-kai Sword study groups.

tome Bottom of a groove (hi).

toran-midare A hamon pattern that resembles large, surging waves.

torii-zori Type of curvature in which the curve is deepest at the center; also known as Kyo-zori.

tori yoku A judge's response given in nyusatsu kantei to a bid which correctly identifies the kaido group, but not the family, province, or school.

Tosando One of the Goki Shichido.

toshin The blade as a whole.

tosu Short blades which are a type of jokoto generally similar in shape to kogatana (small knives).

tsuchidori *See* tsuchioki.

tsuchime Hammered marks; an uneven regular surface created by leveling and finishing the tang with a hammer.

tsuchioki Clay coating applied to the blade during the tempering process; the style of application determines the pattern of the hamon.

tsugi nakago A grafted nakago; one in which the original tang is replaced with one (usually inscribed) from another blade.

tsuka Hilt.

tsuki-no-wa Type of flaw; a crescent-shaped crack inside the boshi.

tsukurikomi Styles of sword structures.

tsume *See* ken.

tsure-bi A second, thinner groove (hi) that extends to the top of the bo-bi.

tsurugi Symmetrical, double-edged blade designed to be used as a thrusting weapon.

U

ubu nakago Original nakago; one that is still shaped as it was first created.

uchigatana Blades typically produced during the Muromachi period, which are deeply curved towards the top, and wielded with one hand.

uchiko Finely powdered polishing stone used to

remove oil from the surface of a blade; a small bag full of uchiko is attached to a small stick, and then used like a hammer to powder the blade.

uchinoke Similar to short nijuba, but resembling crescent moons; these appear in the ji, near the habuchi.

uchi-zori ("Inward curvature.") A curve in the direction opposite that of other sori—in other words, toward the cutting edge.

uma-no-ha midare Horse teeth–shaped, irregular hamon pattern.

umegane A cavity left by a broken fukure which is filled or repaired using the steel of another blade.

u-no-kubi-zukuri ("Cormorant's neck structure.") A sword structured similarly to kanmuri-otoshi-zukuri except that the shinogiji is slanted only in the middle, while the lower part and the kissaki are normal.

ura-mei Inscription appearing on the back of a blade (the side which faces in when the blade is worn). Usually consists of a date, the name of the person who ordered the sword to be made, and other information.

utsuri A misty reflection seen on the ji and the shinogiji, regardless of the type of surface grain; usually made of a steel softer than the rest of the blade's surface.

uzumaki-hada A whirlpool-shaped surface-grain pattern.

W

wakimono Swords produced by smiths who do not belong to any particular swordmaking tradition. During Koto times there were smiths whose workmanship did not correspond to any of the Gokaden, and others who mixed two or three traditions; both are known as wakimono. Also known as majiwarimono.

wakizashi Blades longer than 30 cm and shorter than 60 cm.

warabite no tachi A wide, thick, relatively short sword in which the blade and hilt are one continuous piece of steel.

wazamono Very sharp swords. Yamada Asaemon, who is well known as a tester of the sharpness of swords, ranks various wazamono in his book *Kaiho Kenjaku*, published in the Edo period (1815).

Y

yahazu midare Dovetail- or fishtail-shaped midare in an irregular pattern.

yakemi Blades that have lost their hamon.

yakidashi The exact point at which the hamon begins, below the hamachi.

yakigashira The upper part of an irregular hamon pattern, near the mune.

yakiire The process of heating and then quenching a blade, to create the cutting edge.

yakikuzure A deformed hamon, or deformed part of a hamon.

yakiotoshi A hamon that drops to the cutting edge before reaching the hamachi.

yakitsume A type of boshi with no turn-back; the boshi goes directly to the mune.

yakumo-hada A surface grain pattern that resembles a mass of clouds; this type is remarkably large, and has thick chikei.

yari Spear. The tang is usually inserted into the haft.

yasurime Pattern of file marks on the tang.

yo A type of ashi, separate from the main hamon line, which appears scattered inside the hamon; it resembles tiny footprints.

yokote The line running at a right angle to the cutting edge which divides the kissaki from the rest of the blade.

yoko yasuri *See* kiri yasuri.

yoroidoshi Dagger used to stab an enemy while grappling at close quarters.

Yoshino A picturesque hamon representing cherry blossoms floating on the Yoshino river.

Yoshino-gami Very thin Japanese paper used to spread oil over a blade, to prevent rust.

yubashiri A spot or spots where nie is concentrated on the ji.

Z

zaimei ("Having a signature.") Blades that still bear the original signature.

zuryo-mei Titles given to swordsmiths by the imperial court, such as Kami, Suke, or Daijo.

INDEX